Reading the Contemporary

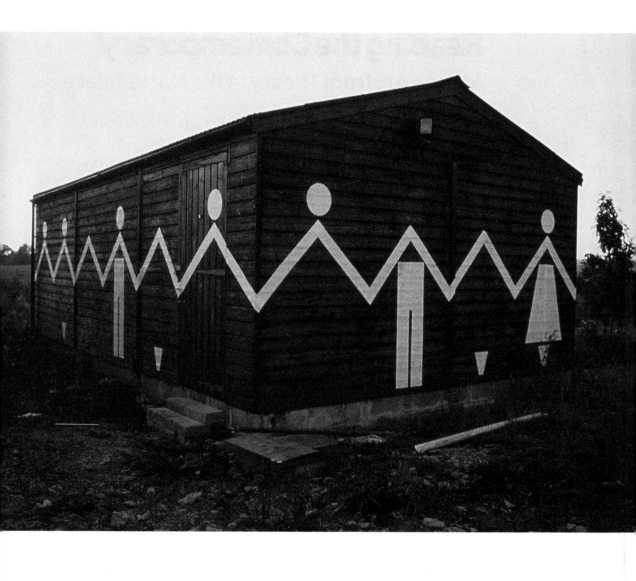

Reading the Contemporary
African Art from Theory to the Marketplace

Edited by Olu Oguibe and Okwui Enwezor

Published by the
Institute of International Visual Arts (inIVA), 1999
Kirkman House
12/14 Whitfield Street
London W1P 5RD

ISBN 1 899846 21 2

A catalogue record for this book is available from
the British Library.

Edited by Olu Oguibe and Okwui Enwezor
Produced by Victoria Clarke
Copy-edited by Melissa Larner
Designed by Glenn Howard
Production co-ordinated by Uwe Kraus
Printed in Italy

Every effort has been made to trace all copyright holders,
but if any have been inadvertently overlooked, the publisher
will be pleased to make the necessary arrangements at
the first opportunity.

This publication has been made possible by the generous
financial support of the Arts Council of England and
London Arts Board.

Front cover:
Yinka Shonibare
Diary of a Victorian Dandy:
14.00 hours, 1998 (detail)
C-type print, series of five
183 x 228 cm
Commissioned by inIVA
Courtesy the artist and
Stephen Friedman Gallery,
London

Frontispiece:
Mary Evans
Ring-a-Rosie, 1995
Shave International Artists
Workshop, Somerset
Courtesy the artist

Acknowledgements

We would like to thank all the authors represented in this volume for their generous co-operation and permission to reprint their essays. Our gratitude also goes to Ann Barrett, Lehni Davies, Lauri Firstenberg, Chika Okeke, Julia Risness, Leilani Roosman and Candy Stobbs for their assistance and to Melissa Larner who copy-edited the texts. Thanks also to the management and staff of the Rockefeller Study and Conference Centre in Bellagio, Italy where work on this book was concluded.

Thanks are due to the following for permission to reprint previously published pieces: *African Arts, Artforum, Atlantica,* Autograph, British Film Institute, *Editions Revue Noire,* Museum for African Art (formerly The Center for African Art), James Currey Publishers, *Nka: Journal of Contemporary African Art,* Indiana University Press, Oxford University Press, *Ten .8, Third Text* and University of California Press.

Finally, we would like to thank all the individuals and institutions who supplied and granted us permission to reproduce images in this volume, with special thanks to: Philippe Boutté, Hiltrud Egonu, Jellel Gasteli, Elizabeth Harney, Sidney Kasfir, Orde Levinson, André Magnin, Amir Nour, Colin Richards, Mark Sealy, Yinka Shonibare and Sue Williamson.

Contents

Location and Practice

Negotiated Identities

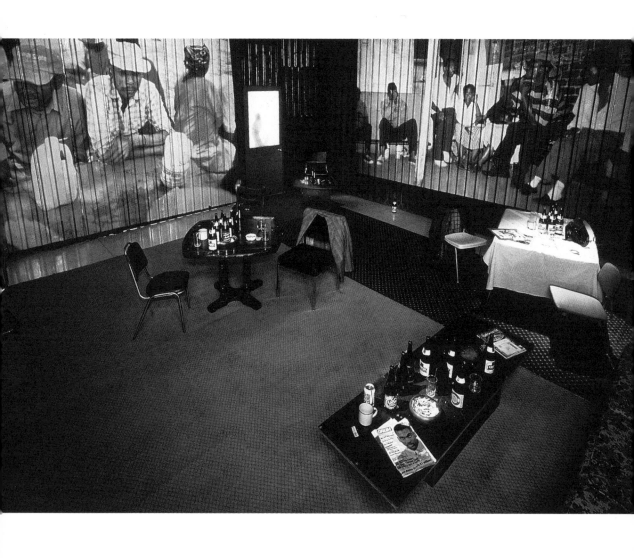

Introduction
Okwui Enwezor and Olu Oguibe

It has been ten years since 'Magiciens de la Terre' (an exhibition that would earn the reputation of being both notorious and seminal) was organised by Jean-Hubert Martin at the Centre Pompidou in Paris. That this exhibition returns again and again for discussion, especially in the consideration of work by contemporary artists of non-European descent, is due in part to the ascendance at the time of a postmodernism whose discourses sought to challenge the exclusive set of values that modernism had constructed for itself against any kind of aesthetic contamination. If modernism's instrumental logic claimed its foundational basis in enlightenment rationality, postmodernism argued the contrary. Postmodernism understood its task to be one in which it would be possible to argue against the notion of cultural purity, to propose a critique of the disregard for the discrepant meanings and detours of modernity inherent in modernism's inscription of a hegemonic and discriminatory Western canon. 'Magiciens de la Terre's' success, though flawed in many areas, was in its ability to make a strong case for a dialogue between artists of various cultures. Another distinction that many still claim for the exhibition was that it was the place in which 'contemporary African art' made its first real appearance in Europe.

Martin predicated the exhibition's governing rhetoric on the reification of difference, unabashedly taking full possession of the postmodernist argument, at least in defending his choice of artists from outside Europe and North America. However, closer examination would reveal that his enterprise failed in its method, because it not only retained those impulses proper to modernism, it misinterpreted the most productive arguments of postmodernism via postcolonial discourse by playing into the hands of a form of postmodernism that Frederic Jameson would exasperatedly call sheer heterogeneity.[1] This was very clear in the kind of artists and works selected from different regions. On the one hand the work of artists from Europe, North America and Japan (what one might call the G-7 artists[2]) were consistent with all the conventions of modernist language, while on the other, the work of artists from outside the G-7 circle looked more and more curious. But this is an old debate, and is raised here not to rehash the unpleasantaries that attended the critiques of Martin's initial inquiry into what today is called 'global art'. Our intention in bringing up Martin's omnibus exhibition is not to damn him, but to sketch the development of a new critical language and method for the evaluation of contemporary African art.

Many of the texts contained in the present volume were written in the days following 'Magiciens de la Terre' and have created a textual network through which Martin's articulation can be better understood. In this regard, 1989 could be seen as an emblematic marker for many of the critical questions with which this volume occupies itself. It is also important to point out that 1989 was the year of a radical global shift in the political economy, and for Africa is reflected in the momentous, historical death of apartheid in South Africa. The object of a critical assessment of this kind then, can be implemented through an understanding of the before, and of the after. It is the after – the post-1989 period – that allows us to chart the changes in the fortunes of contemporary artists from

Africa (living and working both inside and outside the continent) as their work and the complexity of their art enters into greater circulation in the global network of international exhibitions, museums, galleries, magazines, residencies, etc.

On this note, two key forces must be accounted for: globalisation and the production of a new African diaspora, already emergent since the end of World War II. In the context of Africa, globalisation and diaspora recognise the processes of mass mobility, migration, mediation, information technologies, postcoloniality, economic dependencies, etc. They affirm, in our continuous attempts at self-definition, new relationships between home and elsewhere, global and local, tradition and modernity. There are many other issues on which these discussions are predicated, which extend our disparate and extensive travelogues, and challenge the containment of Africa as a monolithic entity; they import complexity into our discourses and in so doing transform the ways in which we approach questions of subjectivity and creative agency.

With the circulation and dissemination of new ideas and contemporary productions by African artists, new strategies, visual languages, forums and institutions have also emerged. There is an increasing acknowledgement of work by contemporary African artists as integral to a highly dispersed international language. In the last ten years, a great many names have emerged in this respect (Georges Adeagbo, Romuald Hazoume, Kay Hassan, Kendell Geers, Oladélé Bamgboyé, Tracey Rose, Barthelemy Toguo, Mary Evans, Wangechi Mutu, Fatimah Tuggar, Mona Marzouk, Moshekwa Langa, Pascale Marthine Tayou, Donald Odita and many others). Equally, the number of artists working with new media, film, photography, installation and new sculptural vocabularies has radically increased and has given a measure of added significance and challenge to the critical explication of the tenets of this work. Not only are there greater numbers of artists working today, there have emerged curators, art historians, scholars, and university departments dedicated to the study of contemporary African art, as well as new spaces, especially within the continent, which are now charting the emergence of what undeniably is a golden age. The Dak'Art Biennial of Contemporary African art in Dakar, Cairo Biennial, Johannesburg Biennial, Grahamstown Festival (South Africa), The Biennial of Photography in Bamako, FESPACO (a forum for African cinema), and many others have been important exponents of the increasing internationalisation of work by contemporary African artists and filmmakers.

Despite all of the above, it is important to recognise that much still needs to be done, particularly in the area of contact between artists who live on the continent and those who live outside. An aspect of this recognition will inevitably be to deal with the work of a vast diaspora (still in formation) of Africans who have emigrated to different parts of the world and are contributing critically to ongoing discussions in their new homes. On this count, the forces of globalisation, while still predicated on unequal access to resources and information, nonetheless serve to keep many artists and their works in direct contact with one another.

As we write this, six African artists (Yinka Shonibare, Pascale Marthine Tayou, William Kentridge,

Moshekwa Langa, Malick Sidibé and David Goldblatt) have, or have had, solo exhibitions in mainstream galleries and museums in New York; and numerous additional shows have taken place in many other locations worldwide. In the Museum of African Art in New York, a spectacular exhibition focusing on the work of late Congolese president Patrice Lumumba is drawing audiences, further emphasising the genre of so-called urban art as an arena of intensive intellectual and political inquiry. What has changed since the days of 'Magiciens de la Terre' to allow for this sudden transformation? What are the mechanisms through which this shift could be properly contextualised and debated? What are the limits of globalisation in pushing the boundaries of art being produced by Africans at the end of the millennium? In fact, what constitutes contemporary African art? Who is its primary audience and how is its position mediated in the realm of global market mercantilism? The questions are numerous, and the art complex, critical, and diverse. *Reading the Contemporary* was compiled with this critical shift in mind.

In the first part of this anthology, 'Theory and Cultural Transaction', contributors investigate various critical and theoretical frameworks and their implications for the construction, evaluation, and reception of contemporary African art. Olu Oguibe's essay begins by laying out issues of contention around the subject. Taking as a premise postmodernist attitudes to contemporary African artists and their practice, he interrogates the questionable criteria applied to the reception and evaluation of this work. Anthony Appiah outlines the peculiar location of African cultures between the hegemonic devices and demands of an outsider-critical establishment and market, and the reality of a sophisticated self-sustaining rhetoric. In his essay, V. Y. Mudimbe proposes the concept of *reprendre* as a context for understanding developments in contemporary African art. Returning to the question of the marginalisation of modern African artists, in 'Bourdieu Out of Europe?' Everlyn Nicodemus considers the applicability of Pierre Bourdieu's theory of the field of cultural production as a method of analysis free from the disadvantages of Western art historiography. In a much-discussed essay, Sidney Kasfir investigates the role of museum displays, connoisseurship, ethnography and the market in the reinvention of meaning in African art. John Picton's essay begins with anecdotal narratives that problematise the interventions of non-African collectors, patrons and cultural mediators who demonstrate a profound lack of understanding of the dynamics of art production and appreciation within Africa.

The contributions in the second section on 'History' map out a number of specific historical trajectories that contribute to the complex matrix of modern and contemporary art on the continent. Ima Ebong takes a historical look at the development of post-Independence Senegalese cultural and artistic ideology under the rubric of the Negritude movement as a paradigm for a new contemporary artistic identity, of which a group of academic painters known as Ecole de Dakar were the official beneficiaries. Chika Okeke locates at the centre of modern Nigerian art the work of the members of the Zaria Art Society, who became active at the dawn of political Independence in 1960. In one of his

many seminal essays on African cinema, Frank Ukadike posits that in terms of theme and creative autonomy, the new cinema in Africa constitutes the voice of African alterity, reflecting a dialogism between geographies of culture and history. Salah Hassan makes an important contribution to the debate on terminologies in African art history. By locating the Manichean traditional/contemporary dichotomy in a discourse founded on colonial anthropological structures, Hassan argues that the work of African artists that is based on their encounter with the academy, the metropolis, and their indigenous origins constitutes an African modernity. Manthia Diawara's essay investigates the historical context of the photographs of Seydou Keïta, the Malian photographer whose meteoric rise from relative obscurity in the West to a growing presence in major shows and publications from New York to Johannesburg, represents a significant moment in the narrative of African photography.

Expectations of contemporary African art tend to exclude a recognition of the mutant configuration of the continent itself, and of the fact that in the present, Africa is constituted not only by resident cultures but also by a significant diasporic population located outside its physical geographies. In the third section 'Location and Practice', writers address the peculiar conditions of diasporic location in relation to the practice and reception of contemporary African artists. Okwui Enwezor looks at the careers of four important conceptual African artists: Iké Udé, Bili Bidjocka, Olu Oguibe and Ouattara, against the backdrop of a Western postmodernist theory and its critical elision of African artists living and working in the Western metropolis. Kobena Mercer's essay on the late Nigerian-British photographer Rotimi Fani-Kayode delves into the photographic world of an artist for whom the body and sexuality was a focal site for an exploration of the relationship between erotic fantasy and ancestral spiritual values. Fani-Kayode himself looks at his own career through what he sees as three levels of disenfranchisement that circumscribe his practice: sexuality, race and cultural dislocation. Octavio Zaya discusses North African photography as represented in the work of five artists (Boutros, Dridi, Ennadre, Gasteli and Naji), most of whom now live in Paris. Despite the profound uniqueness of each artist's work, Zaya identifies certain pointers to that intangible territory defined by relocation and expatriation. Thomas McEvilley takes the exhibition of five contemporary African artists (Moustapha Dimé, Tamessir Dia, Ouattara, Gerard Santoni and Mor Faye) at the Venice Biennale as a point of departure for examination of the cross-cultural and syncretist approaches inherent in the aesthetic ideas from which a postmodern idea of culture has evolved.

As we engage in the contemplation and narration of contemporary African visual cultures, one contentious issue that persists is that of the construction and contestation of identities; identities fashioned by others and foisted on Africans; identities contested and rejected by Africans. The result of this dynamic is the emergence of disparate art histories, the dominant version of which persistently displaces African perspectives on the question of identity, and on the parameters of cultural narration. This is explored in the final section of this volume on 'Negotiated Identities' which opens with Olu Oguibe's text tracing the history of this concept and exploring its

William Kentridge
Drawing from *History of the Main Complaint*, 1996
Charcoal on paper
122 x 160 cm
Courtesy Stephen Friedman Gallery, London
Photo: Stephen White

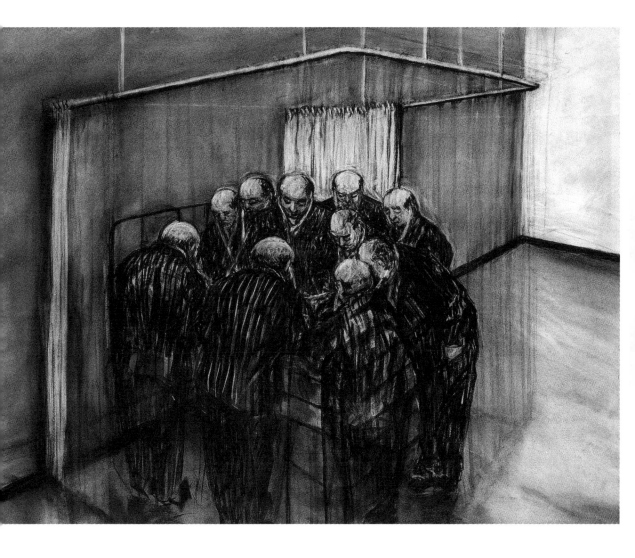

shortcomings and potentials. David Koloane's essay takes a look at the pervasive question of authenticity in relation to the definition of black identity within South African art history and the commercial art establishment. Margo Timm raises a crucial question in her essay on the work of John Ndevasia Muafangejo: that of the role of criticism and the market in the confiscation and violation of identities. Colin Richards elaborates on this theme, observing the important role of nationalism and ethnicity in the construction of identities, and the significance of this preoccupation for a post-totalitarian, postcolonial culture like South Africa in the wake of Apartheid's demise. Continuing the critical investigation of the role of art and identity in post-Apartheid South Africa, Enwezor's second text engages with the historical, political, cultural and social problems that beset artworks which often take the black body's extreme commodification out of the context of its ideological mediation. The essay maps out the itineraries of such ideological mediation from the old colonial archive to popular tourism and the most recent conceptual art made by mostly, young white artists in South Africa. In the final essay of the book, Laura Mulvey argues that African cinema should be seen not as a developing cultural phenomenon, but as a defining space in cinematic aesthetics today, especially as Western cinema goes into decline.

While our preoccupation in this volume is essentially with art, our aim is to extend our inquiry into the entire realm of visual culture, the critique of historicism, and the relationship between art, politics and culture in the production of modern consciousness, as these bear particularly on Africa. Our aim is not only to provide an alternative art history, but also to lay a groundwork for its methodology. We strongly believe that it is in the methodology that art history confronts the proper subject of its operation, that the most difficult and durable questions of its discriminations and discernments occur, that the flawed arguments and perspectives are engaged, that new interpretations are created, and that contestations (necessary for a sustained intellectual productivity) are tackled. But above all, this anthology, while not claiming to be comprehensive, nonetheless brings to light the sophisticated maturity of an area of art-historical discourse too long ignored by scholars, museums and academies. If the intentions of this book are not to be merely corrective and revisionary, they are necessarily a call for a critical re-evaluation of the ideas on which our mutually entangled future rests in the surging course of globalisation, destabilisation and transition as we enter the next century. The philosophical and critical perspectives brought by each of the authors to their subject help to lay a foundation upon which the work of a future generation of artists can be situated, explicated and critiqued.

Notes

1 Frederic Jameson, *Postmodernism, Or, The Cultural Logic of Late Capitalism* (Durham, NC: Duke University Press, 1991).

2 G-7 (Group of Seven Countries) is a term for the world's largest economies. The countries are Britain, Canada, France, Germany, Italy, Japan and the USA.

Theory and
Cultural Transaction

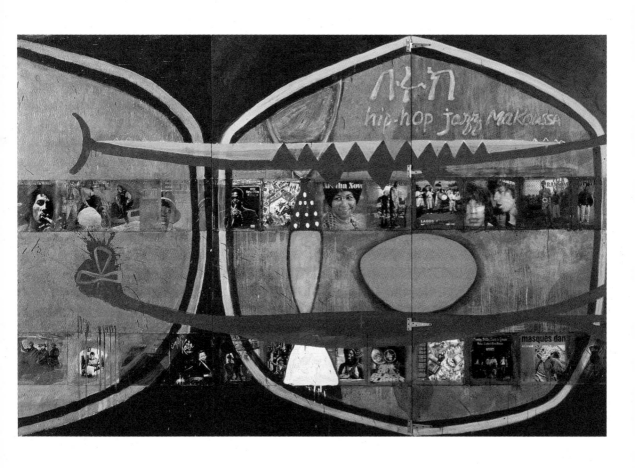

Art, Identity, Boundaries: Postmodernism and Contemporary African Art
Olu Oguibe

In his rather interesting collection of interviews and plates, the postmodernist critic Thomas McEvilley [1] asks Ouattara [2] 'When and where were you born?', to which the temperamental artist responds with barely suppressed irritation. To many, this would seem an innocent and ordinary enough question, especially when the obvious intent is to present to us a, supposedly, relatively unknown artist. Asks the critic next: 'In 1957, was Abidjan a big urban centre, like today?' To which, again, Ouattara duly provides the expected answer. On the first page of the interview, there is a picture of the artist, his face is aligned against the text, his brooding countenance attesting most eloquently and visibly to his impatience with the critic's line of enquiry. One can almost sense a building tension within the artist. Reading closely, however, one also notices that McEvilley, to the contrary, is quite relaxed. For him, the chat is going well, and he is comfortable. And when He is comfortable, everyone else is comfortable. As he maps the artist with his eyes, his mind retrieves from its cabinet of tourist postcards an image of an African mammy-wagon with a line of popular wisdom inscribed on its outer board: *No Hurry in Life*. It is the way of these people, he reminds himself: generous, charitable, accommodating. They take life easy. And so his mind drifts back to Ouattara's studio, hardly taking notice of his quarry as the artist shifts uneasily on his stool, muttering under his breath. Quite predictably, the white boy fails to read the sign on the native's face. For him the gestures of the native are an invisible sign.

The critic runs his pen across his bushy face, and, as if speaking to a child on his first day at school asks: 'Would you tell me a little about your family?' There! Ouattara explodes. But only within. Like a gentleman. The ultimate signifying monkey. He understands – he is brought up to understand, everything in his history and in his experience prepares him to understand and to accept – that in dealing with the power that McEvilley represents, he is engaged in an ill-matched game of survival; a game that he must play carefully if he is to avoid profound consequences; a game he must negotiate with patience to prevent his own erasure, his own annihilation; a game that he must ultimately concede in order to live. Living in New York, Ouattara understands too well how, beyond the boundaries of colonial ethnographic displacement, the introduction of digitisation in our time has sanitised erasure and transformed it into a messless act. He understands how the mark of deletion, the ugly sites of cancellation and defacement, the crossing out, the scarred page, the marginal inscription – that which in the past testified to the processes of obliteration and through this testimonial actively subverted it – are now things of the past; and the object of the obliterative act now disappears together with the evidence of its own excision, making erasure an act without trace. This knowledge further underlines the ominousness of his location. Ouattara understands how much he needs McEvilley, how much he stands to gain by making friends with him. He recognises, albeit painfully, that the terrain he occupies, the terrain to which he is perpetually consigned, in which he is confined, is one under surveillance, where every utterance, every gesture, carries with it implications of enormous weight for himself as an African artist,

and for his practice. And even more importantly, he recognises this terrain as an outpost, a location on the peripheries of the principalities that the critic represents – a border post at which McEvilley is the control official. This is the locality of the African artist dealing with the West, irrespective of her domicile. This I call the terrain of difficulty.

And so, holding his breath firmly down, gritting his teeth and silently but vigorously crossing out the dozen f-words bombing his brain while warning himself to take it all with calm, Ouattara stakes his final but ultimately futile claim: 'I prefer to talk about my work'.

Well. Not quite. The artist's polite caution does not wash with the critic. Deftly and firmly McEvilley waves Ouattara's protest aside and proceeds with his line of questioning. He feels in command; he must be seen to be in command. 'If he hollers let him go', reads an old, American plantation saying. But no. McEvilley is not fazed by the native's protests. This time, the master will have his way. Describing the women of Huxian in *About Chinese Women*, Julia Kristeva images the native as a silent presence.[3] In reading Ouattara's moment with McEvilley, we are reminded of a different silent presence, closer perhaps to the obliterated presence that Chinua Achebe identifies in Joseph Conrad's *Heart of Darkness*, the native whose silence is an objectifying projection – what we may refer to as *significant* silence. For though this silence is not literal, it is nevertheless made real since, beyond the preferred narrative – that specified rhetoric that reiterates palatable constructs of Otherness – the native's utterances are not speech. They occupy the site of the guttural, the peripheries of sense, the space of the unintelligible where words are caught in a savage struggle and sounds turn into noise, into the surreal mirror-image of language. In this void of incoherence, utterance becomes silence because it is denied the privilege of audience. And without audience, there is no speech.

Sprawled out like Barthes in Tangier, or prowling through a market in Abidjan, the esoteric goulash of native utterance is of course the ultimate locale of Occidental desire, the last place in which to hunt for exotic pleasures. But this is not a pleasure trip. McEvilley has a book in mind and must have his story. Under the circumstances, native aspirations to desire and the dialogic ('I prefer . . . '), native pretensions to power and sophistication ('to discuss my work . . . '), are quickly displaced in a hegemonic withdrawal of audience that re-establishes the hierarchical location of the *Self* over the *Other*, of the white critical and artistic establishment over the African artist. On this stage of simulacral dialogue there is only one voice that counts. The Other can exist only as a projection, an echo, as the displaced sound of percussive fracture.

And so McEvilley drives his conversation with Ouattara towards the realisation of his preferred narrative, with questions not intended to reveal the artist as subject, but rather to display him as object, an object of exoticist fascination. 'How big was your family? What school did you go to? What language was spoken in your home? What religion did your family practice? Did it involve animal sacrifice?' In the end, his mission fulfilled, McEvilley finally announces to Ouattara:

'I don't have any more questions, do you have anything more to say?'

For Ouattara, though, the game is already over. It was over before it even began. It was over from the moment he was born, from the moment he was destined to be – designated as – an Other. In answer, he fumbles within for something deep and philosophical to say, something original, something in his and not the master's voice, some desperate utterance in the narrow passage of sanction accorded him, something that represents his, rather than the preferred version, the master narrative. He struggles to speechify, to repossess his body and reinvest it with humanity, with language, with articulation. He struggles at the borders of subjecthood.

Aligned to the text at this stage is another picture of the artist, as if in conclusion. But this time, the strength of determination, even defiance, which we glean from the portrait at the beginning of the text, is gone. Ouattara's countenance no longer projects a brooding tension; it no longer *projects*; that is, it no longer aspires. His disposition no longer indicates a willingness to dare, to utter with Frantz Fanon: 'Get used to me; I am not getting used to anyone'.[4] Instead, he stares into space, his face sunken and forlorn, his anger turned to despair, his attempts at the contested territory of the voice thwarted by McEvilley's hegemonic devices. Failed is his effort to displace the critic's gaze onto his work, to specify the latter as the rightful focus of contemplation, and in so doing, to claim author-ity. Clearly against his will, Ouattara finds himself repositioned in the frame as the object. And though he is coerced to sketch the contours of this object, to narrate himself and to trace the ethnography of his body, he is made to do so within confines defined by another. He is forced to strip for McEvilley's pleasure.

McEvilley's interview with Ouattara in many respects defines the limitations of appreciation and expectation, or what we might call the confines of perception, within which African artists are either constructed or called upon to construct themselves. It speaks to a discourse of power and confinement in current Western appreciation of modern African art; a discourse of speech and regulation of utterance, which, by denying African artists the right to language and self-articulation, incarcerates them in the policed colonies of Western desire.

In his Inaugural Lecture at the College de France, Barthes identifies speech as a code of legislation, and notes that utterance, language, that which we speak or write, and one may add, paint or sculpt, all that we produce as a body of text, as a composite of signifiers, enters the service of power upon coming into being. Though this power may aspire to Barthes' definition as the desire to dominate, *libido domini*, its most fundamental nature, nevertheless, is as a condition for the articulation and definition of the self, as author-ity. When the artist creates or the musician composes, the most fundamental intent is to replicate and reiterate herself as a being, to impact herself upon reality, to assert her author-ness, her authority. When Ouattara paints or sculpts, the primordial intent of the act is to establish on the specific sites of his appointment the contours of his being, his history, his experiences, his existence as a participatory element in the constitution

and cartography of reality. His intent is to imprint on time his being: his loves, his philosophies, his originary or existential circumferences. And if we should agree with Barthes that enunciation is the code of legislation, it becomes clear that its essence is to define the rules of interaction and interrelation between people, to set the limits of intervention and dominatory incursion, of encroachment upon the sites of our individuality and subjectivity, to present ourselves and establish our authority over not only our creativity, but most importantly, over ourselves too. It is enunciation that subjectivises us, the ability to reiterate *our* power over *our* selves. It is this ability and freedom to enunciate, too, that takes us beyond the dominance of others, takes us, as it were, beyond the bounds of power.

To place enunciation, whether it be utterance, writing or art, under surveillance, therefore, is to impair this code. And once this happens, once the code of legislation and self-cartography is damaged or vetoed, the stage is set for others to infringe those sites of reality in which we define ourselves. To check the creative act, whether through institutional or critical sanction, is to transgress the borders of our autonomy, to return us within the boundaries of subjugation, within the bounds of power.

Autonomy. Self-articulation. Autography. These are contested territories in which the contemporary African artist finds herself locked in a struggle for survival, a struggle against displacement by the numerous strategies of regulation and surveillance that today characterise Western attitudes towards African art. Within the scheme of their relationship with the West, it is forbidden that African artists should possess the power of self-definition, the right to authority. It is forbidden that they should enunciate outside the gaze, and free of the interventionist powers, of others. And it is this contestation of their complete subjectivity and their right to co-legislate patterns of interaction that we find in McEvilley's interview with Ouattara.

To veto enunciation is to disenfranchise and symbolically incarcerate, because within the contested territories of enunciation reside power and franchise, the ability to elect or assert. The body upon which such a veto is exercised loses self-possession and slips into vassalage. To further confirm this state, this body is often forced to confess to a narrative of self-denigration, to provide the ultimate authority through self-otherisation. Thus is Ouattara forced, in the interview in question, to repeat and endorse a narrative of savagery, and thus to wedge his savaged body into that requisite margin between nothingness and subjecthood where he transfigures into the object of his possessor's desire, into an inert, Polaroid image.

In vetoing Ouattara's right to self-articulation, in placing a sanction against his preferred site of discourse, McEvilley effects a paradigmatic reiteration of ventriloquy as a structure of reference for Western attitudes towards African artists. This frame has its origins in colonial ethnography and the colonial desire for the faceless native, the anonym. The faceless native, displaced from individuality and coalesced into a tribe, a pack, demands and justifies representation because

she stands for lack. In the event, authority is appropriated and transferred from her, and it is this authority that is subsequently exercised in constructing her for Occidental consumption. The defacement of the native consigns her to the category of the unknown. Displaced to the befuddled corners of obscurity and rudimentary episteme, the native is made available for discovery, and this discovery transforms the discoverer into an *authority*, their supposed privileged knowledge often translating into the right to represent.

Even more specifically, the imposition of anonymity on the native, of course, deletes her claims to subjectivity and works to displace her from normativity. Not only does this conveniently underline her *Otherness*, her strangeness, her subalternity, anonymity equally magnifies the invented exoticism of her material culture, which in turn becomes a sign of her constructed exoticism. For some time, in order to emphasise the Otherness of non-Occidental cultures, ethnography applied a different rule of attribution to art from such cultures, effectively denying the identities of artists even where these were known. The figure of the individual genius, that element which more than any other defines enlightenment and modernity, was reserved for Europe while the rest of humanity was identified with the collective, anonymous production

Until recently, works of classical African art were dutifully attributed to the 'tribe', rather than to the individual artist, thus effectively erasing the latter from the narrative spaces of art history.

pattern that inscribes primitivism. Until recently, works of classical African art were dutifully attributed to the 'tribe', rather than to the individual artist, thus effectively erasing the latter from the narrative spaces of art history. In contemporary discourses, critics like McEvilley represent the continuation of this practice whereby novel strategies are employed to anonymise African art by either disconnecting the work from the artist, thus deleting the author-ity of the latter, or by constructing the artist away from the normativities of contemporary practice.

From Ulli Beier's work on contemporary African art, to André Magnin's presentation of the neo-native African artist, there is a split between the author and the work that effectively depletes individual credit to the artist. While Beier, like McEvilley, focused on details of biographical difference, others dwell on the peculiarity of the work, often situated in a simulacral ambiance of esotericism and fractious submodernity. In each case, the gaze is deflected onto utopia, onto the significance of the Other. We are directed to the existence of animal sacrifice and voodoo in the backgrounds of Ouattara or Moustapha Dimé, rather than to their contributions to, and discursive place in, contemporary sculpture and installation art. We are confronted with Twins

Gerard Santoni
Untitled no. 1, 1993
Oil on canvas
Courtesy the artist and
Museum for African Art,
New York
Photo: Jerry L. Thompson

Seven-Seven's identity as a spirit child and village chief, rather than with his work as a graphic artist. And rather than find Chéri Samba articulated within the discourses of contemporary satire, he is presented to us as symptomatic of a kitsch mimicry that characterises the disintegration of African contemporaneity. And in each case, these misrepresentations are made possible by first crossing out the subject's ability to self-articulate, not only to enunciate but to expatiate also, to exercise their authority.

The effaced African artist, the faceless, anonymous native, is the correlative of Fanon's 'palatable Negro', the tolerable, consumable Other who, stripped of authority and enunciatory autonomy, is opened to the penetrative and dominatory advances of the West. The appeal of the faceless, anonymous native is in the fact that she is also a pornographic object, a docile, manipulable object of desire and pleasure. Pornography as a strategy rests on the localisation of desire and the intensification of pleasure through the effacement of the subject, the detachment of the locality of desire from the web of subjective associations and reality that impinge on the possessor's sense of social responsibility. In other words, its principal device is the objectivisation of the source of pleasure. For maximum derivative effect, the purveyor as well as the consumer of pornography must detach and frame the object, enhanced through the combined mechanisms of magnification and erasure, filling the frame with only that which satisfies the specifications of desire. Even this is further aided by positioning the object within an appropriate narrative, the right sound, the further from speech the better, all of which, by playing on the extremes of perversion and provocativeness, sufficiently hold it within the frames of the spread. Of course, the erasure of the subject, or her transfiguration into the realms of the fantastic, consolidates the purveyor's fiction of ownership, and thus of power. And power, the ability to possess unquestionably, to exercise uncontested authority and manipulate at will, is the essence of pornography.

Angela Dworkin has described the pornographic object as a colony, the terminal site of the colonised body. In Occidental discourses, African artists and African art in turn continue to occupy this site. Decoupled and anonymised, each is turned into a silent colony, a vassal enclave of pleasure and power. Each is fragmented and projected in close-up sequences and pastiches that magnify pleasure for the all-knowing critic or collector; hence the concept of the intimate outsider who is narrated into a positive relationship with these objects. Each is parcelled and packaged to suit the West's machinations and tastes, to satisfy its desires and to fit within its frames of preference.

Even the pricing of contemporary African art and artists on the international art market positions them within the frame of the cheap, pornographic object. Once, a friend who is an African art dealer received a painting by Gerard Santoni, the Ivorian artist, from one of the leading galleries in New York, with a price tag that would be considered quite modest in a degree show. Santoni is a deservedly well-regarded artist whose work has been shown at the Venice Biennale and other

reputable international and contemporary art spaces. He has practised for several decades and, even with the fragmentation of values that ostentatiously characterises our age, his works would still generally be considered of the highest standard. But Santoni is underpriced because, in the West, he and his work are consigned to the category of mere objects of pleasure and fascination, like pornography. They are positioned on those peripheries of creative genius where the aesthetic experience fails to cohere with great material value. This observation becomes particularly relevant when we consider how little collectors are willing to pay for popular art from Africa, despite the fact that it has remained the focus of Western fascination and attention over the past four decades, and has been vigorously promoted as quintessential contemporary African expression. It is to be noted that collectors spend much more money plugging the pieces in their collections and struggling to generate a discourse around them than they have expended on the artworks themselves. Across Africa, popular artists who are much touted in the West, continue to pursue their careers in conditions that bear no comparison with the affluence of their Western contemporaries.

A good illustration of this perpetual disjuncture between hype and remuneration is the Nigerian graphic artist, Middle Art, whose barber-shop signs were brought to the attention of the world by Ulli Beier and others in the early 1970s. In the 1990s, Middle Art's signs are still voraciously collected in the West, especially in Germany, where the artist continues to command critical attention and dealers continue to receive orders from collectors. But after over thirty years of selling to collections, it is remarkable to note that Middle Art has remained poor, unable to afford a proper studio or indeed, as a German dealer recently told me, to make a decent living from his work. In twenty years of narration and promotion, Middle Art's signs have not appreciated in value; nor has the artist come to be regarded as deserving better payment, which would be unimaginable in the case of a Western artist who had been so promoted and collected. Middle Art's work is cheap because the West does not consider it art 'as we know it'. As an artist, he compares to his Western contemporaries in the same way that a porn actor compares to a 'proper' stage actor. One, though highly desired, is nevertheless dispensable and cheap, while the other, identified with high culture, is appropriately valued and appreciated. Porn is recyclable and its appeal is temporary. For this reason, porn is cheap, and the object of pornographic consumption even cheaper. And both belong not in the great spaces of culture but on the supermarket shelf, on the sidewalk, in the quirky fringes of normative taste. Projected on contemporary African artists and their work, these attributes tether them to the lowest rungs of a strictly multi-tiered contemporary art market from where upward mobility is almost impossible.

The perverted desire for the pornographic manifests itself most significantly, however, in the continued preference in the West for that art from Africa that is easily imaged not as art as we know it, but as a sign of the occult, an inscription of the fantastic. The childlike paintings of the

Beninois, Cyprien Toukoudagba, would not ordinarily represent great creative talent in the West, and would not, conventionally, qualify as art beyond the sixth grade. In fact, the critical acclaim enjoyed over the past few years by the fine draughtsmanship of British child artist Stephen Wiltshire testifies more accurately to contemporary Western standards of even juvenile creativity. But Toukoudagba's naïve drawings are today preferred in the West to the more sophisticated, more familiar forms that represent the cutting edge of contemporary African art precisely because his works fall below these standards, and thus inadvertently yield to dubious, perverted desires and expectations. As form, they represent a slip from normativity; they signify a coveted distance between the West and the African; they satisfy the desire for the fantastic; they are open to pornographic translation; they are strange. A few decades ago, this desire for the subnormative and pornographic was fulfilled by 'Outsider' art: the art of the blind, the autistic, the mentally disabled and clinically insane. Today, that desire is projected on Africa, and it is this perversion that locates works like Toukoudagba's within the boundaries of preference.

A few years ago, curators at a major museum in Sydney sent out requests for information on artists in preparation for a show of prints by contemporary African artists. Upon receipt of this request, a dealer in New York collected information and images from some of the most prominent figures at the cutting edge of contemporary African practice, artists who also belong at the forefront of contemporary international practice. These were sent off to the curators. After a long wait, however, a response eventually returned from Sydney. Sorry, it said, but did the dealer have anything by Chéri Samba and artists of that kind? According to the curators, those were preferable for their project. And not so long ago, too, a German intellectual decided to venture into art, dealing with specific interest in contemporary African art. After sending out masses of literature on artists he represented – Obiora Udechukwu, El-Salahi, Rashid Diab and others – with the intent to interest German collectors in what he considered the finest examples of contemporary African art, the dealer discovered that his recipients had a rather different desire and expectation. The demand was for sign writers Chéri Samba and Middle Art.

These anecdotes will come as no surprise to those familiar with the issues I have broached here. In its compulsive proclivity to displace and dismiss comparable African art from the spaces of contemporary art and its narration, the West has regularly elected to question the identity of this art, its authenticity, and in doing so to employ its own constructs of this authenticity. Authenticity suggests history, a tradition that forms a frame of reference, a point against which adherence or departure is gauged. To describe the form as authentic, therefore, is to imply lines of similarity with tradition, with a historical or precedent frame of reference. I have indicated in the past, however, the clear distance between the authenticity that the Western art establishment has fabricated for Africa, and the evidence of tradition. It is asinine that anyone should locate authenticity in the graphic art of sign writers whose structures of reference are entirely

Kane Kwei
*Mercedes Benz-
shaped Coffin*, 1989
**Wood and enamel paint
219 (l) x 85 (w) x 60 (h) cm
Collection of and courtesy
Museum voor
Volkenkunde, Rotterdam**

contemporary and often Western, or in the new forms of folk art that have emerged in parts of
Africa and which have no precedents. Which is not to contest the validity of these forms, but to
point out that in constructing authenticities, the fact that they make no reference whatsoever
to notions of tradition seems irrelevant to self-appointed purveyors of Africa's authenticity in the
West. On the contrary, it is equally half-witted that anyone should fail to identify the obvious lines
of reference to tradition in the works of those African artists whom the West is most vehemently
dedicated to banishing from the spaces of contemporary practice and appreciation; those who
have been severally dismissed as 'academically trained', 'intellectual' and so on; those who,
because they belong to the same tradition as that which modern and postmodern art has
continued to reference, produce work to which contemporary Caucasian art is inevitably affined
for reasons of commonality of source.

The issue of authenticity and its attendant anxieties are of course not matters over which
contemporary African artists are likely to be found losing any sleep. On the contrary, it is those
who construct authenticities and fabricate identities for them who are constantly plagued with
worries. And for the precise reason that I have already indicated: such anxieties have less to
do with facts of authenticity and the relevance of tradition, as with a desire to force African
artists behind the confines of manufactured identities aimed to place a distance between
their practice and the purloined identity of contemporary Caucasian art. In other words, the
introduction of the question of authenticity is only a demand for identity, a demand for the signs
of difference, a demand for cultural distance. It is a demand for the visual and formal distance
without which it is impossible for contemporary Caucasian art not to reveal itself as mimic,
as a culture of quotations, as a mediated translation of cultures and art traditions other than
itself, as pastiche. For, having purloined its form and identity from others, it becomes relevant
for Caucasian art to insist on difference in order to obliterate any traces back to the source,
to E(u)rase the mimetic trail.

It is for this reason that the charge of mimicry is recurrently levelled against contemporary
African artists, their work dismissed as only an imitation of Western art. By employing this device
of reversal, it becomes possible for the mimic – that is contemporary Western art – to invest
itself with originality and a sense of its own authenticity. In proceeding, then, to displace mimesis
away from itself, and to project the same on African artists, contemporary Caucasian art is able
through its narratives to reserve alterity for itself, to reserve the right to be the One and the Other
at the same time and without sanction. The charge of mimicry becomes its tool for defaming and
displacing those who produce from within those traditions which, in truth, it mimics; those whose
existence challenges its fictions of originality.

McEvilley's seemingly innocent question to Ouattara again comes to mind: 'Where were you
born?' One recognises an uncanny ring to this question, the resonance of mechanisms of

surveillance and regulation employed by the West today to keep Africans outside its geographical borders. We notice a confluence of the political and the cultural. The one-sided contest for authenticity that the West insinuates, its overbearing desire to claim originality as a preserve and to dismiss others as inauthentic and mimetic, in several respects parallels its current paranoia over territory, the anxiety that it is about to be overrun by outsiders. Hence the intensification of border regulations and the redefinition of origins and identities, the recurrence of the question: 'Where were you born?'.

The desire to nominalise the cutting edge of contemporary African art is a methodical mapping of territories, a project of surveillance that is one with the tradition of policing the imaginary borders of civility and progress. The implications of the above for creative practice are numerous and far-reaching. Working within the confines of distortive regulatory strategies, African artists find themselves vulnerable to potentially destructive pressures. The demand is for them to produce to specification, to affect anonymity, to concede the ability to enunciate within the sites of normativity. Even more significant is the fact that, for these artists, access to criticality in contemporary discourses is regulated by this demand for subnormativity, and here lies the importance of Thomas McEvilley's interview with Ouattara. For not only do McEvilley's devices illustrate one critic's incarcerating projections on an African artist, even more significantly, they speak to the segregationist criticality and general ambivalence of white, postmodernist contingents in the so-called discourse of Others, a criticality bounded by an interceptory demand for the identity of the Other, by the query: 'Where were you born?' They speak to the fact that within this discourse, postmodernism remains, to a remarkable extent, a mere rehash of entrenched modernist attitudes and methods, 'a continued reproduction', as Peter Hitchcock has suggested, of 'the logic of Western cultural critique that fosters the "othering" of the so-called "Third World Subject"'.[5]

These are peculiar obstacles, of course, which work outside the perimeters of limitation/transgression. The challenges they pose require of artists resistive rather than transgressive strategies. More importantly, they pose an even greater challenge for contemporary cultural theory, and for postmodernism as a critical culture. To bring its object into crisis is the duty of criticism, and postmodernism must extend this responsibility to contemporary African art, and even more so, to the logic that regulates its contemplation of non-Occidental contemporaneity. To engage meaningfully with the contemporary, a credible postmodernist criticism must place its ambivalence under crisis, and extend the borders of criticality beyond the demand for identity and subnormativity.

Notes

1 Thomas McEvilley, *Fusions: African Artists at the Venice Biennale* (New York: Museum for African Art, 1994).
2 New York artist Ouattara was born in Ivory Coast but has lived and worked in France and the US since the 1980s.
3 See Julia Kristeva, *About Chinese Women*, trans. Anita Barrows (New York: Urizen Books, 1977; reprinted 1986).
4 Frantz Fanon after Aimé Césaire, 'The Fact of Blackness', in *Black Skin White Masks*, trans. C. L. Markmann (London: Pluto Press, 1986), p. 131.
5 Peter Hitchcock, 'The Othering of Cultural Studies', *Third Text*, no. 36 (London: Winter 1993-94), pp. 11–20.

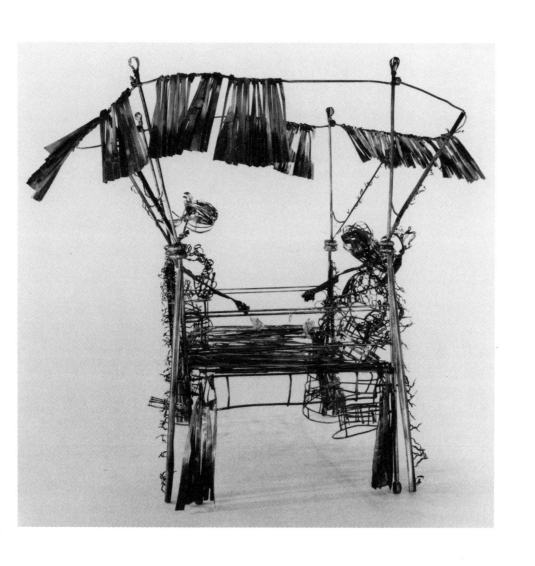

Reprendre: Enunciations and Strategies in Contemporary African Arts

V. Y. Mudimbe

O weaving reeds, may you never be poverty-stricken
May you never be taken for sale in the market
May none be ignorant of your maker
May no unworthy man ever tread on you.
Anonymous women's work song, Somalia [1]

Enunciations and Strategies in Contemporary African Arts

The word *reprendre* – strangely difficult to translate – I intend as an image of the contemporary activity of African art. I mean it first in the sense of taking up an interrupted tradition, not out of a desire for purity, which would testify only to the imaginations of dead ancestors, but in a way that reflects the conditions of today. Second, *reprendre*, suggests a methodical assessment, the artist's labour beginning, in effect, with an evaluation of the tools, means, and projects of art within a social context transformed by colonialism and by later currents, influences, and fashions from abroad. Finally, *reprendre* implies a pause, a meditation, a query on the meaning of the two preceding exercises.

If, however, an African artist does go through these critical phases, consciously or unconsciously, in the creation of art, viewers of the finished work, even some of the most attentive ones, may find themselves looking for traces, for strata and symbols, that might qualify the piece as part of such-and-such a trend in the vague domain of 'primitive art'. Naïve, uninformed, sometimes prejudiced, this kind of looking often involves two *a priori* assumptions, the first concerning the Western notion of art itself and its ambiguous extension to non-Western œuvres, the second supposing the immobility, the stasis, of non-Western arts.[2] Yet, against these assumptions there is a history, or more exactly there are histories, of African arts. In his *Art History in Africa* (1984), Jan Vansina convincingly analyses the variety of the continent's artistic processes, the readjustments and transformations of methods and techniques there, the dynamics of acculturation and diffusion and their impact on creativity. Furthermore, there is no such thing today as 'an' African art. Senegalese trends are different from Nigerian, Tanzanian, or Mozambican, and each is immersed in its own sociohistorical context. Even in traditional masterpieces,[3] the evidence of regional styles and the variety of their histories is clear.

I do not address these historical movements in this study, but I try to indicate broad rhythms, tendencies, and discontinuities extending from a recent period of rupture that brought about new types of artistic imaginations. On the whole, I am interested not in causal successions but in new artistic thresholds, displacements of inspiration, and what we may call an 'architectonic' system – an underlying order that would account for some basic similarities in the amazingly diverse, complex, and conflicting regional styles. This order has led some analysts to suppose a unifying, very ancient 'creative complex' in Africa. I have chosen a more sociological approach, which pays attention to history but is principally concerned with incidences of conversion, patterns of discontinuity, and conflicting or complementary influences.

I move from the radical reconversion of African arts in the colonial settings to their subsequent development. A general overview, this description is intended to avoid mystifying technicalities in the discussion of both broad artistic tendencies and particular pieces. It may seem to focus on sculpture and paintings, but does so only for purposes of illustration; the analysis can be extended to batiks, ceramics, engravings, paintings on glass, and so on. Finally, I would like to point out that my approach has a theoretical *a priori* concerning the status of a work of art: I suggest that we consider African artworks as we do literary texts, that is as linguistic (narrative) phenomena as well as discursive circuits.[4] I hope my analysis will demonstrate the usefulness of such a position.

The Issue of a 'Nilotic' Imagination

'It is', wrote Pierre Romain-Desfossés, 'precisely an Asiatic complex that we find in our Katangais painters and which allows us to use the etiquette of Nilotic'.[5] In this amazing statement, which links geography, race, and art, the founder of the Atelier d'Art 'Le Hangar' in Elisabethville (now Lubumbashi, Zaire) seeks to explain the originality of his African pupils' artistic imaginations. A Frenchman, Romain-Desfossés arrived in the Congo after the last European war. Seduced by what he considered extraordinary artistic potential, he decided to stay, and was soon organising an atelier for a few carefully chosen students. His programme is summarised in his remark, 'We must strongly oppose every method tending toward the abolition of the [African] personality to the advantage of a uniformising aesthetics of White masters'.[6]

Romain-Desfossés' project, its missionary zeal giving rise also to a remarkable generosity, united the political and the artistic to constitute a new aesthetic. But he traced this aesthetic, and the creativity of his students in general, back to an 'Asiatic complex', a 'Nilotic etiquette'. His task as he conceived it was to awaken in his students this ancient, unchanging aesthetic memory.

Independently of its technical implications, this concept seems important as a reference to a lost configuration interrupted, or at least blurred, by history. It suggests a kind of aesthetic unconscious, common to sub-Saharan Africans, which a patient, sensitive, disciplined search could awaken. In 1957, Frank McEwen, founder of the national gallery at Salisbury, Rhodesia (now Harare, Zimbabwe), suggested something similar, by way of metaphor:

> One of the strangest, inexplicable features occurs in the early stages of development through which many of the artists pass, when they appear to reflect conceptually, and even symbolically, but not stylistically, the art of ancient civilisation, mainly pre-Columbian . We refer to it as their 'Mexican period' which evolves finally into a high individualistic style.[7]

Whether we refer to a 'Nilotic etiquette' or to a 'Mexican period', what seems to be described is something that Carl Jung might have called an 'archetypal image', 'essentially an unconscious

content that is altered by becoming conscious and by being perceived, and [that] takes its colour from the individual consciousness in which it happens to appear'. Jung continues, 'The term "archetype" . . . applies only indirectly to the *représentations collectives*, since it designates only those psychic contents which have not yet been submitted to conscious elaboration and are therefore an immediate datum of psychic experience'.[8]

Romain-Desfossés, however, in his 'Nilotic etiquette', was probably thinking of something else – a very ancient datum, something like a lost web, completely forgotten, but still alive, well buried in the unconscious. And, he was convinced that the works of his best disciples – Bela, Kalela, Mwenze Kibwanga, Pilipili – testified to its existence. But the concept of a primitive 'Nilotic' or other complex is very questionable. It might be more prudent to suppose that these young artists invented an *original* texture and a style, situated as they were at the intersection of local traditions and the artistic modernity of Romain-Desfossés. On one side of them was the luminous, inescapable influence of village life; on the other, the not-so-neutral gaze and speech of their teacher. Romain-Desfossés played father (he called his students 'my children' and attended to both their physical and emotional well-being), master (he saw his mission as one of teaching them how 'to see'), guide in a new discipline: 'painting . . . is in itself a new art that we bring to the black African'. As Wim Toebosch writes, Romain-Desfossés dreamed of re-creating a new artistic universe: 'Rather than giving instructions or imposing criteria or principles, he simply asks his disciples, his children as he calls them, to explore with their eyes, to study the world around them and to try to grasp its totality, but also its essence, without referring to this or that notion of faith – or of superstition'.[9]

Moreover, Romain-Desfossés also had very definite opinions on art history. He was a romantic, celebrating his pupils' creativity as springing from 'pure and fresh sources', as opposed to what he called 'Western degeneracy', 'snobism', and 'folly' – labels escaped only by a few European artists, such as Picasso and Braque. A black-and-white photograph of Romain-Desfossés' 'family' is the best illustration of the way he imagined the new artistic world that he was trying to create: the Africans are posed in a subtle arrangement, a kind of square, with Romain-Desfossés, the only white in the picture, at its centre. The overly well-organised balance between left and right and front and back, the sitters' geometric positioning, the exploitation of nature – everything is calculated to produce a sense of communion, friendship, and love uniting the white 'father' and his black 'children'. The dark forest around the group, and the two cultivated banana trees right next to them, seem meant to establish both a gradual progression from nature to culture and the inverse – a regression of sensibilities from the master and guide, through the young artists almost religiously surrounding him, toward the night of the symbolic unconquered forest. Following Freud, one might refer here to a will to master a psychic topography and the cathexis, or investment of energy, in that pursuit. Finally there is the calm confrontation of looks: the respectful deference in the students' gazes on the master, as if awaiting an oracle; and Romain-Desfossés' own eyes, which seem unfocused, as if semi-closed in meditation.

Or is he looking at the three students to the left of the group, or at his own, slightly raised right hand? In any case, the most striking feature in his white visage is his enigmatic smile: the father/master/guide holding a secret he will reveal only when he thinks the time is right.

Whoever plotted the photograph succeeded well in picturing the spiritual frame of the Atelier d'Art 'Le Hangar' d'Elisabethville, and of its offspring, L'Ecole de Lubumbashi. The photograph is a remarkable representation of the workshop's symbolic intersections between sociocultural conceptions bequeathed to it by colonialism and the new politics of acculturation. Romain-Desfossés appears here as a paradigm. The artistic constellation he represents crosses the frontiers of at least two traditions, two orders of difference. And the aim of the art he inspired was to bring to light the desire of a new subject, emerging out of a fragile connection between radically different psychic topographies.

Romain-Desfossés was not alone in incarnating such an ambition. The Belgian frère Marc Stanislas (Victor Wallenda), for example, founded the School Saint Luc in Gombe-Matadi (Lower Zaire) in 1943. The school moved to Léopoldville (now Kinshasa, Zaire) in 1949, and, in 1957, became the Académie des Beaux Arts. A strong believer in the theory of an 'innate African aesthetic imagination', Wallenda, during his long tenure as director of the institution, obliged his students to inspire themselves only from 'traditional œuvres'. He ensured that they would not be exposed to European art and still less to books on the history of art. Another such figure was Frank McEwen, the founder of a workshop at the Museum of Harare (an offshoot of the Rhodesian National Gallery, opened in 1957). His educational principles were based on a refusal to 'corrupt' African artists by exposing them to 'the influence of Western art schools'.[10] Sharing the same philosophy were Margaret Trowell, director of the Makerere School of Art in Uganda, and Pierre Lods and Rolf Italiander at the Poto-Poto School in Brazzaville. One could add the names of Tome Blomfield, who organised a workshop on his farm at Tengenenge (Zimbabwe) for unemployed workers; Cecil Todd, a resolute modernist who, in the 1960s, compulsorily exposed his students at Makerere (Uganda) and later at the University of Benin (Nigeria) to modern European art; and, between the conservatism of Romain-Desfossés and Wallenda and the more recent modernism of Todd, fathers Kevin Carrol and Sean O'Mahoney of the African Mission Society, who, since 1947, have worked among Yoruba craftsmen to promote an art combining 'European ideas and African forms'.[11] And all of Romain-Desfossés' white colleagues had a number of things in common: they believed in an innate African artistic imagination radically different from that of Europe; they invited the local artists they considered capable of growth into a discipline that, by digging into blurred or forgotten memories, could bring forth new arguments and ideas, a new, acculturated ground of creativity.

Between Two Traditions

Marshall W. Mount has distinguished four main categories of contemporary African art.[12] First are survivals of traditional styles, exemplified by such practices as brass-casting in Benin,

Nigeria, Ashanti wood-carving in Ghana, and cloth work in Abomey in the Republic of Benin. Second is the art inspired by the Christian missions. On the west coast and particularly in Central Africa, this kind of work goes back to the first contacts with the Portuguese, in the late fifteenth and the early sixteenth centuries; a religious art, it received a boost in the 1950s when Christian parishes began to sponsor artists' workshops. This art, then, is apologetic, in the sense that it is concerned with the defence and illustration of Christianity, which adapts to the African context. And the works – crucifixes, sculptures, canvases depicting biblical themes, carved doors, and so on – are generally used to decorate churches, parish buildings, and schools. Third is the souvenir-art category – 'tourist art' or 'airport art'.[13] This work is made to please Europeans; as an East African carver put it, 'We find out what the [Westerners] like. We make what they like when we are hungry'.[14] And last is an emerging new art requiring 'techniques that were unknown or rare in traditional African art'. Mount writes, 'The representation of this new subject matter is varied in style. There are works that are conservatively and academically rendered as well as abstract paintings that are reminiscent of Abstract Expressionist work. Most of this new African art, however, falls between these two stylistic poles, and as a consequence it avoids a close following of either'.[15]

Mount's pedagogical classifications seem useful for a first approach to African arts. Not surprisingly, however, their clarity and apparent coherence cannot account for the complexity of genres, schools of thought, and artistic traditions in Africa. One may wonder, for example, whether to situate the work of Mwenze Kibwanga, Pilipili (disciples of Romain-Desfossés) and Thomas Mukarobgwa (a student of McEwen) in the first or the fourth category of Mount's classification. And what about East African batik, or the Senegalese Souwer or glass-painting tradition? There is also a second problem, and a serious one: in which category should one include 'popular art'? This work testifies to emerging trends, yet few of its producers have attended art school, and still fewer have been 'recipients of government scholarships in art schools abroad',[16] like many of the artists in Mount's fourth category. Furthermore, though a number of its creators work with Christian themes, popular art is not, strictly speaking, inspired by the Christian missions. And no one will deny this art's modernity, which places it, in principle, in Mount's fourth category. Yet the motifs of an impressive list of popular artworks are explicitly inspired by traditional objects. What to do?

Mount's classification may be revised according to a simpler notion: the complementarity of the traditions in all the categories he separates. The Austrian-born teacher Ulli Beier considered this complementarity one of the most significant signs of the 'Afro-European culture contact':

It is no longer possible to look at African art and see nothing but a continuous and rapid process of disintegration. We can now see that African art has responded to the social and political upheavals that have taken place all over the continent. The African artist has refused to be

fossilised. New types of artists give expression to new ideas, work for different clients, fulfil new functions. Accepting the challenge of Europe, the African artist does not hesitate to adopt the new materials, be inspired by foreign art, look for a different role in society. New forms, new styles and new personalities are emerging everywhere and this contemporary African art is rapidly becoming as rich and as varied as were the more rigid artistic conventions of several generations ago.[17]

We see then, an aesthetic acculturation between, on the one hand, the complex of African representations and inspirations, its various discursive circuits displaying their depths and tracing their trajectories, and, on the other hand, the European, familiar yet strange to the African artist, and, at the same time, signifying a new starting point. The former belongs to the stubborn local cultural fabric, and reproduces regional *Weltanschauungs* in demonstrative or decorative, naïve or sophisticated fashion. The latter should be posited as a more intellectual and sociological frame.

For the artist trained in colonial-era workshops and art schools, the curriculum there has prescribed powerful reflexes and responses. Even in the most conservative institutions, education meant a conversion, or at least an opening, to another cultural tradition. For all these artists, the organic reality of a modernity was embodied by the discourses, values, aesthetics, and exchange economy of colonialism. One might, in consequence, be tempted by Edmund Leach's general system of oppositions between the two traditions, and might hypothesise a discreet competition between them: the more traditional the inspiration for a work of art, the less its general configuration and style could allow a clear assessment of the qualities of its forms, its content, and the maker's technical skills; conversely, the more Westernised an œuvre, the more easily an observer can make distinctions among these constituent elements. Leach's suggestion is brilliant, but unfortunately it does not address the difficult issues of styles, of 'the formal properties of a work of art', which constitute the core specificity of an artistic tradition.[18]

Two sets of criteria – internal (the artwork's style, motifs, theme, and content) and external (the context of its creation, that context's cultural history, the sociological milieu, and the artist's purpose) – should permit the distinction of three main currents (not categories) in contemporary African arts. There is a tradition-inspired trend, a modernist trend, and a popular art. Such orientations as Christian religious art, tourist art, and so on should be situated between the tradition-inspired and the modernist trends.

These two trends aim, on the one hand, to revitalise the styles, motifs, and themes of yesterday, to bring the past among us, as in the case of the schools founded by Romain-Desfossés, McEwen, and Victor Wallenda; on the other hand, these two trends search for a new, modern aesthetic, a conscious inscription of a modern cultural setting (as in the case, for example, of the Nigerian Lamidi Fakeye). The two ambitions may seem dissimilar but are actually quite compatible.

The third trend, recent popular art, made in the years of independence, tends to run parallel to the art of the trend toward modernity. But the art of the modernist trend is more intellectual; it is usually made by educated artists, and their work explores an academic language acquired in art school. Besides its artistic achievement, such work is also financially significant, for it is made primarily to be sold. Indeed, both the modernist and the tradition-inspired works function in African countries as 'export goods' for the international market.

The third current, the popular art, is perceived as the antithesis of these culminations of aesthetic acculturation. Its artists are generally self-trained, use inexpensive materials, and paint not for export but for ordinary people on the fringes of the local bourgeoisie (like many of the artists themselves). The styles, motifs, and themes of popular art allegorise commonsense perceptions; in native formal style, they comment vividly on historical events, social issues, and the cultural struggles of working-class and rural peoples.[19] In contrast to a 'high' culture sanctioned by international authority and by the respectability of the European art genres, popular art is structured as a number of regional discursive formations whose meanings, codings, status, distribution, and consumption are quite specific to the different places in which they emerge. Modernist and tradition-inspired art reflect the highest cultural values as defined and, supposedly, lived out, in the inner circles of acculturated African society. Popular art, however, made at the periphery of the same society, scans, interprets, and occasionally defies such values by confusing their explicitness, challenging their discursivity, and bringing into circulation new readings of founding events, mythologies, and social injustices, as well as popular representations of a history of alienation.[20]

Regrouping

I still remember the 1983 exhibition of Senegalese tapestries at the Wally Findlay Galleries, New York, and the more recent show 'Contemporary African Artists' at New York's Studio Museum in Harlem in 1990. What was striking in both exhibitions was the modernist styles of these collections of works. Introducing the Senegalese pieces, James R. Borynack, president of the Wally Findlay Galleries, observed that 'the totality of [works] is immersed in a sort of mythological retrospection which seems to issue from the collective unconscious'.[21] The introduction to the catalogue salutes the tapestries as validating 'a true African aesthetic'.[22] The tapestry technique comes from the French Ecole Nationale d'Aubusson, and the execution of the pieces, at least from 1964 to the 1970s, faithfully followed the Aubusson canons. Yet there was a discreet change in the motifs of these works, and it coincided with the introduction, around 1960, of the themes of 'Negritude'. The personal influence of Léopold Sédar Senghor, then president of Senegal, patron of the Manufactures Sénégalaises, and the best-known theorist of Negritude, was visible in the way in which many of the pieces celebrated ancient styles. Colour, line, and movement fused and broke as if driven by a vibrant rhythm. The work was a grand illustration, in fact, of Senghor's idea of the

whole School of Dakar: 'an African cultural heritage', an 'aesthetics of feeling', 'images impregnated with rhythm'.[23] A critic might ask whether such pieces, which claim to expose the virtues of an ancient bubbling aesthetic source, qualify as variants of traditional art. The success of the Senegalese tapestries in this regard, and of School of Dakar art in general, is indubitable, responds the artist and writer Issa Samb.[24] Yet Samb, though reluctant to stem criticism of any kind, fears that the usual critique, emphasising the work's African heritage rather than the individuality of the artist, 'unmasks and misleads simultaneously the system on which the Ecole de Dakar rests'. 'The critique confuses denotation in the sense that the exhibits which have been around the world actually denote Negritude but connote something quite different. And this "quite different" is principally undefinable, it is the painter's psyche'.[25] The 'Contemporary African Artists' exhibition was touched by the same issue: how truly 'African is modern African art?'.[26] Apart from the self-trained Nicholas Mukomberanwa of Zimbabwe, all the artists in the show – El Anatsui (Ghana), Youssouf Bath (Ivory Coast), Ablade Glover (Ghana), Tapfuma Gutsa (Zimbabwe), Rosemary Karuga (Kenya), Souleymane Keita (Senegal), Nicholas Mukomberanwa, Henry Munyaradzi (Zimbabwe), and Bruce Onobrakpeya (Nigeria) – were educated at specialised institutions in Africa and overseas; most of them belong to a second generation in the field, and if they consciously relate to earlier African art they know how to distort it, how to submit it to their own creative process. In fact, they discover in the African past simply art that has preceded them, art both beautiful and ugly. If the past inspires them, it does not bind them. Gutsa, for example, quite consciously distances himself from his Shona culture and conventions by exploring foreign themes (in, for example, *The Guitar*, 1988, in wood, newsprint and serpentine, and in *The Mask, the Dancer*, 1989, in serpentine, steel and wood). And Mukomberanwa's *Chembere Mukadzi* (1988–89; serpentine) expresses a contemporary political agenda of women's rights.

The ideological position of the Sengalese artist Iba N'Diaye reflects the attitude of a number of contemporary artists: 'I have no desire to be fashionable. Certain Europeans, seeking exotic thrills, expect me to serve them folklore. I refuse to do it – otherwise, I would exist only as a function of their segregationist ideas of the African artist'.[27] N'Diaye invokes a right to a personal subjectivity and individual practice. Why should an artist be condemned to the simple reproduction of other narratives?

N'Diaye's forceful statement, of course, brings to mind the well-known lament of William Fagg: 'we are in at the death of all that is best in African art'.[28] And the era of Independence in Africa indeed brought about radical sociocultural transformations and mutations. But why should one *a priori* decide that the ancient art was best? Ulli Beier writes that Fagg's statement 'describes the well-known tragic phenomenon in Africa. All over Africa the carvers down their tools. The rituals that inspired the artist are dying out. The kings who were his patrons have lost their power'.[29] So what? This discontinuity, despite its violence, doesn't necessarily mean the end of African art; it seems, rather, that the ancient models are being richly readapted. Beier himself still finds admirable pieces, evolving 'between two worlds', by artists such as the traditional Yoruba brass-

caster Yemi Bisir, the Benin wood-carver Ovia Idah, and the Muslim carver Lamidi Fakeye. And elsewhere he praises the 1960s work of Twins Seven-Seven, Muraina Oyelami, Adebisi Fabunmi, Jacob Afolabi, Rufus Ogundele, and others of the Oshogbo school whose art – and this was new at the time – was aimed not at the Western market alone. This work reflected a drive to say and illustrate something new, to transcend the crisis of tribal societies and art disorganised by the impact of European culture, and to express the emerging new consciousness. As N'Diaye asserts, 'For me, painting is an internal necessity, a need to express myself while trying to be clear about my intentions concerning subjects that have affected me – to commit myself concerning vital problems, the problems of our existence'. [30]

The real explodes on N'Diaye's canvases. Sometimes the paintings enunciate an intense narrative of violence – a ritual sacrifice in the series *Tabaski, sacrifice du mouton* (Tabaski, Sacrifice of the Sheep, 1970–87), or a frightening surprise in *Juan de Pareja agressé par les chiens* (Juan de Pareja Menaced by Dogs, 1985–86). Of the younger generation of painters, Sokari Douglas Camp, of Nigeria, seems fascinated by the everyday life of her people, the Kalabari of the Niger Delta, whose traditions are shown in her thrilling compositions. Fodé Camara, of Senegal, creates complex dances of colours that reflect another game of colours in his native Gorée: the blue of the sea, of Gorée, of voyages, opposed to the red of fear, of violence. [31] Gorée, that outpost of the slave trade on the Atlantic ocean! Finally, the cosmic conjunctions of Ouattara, from Côte d'Ivoire, reiterate old Senufo and Dogon mythologies in symbolic lines, blocks and hollows. [32] They also make me think of the more peaceful, more domesticated mysticism of another young painter, the Senegalese Ery Camara.

This ongoing work, and the many masterpieces it has already produced really began in the colonial-era ateliers. New generations have learned from the successes and failures of those workshops-cum-laboratories at the same time as they have interrogated their own traditional arts. The artists of the present generation are the children of two traditions, two worlds, both of which they challenge, merging mechanics and masks, machines and the memories of gods.

Popular Art

The term popular art' has at least three different meanings. First, popular art may simply be the art regarded with favour, sympathy, and approval by a given community; in this sense, the traditional masks of the Dogon of Mali, Pilipili's abstract paintings, and Twins Seven-Seven's figural sculptures are all popular. The phrase may also refer to art that represents the common people: as the Mozambican artist Malangatana put it, 'Art for me is a collective expression that comes from the uses and customs of the people and leads to their social, mental, cultural and political evolution'. [33] Finally, there is a popular art suited to and intended for an ordinary intelligence and a common taste. The description might seem pejorative, yet such art can be

highly sophisticated, as in the advertising art designed for the manipulation of the masses.

The term 'African popular art' is generally used to refer to this last kind of work. The artists who make it include Anthony Akoto and Ofori Danso of Ghana and Chéri Samba and Kalume of Zaire. Their art is neither a residue of traditional art nor an offshoot of the tradition-inspired and modernist trends in contemporary art. Those trends, as the importance of non-figurative painting in both of them attests, are less mimetic or representational than symbolic. The meaning of a Tanzanian Makonde mask, for example, or of a canvas by the Nigerian artist Bruce Onobrakpeya or the Zambian Henry Tayali, or of a sculpture by Bernhard Matermera of Zimbabwe, comes from its structuring of signs – signs that combine both with each other, and with signs outside the work, to suggest coincidences of values and ideas. Such works are polysemous and symbolic. The art of Akoto, Danso, and Samba, on the other hand, popular by virtue of its media, the texture of its canvases, the narrative sequences it displays, and its populist messages, is fundamentally mimetic and may seem, *prima facie*, almost monosemous. Works of this kind carry a message, manipulating, arranging, and combining signs so as to make an unambiguous pronouncement. The use of written language – frequent in Samba's paintings – is part of this ambition for a militant clarity, a negation of the polysemous, associative, open principles of most works of art. In this sense, popular art seems fundamentally anti-visionary and anti-imaginative. To what extent, then, does this work really qualify as visual art?

This is the challenge of popular art, which often takes the form of a visual narrative relaying events, phenomena, and issues that the local spectator already knows.[34] *La Mort historique de Lumumba* (The Historic Death of Lumumba, 1970s) and *Héro National Lumumba* (1970s) by Tshibumba Kanda-Matulu, or Samba's *Lutte contre les moustiques* (Battle with the Mosquitoes, 1989), are simply new versions of events and issues familiar from other means – even from other art. Yet there is something new in these canvases: themes are ritualised, objectified, their complex textures transformed into a neat, transparent, limpid frame. Each of them stands, then, as a closed discourse. This ritualisation is of considerable significance insofar as it works out a transmigration of symbols: from the complexity of history, of a real cultural experience, the artist chooses what can speak out the most clearly. The artist essentialises the event, or, perhaps better, symbolises it – in which case it may have been premature to speak of the monosemy of popular art. Indeed, the message of Patrice Lumumba's walk to death in *Héro National Lumumba* is ambiguous. The painting's surface clarity does not prevent the viewer from gleaning a variety of meanings from it: the dignity of the nationalist hero, the symbolic link between the Western-built helicopter and the three Katangan officials, the morality of the soldiers serving a state capable of such a crime, the physical presence of the Belgians themselves, and so on. Meanings, suggestions, images emerge from the frame, and history meets symbols in the mind of a 'popular' viewer with an efficiency impossible in even the best book.

Chéri Samba
Le Respect de l'Heure (Punctuality), 1989
Acrylic on canvas
57 x 65 cm
Courtesy Jean-Marc Patras Galerie, Paris

LE RESPECT DE L'HEURE EST BIEN NORMAL MAIS AVOIR UN PETIT RETARD CE N'EST PAS AUSSI UN PECHE

Popular art is both narrative and art. The grammar of its content, its chromatic logic, and the economy of its compositions escape most of the constraints of academic art. It witnesses something specific: a practice of everyday life. And it does so in an original style – that is, it has 'the meaning of recreating the world according to the values of the man who discovers it'.[35]

An Open Space

Il faudra, avant de revêtir le bleu de chauffe du mécanicien, que nous mettions notre âme en lieu sûr (Before Changing Back into the Mechanic's Overalls, We Need to Put our Soul in Certainty), Cheikh Hamidou Kane, 1961

A traveller, Dorcas MacClintock, a curatorial affiliate at the Peabody Museum of Natural History, Yale University, has a chance meeting with Ugo Mochi, an Italian artist who specialises in the silhouette. An ordinary incident. But then MacClintock discovers Africa, and, eventually, publishes *African Images* (1984), with pictures by Mochi. The book's creators would like it to be a window on African scenery. They introduce it as 'a look at animals in Africa'; and the animals are indeed seen fully the way the dictionary defines them, as living, other than human, beings.

Both MacClintock and Mochi seem concerned not with the actuality of African animals but with the impact on the eye of these 'beings' in the landscapes that frame them. MacClintock notes:

Nowhere on earth is beauty of animal form, modelled through time by physical function and environment, so apparent. Hoofed mammals, always watchful for *predators* reveal tension in the brightness of an eye, the alert stance, the poise of a head or the curve of neck, the stamp of a forefoot, or the whisk of a tail. Predators, too, are tense as they stalk, wait in ambush, or sprint after their prey. At other times, they loll about in the heat of the day. There is beauty of colour as well as of form. Patterns have evolved on some animals – stripes, splotches, and spots – that break up body outlines or provide camouflage. Other animals have conspicuous markings on face, ears, or legs that function for recognition among their own kind, emphasise mood or intent or are flaunted in displays of dominance between rivals.[36]

In the vision of this observer, the beauty of a landscape is rearranged according to the criteria of a 'natural' art. Yes, MacClintock claims to tell the truth about an order she sees clearly. But what she says nevertheless arises out of a grid of feeling (which is not to say – need I add? – that it is fictitious). In theory, anyone could verify what she has to say. Yet the poetic ensemble she offers is a translation of what she has perceived. Through aesthetic desire, the eye stylises the perceived, then returns to the observer her or his own investment.

Natural sceneries might seem to spring from nature but do not: it is in the gaze of the observer that African animals in their spaces are transmuted into aesthetic objects and take on semiotic status, becoming narratives of the natural. In the forest, for example, the appearance and habits of bongo antelopes seem to constitute a discourse: their 'body stripes merge with narrow patterns of sunlight to make their antelope outlines almost invisible . . . Once a bongo scents danger, it freezes. Then breaking cover, it vanishes as though by magic'.[37] Duikers, okapis, drills, porcupines, hogs and other animals have discourses of their own. Along rivers, lakeshores, and rift-valley walls, MacClintock finds variations on the discursive circuits she has discovered in the forests: dignified baboons socialise in families or walk alone, and small armies of bush pigs raid village crops under the moon; light, elegant, colourful bands of flamingos and pelicans fly or feed. In swamps and marshes one may 'read' the activities of sitatungas, colobus monkeys, waterbucks, crocodiles, and hippopotamuses. Is not theirs a *scriptural* activity, asserting a type of existence and beauty of narrative? Other discursive texts can be observed in the bush and in the savannahs: the movements and social lives of elephants, black rhinoceroses, and warthogs, or of sable and roan antelopes and elands; the grace and majesty of giraffes, the handsomeness of nyalas; and, of course, the jubilation of a remarkable variety of birds.

Can 'natural' African landscapes be thought of as texts, as paintings? Do they present themselves to the observer as linguistic and pictorial phenomena, to be read, understood, enjoyed? Do they constitute an incredible number of delightful discursive styles? One must remember that the style of a narrative always grows out of a context – that, as Maurice Merleau-Ponty writes, 'style cannot be taken as an object since it is still nothing and will become visible only in the work'.[38] The 'style' of animals living in their natural milieu, then, is obviously not 'a means of representation' (how could it be?), but emerges in the exchange between the African landscapes and animals and the eyes of the observer. In her epilogue, MacClintock daydreams:

> Africa, with its vast skies and far-off horizons, evokes a sense of wildness, freedom, and wonder. It is a land that echoes the past, where natural order prevails and days are without time . . .

> In the delicate springlike shade of an acacia, a gerenuk browses, its tail switching, ears batting, and front hoofs propped among the branches. A tiny dik-dik with enormous mouse-like ears ringed in white stares shyly from a thicket. A bull elephant threatens, flaring huge veined ears, brandishing tusks, testing with trunk, and swinging his pendulumlike foreleg sideways.[39]

The first paragraph reconstructs (unconsciously?) an old image of Africa; the second consolidates it. The question of the truth of this image seems unimportant, however, since the image credibly represents a possible 'natural' African painting or narrative. It is exotic, true, and might then be a fake

– an imitation of an ancient figure from some other, extraneous narrative. Even so, what it signifies remains pertinent, since it sustains the mimesis of a perception imitating itself in what it stylises and succumbing to the beauty it has thus invented.

If, as we have known since Husserl, no forming can transcend its space, its context, its language,[40] we must posit a relation between African styles and their natural context. MacClintock's language shows one such relation – a Franciscan impulse that transmutes every picture into a narrative celebrating the beauty and joy in nature. Another step might be to try and reconstruct the complex interactions between physical and human milieux, and the passage of these interactions into art. Ulli Beier has wonderfully described such an interaction in his discussion of the Mbari Mbayo Club at Oshogbo.[41] In quite a different vein, Jean-Paul Bourdier and Trinh T. Minh-ha (1985), focusing on vernacular architecture in the Sahel area of Burkina Faso, have shown how the Gurunsi culture has aesthetically domesticated a natural milieu, coherently integrating into it a spatial organisation of compounds and the human activities of daily life.

Images of everyday life also appear in the wall paintings of the Ndebele women of Pretoria, where, as Margaret Courtney-Clarke writes, 'the traditional abstract designs have merged with representational forms to create a unique, highly stylised art that combines the elements of the past with the realities of the present'.[42] If acculturation smacks of necessity in artistic activity such as the Ndebele's, it also sustains the continuity of ancient rituals, techniques and customs. Furthermore, this art not only inserts itself in a tradition, it also espouses the clear light of the Kwandebele region. Thus a conjunction: space, time and human tradition interrelate. MacClintock's beautifully stylised animals have their counterparts, their stylistic variations, in, say, such narratives as Pilipili's paintings of fish or crocodiles; the sculptures of elephants, leopards, and birds sold in tourist shops; and even – why not? – in such Malian masterpieces as the Bamana antelope head-dress or the Dogon antelope mask.[43] The Gurunsi compounds illustrate an aesthetic coherence between human and natural milieux; the Ndebele women's murals demonstrate an evolving tradition. We see, then, that the work of art 'is not fashioned far from things and in some intimate laboratory to which [the artist] alone possesses the key. This also means that . . . the work is not an arbitrary decree and that it always relates to its world as if the principle of equivalences through which it manifests the world had always been buried in it'.[44] As Michel Leiris has written, one should 'conceive of the overall approach to African arts less as primarily "a history of arts and styles" and more as the search for, and the according of spatio-temporal form to, the "visible products of a certain society's history"'.[45]

Conjugating

The Ndebele mural paintings have a sociohistory of their own, but somewhere they become part of the changing permanence of African artistic imaginations, canons, and traditional skills, as witnessed, for example, in pieces from different regions of Central and West Africa which were

made between the late seventeenth and the early twentieth centuries and which specialists class in the category of 'extinct' art. Of various styles and morphologies, they yet retain loose common features: like most traditional artworks, they were made by anonymous authors, the creator's consciousness being fused, then, with his or her social group; and they can be linked to a number of general cultural canons, trends, and sets of symbols. As an African, I relate to them through a double articulation. On the one hand I find in them a common signifying structure that makes them seem part of a single cultural economy. On the other, I also see regional characteristics in each of them, the Grebo masks from Côte d'Ivoire, say, obeying formal customs foreign to those of the Benin plaques. The first articulation is highly subjective, and reflects the ideological climate of Africa since the 1960s, a period when the notion of African cultural unity had been promoted in such books as Willy Abraham's *The Mind of Africa* (1966), Cheik Anta Diop's *L'Unité culturelle de l'Afrique noire* (1960), and in many other places. The second response depends on the findings of anthropologists and art historians, and allows for the exploration of each artist's individuality: the morphological forms, geometric features, chromatic techniques, and symbolisms particular to his or her vocabulary.

In the dialectic between the two articulations, the extinction of the artistic trends of the past ceases to be a closure. In effect, I can credit the ancient styles with inspirational power, and can examine the more recent pieces for their idiosyncratic patterns and styles. A creative continuity appears, and transcends the objective ruptures described by laboratory specialists. Mid-twentieth-century Dogon masks from Mali and early twentieth-century Makonde masks from Tanzania appear to me part of the same cultural order.[46] They can be seen and admired not only in their difference, but also as variations mirroring transformations of the archetypes in a basic imagination. And why shouldn't we relate the style of the early twentieth-century Dogon antelope mask to what appears in the African landscape, which amazed countless African artists before Dorcas MacClintock got to it? This suggestion puts the various forms and styles of African art over time in touch with equivalents in nature. The practices of traditional artists are of interest, say the specialists, because their works are not realistic yet participate in establishing the meaning of reality. They provide metonyms and metaphors for real beings, things, events and natural forces in the world at the same time as abstracting the world. Their perfect insertion in African peoples' ordinary lives has led students of African art to conclude, a bit lazily, that this art is essentially functional. This conclusion erases the complexity of the art's symbolic and allegorical meanings. The mask, for example, a clear objectification of a signifier, refers also to other orders of meanings without which it is useless.

Unlike traditional art, contemporary popular art assumes some of the virtues of realism, advancing its pictures as reflections of a modern culture and its history. Concerned with the politics of the signified, it reinforces its realism with ethnical points (as Samba does) or, more generally, with various sociological functions, thus distancing itself from the symbolic and decorative activity typifying atelier and art-school trends since the 1940s.

In sum

The three trends in current African art – tradition-inspired, modernist, and popular – are recent: the oldest examples date from the first quarter of this century. One might be tempted, then, to relate their genesis to the impact of the colonial era; yet a number of their themes and motifs – reproductions of crucifixes and Madonnas, biblical references, and so on, all along the western coast of the continent – are part of a history of acculturation that goes back to the fifteenth and sixteenth centuries. Viewed in the light of history, the distinction between the tradition-inspired and the modernist trends in contemporary African arts, though useful for the sake of analysis, indicates in the end a kind of enthralment to traditional art. For these two trends in fact constitute a single current. First, both œuvres are created mostly in ateliers and art schools, and even when they are made by self-trained artists they illustrate the colonial acculturation of African societies; second, unlike traditional artworks, both reveal the consciousness, the artistic identity, of their makers; and third, both have as their raison d'être not the imitation of reality but the creation of beauty.

The first of these three shared traits describes the sociocultural context of the new artistic imagination. The second is philosophical, indicating a far-reaching spiritual and intellectual revolution and its new legitimacy in an acculturated social milieu. The third is aesthetic, and brings these two trends into focus: both involve interpretive, symbolic processes of coding what is out there rather than mimetic renderings of reality. And both the tradition-inspired and the modernist impulses often fuse in the work of one artist, for example Malangatana, N'Diaye or Twins Seven-Seven.

Popular artworks situate themselves somehow between these two trends. They often relate to a particular region and its history. As narratives, they deconstruct the memory of this history from the perspective of a single individual. In many respects, popular arts, mostly paintings, are structured as *histoire immédiate*, in Benoît Verhaegen's expression; they are literally a capturing of ordinary, banal stories and events (a market, a drinking party, a political event), of violence and tragedy (a civil war, an assassination) or of mythological motifs, for example Mami Wata. In their extreme manifestations, popular arts come close to publicity and advertisement.

To academic rules of representation and techniques of arriving at 'the beautiful', popular artists propose an opposing vision. They want to transmit a clear message; they claim the virtue of sociological and historical truth; and they try to name and unveil even the unnameable and the taboo. Here technical flaws become marks of originality. The artist appears as the 'undisciplinable' hero, challenging social institutions, including art practices, particularly academic ones. Yet this 'deviant', who sometimes attacks both a tradition and its modern currents, incarnates clearly the locus of their confrontation. In popular art, the politics of memesis inserts in the 'maternal' territory of the tradition a practice that questions both art and history in the names of the subject. This is work that aims to bring together art, the past, and the community's dreams for a better tomorrow.

Notes

1 K. S. Loughran, *et al.* (eds.), *Somalia in Word and Image* (Washington DC: Foundation for Cross-Cultural Understanding, 1986), p. 59.

2 See Sally Price, 'Our Art –Their Art', *Third Text*, no. 6 (London: Spring 1989), p. 65.

3 See, for example, Susan Vogel and Francine N'Diaye, *African Masterpieces from the Musée de l'Homme* (New York: The Center for African Art, 1985).

4 See Julia Kristeva, *Desire in Language. A Semiotic Approach to Literature and Art* (New York: Columbia University Press, 1980).

5 Joseph-Aurélien Cornet, *et al.*, *60 ans de peinture au Zaïre* (Brussels: Les Editeurs Associés, 1989), pp. 68–69.

6 *Ibid.*, p. 66.

7 Frank McEwen, 'The Workshop School', in *Contemporary African Art*, exhibition catalogue (London: Camden Arts Centre, 1970), p.16.

8 C. G. Jung, *The Archetypes and the Collective Unconscious*, trans. R. F. C. Hull (Princeton: Bollingen Foundation and Princeton University Press, 1980), p. 5.

9 Wim Toebosch, in Cornet, *et al.*, *op. cit.*, p. 66.

10 Marshall Ward Mount, *African Art: The Years Since 1920* (Bloomington: Indiana University Press 1973), p. 119 (reprinted with a new introduction, New York: Da Capo Paperback, 1989).

11 *Ibid.*, p. 32.

12 Mount, reprint, 1989.

13 See Benetta Jules-Rosette, *The Messages of Tourist Art: An African Semiotic System in Comparative Perspective*, (New York: 1984).

14 Mount, *op. cit.*, p. 39.

15 Mount, *op. cit.*, pp. 62–63.

16 Mount, *op. cit.*, p. 62.

17 Ulli Beier, *Contemporary Art in Africa* (London: Frederick A. Praeger, 1968), p. 14.

18 See Henri Focillon, *La Vie des formes* (Paris: 1934); Jan Vansina, *Art History in Africa* (London: Longman, 1984).

19 See, for example, J. Fabian and I. Szombati-Fabian, 'Folk Art from an Anthropological Perspective', in I. M. G. Quimby and S. T. Swank (eds.), *Perspectives on American Folk Art* (New York: W.W. Norton, 1980), pp. 247-291.

20 See, for example, Beier, *op. cit.*; Bogumil Jewsiewicki (ed.), *Art and Politics in Black Africa* (Ottawa: Canadian Association of African Studies, 1989).

21 James R. Borynack, *Contemporary Art from the Republic of Senegal* (New York: Wally Findlay Galleries,1983), p. 4.

22 *Ibid.* p. 6.

23 Friedrich Axt and Moussa Babacar Sy El Hadji (eds.), *Anthology of Contemporary Fine Arts in Senegal* (Frankfurt: Museum für Völkerkunde, 1989), p. 19.

24 *Ibid.*, pp. 129–130.

25 *Ibid.*, p. 130.

26 See *Contemporary African Arts: Changing Tradition* (New York: Studio Museum in Harlem, 1990), p.36.

27 See *Iba N'Diaye* (Dakar: Musée Dynamique, 1977) and *Iba N'Diaye: Un peintre, un humaniste* (Nîmes: Chapelle des Jésuites, 1987).

28 *Ibid.*

29 Beier, *op. cit.*, p. 3.

30 *Iba N'Diaye* and *Iba N'Diaye: Un peintre, un humaniste*, *op. cit.*

31 See *Révolution Française sous les Tropiques*, exhibition catalogue (Musée National des Africains et Océaniens, 1989), pp.35-39.

32 See Vrij Baghoomian and Michael Warren (eds.), *Ouattara* (Kyoto: Kyoto Shoin International, 1989).

33 Edward A. Alpers, 'Representation and Historical Consciousness in the Art of Modern Mozambique', *Canadian Journal of African Studies* vol. 22, no. 1, (Montreal: 1988), p. 85, (reprinted in Jewsiewicki, *op. cit.*, pp. 72-94).

34 See Fabian and Szombati-Fabian, *op. cit.*

35 Maurice Merleau-Ponty, *The Prose of the World* (Evanston: Northwestern University Press, 1973), p. 59.

36 Dorcas MacClintock, 1984, *African Images*, pictures by Ugo Mochi (New York: Charles Scribner's Sons, 1984), p. xii.

37 *Ibid.*, pp. 2–3.

38 Merleau-Ponty, *op. cit.*, p. 59.

39 MacClintock, *op. cit.*, p. 140.

40 Edmund Husserl, *The Crisis of European Sciences and Transcendental Phenomenology* (Evanston: Northwestern University Press, 1970), pp. 370–371.

41 Beier, *op. cit.*, pp. 101–111

42 Margaret Courtney-Clarke, *Ndebele: The Art of an African Tribe* (New York: Rizzoli, 1986), p. 23.

43 See Vogel and N'Diaye, *op. cit.*

44 Merleau-Ponty, *op. cit.* p. 61.

45 L. Perrois, 'Through the Eyes of the White Man: From "Negro Art" to African Arts, Classifications and Methods', *Third Text*, no. 6 (London: Spring 1989), p. 52.

46 Vogel and N'Diaye, *op. cit.*

The Postcolonial and The Postmodern

Kwame Anthony Appiah

You were called Bimbircokak
And all was well that way
You have become Victor-Emile-Louise-Henri-Joseph
Which
So far as I recall
Does not reflect your kinship with
Rockefeller
Yambo Ouologuem [1]

In 1987, the Center for African Art in New York organised a show entitled 'Perspectives: Angles on African Art'.[2] The curator, Susan Vogel, had worked with a number of 'co-curators', whom I list in order of their appearance in the table of contents: Ekpo Eyo, former director of the Department of Antiquities of the National Museum of Nigeria; William Rubin, director of painting and sculpture at the Museum of Modern Art New York and organiser of its controversial 'Primitivism' exhibition; Romare Bearden, African-American painter; Ivan Karp, curator of African ethnology at the Smithsonian; Nancy Graves, European-American painter, sculptor and filmmaker; James Baldwin, who surely needs no qualifying glosses; David Rockefeller, art collector and friend of the mighty; Lela Kouakou, Baule artist and diviner from the Ivory Coast (this a delicious juxtaposition, richest and poorest, side by side); Iba N'Diaye, Senegalese sculptor, and Robert Farris Thompson, Yale professor and African and African-American art historian. Vogel describes the process of selection in her introductory essay. The one woman and nine men were each offered a hundred-odd photographs of 'African Art as varied in type and origin, and as high in quality, as we could manage' and asked to select ten for the show.[3] Or, I should say more exactly, that this is what was offered to nine of the selectors. For Vogel adds, 'In the case of the Baule artist, a man familiar only with the art of his own people, only Baule objects were placed in the pool of photographs'. At this point, we are directed to a footnote that reads:

> Showing him the same assortment of photos the others saw would have been interesting, but
> confusing in terms of the reactions we sought here. Field aesthetic studies, my own and others,
> have shown that African informants will criticise sculptures from other ethnic groups in terms
> of their own traditional criteria, often assuming that such works are simply inept carvings of
> their own aesthetic tradition.

I shall return to this irresistible footnote in a moment. But let me pause to quote further, this time from the words of David Rockefeller, who would surely never 'criticise sculptures from other ethnic groups in terms of [his] own traditional criteria', discussing what the catalogue calls a 'Fante female figure':

I own somewhat similar things to this and I have always liked them. This is a rather more sophisticated version than the ones that I've seen, and I thought it was quite beautiful . . . the total composition has a very contemporary, very Western look to it. It's the kind of thing that goes very well with contemporary Western things. It would look good in a modern apartment or house.[4]

We may suppose that David Rockefeller was delighted to discover that his final judgement was consistent with the intentions of the sculpture's creator. For a footnote to the earlier 'Checklist' reveals that the Baltimore Museum of Art desires to 'make public the fact that the authenticity of the Fante figure in its collection has been challenged'. Indeed, work by Doran Ross suggests that this object is almost certainly a modern piece made in my hometown of Kumasi by the workshop of a certain Francis Akwasi, which 'specialises in carvings for the international market in the style of traditional sculpture. Many of its works are now in museums throughout the West, and were published as authentic by Cole and Ross'[5] (yes, the same Doran Ross) in their classic catalogue *The Arts of Ghana*.

But then it is hard to be *sure* what would please a man who gives as his reason for picking another piece (this time a Senufo helmet mask) 'I have to say I picked this because I own it. It was given to me by President Houphouet Boigny of Ivory Coast'.[6] Or one who remarks, 'concerning the market in African art':

The best pieces are going for very high prices. Generally speaking, the less good pieces in terms of quality are not going up in price. And that's a fine reason for picking the good ones rather than the bad. They have a way of becoming more valuable. I like African art as objects I find would be appealing to use in a home or an office . . . I don't think it goes with everything, necessarily – although the very best perhaps does. But I think it goes well with contemporary architecture.[7]

There is something breathtakingly unpretentious in Mr Rockefeller's easy movement between considerations of finance, of aesthetics, and of decor. In these responses we have surely a microcosm of the site of the African in contemporary – which is to say, postmodern – America.

I have given so much of David Rockefeller not to emphasise the familiar fact that questions of what we call 'aesthetic' value are crucially bound up with market value; not even to draw attention to the fact that this is known by those who play the art market. Rather, I want to keep clearly before us the fact that David Rockefeller is permitted to say anything at all about the arts of Africa because he is a *buyer* and because he is at the *centre*, while Lela Kouakou, who merely makes art and who dwells at the margins, is a poor African whose words count only as parts of the commodification[8] of Baule art – both for those of us who constitute the museum public and for collectors, like Rockefeller.[9] I want to remind you, in short, of how important it is that African art is a *commodity*.

But the co-curator whose choice will set us on our way is James Baldwin – the only one who picked a piece that was not in the mould of the Africa of the exhibition 'Primitivism', a sculpture that will be my touchstone, a piece labelled by the museum, *Yoruba Man with a Bicycle*. Here is some of what Baldwin said about it:

This is something. This has got to be contemporary. He's really going to town. It's very jaunty, very authoritative. His errand might prove to be impossible. He is challenging something – or something has challenged him. He's grounded in immediate reality by the bicycle . . . He's apparently a very proud and silent man. He's dressed sort of polyglot. Nothing looks like it fits him too well.

Baldwin's reading of this piece is, inevitably, 'in terms of [his] own . . . criteria' – a reaction contextualised only by the knowledge that bicycles are new in Africa and that this piece, anyway, does not look anything like the works he recalls seeing from his earlier childhood at the Schomburg museum in Harlem. His response torpedoes Vogel's notion that the only 'authentically traditional' African – the only one whose responses, as she says, could have been found a century ago – must be refused a choice among Africa's art cultures because he, unlike the rest of the co-curators, who are Americans and European-educated Africans, will use his 'own . . . criteria'. This Baule diviner, this authentically African villager, the message is, does not know what *we*, authentic postmodernists, now know: that the first and last mistake is to judge the Other on one's own terms. And so, in the name of this, the relativist insight, we impose our judgement that Lela Kouakou may not judge sculpture from beyond the Baule culture zone because he will – like all the other African 'informants' we have met in the field – read them as if they were meant to meet those Baule standards.

Worse than this, it is nonsense to explain Lela Kouakou's responses as deriving from an ignorance of other traditions – if indeed he is, as he is no doubt supposed to be, like most 'traditional' artists today; if he is like, for example, Francis Akwasi of Kumasi. Kouakou may judge other artists by his own standards (what on earth else could he, could anyone, do, save make no judgement at all?), but to suppose that he is unaware that there are other standards within Africa (let alone without) is to ignore a piece of absolutely basic cultural knowledge, common to most precolonial as to most colonial and postcolonial cultures on the continent – the piece of cultural knowledge that explains why the people we now call 'Baule' exist at all. To be Baule, for example, is, for a Baule, not to be a white person, not to be Senufo, not to be French.[10] The ethnic groups – Lela Kouakou's Baule 'tribe', for example – within which all African aesthetic life apparently occurs, are the products of colonial and postcolonial articulations. And someone who knows enough to make himself up as a Baule for the twentieth century surely knows that there are other kinds of art.

But Baldwin's *Yoruba Man with a Bicycle* does more than give the lie to Vogel's strange footnote;

it provides us with an object that can serve as a point of entry to my theme: a piece of contemporary African art that will allow us to explore the articulation of the postcolonial and the postmodern. *Yoruba Man with a Bicycle* is described as follows in the catalogue:

Page 24
Man with a Bicycle
Yoruba, Nigeria, 20th century
Wood and paint H. 35 ³/₄ in.
The Newark Museum

The influence of the Western world is revealed in the clothes and bicycle of this neo-traditional Yoruba sculpture which probably represents a merchant en route to market.[11]

And it is this word 'neo-traditional' – a word that is almost right – that provides, I think, the fundamental clue.

But I do not know how to explain this clue without saying first how I keep my bearings in the shark-infested waters that surround the semantic island of the postmodern. And since narratives, unlike metanarratives, are allowed to proliferate in these seas, I shall begin with a story about my friend the late Margaret Masterman. Sometime in the mid-1960s, Margaret was asked to participate at a symposium, chaired by Karl Popper, at which Tom Kuhn was to read a paper and then she, J. M. W. Watkins, Stephen Toulmin, L. Pearce Williams, Imre Lakatos and Paul Feyerabend would engage in discussion of Kuhn's work. Unfortunately for Margaret, she developed infective hepatitis in the period leading up to the symposium and was unable, as a result, to prepare a paper. Fortunately for all of us, though, she was able to sit in her hospital bed – in Block 8, Norwich hospital, to whose staff the paper she finally did write is dedicated – and create a subject index to Kuhn's *The Structure of Scientific Revolutions*. In the course of working through the book with index cards, Margaret identified no 'less than twenty-one senses, possibly more, not less' in which Kuhn uses the word 'paradigm'. After her catalogue of these twenty-one uses, she remarks laconically that 'not all these senses of "paradigm" are inconsistent with one another'. She continues:

Nevertheless, given the diversity, it is obviously reasonable to ask: 'Is there anything in common between all these senses? Is there, philosophically speaking, anything definite or general about the notion of a paradigm which Kuhn is trying to make clear? Or is he just a historian-poet describing different happenings which have occurred in the history of science, and referring to them all by using the same word, 'paradigm'?[12]

The relevance of this tale hardly needs explication. And the task of chasing the word 'postmodernism' through the pages of Lyotard and Jameson and Habermas, in and out of the *Village Voice* and the *TLS* and even the *New York Times Book Review* makes the task of pinning down Kuhn's 'paradigm' look like work for a minute before breakfast.

Nevertheless, there is, I think, a story to tell about all these stories – or, of course, I should say, there are many, but this, for the moment is mine – and, as I tell it, the Yoruba bicyclist will eventually come back into view.

Let me begin with the most obvious, and surely one of the most often-remarked features of Jean-François Lyotard's account of postmodernity: the fact that it is a metanarrative of the end of the metanarratives.[13] To theorise certain central features of contemporary culture as 'post' anything, is, of course, inevitably to invoke a narrative, and, from the Enlightenment on, in Europe and European-derived cultures, that 'after' has also meant 'above and beyond' and to step forward (in time) has been *ipso facto* to *progress*.[14] Brian McHale announces in his recent *Postmodernist Fiction:*

> As for the prefix POST, here I want to emphasise the element of logical and historical *consequence* rather than sheer temporal *posteriority*. Postmodernism follows *from* modernism, in some sense, more than it follows *after* modernism . . . Postmodernism is the posterity of modernism, that is tautological.[15]

My point, then, is not the boring logical one that Lyotard's view – in which, in the absence of a 'grand narrative of legitimation', we are left with only local legitimations, imminent in our own practices – might seem to presuppose a 'grand narrative of legitimation' of its own, in which justice turns out to reside, unexcitingly, in the institutionalisation of pluralism. It is rather that his analysis seems to feel the need to see the contemporary condition as over and above an immediately anterior set of practices and as going beyond them. Lyotard's postmodernism – his theorisation of contemporary life as postmodern – is *after* modernism because it rejects aspects of modernism. And in this repudiation of one's immediate predecessors (or, more especially, of their theories of themselves) it recapitulates a crucial gesture of the historic avant-garde. Indeed, it recapitulates a crucial gesture of the 'modern artist', in the sense of modernity characteristic of sociological usage in which it denotes 'an era that was ushered in via the Renaissance, rationalist philosophy, and the Enlightenment, on the one hand, and the transition from the absolutist state to bourgeois democracy, on the other';[16] in that sense of 'artist' to be found in Trilling's account of Arnold's *Scholar Gypsy*, whose 'existence is intended to disturb us and make us dissatisfied with our habitual life in culture'.[17]

This straining for a contrast – a modernity or a modernism to be *against* – is extremely striking given the lack of any plausible account of what formally distinguishes the modern from the postmodern. In a recent essay, Frederic Jameson grants at one point, after reviewing recent

French theorisings (Deluze, Baudrillard, Debord) that it is difficult to distinguish formally the postmodern from high modernism:

> Indeed, one of the difficulties in specifying postmodernism lies in its symbiotic or parasitical relationship to [high modernism]. In effect, with the canonisation of a hitherto scandalous, dissonant, amoral, antisocial, bohemian high modernism offensive to the middle classes, its promotion to the very figure of high culture generally, and perhaps most importantly, its enshrinement in the academic institution, postmodernism emerges as a way of making creative space for artists now oppressed by those henceforth hegemonic categories of irony, complexity, ambiguity, dense temporality, and particularly, aesthetic and utopian monumentality.[18]

Jameson's argument in this essay is that we must characterise the distinction not in formal terms – in terms, say, of an 'aesthetic of *textuality*' or of 'the eclipse, finally, of all depth, especially historicity itself', or of 'the "death" of the subject', or '*the culture of the simulacrum*' or 'the society of the spectacle' [19] – but in terms of 'the social functionality of culture itself':

> High modernism, whatever its overt political content, was oppositional and marginal within a middle-class Victorian or philistine or gilded-age culture. Although postmodernism is equally as offensive in all the respects enumerated (think of punk rock or pornography), it is no longer at all 'oppositional' in that sense; indeed, it constitutes the very dominant or hegemonic aesthetic of consumer society itself and significantly serves the latter's commodity production as a virtual laboratory of new forms and fashions. The argument for a conception of postmodernism as a periodising category is thus based on the presupposition that, even if *all* the formal features enumerated above were already present in the older high modernism, the very significance of those features changes when they become a cultural *dominant* with a precise socio-economic functionality.[20]

It is the 'waning' of the 'dialectical opposition' between high modernism and mass culture – the commodification and, if I may coin a barbarism, the 'deoppositionalisation', of those cultural forms once constitutive of high modernism – that Jameson sees as key to understanding the postmodern condition.

There is no doubt much to be said for Jameson's theorising of the postmodern. But I do not think we shall understand what is common to all the various postmodernisms if we stick within Jameson's omnisubsumptive vision. The commodification of a fiction, a stance, of oppositionality that is saleable precisely because its commodification guarantees for the consumer that it is no substantial threat was, indeed, central to the cultural role of punk rock in Europe and America.

But what, more than a word and a conversation, makes Lyotard and Jameson competing theorists of the same postmodern?

I do not – this will come as no surprise – have a definition of the postmodern to put in the place of Jameson's or Lyotard's. But there is now a rough consensus about the structure of the modern/postmodern dichotomy in the many domains – from architecture to poetry to philosophy to rock to the movies – in which it has been invoked. In each of these domains there is an antecedent practice that laid claim to a certain exclusivity of insight and in each of them postmodernism is a name for the rejection of that claim to exclusivity, a rejection that is almost always more playful – though not necessarily less serious – than the practice it aims to replace. That this will not do as a *definition* of postmodernism follows from the fact that in each domain this rejection of exclusivity takes up a certain specific shape, one that reflects the specificities of its setting.

To understand the various postmodernisms this way is to leave open the question of how their theories of contemporary social, cultural, and economic life relate to the actual practices that constitute life; to leave open, then, the relations between postmodernism and postmodernity. Where the practice is theory – literary or philosophical – postmodernism as a *theory* of post-modernity can be adequate only if it reflects to some extent the realities of that practice, because the practice is itself fully theoretical. But when a postmodernism addresses, say, advertising or poetry, it may be adequate as an account of them even if it conflicts with their own narratives, their theories of themselves. For, unlike philosophy and literary theory, advertising and poetry are not largely *constituted* by their articulated theories of themselves.

It is an important question *why* this distancing of the ancestors should have become so central a feature in our cultural lives. And the answer, surely, has to do with the sense in which art is increasingly commodified. To sell oneself and one's products as art in the marketplace, it is important, above all, to clear a space in which one is distinguished from other producers and products – and one does this by the construction and the marking of differences.

It is this that accounts for a certain intensification of the long-standing individualism of post-Renaissance art production: in the age of mechanical reproduction, aesthetic individualism – the characterisation of the artwork as belonging to the œuvre of an individual – and the absorption of the artist's life into the conception of the work can be seen precisely as modes of identifying objects for the market. The sculptor of the bicycle, by contrast, will not be known by those who buy this object; his individual life will make no difference to its future history. (Indeed, he surely knows this, in the sense in which one knows anything whose negation one has never even considered.) Nevertheless, there is *some*thing about the object that serves to establish it for the market: the availability of Yoruba culture and of stories about Yoruba culture to surround the object and distinguish it from 'folk art' from elsewhere. I shall return to this point. Let me confirm this proposal by examples:

1 In philosophy, postmodernism is the rejection of the mainstream consensus – from Descartes
 through Kant to logical positivism – on foundationalism (there is one route to knowledge,
 which is exclusivism in epistemology) and of metaphysical realism (there is one truth, which is
 exclusivism in ontology), each underwritten by a unitary notion of reason; it thus celebrates such
 figures as Nietzsche (no metaphysical realist) and Dewey (no foundationalist). The modernity
 that is opposed here can thus be Cartesian (in France), Kantian (in Germany), and logical positivist
 (in America).
2 In architecture, postmodernism is the rejection of an exclusivism of function (as well as
 the embrace of a certain taste for pastiche). The modernity that is opposed here is the
 'monumentality', 'elitism', and 'authoritarianism' of the international style of Le Corbusier
 or Mies.[21]
3 In 'literature', postmodernism reacts against the high seriousness of high modernism,
 which mobilised 'difficulty' as a mode of privileging its own aesthetic sensibility and celebrated
 a complexity and irony appreciable only by a cultural elite. Modernity here is, say, and in no
 particular order, Proust, Eliot, Pound, Woolf.
4 In political theory, finally, postmodernism is the rejection of the monism of Big-M Marxist
 (though not of the newer little-m marxist) and liberal conceptions of justice, and their overthrow
 by a conception of politics as irreducibly plural, with every perspective essentially contestable
 from other perspectives. Modernity here is the great nineteenth-century political narratives
 of Marx and Mill but includes, for example, such latecomers as John Rawl's reconstruction of
 The Liberal Theory of Justice.

These sketchy examples are meant to suggest how we might understand the family resemblance
of the various postmodernisms as governed by a loose principle. They also suggest why it might
be that the high theorists of postmodernism – Lyotard, Jameson, Habermas,[22] shall we say –
can seem to be competing for the same territory: Lyotard's privileging of a certain philosophical
antifoundationalism could surely be seen as underwriting (though not, I think, plausibly, as causing)
each of these moves; Jameson's characterisation of postmodernism as the logic of late capitalism –
with the commodification of 'cultures' as a central feature – might well also account for many
features of each of these transitions; and Habermas' project is surely intended (though in the name
of a most un-Lyotardian metanarrative) to provide a *modus operandi* in a world in which pluralism
is, so to speak, a fact waiting for some institutions.

Postmodern culture is the culture in which all of the postmodernisms operate, sometimes in
synergy, sometimes in competition. And because contemporary culture is, in certain senses to
which I shall return, transnational, postmodern culture is global – though that does not by any
means suggest that it is the culture of every person in the world.

If postmodernism is the project of transcending some species of modernism – which is to say, some relatively self-conscious self-privileging project of a privileged modernity – our 'neo-traditional' sculptor of the *Yoruba Man with a Bicycle* is presumably to be understood, by contrast, as premodern, that is, traditional. (I am supposing, then, that being neo-traditional is a way of being traditional; what work the 'neo' does is a matter for a later moment.) And the sociological and anthropological narratives of tradition through which he or she came to be so theorised is dominated, of course, by Max Weber.

Weber's characterisation of traditional (and charismatic) authority *in opposition* to rational authority is in keeping with his general characterisation of modernity as the rationalisation of the world, and he insisted on the significance of this characteristically Western process for the rest of humankind. The introduction to *The Protestant Ethic* begins:

> A product of modern European civilisation, studying any problem of universal history, is bound to ask himself to what combination of circumstances the fact should be attributed that in Western civilisation, and in Western civilisation only, cultural phenomena have appeared which (as we like to think) lie in a line of development having universal significance and value.[23]

There is certainly no doubt that Western modernity now has a universal *geographical* significance. The Yoruba bicyclist – like Sting and his Amerindian chieftains of the Amazon rain forest, or Paul Simon and the Mbaqanga musicians of *Graceland* – is testimony to that. But if I may borrow someone else's borrowing, the fact is that the Empire of Signs strikes back. Weber's 'as we like to think' reflects his doubts about whether the Western imperium over the world was as clearly of universal value as it was certainly of universal *significance*, and postmodernism surely fully endorses his resistance to this claim. The bicycle enters our museums to be valued by us (David Rockefeller tells us *how* it is to be valued). But just as the presence of the object reminds us of this fact, its *content* reminds us that the trade is two-way.

I want to argue that to understand our human modernity we must first understand why the rationalisation of the world can no longer be seen as the tendency either of the West or of history; why, simply put, the modernist characterisation of modernity must be challenged. To understand our world is to reject Weber's claim for the rationality of what he called rationalisation and his projection of its inevitability; it is, then, to have a radically post-Weberian conception of modernity.

We can begin with a pair of familiar and helpful caricatures: Thomas Stearns Eliot is against the soullessness and the secularisation of modern society, the reach of Enlightenment rationalism into the whole world. He shares Weber's account of modernity and more straightforwardly deplores it. Le Corbusier is in favour of rationalisation – a house is a 'machine for living in' – but he, too, shares

Weber's vision of modernity. And, of course, the great rationalists – the believers in a transhistorical reason triumphing in the world – from Kant on are the source of Weber's Kantian vision. Modernism in literature and architecture and philosophy (the account of modernity that, on my model, *post*modernism in these domains seeks to subvert) may be for reason or against it: but in each domain rationalisation – the pervasion of reason – is seen as the distinctive dynamic of contemporary history.

But the beginning of postmodern wisdom is to ask whether Weberian rationalisation is in fact what has happened. For Weber, charismatic authority – the authority of Stalin, Hitler, Mao, Guevara, Nkrumah – is antirational, yet modernity has been dominated by just such charisma. Secularisation seems hardly to be proceeding: religions grow in all parts of the world; more than ninety percent of North Americans still avow some sort of theism; what we call 'fundamentalism' is as alive in the West as it is in Africa and the Middle and Far East; Jimmy Swaggart and Billy Graham have business in Louisiana and California as well as in Costa Rica and Ghana.

What we can see in all these cases, I think, is not the triumph of Enlightenment capital-R Reason – which would have entailed exactly the end of charisma and the universalisation of the secular – not even the penetration of a narrower instrumental reason into all spheres of life, but what Weber mistook for that: namely, the incorporation of all areas of the world and all areas of even formerly private' life into the money economy. Modernity has turned every element of the real into a sign, and the sign reads 'for sale'; this is true even in domains like religion where instrumental reason would recognise that the market has at best an ambiguous place.

If Weberian talk of the triumph of instrumental reason can now be seen to be a mistake, what Weber thought of as the disenchantment of the world – that is, the penetration of a scientific vision of things – describes at most the tiny, and in the United States, quite marginal, world of the higher academy and a few islands of its influence. The world of the intellectual is, I think, largely disenchanted (even theistic academics largely do not believe in ghosts and ancestor spirits), and fewer people (though still very many) suppose the world to be populated by the multitudes of spirits of earlier religion. Still, what we have seen in recent times in the United States is not secularisation – the end of religions – but their commodification; with that commodification, religions have reached further and grown – their markets have expanded – rather than dying away.

Postmodernism can be seen, then, as a new way of understanding the multiplication of distinctions that flows from the need to clear oneself a space; the need that drives the underlying dynamic of cultural modernity. Modernism saw the economisation of the world as the triumph of reason; postmodernism rejects that claim, allowing in the realm of theory the same multiplication of distinctions we see in the cultures it seeks to understand.

I anticipate the objection that the Weber I have been opposing is something of a caricature. And I would not be unhappy to admit that there is some truth in this. Weber foresaw, for example,

that the rationalisation of the world would continue to be resisted, and his view that each case of charisma needed to be 'routinised' was not meant to rule out the appearance of new charismatic leaders in our time as in earlier ones: our politics of charisma would, perhaps, not have surprised him.[24] Certainly, too, his conception of reason involved far more than instrumental calculation. Since much of what I have noticed here would have been anticipated by him, it may be as well to see this as a rejection of a narrow (if familiar) misreading of Weber than an argument against what is best in the complex and shifting views of Weber himself.

But I think we could also construe this misreading – which we find, perhaps, in Talcott Parsons – as in part a consequence of a problem with Weber's own work. For part of the difficulty with Weber's work is that, despite the wealth of historical detail in his studies of religion, law, and economics, he often mobilises theoretical terms that are of a very high level of abstraction. As a result, it is not always clear that there really are significant commonalities among the various social phenomena he assimilates under such general concepts as 'rationalisation' or 'charisma'. (This is one of the general problems posed by Weber's famous reliance on 'ideal types'.) Reinhard Bendix, who is amongst Weber's most important and sympathetic interpreters, remarks at one point in his discussion of one of Weber's theoretical distinctions (the distinction, as it happens, between patrimonialism and feudalism) that 'this distinction is clear only so long as it is formulated in abstract terms'.[25] In reading Weber it is a feeling that one has over and over again. The problem is exemplified in his discussion of 'charisma' in *The Theory of Social and Economic Organisation*:

> The term 'charisma' will be applied to a certain quality of an individual personality by virtue of which he is set apart from ordinary men and treated as endowed with supernatural, superhuman, or at least specifically exceptional powers or qualities. These are ... regarded as of divine origin or exemplary, and on the basis of them the individual concerned is treated as a leader.[26]

Notice how charisma is here defined disjunctively as involving either magical capacities ('supernatural, superhuman', or of 'divine origin'), on the one hand, or merely 'exceptional' or 'exemplary' qualities on the other. The first disjunct in each case happily covers the many cases of priestly and prophetic leadership that Weber discusses, for example, in his study *Ancient Judaism*. But it is the latter, presumably, that we should apply in seeking to understand the political role of Hitler, Stalin, or Mussolini, who though no doubt 'exceptional' and 'exemplary', were not regarded as having 'supernatural' powers of 'divine origin'. The point is that much of what Weber has to say in his general discussion of charisma in *The Theory of Social and Economic Organisation*, and in the account of 'domination' in *Economy and Society*, requires that we take its magical aspect seriously. When, however, we do take it seriously, we find his theory fails to apply to the instances of charisma that fall under the second disjunct of his definition. In short, Weber's account of charisma

assimilates too closely phenomena – such as the leadership of Stalin, at one end of the spectrum, and of King David or the Emperor Charlemagne, at the other – in which magico-religious ideas seem, to put it mildly, to play remarkably different roles. If we follow out the logic of this conclusion by redefining Weberian charisma in such a way as to insist on its magical component, it will follow, by definition, that the disenchantment of the world – the decline of magic – leads to the end of charisma. But we shall then have to ask ourselves how correct it is to claim, with Weber, that magical views increasingly disappear with modernity. And if he is right in this, we shall also have to give up the claim that Weber's sociology of politics – in which charisma plays a central conceptual role – illuminates the characteristic political developments of modernity.

There is a similar set of difficulties with Weber's account of rationalisation. In *The Protestant Ethic and the Spirit of Capitalism*,[27] Weber wrote: 'If this essay makes any contribution at all, may it be to bring out the complexity of the only superficially simple concept of the rational'. But we may be tempted to ask whether our understanding of the genuine complexities of the historical developments of the last few centuries of social, religious, economic, and political history in Western Europe is truly deepened by making use of a concept of rationalisation that brings together a supposed increase in means-end calculation (instrumental rationality); a decline in appeal to 'mysterious, incalculable forces' and a correlative increasing confidence in calculation (disenchantment or intellectualisation);[28] and the growth of 'value rationality', which means something like an increasing focus on maximising a narrow range of ultimate goals.[29] Here, seeking to operate at this high level of generality, assimilating under one concept so many, in my view, distinct and independently intelligible processes, Weber's detailed and subtle appreciation of the dynamics of many social processes is obscured by his theoretical apparatus; it is, I think, hardly surprising that those who have been guided by his theoretical writings have ascribed to him a cruder picture than is displayed in his historical work.

I have been exploring how modernity looks from the perspective of the Euro-American intellectual. But how does it look from the postcolonial spaces inhabited by the *Yoruba Man with a Bicycle?* I shall speak about Africa, with confidence *both* that some of what I have to say will work elsewhere in the so-called Third World *and* that, in some places, it will certainly not. And I shall speak first about the producers of these so-called neo-traditional artworks and then about the case of the African novel, because I believe that to focus exclusively on the novel (as theorists of contemporary African cultures have been inclined to do) is to distort the cultural situation and the significance within it of postcoloniality.

I do not know when the *Yoruba Man with a Bicycle* was made or by whom. African art has, until recently, been collected as the property of 'ethnic' groups, not of individuals and workshops, so it is not unusual that not one of the pieces in the 'Perspectives . . .' show was identified in the 'Checklist' by the name of an individual artist, even though many of them are twentieth century; (and no one will

have been surprised, by contrast, that most of them *are* kindly labelled with the name of the people who own the largely private collections in which they now live). As a result, I cannot say if the piece is literally postcolonial: produced after Nigerian Independence in 1960. But it belongs to a genre that has certainly been produced since then: the genre that is here called 'neo-traditional'. And, simply put, what is distinctive about this genre is that it is produced for the West.

I should qualify. Of course, many of the buyers of first instance live in Africa, many of them are juridically citizens of African states. But African bourgeois consumers of neo-traditional art are educated in the Western style, and, if they want African art, they would often rather have a 'genuinely' traditional piece – by which I mean a piece that they believe to be made precolonially, or at least in a style and by methods that were already established precolonially. And these buyers are a minority. Most of this art is 'traditional' because it uses actually or supposedly precolonial techniques, but is 'neo' – this, for what it is worth, is the explanation I promised earlier – because it has elements that are recognisably from the colonial or postcolonial in reference, has been made for Western tourists and other collectors.

The incorporation of these works in the West's world of museum culture and its art market has almost nothing, of course, to do with postmodernism. By and large, the ideology through which they are incorporated is modernist: it is the ideology that brought something called 'Bali' to Artaud, something called 'Africa' to Picasso, and something called 'Japan' to Barthes. (This incorporation as an official Other was criticised, of course, from its beginnings: Oscar Wilde once remarked that 'the whole of Japan is a pure invention. There is no such country, no such people'.[30] What *is* postmodernist is Vogel's muddled conviction that African art should not be judged 'in terms of [someone else's] traditional criteria'. For modernism, primitive art was to be judged by putatively *universal* aesthetic criteria, and by these standards it was finally found possible to value it. The sculptors and painters who found it possible were largely seeking an Archimedean point outside their own cultures for a critique of a Weberian modernity. For *post*moderns, by contrast, these works, however they are to be understood, cannot be seen as legitimated by culture- and history-transcending standards.

What is useful in the 'neo-traditional' object as a model – despite its marginality in most African lives – is that its incorporation in the museum world (while many objects made by the same hands – stools, for example – live peacefully in non-bourgeois homes) reminds one that in Africa, by contrast, the distinction between high culture and mass culture, insofar as it makes sense at all, corresponds by and large to the distinction between those with and those without Western-style formal education as cultural consumers.

The fact that the distinction is to be made this way – in most of sub-Saharan Africa excluding the Republic of South Africa – means that the opposition between high culture and mass culture is available only in domains where there is a significant body of Western formal training, and this

excludes (in most places) the plastic arts and music. There are distinctions of genre and audience in African musics, and for various cultural purposes there is something we call 'traditional' music that we still practice and value. But village and urban dwellers alike, bourgeois and non-bourgeois, listen, through discs and, more importantly, on the radio, to reggae, to Michael Jackson, and to King Sonny Adé.

And this means that by and large the domain in which it makes most sense is the one domain where that distinction is powerful and pervasive – namely, in African writing in Western languages. So that it is here that we find, I think, a place for considering the question of the *post*coloniality of contemporary African culture.

Postcoloniality is the condition of what we might ungenerously call a comprador intelligentsia: a relatively small, Western-style, Western-trained group of writers and thinkers who mediate the trade in cultural commodities of world capitalism at the periphery. In the West they are known through the Africa they offer; their compatriots know them both through the West they present to Africa and through an Africa they have invented for the world, for each other, and for Africa.

All aspects of contemporary African cultural life – including music and some sculpture and painting, even some writings with which the West is largely unfamiliar – have been influenced, often powerfully, by the transition of African societies *through* colonialism, but they are not all in the relevant sense *post*colonial. For the *post* in postcolonial, like the *post* in postmodern is the *post* of the space-clearing gesture that I characterised earlier; and many areas of contemporary African cultural life – what has come to be theorised as popular culture, in particular – are not in this way concerned with transcending, with going beyond, coloniality. Indeed, it might be said to be a mark of popular culture that its borrowings from international cultural forms are remarkably insensitive to – not so much dismissive of, as blind to – the issue of neo-colonialism or 'cultural imperialism'. This does not mean that theories of postmodernism are irrelevant to these forms of culture: for the internationalisation of the market and the commodification of artworks are both central to them. But it *does* mean that these artworks are not understood by their producers or their consumers in terms of a postmodern*ism*: there is no antecedent practice whose claim to exclusivity of vision is rejected through these artworks. What is called 'syncretism' here is made possible by the international exchange of commodities, but is not a consequence of a space-clearing gesture.

Postcolonial intellectuals in Africa, by contrast, are almost entirely dependant for their support on two institutions: the African university – an institution whose intellectual life is overwhelmingly constituted as Western – and the Euro-American publisher and reader. (Even when these writers seek to escape the West – as Ngugi wa Thiong'o did in attempting to construct a Kikuyu peasant drama – their theories of their situation are irreducibly informed by their Euro-American formation. Ngugi's conception of the writer's potential in politics is essentially that of the avant-garde, of Left modernism.)

Now this double dependence on the university and the European publisher means that the first

generation of modern African novels – the generation of Achebe's *Things Fall Apart* (1958) and Laye's *L'Enfant noir* (1959) – were written in the context of notions of politics and culture dominant in the French and British university and publishing worlds in the 1950s and 60s. This does not mean that they were like novels written in western Europe at that time: for part of what was held to be obvious both by these writers and by the high culture of Europe of the day was that new literatures in new nations should be anticolonial and nationalist. These early novels seem to belong to the world of eighteenth- and nineteenth-century literary nationalism; they are theorised as the imaginative recreation of a common cultural past that is crafted into a shared tradition by the writer; they are in the tradition of Scott, whose *Minstrelsy of the Scottish Border* was intended, as he said in the preface, to 'contribute somewhat to the history of my native country; the peculiar features of whose manners and character are daily melting and dissolving into those of her sister and ally'. The novels of this first stage are thus realist legitimations of nationalism: they authorise a 'return to traditions' while at the same time recognising the demands of a Weberian rationalised modernity.

From the later 1960s on, these celebratory novels of the first stage become rarer: Achebe, for example, moves from the creation of a usable past in *Things Fall Apart* to a cynical indictment of politics in the modern sphere in *A Man of the People*. But I should like to focus on a francophone novel of the later 1960s, a novel that thematises in an extremely powerful way many of the questions I have been asking about art and modernity: I mean, of course, Yambo Ouologuem's *Le Devoir de violence*. This novel, like many of the second stage, represents a challenge to the novels of the first stage: it identifies the realist novel as part of the tactic of nationalist legitimation and therefore it is (if I may begin a catalogue of its ways-of-being-*post*-this-and-that) *postrealist*.

Now postmodernism is, of course, postrealist also. But Ouologuem's postrealism is surely motivated quite differently from that of such postmodern writers as, say, Thomas Pynchon. Realism naturalises: the originary 'African novel' of Chinua Achebe *(Things Fall Apart)* and of Camara Laye *(L'Enfant noir)* is 'realist'. So Ouologuem is against it, rejects – indeed, assaults – the conventions of realism. He seeks to delegitimate the forms of the realist African novel, in part, surely, because what it sought to naturalise was a nationalism that, by 1968, had plainly failed. The national bourgeoisie that took up the baton of rationalisation, industrialisation, bureaucratisation in the name of nationalism, turned out to be a kleptocracy. Their enthusiasm for nativism was a rationalisation of their urge to keep the national bourgeoisies of other nations – and particularly the powerful industrialised nations – out of their way. As Jonathan Ngaté has observed, '*Le Devoir de violence*...deal[s] with a world in which the efficacy of the call to the Ancestors as well as the Ancestors themselves is seriously called into question'.[31] That the novel is in this way postrealist allows its author to borrow, when he needs them, the techniques of modernism, which, as we learned from Frederic Jameson, are often also the techniques of postmodernism. (It is helpful to remember at this point how Yambo Ouologuem is described on the back of the Editions Du Seuil

first edition: 'Né en 1940 au Mali. Admissible à l'Ecole normale supérieure. Licencié ès Lettres. Licencié en Philosophie. Diplômé d'études supérieures d'Anglais. Prépare une thèse de doctorat de Sociologie'. Borrowing from European modernism is hardly going to be difficult for someone so qualified; to be a Normalien is indeed, in Christopher Miller's charming formulation, 'roughly equivalent to being baptised by Bossuet'.)[32]

Christopher Miller's discussion – in *Blank Darkness* – of *Le Devoir de violence* focuses usefully on theoretical questions of intertextuality raised by the novel's persistent massaging of one text after another into the surface of its own body. The book contains, for example, a translation of a passage from Graham Greene's 1934 novel *It's a Battlefield* (translated and improved, according to some readers!) and borrowings from Maupassant's *Boule de suif* (hardly unfamiliar work for francophone readers; if this latter is a theft, it is the adventurous theft of the kleptomaniac, who dares us to catch him at it).

The book's first sentence artfully establishes the oral mode – by then an inevitable convention of African narration – with words that Ngaté rightly describes as having the 'concision and the striking beauty and power of a proverb',[33] and mocks us in this moment because the sentence echoes the beginning of André Schwartz-Bart's decidedly un-African 1959 holocaust novel *Le Dernier des justes*, an echo confirmed by later, more substantial borrowings.[34]

Our eyes drink the flash of the sun, and, conquered, surprise themselves by weeping. Maschallah! oua bismillah! . . . An account of the bloody adventure of the niggertrash – dishonour to the men of nothing – could easily begin in the first half of this century; but the true history of the Blacks begins very much earlier, with the Saifs, in the year 1202 of our era, in the African kingdom of Nakem…'[35]

'Our eyes receive the light of dead stars. A biography of my friend Ernie could easily begin in the second quarter of the 20th century; but the true history of Ernie Lévy begins much earlier, in the old anglian city of York. More precisely: on 11 March 1185.[36]

The reader who is properly prepared will expect an African holocaust, and these echoes are surely meant to render ironic the status of the rulers of Nakem as descendants of Abraham el Héit, *le Juif noir*.[37]

The book begins, then, with a sick joke against nativism at the unwary reader's expense, and the assault on realism is – here is my second signpost – postnativist. This book is a murderous antidote to a nostalgia for *Roots*. As Wole Soyinka has said in a justly well-respected reading, 'the Bible, the Koran, the historic solemnity of the *griot* are reduced to the histrionics of wanton boys masquerading as humans'.[38] It is tempting to read the attack on history here as a repudiation not of roots but of Islam, as Soyinka does when he goes on to say:

A culture which has claimed indigenous antiquity in such parts of Africa as have submitted to its undeniable attractions is confidently proven to be imperialist; worse, it is demonstrated to be essentially hostile to the indigenous culture . . . Ouologuem pronounces the Moslem incursion into black Africa to be corrupt, vicious, decadent, elitist and insensitive. At the least, such a work functions as a wide swab in the deck-clearing operation for the commencement of racial retrieval.[39]

But it seems to me much clearer to read the repudiation as a repudiation of national history; to see the text as postcolonially postnationalist as well as anti- (and thus, of course, post-) nativist. (Indeed Soyinka's reading here seems to be driven by his own equally representative tendency to read Africa as race and place into everything.) Raymond Spartacus Kassoumi – who, if anyone, is the hero of this novel – is, after all, a son of the soil, but his political prospects by the end of the narrative are less than uplifting. More than this, the novel explicitly thematises, in the anthropologist Shrobenius – an obvious echo of the name of the German Africanist Leo Frobenius, whose work is cited by Senghor – the mechanism by which the new elite has come to invent its traditions through the 'science' of ethnography:

Saïf made up stories and the interpreter translated, Madoubo repeated in French, refining on the subtleties to the delight of Shrobenius, that human crayfish afflicted with a groping mania for resuscitating an African universe – cultural autonomy, he called it, which had lost all living reality . . . he was determined to find metaphysical meaning in everything . . . African life, he held, was pure art . . .[40]

At the start we have been told that 'there are few written accounts and the versions of the elders diverge from those of the *griots*, which differ from those of the chroniclers'.[41] Now we are warned off the supposedly scientific discourse of the ethnographers.[42]

Because this is a novel that seeks to delegitimate not only the form of realism but the content of nationalism, it will to that extent seem to us misleadingly to be postmodern. *Mis*leadingly, because what we have here is not postmodern*ism* but postmodernis*ation*; not an aesthetics but a politics, in the most literal sense of the term. After colonialism, the modernisers said, comes rationality; that is the possibility the novel rules out. Ouologuem's novel is typical of this second stage in that it is not written by someone who is comfortable with and accepted by the new elite, the national bourgeoisie. And, so it seems to me, the basis for that project of delegitimation is very much not the postmodernist one: rather, it is grounded in an appeal to an ethical universal; indeed, it is based, as intellectual responses to oppression in Africa largely are based, in an appeal to a certain simple respect for human suffering, a fundamental revolt against the endless misery of the last thirty years.

Ouologuem is hardly likely to make common cause with a relativism that might allow that the horrifying new-old Africa of exploitation is to be understood – legitimated – in its own local terms.

Africa's postcolonial novelists – novelists anxious to escape neo-colonialism – are no longer committed to the nation, and in this they will seem, as I have suggested, misleadingly postmodern. But what they have chosen instead of the nation is not an older traditionalism, but Africa – the continent and its people. This is clear enough, I think, in *Le Devoir de violence*, at the end of which Ouologuem writes:

> Often it is true, the soul desires to dream the echo of happiness, an echo that has no past.
> But projected into the world, one cannot help recalling that Saïf, mourned three million times,
> is forever reborn to history beneath the hot ashes of more than thirty African republics.[43]

If we are to identify with anyone, *in fine*, it is with *la négraille* – the niggertrash, who have no nationality. For these purposes one republic is as good – which is to say as bad – as any other. If this postulation of oneself as African – and neither as of this or that allegedly precolonial ethnicity nor of the new nation states – is implicit in *Le Devoir de violence*, in the important novels of V. Y. Mudimbe, *Entre les eaux*, *Le Bel immonde* – recently made available in English as *Before the Birth of the Moon* – and *L'Ecart*, this postcolonial recourse to Africa is to be found nearer the surface and over and over again.[44]

There is a moment in *L'Ecart*, for example, when the protagonist, whose journal the book is, recalls a conversation with the French girlfriend of his student days – the young woman on whom he reflects constantly as he becomes involved with an African woman.

> "You can't know, Isabelle, how demanding Africa is."
> "It's important for you, isn't it?"
> "To tell you the truth, I don't know . . . I really don't . . . I wonder if I'm not usually just playing around with it."
> "Nara . . . I don't understand. For me, the important thing is to be myself. Being european isn't a flag to wave."
> "You've never been wounded like . . . "
> "You're dramatising, Nara. You carry your african-ness like a martyr . . . That makes one wonder . . . I'd be treating you with contempt if I played along with you."
> "The difference is that Europe is above all else an idea, a juridical institution . . . while Africa . . . "
> "Yes? . . . "
> "Africa is perhaps mostly a body, a multiple existence . . . I'm not expressing myself very well." [45]

This exchange seems to me to capture the essential ambiguity of the postcolonial African intellectual's relation to Africa. But let me pursue Africa, finally, in Mudimbe's first novel,

Entre les eaux, a novel that thematises the question most explicitly.

In *Entre les eaux* – a first-person narrative – our protagonist is an African Jesuit, Pierre Landu, who has a *doctorat ne théologie et [une] licence en droit canon*,[46] acquired as a student in Rome. Landu is caught between his devotion to the church and, as one would say in more protestant language, to Christ; the latter leads him to repudiate the official Roman Catholic hierarchy of his homeland and join with a group of Marxist guerrillas, intent on removing the corrupt postindependence state. When he first tells his immediate superior in the hierarchy, Father Howard, who is white, of his intentions, the latter responds immediately and remorselessly that this will be treason.

> "You are going to commit treason", the father superior said to me when I informed
> him of my plans.
> "Against whom?"
> "Against Christ."
> "Father, isn't it rather the West that I'm betraying. Is it still treason? Don't I have the right
> to dissociate myself from this Christianity that has betrayed the Gospel?"
> "You are a priest, Pierre"
> "Excuse me, Father, I'm a black priest." [47]

It is important, I think, not to see the blackness here as a matter of race. It is rather the sign of Africanity. To be a black priest is to be a priest who is also an African and thus committed, *nolens-volens*, to an engagement with African suffering. This demand that Africa makes has nothing to do with a sympathy for African cultures and traditions; reflecting – a little later – on Father Howard's alienating response, Landu makes this plain.

> Father Howard is also a priest like me. That's the tie that binds us. Is it the only one? No.
> There's our shared tastes. Classical music. Vivaldi. Mozart. Bach . . . And then there was
> our reading. The books, we used to pass each other. Our shared memories of Rome.
> Our impassioned discussions on the role of the priest, and on literature and on the mystery
> novels that we each devoured. I am closer to Father Howard than I am to my compatriots,
> even the priests. Only one thing separates us: the colour of our skins.[48]

In the name of this *couleur de la peau* which is precisely the sign of a solidarity with Africa, Landu reaches from Roman Catholicism to Marxism, seeking to gather together the popular revolutionary energy of the latter and the ethical – and religious – vision of the former; a project he considers in a later passage, where he recalls a long-ago conversation with Monseigneur Sanguinetti in Rome. "The

Church and Africa", the Monseigneur tells him, "are counting on you". [49] Landu asks in the present:

> Could the church really still count on me? I would have wished it and I wish it now. The main thing meanwhile is that Christ counts on me. But Africa? Which Africa was Sanguinetti speaking of? That of my black confrères who have stayed on the straight and narrow, or that of my parents whom I have already betrayed? Or perhaps he was even speaking of the Africa that we defend in this camp? [50]

Whenever Landu is facing a crucial decision, it is framed for him as a question about the meaning of Africa.

After he is accused of another betrayal – this time by the rebels, who have intercepted a letter to his bishop (a letter in which he appeals to him to make common cause with the rebels, to recover them for Christ) – Landu is condemned to death. As he awaits execution, he remembers something an uncle had said to him a decade earlier about 'the ancestors'.

> "You'll be missed by them. . ." my uncle had said to me ten years ago. I had refused to be initiated. What did he mean? It is I who miss them. Will that be their curse? The formula invaded me, at first unobtrusively, but then it dazzled me, stopping me from thinking: "Wait till the ancestors come down. Your head will burn, your throat will burst, your stomach will open and your feet will shatter. Wait till the ancestors come down. . ." They had come down. And I had only the desiccation of a rationalised Faith to defend myself against Africa. [51]

The vision of modernity in this passage is not, I think, Weberian. In being postcolonial, Pierre Landu is against the rationalising thrust of Western modernity (that modernity here, in this African setting, is represented by Catholicism confirms how little modernity has ultimately to do with secularisation). And even here, when he believes he is facing his own death, the question 'What does it mean to be an African?' is at the centre of his mind.

A raid on the camp by government forces saves Pierre Landu from execution; the intervention of a bishop and a brother powerfully connected within the modern state saves him from the fate of a captured rebel. He retreats from the world to take up the life of a monastic with a new name – no longer Peter-on-whom-I-will-build-my-church but Mathieu-Marie de L'Incarnation – in a different, more contemplative order. As we leave him, his last words, the last of the novel, are, *'l'humilité de ma bassesse, quelle gloire pour l'homme!'*. [52] Neither Marx nor Saint Thomas, the novel suggests – neither of the two great political energies of the West in Africa – offers a way forward. But this retreat to the otherworldly cannot be a political solution. Postcoloniality has, also, I think, become a condition of pessimism.

Postrealist writing; postnativist politics; a *transnational* rather than a *national* solidarity. And pessimism: a kind of *post*optimism to balance the earlier enthusiasm for *The Suns of Independence*. Postcoloniality is *after* all this: and its *post*, like postmodernism's, is also a post that challenges earlier legitimating narratives. And it challenges them in the name of the suffering victims of 'more than thirty republics'. But it challenges them in the name of ethical universal; in the name of *humanism, le gloire pour l'homme*. And on the ground it is not an ally for Western postmodernism but an agonist, from which I believe postmodernism may have something to learn. For what I am calling humanism can be provisional, historically contingent, anti-essentialist (in other words, postmodern), and still be demanding. We can surely maintain a powerful engagement with the concern to avoid cruelty and pain while nevertheless recognising the contingency of that concern.[53] Maybe, then, we can recover within postmodernism the postcolonial writers' humanism – the concern for human suffering, for the victims of the postcolonial state (a concern we find everywhere: in Mudimbe, as we have seen; in Soyinka's *A Play of Giants* (1934); in Achebe, Farrah, Gordimer, Labou Tansi – the list is difficult to complete) while still rejecting the master narratives of modernism. This human impulse – an impulse that transcends obligations to churches and to nations – I propose we learn from Mudimbe's Landu.

But there is also something to reject in the postcolonial adherence to Africa of Nara, the earlier protagonist of Mudimbe's *L'Ecart*: the sort of Manicheanism that makes Africa *'a body'* (nature) against Europe's juridical reality (culture) and then fails to acknowledge – even as he says it – the full significance of the fact that Africa is also *'a multiple existence'*. *Entre les eaux* provides a powerful postcolonial critique of this binarism: we can read it as arguing that if you postulate an either-or choice between Africa and the West, there is no place for you in the real world of politics, and your home must be the otherworldly, the monastic retreat.

If there is a lesson in the broad shape of this circulation of cultures, it is surely that we are all already contaminated by each other, that there is no longer a fully autochthonous echt-African culture awaiting salvage by our artists (just as there is, of course, no American culture without African roots). And there is a clear sense in some postcolonial writing that the postulation of a unitary Africa over and above a monolithic West – the binarism of Self and Other – is the last of the shibboleths of the modernisers that we must learn to live without.

Already in *Le Devoir de violence*, in Ouologuem's withering critique of 'Shrobeniusologie' there were the beginnings of this postcolonial critique of what we might call 'alteritism', the construction and celebration of oneself as Other. Ouologuem writes, 'henceforth Negro art was baptised "aesthetic" and hawked in the imaginary universe of "vitalising exchanges"'.[54] Then, after describing the phantasmic elaboration of some interpretative mumbo jumbo 'invented by Saïf', he announces that 'Negro art found its patent of nobility in the folklore of mercantile intellectualism, oye, oye, oye . . .'.[55] Shrobenius, the anthropologist, an apologist for 'his' people; a European audience

that laps up this exoticised other; African traders and producers of African art, who understand the necessity to maintain the 'mysteries' that construct their product as 'exotic'; traditional and contemporary elites who require a sentimentalised past to authorise their present power: all are exposed in their complex and multiple mutual complicities.

> Witness the splendour of its art – the true face of Africa is the grandiose empires of the Middle Ages, a society marked by wisdom, beauty, prosperity, order, non-violence, and humanism, and it is here that we must seek the true cradle of Egyptian civilisation.
>
> Thus drooling, Shrobenius derived a twofold benefit on his return home: on the one hand, he mystified the people of his own country who in their enthusiasm raised him to a lofty Sorbonnical chair, while on the other hand he exploited the sentimentality of the coons, only too pleased to hear from the mouth of a white man that Africa was 'the womb of the world and the cradle of civilisation'.
>
> In consequence the niggertrash donated masks and art treasures by the ton to the acolytes of 'Shrobeniusology'.[56]

A little later, Ouologuem articulates more precisely the interconnections of Africanist mystifications with tourism, and the production, packaging, and marketing of African artworks.

> An Africanist school harnessed to the vapours of magico-religious, cosmological and mythical symbolism had been born: with the result that for three years men flocked to Nakem – and what men! – middlemen, adventurers, apprentice bankers, politicians, salesmen, conspirators – supposedly 'scientists', but in reality enslaved sentries mounting guard before the 'Shrobeniusological' monument of Negro pseudosymbolism.
>
> Already it had become more than difficult to procure old masks, for Shrobenius and the missionaries had had the good fortune to snap them all up. And so Saïf – and the practice is still current – had slapdash copies buried by the hundredweight, or sunk into ponds, lakes, marshes, and mud holes, to be exhumed later on and sold at exorbitant prices to unsuspecting curio hunters. These three-year-old masks were said to be charged with the weight of four centuries of civilisation.[57]

Ouologuem here forcefully exposes the connections we saw earlier in some of David Rockefeller's insights into the international system of art exchange, the international art world: we see the way in which an ideology of disinterested aesthetic value – the 'baptism' of 'Negro art' as 'aesthetic' – meshes with the international commodification of African expressive culture, a commodification that requires, by the logic of the space-clearing gesture, the manufacture of Otherness.

(It is a significant bonus that it also harmonises with the interior decor of modern apartments.)

Shrobenius, *ce marchand-confectionneur d'idéologie*, the ethnographer allied with Saïf – image of 'traditional' African ruling caste – has invented an Africa that is a body over and above Europe, the juridical institution, and Ouologuem is urging us vigorously to refuse to be thus Other.

Sara Suleri has written recently, in *Meatless Days*, of being treated as an 'Otherness-machine' – and of being heartily sick of it.[58] If there is no way out for the postcolonial intellectual in Mudimbe's novels, it is, I suspect, because as intellectuals – a category instituted in black Africa by colonialism – we are always at risk of becoming Otherness-machines. It risks becoming our principal role. Our only distinction in the world of texts to which we are latecomers is that we can mediate it to our fellows. This is especially true when postcolonial meets postmodern, for what the postmodern reader seems to demand of its Africa is all too close to what modernism – as documented in William Rubin's Primitivism exhibit of 1985 – demanded of it. The role that Africa, like the rest of the Third World, plays for Euro-American postmodernism – like its better-documented significance for modernist art – must be distinguished from the role postmodernism might play in the Third World. What that might be, it is I think, too early to tell. And what happens will happen not because we pronounce upon the matter in theory but naturally, out of the changing everyday practices of African cultural life.

For all the while, in Africa's cultures, there are those who will not see themselves as Other. Despite the overwhelming reality of economic decline; despite unimaginable poverty; despite wars, malnutrition, disease, and political instability, African cultural productivity grows apace: popular literatures, oral narrative and poetry, dance, drama, music, and visual art all thrive. The contemporary cultural production of many African societies – and the many traditions whose evidences so vigorously remain – is an antidote to the dark vision of the postcolonial novelist.

And I am grateful to James Baldwin for his introduction to the *Yoruba Man with a Bicycle* – a figure who is, as Baldwin so rightly saw, polyglot, speaking Yoruba and English, probably some Hausa and a little French for his trips to Cotonou or Cameroon; someone whose 'clothes do not fit him too well'. He and the other men and women among whom he mostly lives suggest to me that the place to look for hope is not just to the postcolonial novel – which has struggled to achieve the insights of Ouologuem or Mudimbe – but to the all-consuming vision of this less-anxious creativity. It matters little who it was made *for*; what we should learn from is the imagination that produced it. *The Man with the Bicycle* is produced by someone who does not care that the bicycle is the white man's invention – it is not there to be Other to the Yoruba Self; it is there because someone cared for its solidity; it is there because it will take us further than our feet will take us; it is there because machines are now as African as novelists – and as fabricated as the kingdom of Nakem.[59]

Notes

1 Yambo Ouologuem, 'A Mon Mari', *Présence Africaine*,
 no. 57 (Paris: 1966), p.95.
2 Susan Vogel, *et al.*, *Perspectives: Angles on African Art*
 (New York: The Center for African Art, 1987) by James
 Baldwin, Romare Bearden, Ekpo Eyo, Nancy Graves,
 Ivan Karp, Lela Kouakou, Iba N'Diaye, David Rockefeller,
 William Rubin and Robert Farris Thompson, interviewed
 by Michael John Weber, with an introduction by Susan
 Vogel.
3 *Ibid.*, p.11.
4 *Ibid.*, p. 138.
5 *Ibid.*, p. 29.
6 *Ibid.*, p. 143.
7 *Ibid.*, p. 131.
8 I should insist this first time I use this word that I do not
 share the widespread evaluation of commodification:
 its merits, I believe, must be assessed case by case.
 Certainly critics such as Kobena Mercer – for example,
 in his 'Black Hair/Style Politics', *New Formations*, no. 3
 (London: Winter 1987) – have persuasively criticised
 any reflexive rejection of the commodity form, which
 so often reinstates the hoary humanist opposition
 between 'authentic' and 'commercial'. Mercer explores
 the avenues by which marginalised groups have
 manipulated commodified artifacts in culturally novel
 and expressive ways.
9 Once Vogel has thus refused Kouakou a voice, it is less
 surprising that his comments turn out to be composite
 also. On closer inspection, it emerges that there is no
 single Lela Kouakou who was interviewed like the other
 co-curators, Kouakou is, in the end, quite exactly an
 invention: thus literalising the sense in which 'we' (and
 more particularly, 'our' artists) are individuals while 'they'
 (and 'theirs') are ethnic types.
10 It is absolutely crucial that Vogel does not draw her line
 according to racial or national categories: the Nigerian,
 the Senegalese, and the African-American co-curators
 are each allowed to be on 'our' side of the great divide.
 The issue here is something less obvious than racism.
11 Vogel, *et al.*, *Perspectives: Angles on African Art*, *op. cit.*,
 p. 23.
12 Margaret Masterman, 'The Nature of a Paradigm', in Alan
 Musgrave and Imre Lakatos (eds.), *Criticism and the
 Growth of Knowledge* (Cambridge: Cambridge University
 Press, 1970), p. 59, n. 1; pp. 61, 65.
13 Jean-François Lyotard, *The Postmodern Condition:
 A Report on Knowledge*, vol.10, *Theory and History of
 Literature*, trans. Geoff Bennington and Brian Massumi
 (Minneapolis: University of Minnesota Press, 1988).
14 *Post-* thus images in modernity the trajectory of meta in
 classical metaphysics. Originating in the editorial glosses
 of Aristotelians wishing to refer to the books 'after' the
 Philosopher's books on nature (physics), this 'after' has
 also been translated into an 'above and beyond'.
15 Brian McHale, *Postmodernist Fiction* (New York:
 Methuen, 1987), p.5.
16 Scott Lash, 'Modernity or Modernism? Weber and
 Contemporary Social Theory', in Scott Lash and Sam
 Whimster (eds.), *Max Weber, Rationality and Modernity*
 (London: Allen and Unwin, 1987), p. 355.
17 Lionel Trilling, *The Opposing Self: Nine Essays in
 Criticism* (New York: Viking Press, 1955), p. xiv.
18 Frederic Jameson, *The Ideologies of Theory: Essays
 1971-1986*, vol. 2, *Syntax of History* (Minneapolis:
 University of Minnesota Press, 1988), pp. 178–208, 195.
19 *Ibid.*, p. 195.
20 *Ibid.*, pp. 195, 196.
21 *Ibid.*, p. 105.
22 Habermas is, of course, a theorist against
 postmodernism.
23 Max Weber, *The Protestant Ethic and the Spirit of
 Capitalism*, trans. Talcott Parsons (London: Unwin
 University Books, 1930), p. 13.
24 All that Weber was insisting upon was that these new
 charismatic leaders would also have their charisma
 routinised.
25 Reinhard Bendix, *Max Weber: An Intellectual Portrait*
 (London: Methuen University Paperback, 1966), p. 360.
26 Weber, *The Theory of Social and Economic Organisation*
 (New York: Oxford University Press, 1947), pp. 358–59.
27 Weber, *The Protestant Ethic and the Spirit of Capitalism*,
 op. cit., p. 194.
28 See 'Science as a Vocation', in H.H. Gerth and C. Wright
 Mills (eds.), *From Max Weber: Essays in Sociology*
 (London: Kegan Paul, 1948), p.155.
29 It is this tendency that leads, for example, in the case of
 nineteenth-century British utilitarians such as John
 Stuart Mill, to the view that we can identify a single goal –
 'the greatest good of the greatest number' conceived of as
 maximising happiness or 'utility'.

30 Oscar Wilde, 'The Decay of Lying: An Observation', in *Intentions* (London: 1909), p. 45.

31 Jonathan Ngaté, *Francophone African Fiction: Reading a Literary Tradition* (Trenton, NJ: Africa World Press), p.59.

32 Christopher Miller, *Blank Darkness: Africanist Discourses in French* (Chicago: University of Chicago Press, 1985), p. 218.

33 Ngaté, *Francophone African Fiction, op. cit.*, p. 64.

34 Ngaté's focus on this initial sentence follows Aliko Songolo, 'The Writer, the Audience and the Critic's Responsibility: The Case of *Bound to Violence*', cited by Ngaté, *Francophone African Fiction, ibid.*, p. 64.

35 Yambo Ouologuem, *Le Devoir de violence* (Paris: Editions du Seuil, 1968), p. 9.
'Nos yeux boivent l'éclat du soleil, et, vaincus, s'étonnent de pleurer. Maschallah! oua bismillah! . . . Un récit de l'aventure sanglante de la négraille – honte aux hommes de rien! tiendrait aisément dans la première moitié de ce siècle; mais la véritable histoire des Nègres commence beaucoup plus tôt, avec les Saïfs, en l'an 1202 de notre ère, dans l'Empire africain de Nakem . . . '

36 André Schwartz-Bart, *Le dernier des justes* (Paris: Editions du Seuil, 1959), p.11.
Cf. nn. 35 and 36. *'Nos yeux reçoivent la lumière d'étoiles mortes. Une biographie de mon ami Ernie tiendrait aisément dans le deuxième quart du xxe siècle, mais la véritable histoire d'Ernie Lévy commence très tôt, dans la vielle cité anglicane de York. Plus précisément: le 11 mars 1185'.*

37 Yambo Ouologuem, *Le Devoir de violence, op. cit.*, p.12.

38 Wole Soyinka, *Myth, Literature and the African World* (Cambridge: Cambridge University Press, 1976), p. 100.

39 *Ibid.*, p. 6.

40 Ouologuem, *Le Devoir de violence, op. cit.*, p. 102; Ouologuem, *Bound to Violence*, trans. Ralph Mannheim (London: Heinemann Educational Books, 1968), p. 87.

41 *Ibid.*, p. 6

42 Here we have the literary thematisation of the Foucauldian *Invention of Africa* that is the theme of Valentin Mudimbe's important recent intervention.

43 Ouologuem, *Bound to Violence, op. cit.*, pp.181–82, 207.

44 It would be interesting to speculate as to how to account for an apparently similar trend in African-American writing and cultural theory.

45 V. Y. Mudimbe, *L'Ecart* (Paris: Présence Africaine, 1979), p. 116.

46 Mudimbe, *Entre les eaux* (Paris: Présence Africaine, 1973), p. 75.

47 *Ibid.*, p. 18.

48 *Ibid.*, pp. 73 – 74.

49 *L'Eglise et l'Afrique comptent sur vous.*

50 Mudimbe, *Entre les eaux, op. cit.*, pp. 73 – 74.

51 *Ibid.*, p. 166.

52 *Ibid.*, p. 189.

53 See Richard Rorty, *Contingency, Irony and Solidarity* (Cambridge: Cambridge University Press, 1988).

54 Ouologuem, *Le Devoir de violence, op. cit.*, pp. 94–95.

55 *Ibid.*

56 *Ibid.*, p. 111. Ouologuem, *Bound to Violence, op. cit.*, pp. 94–95.

57 Ouologuem, *Le Devoir de violence, op. cit.*, p. 112. Ouologuem, *Bound to Violence, op. cit.*, pp. 95–96.

58 Sara Suleri, *Meatless Days* (Chicago: Chicago University Press, 1989), p. 105.

59 I learned a good deal from trying out earlier versions of these ideas at an NEH Summer Institute on 'The Future of the Avant-Garde in Postmodern Culture' under the direction of Susan Suleiman and Alice Jardine at Harvard in July 1989; at the African Studies Association (under the sponsorship of the Society for African Philosophy in North America) in November 1989, where Jonathan Ngaté's response was particularly helpful; and, as the guest of Ali Mazrui, at the Braudel Centre at SUNY Binghamton in May 1990. As usual, I wish I knew how to incorporate more of the ideas of the participants on those occasions.

Aina Onabolu
*Portrait of Chief
Dr William Sapara,*
(no date)
Oil on canvas

Bourdieu out of Europe?

Everlyn Nicodemus

To be unaware that a dominant culture owes its main features and social function – especially that of symbolically legitimising a form of domination – to the fact that it is not perceived as such, in short, to ignore the fact of legitimacy, is either to condemn oneself to a class-based ethnocentrism which leads the defenders of restricted culture to ignore the material foundations of the symbolic domination of one culture by another, or implicitly to commit oneself to a populism which betrays a shameful recognition of the legitimacy of the dominant culture in an effort to rehabilitate middle-brow culture. Pierre Bourdieu [1]

Critical analysis of the amnesia inherent in Eurocentrism and the positional superiority manifested in Western cultural dominance has been carried out for two decades by, among others, distinguished scholars and authors like Edward Said and Toni Morrison and by scholarly periodicals like *Third Text*. Whilst the self-absorbed Western cultural establishment remains astoundingly unconcerned, a shameful recognition of the existence of cultures 'on the periphery' nevertheless finds expression by prompting exotic middle-brow art like rehabilitated sign paintings and ethnic market products. In contemplating this scenario, I should like to read the observation quoted above of the French cultural sociologist Pierre Bourdieu as an apposite description of the current international situation.

When Bourdieu states that the definition of what is legitimate culture occurs through exclusion as much as through selection, and when he calls the establishment of a canon in the guise of a universally valued patrimony an act of 'symbolic violence', the whole scene of excluded Third World and minority artists comes to my mind. This is a wilful misreading but close to the spirit of Bourdieu's thought. The cultural domination he refers to is in fact the domination within Western society of one class by another. In order to make its mechanisms evident, he nevertheless talks in terms that can lead our thoughts to colonial oppression. He thus confirms the existing parallelism between class domination and inter-national cultural domination.

Central to Bourdieu's thought, as expressed for instance in the collection *The Field of Cultural Production*, is the notion of the field of autonomous cultural production. According to the historical analysis he makes, it was 'invented' in the nineteenth century with, as key figures, authors and artists such as Flaubert and Manet. It managed to create its own laws and rules of the game by the simple fact that authors and writers were producing more or less for each other: 'producers for producers'. It developed what he calls a 'restricted production' as opposed to the large-scale production submitted to the demands of the market. In its extension, it constitutes the world of what we commonly call (Western) modern art and literature. As a painter, I will apply his analysis mainly to visual art, although he begins with a study of the literary field and in particular the writings of Flaubert. [2]

By the construction of fields – as structured spaces and specific worlds-of-their-own, like those

of science, education, religious institutions – Bourdieu marks off domains in order to study them and to observe conflicts and interactions within them. The cultural field with its two opposed poles, the autonomous and the middle-brow production, constitutes an integral part of a wider social field. It belongs to its dominant part, to the field of economic and political power. There, it has a subordinate place, mainly due to its lack of economic capital. Nevertheless, it plays an important role thanks to its symbolic capital.

Basically, to Bourdieu, this role is to legitimise the mastery of the dominant class. Without admitting its domination, this class can both legitimate and articulate it's power through the field of restricted cultural production. Bourdieu here talks about 'homologies', correspondences rather than casual relations. This is the main aspect he elaborates, which means that he treats modern art and literature in a structural class perspective, as ultimately existing through the conditions of those who dominate.

In a careful reading of Bourdieu, one finds a dialectic counter-perspective. The historical analysis, integral to his method, shows how the field of autonomous cultural production initially was established as a defensive measure, as an answer to a growing bourgeois oppression of culture, to its heavy interference in cultural affairs in the fully developed capitalist French society.[3] It was invented as a third alternative. The other two, from which it distanced itself, were, on the one hand, the submissive bourgeois production (the Salon, the Opera) and, on the other, a social art and literature in revolt, appearing around 1848 with figures like Courbet. The field of autonomous production, he writes, was constructed 'by a series of breaks, partly cumulative, but sometimes followed by regressions'.

The dialectical dimension clearly appears when, concerning this field, he writes that it constitutes 'a tradition of freedom and criticism . . . in the form of a field of competition, equipped with its own institutions'.[4] In 1989, apparently alarmed by a current regression in autonomous thinking, he delivered an appeal to Europe's intellectuals.[5] He further discussed the threat to the autonomy of art and to freedom of speech in a book of dialogues written together with the artist Hans Haacke, published in Paris in 1994.[6] Autonomous culture functioning as a legitimation of class domination and at the same time as a space of freedom to defend!

Contradictions and opposing forces are the generative impetus in the reality he analyses, as in the structure of his thinking, which appears at the same time as holistic and dialectic. This is what makes Bourdieu so stimulating to read for me as an artist. This is more or less how the process of thought functions when a painting is taking shape out of contrasts and collisions between colours and forms.

When I first became absorbed in Bourdieu's theories of the artistic field, I was hoping to find a method, free from the disadvantages of conventional Western art historiography, to narrate the genesis and the situation of modern art in African countries. However, it quickly proved difficult to

apply his method outside Europe. It is bound to, and thus part of, the exuberant wealth of information characteristic of the Western society that he describes, to the abundant access to documentation, which in the case of art means exhibitions, catalogues, art magazines, critical reviews, etc. His method of analysis proceeds by continuously returning to detailed examinations of the material basis, by statistical research and sociological and historical case studies. This kind of dense factual foundation is missing, and will probably remain indefinitely insufficient in the Third World.

I will not completely give up my tentative explorations. But first and last, Bourdieu's method enables us to carry out a more precise scrutiny of how the Western art world sustains its domination and of the nature of its mechanisms of exclusion. As he dissects the nucleus of what was to become universally the production of modern visual art, related to our time, he offers a setting against which contemporary art structures in the so-called periphery have to be studied.

He deals above all with the autonomous artistic field as established in France and developed in the West. It consists of positions, position-takings and agents. When an individual artist or a group of artists enter the field and manage to position themselves as producers of what is

More or less in the same way that the French pre- and post-revolutionary artists ideologically/stylistically resorted to Greek and Roman classical antiquity, these African pioneers resorted to traditional art as a revived classical African language.

recognised *as* 'different' and new, this positioning changes the whole field. What was until then recognised as the most advanced avant garde is pushed back to become *passé* or classic, and all other positions in the field, which their holders defend with all possible means and arguments, are displaced and changed accordingly.

This struggle constitutes the vital existence of the field as well as its history. The history of the field, as a chain of positionings, is included in every new position-taking more or less in the same way, writes Bourdieu, as the six previous numbers are included in the seventh when you dial a telephone number. The consciousness of this history is also invested in the reception, that is, in the appropriation and consecration by the *habitués* and the public of what is accepted as new in the field. Thus, at each moment, the field – by the 'logic of its history' – decides which are the *possible* positions to take.

When one contemplates this play of chess within a group of chosen ones, one suddenly perceives the enormous difficulty, if not impossibility, for outsiders from 'other art histories' to enter such a closed game. The idea of progress has permeated the concept of modernity and

temporalised otherness, making notions like 'behind the times', 'outdated' and 'not-yet-properly developed' into disparaging arguments of a commonly held superiority complex handed down from colonial times.

The specific temporalisation of the artistic field, functioning as the metaphor of progressive modernity, turns allegedly 'allochronic'[7] modern art producers from alternative cultures into something even more despicable in the eyes of the Western players. They are not only accused of being behind or of imitating the West, but looked upon as naïve and unable to play the game according to the rules; they are thus, from the very beginning, dismissed from the field. Only some miraculous exceptions have happened to fit into existing Western positions and been consecrated by connected agents, as for instance Wifredo Lam and Frida Kahlo. In both cases, their work was appropriated into Surrealism.

When Bourdieu uses the term 'agent', he makes the point that it cannot be reduced to the immediate producer, the artist, perceived as the first and last creator of art as value. On the contrary, the meaning and the value of the work as art is produced by the field. A whole set of agents contribute and interact in creating it, from the art dealer, who, as a 'symbolic banker', invests his reputation in the consecration and defence of an artist; the art critic, who, in writing about a work, also claims her/his right to judge it, thus participating in the struggle for the monopoly of legitimation that occurs all over the field, and all the way via gallery directors, curators, collectors, academies and museums, out into the initiated art public.

Here is the symbolic value, the 'cultural capital'. With the invention of the autonomous field, an 'economy turned upside down' was introduced. The producers in the restricted field of 'art for art's sake', who distinguished themselves by their disinterestedness and devotion to art from those in the opposite field of large-scale production, who were primarily submitted to a market, accepted that the symbolic capital they produced (primarily the prestige they gained in the eyes of colleagues) did not give any immediate pecuniary dividend, so that even the notion of 'losers win' gained currency, quick economic success being looked upon as signalling a lack of seriousness. This reversed economic thinking counts for much of the opaque and crooked way in which the restricted field has followed its unwritten laws 'with customs as organised and mysterious as those of a primitive tribe'.[8]

To what degree the disinterestedness of, for instance, Flaubert was an adopted attitude is difficult to say. But when we look at the more recent developments within the Western art world, especially during the boom in the 1980s when the market accelerated, one starts to ask oneself if the analysis of Bourdieu, which is mainly related to the historical genesis of the field of autonomous cultural production, can be applied to the actual situation without far-reaching reservations. To simplify, we can say that the restricted production during the 'heroic' period meant a symbolic investment with postponed dividend, where the interest in building up a symbolic capital

dominated. But a good century after Flaubert, this orthodox disinterestedness was deconstructed by artists like Andy Warhol. And at the same time, an overheated art market reduced to nearly nothing the space between the position-taking – now often calculated as part of market strategy – and the economic reward. The economic 'upside-down' ended up as a somersault.

Historically, the reversed economic thinking and the field of autonomous production of which it is an inseparable part have nevertheless produced a set of specific functional prerequisites. The subjection to art's requirements and laws, the insistence on solving artistic problems, the persistence of research, irrespective of prompt results or response, are part of this spirit, as well as the ruthless launching of one's own ideas and the stubborn defence of a taken position. This aggressiveness, together with the spirit of self-sacrifice and the power to resist the temptations of the market, constitute the strength of what Bourdieu refers to as a *coin de folie*, a corner of madness within the field of power. 'The only empire is that of truth and reason', he quotes from the French seventeenth-century philosopher, Pierre Bayle; nevertheless, 'war is naively waged against just about anybody. Friends must protect themselves from their friends, fathers from children . . . In it everyone is both ruler and subject of everyone else'.[9]

This pattern is generally both ignored and taken for granted in studies of the development of modern art in the West. But when we study a history of contemporary art outside this cultural field, it should be fished up to the surface as a reminder. It is a parameter that is not applicable, at least not to the same degree, when one observes the histories of modern art elsewhere. It is, for instance, easy to see that where a field of autonomous artistic production has not crystallised, those prerequisites cannot be identical. One has simply to look to other structures for other parameters.

The struggle in the artistic field as Bourdieu describes it is about the power to consecrate. Art does not exist unless it is received and recognised as such. Until then it is just 'a mundane thing or a simple utensil'. The striving for legitimation and consecration produces as a result, and a consummation, the *belief*, upon which the whole magical seance of the art business is based. The artistic field is a 'universe of a belief'. It was shown in the 1960s how unshakeable this general acceptance is once established. It is an example that Bourdieu gives with a smile. Attempts were made to break the circle of belief through profanations and mockery, like exposing 'the artist's shit'. But the only result was that the art world, the field, converted these 'sacrileges' into yet more artistic acts, thus consecrating them. The belief was sustained.[10]

It is when we come to the other central notion of Bourdieu's theory, the notion of *habitus*, that we are reminded of the dimensions of cultural differences between north and south (differences in a way totally at variance with what, for example, anthropologists used to call 'cultural otherness'). The cultured *habitus* is a system of dispositions that enables the agents – the artists as well as the other agents – to enter the field and to act there without even having to elaborate conscious

strategies or cynical calculations. The rules of the games are internalised, partly unconscious. It is the *habitus* that makes the initiated consumers capable of knowing and recognising the work of art as such. It is, writes Bourdieu, the result of a long process of inculcation, beginning in early childhood, which becomes a 'second sense' or a second nature.

He exemplifies this by what he calls the 'pure gaze'. This was an invention that broke the ties between art and morality and enabled the beholder to look upon art as an aesthetic reality in itself. But it couldn't have been invented without the establishment of institutions like museums and galleries whose function it was to get people in the habit of contemplating works of art. In the same way, the *habitué* can only become a *habitué* through successive exposures to art, or rather, to successive experiences of appropriating works of art, because art is individual and cannot be consumed according to manuals.

But, he also stresses, 'it is impossible to understand the peculiar characteristics of restricted culture without appreciating its profound dependence on the educational system'. And he refers not only to teaching in the schools, the universities, the art schools but also to the dispositions and cultural needs and training given in the family, without which the individual will be handicapped in further education. Already at this stage functions the brutally efficient class divide.

It is via the *habitus*, the set of collectively existing inclinations internalised in individuals, that Bourdieu gets his 'objectivity of the subjective' to work, that he avoids the dichotomy between internalist and externalist readings of cultural products by introducing into structural hermeneutics the structuring *subject* without which it has been playing. It means that when one deals with cultures, one perceives producers of art as acting and thinking subjects, not just as 'bearers' of some cultural structure. Bourdieu thus places art and artists in a social, relational reality without having recourse to the kind of generalisations that tend to exclude individual experience and human consciousness. To me, at the same time, the striking thing is how rooted the whole social/cultural structure that he describes is in the history of European and Western societies and how the *complicity* it constitutes tends totally to exclude other practices with an equal claim to be recognised as modern art.

Let me try to look at Bourdieu from inside sub-Saharan Africa. I would like to dwell tentatively upon three different situations/sets of works from its history of modern art, chosen from the first- and from the second-pioneer generation in western Africa and finally from the pioneering phase in eastern Africa, represented by the sphere of the Makerere University College Art School.

The portraits painted by the Nigerian painter Aina Onabolu (1882-1963), documented as early as 1903 (and for easel-paintings in oil on canvas as early as 1906), are mainly referred to as the first examples of a new art practice 'adapted' from Europe. They have often been characterised by Western scholars as alien in the African context and as (from a European point of view) old-fashioned and academic. But if we look closer, we will find that they were not a colonial implant

but an appropriation made in revolt against the imperial masters, who simply thought Africans not capable of easel-painting.[11]

We will also find that many of the figures in the portraits represented prominent black Nigerian personalities and advocates of African nationalism. They were, like Onabolu himself, part of a modernising Africa which, in the making for centuries, now entered a decisive phase and needed its own symbolic affirmation. They wanted to position themselves within the current of modernising African nationalism.

While there can be no discussion about the Europeanness of the carriers in this pollination process, what was growing out of it was nothing less than a modern African art. Beyond the 'dated' stylistic features of the portraits, they represented a daring, revolutionary step. The artistic production of visual objects in Africa had been determined by religious notions and ritual functions and the visual language of classical African art is marked by this fact, as noted for instance by Carl Einstein in 1915. What we generally call 'traditional' art continued for decades to have a dominant place in the society, adapting to new forms of patronage (the church, collectors) without changing its structure. The new chapter that Onabolu introduced meant cutting clean from this pre-modern past, establishing a completely new notion of art that is related to the individual and aesthetic contemplation. He consciously built the basis for it by exhibiting and publishing essays about it and introducing it through art education in the schools of Lagos, thus creating an embryo of what Bourdieu calls a *habitus*.

It so happened that this new start coincided with a pollination in the opposite direction when Picasso and the Cubists were instructed by classical African art, laying the formal basis for twentieth-century modernism. It is an open question which of the two paradigm shifts was the most radical. There are striking parallels. The relationship between the producer of art works and the spheres of power, which according to Bourdieu is rather intricate, becomes often more undisguised when it comes to portraiture. If the Nigerians who commissioned their portraits by Onabolu wanted to pose as modernisers, it was no less a desire to be symbolically connected to modernity than that which, at the same time, made Gertrude Stein commission Picasso to paint her portrait. She wanted to pose as a patroness of modernism.

Onabolu was a self-trained artist. He is said to have picked up portraiture from books and foreign newspapers. Later, 1920-22, he studied in art schools and academies in London and Paris, widening his repertoire to include landscapes and nudes. I have seen a few reproductions of the latter. And I have noticed in them a slight but extremely interesting deviation from the European scheme of academic life studies: his nudes have an individual expression and communicate intellectually with the viewer.

The difference illustrates, in my opinion, to what extent the drawing and painting from a model, as part of Western academic training, constitutes an exercise in the pure gaze, which, according

to Bourdieu, was invented as a breaking of the ties between art and morality, requiring an attitude of impassivity and indifference. To a certain degree, it can be compared with the exercise to which the beholder is exposed when accustomed to visiting museums, that is, the training in disregarding ways of looking at objects other than that of the contemplation of consecrated art. The model is conceived as a diagram of forms and shades. A painter from Romania has confessed the shock he experienced as an unsophisticated young man when he first entered a drawing class at an academy and saw a naked woman in the midst of apparently unaffected young men.[12] A nude, as an abstraction in the perception coded by academic training, could hardly be thought of as undressed, no more than a circle or a triangle could be imagined stripped. But in an African context, where this code of pure gaze has not been inoculated for generations and where, besides that, being naked or clothed was never conceived as an inflammatory contradiction, the code seems to have had little bearing. At least this seems to be valid for Aina Onabolu who, even when he appropriates the Western scheme of the 'nude', keeps his freedom to paint the naked African woman as a human and thinking being, a subject rather than an object.

Kojo Fosu, the art historian from Ghana, writes about what he calls the second generation of pioneers: 'Immediately following political independence, almost all the (pioneer) artists received large numbers of important commissions to create national monuments for their countries . . . As part of the continuous policy of their government to unite the various ethnic groups into single national entities and encouraging a total sense of national allegiance, these artists were mandated literally to create new national consciousness and identities'.[13]

It is a clarifying perspective. This policy was intimately related to the immediate postcolonial African situation, to the very legitimate urge to replace old symbols of a foreign oppression – from colonial monuments to stamps and coins – with expressions of a new African self-esteem. 'The new artists functioning as state artists became the new visual communicators of the new image.'[14]

Kojo Fosu also tries to see the involvement of the new national governments as 'deeply rooted' in how traditional royal courts took artists into their service. I guess it is an attempt at 'Africanising' history. But the only thing he shows is how easily those kinds of ambitions obfuscate the understanding of a specific situation and its implications. It tells us nothing about the significance of the convergence of political, cultural and artistic strivings in newly independent Africa. It is as if one would place on an equal footing Louis David's *The Oath of the Horatii* (1784) with its patriotism, virtue and civic spirit, and Hyacinthe Rigaud's portrait of Louis XVI (1701), with its sense of autocracy and arrogance, just because the paintings happened to be state commissions.

The art situation Kojo Fosu describes is probably better understood in terms of a progressive element in bourgeois society operating in mutual understanding with the then modern artists. Which means, in terms of European history, that we look at the stage before the invention of an autonomous art in reaction against growing bourgeois oppression, or, more specifically,

the period of David and early history painting.

More or less in the same way that the French pre- and post-revolutionary artists ideologically/stylistically resorted to Greek and Roman classical antiquity, these African pioneers resorted to traditional art as a revived classical African language. Thus, they simultaneously drew identity from, and rehabilitated, an African patrimony formerly despised by their oppressors. They combined these elements with others loaded with international modernism, realistic as well as abstract, positioning themselves at the same time in an African tradition and at the edge of a new, modern epoch.

The references to traditional art had a double aim. They were also used, as Kojo Fosu shows, in strategies to promote national integration through crossing borders between ethnic groups. The Nigerian artist Ben Enwonwu, for instance, made reference in his work to traditional art of the Yoruba, Hausa, Fulani as well as of his own people, the Igbo.

In this way, the discussion about modernism versus traditionalism, which was the first, and which has been, and still is, the most committed and difficult debate in the African art world, was dissolved before it was solved. Two Ghanaian artists belonging to this pioneer chapter, Oku Ampofu and Kofi Antubam, had, for instance, originally adopted totally opposed attitudes.

To try to apply Bourdieu's grid to a chapter of twentieth-century African art takes me far from its chronological order and its strict logic. What it illustrates is, rather, how complex and mixed up things are outside the Western field when seen from its perspective. If Bourdieu makes the shift of 'nomos' by the invention of the autonomous field perfectly clear, from the central authority of all consecration, represented by the Academy, to an 'anomy' where consecration was produced by the field and by the struggle between position-takings within it, some basic facts are implicitly understood.

One is that diversity is an aspect and a product of that struggle. And another is that each position-taking must be pointed and precise in order to be able to penetrate the field.[15] When Kojo Fosu praises the stylistic differences internal to the artistic practice of, for instance, Ben Enwonwu, and does not even try to problematise them, he only illustrates how a lack of certain criteria tends to place an artist's work adjacent to a notion of serious commitment in its reception from outside (and not only from the West). 'As an artist who "could switch from one style to another"', he writes, 'he always remembered that cultural diversity in his country also calls for diversity in its creative representation'.[16] To be read as a critical comment, I must admit it makes no sense to me.

There is a long perspective implicit in Bourdieu's historically based model, even if it builds mainly on observations of the last 150 years in France, Europe, the West – a long course when it comes to the growth of the *habitus*. And also when it comes to the technical, economic and artistic development of the production of art, extending at least from the Renaissance.

In Africa, we meet this long perspective compressed almost to a simultaneity. Let me take as an example Elimo Njau's painting *Nativity*, which Marshall W. Mount reproduced in his *African Art: The Years Since 1920* as representing a generation of pioneering art in eastern Africa from the Makerere University College Art School in Kampala, Uganda.[17]

The school was founded by Margaret Trowell in 1937. Important pioneer artists like Gregory Maloba and Sam Ntiro both studied and taught there. The teaching method was clearly instructed by European academic training, including modelling figures and forms with light and shade and constructing space by perspective. It was characterised by a clear and broadminded awareness of what are the prerequisites for being an artist. From the late 1950s, the curriculum also included studies in international modernism.

In its early phase, the school received commissions for its students and graduates to produce murals for Christian churches in eastern Africa. Elimo Njau's mural series in the Church of the Martyrs in Fort Hall, Kenya, from 1956, is part of those commissions.[18] If put into a European chronology, his *Nativity*, with its wide space of firmly constructed mountainous landscape, and with the Biblical scene placed in a contemporary setting (here African), could have been thought to belong to the anti-modernist 'back to the *quattrocento*' backlash of the 1920s. But in a part of Africa where traditional art had prevailed up to the time of his generation, it can be seen as revolutionary – at least in the sense that it represented a drastic break with the principles of religious images in Africa. (I here consciously disregard its obvious place in the cultural transformation carried out by European missionaries.)

A traditional African work of art, produced for practical ritual use and building on the belief in magic, functions through the symbolic presence of the god, or of divine forces, which are contained and represented in the forms. If it (exceptionally) is the question of a two-dimensional work, the forms are juxtaposed on the surface, where their visual power is at its strongest.

The construction of an illusionistic three-dimensional space, on the other hand, abolishes the magical sense of presence and replaces it with an illusion of looking into a scene or a vision. If intended for religious contemplation, this visuality can be endowed with a biblical narrative, as here. It might even produce an effect experienced as a 'miracle', simply by breaking the logic of the illusion by, for instance, seemingly annulling the law of gravity. Still, the miracle takes place 'over there' and does not function as a presence in the object of art itself. In short, magic and perspective are incompatible.

In the long run, European artistic representation, the Renaissance heritage and especially geometric perspective, have been dismantled. The principle of juxtaposition has been restored. But this time it has been for purely aesthetic reasons, for the expressivity of forms and colours, which has nothing to do with magic. In spite of all the theorising about 'spiritual art', no one uses modern objects of art for practical magic purposes. In working on establishing the new principle

Elimo Njau
Nativity, 1956
Tempera
Nave Mural for Church of
the Martyrs, Fort Hall,
Kenya

of juxtaposition – a crucial moment within it was synthetic Cubism – European modernists found instruction in traditional magic art, not least in classical African art. Thus two separate worlds of basically different notions of art, of functionally totally different practices, met in an act of Western appropriation which, seen within Bourdieu's field, was part of a crucial position-taking.

While the last phase (from Manet to Picasso) of this process spanning six centuries in Europe took some forty years, the whole process, the successive steps from magical juxtaposition to perspectival space and then to aesthetic juxtaposition, was present, higgledy-piggledy, in the African scene at the same time. This overlapping of historical stages has predictably produced misunderstandings and confusion of notions and categories in the reading of the African transition to modern art and of its further development, in African discourses as well as in the Western approach. Things have not been made clearer by the continued reference to pre-modern African art within certain Western modernist positionings summed up as 'primitivism', as it has contained deliberate confusions of ideas around notions like 'magic' and 'ritual', here used in a somewhat metaphoric sense and in what I would prefer to call 'aesthetic masquerades'.

The conclusion to be drawn is that, when it comes to the theoretical work to be done and the critical discourses needed, the challenge is tremendous, in the West as well as in Africa, where the lack of such critical work has often been pointed out as a crucial problem by its scholars and artists.[19] This work cannot be carried out as an internal African affair, disregarding the European genesis of modern art; neither can it proceed by taking over ready-made discourses from the West, which are often field-specific there. It has to build on independent analysis and on an understanding both of the African and the Western social structures and their interplay. It must find instruction in comparative studies of other cultures and parallel confrontations between art histories. In this work, it is necessary that African inferiority complexes as well as compensatory wishful thinking be swept away once and for all.

In the Western art field, the tendencies we observe today, its closed circuits and the extension of its power structure – an internationalisation that seems to counteract rather than facilitate an opening up to a new inter-cultural internationalism – does not inspire great optimism. Domination and exclusion seem to prevail. But, as writes the American feminist scholar Toril Moi in her paper 'Conquering Bourdieu',[20] times of crisis force a redefinition of experiences resulting in new forms of language. Groups in revolt who were once kept out, gain power from their capacity to objectify previously unspoken experiences, to make them commonly known – a step on the way to seeing them legitimated. That is the confidence she draws from Bourdieu.

It is a challenge today to Third-World intellectuals and not least to the growing multitudes of diasporan intellectuals and artists in Western metropolises. The path to change goes, Moi writes, for Bourdieu as for Freud, through analysis and verbalisation of the unspoken rules that guide our behaviours. These rules are not just tacit. According to Bourdieu, their ability to stay in force and an

ongoing, functioning cultural domination presuppose a collective unawareness and renunciation. Thus, his theoretical intervention, which aims to make the foundations of Western bourgeois aesthetics visible, will contribute to its transformation and hopefully to a wider change. It is up to us to follow it up.

Notes

1 Pierre Bourdieu, in Randal Johnson (ed.), *The Field of Cultural Production* (Oxford: Polity Press, 1993), p. 129.
2 *Ibid.* Part II, 'Flaubert and the French Literary Field'.
3 Bourdieu, *Les règles de l'art. Genèse et structure du champ litteraire* (Paris: Editions du Seuil, 1992), p. 76. 'One cannot understand the experience that the authors and the artists might have had of the new forms of domination to which they found themselves exposed in the second half of the nineteenth century, and the horror with which the figure of the "bourgeois" sometimes inspired them, if one hasn't an idea about what the emergence meant, favoured by the industrial expansion of the Second Empire, of industrialists and business people with enormous fortunes (people like the Talabots, the de Wendels or the Schneiders), parvenus without culture, ready to let the power of money triumph over all the society and with an outlook deeply hostile to everything intellectual.' In the chapter 'A Structural Subordination', translated from the French by Kristian Romare.
4 Bourdieu, *The Field of Cultural Production, op. cit.*, p. 63.
5 Bourdieu, 'Pour une internationale des intellectuels', conference paper, Turin, 1989.
6 Bourdieu and Hans Haacke, *Libre-échange* (Paris: Seuil/les presses du reel, 1994).
7 Zygmunt Bauman, *Postmodern Ethics* (Oxford, England and Cambridge, MA: Blackwell, 1993), pp. 38-39. 'The otherness . . . was *temporalised* in a way characteristic of the idea of progress: time stood for hierarchy . . . Johannes Fabian dubbed this widespread habit "chronopolitics": projecting the contemporary differentiation upon the time arrow, so that cultural alternatives may be depicted as "allochronic" – belonging to a *different* time and surviving into the present on false pretences, while being merely relics, doomed to extinction.'
8 Bourdieu, *The Field of Cultural Production, op. cit.*, p. 164.
9 *Ibid.*, p.163.
10 *Ibid.*, p. 80. 'One thinks of Manzoni, with his tins of "artist's shit".'
11 Kojo Fosu, *20th Century Art of Africa* (Zaria: Gaskiya Corporation, 1986), p. 7. The author refers to a Ph.D. thesis on the artist by Ola Oloidi.
12 Personal communication by Jacques Hérold to art critic Kristian Romare.
13 Fosu, *op. cit.*, p.12.
14 *Ibid.*, p. 12.
15 Most modern Western artists, except Picasso and a few others, stuck to and developed the style with which they positioned themselves. Changing style after the position-taking has even caused bitter controversies with connected agents, as in the case of Nicholas de Staël.
16 Fosu, *op cit.*, p.29.
17 Marshall W. Mount, *African Art: The Years Since 1920* (New York: Da Capo Paperback, 1989), p. 101. (Originally published Bloomington: Indiana University Press, 1973).
18 Fosu, *op. cit.*, p.80.
19 See for instance Chidi Amuta, *The Theory of African Literature* (London: Zed Books Ltd, 1989), where the author characterises the lack of critical and theoretical work in Africa as the most serious cultural underdevelopment. 'The challenge of the contemporary African situation is that of confronting reality at the level of praxis informed by relevant and systematic theory. All else is conjecture', (p. viii). The problems of a low standard of art criticism in Africa have been addressed by Ola Oloidi, Obiora Udechukwu and others. See Bernice Kelly, *Nigerian Artists: A Who is Who and Bibliography* (Washington DC: National Museum of African Art, Smithsonian Institute, 1983), pp. 540, 547; see also my 'The Art Critic and Advocate', *Art Criticism and Africa*, (London: Saffron Books, 1998), p.29.
20 Quoted from Toril Moi, 'Conquering Bourdieu' (Att erövra Bourdieu), a paper presented at Lund University, Sweden in 1994; translated from Swedish.

African Art and Authenticity:
A Text with a Shadow
Sidney Kasfir

*There are those who want a text (an art, a painting) without a shadow, without the 'dominant
ideology'; but this is to want a text without fecundity, without productivity, a sterile text . . .
The text needs its shadow . . . subversion must produce its own chiaroscuro.*
Roland Barthes [1]

A controversial debate about African art that has surfaced in the past few years concerns its role
as a mirror of Western colonial history. The criticism prompted by the '"Primitivism" in 20th Century
Art' exhibition at the Museum of Modern Art [2] was reopened, and subverted, by 'Magiciens de
la Terre' at the Centre Pompidou in 1989. In the former, precolonial African and Oceanic art was
presented as a set of powerful divining rods for proto-Cubists, Expressionists, and Surrealists.
In the latter, the enigmatic (to Westerners) nature of contemporary African, Asian, and Diaspora
art was translated into the art of the conjurer *(magicien)*, and at the same time, this act of conjuring
was equated (quite misleadingly) with the cultural production of a Western avant garde. In both
exhibitions there was an attempt to demonstrate the 'affinities' between 'the tribal and the modern',
Third World and First World.

Postmodern critics have used these exhibitions (the first a powerful articulation of the Modernist
paradigm, the second a flawed attempt at paradigm-breaking) to comment upon the intellectual
appropriation of African and other Third World art by Western museums and collectors. [3]
Meanwhile, most mainstream institutions and a surprising number of scholars continue to think
about African art and its public presentation as if this debate were not taking place at all. In most
of the major exhibitions of African art currently circulating in the United States there is little attempt,
either explicit or implicit, to subvert omniscient curatorial authority. [4] Perhaps it is time to cast a
shadow on this authority by re-examining the way it operates in defining African art, both as
commodity and as aesthetic act.

The West and the Rest [5]

Two questions are central to this debate: who creates meaning for African art? Who or what
determines its cultural authenticity? The authenticity issue has been raised many times in the
pages of the journal *African Arts*, [6] but I want to examine it specifically in the light of the current
discussion of cultural appropriation, since in the past it has been reviewed in terms of fakes,
forgeries, and imitations – terms that are themselves heavily laden with the weight of earlier ideas
about African art and culture, most specifically the primacy of 'traditional society'. To talk about
authenticity, it is first necessary to unpack the meanings assumed for 'traditional society', and by
extension, 'traditional art'.

A major underpinning for the argument I am making here is that what we call 'traditional society'
is a legacy of our Victorian past, owing as much to nineteenth-century Romanticism and the social-

evolutionary notion of disappearing cultures as to any reality found in Africa itself. In African studies it continues to function as a more benign, euphemistic version of that recently shelved artifact, 'primitive society'.[7] The idea that before colonialism most African societies were relatively isolated, internally coherent, and highly integrated has been such a powerful paradigm and so fundamental to the West's understanding of Africa that we are obliged to retain it even when we now know that much of it is an oversimplified fiction.

This assumed combination of isolation and a tightly knit inner coherence has given rise to a presupposition of uniqueness in material cultures (William Fagg's 'tribality', leading to unique tribal styles[8]), ritual systems, and cosmologies. Nowhere has this orthodox and conservative view of African culture been so obvious as in Dogon studies, where the Dogon were made to seem unique not only in Mali but in all of Africa.[9] Such ideas are losing their currency, but only slowly.

In African art studies our most uncritical assumption has been the before/after scenario of colonialism, in which art before colonisation, occurring in most places from the mid-nineteenth to early twentieth century, exhibited qualities that made it authentic (in the sense of untainted by Western intervention). Most crucially it was made to be used by the same society that produced it. In this scenario, art produced within a colonial or postcolonial context is relegated to an awkward binary opposition: it is inauthentic because it was created after the advent of a cash economy and new forms of patronage from missionaries, colonial administrators, and more recently, tourists and the new African elite.

This view of authenticity, though now questioned by many scholars, is still held firmly by major art museums and the most prominent dealers and collectors. It is, almost by necessity, the implicit principle of selection for the art seen on display in large-budget, foundation-supported circulating exhibitions such as the recent 'Yoruba: Nine Centuries of African Art and Thought' and 'Gold of Africa' as well as in the permanent displays of the National Museum of African Art, the Metropolitan Museum's Rockefeller Wing, and the National Museum in Lagos. In addition, such art, ideally precolonial or more often dating from the early colonial period, is the subject of virtually all the advertisements placed by dealers in the pages of *African Arts* and *Arts d'Afrique Noire*.

Ironically, what we could call canonical African art – that which is collected and displayed and hence authenticated and valorised as 'African art' – was and is only produced under conditions that ought to preclude the very act of collecting. Seen from an anticolonial ideological perspective, collecting African art is a hegemonic activity, an act of appropriation; seen historically, it is a largely colonial enterprise; and seen anthropologically, it is the logical outcome of a social-evolutionary view of the Other: the collecting of specimens as a corollary of 'discovery'. Even if none of this were acknowledged, one cannot escape the internal contradiction in the working definition of authenticity – namely that it excludes 'contamination' (to continue the specimen metaphor) while at the same time requiring it in the form of the collector.

It is possible, in wishful thinking, to circumvent this collector or at least neutralise him or her: a simple gift from a local ruler to a colonial administrator (Ruxton in the Benue), to a missionary (Sheppard in Kuba country), or to an explorer (Vasco da Gama on the Swahili coast) might seem non-interventionist.[10] But we know from Leo Frobenius' diaries how very acrimonious, even hostile, such exchanges could become within the web of conflicting interests that surrounded them. The notion that they were somehow devoid of political or economic motive on either side seems patently ridiculous now, yet that is the implicit assumption in the 'invisible collector' required of paradigmatic 'authentic' art.

A second fiction in the construction of the canon is that no important changes occurred in artistic production during the period of early contact collecting – that is, neither style nor iconography nor the role or position of the artist was affected in any important way by the initial European presence. That this is an equally dangerous and naïve assumption can be shown by looking at the radical transformation in warrior masquerades in the Cross River and Ogoja region of south-eastern Nigeria with the coming of the British. The early documentation of these masks described them as skulls worn on the dancer's head.[11] Very few examples exist in collections, since these were not 'art' by any stretch of the colonial imagination. Those few still extant are starkly real skulls, over-modelled with mimetic touches such as hair and false eyes, or rearticulated lower jaws. As the *pax Britannica* depleted the availability of enemy skulls, these were replaced by carved wooden imitations, in some areas (Cross River) covered with skin for greater realism and in others (Igede, Idoma) painted white with black cicatrisation patterns.[12] It is these, and not the truly precolonial decorated skulls, that have been accepted into the canon and are highly sought after by collectors as authentic. Here Western taste, not Western contamination, has dictated what is art and what is merely ethnographic specimen.

Another example is Yoruba resist-dyed textiles. Prior to the importation of factory cloth from Manchester, these were made from handspun, handwoven cotton that was too coarsely textured, too soft, and too thick for complex *adire* techniques and patterns to develop. Yet the elaboration of *adire* in the heavily missionised town of Abeokuta, and the growth of its production, were in no way thought of as inauthentic by collectors until the 1960s, when it began to be produced for a Peace Corps and tourist market in colours other than indigo. In both of these examples it was not the intervention of Europeans and subsequent modification of a tradition that marked its 'authentic' and 'inauthentic' phases. Rather, 'authentic' was defined in terms of the collectors' taste.

If there were no such thing as collections, if the processes of appropriation, reclassification, and public display did not exist, it might be possible to push back the before/after scenario to a much earlier date – say, to the advent of Islam in West Africa or to the coming of the Portuguese. Seen strictly in terms of their cultural impact, these earlier encounters were surely as important as colonialism. But because such a revision would limit authenticity to a handful of collected objects,

almost none of which would be sculpture in wood, it could not possibly find acceptance in the world of museums and collectors. The canonical 'before' therefore was defined originally in terms of a Victorian ideology fed by a felicitous combination of imperial design, social Darwinism, and collecting zeal.

But the fact is that Africa is a part of the world and has a long history. There are innumerable befores and afters in this history, and to select the eve of European colonialism as the unbridgeable chasm between traditional, authentic art and an aftermath polluted by foreign contact is arbitrary in the extreme. While it is very true that both the nineteenth and the twentieth centuries were periods of 'fast happening', in George Kubler's phrase,[13] it would be naïve to assume that no other such periods existed in African art history.

What is far more likely is that there were several – some associated with the spread of new technologies (brass-casting, weaving, tailoring, the introduction of the horse), others with the spread of ideas (Islam, a sky-dwelling creator god, the concept of masking). I am suggesting that there is no point in time prior to which we could speak of the ascendancy of 'traditional culture' and after which we could speak of its decline. The old biological model of birth, flowering, decay, and death imposes on culture not only an order that is seldom there but also, in this case, the strong temptation to identify the onset of 'decay' with the onset of colonialism. This is the historicist flaw in the authenticity test used to construct the canon of African art.

The third fiction concerning African art is that it has a timeless past, that in the long interlude before colonialism, forms remained more or less static over centuries. Occasional pieces of evidence that support this view, such as the Yoruba-derived divination board collected at Ardra before 1659,[14] have been extrapolated to create a mythic steady-state universe of canonical art. The logical corollary of the 'timeless past' is the fiction of the 'ethnographic present', that eve of contact forever fixed in the narrative structures of contemporary ethnography. Even scholars who readily acknowledge the absurdity of the former may frequently cling to the latter as their putative time frame. In doing so they privilege this artificially constructed eve of contact as if what came afterward is by definition less relevant, and (one hardly need say) less authentic. Yet only societies in which all change was compressed into a cataclysmic surge of Western penetration could be imagined to cease to exist after that moment. For nonexistence, in the cultural sense, is assumed when change is read as destruction of a way of life, rather than its transformation. And indeed, in much of the writing on African art, this after-contact period is simply a blank white space on the page.

Thus in typical exhibition catalogues of Yoruba art, we learn that there are *orisas* and their ritual objects, but as a rule there is no mention of how these fit into the complex twentieth-century renegotiation of *orisa* discipleship, Islam, and Christianity that now characterises Yoruba religious life. Instead, the reader is invited into a fictional ethnographic present where these radical changes do not intrude.[15]

Just as casting African art in an ambiguous ethnographic present denies it history, insistence on the anonymity of African artists denies it individuality.[16] Far from seeing this anonymity as a result of the way African art is usually collected in the first place – stolen or negotiated through the mediation of traders or other outsiders – we have come to accept it as part of the art's canonical character. The nameless artist has been explained as a necessary precondition to authenticity, a footnote to the concept of a 'tribal style' that he has the power neither to resist nor to change.[17] Although the principal architect of the tribal style notion, William Fagg, nonetheless recognised that 'the work of art is the outcome of a dialectic between the informing tradition and the individual genius of the artist',[18] it has been more common to speak of the artist as simply bound to and by tradition.[19]

Among French dealers and collectors of African art, 'authentic' frequently means 'anonymous', and anonymity precludes any consideration of the individual creative act. One Parisian collector told Sally Price: 'It gives me great pleasure not to know the artist's name. Once you have found out the artist's name, the object ceases to be primitive art'.[20] In other words, the act of ascribing identity simultaneously erases mystery. And for art to be 'primitive' it must possess, or be seen to possess, a certain opacity of both origin and intention. When those conditions prevail, it is possible for the Western collector to reinvent a mask or figure as an object of connoisseurship. But when Price asked one such connoisseur whether he thought the creator of such a work might be aware of these same aesthetic considerations, the answer was an emphatic denial.[21] The 'primitive' artist, in this Africa of the mind, is controlled by forces larger than himself and is consequently ignorant of the subjective feelings of aesthetic choice. In such an equation, the Western connoisseur is the essential missing factor that transforms artifact into art.[22] In a seminal essay on issues surrounding the authenticity of Oriental carpets,[23] Brian Spooner argues that an important aspect of the carpets' appeal to Western collectors is this marked cultural distance between maker and collector, and the corresponding lack of information about the artist that it usually implies. In such situations the collector is able to construct a set of attributes that describes the 'real thing'. Ironically, it is not knowledge but ignorance of the subject that ensures its authenticity.

The corollary of this all-in-one anonymity is that one artist's work can stand for a whole culture, since the whole culture is assumed to be homogeneous (yet at the same time unique). Although it is a tautology, this has long been a major argument for the concept of a tribal style: an identifiable cultural style is a major ingredient in defining ethnicity, and a Yoruba (Idoma, Kalabari, etc.) artist is one who works in that identifiable style. In a video accompanying one currently circulating exhibition, a pleasant-voiced narrator explains, 'The Yoruba believe . . .'. I couldn't help wondering, Which Yoruba? Muslims? Baptists? Aladura? Those who still follow the *orisas*? Lagos businessmen? Herbalists?[24] Omniscient curatorial authority has the power to flatten out these hills and valleys, but should it? Is the public really incapable of understanding that African cultures, and

the arts they produce, are not monolithic? Do we really want a 'text without a shadow'?

The faraway collector also reinvents each mask or figure as an object of desire: a projection of alterity (in earlier times, the colonised 'primitive'), seen in whatever intellectual fashion prevails at the moment. The Kongo nail figure became a 'fetish', every female image a 'fertility emblem', and so on. Naming and categorising are interventions as important as connoisseurship. When catalogues of collections appear, they are frequently organised under a dual 'tribal style' and 'culture area' rubric. While classificatory principles may be necessary to organise a large body of material, they obscure certain correspondences as well as illuminate others. Although Yoruba Gelede and Maconde Mapiko masks often bear striking visual similarities, these are never recognised or commented upon because the masks appear in widely separated parts of any catalogue or exhibition: the Guinea Coast and East African sections, respectively.

The most powerful of the classificatory interventions are the words 'traditional' and 'authentic', which become shorthand designations for 'good', and their negations 'non-traditional' and 'inauthentic', which become synonymous with 'bad'. In the same way, a Dogon mask to which a recognised expert applies the epithet 'export piece' is instantly transformed from an object of desire with a high market value to a piece of flotsam afloat in the postcolonial world. The language of classification used to canonise or decanonise a piece of African sculpture is powerful, one sided, and usually final. A sculpture's worth as an aesthetic object, a piece of invention, a solution to a puzzle of solids, voids, and surfaces, is left totally unexamined unless it first passes the authenticity test. No Kamba carving, however brilliant or extraordinary, would get past the front door of any reputable New York gallery specialising in African art. It would be said to 'lack integrity', implying that somehow nontraditional artists have detached themselves from their cultures and that their work is therefore inauthentic.

In the earlier debates about authenticity in African art, much discussion centred on copies, replication, and fakes.[25] We may ask what kind of assumptions underlie such questions. What is being falsified? And in whose eyes? On the one hand the construction of the idea of 'tribal' style presumes a fairly high degree of uniformity from one artist's work to another, and such replication has been accepted as part of the 'traditional art' paradigm. But when a contemporary carver from another ethnic group (or 'tribal style area') intentionally takes up this same style, the resulting object is said to be a fake because, it is claimed, there is conscious intent to deceive. The same claim is made even if the carver is a member of the 'traditional' culture that produced the object in the first place, if he artificially ages the piece or allows it to be thought old by the buyer. Given the absence of a signature or known artist's hand in most cases, intentionality is seemingly crucial in deciding what is authentic and what is fake.

But it is not so clear that the distinctions of these Western collectors are very resonant in the mind of the African artist. Asante carvers are an interesting case in which artists' attitudes toward copying

successful forms have been well documented.[26] For Asante (and many other) carvers,[27] imitating a well-known model is considered neither deceptive nor demeaning; rather, it is viewed as both economically pragmatic and a way of legitimating the skill of a predecessor (if an old model) or paying homage to a fellow artist (in the case of a recent innovation).[28]

This attitude stems directly from the way in which carving is regarded as a livelihood. While this view is well known, it bears repeating in this context: whereas Western artists often see their work primarily as a vehicle for self-realisation, that attitude is as unfamiliar to African artists as it is in African culture generally, unless we refer to elite artists trained in Western-type art schools. Typically, the carving profession, or any other that results in the construction of artifacts (brass-casting, weaving, pottery-making etc.), is seen as a form of work, not qualitatively very different from farming, repairing radios, or driving a taxi. This does not mean that it is not 'serious' – work is indeed serious – but that it is viewed matter-of-factly as aiming to satisfy the requirements set down by patrons. One does whatever is necessary to become a successful practitioner.

Furthermore, in precolonial patron-client interactions, it was the custom for artists to try openly to please patrons, even if this meant modifying form. Not surprisingly, that attitude has carried over into colonial and postcolonial relations with new patrons, including foreigners. It is unclear why making what the buyer prefers should be regarded by Western collectors as acceptable in the past but opportunistic now. One reason may be that they see types of payment for traditional commissions – yams, goats, iron rods – as less commercial than currency transactions, and this has the effect of 'softening' the economic motive for the transaction. But the more likely reason is the Western collector's failure to recognise that even precolonial African art was essentially 'client-driven'.[29]

The other major difference between African artist and foreign collector is the antiquarianist mindset of the latter. African art in a Western (or equally, Japanese) collection takes on greater significance, prestige, and market value if it is old. While most Africans do not share this attitude toward their art, they are willing to accept the fact that collectors prefer 'antiquities'[30] and consequently see nothing wrong with replicating them. The intentional deception (and it happens with regularity) occurs more frequently in the marketing of a work by traders and later by art dealers. It is usually less a matter of collusion between artist and trader than of the marked difference between African and Western thinking about the significance of one-of-a-kind originality.

On the question of imitation and its relation to deception, we could conclude, first, that Western collectors have nothing against imitation in the sense of artists following time-worn prototypes – in fact a completely unsurprising mask or figure in a well-documented 'tribal' style is usually preferable to something wildly original and idiosyncratic, since there are no standards for judging the worth of the latter. Second, the same Western collector (or museum professional) is distinctly uncomfortable with any tampering with the prototypical imitation, through attempts to make it look

old or through imitation by an artist outside the group with whom the prototype is thought to have originated. Either of these serves to de-authenticate the piece, regardless of its merits as a work of art. Third, most (I am guessing here, but based on fairly broad experience) non-elite African artists, whether rural or urban, would find these ideas arbitrary rather than obvious, and more than a little baffling in their seeming inconsistency toward imitation.

If we now go back to the question of what is being falsified in the case of 'fakes', we might wish to look beyond the short range. In a centre-versus-periphery view of cultural production, the centre defines legitimate means and ends, to which the periphery can only respond. If we allow that collecting became the coloniser's role, can it be surprising that the colonised responded with the willing supply of what the centre seemed to demand? That the 'antiquity' may have been new both complied and retaliated – subversion producing its 'own chiaroscuro'.

Authenticity as an ideology of collection and display creates an aura of cultural truth around certain types of African art (mainly precolonial and sculptural). But the implications of authenticity extend even further into an ideology of recording culture, whether through film or through writing. The ethnographic film is particularly vulnerable to this form of selective perception. In 1978 in Ibadan I watched a crew of perfectly serious German filmmakers systematically eliminating the Jimmy Cliff T-shirts, wristwatches, and plastic in various forms from a Yoruba crowd scene at an Egungun festival. They were attempting to erase Westernisation from Yoruba culture, rewriting Yoruba ethnography in an effort to reinvent a past free of Western intervention – a pure, timeless time and space, an 'authentic' Yoruba world.

Charles Keil relates the story of the Tiv women's dance known as Icough and how it was modified by filmmakers (in the face of considerable Tiv resistance) to fit the requirements of cultural authenticity and the attention span of a Western audience.[31] A dance sequence of eight segments lasting well over an hour was reduced to three; the usual audience of 'enthusiastic supporters pushing forward for a better look or breaking into the dance to press coins on perspiring brows' was completely absent. But most serious, the aesthetics governing the dance itself – what Keil refers to as the Tiv expressive grid – were modified by the insistence of the filmmakers that the women change their costumes from the Western-style, circle-skirted dresses and pith helmets usually worn for this dance to the more common Tiv 'native' wrappers. What is subsequently lost in the film is the interaction of costume and movement that is central to this particular dance:

> The dresses in the original dance, all flounced and starched out in circular hems around the knees, provided a moving circumference against which knee bends, elbow actions and neck angles could counterpoint themselves . . . the removal of pith helmets from the heads of the dance co-leaders seems a petty suppression to complain of until one realises that two pivotal hubs that literally cap the presentation and balance the skirt circles are missing . . .

Not only were the central symbols of a 'rite of modernisation' taken away or repressed, but the power of Tiv tradition to master those symbols, incorporate them into Tiv metaphor, was being denied.[32]

Having been shown David Attenborough's film *Behind the Mask* (1975), my students are always shocked to learn that tourists regularly visit certain Dogon villages. The film artfully presents the Dogon as a 'pure' culture, untainted by contact with outsiders. In an equally popular film, Peggy Harper and Frank Speed's *Gelede* (c. 1982), the Western Yoruba mask festival is performed in a nearly empty space with almost no audience, even though we know that in fact it takes place in a crowded marketplace amidst noise, dust, and confusion.[33] Presumably, clear camera angles took precedence over contextuality. By strict definition these are not documentary films, because they control and regulate the participants. Yet they are widely used in both museums and university classrooms. Despite their flaws they have defined and authenticated the performative aspect of African art for a generation of students.

I have quoted at length the instance of the filming of the Icough dance because it provides such a striking analogy to the redefining of objects such as masks, in the process of removing them from the scene of their production and use and installing them in a museum. This reduction and stripping away of meaning by the removal of 'extraneous' facts – whether a decaying masquerade costume or a starched dress and pith helmet – serve seemingly opposite purposes in the two cases. In the dance, it self-consciously traditionalises the performance for a film audience that expects the exotic; in the example of the mask installed in a museum, the removal of accoutrements reduces it to uncluttered sculpture that can be displayed in the Modernist idiom, as pure form. But both cases involve the same act of erasure and imposition of new meaning. And both are so frequently done that we take them wholly for granted.

Art and Artifact: The Creation of Meaning
This leads to a very troubling question: who creates meaning for African art? It is difficult not to conclude that it is largely Western curators, collectors, and critics (whose knowledge, as we will see, is deftly mediated by entrepreneurial African traders along the way) rather than the cultures and artists who produce it. This is not to suggest that the original work possesses no intentionality. It is fully endowed with intention by its creator as well as by its patrons. But the successive meanings an object is given are fluid and negotiable, fragile and fully capable of erasure as it passes from hand to hand and ultimately into a foreign collection. Here it must be invented anew, most often in the context of a museum culture dominated either by a Modernist aesthetic that looks for 'affinities' with the Third World or by a potentially deadening 'material culture' approach. A handful of museums have found other ways of reinventing African art that strive consciously to be anti-Modernist and anti-hegemonic, such as the Centre Pompidou's 1989 installation of 'Magiciens de la Terre',[34] or richly contextualist, such as the

Museum of Mankind's Yoruba installation of the mid-1970s; they are reinventions nonetheless, since that is an inescapable aspect of what museums do. Even the contextual approaches that are consciously designed to preserve the integrity of cultures represented are far from neutral. Barbara Kirschenblatt-Gimblett reminds us that designing the exhibition is also constituting the subject, and that 'in-context approaches exert strong cognitive control over the objects, asserting the power of classification and arrangement. . . '.[35]

James Clifford further reminds us that prior to the twentieth century, African artifacts were not 'art' in either African or Western eyes.[36] Jacques Maquet made the same point earlier,[37] referring to African art as 'art by metamorphosis'. In Western museums these objects underwent a double taxonomic shift – first from exotica to scientific specimens when the earlier 'cabinets of curiosities' gave way to newly founded museums of natural history in the late nineteenth century; and following their 'discovery' by Picasso and his friends in the early decades of the twentieth century, they underwent a second promotion into art museums and galleries where they were recontextualised as art objects.[38]

This migration of objects through classificatory systems can be mapped topologically as well as diachronically. The experienced museum-goer knows that the art-museum display policy in which an isolated mask or figure is encased in a vitrine or lit with track lights means to convey the information that the object is to be apprehended as 'art'; the same object embedded in the busy diorama of a natural history museum display is meant to be read differently, as a cultural text. In the former, its uniqueness is stressed, in the latter, its (con)textuality. Yet, as museums, both confer cultural authenticity upon the objects displayed there, which are canonised in the popular coffee-table title, *Treasures of the*

That from an African perspective these objects are not art in the current Western sense is too well known to discuss here. Our museum collections, on the other hand, are constituted by criteria that we, and not they, devise. The fact that the various Idoma (Alago, etc.) lexical terms for 'mask' are wholly non-aesthetic will not perturb even the most inexperienced museum docent. As Maquet suggests,[39] why not define art as those objects that are displayed on museum walls?

Every collected mask or figure is defined and given boundaries by its surroundings: the village shrine house (where it is wrapped in burlap and hung out of the reach of white ants when not in use), the trader's kiosk in an African city (where it rests among hundreds of other de/recontextualised objects and is first given an 'art' identity), the Madison Avenue gallery (where it is put through the 'quality' sieve and aestheticised with other 'quality' objects), and finally the home of the wealthy collector (where it is reincorporated into a domestic setting, but unlike the situation in the village, is on constant display, 'consumed' visually by collector and friends). Taken in sequence, the definitions overlap at least somewhat, but between the first and last there is an almost total reinvention of how and what the object signifies.

Tourist Art and Authenticity

Of all the varieties of African art that trigger the distaste of connoisseurs and subvert the issue of authenticity, surely so-called tourist art is the worst-case scenario. In the biological model of stylistic development it exemplifies 'decay' or even 'death'; in discussions of quality it is dismissed as crude, mass-produced and crassly commercial; in the metaphors of symbolic anthropology it is impure, polluted; in the salvage anthropology paradigm it is already lost. The Center for African Art in New York decided to omit it from its supposedly definitive contemporary art exhibition 'Africa Explores', presumably for some or all of the above reasons.

At the same time it is a richly layered example of how the West has invented meaning (and in this case denied authenticity) in African art. Without Western patronage it would not exist. It is a Marxist's nightmare, hegemonic appropriation gone wild. But what actually is 'it'? The rubric 'tourist art' seems to include all art made to be sold that does not conveniently fit into other classifications. It is easier to state what it excludes: 'international' art made by professionally trained African artists and sold within the gallery circuit, 'traditional' art made for an indigenous

> We have seen then that the 'tourist' in 'tourist art' is not the crucial distinction that keeps Western authorities from admitting it to the canon. Rather it is the belief that it is cheap, crude, and mass-produced.

community, and 'popular' art that is non-traditional but is also sold to, performed for, or displayed to 'the people'.

To someone only passingly familiar with the African urban scene, this definition might seem to leave only curios – 'airport art' – the carved giraffes and elephants seen in any Woolworth's or in front of any tropical Hilton. In fact it leaves a great deal more, from the ingenious (embroidered helicopters and jewellery from recycled engine parts); to the inevitable (Samburu beaded watchstrap covers), as well as various types of sculpture and painting. But by assigning everything else under one classificatory, and inevitably dismissive, label, Western art museums and galleries cause all other 'unassigned' forms to become invisible, to fall through the canonical sieve. The erasure is as complete as the remaking, on film, of the Icough dance or the Gelede festival.

Conversely, the fact that considerable numbers of tourists buy a type of art does not make it tourist art by current definitions. Osogbo art is sold mainly to tourists and expatriates resident in Nigeria, but because it was canonised as authentic contemporary art back in the 1960s, most writers do not treat it as tourist art.[40] Yoruba *ibeji* figures, originally used to commemorate dead twins, but frequently transformed into art objects in galleries from Abidjan to Nairobi, are also sold

to tourists in great numbers (being small and usually cheaper than masks) but are not considered by anyone to be tourist art. The reasons are different in the two cases. Osogbo art escapes the tourist label by being the work of several individually known artists, each with a recognisable style. The most famous of these, Twins Seven-Seven, was included in the 'Magiciens de la Terre' exhibition in 1989. When he first came to prominence in the 1960s, he received the same extravagant praise and adulation from the art world as Chéri Samba garners today. But what of the host of imitations Twins' work has spawned, each being peddled on the sidewalks of Lagos and Ibadan? Most are lacking in skill and inventiveness, but one or two are almost as good as the work of Twins himself. Is that work tourist art? Neither patronage nor quality seems to be the crucial factor.

In the case of the *ibejis*, this status demotion is avoided by virtue of the artist's intention: they were made to be used by a Yoruba patron in a sacred context. The fact that they are sold to tourists nowadays cannot dislodge their place in the canon. Yet even intentionality is not a reliable test for admission to, or exclusion from, the canon. Let us take the frequently cited case of the Afro-Portuguese ivories. While clearly made for foreign consumption, they suffer no disapprobation and are not classified as tourist art by museums or collectors.[41] For one thing they are precolonial in date and therefore do not fit the view of tourist art as a colonial and postcolonial phenomenon. The antiquarianism of Western museums and collectors strongly predisposes toward their admission to the canon on the basis of age. But there is another, equally important reason: they are technically works of great virtuosity and they are carved from ivory, a material associated with expense and rarity in Western taste. Tourist art is thought to be both crude and cheap. Objects seemingly escape this classification by being old, very expensive, or technically complex.[42]

We have seen then that the 'tourist' in 'tourist art' is not the crucial distinction that keeps Western authorities from admitting it to the canon. Rather it is the belief that it is cheap, crude, and mass-produced. But all African art is cheap, in art market terms, prior to its arrival in the West. Much 'authentic' art is crudely fashioned – Dogon *Kanaga* masks, for example – but this seems no deterrent to its popularity with collectors. And what of mass production? Even a humble curio is hand crafted. Mass production implies the use of standardisation techniques and assembly lines – hardly a description of what goes on in a carvers' co-operative. What the Western connoisseur imagines, with obvious distaste, is a kind of machine-like efficiency, a perception that totally obscures the fact that the working relationship among these carvers is fundamentally no different from, say, that of a group of Yoruba apprentices in an Ife workshop turning out everything from Epa masks to nativity scenes.[43] Even in very large Kamba co-operatives, such as that at Changamwe outside Mombasa, the hundreds of carvers are broken down into separate sheds of a dozen or fewer men who maintain close ties over many years, who train new apprentices, and who may even be relatives from the same village in Ukambani, the Kamba homeland. Within these co-operatives, apprentices learn from, and are permanently indebted to, master carvers in much the same way as

Lawrence Kariuki, the
only Kikuyu member
of the Kamba carving
co-operative, Pumwani,
Nairobi, 1987
Photo: Sidney Kasfir

in the past. The Kamba were not makers of wood sculpture in the precolonial period; they were celebrated as blacksmiths, ivory carvers, and by the late nineteenth century, as beadworkers. Their ability to take up curio carving on a wide scale did not suddenly appear one day out of thin air, but was made possible by their long collective experience as craftsmen.

John Povey's comments on Kamba carvers are typical of the inaccurate way in which carvers' co-operatives are envisioned: 'The conveyor-belt system of their production prevents any suggestion that they can offer career options for local artists. They require factory workers'.[44] There is role specialisation in many co-operatives, which leads to repetition of certain forms in response to consumer demand. On the other hand there are also superior carvers as well as 'hacks' in these groups – not everyone works at the same technical level. This fact is well documented for the Kamba,[45] Asante,[46] Kulebele,[47] and Maconde.[48] Working alongside a young apprentice who carves only spoons may be a master carver such as Lawrence Kariuki (the only Kikuyu member of the Nairobi Kamba co-operative), who may work on the same piece for weeks and carves only on individual commission. But once again, it would appear that the forced anonymity that results from a collective group identity – the 'tribal style' – causes Western critics to lump together the good, the bad, and the indifferent under a single rubric.

Even originality, the *sine qua non* for 'significant' Western art, occurs as frequently in tourist art as in other types. Innovation, after all, is fundamental to a genre that depends upon its novelty for acceptance by the foreign patron. Yet this very inventiveness is found offensive by connoisseurs of African art. Why? Perhaps because it violates the canonical model of a timeless and eventless past. Paula Ben-Amos, in an incisive comparison of tourist art and pidgin languages, argued for another important difference between traditional and tourist arts: a different set of rules for the manipulation of form itself.[49] Whereas precolonial African sculpture was characterised by 'rigid symmetry and frontality', the deviance of tourist art from that norm results in either 'surreal distortion' or a move toward naturalism. The former is often seen as 'grotesque' by connoisseurs of traditional art – a normative judgment based on the preference for the more 'classic', self-contained precolonial styles. This comes down to the problem of taste, an important issue often neglected in the authenticity debate and one that I have treated elsewhere.[50]

Behind and beneath many of the attempts to dismiss the authenticity of so-called tourist art is its inability to resist commodification. No collector wishes to see a piece nearly identical to his or her own in a shop window, since in Western culture there is no prestige (and little investment potential) in owning a thing that is not one-of-a-kind. Spooner calls attention to the 'obsession for distinction' that motivates many collectors of Oriental carpets.[51] Kirschenblatt-Gimblett notes the same problems of commodification in the collection of American folk art and relates this to the Modernist agenda as it is spelled out by the critic Frederic Jameson: 'Modernism conceives of its formal vocation to be the resistance to commodity form, not to be a commodity, to devise an

aesthetic language incapable of offering commodity satisfaction . . . '.[52] It would be difficult not to see the relevance of these arguments to the fears of collectors or to the acquisition policies of art museums.[53]

Maconde sculpture,[54] which since 1959 has been produced in two substyles, one naturalistic (*binadamu*, 'human beings') and one anti-naturalistic (*shetani* or *jini*, 'spirits'), is a perfect illustration of the bifurcation between a precolonial, self-contained symmetry and a postcolonial expressionism. It is routinely rejected by fine art museums and owned mainly by those who do not collect canonical African art.[55] But not all museums are concerned with canonicity. A Maconde collection has been accepted by the Smithsonian's National Museum of Natural History, as testimony to the role played by aesthetics in the processes of cultural change. The ecumenically inclined organisers of 'Magiciens de la Terre' at Centre Pompidou also ignored precedent and included the work of one Maconde sculptor, John Fundi. He is quoted in the catalogue with a single sentence: '*Toutes mes œuvres ont une histoire*'.[56] This storytelling is one more violation of the rules of the canon, since 'traditional' sculpture lacks a narrative character.

Fundi's art is indeed 'grotesque' by the prevailing canon of taste that precolonial art has generated. It is also an act of *bricolage*. What this means is perhaps clearer if we begin with the artist's name, one more 'subversion which creates its own *chiaroscuro*'. In KiSwahili, a *fundi* is an artisan,[57] but the word also carries the connotation of 'one who fixes things'. If my bicycle chain is broken, I take it to the bicycle *fundi*. Also to the point, it may connote a person who has the peculiar skill or talent needed to 'bring things off'.[58] He is the East African equivalent of Claude Lévi-Strauss' *bricoleur*,[59] mending what is broken with whatever materials come to hand. In the Third World, everything useful is collected and recycled: old rubber tyres become sandals, cows' tails become flywhisks, safety pins and zippers become jewellery. This inventiveness, which requires a constant shifting about of means and ends, causes the products of the *fundi's* labour to be constantly in flux.

This habit of mind, making a virtue of necessity, is as true of the woodcarver as it is of the man who repairs bicycles. The first Maconde *shetani* carving is attributed by the carvers themselves to Samaki Likonkoa, who in 1959 was carrying a 'normal' *binadamu* figure to the trader Mohamed Peera in Dar es Salaam when one of its arms was accidentally broken off.[60] Disconsolate, Samaki returned home, where he dreamed that night of his dead father. In his dream, his father instructed him to smooth the broken shoulder socket and gouge out the eyes. It would then represent a bush spirit, a *djinn*.[61]

The fact that none of the Dar es Salaam immigrant Maconde had made a *shetani* before was immaterial, since this was not intended for use within the Maconde community. It would be sold by Peera to anyone who walked into his shop and fancied it. Samaki's act of *bricolage* came to him in a dream in which tradition (his father) sanctioned innovation by relating it back to tradition.

(Bush spirits are an integral part of Maconde belief.) This spiralling off into new forms would have been much more difficult in the precolonial past. But the radically different situation introduced by foreign patronage opened the way for invention. In precolonial art, object, symbol and function have been represented as tightly bound up with each other in a highly structured system, leaving little room for either subverting or extending meanings.[62] But the new genres developed under colonialism (and I include in this category both 'popular' and 'tourist' art) feed upon the fluid, highly situational patronage of the African city, not the more predictable needs of chiefs, age grades, and descent groups. This city is linked in turn to the former colonial centre, with its foreign patrons and exotic culture, and to the villages to which its inhabitants regularly return and from which they draw an important part of their identity.[63]

Paula Ben-Amos marshalled Lévi-Strauss' argument that the semantic function of art tends to disappear in the transition from 'primitive' to modern.[64] In modern art (or more accurately, Renaissance to nineteenth-century European art), it is replaced by a mimetic function. That this has happened in Benin tourist art is clear from Ben Amos' interview with Samson Okungbowa: 'The commemorative head [made by a traditional guild] represents the head of a spirit, not a human being. Its purpose is to instill fear and it is made for a shrine. No one was ever afraid of an ebony head!'. This example likens tourist art (the ebony head) to pidgin languages, Ben-Amos concludes, because in both cases there is a restricted semantic level and a limited range of subject matter.[65]

Questioning these limitations, Bennetta Jules-Rosette has argued that the semiotic content of tourist art does not disappear but only becomes hidden.[66] Although operating in a few standard formats and a more or less 'generic' style of representation, both tourist and popular painting 'use metaphor, metonymy, and allegory to point to an unvoiced layer of meaning that remains implicit in the artist's rendition'.[67] Significantly, the subject here is painting, not sculpture. Painting has a more literary, 'message bearing' character than the plastic arts and is also a greater artifice, collapsing three dimensions onto a flat surface. As such, it is riper for semiotic analysis than sculpture. Building upon the classificatory system of Ilona Szombati-Fabian and Johannes Fabian,[68] Jules-Rosette extends it to include tourist as well as popular art. In her argument, both tourist and popular Zairian (Congolese) painting express collective memory and consciousness through the employment of stereotypic themes such as idyllic landscapes ('things ancestral'), *colonie belge* paintings ('things past'), and scenes of city life ('things present').[69]

An interesting question then is how applicable these categories are to other forms of so-called tourist art. Transferring this typology to Maconde sculpture, one might classify *ujamaa* poles (family trees) and Mama Kimakonde ('Mother of the Makonde', derived from the matrilineal ancestor) as 'things ancestral', the well-known caricatures of Europeans, especially priests, as 'things (of the colonial) past', and genre pieces such as the barber giving a haircut as 'things present'.

Unfortunately, the most innovative sculptures, the *shetani* figures, are too complex to work into

a simple chronological scheme such as this. In a memory frame they represent a qualitatively different dimension, a persistent 'past in the present'. Yet except for the 'things ancestral', they are the most powerful examples of collective memory at work in Maconde sculpture, referring as they do to a set of beliefs about nature spirits, *nnandenga*, embedded in Maconde oral traditions and masquerade performance. At the same time, as *shetani*, they are inventions for a modern audience of foreigners. As effective as this schema is for eliciting the 'messages' of popular and tourist paintings in Zaire (now Democratic Republic of Congo) and Zambia, it requires recasting to fit the problem of Maconde sculpture. The issue of collective memory, I will argue, is crucial in this rethinking, though not in quite the same way as it works for the patrons of Zairian popular painting.

The Maconde carvers of Dar es Salaam and its environs are immigrants from Cabo Delgado province in their Mozambican homeland. They reinvent their culture in the alien landscape of Tanzania, usually in scattered settlements outside Dar and Mtwara. In the early 1970s they still harboured a reputation for fierceness among the local Tanzanians, partly because they chose to live apart and partly because they alone continued to cicatrise their faces and file their teeth: the same acts of cultural inscription that appear on their *mapiko* initiation masks. This high visibility is shared by their *shetani* figures, which deviate so radically from the typical curio shop repertoire. One might say that the uneasiness felt by the Dar es Salaam locals is equivalent to the discomfort of 'proper' art collectors, both of whom see the Maconde as culturally alien to their landscape. How then are we to understand what the Maconde are doing? And why should it be rejected by Western cultural institutions as inauthentic?

My own sense is that they are engaged in a complex renegotiation of Maconde identity, particularly the identity of the artist, in this new cultural setting. It is this that gives *shetani* carvings their 'emergent' quality, identified by Karin Barber as the most distinctive feature of the popular arts (which, ironically, are rejected by fine art museums and collectors for this very reason).[70] In Dar es Salaam the Maconde carvers were at pains to separate themselves from local Zaramo carvers who produced small curios. The Maconde, unlike the Zaramo, could not be commissioned by a trader to produce a certain number of carvings of a certain type in a certain number of days. To the consternation of the traders, they regarded themselves as 'artists', meaning that they made whatever they felt like making that day, week, or month. They would also travel back and forth frequently, crossing the Rovuma River and ascending the Maconde Plateau in northern Mozambique.

This seemingly casual attitude towards carving could not have improved their financial status, since an unpredictable output could only make an already meagre living more precarious. Rather, it had to do with the Maconde carvers' self-perception. Carving is work, but it is also a form of mediation between the old life, still very much alive in collective memory ('We come from Mueda, we all come from Mueda'), and the new one outside the Maconde homeland. Some carvers

continue to make the *mapiko* masks for initiation rituals while fashioning *binadamu* or *shetani* figures for sale to foreigners. There is no overlap in style, content, or clientele between these two types of transactions.

But it would be wrong to conclude, as Vogel has done,[71] that only the *mapiko* masks are authentic cultural expressions. In the artists' eyes, all of their sculptures are equally so: one makes 'what people want', whether in the indigenous or the foreign patronage system.[72] Barber's example of West African bands who record different music for the local and the foreign markets is an excellent analogy.[73] On the one hand, as Jean Comaroff comments, in a situation of contradictory values introduced through radical social change, 'traditional' ritual [or here, art] serves increasingly as a symbol of a lost world of order and control'.[74] But we might also hypothesise that new forms of cultural expression serve to anchor the immigrant's experience in a series of mediations required by the adopted culture and its setting.

The *shetani* carvings do this very successfully because they are in demand by a new clientele and also serve to legitimate a set of beliefs about the Wild that encompass both the old and new homelands. They are 'signs ... disengaged from their former contexts' that 'take on transformed [and visually concrete] meanings in their new associations'.[75] In short, the artist continues to play the role of the *fundi* or the *bricoleur*.

Why this role should be regarded by Western connoisseurs as inauthentic is perhaps because until now, authenticity has been intimately associated with that 'lost world of order and control', but not with any of the cultural renegotiations following that loss. We need first of all to recognise that the precolonial past, seen from the present, is an idealisation for Europeans and Africans alike; second, it is crucial to relocate the notion of authenticity in the minds of those who make art and not those on the other side of the Atlantic Ocean who collect it.

Context is Everything: The Street, the Trader, and the Market

It is not only in museum displays and in the houses of connoisseurs that the meanings of African art are reinvented. Until now, I have focused on the contemporary artist and the collector. But unless we consider the intermediary in this transaction, the description is incomplete in an important way. In two seminal essays and his book *African Art in Transit* (1994), Christopher Steiner has drawn attention to the mediation of knowledge by traders in African art,[76] using as his example the Hausa, Mande, and Wolof traders in Côte d'Ivoire. I will attempt to expand this world to encompass their counterparts in Nairobi.

Unlike most cities in West Africa, Nairobi is awash with tourists every day of the year.[77] It has many more boutiques and galleries than one finds in a typical West African capital, and these exist at every rung of the economic ladder. Most noticeably, there is almost as much West African and Zairian (Congolese) art for sale in Nairobi as there is art emanating from Kenya, Tanzania, Uganda,

and Ethiopia. Yet these are surface differences: underneath, the same principles apply as in Abidjan, Douala, or Kano. The dealer, whether a Kamba market trader, a Gujarati shopkeeper, or an expatriate gallery owner, plays the same role in framing, contextualising, and authenticating the artifacts on sale.

For example, a brisk business exists in Maconde sculpture as well as in copies of it. The Maconde do not live in Kenya, but it is still profitable to take their work across the Kenyan-Tanzanian border from Dar es Salaam. First, there is the fully-fledged gallery treatment given to major works by established Maconde sculptors. These are displayed in isolation under spotlights and authenticated by stories about origin myths concerning the image of Mama Kimakonde, the 'first woman'.[78] As with Zairian painting, sellers understand that the storytelling aspect of the figure is important to Western buyers. As a result, ingenious hagiographies of this or that *shetani* abound ('the *shetani* who causes road accidents', 'the *shetani* who lurks in the pit latrine and causes dysentery', etc.). Everyone is satisfied: the gallery owner makes his sale, the buyer feels she has bought an authentic artifact, and the Maconde carver is allowed to keep his own cultural knowledge to himself. There is also an active book market for Maconde sculpture. Its inventiveness knows no bounds, and every year the pile of romanticised fiction (mainly by German authors) written about the Maconde grows a little higher.

While a practised eye can tell the difference, street hawkers in both Nairobi and Mombasa manage to sell 'Maconde' carvings that are made by non-Maconde carvers working in the industrial area of the two cities. Various hardwoods can be made to look like ebony by a judicious application of black shoe polish. (The Maconde themselves do not use these other woods, but ebony is scarcer in Kenya than in Tanzania.) Smaller in scale and price and more clearly commodified, these are often the 'Maconde' carvings that make their way to American department stores. All of these marketing strategies correspond closely to Steiner's observations on the presentation, description, and alteration of objects by Ivorian traders.[79]

Not only Maconde and pseudo-Maconde sculpture but other popular artifacts can be purchased, on a sliding price and quality scale, in galleries or boutiques near the large international hotels, from *dukawallahs* (petty traders) in small Indian shops near the city centre, in the city market or in one of the nearby overflow markets, and finally from street hawkers. Between the sidewalk entrepreneur and the well-appointed boutique or gallery there may be a ten-fold difference in price. But technical quality will vary too, because boutiques are willing to pay artists more than a street hawker would. For example, Maasai women from the Ngong hills outside Nairobi go to the city once a week to sell their beaded neck rings and ear pendants. First, they take their work to Alan Donovan's African Heritage Gallery where his buyer will evaluate it and purchase only the best pieces. What is left over is then taken to street vendors, who will pay considerably less for it (and sell it for less). Finally the women visit Lalji and Sons, the trade-bead shop that has been in business on

Biashara Street since the early 1900s. Here, they stock up on bead supplies for the coming week and return to Ngong.[80]

Inside African Heritage, a combination of sophisticated marketing techniques and superior-quality merchandise makes it an irresistible beacon for both collectors of ethnic jewellery and collectors of art.[81] Original designs by Angela Fisher,[82] as well as new and old pieces of Maasai, Samburu, Rendille and Turkana beadwork are sold in an ambience of authenticity and casual chic. Mijikenda grave markers sprout in the garden beside the coffeeshop. West African sculpture, from the strictly canonical (Yoruba *ibejis*) to the recently invented (large Akan masks), graces another section. Decorated gourds and intricately woven baskets mediate the art/craft boundary. Upstairs there are batik shifts and safari clothes. Like a Ralph Lauren advertisement, African Heritage evokes the quintessentially Kenyan Settler/Hunter style of Karen Blixen or Denys Finch-Hatton. It reminds us that objects have the ability to create personalities for their owners, not just for their makers. And no one is more aware of this than the trader. Not only is the Maasai woman renegotiating her own identity as an artist by selling her work to a boutique, but the woman buying and subsequently wearing it is also inventing a new persona for herself. That the Maasai make subtle differentiations in the colours and patterns of things made for strangers versus those made for each other does not matter here. What is salient is the playing out of new identities on both sides.

In the none-too-distant past (say, fifteen years ago) it would have been claimed that both of these renegotiations were culturally spurious and that only a Maasai woman making beadwork for herself and other Maasai could lay claim to cultural authenticity: anything else would be an illustration of the cultural 'decay and death' theme that inevitably follows colonial contact.[83] But this nomadic jewellery, now much in demand, coexists simultaneously in four or five distinct cultural settings in Nairobi alone. Unlike precolonial African sculpture, which migrated over time from cabinet of curiosities to natural history museum to fine art museum with accompanying changes of status, we can, on the same day, see all of this and more. Beginning at the ethnographic gallery of the National Museum in Nairobi, we may view Maasai or Samburu beadwork displayed as part of a standard 'natural history' functionalist array with gourds, spears, and the like. Near the front entrance, the museum shop does a brisk business in pastoralist jewellery, especially earrings, as souvenirs. At African Heritage, we may see not only this same work being sold as aesthetic objects but also (on Tuesday mornings) the Maasai women selling it to the buyer and at the same time wearing it themselves. Or the artifacts may be seen on dancers performing at the Nairobi tourist village, Bomas of Kenya. Finally, bookshops all over Nairobi sell Tepilit Ole Saitoti and Carol Beckwith's *Maasai,* Mirella Ricciardi's *Vanishing Africa*, Angela Fisher's *Africa Adorned*, Mohamed Amin's *Last of the Maasai*, and Nigel Pavitt's *Samburu*, in which photographs of the same objects and their wearers are now recast as evocations of a vanishing 'golden land'.[84] (In fact, we recognise that coffee-table books such as these are the twentieth century's 'cabinets of curiosities'.)

Each of these realities – functional artifact, art object, souvenir, article of dress, and body art refracted through the lens of the camera – exists simultaneously in a dialogic relationship to the others, each with its own fragment of the truth.

But the ultimate artifacts in this freeze-frame view are the Maasai themselves. In 1987 one enterprising Mombasa curio shop employed a Maasai *moran* (warrior), resplendent in all his finery, to stroll about the premises and attract potential buyers. Tourism itself is a form of collecting, and taking photographs its most aggressive act of appropriation. The Kenyan parliament finally felt impelled to pass a law forbidding tourists to take pictures of Maasai, a self-defensive act analogous to those taken by tribal councils much earlier in the American Southwest. But where is the 'authentic' Maasai culture in all this? As with the Maconde *shetani* carvings, if we shift the locus of authenticity to the minds of the makers and not the collectors, the issue must be recast. The *moran* in the curio shop is real; he is neither David Byrne playing at being a mambo king,[85] nor the folkloric 'Indian' of cigar-selling days. He has lived in cattle camps and been initiated with his age group into *moran*-hood, which does not normally include wage employment. But perhaps he needs money for school fees or to pay a fine. By the act of standing outside the curio shop he has become, in effect, a living sign of himself.[86]

I began with the questions of who creates meaning for African art and what determines its cultural authenticity. In one sense they are rhetorical, because we already suspect the answer. If 'tourist art', the lowest common denominator of what is thought by Westerners to be inauthentic in African art, can be deconstructed in ways that make the definition of authenticity full of self-contradictions, then the same kinds of questions can be asked even more readily about other non-canonical categories such as 'elite' or 'international' art. Now, in the closing years of the twentieth century, it is perhaps time to bring the canon into better alignment with the corpus, with what African artists actually make, and to leave behind a rather myopic classificatory system based so heavily on an Africa of the mind.

Notes

1 Roland Barthes, *The Pleasure of the Text*, trans. Richard Miller (New York: Hill & Wang, 1975), p. 32.

2 William Rubin (ed.), *'Primitivism' in Modern Art: Affinity of the Tribal and the Modern*, vols. I and II (New York: Museum of Modern Art, 1984).

3 Rasheed Araeen, 'Our Bauhaus, Others' Mudhouse', *Third Text*, no. 6 (London: Spring 1989), pp. 3–14; James Clifford, *The Predicament of Culture* (Cambridge: Harvard University Press, 1988); Thomas McEvilley, 'Doctor Lawyer Indian Chief', *Artforum* (New York: November 1984), p. 59; McEvilley, 'Marginalia', *Artforum* (New York: March 1990), pp. 19–21; Yves Michaud, 'Doctor Explorer Chief Curator', *Third Text*, no. 6 (London: Spring 1989), pp. 83–88.

4 A partial exception to this is the contemporary art exhibition 'Africa Explores', organised by Susan Vogel for The Center for African Art in New York. I have tried to address the somewhat different problems raised by this exhibition in another article, 'Taste and Distaste: The Loaded Canon of New African Art', *Transition*, vol. 2, no. 3, issue 57 (Cambridge, MA: Oxford University Press, 1992), pp. 52-70.

5 Chinweizu, *The West and the Rest of Us* (New York: Nok Publishers, 1978).

6 See especially the symposium in *African Arts*, vol. 9, no. 3 (Los Angeles: 1976).

7 Adam Kuper, *The Invention of Primitive Society* (London: Routledge, 1988).

8 William Fagg and John Pemberton III, *Yoruba Scupture of West Africa* (New York: Alfred A. Knopf, 1982).

9 An important recent study by Walter E. A. van Beek, 'Dogon Restudied: A Field Evaluation of the Work of Marcel Griaule', *Current Anthropology*, vol. 32, no. 2 (Chicago: April 1991) pp. 139–67, attempts to return the Dogon to the same universe as other Sudanic West African cultures.

10 Seen in Gramscian terms, the giving of such gifts simply underscores the hegemonic relationship of the coloniser over the colonised.

11 P. Amaury Talbot, *Peoples of Southern Nigeria*, vol. 3 (London: Oxford University Press, 1926), pp. 788–89.

12 Sidney L. Kasfir, 'Celebrating Male Aggression: The Idoma Oglinye Masquerade', in Sidney L. Kasfir (ed.), *West African Masks and Cultural Systems* (Tervuren: Musée Royal de L'Afrique Centrale, 1988).

13 George Kubler, *The Shape of Time: Remarks on the History of Things* (New Haven: Yale University Press, 1962), pp. 84–96.

14 Jan Vansina, *African Art History: An Introduction to Method* (New York: Longman, 1984), p. 2.

15 Diaspora studies are of course the exception. Here, change is the *sine qua non* of aesthetic activity of all kinds and is thought to be axiomatic.

16 Kasfir, 'One Tribe, One Style? Paradigms in the Histiography of African Art', *History in Africa*, no. 11 (Waltham, MA: 1984), pp. 163-93; Sally Price, 'Our Art, their Art', *Third Text*, no. 6 (London: Spring 1989), pp. 65–72.

17 Kasfir, *op. cit.*; Kasfir, 'Apprentices and Entrepreneurs', in Christopher Roy (ed.), *Iowa Studies in African Art*, vol. 2 (Iowa City: 1987), pp. 25–47.

18 Fagg and Pemberton, *op. cit.*, pp. 35.

19 Daniel Biebuyck, *Tradition and Creativity in Tribal Art* (Berkeley: University of California Press, 1969), p. 7. Anonymity is an issue on which scholars (who in most cases have done field-collecting themselves) tend to part company with dealers and collectors, who are far from homogeneous on either side of the Atlantic. A number of American collectors take pains to discover the authorship of pieces they own, while the conversations Sally Price

reports would seem to reflect a more European (and more romantic) sensibility toward the art of 'exotic' people.

20 Price, *op. cit.*, p. 69.

21 *Ibid.*, p. 70.

22 Price quotes the well-known dealer Henri Kamer, who makes this point precisely: 'The object made in Africa . . . only becomes an object of art on its arrival in Europe', (*ibid.*, p. 70).

23 Brian Spooner, 'Weavers and Dealers: The Authenticity of an Oriental Carpet', in Arjun Appadurai (ed.), *The Social Life of Things* (Cambridge: Cambridge Univeristy Press, 1986), pp. 199, 222.

24 The problem is historical as well as sociological: the idea of 'being Yoruba' as a commonly held cultural identity dates only from the nineteenth century. See Michel R. Doortmont, 'The Invention of the Yorubas: Regional and Pan-African Nationalism Versus Ethnic Provincialism', in P. F. de Moraes Farias and Karin Barber (eds.), *Self-Assertion and Brokerage: Early Cultural Nationalism in West Africa* (Birmingham: Birmingham University African Studies Series 2, 1990) p. 102.

25 Herbert M. Cole, *et al.*, 'Fakes, Fakers, and Fakery: Authenticity in African Art', *African Arts*, vol. 9, no. 1 (Los Angeles: 1976), pp. 20–31, 48–74.

26 Harry R. Silver, 'Calculating Risks: The Socioeconomic Foundations of Aesthetic Innovation in an Ashanti Carving Community', paper presented at the 23rd Annual Meeting of the African Studies Association, Philadelphia, 1980; Doran H. Ross and Raphael Reichert, 'A Modern Kumase Workshop', in Doran H. Ross and Timothy F. Garrard (eds.), *Akan Transformations* (Los Angeles: UCLA Museum of Cultural History, 1983).

27 My own fieldwork was based on many Idoma, a few Tiv, Afo, and other carvers in Nigeria, Maconde immigrant carvers from Mozambique in Tanzania, and Kamba carvers in Kenya; all support the Asante data.

28 Silver, *op. cit.*, p.6.

29 Susan Vogel, *et al.*, *Africa Explores: 20th Century African Art* (New York: The Center for African Art, 1991), p. 50.

30 Because Nigeria has an antiquities law and considerable illegal trafficking in sculpture, 'antiquity' has become the pidgin term for any artifact that changes hands illegally.

31 Charles Keil, *Tiv Song* (Chicago: University of Chicago Press, 1979), pp. 249–50.

32 *Ibid.*, p. 250 (emphasis added).

33 Henry John Drewal and Margaret Thompson Drewal, *Gelede* (Bloomington: Indiana University Press, 1983).

34 McEvilley, *op. cit.*

35 Barbara Kirschenblatt-Gimblett, 'Objects of Ethnography', in Ivan Karp and Steven Lavine (eds.), *Exhibiting Cultures* (Washington DC: Smithsonian Press, 1991), pp. 389–90.

36 James Clifford, *The Predicament of Culture* (Cambridge: Harvard University Press, 1988), p. 226–29.

37 Jacques Maquet, 'Art by Metamorphosis', *African Arts*, vol. 12, no. 4 (Los Angeles: 1979), p. 32.

38 Clifford, *op. cit.*, pp. 227–28.

39 Maquet, *The Aesthetic Experience: An Anthropologist Looks at the Visual Arts* (New Haven: Yale University Press, 1987), p.15.

40 The Nigerian art historian Babatunde Lawal formerly argued that it was, but once again, this was an attempt to deny its authenticity.

41 They were included, for example, in the exhibition 'Circa 1492' (1992), a show intended to display masterworks from around the world, at the National Gallery in Washington.

42 A parallel example is the intricately carved Chinese ivory puzzles intended for the export trade but now seen as works of art in their own right.

43 Kasfir, 'Apprentices and Entrepreneurs', *op. cit.*

44 John Povey, 'The African Artist in a Traditional Society', *Ba Shiru*, vol. 11, no. 1 (Madison, WI: 1980), p. 5.

45 Bennetta Jules-Rosette, 'Aesthetics and Market Demand: The Structure of the Tourist Art Market in Three African Settings', *African Studies Review*, vol. 19, no. 1 (Waltham, MA:1986), pp. 41–59.

46 Silver, *op. cit.*

47 Dolores Richter, *Art, Economics and Change* (La Jolla: Psych/Graphic Publishers, 1980).

48 Kasfir, 'Patronage and Maconde Carvers', *African Arts*, vol. 13, no. 3 (Los Angeles: 1980), pp. 67–70, 91.

49 Paula Ben-Amos, 'Pidgin Languages and Tourist Arts', *Studies in the Anthropology of Visual Communication*, vol. 4, no. 2 (1977), pp. 130, 132.

50 Kasfir, 'Taste and Distaste', *op. cit.*.

51 Spooner, *op. cit.*, p. 200.

52 Barbara Kirschenblatt-Gimblett, 'Mistaken Dichotemies', *Journal of American Folklore*, vol. 101, no. 400, (Bloomington, IN: April-June 1988), p. 148.

53 For an incisive treatment of the issue of collectors and commodification in African art, see K. Anthony Appiah's review of *Perspectives: Angles on African Art* (exhibition catalogue, The Center for African Art, New York, 1987), in *Critical Inquiry*, no. 17 (Chicago: Winter 1991), pp. 338–42.

54 I use the spelling 'Maconde' to differentiate the immigrant Mozambican carvers from the indigenous Tanzanian Makonde whose cultural production is distinct and who are only marginally involved in the carving profession.

55 The typical collectors of Maconde sculpture are academics and journalists, people who cannot easily afford to collect 'traditional' African art. Thus there is a class distinction implicit in the purchase and display of an accepted canon on the one hand and 'tourist art' on the other. The latter is much cheaper to own.

56 'All my works have a story'; *Magiciens de la terre*, exhibition catalogue (Paris: Centre Pompidou, 1989), p. 137.

57 In Dar es Salaam the dominant language is KiSwahili. The KiMakonde term is *puundi*. See J. A. R. Wembah-Rashid, *Makonde Art: The Mask and Masked Dance Tradition* (Nairobi: Institute of African Studies, University of Nairobi, 1989), p. 5.

58 I am grateful to Allen Roberts for this second meaning. East African and Zairian usage appear to be similar, though not identical, on this point. See also Roberts' discussion of *bricolage* in his article, 'Chance Encounters, Ironic Collage', in *African Arts*, vol. 25, no. 2 (Los Angeles: April 1992), pp. 54-63, 97-98.

59 Claude Lévi-Strauss, *The Savage Mind* (*La Pensée sauvage*) (London: Weidenfeld & Nicholson, 1966), p. 16ff.

60 Kasfir, 'Patronage and Maconde Carvers', *op. cit.*

61 *Jini*, or *shetani* in KiSwahili.

62 See for example Lévi-Strauss, *op. cit.*, p. 26. The formulation is necessary to Lévi-Strauss' argument, but is overdrawn. As I indicated earlier, this sense of 'oneness' about precolonial art is as much a Western predisposition to idealise Primitive Society as it is an observable fact.

63 I am grateful to my colleague David Brown for urging me to re-examine the concept of *bricolage* in this context. 'John Fundi' was of course a happy coincidence. For a treatment of *bricolage* in an Afro-Cuban Diaspora context, see Brown's description of the self-conscious cultural style of *los negros curros* in early nineteenth-century Havana, 'Garden in the Machine: Afro-Cuban Sacred Art and Performance in Urban New Jersey and New York', Ph.D. dissertation, Yale University, 1989, pp. 35–38.

64 Ben-Amos, *op. cit.*, p. 131.

65 *Ibid.*, p. 129.

66 Bennetta Jules-Rosette, 'What is "Popular"? The Relationship Between Zairan Popular and Tourist

Paintings', (paper presented at the Workshop on Popular Urban Paintings from Zaire, Smithsonian Institute, Washington DC, 1987), p. 3; 'Rethinking the Popular Arts in Africa', (commentary), *African Studies Review*, vol. 30, no. 3 (Waltham, MA: 1987), p. 93.

67 Jules-Rosette, 'What is "Popular"?', *op. cit.*, p. 3.

68 Ilona Szombati-Fabian and Johannes Fabian, 'Art, History and Society: Popular Painting in Shaba, Zaire', *Studies in the Anthropology of Visual Communication*, vol. 3, no. 1 (1976), pp. 1–21.

69 Jules-Rosette, *op. cit.*, p. 4.

70 Karin Barber, 'Popular Arts in Africa', *African Studies Review*, vol. 30, no. 3 (Waltham, MA: 1987), pp. 1–78. Barber's typology does not demote tourist art to a liminal category but refers to it as commercially motivated popular art, 'produced but not consumed by the people', (p. 26).

71 Vogel, *et al., op. cit.*, pp. 41–42, 238.

72 Vogel herself makes this point earlier in the same text (p. 50). Part of the difficulty is that very few art historians have done field interviews with those who make tourist art.

73 Barber, *op. cit.*, p. 27.

74 Jean Comaroff, *Body of Power, Spirit of Resistance* (Chicago: University of Chicago Press, 1985), p. 119.

75 *Ibid.*, p. 119.

76 Christopher B. Steiner, 'African Art in Movement: Traders, Networks and Objects in the West African Art Market', in *Discussion Papers in the Humanities*, no. 3 (Boston: Boston University African Studies Center, 1989); Steiner, 'Worlds Together, Worlds Apart: The Mediation of Knowledge by Traders in African Art', paper presented at the 32nd Annual Meeting of the African Studies Association, Atlanta, 1989. See also, Steiner, *African Art in Transit* (Cambridge: Cambridge University Press, 1994).

77 Tourism has now replaced coffee as the major source of foreign exchange earnings.

78 Although this story has been published several times, I was never able to find a Maconde carver who had any knowledge of it.

79 Steiner, 'Worlds Together, Worlds Apart', *op. cit.*, p. 3.

80 I am grateful to Maasai art specialist Donna Klumpp for numerous insights concerning the bead trade in Nairobi, and to Melania Kasfir, who was then a secondary-school student, for helping me to trace the Ngong-Nairobi bead circle outlined by Klumpp. Since the original publication of this article, Lalji and Sons has ceased to trade in beads, but their former competitors continue to operate.

81 Donovan is in a position to do both very well: he is trained in marketing and is also a field collector and connoisseur of pastoralist arts. See his essay 'Turkana Functional Art', *African Arts*, vol. 21, no. 3 (Los Angeles: 1988), pp. 44–47.

82 Author of *Africa Adorned* (New York: Abrams Publishers, 1984).

83 The parallel debate in folklore studies ('folklore versus fakelore') engaged many of the same issues, though the battle-lines were drawn somewhat differently, between purists and popularisers rather than their texts. See Richard M. Dorson, *Folklore and Fakelore* (Cambridge: Harvard University Press, 1976), pp. 1–29.

84 Tepilit Ole Saitoti, *Maasai*, with photographs by Carol Beckwith (London: Elm Tree, 1980); Mirella Ricciardi, *Vanishing Africa* (London: William Collins, 1971); Angela Fisher, *op. cit.*; Mohamed Amin et al., *Last of the Maasai* (London: Bodley Head, 1987); Nigel Pavitt, *Samburu* (London: Kyle Cathie, 1991).

85 Donald J. Cosentino, 'First Word', *African Arts*, vol. 23, no. 2 (Los Angeles: 1990), p. 1.

86 For a discussion of the same phenomenon in the sponsored cultural festival, see Kirschenblatt-Gimblett, 'Objects of Ethnography', *op. cit.*, p. 388.

In Vogue, or The Flavour of the Month:
The New Way to Wear Black

John Picton

*Jungle Fever: international socialite 'Johnny' Pigozzi collects houses, celebrities, kitsch –
and now, with characteristic enthusiasm, African art.* Andrew Graham Dixon [1]

I

'The New Way to Wear Black' was a major theme of British *Vogue* in October 1992. Any connection
between this and the article, 'Jungle Fever', about the art collector 'Johnny' Pigozzi and the
forthcoming Saatchi Gallery exhibition 'Out of Africa' was entirely coincidental. At any rate, judging
from this article, Susan Vogel, curator of the controversial, 'Africa Explores', held the year before at
the Center for African Art in New York, could at last breathe a sigh of relief: 'Johnny' Pigozzi was now
the person we could all love to hate.

Jean-Christophe Pigozzi is said to have the largest collection of contemporary African art in the
world. 'I am fascinated by people who have no training ... What I find interesting about these African
artists is that they are very intelligent but they have no training and the results are, well, remarkable
– a kind of pure self-expression'.[2]

Perhaps we can allow him the latter-day mythologising; but whether or not his collection is the
largest – and it may well be – just what does it represent if artists who have been 'trained' are
excluded by virtue of that training? Now, from one point of view anyone, Pigozzi included, is free to
collect as s/he chooses, all other things being equal. A collector can follow his/her own particular
interests where a curator must in some sense represent a more collective view of things. Some
years ago, Josef Herman, for example, put together a collection of African 'miniatures'; from his
point of view, that such a category does not exist, beyond the fact that many African sculptures are
little, does not matter. He can collect things on the basis of small size if he wants to. More recently,
Peter Adler has been collecting southern Ghanaian flags; many of them were in an exhibition at
the South Bank Centre, London, in November and December 1992; as before, if he wants to collect
textiles he can. Jean-Christophe Pigozzi, however, is no mere collector. He claims to be 'an
ambassador for Africa'[3] and that puts matters, including the issue of his taste in African art,
in a very different light. He has, it seems, appropriated to himself an authority as representative and
mediator. As Andrew Graham-Dixon wrote: 'The benefits of his interest to the artists who have been
granted his patronage should not be underestimated, but the danger is that his own, idiosyncratic
taste may acquire something like institutional force, that it may be taken for the truth about the
artistic activity of a continent'.[4]

II

In 1961 I was appointed to the staff of the Department of Antiquities of the Federal Government
of Nigeria, taking up the appointment as curator of the Lagos Museum in June of that year.
My qualifications for the post were a not-very-good degree in anthropology, and five months

working as a part-time assistant to William Fagg, the authority on African art at the British Museum. Whether I was qualified for this work, I leave others to judge. Personally, I was grateful for what was my first full-time professional appointment, and it was within the first year of Independence, a time of extraordinary hope, expectation and exuberance.

The purpose of the Lagos Museum was the preservation, documentation and display of the art traditions of Nigeria – not the new forms of practice that had emerged in the developments of the present century, but the archaeological and the 'ethnographical'. With such a small professional staff – eight senior officers in all – and local dealers with little conscience about ripping off their own cultural heritage for the profits to be made, this concentration was perhaps inevitable. Of course, living in Lagos one could hardly be unaware of all the new developments in art, just as one soon met Ulli Beier whose critical writing was so important in the Nigerian art world of the time. Ulli was living, still with Suzanne Wenger, in Oshogbo, and their house was always open and hospitable. Oshogbo was one of those places one had to visit in any case on account of the great forest grove beside the river dedicated to Oshun. The river was, indeed, her veritable icon and the grove was empty of any artifact and adornment except for a small temple built according to the traditions of Yoruba architecture. This too, was without ornament other than the black, white and red stripes painted along the pillars supporting the veranda roof. Now, I had a degree in anthropology, I had worked at the British Museum, I had read a book or two on the subject, and I thought that this little temple was a rather fine example of 'traditional' architecture, not spectacular, but worth attending to. But it was in a condition of disrepair: pillars had collapsed and termites were eating the roofing timbers. I wanted to help, so I asked Suzanne Wenger if she knew people who could repair and restore it, and how much it would cost. The answer was that it could be done for £25. I then obtained permission from my head of department, Bernard Fagg, younger brother of William, to advance £25 to Suzanne, and the work commenced. Some weeks later, I heard that the job was done and I went to see it.

I called round to the house first and found Ulli who said I must go and see what they had done: it was absolutely wonderful. We went together; but when I saw it my first thought was 'I hope Bernard Fagg never sees this'. I made rather more approving noises to Ulli, whose friendship I valued and whose knowledge and experience of Yoruba culture was infinitely greater than mine. The building had been repaired, but the previously aniconic temple and grove was now a riot of figurative sculpture and ornament. The pillars of the temple were all figurated in a manner completely 'untraditional'. The grove itself had sprouted cement sculptures at the bases of the important trees, and beside the river. The walls around the grove were covered in relief imagery.

Apparently, the work had been almost completed when one of the plasterers moulded a face in the cement used to protect the earthern pillars of the temple, and either Ulli or Suzanne had suggested they do some more. Sculpture and figurative embellishment were as new to these plasterers as they were to anyone else; but having effected this transformation of the grove and

its little temple they went on to create sculptural embellishments in cement elsewhere in the town. Although many people find the Oshogbo developments problematic – and whatever our assessment we should not forget that there are several Nigerian artists who owe their living to Oshogbo – this episode is worth noting for precisely the reason that in my ethnographical wisdom I had made the mistake of reckoning without the people to whom, in some sense, the place belonged.

III

In 1989, twenty-eight years later, I was attending a conference on African art in Washington DC, and during a break for lunch, I suggested to a group of Africanist curators that they should collect works of the kind to which we gave the not-very-satisfactory label 'contemporary African art' (contemporary with what?) Their response was: how do we know if it's any good?

It's all very well to laugh, but the question does require an answer. If a curator is to steer a path between buying nothing – a sign of meanness? – and buying everything – a sign of madness? – a choice has to be made, and judgement exercised. Yet the response of that group of curators seemed to betray an astonishing lack of self-confidence, especially in view of the privileged role of the curator in shaping public taste (all the more so given the European art-historical placing of Africa in relation to Primitivism/Modernism; and where would Picasso have been without Kahnweiler?) More importantly, it displayed not only an unwillingness to trust one's own judgement in the matter of art, but also an unwillingness to open one's eyes and ears to local taste, and to the discourse of artists and critics themselves. I had learnt some kind of lesson in the grove of Oshun, and now I found myself with others still making essentially that same mistake of reckoning without the people to whom the visual arts of Africa belong.

IV

Among the most obvious things about postcolonial Africa is that there are a lot of artists producing a lot of art. Moreover, the volume, detail and complexity of the locally available data makes it possible to place discourse about art in Africa in some sense in the same dimension as discourse about art in Europe. I do realise, of course, that a simple quantitative assessment does not get us very far, and that the fact that one might begin to write an African art history in a manner something like a European art history may or may not be a good thing; and of course I am not ignoring the possibilities of distinctive African models of art-historical practice. In any case, it becomes ever more difficult to consider Africa as a single entity. In each country, artists find themselves with distinctive agendas. Senegal, Egypt, Ethiopia, Zimbabwe, South Africa – especially South Africa – each has a very different art history.

These things are disconcerting for an Africanist art studies establishment, dominated by a tradition of thinking, seeing and writing in terms of the functionalist generalities of a

pre-Independence anthropology. The problem here is not with anthropology, which has moved on over the past thirty years, nor with a functionalist perspective, which is essentially about the inter-relatedness of things. But a slipshod functionalism remains a conceptual ghost still to be fully exorcised from the literature of African art. As I have argued elsewhere [5] – and the argument is now in any case commonplace – the anthropology of the colonial period promoted a way of writing about Africa characterised as the Ethnographical Present. This, in effect, denies both history and contemporary reality while encouraging the invention of a 'traditional' Africa that privileges certain social, ritual and visual practices at the expense of others.

It appears that people in Africa can never win, for if they remain attached to the traditions of the past, they are innocent and exotic, and if they move into the present, they are merely foolish. The problem here is not with the notion of tradition, from the Latin *tradidere*, to hand on/hand over, for the handing on of practices and expectations is an inevitable and necessary part of social life. On the other hand, a local sense of what is 'traditional' can serve to legitimate the maintenance of practices on the basis of past performance, and to deny history other than as a sequence of repetitions of essentially the same practices, whatever their temporal status might be.

V

In recent years, several publications have discussed the developments in art in Africa in the twentieth century, sometimes as accompaniments to exhibitions. They include: *Ethnic and Tourist Arts* by Nelson Graburn, 1976; *20th Century Art of Africa* by Kojo Fosu, 1986; *Magiciens de la Terre* by Jean-Hubert Martin *et al.*, 1989; *Contemporary African Artists*, 1990; *Fusion: West African Artists at the Venice Biennale* by Thomas McEvilley, 1990; *Africa Explores* by Susan Vogel *et al.*, 1991; *Africa Today* by André Magnin *et al.*, 1991 and *Out of Africa*, Saatchi Gallery, London, 1992, both accompanying exhibitions drawn from the collection of Jean-Christophe Pigozzi.[6] Each of these claims to represent Africa in different ways from, for example, three first-rate exhibitions of the same period: 'Chéri Samba' (Institute of Contemporary Arts, London, 1991), 'Art from South Africa' (Museum of Modern Art, Oxford, 1990) or 'The Other Story' (Hayward Gallery, London, 1989).

In addition to Africa, Nelson Graburn also attempts to represent the rest of what he calls the 'Fourth World' (by which he means minority populations dominated by more powerful cultural orders). When his book first came out, it seemed an interesting text. He wanted us to understand the various developments in terms of two variables, or functional co-ordinates: whether the style was internal or external to the dominated minority; and whether the patrons were internal or external to the minority. Bearing in mind the possibilities of forms and styles that were a synthesis of internal and external, this allowed for a six-part categorisation. He admitted that the categorisation could not be accurate, and that some forms might belong in more than one. Graburn's categories now only really have their uses in a teaching environment, as something to

argue against. In any case, an essential fault with this form of analysis is that any kind of internal/external paradigm is simply unworkable: just where, for example, do we place the institutional and private collectors of art in Nigeria?

Admittedly, there was a time, around 1960, when the greater part of available patronage was expatriate. Some artists preferred to keep their paintings themselves rather than sell them to expatriate collectors, who were likely to take them out of the country; but this is no longer the case. With the construction of the Independence Building at the western end of the Lagos racecourse, and its use of work by Nigerian artists, a revolution in patronage was instituted, the fruits of which can be seen all over Lagos and throughout Nigeria. There are several public and private collections, and there are Nigerian professional art brokers. Perhaps this patronage is still not enough; perhaps it never will be enough; but both state and individual patronage are evident for all to see. Sometimes, though, one's seeing can be misconstrued, as, for example, Cosentino's reference to 'Yoruboid Pharaohs',[7] which are, in fact, relief sculptures on the Lagos Independence building by Felix Idubor, a non-Yoruba sculptor.

The more serious objection, however, is that the artist in such an arrangement seems only

This is what I call the Jack-in-the-Box syndrome: the artist is thrust in a certain category, ready to jump out and dance only when the art historian springs the catch.

to exist as a function of categories that cannot take account of the fact that he/she is an agent acting not just within, but equally upon, his/her social environment. This is what I call the Jack-in-the-Box syndrome: the artist is thrust in a certain category, ready to jump out and dance only when the art historian springs the catch.

In contrast, Kojo Fosu gives us a brief but, in principle, encyclopaedic account of artists across the continent from one country to another, beginning with the earliest pioneers, notably Aina Onabolu (1882–1963).[8] It is not a definitive account, but that is not a point of criticism, not least because no account will ever be definitive; but it does matter that he begins with people rather than *a priori* boxes.

Grace Stanislaus, who was responsible for the Harlem 'Contemporary African Artists' exhibition and text, while deliberately more selective in choosing to exhibit a mere half-dozen artists, nevertheless included work from several countries across sub-Saharan Africa. Indeed, with essays by Wole Soyinka, dele jegede and herself, her catalogue seems to me to be the most instructive introductory text on this particular matter in Africanist art-historical study.

A comparison of approaches might be in order, even if what I have to say next may seem unfair;

and I realise that neither one, two nor three swallows make a summer, and that between Graburn and Stanislaus some fifteen years had elapsed; but the contrast between Graburn (and, as we shall see, Vogel, both European-American) on the one hand, and Fosu (Ghanaian) and Stanislaus (African-American) on the other, could hardly be more striking. For whereas Graburn tells about categories, within which he constitutes the artists, Fosu and Stansilaus tell us about the artists. Make of that what you will.

VI

As to 'Magiciens de la Terre', enough ink has been spilled across the pages of *Third Text* on that subject. Maybe there is more to be written, but not by me. I wish only to take up one small point. As we all know, the selection was bizarre, juxtaposing artists such as Francesco Clemente, Anselm Kiefer and Richard Long with Sossou Amidou, Kane Kwei and Chéri Samba. These are, of course, all interesting artists, the Europeans no less than the Africans, and at least the selectors might seem to have begun with the artist; except that as we all equally know, there was a categorisation operating in the selection of, for example, a mask carver, a coffin maker and a sign painter as representative of Africa. In effect, there was a wholesale writing-off of the achievements of artists in every country in Africa. Whether the selectors were naïve or high-handed, the effect is astonishing in serving to legitimate only one small part of contemporary visual culture in Africa. 'Africa Today' and 'Out of Africa', of course, continued this particular line of curatorial authority, again taking the self-taught artist as the paradigm of creative authenticity; and as these exhibitions derive from Pigozzi's wish to buy up all the African material in 'Magiciens de la Terre', hiring the relevant curator, André Magnin, to collect for him when this was not possible, this comes as no surprise. In the catalogue of 'Out of Africa', André Magnin writes: 'I have deliberately chosen artists I think are among the most original and representative of contemporary sub-Saharan creators'.[9] We remember of course, that Magnin is responsible for informing Jean-Christophe Pigozzi's taste for 'people who have no training'.

One might be tempted to ask who really cares what André Magnin thinks, except that, for some people, his thoughts might serve to animate a (one-sided) legitimacy. Infinitely more important are the matters of patronage, evaluation and criticism, and their relationship to the production of artworks. Of course, some artists are working for a largely expatriate patronage (including André Magnin's), and that needs to be exposed for what it is, for better or worse, and I am certainly not denying the right to earn a living by art; but there is a patronage, an evaluation and a criticism within the countries of Africa that is not predetermined by an expatriate presence. André Magnin tells us nothing about that.

It hardly needs saying that the continued rejection of the art academy as a legitimate institution in the making of art is, in effect, the legitimation of a re-invented Primitivism. In any case,

a trained/untrained paradigm will not withstand close scrutiny; for among the ironies of all this, of course, is the fact that it was a self-taught artist, Aina Onabolu, who campaigned for the institution of formal art education in colonial Africa.

VII

Susan Vogel seemed to annoy everyone with her 'Africa Explores' exhibition. The New York art press almost unanimously condemned it; a group of visiting curators from Africa were said not to like it much either: it was confused, did not address any obvious issues, and it juxtaposed in an uncritical manner self-taught sign painters and professionally trained artists to the detriment of the latter. This art was not up to the quality of work produced within the older traditions. These criticisms were, each in its own way, true enough; and yet they missed the point, which (for me) was the sheer value of having this material on display, whatever Susan Vogel had done with it. So I thoroughly enjoyed it – not because it was beyond criticism, not because all the lessons had been learned, but because there were old friends and new among the works on display and it was good to see them. It was ambitious, and there were problems arising from the relatively small size of the Center for African Art on East 68th Street, and the division of the exhibition between the Center and the New Art Gallery in downtown Manhattan. (The Center has now moved downtown to more substantial premises and calls itself a Museum.) It was rather like seeing a series of apparently unconnected snapshots taken across the face of an immense building and displayed without the help of any key to how they might fit; or like a few unjoined pieces of an enormous jig-saw puzzle; and people were puzzled. Susan Vogel had built up a justifiable reputation for first-rate exhibitions with a clear thematic focus; but insofar as there was a coherent thematic structure to the exhibition and its accompanying text, it was that the developments of the twentieth century could be considered in terms of five 'strains'.

I have written at length elsewhere about this exhibition and its catalogue,[10] but further criticisms are relevant here. In the catalogue to 'Africa Explores', Susan Vogel writes:

> 'Africa Explores' seeks to focus on Africa . . . Western perceptions of Africa . . . are entirely secondary here . . . My working procedure began with looking at hundreds of paintings, sculptures, photographs and objects of all kinds, and with reading or listening to as many African artists and critics as possible . . . Five loosely defined strains emerged that run through this century. Though the strains themselves are clearly distinguishable and describable, they converge and overlap at times, and individual artists occasionally move from one to another . . .[11]

The 'strains' themselves were: Traditional, New Functional, Urban, International and Extinct [sic]. I have argued elsewhere that their definition reveals a conceptualisation of Africa based upon the following paradigms: Africa/Europe, craft/art, functional/aesthetic, traditional/contemporary,

rural/urban. I do not intend to repeat that discussion here beyond insisting that as a structure of ideas with which to comprehend twentieth-century and post-Independence Africa, this is empirically and intellectually untenable. Nevertheless, by manipulating rural/urban contrasts in regard to form and patronage, this paradigm serves to enable the invention of a set of Graburn-like categories ('strains'); but whereas Graburn has six 'plus extinction', Susan Vogel has four plus 'extinct'. Vogel continues:

> This book is organised according to these strains, which should be considered conceptual tools rather than sequential or developmental phases, for they provide not a history of twentieth-century African art but an interpretation of it. Nor are they rigid or exclusive, since it is clear that some artists and some works can pass from one strain to another, and rarely is a trait limited to only one category.[12]

The term 'category' turns out to be unavoidable; and 'strains' are categories. But, much as we might try to keep Jack in his box, things and people will keep jumping from one category to another. Here, the implication is that the categories are not simply metaphorical, but have a real, material existence, and, moreover, that they existed before things and people. There are several problems here.

Firstly, this discussion is reminiscent of a hundred and one others, across the pages of books, catalogues (whether academic museum or sale-room) and accession registers. In other words, discussions as to tribal attribution: this feature is shared by that 'tribe' and others; here is an object that crosses boundaries; does it belong to this 'tribe' or another? But just when reputable scholars have ceased to accept the 'tribal' boundary as a social and historical reality, once again we are presented with ready-made categories into which things and people have to be fitted. There is a marked analogy between the categorical forms and procedures of both Nelson Graburn and Susan Vogel, on the one hand, and the tribal classifications that characterise the proto-history of African art studies on the other.

Second, it must be insisted upon that the problems are not with categories as such. Categories are an indelible part of human life, without which there is no art, no language and no society. The relationships between categories of people and categories of things, between aesthetic and social categories, are nothing if not complex, and we do inherit knowledge and practice that presuppose categories and their inter-relationship. The problem here is essentially with the specific categories that these commentators have employed.

Third, therefore, the very fact that Susan Vogel describes her 'strains' as an interpretation of history suggests that, far from being categories that emerged within the processes of social life, they are a means that she has developed in her attempt to understand what is happening in Africa.

Uzo Egonu
Will Knowledge
Safeguard Freedom?
No. 8, 1988
Oil on canvas
168 x 244 cm
Private Collection
Photo: Hiltrud Egonu

She later describes 'Africa Explores' as a 'working proposal . . . that invites elaboration and improvement'. In other words, they have merely provisional status (which indeed is true of all explanatory theories). The question, then, is: whose categories are they? And the answer is, of course, Vogel's, just as the interpretation of history that 'Africa Explores' gives us is also hers.

Fourth, we are warned at the outset that things and people can jump from one 'strain' to another; but does this not suggest that their usefulness as categories is to be questioned? Perhaps there are other categories and 'strains' that might be more stable. The essential problem here, I would suggest, is that neither the categories themselves, not the paradigm contrasts that underpin them, have their origins in the lives of the people whose things are the subject matter of 'Africa Explores'. In that case, no matter how provisional one might insist them to be, their maintenance is nevertheless a cart-before-the-horse fiction. Moreover, Vogel's insistence on reiterating these categories throughout the book is one of its most irritating features. Indeed, had she simply omitted the introduction, and deleted all reference to her 'strains', she could have released her discussion from the straitjacket they impose. It would have liberated several interesting discussions: for example, her suggestion that in the contesting of colonial rule, one available strategy was for local people to connive at the invention of a 'traditional' Africa as a means of contesting European authority by asserting an identity that could not be over-ruled.

Fifth, an interpretation of history on the basis of 'strains' that are, in effect, granted pan-African status, suggests, at least by implication, that across Africa, art produced within each category, and artists working – or boxed – within each category will manifest some essential similarity. The best one can say about that is that it is not proven, much as it sounds like a version of the 'unanimism' rejected by Paulin Hountondji, Kwame Anthony Appiah, and others.

Of course there are distinct functional complexes in the sense that the mask carver, the fancy coffin maker, the sign painter, and the 'Fine Art' painter are each working within particular traditions and institutions of practice, but we lack the detailed studies of such practices that might enable a comparative discussion on any basis other than the most superficial. In any case, as already noted above, different countries have different art histories, which might suggest that before we compare glass painters in Senegal with sign painters in Zaire (both considered together in Vogel's 'Urban' category), we might consider Senegalese glass painters in relation to the Ecole de Dakar. Moreover, we have little to go on by way of studies of local patronage, criticism, and evaluation.

It is perhaps for this reason that Vogel is able to write on page sixteen of 'Africa Explores': 'Visual links between current and past African art are surprisingly hard to find'. As I have remarked elsewhere, it all depends where you are. In South Africa, local tradition was hijacked by apartheid and this fact alone renders that tradition unavailable to artists in the culture of resistance. In Nigeria, on the other hand, artists are very conscious of their inheritance from the past. In any case, the links do not have to be visual; if Bruce Onobrakpeya illustrates a folk tale about a tortoise and a hare,

he is certainly creating continuity between past and present. The fact that in the past the folk tale may not have received visual form does not represent lack of continuity, but suggests that the visual is not the only medium of that continuity. Moreover, there are all manner of indigenous, functional networks of patronage, production and evaluation, and artists do address common themes across these networks and institutions, but we shall never see any of this as long as we put artists into ready-made curatorial boxes.

VIII

The last time I was in Nigeria, I spent time in Ibadan and in Lagos, among other places. After an absence of eight years I was struck by how much art there was about in schools, banks, office blocks and other public buildings. In Lagos I was able to visit the national collection of contemporary art housed at the National Theatre. Also in Lagos, Jankara market was full of the most astonishingly varied hand-woven textiles, combining all manner of textures and colours. In Ibadan, mural and sign painting was in evidence everywhere. I was surprised to find that the kind of art popularised by Ulli Beier in the 1960s as urban/popular/naïve/commercial was still in evidence. However, in contrast to the stereotypes about this kind of art (that it is self-taught, and so forth) it was evident that sign-painting was produced within several traditions of practice. For instance, close to the entrance to the campus of Ibadan University was the workshop of Sola Olusola, who once did an apprenticeship in the Mokonla area of Ibadan. He now had his own apprentice, and although there was not so much work, it filled his stomach. Panels surrounding the workshop displayed his skill and gave evidence of his abilities as an artist. Is he 'any good'? (Remember the Africanist curators.) I have no idea, and with so little documentation to hand, the question hardly matters. Certainly I am not in any position to comment on local opinion of Olusola's work; but its formal characteristics set it apart from the imagery and execution of a Chéri Samba, and my guess is that he is not the kind of artist who would have been chosen by Susan Vogel, and definitely not by André Magnin.

Olusola's work provides evidence of the kind of selectivity that, for reasons that are never really made clear, promotes the work of some artists at the expense of others. As with other forms of categorisation, selectivity may not be wrong in itself: it depends on who is making the selection, and the circumstances in which it is made. If that selectivity is based on local criteria of value, it is only proper that these should be made known, and a detailed study of public art in a city like Ibadan would be extraordinarily valuable. It would also be a step along the way towards a position in which it would no longer be possible for anyone to gain an audience for generalities of the kind that introduce and underpin 'Africa Explores', or the neo-primitivist exoticism, the new way to wear 'black', reinvented by André Magnin for 'Johnny' Pigozzi.

Notes

1 *Vogue* (London, October 1992), p.209.
2 *Ibid.*, p.212.
3 *Ibid.*.
4. *Ibid.*.
5 John Picton, 'Transformations of the Artifact', in
 Clementine Deliss (ed.), *Lotte or the Transformation of
 the Object*, exhibition catalogue (Graz: Kunstverein,
 1990), John Picton, 'Technology, Tradition and Lurex', in
 *History, Design and Craft in West African Strip-woven
 Cloth* (Washington DC: Smithsonian Institution, 1992).
6 Nelson Graburn, *Ethnic and Tourist Arts* (Berkeley:
 University of California Press, 1976); Kojo Fosu, *20th
 Century Art of Africa* (Zaria: Gaskiya Corporation, 1986);
 Jean Hubert Martin, *et al.*, *Magiciens de la Terre*
 (Magicians of the Earth), exhibition catalogue (Paris:
 Centre Pompidou, 1989); *Contemporary African Artists*,
 exhibition catalogue (New York: Studio Museum, Harlem,
 1990); Thomas McEvilley, *Fusion: West African Artists at
 the Venice Biennale* (New York: Museum for African Art,
 1993; Susan Vogel, *et al.*, *Africa Explores*, exhibition
 catalogue (New York: The Center for African Art, 1991);
 André Magnin, *et al.*, *Africa Hoy* (Africa Today), works
 from the collection of Jean-Christophe Pigozzi (Las
 Palmas de Gran Canaria: Centro Atlántico de Arte
 Moderno, 1991); *Out of Africa*, exhibition catalogue
 (London: Saatchi Gallery, 1992).
7 In Vogel, *et al.*, *op. cit.*, p.251.
8 Kojo Fosu, *op. cit.*
9 André Magnin, *op cit.*
10 John Picton, 'Desperately Seeking Africa, New York,
 1991', in *Oxford Art Journal*, vol.15, no. 2 (Oxford: 1992)
 pp. 104–112.
11 Vogel, *et al.*, *op. cit.*, pp. 9–10.
12 *Ibid.*, pp. 11–12.

History

Negritude: Between Mask and Flag – Senegalese Cultural Ideology and the Ecole de Dakar

Ima Ebong

'Che Guevara', Laboratoire
Agit-Art, 1994
Photo: Elizabeth Harney

Taking, means . . . being taken: thus it is not enough to try to free oneself by repeating proclamations and denials. Frantz Fanon [1]

In the centre of Dakar, five minutes' walk east from the Presidential Palace and five minutes' walk west from a notorious street of prostitutes and pickpockets called Boulevard Pompidou, is a rundown little compound owned by a Senegalese artist and writer called Issa Samb. It is filled with an incongruous array of artworks, objects once used as props for a performance-art group and now lying scattered in various stages of decay. In some ways, these objects are a collection of clues to the formation of contemporary art in Senegal.

One of them is a simple construction hanging from a tree: a mask bound by a rope, like an unsevered umbilical cord, to a flagpole that bears a weathered Senegalese flag. The mask appears as an ironic simulation of antiquity; the wood-and-fibre detritus that hangs precariously from it heightens its ethnographic effect, its ancestral pose.

What can be understood by this pairing: the Senegalese flag, a symbol of the modern nation, and the mask, more than any other artifact a signifier of traditional African culture? Perhaps this is a commentary on the ambiguous, often tense relationship between the homogenising impulses of the nation and the traditional cultures that African governments try to use to shape their own image. The dangling rope that connects the two objects suggests that the alliance between them is tenuous.

This assemblage is a particularly appropriate paradigm in the case of Senegal, where the postcolonial state has tried to develop a culture that incorporates the modern and the traditional, the political and the poetic, the hiding and the hidden, the flag and the mask. Since Senegal's Independence, state ideology has attempted to define contemporary African culture by the concept of 'Negritude'. And Negritude became the national discourse that decided which groups and individuals in the arts were considered mainstream and which were marginal.

I want to explore the cultural ideology of Negritude as a force shaping contemporary art in Senegal. My emphasis will be on the Ecole de Dakar,[2] a generation of Senegalese artists whose proximity to former President Léopold Sédar Senghor, and to his cultural theories, earned them the name 'Negritude painters'.[3] I am interested not so much in a history of the school, as in a description of a particular, unstable space within the Senegalese cultural mainstream, and of the lateral shifts and adjustments within it.

It is impossible to discuss contemporary art in Senegal without invoking the name of Senghor, a major architect of the philosophy of Negritude and, in his various roles as art patron, poet, cultural promoter, politician and President of Senegal from 1960 to 1980, a man of unparalleled impact on the country.[4] His position as president, especially, allowed Senghor legitimately to transgress the boundaries between culture and politics, strategically aligning the former to serve

the interests of the latter. His ability to negotiate the space between art and culture, and to occupy various positions in both, has had important implications for contemporary Senegalese art, which, from its inception, was incorporated into a national agenda. Even before Senegal's Independence, in 1960, Senghor emphasised the functional aspect of the arts, promoting a kind of 'development aesthetic' that could support the economic and social agenda of the arriving nation. In the foreword to *Cultural Policy in Senegal* (1973), Alioune Sene, then Senegal's Minister of Culture, explicitly sets out the state's position:

> Under the vigilant care and inspiring influence of Senegal's leader, our research workers
> are busy evolving a style that will express the Negro-African conception of modern social life.
> Public buildings, private houses and housing developments will, in their turn, soon bear
> witness to African man through the grace of a supremely eloquent art. This confirms that,
> in Negritude, art in the general sense of the word is functional and part and parcel of the living
> day-by-day reality of things . . . Faithful therein to the teaching of the founders and theorists
> of Negritude, Senegal believes that culture is not an adjunct of politics but its pre-condition
> and justification.[5]

The idea of 'the rehabilitation of Africa', the underlying agenda of Senghorian Negritude,[6] began to develop a practical edge in Senghor's writing after 1950. His desire to translate his theoretical concepts into pragmatic terms derived in part from his growing participation in the political machinations of pre-Independence Senegal, and from his subsequent rise to the presidency. It was when he attained this dual role as cultural broker and president that Negritude began to achieve the status of a national aesthetic, transgressing its boundaries as Senghor's own personal philosophy, to inhabit a more public space as the 'cultural constitution' of the nation.

Assimilating: The Art and Craft of Negritude

Senghor used various forums – exhibition openings, art publications, speeches on special occasions – to shape and promote his vision of Negritude as cultural policy.[7] When he directly addressed artistic issues, his views often had a prescriptive edge; the tone of his writing was didactic. He liked to provide examples linking key concepts of Negritude to modern art. Two contrasting views of art emerge in Senghor's writings. First, he believed that artists should shape an identity faithful to their cultural environment – faithful to African ancestral traditions and to traditional art. On the other hand, he also felt that artists should be open to influences of different kinds, and he used the term 'assimilation' to express the pragmatic way in which Western cultural values could be accommodated.

In Senghor's address *Picasso en Nigritié*, which he gave to mark the opening of a Pablo Picasso

exhibition at the Musée Dynamique, Dakar, in April 1972, we get a sense of the kind of aesthetic he envisioned for Senegalese art and the Ecole de Dakar. He began by asking the rhetorical question, *pourquoi Picasso en Nigritié?* He then proceeded to answer with a skilful and systematic re-reading of Picasso's formal achievements through key concepts of Negritude. Senghor prefaced his remarks with the comment. 'No artist could be more exemplary. He is a model for the School of Dakar, and his closeness to us here is a rich inspiration'.[8] He continued with an analysis of Picasso, taking off from the ethnically based concept of identity on which rested Negritude itself. Situating the artist within the ethnic mix of Mediterranean culture, Senghor discussed Picasso not within the framework of the formal aesthetic of European Modernism but in terms of the artist's Andalusian heritage. Somewhat didactically, he noted, 'Here, then, is the first lesson of Picasso: the necessary faithfulness of the artist – and, finally, of the writer – to his surrounding milieu, to his country, his region. In a word, his rootedness in the earth'.[9] The statement reflects the importance Senghor attached to cultural specificity, and the role he believed it played in developing a national consciousness. On this he was most emphatic.

Senghor also discussed Picasso's formal achievements within a broad, ethnically determined complex: the artist's use of 'archetypal images' drawn from his Mediterranean heritage, with its myths, fables, gods, and heroes. To Senghor, Picasso's use of symbols, and the form and content of his work in general, owed much to his assimilation of a variety of specific cultural forms. A controversial description of traits said to be inherently African – rhythm and emotion, for example, supposedly the bases of an African system of knowledge – provided the foundation for Senghor's elaboration of the influence of African art and sculpture on Picasso. Of Picasso's rhythm he noted:

[It] is the opposite of monotony. It is not the simple repetition of an element: of a sound, of a word, of a plastic phrase, I want to say of a form . . . That is to say that it is also a rhythm of contrasts and of oppositions, of dissonances and of 'counter-rhymes', in short, a rhythm that is dynamic, 'living' even in sculpture, which is the immobile face of figuration.[10]

Senghor's preoccupation with ethnicity and cultural identity is particularly apparent in his conclusion:

In a word, the Andalusian artist teaches us Arab-Berbers and black Africans that there is certainly no art without the active assimilation of input from abroad, but above all that there is no original spirit without rootedness in the originary earth, without fidelity to one's ethnicity – I don't say to one's race, but to one's national culture.[11]

Senghor's efforts to promote Negritude as a viable aesthetic of cultural nationalism are of crucial importance to the modern-day arts in Senegal. Negritude served as a frame of reference for the Ecole de Dakar, helping to resolve questions of identity by providing ready-made, authenticated symbolic forms, and an interpretative vocabulary for them, that articulated an African world view. Senghor's tactical ability to merge the formal language of European Modernist abstraction with the values of Negritude, as well as his revisionist reading of traditional African art through the achievements of Modernist painters like Picasso, opened the way for a strategy of reappropriation that at least on a formal level resolved the dialectic between modernity and tradition in African art. He made it clear that the absorption of Western values need not come only at the expense of traditional African ones. In addition, Senghor's concept of assimilation through various panethnic affiliations (among Berber-Arab, black African, Mediterranean, and Indo-European ethnic groups), allowed for a global concept of Negritude as an African world view.

In many ways, however, Negritude was limited as an aesthetic, not only by its valorisation of ancestral African art forms, but by its abstract characterisation of the values it imagined as inherently African – values such as intuition, emotion, rhythm, and vital force. These values were to be realised through a specific formalist agenda, calculated to accommodate the metaphysical dimension claimed for them. Negritude also seemed to function as a litmus test, measuring any art's ability to fulfil Senghor's requirements for a national culture. In this way, Senghor effectively narrowed the Ecole de Dakar's aesthetic options to a tightly prescribed formal and ideological zone.

Almost all of the Ecole de Dakar artists attended Senegal's main art school, the Ecole Nationale des Beaux Arts in Dakar. They were linked by their cosmopolitanism, their participation in local and international art institutions, rather than by any consciously unified stylistic programme or theoretical position. Yet most of these artists explored an abstract, non-mimetic kind of figuration, a 'semi-abstraction'. Masks, imaginary spirits, wildlife, traditional artifacts, generic urban scenes, landscapes, rural life and ritual, traditional mythology and folktales – these are the themes and motifs that have dominated the paintings of the Ecole de Dakar since the 1960s. Together, they form an idealised inventory of the nation's heritage, partially reworked in the modernising language of paint on canvas. It is true that this ambiguous aesthetic convention has often allowed for highly individual formal solutions. All fall, however, within the restrictive framework of Senghor's demands for an 'African' art.

Ibou Diouf, Bacary Dieme, Samba Balde, and Boubacar Coulibaly may exemplify for us the varied treatment of such ethnographic material as masks and traditional sculpture in the Ecole de Dakar. All of these painters attended the Ecole Nationale des Beaux Arts in the 1960s – during the peak of nationalist sentiment, in other words, just after Senegal's Independence. The subjects of both Diouf's *Untitled* (1965), a portrait of a lady, and Dieme's *Water Carrier* (1970s), are tightly integrated into a network of forms that intersect with those of traditional sculpture.

Iba N'Diaye
Juan de Pareja Menaced by the Dogs, 1986
Oil on canvas
163 x 130 cm
Collection of Nadine and Raoul Lehuard
Courtesy the artist

Viyé Diba
Géometrie Vitale, 1993
(installation view)
Acrylic on wood,
cotton cloth
120 x 114 cm
Courtesy Elizabeth
Harney, New York
University

In Diouf's portrait, the naturalistic elements of the figure are reduced to fit the curvilinear forms of a mask. The incorporation of elements of traditional sculpture testifies to the 'African' identity of this otherwise anonymous abstract portrait. In the work of many Ecole de Dakar artists, traditional masks and other ethnographic material secures an affiliation with a past heritage. Ancestral subjects, annexed to the modernising language of European abstraction, serve as the foundation of a new cultural identity. For the artists, the challenge seems to have lain in devising formal strategies that would retain the authority of a traditional identity while at the same time modifying it to accommodate more individualised artistic agendas. Diouf's extravagant combination of colour and abstract pattern introduces other formal possibilities to the static mask portrait.

Likewise, in Dieme's *Water Carrier*, the spare outlines of figures and gourds are overlaid with geometric and symbolic forms and patterns that reinforce a traditional African identity. The allover patterning – which recalls African textiles – and the strong graphic design give this painting a decorative quality. Elongated arms and legs distort the figures; Dieme virtually reinterprets the human form, making it yield to his symbolic language and the mannerism of his formal design.

Similar forms and patterns appear in Coulibaly's *Rencontre des masques* (Meeting of Masks, 1976), once again evoking an African identity. In this painting, the traditional sculpture of a variety of peoples expresses an idealised common heritage. Ecole de Dakar artists in general quote freely from a mix of ethnic groups, but the gesture is more symbolic than truly investigative of specific regional artifacts. Ethnographic material also serves as a structural support for contemporary designs. Here, traditional shapes fuse with invented forms, creating a variety of improvised abstract patterns and designs. The Expressionistic surface of the canvas – a thickly worked impasto coupled with a rich mix of colour – completes Coulibaly's reinterpretation of traditional sculpture.

The eight red curvilinear strips placed against a green background in Samba Balde's painting *Masque* (1974) are inspired by a traditional *chi wara* antelope head-dress. Balde's updated shorthand version of the *chi wara* pushes the codes of recognisability governing the Ecole de Dakar's use of traditional African themes as far as possible. The ambiguity between modern abstraction and traditional African sculptural form reveals an awkward moment in which rediscovery of a past occurs through the modernist present. For the artist, however, the authority of the traditional prevails, the painting's title, *Masque*, ensuring its ancestral affiliation.

Despite the inventiveness of works like these, the reworking of ethnographic material in the two-dimensional language of abstraction was in the end a constraint: it limited the imagination of the artist to formal variations arranged around a specific subject or theme. Attempts to broaden the thematic vocabulary can be seen in Amadou Seck's *Homme oiseau* (Bird-man, 1978) and in Cherif Thiam's *De la réalité au mystère* (From Reality to Mystery, 1977). Here, the artists use traditional myths and legends as a basis for their own repertoire of fantastic creatures.

The binary structure of Thiam's *De la réalité au mystère* reflects a tension between representational and abstract imagery: the bottom half of this sufficiently realistic ink drawing of a reptilian creature, which recalls Surrealist imagery, gives way to two triangular forms that appear to be its wings, filled in with a strange arrangement of circular and geometric shapes. Perhaps in a reflection of the artist's assertion of creative control, the distinctions between reality and fantasy are subverted by odd patterns and curvilinear forms that unexpectedly cohere into recognisable features.

The parallels between Senghor's concept of Negritude and the themes and formal structures of most of the Ecole de Dakar artists suggest the ideological dominance of Negritude as a national aesthetic. The individuality of these artists' work was contained within a system of signification that ultimately referred back to Senghor's idealisation of African culture. A famous exhortation of the former President reflects his ambitions for art within his optimistic panorama of a national culture of Senegal:

> *Art nègre* saves us from despair, uplifts us in our task of economic and social development
> in our stubborn will to live. These are our poets, our storytellers and novelists, our singers
> and dancers, our painters and sculptors, our musicians. Whether they paint violent mystical
> abstractions or the noble elegance of the courts of love, whether they sculpt the national
> lion or strange monsters, whether they dance the development plan or sing the diversification
> of the crops, African artists. Senegalese artists of today, help us live for today better and
> more fully.[12]

Economic support from the state, a major patron of the arts, was of enormous consequence to the Ecole de Dakar. The government bought artworks not only for its own collection but also to decorate its offices and embassies. This economic dependence on the state set further limits on these artists' exploitation of the creative options open to them. Indeed, artworks under state ownership often functioned as instruments of diplomacy: art and artists were seen as ambassadors for the ideals of a modern progressive African state.

'A New Art for a New Nation': Building a Cultural Infrastructure

Senghor's prescriptions for the role of art in the framework of national development were implemented in an intensive build-up of cultural capital during the 1960s and 1970s.

One cannot over-emphasise the role of government-funded cultural institutions in fostering the national consciousness during this period. Important examples were the Sorano National Theatre, which housed Senegal's dance and music schools; the Institut Fondamental Artistique National, a research faculty devoted to the collection of ethnographic and other such material;

the Musée Dynamique, created to house contemporary art; the National Gallery, a temporary exhibition space for artists; and the Ecole Nationale des Beaux Arts, devoted to the teaching of painting, sculpture, film, and art education.

The decision to establish a national school of art was made in 1960, the same year in which Senegal seceded from its federation with Mali and formally established itself as an independent state. Located in Dakar, the Ecole Nationale des Beaux Arts, as it is called today, has turned out a cadre of academically trained professional artists and art educators. It is the primary degree-granting arts institution in the country.

Since it opened, the school has undergone a number of adjustments, reflected in its many changes of name and in the development of its curriculum and departments. From early on, it has taught music, dance and drama, along with the fine arts. As was common in Africa, the original educational programme at the school replicated that of French art schools, and its diplomas were recognised as equivalent to the French *Certificat d'aptitude à la formation artistique supérieure*.[13] The curriculum included drawing from plaster models, still life and anatomy drawing, perspective, abstraction, painting, and sculpture. In addition, a liberal-arts programme provided general courses in the humanities, including African and Western art history. It would be a mistake, however, to assume that the Senegalese *école* was simply a reproduction of the colonial original. Senghor's interest in the school, and his belief in the role of art in the development of a national consciousness, made the institution an important agency for the realisation of his cultural plan, especially in the 1960s. The objective, much as in his Negritude theory, was to take existing colonial structures and to graft onto them values more in line with the aspirations of a newly created African nation.

Among the earliest and perhaps most important appointments to the school were two of Senegal's best-known artists, Papa Ibra Tall and Iba N'Diaye, both of whom Senghor invited to head departments in the fine arts. The unusual need for two quite separate fine-arts departments underscores the anxiety among intellectuals over the structuring of a postcolonial aesthetic. In many ways, each department reflected the philosophies and aesthetic concerns of its directors. N'Diaye had attended the Ecole des Beaux Arts in Paris, and had studied under the sculptors Zadkine and, at the Grande Chaumière, Yves Brayer. He was known for his analytic construction of semi-abstract forms. As a teacher, he wanted his students to be technically accomplished and to have a familiarity with, and a command of, both classical and modern elements of Western art. As an artist, he was resolutely independent and something of an individualist, with a healthy scepticism about the advocacy of a uniquely African aesthetic.

Tall, whose department was known as the Recherches Plastiques Nègres, had also been educated in Paris, at the Ecole Spéciale d'Architecture, and later studied comparative education in Sèvres. In many respects, Tall shared Senghor's concern with establishing a theoretical

foundation for the practice of contemporary art. Unlike N'Diaye's, his department was noted for its work in exploring materials and techniques consistent with an 'African' frame of reference. An interest in the intuitive, the subconscious and the spontaneous was reflected in the abstract art created by many of his department's pupils.

Senghor himself took great interest in the Recherches Plastique Négres, personally recruiting Pierre Lods, the Belgian art teacher and founder of the Poto-Poto art school in the Congo, to assist Tall in the department: 'I heard about Pierre Lods' work and decided to include him in Senegal's cultural politics in the field of Fine Arts'.[14] Senghor's seemingly straightforward comment belies the irony of employing the Belgian Lods to help African artists invent an authentically African style of contemporary painting. Lods' somewhat exoticising belief in the innate creative talents of Africans, mixed with his quasi-Surrealist faith in creativity propelled by intuition, seemed to provide a counterbalance to Tall's more theoretical, less liberal views.

The Limits of Flag and Mask

The artists of the Ecole de Dakar were in an unusual position of privilege, receiving official patronage and institutional support from the state. Catalogues and exhibition statements described their work as giving meaning to the state, and as late as 1989, in his introduction to the Frankfurt Museum für Völkerkunde publication *Anthology of Contemporary Fine Arts in Senegal,* Senghor described artists as 'ambassadors of their country', or, alternatively, as public proof of the government's progressive tendencies, reminding us that 'as patron of the artists since Independence, the role of the state, which has bestowed more than twenty-five percent of its budget for education and culture, should not be forgotten'. In many ways these artists were a new 'performative subject' – a new kind of Senegalese individual in a new social role.

The fictional ethnographic repertoire of the Ecole de Dakar, coupled with the state's appropriation of the works these artists made, aligned the school with an official, largely a historical national space in which artists were generally unable to reflect on or adjust to social and political change. The departure of Senghor as President in 1980 revealed the privileged position he had accorded to artists as somewhat fragile: the images and identities that artists had produced in support of the national cultural policy were now understood as surplus signs, no longer affordable under the new spirit of economic and political pragmatism, and impossible to reconcile ideologically with the reality of life after Senghor. Indeed, it seemed by the 1980s that the historical importance of the work of the Ecole de Dakar had been exhausted.

Issa Samb, noting the tenuous position of artists in present-day Senegal, frames an implicit critique of the conservatism of the Ecole de Dakar. To Samb, the commitment of these artists to purely formal concerns contributed to their co-option as accessories in the narrative of Negritude:

The Ecole de Dakar, in the fringe that calls itself apolitical, has shown no participatory or courageous action in social matters. On the contrary: the school deceitfully tries to work both sides. This is dangerous because it convokes Negritude but allows itself to be used by the reigning political current.

These painters are actually absent from the places where things are decided upon. They are no longer involved in an intellectual struggle alongside the novelists, the poets and the scientists. Formerly the state's pampered children, most of them are simply floating in the wake of a political idea. They are torn between the image the public has of them and the call of the spirit of painting . . . This ambiguous situation is the symptom, as painful as it is obvious, of the contempt for every effort of investigation, and for any type of art independent of the state.[15]

Two incidents in the 1980s reveal the declining status of artists and of the state-sponsored cultural institutions after Senghor's departure. In 1983, artists were dramatically expelled from the Village des Arts, a cluster of old colonial buildings granted to them as studios and living quarters by the Senghor government. The artists tried to negotiate with the new government to stay in the village, but their efforts were in vain and they were evicted. In an open confrontation, police dealt with the artists sternly; their paintings, sculptures, and other personal possessions were carelessly thrown into a heap. The site was then turned over to the ascendant ministries for technical administration, water supply, and tourism.[16]

A second incident involved the Musée Dynamique, a pristine, colonnaded building overlooking the sea, which many considered a symbol of the Senghor government's commitment to cultural renewal and one of the architectural highlights of the first World Festival of Pan-African Arts of 1966. Twenty-two years later, in 1988, the museum held its last exhibition.[17] It was closed after prolonged negotiations between museum officials, Senghor's successor President Abdou Diouf, and the Department of Justice, which needed a new building and wanted the museum as its site. The museum's archives – two decade's worth of material – were moved to warehouses on the outskirts of Dakar.

Laboratoire AGIT-Art

Of the recent attempts to expand the boundaries of artistic discourse in Senegal, the work of the Laboratoire AGIT-art is among the most innovative. This group of Dakar-based artists includes painters, writers, filmmakers, and musicians, many of whose careers span the two decades between the idealistic cultural nationalism of the 1960s and the more pragmatic spirit of the 1980s. Laboratoire AGIT-art has attempted nothing less than a reshaping of both the language of Senegalese art and the terms on which artistic production occurs in that country today. Like the Ecole de Dakar, the group engages aspects of Western modernism, but it concerns itself

**Issa Samb, Laboratoire
Agit-Art, 1994
Photo: Elizabeth Harney**

with the conceptual ideologies of the avant garde rather than with modernist formalism. Its tactics of provocation and agitation, in keeping with its name, suggest a connection with the Western anti-art performance aesthetic. These artists work outside the government-sponsored system of galleries and museums, distancing their collaborative creations from the painting on canvas, an art form subject to a deeply rooted system of commodity control. The interiorised, individualistic works of the Ecole de Dakar, with their overdependence on formal solutions, were ultimately subordinated to the cultural apparatus created to contain them. By focusing on the impermanent, contingent character of performance art, the AGIT-art group hopes to evade the existing cultural system and to become more autonomous in the process. Here, art objects function as stage props, and are clearly secondary to the conceptual aspect of the performance. In this context, the art object functions as a didactic tool, discarded after the performance as a mere footnote to the event.

The found and ready-made objects scattered around the Laboratoire AGIT-art compound – for it is this compound with which I began my discussion – indicate the oppositional framework within which the group works. The compound's kaleidoscope of variegated stuff provides a strong contrast with the carefully finished products of the Ecole de Dakar. The cultivation of an anti-aesthetic extends to the surroundings: this is not a display space like a gallery, but rather a 'laboratory', a place concerned with process rather than product, an open forum for the development of concepts and ideas. The space itself reflects the group's flexibility and its ethic of contingency, for it doubles as a multi-family home. It is an outdoor living room, a laundry, and a playground in which children scramble among the debris of artworks/stage props indiscriminately piled up alongside firewood and scrap paper.

Tacked to the cement walls of the compound are weathered cloth backdrops covered with hand-written notes, photographs, fragments of terracotta sculpture and painted images. Inscribed on these cloths are references to Gandhi, France and its role in Senegal's colonial past, Soweto, Lenin, Che Guevara and Nelson Mandela. This appropriation and mixture of local symbols with icons and political imagery from a diversity of sources reflects the Laboratoire AGIT-art group's attempt to expand artistic activity beyond the formal conventions of Ecole de Dakar. Strewn over tables and chairs are weathered Senegalese flags. Here stands a flag trapped in the roots of a cactus tree; there, bound with heavy rope, a flag bandages an effigy; and at the entrance to the compound is the flag attached to the mask, a piece once used as a stage prop in one of their performances. The predominance of the flag in the compound suggests Laboratoire AGIT-art's concern with state power and authority. In what appears to be a mock courtroom, the state seems to be on trial, symbolised by the bound and gagged, sunglass-wearing, anonymous figure wrapped in the flag. Taken as a whole, the compound may be seen as an attempt to expose the faultlines of Senegal's recent cultural history, to reveal the fractures between individuality and national identity. In this setting the very fabric of the state is a dominant motif.

Trespassing: Past, Present and Future

Perhaps the most important factor distinguishing the artists of the AGIT-art group and younger artists such as Fode Camara from those of the Ecole de Dakar is their refusal to accept unquestioningly any identity based on an unmediated African past. They use masks, traditional sculpture and a catalogue of ethnographic forms not simply as ready-made 'African' symbols, authenticated artifacts of a usable past to be worked into emblematic formal schemes, but rather as fragments of identities left to them from the contingencies of history. They realise that pieces drawn from the African past must be critically reconstituted to suit the internal dynamics of Senegalese culture today.

And what of the future? What possibilities are open to contemporary African artists trying to secure their own strategies and identities in the face of renewed attention from the Western culture industry? Groups such as the Ecole de Dakar, and the more recent Laboratoire AGIT-art, continue to seek alliances with the Western modernist past in working out their cultural agendas – this at the very moment when the progressive strands of postmodernist discourse in the West are dismantling the unilateral status of modernism in favour of various pluralist proposals under the umbrella of global culture. As Nelly Richard notes, this attachment to modernism in African art 'reformulates the old dependencies (centre/periphery, progress/backwardness) in a way that creates a new hierarchy'.[18] But Richard also offers an alternative to this pessimistic outlook: the critiquing of Modernism 'offers us the chance to reconsider all that was "left unsaid"'.[19] Although Richard speaks of the situation in Latin America, her insights are pertinent to postcolonial Africa, particularly as she notes the possible benefits of a response to the opening up of modernism's various awkward moments:

> This review of modernity allows us, once again, to pose the question of our own identity, that of individuals born of and into the dialectic mixture of different languages surrounding us, which have partially fused to produce a cultural identity experienced as a series of collisions. This identity can be understood as an unstable product of modernity's tropes which involves a continuous regrouping, distorting and transforming of imported models, according to the specific pressures pertaining to the critical re-insertion of these models into a local network. This active participation which the individual at the periphery performs, emphasises a creativity based almost exclusively on the re-use of previously existing materials which are available either as part of the Western tradition or, more recently, prefabricated by the international culture industry. Innovative responses to these materials are based on strategies of re-determining the use of fragments or remains in ways which differ from their original frame of reference.[20]

In the case of Senegal, the most effective art today is open to multiple, hybrid context. It oscillates between the grey areas of cultural identity with a taunting sense of free play, reflexively deploying various meanings, sometimes exaggerated or conflicting, across many different lines of interest. In this sense, the Laboratoire AGIT-art's mask-and-flag construction marks both a beginning and an ending, for it parodies the clichéd idea of the authority of the state, and of the state's sponsorship of ancestral cultural identity – a sponsorship literally bound by mutual interests. Somewhat humorously, the piece stages a mock execution. Both flag and decaying mask hang from the branch of a tree, left to twist interminably in the unpredictable breeze that blows off the Atlantic toward this coastal city.

Notes

1 Frantz Fanon, 'On National Culture', *The Wretched of the Earth* (London: Penguin Books, 1961).

2 The term *Ecole de Dakar* refers to the first generation of Senegalese painters, who made their public debut at the exhibition '*Tendances et confrontations*', organised by Iba N'Diaye for the first World Festival of Pan-African Arts in Dakar in 1966. Among the best-known artists participating in the exhibition were Amadou Ba, Alpha Diallo, Ibou Diouf, Bocar Diong, Ousmane Faye, Amadou Seck, and Papa Ibra Tall. A wider definition of the Ecole de Dakar would take into account certain artists of the same generation who were not included in the exhibition, such as Boubacar Coulibaly, as well as younger artists, born in the late 1940s and starting to exhibit in the 1970s, who were trained at the Ecole Nationale des Beaux Arts, in many cases by members of the first generation. These younger painters, including Souleymane Keita, Chérif Thiam, Amadou Sow, and Philip Sene, have developed highly individual styles, yet in many respects have not departed much from the 'semi-abstract' generic style of painting associated with the Ecole de Dakar's first generation. They tend to appear less constrained by their ancestral legacy and by the concern with establishing a national culture, but their work in many respects has become more insular, in the sense that an imaginative repertoire of themes and subjects becomes locked into an endless play of abstract forms and patterns.

3 Issa Samb, 'The Social and Economic Situation of the Artists of the "Ecole de Dakar"', in Friedrich Axt and Moussa Babacar Sy El Hadji (eds.), *Bildende Kunst der Gegenwart in Senegal* (Frankfurt: Museum für Völkerkunde, 1989), pp. 117–120.

4 Abiola Irele, *The African Experience in Literature and Ideology* (London: 1981); M. Hauser, *Essai sur la poétique de la negritude* (Lille: 1982).

5 M. S. M'Bengue, *Cultural Policy in Senegal* (Paris:1973), p.10.

6 Irele, *op. cit.*

7 See Léopold Sédar Senghor, *Liberté III: Négritude et Civilisation de l'Universel* (Paris: Seuil, 1977).

8 Senghor, *op. cit.*, p. 324.

9 *Ibid.*, p. 325.

10 *Ibid.*, p. 330.

11 *Ibid.*

12 *Ibid.*, p. 62

13 Kalidou Sy, 'The School of Fine Arts of Senegal', in Axt and Babacar Sy, *op. cit.*, p. 38.

14 Source unknown.

15 Samb, *op. cit.*, p. 114.

16 M. B. Sy El Hadji, 'The "Cité of the Artists" and the "Village of Arts"', in Axt and Babacar Sy, *op. cit.*, p. 108.

17 Ousmane Sow Huchard, 'The Musée Dynamique', in Axt and Babacar Sy, *op. cit.*, p. 56.

18 Nelly Richard, 'Postmodernism and Periphery', *Third Text*, no. 2 (London: Winter 1987-88), p. 10.

19 *Ibid.*, p. 12.

20 *Ibid.*

The Quest for a Nigerian Art:
Or a Story of Art from Zaria and Nsukka
Chika Okeke

Charting the Journey

The standard history of modern Nigerian art begins with the pioneering efforts of Aina Onabolu (1882-1963), who studied and copied what he believed was 'true' painting: academic portraiture. The most significant events in that history, however, began in the late 1950s when a group of young artists at the Nigerian College of Arts, Science and Technology, Zaria, formed an association for the primary purpose of reconsidering the validity of the ubiquitous Onabolu legacy. They commenced a collective search for alternatives informed by their indigenous art traditions – of sculpture that was savaged, but prized, by the colonial officers, and of painting whose existence was denied, much against the overwhelming evidence on the compound walls in Igbo and Yoruba land. The members of the Zaria Art Society were clearly aware of the continuing elision of the art traditions of their own peoples in the evolution of the new art that was being taught in the academy. There was, in their estimation, something fundamentally wrong in this apparent self-denial by the emerging Nigerian artists. A reversal was needed if the true, modern Nigerian art were to be established. In order to focus their thoughts, the Zaria Art Society advanced their theory of Natural Synthesis which, essentially, called for the merging of the best of the indigenous art traditions, forms and ideas with the useful Western ones. Uche Okeke, Demas Nwoko and Bruce Onobrakpeya championed the cause of the Zaria Art Society, even beyond the academic tutelage at Zaria. Interestingly, the individual attitudes to the synthesis theory amongst the group, although similar in conceptual terms, varied in form.

The events in Zaria were not without precedents, however remote, however indistinct. A possible foundation had been laid by the British art teacher, Kenneth Murray, who came to Nigeria in 1927, at the suggestion of Onabolu, to help in the development of art teaching. He taught his students, Ben Enwonwu among them, to reflect their cultural environments in their art. But the 'reflection' hardly called for a vigorous study or analysis of the conceptual and formal nuances of indigenous cultural manifestations. It was only much later that Enwonwu, perhaps alone among his peers, moved further in 'reflecting' the art traditions of his people in his art. The Zaria Art Society took up the challenge from that point, employing more dialectical means in its quest for a truly modern Nigerian art. But it was not alone. In cultural centres around the country several other young artists were involved in the process of seeking alternatives to the status quo that was synonymous with the colonialism that the imminent national independence was set to overthrow. The strategies of these artists differed from the logic of Natural Synthesis but it also provided an alternative platform for that search, the quest for a new art in the spirit of independence.

In later years, after the 1960s, reactions to Natural Synthesis yielded even more interesting results. At the University of Nigeria, Nsukka, there developed a strident, sympathetic response, beginning in the early 1970s. The *uli* style for which Nsukka is known is a consequence of an invigorated advancement of the preachings of the Zaria Art Society. In more recent times,

and perhaps due to the success of the *uli* experiment at Nsukka, a similar idea called *Ona* is being developed at Obafemi Awolowo University, Ife.[1] If there is any modification of the idea of 'synthesis' in Nsukka and Ife, it is a redefinition of Natural Synthesis, marking a shift from its earlier ambivalence to a more clear-cut, indigenous centre, drawing on ideas from the more peripheral West.

Then, in Zaria in the mid-1970s, there was a reversal: a rejection of the idea of synthesis developed in the very institution in which it was born. This reversal represents a continuation of the ideas of the artists who, in the 1960s, had a different attitude from the 'Zarianists' in articulating the new art. For the later Zaria artists, the art experience had to be founded on the individual, not so much on collective inheritances. They saw a contradiction in the Zaria Art Society's attempt to define a uniquely, 'Nigerian' art in an evolving, multicultural world. The new art, they believed, must reflect this transcultural, even globalist identity in their work. This attitude later devolved to other art schools – an example of which is the Auchi Polytechnic whose artists have made some impact on recent painting in Nigeria.[2]

What we witness in the works of the younger generation of artists in Nigeria follows or modifies in relative terms the Nsukka or Zaria archetypes. The underlying principle in all cases, however, is the quest for a true, modern, Nigerian art.

This narrative does not tell the whole story; it cannot. It is an attempt to show some of the significant developments stemming from the epoch-making phenomenon of the Zaria Art Society. It takes a historical approach, looking back to the artist who may have planted the seed that flowered in Zaria in the 1950s, Ben Enwonwu. It looks particularly at the works of two artists who took part in the activities of the Society – Uche Okeke and Bruce Onobrakpeya – and at Erhabor Emokpae, who epitomised the alternative route taken by artists in the 1960s toward defining true Nigerian art. Responses to the 'Zarianists' are traced, through Nsukka, which became a watering hole for younger 'pro-Natural Synthesis' artists, and through Zaria, again, where the response is somewhat different. These two schools approximate the diverse currents evident in modern Nigerian art.

This story is an attempt to begin to understand the larger narrative of Nigerian art by looking at a part that, in essence, contains the fundamental elements of the overall story. It is not the whole story, nor does it define the entirety of the phenomenon, but it is one through which we can begin to appreciate the scope, diversity and unity of artistic expression in Nigeria – the several paths that Nigerian artists have taken in their quest for the ultimate essence that unifies all.

The Story

Ben Enwonwu is arguably the first important post-classical Nigerian artist who became conscious of the sculptural traditions of his people. That awareness profoundly affected the nature of his art,

which in turn set in motion the renegotiation of the earlier constructs for modern Nigerian art. The British art teacher, Kenneth Murray, had in his own way attempted to direct the conceptual focus of his students, including Enwonwu, away from the academic portraiture tradition of Aina Onabolu. Murray's methods, however, did not yield much: his students, even Enwonwu at the time, settled for the kind of painting that became a contemporary tradition. Many artists today are building on that legacy, the hallmark of which is the landscape genre typical of the Yaba School in Lagos.

In 1944, Enwonwu travelled to England, where he studied at Goldsmiths, Ruskin College, and finally, the Slade. That experience helped him to sharpen his skills and techniques and in the process to assimilate some of the finest traditions of sculpture and painting offered by European academies. In the end, however, Europe did not solve or satisfy his yearning for an appropriate response to the existential, even dialectical, problems faced by many African artists after encountering Europe and its culture during the colonial period. Beyond the wonder that was academic art lay a deeper mystery. Enwonwu's great learning had made him virtually a stranger to the art traditions of his own people. He needed to go back home.

On his return, Enwonwu also returned to Nigeria's cultural environment, but not in the manner that Murray's earlier classes may have envisaged. He had become more sensitive to the nuances of his cultural inheritance, having accepted Léopold Sédar Senghor's philosophy of Negritude. But his search for a new language offered him the opportunity not so much to create visual correlations of Negritudist thought, as earnestly to retune his sensibilities to the art and cultural traditions of his own people, the Igbo.

From the earliest period of Enwonwu's 'African style', he seems to have been preoccupied with two major ideas: the woman and the masked dancer. His Negritudist leaning may have informed his initial interest in the idea and form of the African woman, who was both Mother Africa and the alluring beauty whose colour elicited superlatives, her body the object of much poetic contemplation. The Enwonwu woman is a dancer, and dance, Senghor said, is the unifier – the natural, physical, even emotional expression of all African peoples. The female dancer is the icon, the essence, of a cultural expression that had been discouraged, debased and heathenised by colonialism and its institutions. The frenzy of her movement approximates an outward manifestation of a resilient spirit that defies 'cultural cleansing'. In her attenuated physique is the glory and the grandeur of past and evolving Africa; Africa that must reach out to its destiny, hopeful Africa.

The second most enduring subject in Enwonwu's art are the Igbo masked spirits, *Agbogho Mmuo* and *Ogolo*. The woman and the masked dancer share a common denominator – even if one exists in the sensual world and the other in the para-cognitive plane – dance connects both. And even when, as is sometimes the case, Enwonwu's female dancers seem to perform with hasty

choreography, they still suggest a frenzied transition, through inspired motion, from physical to spiritual states. It is the type of dance that Chielo, the mediumistic woman in Chinua Achebe's *Things Fall Apart* (1958) might have performed. Enwonwu's choice of masked dancers is therefore important beyond its signification of a 'return to roots'.

Agbogho Mmuo, Ogolo and the *Nne Mmuo* represent only a fraction of the pantheon of Igbo masked spirits, but they are some of the finest dancers. Their dance, ever graceful, is a sublime recasting of the kinetic essence of Igbo female dance steps. The dancing act not only bridges the distance between the mundane and the other-worldly, but also unifies two spiritual power nodes. After all, in many African societies the woman has immense power, *ase*, which translates to a higher spiritual consciousness. When she dances, or the masked spirit performs, the experience for the audience becomes that of a real or conceptual metaphysical contemplation.

Critics of Enwonwu see in his art the quintessential split personality of the confused African artist, trapped at the cultural crossroads with the Mazruian 'Triple Heritage'. The reasoning is that Enwonwu's method of delivery remains technically faithful to the academy, even if his subject does not. The same, however, could be said of many pioneering efforts that must break away from the known to the unknown. His is an attempt to translate the secular, sensual process of painting or sculpture into a contemplative, metaphysical experience. If his earlier *Agbogho Mmuo* or *Ogolo* appear illustrative, suggesting Negritudist nostalgia, they are also the beginning of a sustained attempt to capture and tame the evanescent spirit behind the mask, relocating it from the space/time reality of the market square to canvas and bronze. We do not see in these works the frustrations of a 'detribalised African' yearning for his mythic roots. We see a creative consciousness manipulating relevant skills and media to attune itself to the spirituality embodied by the masked dancer and to the inner essence that contemplates a metaphysical form and idea. Towards the end of his career, Enwonwu got very close to that goal.

Enwonwu was peerless. His colleagues from the Kenneth Murray days mostly became instructors in teacher-training colleges, hardly going beyond the simplistic genre typical of the Murray school. If Enwonwu had possessed any group forum through which his new ideas could be passed on to the younger artists of the time, the transmission process might have been markedly faster and more direct. Or had he taken up a teaching position at Zaria or any other college, he might have turned his students into Enwonwu proselytes. But since there was no group forum, and since he neither taught art nor established a workshop, Enwonwu's legacy devolved to the next generation of artists only indirectly.

As has been noted earlier, Negritude provided Enwonwu with the ideological basis for his enquiry into indigenous cultural phenomena and his articulation of a new artistic reality. It gave him the impetus to become confident and assertive in his conceptual convictions. This is Enwonwu's legacy to the generation of Nigerian artists after him, who became active in the late

1950s at the dawn of political independence. To them, Enwonwu was a spectacular summation of professional success. His image loomed large in the minds of the younger artists. Yet, due to the exigencies of the approaching political independence, they became more involved in the dialectics of nationalism and an even deeper appreciation of Nigerian cultures, especially classical art traditions. If impending independence would bring with it a new Nigerian polity, reasoned these young artists, then an appropriate new Nigerian art had to emerge. The time had arrived for a redefinition of individual and collective identity. In search of that much-needed identity, therefore, a group of art students at the Nigerian College of Arts, Science and Technology (now Ahmadu Bello University) at Zaria met and formed the Zaria Art Society with members including Uche Okeke and Bruce Onobrakpeya.

The members of the Zaria Art Society were later to become known as the 'Zaria Rebels' due to their supposedly radical approach to the new art. Rather than ingest all Western models and methods taught by a largely European faculty, the Society preferred to draw directly from art forms indigenous to their various cultural backgrounds. Yet, as if to build on a more resilient foundation, Natural Synthesis – the theoretical basis upon which their art derived sustenance – advocated a merging of the best of indigenous and foreign (Western) art forms and ideas. To Uche Okeke, the ideologue of the Society, *uli* became the art form upon which he founded his new art.

The *uli* body and wall decoration of the Igbo is one of the most striking drawing and painting traditions in Africa.[3] It existed long before Aina Onabolu, who claimed that there was no painting tradition in Nigeria prior to him. During the colonial period, many Western ethnologists and anthropologists came to Igboland and documented *uli* (as part of 'vanishing Africa') for their museums and journals. Their interest hardly went beyond this 'salvage scholarship'. Drawing is central to *uli* aesthetics, but it was not the kind of drawing that Zaria taught Okeke. So he embarked on a vigorous study of *uli*, visiting museums that housed material on *uli* and learning the relevant skills from his mother who herself was an accomplished *uli* draughtswoman and painter. The *uli* lexicon, though varied and dynamic, consists mainly of abstracted forms derived from nature: animal, plant and cosmic forms. The artist distills the formal essence of her design elements through manipulation of line. These principles posed a challenge to an artist in search of a new, modernist idiom.

Okeke found in *uli* the path to such formal sensibilities as were sympathetic to the pre-Independence nationalist aspirations. He also found his personal artistic independence. His art went through quick evolutionary turns within a short period of time, before attaining what seems to have been the goal he set for himself. By 1962, his drawings had become organic, lyrical and appreciably abstract.

That year, while awaiting his travel papers in Abule Oja, Lagos, Okeke produced an important set of small format drawings, the *Oja Suite*, which display the gestural nuances of *uli*. Vegetative

and human forms are stripped of superficialities, leaving only the essential components: the same reductivist process that yields 'traditional' *uli* design motifs. In the *Oja Suite*, lines twirl in ambient space, engaging the negative space such that the spatial dynamics of the positive and the negative is sensitively organic. The strength of the lines is uniform. They move, avoiding in most cases the straight course, developing ultimately into whorls and spirals. There is a cleanness of line here that approximates that of *uli* body designs. The major difference, however, is Okeke's consciousness of his compositional format; unlike the body decorators, the wall painters share this spatial sensitivity.

At the end of 1962, Okeke travelled to Germany to train at the Franz Meyer Studio in mosaic and stained-glass techniques. It was during this period that he produced his *Munich Suite* drawings. In the earlier *Oja Suite* drawings he drew with pen and ink, but in the *Munich Suite* he took up the brush. This transition suggests a heightened technical confidence, a facility with the drawing tool. The lines are broad, more expressive, and have lost much of the sensitive elegance of the earlier drawings. He appears to have internalised the *uli* drawing technique, now employed to serve his modernist sensibilities. Do we see a reversal of the Enwonwu situation here? There is a way in which these drawings carry the expressive power of Franz Kline's, but they do not suggest the brutality and restrained violence of the latter. The brush strokes avoid the angular, preferring the curved path. The masses are heavy, leaving the unworked space as a complex arrangement of shapes that acquire active presence, not merely serving as a background. The *Munich Suite*, for Okeke, marks a high point in the synthesis doctrine of the Zaria Art Society.

In the works of Bruce Onobrakpeya, another leading member of the Zaria Art Society, we see an interpretation of the Natural Synthesis similar to Okeke's. But due to Onobrakpeya's different cultural background and his own independent creative sensibility, he arrived at a unique formal expression. Having spent his early years in Benin (the locus of the vast, rich artistic traditions of the Edo culture that produces the famed 'Benin Bronzes'), Onobrakpeya drew not only upon his native Urhobo culture, but also on that of Benin in his response to the ideological stand of the Zaria Art Society. Onobrakpeya studied painting in Zaria with Okeke, but it was in printmaking that he found a more responsive vehicle for developing a new formal identity. In his earliest prints, made in Zaria, he explored new forms using the media of linoleum and wood-cut. The experience that was to change the direction of his art, however, took place after Zaria, at the printmaking workshops in Ibadan.

The early post-Independence period saw a ferment of creativity in art, theatre and literature around the country, but it was at Ibadan that the finest young artists and writers met to exchange ideas, to work together. The forum for that experience was the Mbari Club. Artists from around the country gathered there to present, exhibit and discuss new, original works. There were also studio workshops directed by expatriate artists. Onobrakpeya participated in the printmaking

Uche Okeke
Christ Entry into Nimo, 1962
Stained glass window
104 x 104 cm
Collection of Asele
Institute Gallery, Nimo
Courtesy the artist
Photo: Simon Ottenberg

workshops and it was there that he was introduced to the etching technique. He immediately took up this process, pushing it to its logical limits in search of a process-medium that is beyond the ordinary. For him the journey to Natural Synthesis yielded not just a new idea, but also a new process and medium.

The first successful step towards that goal came in the late 1960s when he 'accidentally found' the plastographic technique in the course of his etching experiments. If that transition from 'deep' etching (as he was to call his new prints) to plastography was the result of a studio 'accident', the formal progress of his work from the planar, two-dimensionality of normal etching, to deep etching, to plastographs, to plastocast, and a corresponding transfer from flat surface, to low/high relief, to three-dimensional sculptural installations, was certainly not accidental. For as his techniques change, becoming increasingly complicated, they are sustained by the formal complexity of his designs/compositions. It is therefore not surprising that he reached beyond the Edo-Urhobo culture for inspiration: he draws from Yoruba, Igbo, Hausa-Fulani and even Akan sources.

Onobrakpeya calls his sculptures plastocasts because they are casts taken from 'negative' resins. This process yields only two-dimensional reliefs, but the artist then rolls these into columnar sculptures. It was in the course of his search for a rich and complex symbolic form (not least, idea), that he incorporated into them Akan brass gold-weights, Fulani leather works and other assorted objects from diverse African cultures. The monolithic nature of the rolled-up columns is in itself a signification of the tubular bronze staffs of Urhobo shrines, the bronze ivory mounts of Benin court art, and the thousand-year-old cylindrical bronze anklets unearthed at Igbo Ukwu in the heart of Igboland.

Much as Onobrakpeya's installations may be appreciated from the standpoint of the late twentieth-century invention of the installation medium by Western artists, their historical antecedents are to be found in the shrine art of the Bini and Urhobo, a tradition that flourished millennia before the birth of modern art in the West. Rather than affecting the stark absurdism of much Western installation art, Onobrakpeya's work approximates the emotive object-space symbolism of African religious shrines. His is the modern shrine, the secular altar of the new-age priest. In these installations, art and religion, priest and artist, ritual and spectacle all become one, as in the masquerade performance. There is an interface between the object and the subject, between a modern sensibility and 'traditional' reality, which is the essence of Synthesis.

We may recall that the members of the Zaria Art Society derived much impetus from the euphoric pre- and post-Independence nationalism. But as has been suggested earlier, they were not alone in that quest for a new art. Several other young artists who formed no associations, but were conversant with the political and cultural currents of the time, were equally involved. A number of these trained in the technical institutes and colleges while a few were taught in Europe. They all shared the belief (which differed markedly from that of the 'Zaria Rebels') that there was no future

for a modern Nigerian art located in, and defined and sustained solely by, indigenous art traditions. For them, the spirit of political independence also dictated a replacement of colonial academic art with avant-garde, modern (read Western) forms and ideas.

Erhabor Emokpae was amongst the most prominent of the artists who advocated this new sensibility. Emokpae trained at the Yaba Technical Institute, Lagos. Like Zaria, Yaba had a conservative academic style. However, after his two-year training there, Emokpae took to abstraction and severe stylisation, especially in his paintings. That change was his own way of rejecting colonialism, of celebrating the collective political independence, and of expressing his personal creative freedom: the freedom to create something new. But he did not, like Okeke or Onobrakpeya, seek new forms based on the art of his own people, the Edo, whose traditions are among the richest anywhere in the world. Nothing bound him to any cultural specifics. Rather, his freedom to draw from such international 'rebel' art as Surrealism and the biomorphic abstractions of Constantin Brancusi, Henry Moore, or Barbara Hepworth, informed the direction of his paintings in the early 1960s and his sculpture a little later.

His early paintings affected the pictorial nuances of Surrealism by a recourse to abstract automatic drip painting in some cases, and the juxtaposition of shocking stylised images in others. It was in the later mode that his series of important, mainly black and white pictures evolved. Emokpae felt the need to question and even controvert established knowledge, especially the Christian religious dogma. He took up that most visible of colonial institutions, challenged its fundamental principles and judged them deficient, even primitive. In one of his most important pictures, he implied that the Christian Last Supper, the feast of flesh and blood, is essentially based on cannibalistic instincts.

Emokpae's sculpture combines Western and African imagery but the former exerts considerably more influence on their form. Often, his subject matter touches on Yoruba traditional concepts, but his forms are realised through a combination of the reductivist tendencies of Brancusi; the feel for negative and positive volume typical of Moore; and the clean, almost mechanical finish of Hepworth. The formal influence of African traditional sculpture is minimal.

The 1960s therefore saw the redefinition of the direction of Nigerian art by the members of the Zaria Art Society. Within the decade an alternative attitude developed in tandem with that of the 'Zaria Rebels'. Kojo Fosu calls the protagonists of this reactionary tendency, 'Kindred Rebels',[4] artists concerned with evolving an independent creative sensibility founded more on multi-universal sources than on indigenous art traditions. At the end of that decade the stage was set for the emergence of another generation of artists whose careers were to be defined by their responses to the parallel currents in Nigerian art. At this time too, the bitter Nigerian Civil War (1967–70) had a profound influence on the political and cultural atmosphere of the Nigerian nation.

In cultural terms, the civil war was especially important to the Biafran secessionist side.

Among the new generation of artists, this period witnessed significant creative ferment that matched the Mbari phenomena at Ibadan. Many of these artists had participated earlier in the activities of the Mbari Art Centre, Enugu, under Okeke's directorship. In the din of war, artists, along with poets, novelists and dramatists, organised themselves into cultural groups. They produced art, literature and performances reflecting the war experience. One of the most important of these young artists was Obiora Udechukwu. He had earlier begun his art training in Zaria in 1966, but was forced to move over to the University of Nigeria, Nsukka due to the exigencies of the Civil War.

The war had a profound influence on Udechukwu, just as it did on many of his generation and even generations after them. It heightened Udechukwu's awareness of the humanity of man, of his failures, his hopes, his tragedy. But while he recorded images of the war, the troubled times did not allow him to develop an appropriate visual language that could convey the philosophical depth of his creative consciousness. When the war ended in 1970, he returned to Nsukka where he commenced what was to become a long, faithful quest for a new idiom.

As a child, Udechukwu saw the beautiful *uli* murals that decorated family compound walls. He also saw *uli* at the revered shrines to deities of his Agulu community. And, in the years just before the war, he knew about Okeke's new paintings and drawings, but he was yet to perceive their associations with the *uli* murals, or to perceive in *uli* the limitless formal and conceptual possibilities that could be useful to his own art. It was at Nsukka that the message of the synthesis theory of the Zaria Art Society reached Udechukwu, who, at that time, was training under Okeke. The theory corresponded to his own personal conviction, so he began in earnest, a process of distilling the *uli* essence, the elegance and sensitivity of line. His powerful draughtsmanship was requisite for the new work. By the mid-1970s his drawings had acquired the formal lyricism of *uli*. From then on, his lines became powerful vehicles for social commentary and visual poetry that drew its richness from the verses of Christopher Okigbo (1932-1967) and Igbo oral poetry.

During this period, Udechukwu also studied Chinese calligraphy. The Chinese *li* and Igbo *uli* share a tendency for formal simplicity.[5] While Udechukwu studied the wall painting and drawing techniques of female Igbo artists, he also learnt the principles of Chinese gestural ink and brush work, the *Tao* of painting. Brevity of statement and spontaneity are fundamental to both traditions, qualities that Udechukwu considers paramount. He called the result 'cerebral art'. However, the synthesis of Igbo and Chinese design principles in his drawings is interesting. He merges an indigenous art form, not with a Western one, but with another *non*-Western one. In this way he re-affirms the essential tenets of Synthesis.

In the evolution of Udechukwu's own *uli* forms, there is a conscious incorporation of *nsibidi*, the pictographic script of the Efik and North-Eastern Igbo area. The result is a unique pictorial invention that combines the beauty of *uli* with the symbolism of *nsibidi*. Having developed the appropriate visual language, his drawings then became vehicles for social criticism and satire.

Due to his preoccupation with the socio-political dynamics of the post-'Oil Boom' era, Udechukwu's drawings combine the truculency of media cartoons with the profundity of philosophical treatises. Satiric terseness takes the form of suggestive poetic elegance. Leaving much unsaid, the drawings require the viewer to participate in the completion of the picture and the idea.

In more recent times, Udechukwu has shifted his focus from drawing to painting; from line-space dialogue to the dynamics of shape and texture. This is the consequence of his many years of research into the techniques and processes involved in the making of *uli* wall painting by the Igbo muralists. Although his interest in this started early in the 1970s, it was in the 1980s that he embarked on several projects that allowed him to witness *uli* artists at work, demonstrating the procedural techniques of their art. In this way, Udechukwu studied and perfected the consummate skill required to engage large open spaces with expansive colour fields.

In order to break up the monotony of flat colours, the women create textures by using a scrubbing technique that produces a *sgraffito* effect. In addition, they use stippled dots to 'hem' actual or virtual lines that delineate borders between shapes of colour. Udechukwu pulls all these together in his recent paintings. However, while the *uli* murals are restricted to earth tones and occasional blue from imported 'washing blue', Udechukwu's palette is rich. Furthermore, he goes beyond the earlier social commentary to take on deeper philosophical questions using such unlikely subjects as landscapes and the seasons.

A similar appropriation of *uli* enriched with parallel art traditions is to be found in the work of El Anatsui, who demonstrates a more expansive sensitivity to diverse African art traditions. Since the mid-1970s, Anatsui has worked closely with other artists at Nsukka, developing a unique form based not only on *uli* or *nsibidi*, but also on Nok, Ewe and Ife art traditions. He is a student of Africa's history, especially of its great migrations, the impact of slavery and current historical developments.

His earlier training in Ghana, at the Kumasi College, made him proficient in sculptural techniques in the Western academic mode. That experience proved useful in his later exploration of African sculptural traditions at Nsukka. Modern art, for Anatsui, can claim no legitimacy if it is not based on one's originary art traditions and culture, from which vantage it can then seek to appropriate foreign ideas or techniques. Nsukka provided Anatsui with the environment for that realisation.

Anatsui made some of his most forceful formal statements in the medium of ceramic sculpture. In the 1979 series of ceramic and stoneware, *Broken Pots*, we see echoes of Nok and Ife terracotta sculptures as well as Ewe ritual pottery. The pot is a metaphor both for 'decay, break up, dilapidation', and for regeneration. Its shards play an important role in African ritual and votive offering; when further broken up, they form the grog that strengthens a new pot. In this cyclic

evolution there is a re-enactment of the movement of life from birth to death to re-incarnation. Even when Anatsui creates whole pots, they are never complete to the point of practical function: their components are bound together by their ritual contents, which defy formal logic. The anatomy of the pots, or their broken fragments, raise memories of a past spirituality and rich traditions, also portending the fragmentation of a fragile, secular communal bond.

Prior to his ceramic sculptures, Anatsui made circular, wooden plaques carved and burnt with mostly *adinkra* and *uli* symbols. In the early 1980s he returned to wood and began what would become one of the most significant sculptural expressions anywhere: multi-panel relief sculptures carved with power tools and fire. These composite panels bore the ravaging marks of the power saw and the scorch of the blow torch. Fire and the saw now became metaphors for slavery and colonialism, while the 'victims' – the wooden panels – symbolise the many African peoples who share a collective cultural devastation.

In his *Migration Series*, Anatsui tells the histories of the African continent, the movements of whole settlements before and during the days of slavery, and the forced relocation of entire groups on the grounds of colonialist commercial considerations. In recalling these histories, he seeks to trace the present 'otherisation' of Africa to the systematic sabotage of its true history of rich civilisations by an imperialising Western culture. The awareness of these historical realities on the part of contemporary African peoples could engender the necessary collective re-affirmation.

The design form in the panels draws from the decorative designs of *uli* and the symbolic motifs of *adinkra*. These combine with the ideograms and pictographs from such African syllabary as *nsibidi*, *Bamun*, *Njoya* and *Bolange* to create a complex new form.

In the mid-1970s, at about the same time as Anatsui arrived at Nsukka, an interesting development was taking place in Zaria. When the members of the Zaria Art Society and other artists sympathetic to the doctrine of Natural Synthesis left the school in the early 1960s, their impact did not last. Zaria remained the standard academy that had existed before the Rebels. Observable stylistic changes came mostly from the expatriate teachers who taught in the institution until very recently. The most significant of these was Charles Argent, whose influence on Zaria painting is still evident in recent works to emerge there, even though he left the city almost two decades ago. Argent believed that the painter must explore colour in order fully to understand its nuances, its hidden character. In the process of doing this, the artist resolves established theories of colour with his or her own personal experience with painting processes and media.

These precepts seem to have been carried to their logical conclusion by Gani Odutokun, who reinstated Zaria to its position of influence. He also changed the direction of Zaria painting. His art benefited from a faculty made up of artists from diverse cultures. Rather than insisting on drawing from indigenous art traditions, he preferred a universalist approach. For Odutokun, the world is his constituency and he is a legatee of its multiculturality. The only limitation to the sources from which

he can draw inspiration are technical, studio exigencies and the changing environment. He reclaims the individual freedom of the artist: the freedom to absorb or reject any art tradition, or to combine all of them since the modern artist is a product of many cultures and of the new global experience. It is important to note the similarity between this attitude and that of Emokpae in the 1960s. Whereas the Nsukka artists of his generation took to the tenets of Natural Synthesis, Odutokun aligned himself with the alternative ideas of Emokpae.

Early in his career, Odutokun made a series of paintings with liquidised oils, thinning his pigments until they became fluid, then dripping the colours directly onto the canvas. In this process, there are obvious allusions to the abstract action or automatic painting that blossomed in the West several decades ago. But Odutokun's attitude is different: he strives to control the intractable process in order to create pictures. In the more recent paintings, he seems to have finally mastered the technique, for he easily simulates Islamic calligraphic symbols and Hausa architecture and design with dripped lines of colour. The most interesting pictures, however, are those in which a combination of bleeding, stained colour and a maze of vertical, horizontal or whirling lines define recognisable forms. In these we see the artist reconciling the realities of contemporary, diverse art traditions fused into one complex, rich form. They speak of the complexities of modern, existential man. There are no definite boundaries between what is African and what is not. Only the instincts and intentions of the artist are important and constant, everything else is variable.

In the same way that Islamic calligraphy and architecture contribute to the richness of Odutokun's design sources, Hausa calabash and leather work form part of Tayo Quaye's formal repertoire. In his prints there is a confluence of sources from contemporary art and the cultural traditions of Northern and Southern Nigeria. Since his graduation from Yaba College of Technology, Lagos, Quaye has maintained contact with Odutokun. His residence in nearby Kaduna has ensured his continuing interaction with Zaria artists.

However, Quaye's art draws essentially from that of Bruce Onobrakpeya. It was in Onobrakpeya's studio, where he worked as an assistant between 1974 and 1976, that he received his earliest training in art. While there, he assimilated the rudiments of his master's art. Onobrakpeya's studio has, over the years served as a training ground for many younger artists. In some ways it continues to play the same role as the art schools in Zaria and Nsukka where ideas have continued to devolve from the studio masters/teachers. Yet, even if Quaye's work shows an originary attachment to Onobrakpeya's, it is still significantly different; several factors account for this.

Born in Lagos, Quaye experienced from childhood a cosmopolitan life. His ideas and understanding of 'tradition' in later years, therefore, are framed by the urban realities of Lagos and whatever semblance of Yoruba cultural traditions the city offered. After his training with Onobrakpeya, Quaye recieved his formal tuition in painting at Yaba. The Yaba experience distanced Quaye even more from his former master's preoccupation with 'traditional' art and lore, but its

influence was not strong enough to make him take to Yaba's landscape 'style'. Nor could it turn him away from printmaking.

Quaye's lino-engravings and relief prints represent some of his most striking work. They display the same dense pictorial composition that one sees in Onobrakpeya's prints. However, his forms are stronger and his design motifs bolder, highlighting his sensitive draughtsmanship. This facility in drawing is responsible for the elegant, confident lines, especially those defining major compositional structures. One also finds the characteristic emphasis on the beauty and visual power of the line that is reflected in the work of the finest Nsukka artists.

In 1981, the same year that Quaye left the Yaba College for Kaduna, Jerry Buhari graduated from the art department at Zaria. His teachers were drawn from Nigeria, Britain, the United States and the Philippines. But it was Gani Odutokun who had a lasting influence on him. Today, the two artists continue to define the direction of painting in Zaria. Buhari shares with Odutokun the urge to experiment with techniques of painting, from the traditional to the unconventional. Both agree that the painter must not strive to make paintings that are tied to African cultural specificities. Yet there is a marked difference in their sensitivity to colour. Whereas the aesthetics of colour is fundamental

But what is that essence for which all the artists in the story seek? Is it even likely that there is *an* essence, a collective goal that may be called Nigerian?

to Odutokun, for Buhari it is its expressiveness that is paramount.

The Zaria doctrine of transcultural art is evident in Buhari's paintings and he never aspires to create art that could be defined as 'Nigerian'. His explorations into colour and method derive from his personal encounter with nature and his social environment. In 1989, he made a series of paintings, *Floral Notes*, in which he explored the symbolism of colour using the flower as a metaphorical source. In this series, Buhari subverts the natural association of flowers with beautiful colour. His flowers are troubled, their colours bright and clashing as if simulating contemporary social realities. Here, the feeling of restrained violence is heightened by his temperamental brushwork. The outcome is unsettling.

In his more experimental, liquidised oil paintings, Buhari shows a tendency towards complete abstraction. He makes little effort to control the flow of colours when he tilts his canvas, allowing them to flow down and out of the canvas. Wasting away. This deliberate wasting of 'precious' pigments is the artist's way of reacting to his social environment. He draws a parallel between his actions and the wasteful destruction of the natural environment by man. There is also a different interpretation of the process: the painter takes on a purist approach to creating

pictures, much like in automatic painting where intuition takes over logical reasoning. Accident becomes design. The colours create their own associations as they flow down the canvas without the artist's intervention.

While Buhari strives to create new forms through manipulation of the painting process, his classmate Jacob Jari's interest is in finding an alternative painting medium. Earlier, Jari had taken part in experiments with colour and technique led by Gani Odutokun. But he gradually redirected his search toward a different goal: developing a cheaper, newer medium; something different from oils and acrylics. He devised corn-stalk mosaic. His tesserae consist of dried, button-size sections of corn stalk dyed with fabric dyes or liquidised pigments.

In the earliest of these mosaics, Jari is preoccupied with understanding the language of the new medium, working out the possible colour variations of the limited tesserae colours. He begins with geometric designs and then moves on to complex pictures such as landscapes. Since mosaic painting does not allow for detailing, these realistic pictures are simple, using bold areas of colour.

Jari's recent works are abstract. The degree of formal success is therefore dependent upon the interplay of colour and allusive shapes or patterns. From the complex to the simple, the mosaics make no definite statements; they suggest forms and ideas that come to full realisation in the mind of the viewer. In the same way that Odutokun and Buhari believe in the universality of the language of art, Jari makes no allusions to indigenous African art forms or concepts. His corn-stalk mosaic is not a reaction to Western academic art. It is not a sentimental return to 'tradition' and local materials as with some of the *Ona* artists at Ife. His is a search for a convenient, eloquent medium for advancing a purely personal, modernist iconography.

There is a formal relationship between Jari's multi-picture compositions and Buhari's round-format arrangements. Both artists attempt to make allusions to multiple psychological states, to which each person encountering the pictures relates through his/her individual mental disposition. The effect may not be the same due to the different media of expression, yet the underlying conceptual structures are correlative.

Ayo Aina, one of the newest generation of Zaria artists, considers his ultimate goal to be the realisation of pure sensual beauty through a sheer manipulation of colour. There may be in this attitude a suggested summation of the formalist striving of the Zaria artists. Rather than adopting the liquidised oils medium, he paints with palette knife and brush, displaying the gestural boldness of Odutokun's earlier oils. His 1992 paintings are almost entirely abstract. In these, he engages the picture space with broad knife strokes of brilliant colours. Sometimes the patches of pigment seem like collage compositions, each independent statement becoming an element that derives its justification from its relationship with the next.

Gradually, his abstract compositions have given way to illustrative pictures with human and linear decorative elements. But there is a conscious attempt to subjugate recognisable images

so that they do not interfere with the celebration of colour. They are intended to be seen only as areas of colour. The pertinent question perhaps is, who determines what colours and which colour combinations are most likely to approximate sensual beauty? Aina believes that the artist makes all the decisions. The colours he chooses represent the beautiful; his personal aesthetic sensibility accounts for their organisation within the painting. If at the end of the process he is satisfied with the result, he *hopes* that the viewer will share in his experience of colour transferred to the canvas.

The act of stripping colour of any symbolism, of insisting on the irrelevance of suggested images and of the imposition of titles that create associative mind pictures, may be the artist's ploy to tease us away from inhibitive subject matter. It is a way of drawing us into the world he creates, where non-associative colours are all that remain, all that matter.

The 1980s in Nsukka marked the emergence of a third generation of *uli* artists with the presence of Tayo Adenaike, who trained under Uche Okeke and Obiora Udechukwu. He is also one of the first major non-Igbo *uli* artists. Since 1980, when he received his debut one-man exhibition, 'Childhood Fears', Adenaike has refined his technique and form, weaning himself from the earlier influences of Udechukwu in the process. He has developed a distinctive style that is informed by his Yoruba background and his experience of Igbo *uli* painting. His early drawings are heavy, less lyrical, but with more decorative *uli* motifs than Udechukwu's, or even Okeke's works. The same may be said of his early attempts in the watercolour medium. With time, Adenaike's watercolours have come to acquire a remarkable fluidity and organicity. Interestingly, he has worked almost entirely with watercolour in the past thirteen years, exploring the formal possibilities of *uli* design in that medium more than any other artist to date.

Adenaike does not display the linear sensitivity that has become the hallmark of the older generation of *uli* artists, yet he does convey the same formal elegance with his fluid, distinct boundaries between areas of colour. In his more recent work, he combines bold geometric patterns that, though based on *uli* design, are reminiscent of Yoruba *adire* textile design, executed with colours more brilliant than have hitherto been associated with modern *uli*.

Adenaike synthesises the myths and folklore of the Yoruba and Igbo. He also draws from proverbs and stories that he recalls from his childhood years with his grandmother. These sources form the basis for his enquiries into contemporary subject matter. More importantly, a fusion of traditional myths and lore with contemporary existential realities combine with an *uli*-based design to produce what Adenaike considers to be the essence of his art.

By the mid-1980s, further developments in the Nsukka experience continued with Ndidi Dike. Dike trained as a painter, but later took to sculpture. Her painting experience continues to modify her glyptic sensibilities. In her painting, she explored a variety of natural media, especially dried banana fibres, seeds and sand. She did not adopt *uli* in the manner of Obiora Udechukwu or Uche Okeke; her interest in drawing was perhaps not sufficient to sustain the demands of *uli* for linear

elegance or essentialisation of forms. Although she had recourse to basic *uli* compositional formats – the dynamics of positive and negative spaces – her pictures drew attention more to the interplay of diverse, unusual media. Her painting changed from normal canvas or masonite, through fire-stained boards, and finally to sculptural mixed media, relief and three-dimensional sculptures. This development parallels Onobrakpeya's transition from painting to printmaking, and to installations.

In common with Anatsui, Dike's relief sculptures are made with tools ranging from manual and power-carving tools, to the blow torch. They derive their formal complexities not so much from the interchangeability of their composite parts, as from the inclusion of brass figurines, coins, animal and vegetable fibres, and cowries. Although the composite form defies the monolithic nature of much of African wood sculpture, the extraneous materials make a symbolic gesture to their contextual background, which is African. In Dike's, as in Onobrakpeya's mixed media installations, objects from Akan, Fulani and Igbo material cultures (along with an unmistakable presence of *uli*, *nsibidi* and *akwete* motifs and designs) all fuse together to create something tellingly African, dispassionately contemporary. Dike pays fleeting attention to the indigenous art traditions of Africa as though leafing through a vast volume of African cultural history. Images do not stay long enough to make any lasting impression. She is drawn to the culture and art of Africa, yet she is distanced from it to the extent that she enjoys her freedom to take as much from the vast resources as her spirit wills. Consequently, Dike's sculptures suggest their cultural provenance, making no definite claim to particulars.

Unlike Ndidi Dike (who trained at Nsukka before him), Olu Oguibe's attitude to the recovery of 'tradition' is fundamentalist. His training under Udechukwu made him conscious of the raw visual power of *uli* wall painting. The result of that experience for Oguibe was a reversal, a return to the basis of the modern *uli* experiment. The design and compositional nuances of the *uli* mural, which was only beginning to inform Udechukwu's new paintings, defined the formal structures of Oguibe's. Oguibe learnt the techniques of the *uli* artists, internalised them and then refashioned them to create a new form that is at once 'traditional' and 'modern'. The problem he seemed to have had was that *uli* does not readily yield itself to the needs of an artist whose mission is to communicate, literally, with his audience. So Oguibe combines *uli* and *mbari* aesthetics with a powerful communicative element: the written word.

In the *National Graffiti* series (1989), painted while the Babangida dictatorship was beginning its intrigues, Oguibe makes a beautiful and powerful statement on the worsening socio-political environment. The fact that the pictures are painted on woven mats is significant: the political protest develops into a cultural one as he rejects modern Western 'specifications and delineations'.

A purer response to *uli* aesthetics is evident in Oguibe's *Nsukka Triptych* where he simulates classical *uli* design with a simple, clean format that provides a clear background for the graffiti.

As in the earlier *National Graffiti*, the phrases, words and signs allude to historical and political issues that form part of our collective national experience. The social commentary championed by Udechukwu becomes more biting, more declamatory and turns into a form of protest. Graffiti gives the artist an opportunity to give vent to his gut feelings about his society. It is also the *vox populi* from which one can read the times. Oguibe continues a tradition that is long-established inside prison cells, public toilets and railway stations. Against the backdrop of a rich art tradition, we hear the individual and collective voices of a society in the throes of change.

By the end of the 1980s, Oguibe had left Nigeria for England. After him at Nsukka came Chika Okeke, whose work shares similar thematic preoccupations. Okeke's training in sculpture, under El Anatsui, and in painting, under Obiora Udechukwu, as well as his association with Oguibe at Nsukka, provide the background for his art. In his painting there is an unmistakable influence of the sculptural form. The realistic or stylised figures and the sometimes rigid handling of colour point to this. Even when there is an attempt to seek a balance, form and composition still supercede colour in importance.

In Okeke's earlier work, the use of space was in accordance with the quintessential *uli* design, but this has changed with time. Even if there is still a recourse to the power of line, there is also an evolving form that includes not just the *uli* line, but also *mbari* geometric design patterns and ideographic forms based on *nsibidi* scripts. The fundamental negative-positive space dynamic evident in earlier *uli* is replaced by dense pictorial compositions. The expressive, illustrative form recurs in his work as a result of its aspiration to engage in social criticism and political commentary. Similarly, symbols from *uli* and *nsibidi* sources interact with those from contemporary life, giving the resulting picture several levels of meaning that in the end recount and disparage the spectre of the dictatorship in Nigeria.

In the Arena

But what is that essence for which all the artists in the story seek? Is it even likely that there is *an* essence, a collective goal that may be called Nigerian? A characteristic product, a common quest? This is where we seek explanations in the phenomenon of the masquerade:[6] the masquerade that exists in and beyond the world of finite senses; the masquerade of several parts, each as spectacular, awesome, beautiful, intriguing, different, yet complementary to the other. Like the Igbo *Ijele* mask, the masquerade is a summation of a people's culture and philosophy. Its beauty can hardly be comprehended in a stasis, rather, in its pirouetting movement; its constantly changing position; and its 'multiplicity of frames' is its beauty, its essence.

The artists presented here are like masqueraders. As we have seen, they continuously change their interests, attitudes and techniques as dictated by their individual enquiries into the nature and essence of art, or due to associative influences from other artists. Each artist

takes part in the masquerade, performing before an active audience.

In the beginning, Ben Enwonwu learnt a dance step that had been introduced before his time. He refined his movement and danced so well that he became the most spectacular performer in the arena. But because his performance included many of the styles he had learnt from other lands, his interpretation of the musical rhythms was not convincing enough to draw the next performers to his style. However, the new masqueraders learnt one thing from Enwonwu: the need to add vigour to their dance.

The members of the Zaria Art Society took to the square after Enwonwu. They danced in a manner never seen before. They performed acrobatic movements, somersaults and gesticulations that drew largely from those of the ancestors. This made the audience ecstatic with pride. Even though the Art Society masqueraders knew and acknowledged foreign dance steps and even incorporated them into their dance repertoire, they insisted that only when the masqueraders mastered the steps of the ancients could they add 'flavour' to the performance by borrowing from those of other lands. As in the cases of Uche Okeke and Bruce Onobrakpeya, each had a different ancestry and temperament, so their performances were not entirely the same.

Although the 'Zaria Rebels' took centre stage, in a corner of the arena there were other masqueraders who added variety to the event by performing dance movements from foreign lands, adapted in ways to which their audience was able to relate. Erhabor Emokpae was one of these off-centre masqueraders who felt that the origin of a dance step did not matter so long as the performer did it well and his audience understood it.

Time elapsed and new masqueraders arrived who performed all kinds of dances at the same time. The centre stage split in two.

Obiora Udechukwu and El Anatsui took one corner, inspired by the dance of the 'Zaria Rebels' whose member, Uche Okeke, had gone to that corner to continue the dance he began earlier. Udechukwu added even more to Okeke's style and it became richer, while Anatsui (who came from another community) brought with him his own ancestral dance steps and others he had learnt along the way.

In the other corner, Odutokun started a new dance that included several movements, some of which he learnt from dance masters from other lands. In fact, he borrowed freely from any of the many styles he knew, both those of his people, the audience, and those from distant and nearby villages. Even as he danced these recognisable steps, he also created some that were unique because no one in the audience could readily say where they came from. However, there was something in his performance that was similar to Emokpae's eclectic dance.

Time moved as it always does. Many new masqueraders took to the arena.

So what do we make of all these? How do we watch several masqueraders performing at the same time, turning, changing steps in either slow or quick turns? Perhaps we can do it by altering

our own positions as often as necessary. However, it is not yet time to pass judgment on what the masqueraders are doing, or from which corner the best performance comes. That really is not necessary, for the eternal music continues, and the masqueraders will continue to perform, filling our appetites and imaginations with excitement. However, given that the arena is so vast; given that one can only see two corners at a time, we must not forget that two corners do not make the *market square*, the whole arena. We can say with certainty that the similarity and variety of the masquerades and performances we see here, are but pointers to what goes on elsewhere.

As the masqueraders perform, many more are bound to emerge. If there is anything they have in common it is the need to dance those steps that are best suited to their type, stature and size in order to enthrall the audience and themselves. That is the quest. Again, since a masquerader does not perform in an empty arena, without an audience, and since there are several masquerades, what unifies all is the space in which the events take place. That arena is Nigeria and the summation of the ever-changing experience of the masqueraders is perhaps what we may call Nigerian art. No attempts at characterising the events in the arena with reductionist classifications and in definitive terms would suffice. Everything, the masquerades, the audience, even the experience, is in a state of flux.

Notes

1 The members of the *Ona* group include Moyo Okediji, Victor Ekpuk, Kunle Filani and Bolaji Campbell. The artists draw primarily on Yoruba design and symbolism. Ekpuk, however, includes *uli* and *nsibidi* forms in his work, perhaps because he is not Yoruba.

2 By the early 1990s, Edwin Debebs, Sam Ovraiti, and Zinno Orara from Auchi were already recognised for the brilliant, Impressionistic colour that has become the hallmark of the Auchi School.

3 For more information on *uli* art and decoration, see H.M. Cole and C.C. Aniakor, *Igbo Arts: Community and Cosmos* (Los Angeles: UCLA Museum of Cultural History, 1984); Elizabeth Courtney-Clarke, *African Canvas* (New York: Rizzoli International Publications, Inc., 1990); and Liz Willis, '*Uli* Painting and the Igbo World View', *African Arts*, vol. 23, no. 1 (Los Angeles: 1989), pp. 62-67, 104.

4 The terms 'Zaria Rebels' and 'Kindred Rebels' were devised by Kojo Fuso. See Kojo Fuso, *20th Century African Art* (Zaria: Gaskiya Corporation, 1986).

5 See Obiora Udechukwu, '*Uli* & Li: Aspects of Igbo and Chinese Drawing and Painting', *Nigeria Magazine*, no. 134–135 (Lagos: 1981), pp. 40–50.

6 The Masquerade concept outlined here is largely drawn from Olu Oguibe's Masquerade theory of African art, in which he proposes a multi-perspectival critical strategy for the reading and appreciation of the work of modern African artists. See Olu Oguibe, 'The Paintings and Prints of Uzo Egonu: 20th Century Nigerian Artist', Ph.D. Thesis, SOAS, University of London, 1992. A version of this thesis, without the chapter on the Masquerade theory, was published as *Uzo Egonu: An African Artist in the West*, (London: Kala Press, 1995).

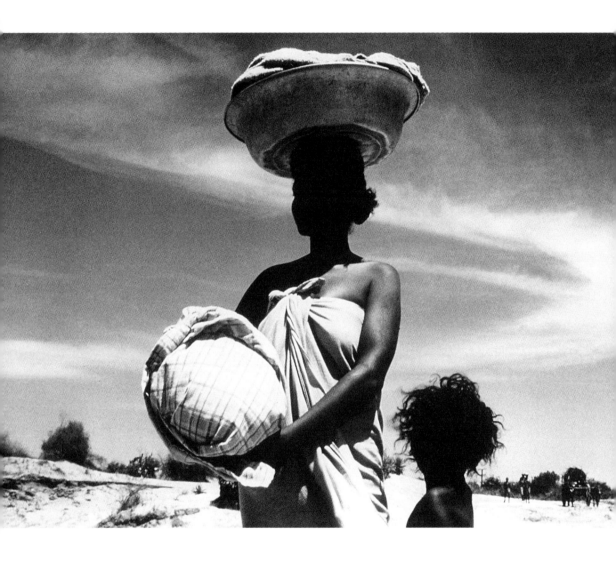

New Developments in Black African Cinema
N. Frank Ukadike

*Today, we can summon to memory the languages of our ancestors. What is important though,
is the rediscovery of the power of words of our people. Metropolitan French, English, Spanish
– all languages of colonisation to be colonised in turn.*
Maryse Conde

*I shall speak about Africa, with confidence both that some of what I have to say will work
elsewhere in the so-called Third World, and that it will not work at all in some places.*
Kwame Anthony Appiah

Contours of an Emerging Trend: Towards a New Cinema?

The above statements vividly address problems of cultural production within the African diaspora
and Third-World societies. With production processes becoming increasingly validated in terms
of new modes of film practice, this endeavour, utilising indigenous systems of thought, is creating
aesthetic practices that illuminate developmental struggles. Even though positive results have
emerged from this collective cultural experience, the urge to give more specific character to
cultural products means widening the indigenous boundaries for the investigation of modes
of representation to provoke discussion. We can see this in the reading of 'nativist texts', when
interrogation of production processes stimulates the selection, arrangement, and reception of
cultural products. African cinema is shaped by the producer's avowed determination to move
ahead, unencumbered by the legacy of the dominant paradigms.

In recent years, innovative works of historical, cultural, political and aesthetic significance have
emerged from 'new breed' African filmmakers as well as from the pioneers, enabling us to speak
about 'interrogation of origins' (that is, transformation of negative conventions into a positive source
of signification), 'analytical complexities' (exploration of African alterity via sociocultural dynamics),
and 'aesthetic diversion' (nationalistic practices versus aesthetic internationalism). It is now
possible to say that African cinema is at last penetrating the world market with major works of
indigenous cultures that explore and adapt their own oral and literary traditions in the articulation
of a new film language. Yet, the relationship between the perception of African cinema and the
realities it tries to depict is a paradox marked by the filmmakers' indefatigable struggle.

On the one hand, experimental trends inherent in recent developments in African cinema
exemplify a characteristic emphasis on film as cultural and political practice. As the concern
for economic viability deepens, African cinema can also be understood from the perspective of
thematic and aesthetic pluralism. On the other hand, the aesthetic orientation seen at first as
hybrid was gainfully used to critique the aesthetics and ideology of alien film practices, later
developing as a renovated film language. Additionally, the employment of oral tradition and other
cultural codes that served as the base for indigenous aesthetics also helped to repostulate

canonised Western paradigms (modes of production and spectatorship). However, while oral narrative illuminates the paradigmatic exigency of black African film practice, the engendering configurations for the new aesthetic are in danger of being misread as an alienating convention. It is my contention that this alienating posturing is inescapable – involving both the combative didactic practices of nationalistic concerns (Ousmane Sembene, Med Hondo, Haile Gerima, Gaston Kaboré, Souleymane Cissé, and Kwaw Ansah exemplify this category) and the politically compromised aesthetic internationalism of economic concerns (represented by the works of Idrissa Ouedraogo, Cheick Oumar Sissoko, and Henri Duparc).

In the first instance, we have categories of films put in the service of political consciousness, and in the second, films that are thematically audacious and innovative but whose sociopolitical allegory is diffused by pandering to the imitation of alien conventions and commercialisation. If it is true that within the confines of political awareness and cultural affirmation the latter works would be deemed as abandoning the collective consciousness engendered in the pioneering films, it is the recourse to aesthetic internationalism – the fusion of traditional codes with canonised Western forms – with which they aspire to break through national and international alienation.

Politically conscious films constituted the mainstream, at least through the early 1980s, especially in the francophone and lusophone regions. In the late 1980s, the new African films created by newcomers launched an opposition to the dominant didactic formulas. Seeing themselves as no longer on the periphery, these filmmakers discarded heavy-handed didacticism for narrative conventions that stressed entertainment over instruction. Although the films are modelled after oral tradition, the majority, as we shall see, cannot be said to be revitalising film language. There seems to be a movement away from the political use of the film medium, which addresses and relates to authentic cultures and histories, toward a concern with film as an object of anthropological interest. It has been argued that most films employ the same Western ethnographic conventions that have historically worked to limit the understanding of Africa's sociocultural formations.[1] Is African cinema in general lacking the dynamism and experimentalism of the 1960s and 70s? How has it developed operational tactics that promote (inter)nationalisation of film form and ideological precepts? Has the diversity of textual expressions created new attitudes towards black African film culture? This text will provide a matrix of convergent and divergent perspectives by examining recent films, illuminating their historical, sociopolitical, and cultural affirmations, while at the same time foregrounding the approaches and structuring complexities of the emerging trends.

African cinematic practice of the 1980s, if nothing else, has done an enormous job in terms of restating the authentic values of African society and, given the popularity of some of the films, enhancing the position of this cinema within the stylistic repertoire of world cinema. With the protean notion of Africa as 'cinematographic desert' now obsolete, the question is no longer

whether Africans can make films. The excitement and expectation offered by recent films compel one to accept that there can be a prosperous African film practice given the right incentives. The unprecedented success of some recent African films, both in terms of critical acclaim as well as box-office receipts (in Africa, Europe, and the United States), promulgates speculation regarding the emerging trend of new African cinema. Does the current trend constitute what might be considered the quintessence of African cinematographic art and industry? It is with this question in mind that I shall examine *Yeelen* (Brightness, 1987) by Souleymane Cissé, *Yaaba* (1989) and *Tilai* (1990), both by Idrissa Ouedraogo, and the following social-realist films (also with cultural ramifications): *Finzan* (1989) by Cheick Oumar Sissoko, *Bal poussière* (Dancing in the Dust, 1988) by Henri Duparc, and *Zan Boko* (1988) by Gaston Kaboré. I shall also address this study to the historical affirmations in Med Hondo's *Sarraounia* (1987), Kwaw Ansah's *Heritage ... Africa* (1988), and *Camp de Thiaroye* (The Camp at Thiaroye, 1987) by Ousmane Sembene and Theirno Faty Sow, examining their historical propensities and methods of construction.

The new African films have not strayed too far from the issues depicted in earlier ones, yet the impact of the popular films by the 'new breeds' are more strongly felt than that of their predecessors. I will argue that the impact of the popular African films of the 1980s is a result of filmic subterfuge: passion for ethnographic information (thematic construction); profilmic and extrafilmic organisation (immutable landscape); and aesthetic reconciliation (the incorporation of oral art).

In black African film practice, Ntongela Masilela identifies the historical and cultural meaning of African cinema as relating to the 'dialogism' between Frantz Fanon's philosophy of culture and Amilcar Cabral's philosophy of history, noting that the former is a deliberate attempt to restructure Africa's political systems while the latter strives to redraw the map of the 'social geography of African history'.[2] Applied to the new African cinema of the late 1980s, it is possible for one film to embrace both philosophies, as in the cases of *Camp de Thiaroye, Zan Boko, Heritage ... Africa*, and *Sarraounia*, whose structures exhibit affinities with the social and historical philosophies of Cabral as well as the cultural and political philosophies of Fanon. Although films such as *Yeelen, Tilai, Bal poussière*, and *Finzan* openly exhibit an exquisite affinity with culture, they lack the political candour of Fanon's ideas. Exception, however, can be made for *Yeelen*, whose analytical complexity and (arguably) biased political undercurrents are hidden beneath the umbrella of traditional culture.[3]

As indigenous cultural expressions, the films are situated within the social context of multicultural Africa. Hence, the symptomatic trend is a wide range of representation and interpretation in works inspired by African and Third-World resentment of Western processes of conversion (*Camp de Thiaroye, Heritage*, and *Sarraounia*) to culture-based representational structure (*Yaaba, Yeelen, Finzan* and *Zan Boko*). It is this resistance to assimilation that unites black African cinema with Africanist theories on African culture. Although the films display their 'unity

on a continental plane . . . they equally differentiate themselves from each other by simultaneously articulating national cultural patterns, national ideological conflicts and national class confrontations'[4] and, we might also add, national economic patterns. For example, *Bal poussière* could be read as a political film, although its few political jabs get lost in the comedic structure. Yet, like the film's environment, some narrative codes (its theme and music) are typically African. Although the focus of each film is on geographically divergent zones, the contents and significations indicate similarity of purpose and goals. Ideologically, there is the persistent struggle to develop genuine film practice; politically, there is an attempt to use the film medium as a speaking voice of the people; and aesthetically, there is relentless experimentation with film form aimed at achieving indigenous film culture, although it has not been possible to reach this goal. Similarly, there is a profound urge to satisfy the tastes of both African and foreign audiences. Reflecting the economic realities in Africa today, the targeting of foreign audiences connects philosophically with the notion of economic viability, in which effective export of goods enhances the gross national product.

Narration, Transgression, and the Centrality of Culture

Black African film practice rejects all vestiges of colonialism and acculturation. Because cultural assimilation has involved the protracted colonial process of stripping Africans of their individuality, the various steps taken to counter this process argue for the linkage of self-affirmation with universal consciousness, for example, attachment of the individual to society, and society's place in the centrality and the collectivity of world culture. This process of inclusion and retrievability, of what John A. A. Ayoade terms 'reculturation and re-Africanisation'[5] echoes the need for the restitution of social institutions, relations, beliefs and practices congenial to indigenous traditions expressed in nationalist agendas. In his essay 'Cultural Restitution and Independent Black Cinema', Tony Gittens identifies some essential characteristics of indigenous beliefs and practices. He states that 'they are usually ritualised and celebrated in a process which helps to engender a sense of national, secular, regional, or ethnic pride, dependent on the type of cohesive force and social priorities binding a particular group together'.[6] This explains why cultural productions are viewed critically and, regarding African films considered by Africanists as the epitome of decolonisation, there is continuous demand for African dignity to be forcefully depicted on screen. 'Dignity', in the words of the late Captain Thomas Sankara, the ex-president of Burkina Faso,

> has not been presented enough [in African films]. The cry from the heart, justice, too, the nobility and the necessity for struggle in Africa, that has not been shown enough. Sometimes one has the impression that Africans are striving in vain in a world of evil men. What we have experienced, what we have suffered, what we are now experiencing, what we are still suffering – this has not been publicised enough and we also know that the media elsewhere in the world

are efficacious in preventing people in other countries from understanding the struggle which we are waging here.[7]

African films such as *Yaaba, Tilai, Zan Boko, Yeelen,* and *Finzan* offer meticulous anthropological renditions of African cultures. The films are true to life and do not attempt to rearrange natural settings or modernise them to look foreign. In their cultural manifestations, certain rituals, music, dance, and song, once considered primitive, are frequently adopted motifs in these films. It has not been easy to achieve a way of reconfiguring the images created, of transforming them into counter-hegemonic images capable of confronting dominant paradigms in order to engender a sense of African pride and the sort of identity envisaged by Sankara. Sensibility and sensitivity as the mainstay of African film practice, and the need for indigenous characteristics, simply require a formula that presents the environment and characters without running into the Hollywood situation in which non-Western images connote the exotic 'Other'.

While sympathising with the pioneering impulse that created African cinema, the 'new breed' African filmmaker seeks to advance cinematic strategy beyond the ideologies that have defined the contours of didactic sociopolitical films. In the first place, there has been no inclination toward cultivating the services of professional actors. Second, in the absence of a sound infrastructure to pursue glamorous projects, the filmmakers feel there is an overabundance of local themes and an inexhaustible number of sociocultural motifs with which to sustain production. Thus, as long as village scenery and pastoral landscapes continue to provide the desired spectacle and backgrounds that urban landscapes lack (for example, skyscrapers that are similar to the ones in Paris, London, and New York), filmmakers capitalise on this simple arithmetic of economics.

The cultural dynamics of African cinema must also be examined within the larger significations of African cultural discourse. Africanist thinking has long recognised the dialectical link between one factor of development and another, in this case, the coalition of cultural and economic enterprises. For example, on the dynamics of culture, Sékou Touré of Guinea notes that 'every people must struggle to exist by creating the material means of its existence'.[8] For him, culture is 'a social process, an infrastructure' whose characteristics are determined by 'the level of development of productive forces and the nature of the means of production as determined by the historical and social context'.[9] Bringing this point closer within the environs of the dominated people's struggle in Africa in particular, Touré goes on to emphasise that 'the cultural level of a people . . . its means of conquering knowledge, its manner of explaining phenomena, will depend on the . . . degree of objectivity and abstraction attained in the heat of action to gain mastery over ever more perfect techniques'.[10]

In the African film industry, the tripartite relationship amongst the cultural, economic, and historical forces responsible for the development of African cinema reflects the shifting

conditions of African culture and its economy. If the responsibility of the African film industry is to cultivate audiences for African film, then the accomplishments gained in production – the instinct for self-preservation (cultural restitution) and fulfilment (aesthetic development) – must embrace societal and infrastructural requirements (audience reception). As it is now, African cinema has presented African culture both realistically and impressively on screen. But it has not been able to exploit the continent's economic potential. An attempt to pull African film practice out of its current form of marginality can only be achieved if genuine development of the audience and reception patterns are refocused. And, if there is to be a common ground in this film practice, it will undoubtedly be found in the aspect of production to be nurtured rather than patronised in Africa, not perceived as a metaphor for otherness, isolation, and difference but as a continent central to world power institutions, no longer bound to the periphery.

Generally, while African film practice has succeeded in renovating its film language, it can also be argued that it has failed to produce a new African audience capable of exploring different patterns of signification while pondering this 'new' African film language. Toward this goal, the most important endeavour would be the making of films that challenge the reception patterns of the African audience. While some African films succeed in attaining this goal, others actually alienate their audiences, precluding the building of a strong African audience for African films.

Yeleen, Yaaba, Tilai, Zan Boko, and *Finzan* are films made in the 1980s that have emphasised African culture specifically and, in the case of *Zan Boko,* have contrasted precolonial tranquillity with the turbulence of contemporary life. This is not the first time that African culture has been meticulously studied in African cinema. If compared with earlier black African films, these new ones show shifting aesthetic and formal concerns. Here we find that the sociocultural dynamics that influence the cinematic language of explication can be both asset and anathema. In this sense, structural configuration poses methodological questions not only about what the artists are saying with the images they create but also about how they say it. This surging interest in these recent African films stems from the curious anthropological images they proffer, some critics reading them as innovative, others as repugnant. There is vivid concern to stretch enquiries about Africa beyond cultural and anthropological limitations. The crux of the matter is that, while the majority of films are packed with realistic images of everyday village life, over-emphasis on 'lowlife' details reinforces the fascination with the exotic African images in Western ethnographic films. Rather than destroying and deconstructing canonised codes of spectatorial fascination through rejuvenated film form and modes of production, some of the films perpetuate marginality and also invite reductionist readings, mainly within the confines of ethnographic film discourse.

From another perspective, some critics have argued that the images and verisimilitude present in African films indicate structures that manifest African notions of ethnography, and that by depicting the African peoples the way they are, showing their cultures and histories, these images

explore value systems contrary to Western ethnocentric understanding (in which non-Western images are evaluated by Western norms). In this sense, the films are also read as reversing the institutionalised condescension and master-race narcissism offered in Western ethnographic films.[11] It is in this light that we focus on the varying trends of the African films of the 1980s by examining their thematic, aesthetic, and textual configurations.

Souleymane Cissé's *Yeelen* (prize winner at the 1987 Cannes Film Festival) epitomises the daring stance shared by African cinema pioneers. In every respect the filmmaker's quest for an indigenous film structure parallels the film's exploratory tactics and is realised in a complex cinematic style. The film narrates an initiation journey that puts father (Somo Diarra) and son (Nianankoro) on a collision course as they struggle for supremacy in the possession of a special knowledge – the secrets of nature – that is exclusive to the Bambara people of Mali. The father, seeking to prevent his son from acquiring this special knowledge, plans to kill him. But Nianankoro's mother intervenes by sending her son away on an initiation journey that introduces him to the oral cultures and traditions common to the Sahel. This pilgrimage takes him across the semi-arid regions spanning the Bambara to Dogon and Fulani lands, enabling him to acquire the ultimate knowledge that establishes his own supernatural powers.

Cissé documents that this film was accomplished through mutual understanding and respect, by placing the significations of form and content within social, cultural, and historical contexts and in a transgressive mode of address far apart from dogmatic codes and conventions. For example, *Yeelen* could either be seen as promulgating a strict reflectionist or deterministic notion of cultural and social connotations or, more daringly, it could be read as an anti-traditionalist allegory that introduces 'the correlate' and 'the resilient' as dichotomous canons for the critique of tradition and change.[12] The very depiction of the *Komo* secret society, in which the camera lens witnesses the actual initiation, rituals, and ceremonies, would ordinarily have been regarded as sacrilegious and intrusive. In fact, traditional Malians have long been suspicious of what they term the 'diabolic images' of the devil's magic machine named *Tiyatra*.[13] But Cissé holds the middle ground between the Western ethnographic conception of the moving image, which seeks out the misery of the Third World, and the falsehood of repressing it on the grounds of cultural intrusion. Thus *Yeelen* is significant for a number of reasons: the film creates a dialectic of old and new; as a critique of culture, it displays new ideas; and as a critique of convention, the filmic strategy suggests a resolute trend in creativity, fresh and focused on African film language. Out of this practice, however, emerge certain questions of perspicacity and contradictions of ideological ramification. I attempt to expedite this study through an examination of Cissé's concern for authenticity and respectful treatment of the subject and the cinematic strategies contiguous to the film's realisation.

Structured around mythological patterns, *Yeelen's* complex narrative allows one to explore the articulation of the precolonial and the traditional. The film's binary structure foregrounds the

distinctive dynamic of traditional culture, also revealing its contradictions, such as the antecedent practices indicative of what Kwame Anthony Appiah, in another context, terms 'exclusivity of insight'.[14] By calling attention to the opposition and rejection that dichotomise traditional systems, Cissé's projection of the inevitability thus centres around apostasy, which works as a revisionist code that, though not on a par with traditional systems, enables him to construct the dialectics of culture and morality. By having Diarra refuse to transfer generations of secrets to his son, the viewer is forced to sympathise with Nianankoro when he attempts the retrieval of this knowledge by force. In this respect, the father's action nullifies one of Africa's most cherished traditions – the quest for knowledge – while the son's rebellion is just another case of nonchalance typifying negation of the tradition of morality that is emblematic of respect and loyalty to the elders. This film does not show us, however, that Diarra is not obligated to reveal such secrets to his son since he is too young to be entrusted with the secrets of the *Komo*, which only members who have attained the rank of *Kore* can possess. According to Kate Ezra, it takes a neophyte 'seven-year cycles through six grades of progressively more arcane knowledge' to reach, at old age, the Kore stage.[15] Because the *Komo* is highly restrictive, and because the powers wielded by the members are all-encompassing, like other secret societies all over the world, it is prone to criticism and rejection. But considering that Cissé's background is in the Soninke – early Islamised marabouts – [16] it is possible that the director is speaking on behalf of his own clan, which may be deprived of admission to this impregnable Bambara knowledge.

The nation of Mali is ninety percent Islamic, and Cissé's view, while its focus is mainly on contemporary Muslim urban and rural society, does not necessarily indicate that traditional systems should be discounted. Rather, he reflects on what has plagued African sensibility for many years. He ponders the potentials of traditional culture – for example, the practise of witchcraft – which is not put at the service of advancement, in what amounts to an Africanist injunction to garner such culture for posterity. Put another way, this implies that beyond witchcraft's present scope, Cissé is advocating a new kind of thinking, a refinement in which such powers are no longer misused but are transformed from destruction to invention, as have been the inspirations that have shaped Western scientific and technological prowess.

It is interesting to note that he has the ability to tell a legendary tale against the backdrop of a cultural motif without resorting to reductionist conventions. His fabulous attention to detail is not simply exploitive, illustrative, or didactic; rather, he develops a way of introducing new cultural perspectives – new ways of looking, discovering, and identifying. He does not select his characters and locations in order to simplify or exoticise them; his composition in depth, camera movement, *mise-en-scène* and sound coalesce into what might be termed a discerning vision. Together with the natural movement and mannerisms of his non-professional actors, the distinctions between society and culture and fiction and reality are interrogated as fictional characters are juxtaposed

against ritual and the ritualistic to evoke specific sociocultural dynamics. This prerogative, charged with the inclination for authenticity, is attributable to the philosophy emerging from the 'mastery of content' as he says, which forces one 'to select forms that are appropriate'.[17]

In *Yeelen* the characters must go through a series of encounters as part of an initiation process that would enable them to acquire more power and knowledge. In the end, both father and son perish. For Nianankoro to attain the level of maturity necessary to confront his father's prowess means the acquisition of occult powers. He must recover the *kore*, a 'spectre' – a long piece of carved wood shaped like a wing, symbolising knowledge and power – which is the only thing capable of destroying the *Komo*. Already he has retrieved parts of the missing wing from his mother, and she now reveals to him that the remaining piece is in the possession of his father's identical twin brother, Djigui, a blind man who fled the Bambara land. Later, we learn that Djigui himself lost his sight trying to acquire the *Komo* secret. A series of encounters that attempts to cast doubt on the relevance of the whole process of this mystical acquisition and the negative connotations of the cult are set in motion: Nianankoro kills Baafing, one of his other uncles, who had tried to persuade him to give up his vengeful mission. In the land of the Fulanis (Peul), he seduces the King's wife, Attou, proclaiming, 'My penis betrayed me'. Later he marries her and she bears him a son.

On the other side of the conflict, members of the *Komo* cult are meeting secretly and deciding what kind of punishment to inflict upon Nianankoro. He must be stopped before he acquires the power to destroy them, and this means destroying him. It is not surprising that his father, armed with the pestle of the *Komo*, embarks on the dreadful task of tracking him down. When they finally meet, Cissé unleashes one of the cinema's most dramatic moments. Nianankoro, with the wing of the *Kore*, and his father, with the pestle of *Komo*, stand gazing at each other. In this confrontational stance there is a powerful and unpretentious composition: the extreme close-up of both men's faces compels us to witness a wide range of moving emotions. Few words are exchanged. We see both men perspiring feverishly, and when the tears in Nianankoro's eyes begin to trickle down, both the *Kore* and the pestle emit magical rays. The screen turns translucent, an indication that the competition is over, as both men are destroyed and the earth scorched.

By allowing Attou and her son to survive, Cissé's prophecy is fulfilled. This is first implied when Nianankoro is seen deliberating with Djigui on the parched ground of the Dogon, when we learn that the *Komo* cult, if unchecked, will continue to use its powers to subjugate the inhabitants. In the last scene, Nianankoro's son is seen walking over a large sand dune through a beautiful desert. He uncovers two 'orbs', gives one to his mother, who in turn gives him Nianankoro's *grand boubou* (robe). If an accurate reflection of a particular society is the main point of *Yeelen's* narrative structure, the film can be read as criticising redundant aspects of the *Komo* cult and at the same time presenting it as an authentic culture specifically valorised to project its cultural significance. The film's utilisation of the myth of origin with which it embellishes its structure is indicative of the

credo of returning to one's roots as a paradigm of reaffirmation, politically as well as aesthetically.

Amie William's observation that *Yeelen* and some other African films 'dip into the ancient past not to escape the present or lapse into nostalgia but to extract knowledge and history relevant to the present condition of its viewers as dispersed postcolonial subjects'[18] echoes Cissé's contentious stance of transforming spectator intractability (African or Western) into docility, a transformation involving active processes of 'looking', 'interpreting' and 'discovering'.

Nianankoro's position not only exemplifies hope for Africa but also ratifies, once again, what many Africans have wished for in the postcolonial era: eradication of all forms of dictatorship and the sweeping aside of all dictators, tyrants, and corruption, making way for a new generation to emerge. In this sense, the dramatic closure reminiscent of many African films, *à la* Sembene, withholds judgement. Cissé's *Yeelen* imposes the filmmaker's vision.

Yeelen displays Cissé's powers of directional invention in its combination of forms. As a poetic celebration of African culture it is dynamic; in the sense of authenticity and cultural iconography and in the sense of indigenous African art form, it is a classical epic reminiscent of the tradition of Sanjata, weaving aspects of repressed cultural motifs – rituals, folklore, and symbols – into a historical tapestry of ritual values. As a cinematic summa encompassing the indigenous and the mainstream, it specifically alludes to styles ranging from Sembene's candid didacticism to Hondo's eruptive style; in it we find the fusion of ethnographic and documentary modes, fiction and reality, *cinéma vérité* and oral literature.

Although *Yeelen* is not exactly a film that fits well into the tradition of social realism, its pattern of construction reflects a synthesis of ideology and aesthetics that is reminiscent of early Soviet filmmaking. For instance, Dziga Vertov's radical documentary practice was distinguished by artistic and innovative editing and camera technique. So too is *Yeelen* in its formalist criteria of *mise-en-scène*, lighting, photography, and directing, all fused with the cultural components of African oral tradition to produce a distinctive narrative structure and rhythmic patterning that make it brilliantly evocative. It is here that Cissé succeeds where many have failed. However, our concern is not to appraise the film as the 'most beautiful film ever to have emerged out of Africa'[19] since it would be naïve to subscribe to that view, but rather to see it as a dynamic construction whose beautiful photography demystifies the notion of the photogenic. This film compels the viewer to feel as if, in Alice Walker's phrase, 'one has been in Africa during several centuries'.[20] It is this that is central to our discourse.

Yeelen's inventiveness is also notable in its subversion of linear narrative structure. For example, favouring short vignette over lengthy narrative development, it could be argued, is instrumental to the film's complex structure. Many scenes and sequences are particularly illuminating due to various innovative devices. But his structure emanates from the complex paradigms of the cultures presented in each episode. The purpose is to foreground the use of cultural codes so that the viewer is forced to articulate the complex relationship of precolonial structures to the present.

Yeelen (Brightness),
Mali, 1987
(dir. Souleymane Cissé)
Film still courtesy
California Newsreel,
San Francisco

For instance, the film's flashbacks draw attention to the interplay between past and present, and, since the film is replete with so many allusions, it also illuminates the boundaries of fact and fantasy. This means that the language of indigenous modes of enquiry is presented in a dichotomous art that bridges the distinction between the African mode of address (precolonial past) and the technologically inspired mode of representation (neo-colonial present). I will expand upon this with specific examples to illustrate that there is a dialectical connection between traditional art forms and the mainstream, based around reconstitution, and I will show how this duality affirms cultural existence and identity in a non-convoluted fashion.

Nature and scenery have constituted the settings of the majority of African films, although not as a focal point of interest as is the case in Cissé's *Yeelen*. Most of the events take place in the bush, such as the initiations, or on the parched grounds of the Sahel, but these settings are neither romanticised nor reduced to exotic decor in the Hollywood fashion, which would deny Africans their culture. Universal significance is accorded nature's gifts; for example, ancestral soil, water, and trees are assigned symbolic values. In the scene in which Nianankoro and Attou are seen bathing, water symbolises purity and fecundity, and the respect attached to the shooting of this sequence clearly indicates Africa's notion of morality maintaining the human body as a sacred entity. Although there is semi-nudity, it is presented in a wholesome, nonsensational way. Similarly, colours are significant, as in the black pigmentation of Attou, Nianankoro, and the close-up shot of Nianankoro's mother as her fingers mix the water in the bowl before she uses it to purify her son. Consider also the shot of the stream water and blue sky, together with the natural shadows cast by the sunlight; these are captured in their purest naturalism. This visual simplicity compels one to think about the close-up shots of the cliff leading to the stream as Cissé's panoramic camera pans slowly around to highlight natural beauty at its best.

In Africa the tree is universally symbolic, and like any other of nature's creations, accorded multiple interpretations. What one might call the 'cosmic tree' is believed by Africans to eternalise the link between the earth and the cosmic universe, an intermediary between the natural and the supernatural. Trees are also valued for providing basic necessities of life: food, medicine, and knowledge. Residents of the Sahel attach special importance to the baobab tree: it plays a significant role in initiations and ceremonies.[21] In *Yeelen*, rituals are performed under a baobab tree, which serves as a meeting place for cult members. (Cissé was particularly concerned with appropriate representation of the rituals to instil their significance and meanings, transcending the images of Africa offered in ethnographic films.) The tree is also an instrument of power and has mystical dimensions; the wing of *Kore* and the pestle of *Komo* (symbols of power and knowledge) are both carved from the tree of wisdom. As cultural 'eyes', they are deemed to have seen ancestors come and go. There is hardly a film of the Sahel region that does not feature the baobab tree.

The level of experimentation, solid as it is here, ratifies Cissé's contention that 'knowledge is

built and consolidated by one generation [precolonial], it is destroyed by another [colonialism], and recreated by a new generation [indigenous practices]'.[22] In his discussion of the production and commodification of African art, Kwame Anthony Appiah distinguishes between the 'traditional' and the 'neo-traditional'.[23] 'Traditional' African art – likely to be favoured by minority African elites, 'if they [buy] art' – dons the accoutrements of precolonial 'styles' and 'methods', whereas the 'neo-traditional' is tourist art 'produced for the West'.[24] Applied to African cinema, I would argue that there is no precolonial African structure in cinema, but rather that oral narrative gave African cinema precolonial traits that were integrated into the postcolonial cinematic paradigm. It is more plausible, therefore, to state that since African cinema originated after independence from two conventions – the mainstream and the indigenous – it exhibits affinities with the 'neo-traditional' in terms of inception but not in terms of commodification as in the neo-traditional genre of African art.[25] However, since Africa is deeply immersed in a culture of poverty that worsened in the late 1980s, some sections of African film practice transmogrified to what one might call 'bi-traditional' structures. This in turn, with respect to the popular films of the late 1980s, made them susceptible to exploitation, commercialisation, and misinterpretation. Simply put, what is typical about this genre of bi-traditional structure is the choice of a universalist theme distinguished by hybrid conventions, which targets foreign spectators for materialistic ends. Does this mean that the films are incapable of cultivating African audiences, or confronting and challenging the dominant conventions that Hollywood uses to construct denigrated images of the 'other'?

Gaston Kaboré, Idrissa Ouedraogo, and Cheick Oumar Sissoko, Françoise Pfaff notes, 'seem to have a predilection for the filming of rural lifestyles', but their films are 'not made with specific ethnographic intentions'.[26] But of the monotonous images of women pounding millet or corn, or families cooking or eating, as is the case with almost every film, one cannot help but caution that Africans already know the processes of pounding, weaving, and tilling the soil. While these images unquestionably connote vignettes of life as actually lived in the villages, they can only appeal to non-Africans at the expense of alienating the African audiences at whom they are aimed.

We must also acknowledge that in using these images of rural lifestyles, some filmmakers have been able to construct culturally, politically, and aesthetically inventive films. One such director is Gaston Kaboré. His film *Zan Boko*, like his other feature *Wend Kuuni* (1982), depicts the confrontation between two humanities', as he puts it, and critically examines the disrupted lives of people forced out of their ancestral village as a result of urban expansion. *Zan Boko*'s main focus is on social justice, corruption, arbitrary misuse of power, acculturation, and freedom of the media to deal with the problems of modernisation and urbanisation.

Tinga Yerbanga, the film's protagonist, is forced to abandon his ancestral land to urban expansion partly because his wealthy neighbour wants to use the land for a swimming pool. A fearless journalist is thrown into the centre of this social injustice when he aspires to reveal Tinga's

predicament. His live television current events show mounts a forum on the problem of forced urbanisation, which Tinga attends. Because it implicates government officials, the show is suddenly cut off the air when the minister of information orders an end to the broadcast.

Zan Boko is a courageous film and ironic in the sense that the very establishment it lampoons – the Ministry of Information – helped to finance the film's production. It thus echoes the audacity and the strategy of denunciation in Cissé's *Finye* and Arthur Si Bita's *Les coopérants*, which also critique the governments that financed them. Kaboré, however, makes it clear that his film was started before the regime of the late Thomas Sankara was instigated.

The film starts at a leisurely pace as ethnographic realism dealing with images of everyday life. But it uses this meticulous exploration of village culture to inform the audience about the politically charged atmosphere of its second half. Kaboré skilfully transforms what could have been an innocuous and romantic evocation of the patina of exoticised life into an extremely combative sociopolitical critique. John H. Weakland refers to fiction film as narrative film that presents 'an interpretation of some segment of life by selection, structuring and ordering images of behaviour'.[27] In *Zan Boko*, this reference is recontextualised as a heuristic device rather than as an ethnographic study, and should not be misunderstood as such. When Kaboré's camera slowly takes its viewers to witness scenes of workers in the field, we are reminded of communal labour activities spanning time immemorial. Women carrying water gourds on their heads do not signify misery; rather, we are informed that it is a way of life. A woman giving birth to a baby outside a modern clinic makes crystal clear the prowess of traditional medicine rather than the backwardness of 'witchcraft'. When men gather around fires each evening and women chatter, the relevance of oral culture is amplified. These are selections of images that accent the sociocultural parameters of this work as reflected by its title, which Kaboré explains in his production notes:

> Amongst many black African cultures the birth of a child is accompanied by rituals that are designed to prepare the introduction and acceptance of a new member of the community. Among the rites practised by the Mossi in West Africa, is the burial of the mother's placenta. This act consecrates the first bond between the newborn child and the nourishing earth. It is also the home of the ancestors and of the spirits which protect the family and social group. The place where the placenta is buried is called 'Zan Boko'. These two words are used by the Mossi when speaking of their native land, with a meaning that is at once religious, cultural, historic and emotional but also signifies a real relationship with place. 'Zan Boko' is an expression of the concepts of 'roots' and 'identity'.

In *Zan Boko* the special relationship of attachment to one's ancestral land is disrupted, turning that energising cultural icon of existentialism, popularly tagged 'son of the soil', into a figure of

displacement and disillusion. This obliteration of tradition begins when the modernising government surveyors arrive and start defacing the 'pretty mud brick huts' with 'white harsh numerals' in *Variety* reviewer Yung's phrases.[28] In this scene, where natural sunlight casts interesting patterns on the wall, Kaboré eloquently dramatises his concern for relationship and, above all, identity. In an unusually long take, the camera lingers on a nine-year-old boy as he moves gradually toward the numerals on his father's wall, which he laboriously rubs off with a piece of brick. In this sequence, Kaboré knows when to alternate psychological time with cinematic time. The first shot establishes the boy's intentions: the spectator is positioned to witness him perform the act. For emotional impact, Kaboré then cuts to a medium close-up of the boy's face, which reveals consternation. Finally, the third shot (a close-up) shows the numbers almost completely erased as the boy's hand goes in and out of the frame – still rubbing. The sadness on his face suggests everlasting memory, paralleling the scar of remembrance indelibly etched on the wall. Although the numerals are gone, the wall no longer retains its original look, just as the boy's experience is likely to remain with him as he grows up.

A visual collage of village life comprises the tapestry of indigenous cultures that Kaboré exploits for intelligibility. In the second part of the film, when the focus shifts to the interrogation of the role of media in society, the conflict between the traditional endogenous systems of communication and the technological, imported television culture is dramatised. This dramatisation can be seen to represent an imposing dialectic between appropriating Western conventions and deviating from its norms. As an example, *Zan Boko's* focus is on the problems of urbanisation and modernisation, their impact on the people, and their relationships with the environment. But when the dauntless journalist, Yabre Tounsida, decides to hold a live debate on his current affairs programme, television's role as a symbol of enlightenment is reversed, becoming one of disinformation. He introduces his guests, the secretary general of the mayor's office, the general manager of national lands, the general manager of public works, and a sociologist, after which he announces that he is expecting a fifth guest. This guest, Tinga, is deliberately made to appear late in order to disguise the main focus of the show – the misappropriation of his land, nepotism, and governmental corruption.

The whole process of staging a live-action show of this type undercuts the subversive nature of television culture in developing countries such as Burkina Faso. As Tinga walks onto the stage, we can tell that he is in an alien environment. The only forum he knows is the traditional type in which the elders meet under the baobab tree or in the King's court, where knowledge is transmitted and disseminated. As if in this traditional forum, when Tinga walks into the studio he offers his hand to the other invited guests, only to be told by the host, 'It is not necessary to shake hands. Have a seat'. He heads toward the floor before Yabre points to an empty seat reserved for him. Momentarily, Tinga is carried away, mesmerised by a beautifully painted backdrop, artificial decor that he finds alienating and far removed from the kind of natural environment, fresh air and sunlight, in which

traditional meetings are held – as opposed to this air-conditioned room with hot lights pointed at his forehead. The programme continues for a short period of time, but when the host acknowledges that Tinga's problem is scheduled to be discussed, the programme is ordered off the air. Tinga's presence is symbolic because it is his story that causes rupture, forcing the minister of information to cut off the programme arbitrarily.

During this period, Kaboré's camera frames the participants in television-news style, using medium shots and close-ups and eschewing the long takes and long shots that are characteristic of the first part of the film. A female announcer, dressed in a colourful African print with head tie to match, walks in a few seconds after the screen goes blank, to announce, 'We ask every faithful viewer to please excuse us for this technical problem. But our programme will continue with the third episode of the magnificent serial "The Golden Dream", which will take us to the enchanting Riviera'. This statement mocks the very identity that the traditionally dressed announcer represents. The words, 'faithful viewer' and 'enchanting Riviera' metaphorically connote compliance and cultural erasure. Perhaps we would have accepted the naïve excuse for technical problems if the audience had been taken to the splendour of Victoria Falls (at the border of Zambia and Zimbabwe) or to Maroko, in Lagos, Nigeria (to witness urban slums, chaos, and helplessness). That a programme intended to debate national problems is replaced by a foreign one suggests a myopic vision that is indicative of national disaster. Kaboré uses this irony to look critically at society, its cultural heritage, and diversity. While questioning, he also subverts and destabilises anachronistic dichotomies rooted in the traditional and modern.

The pervasive codes of media communication in this circumstance pose a serious challenge to traditional oral communication patterns. The rich man's message is communicated to Tinga via word of mouth, as opposed to the newsroom situation in which telephones function as an oppressive device. It is possible for the government dignitaries to connive with one another through the telephone to stop Yabre's broadcast. In both cases, television and telephone, as subversive communication devices, demarcate what we see, how we see it, and how we evaluate the images represented. The interesting thing is that it is through the omnipotence of oral literature, which modern technology here tries to subvert, that *Zan Boko* becomes indefatigable. Therefore, it is right to observe that the film's peculiar hybrid nature is capable of introducing a situation that makes it possible to negotiate between generic codes and cinematic forms both affirmatively and transgressively, creating a nationalist work.

The film also shows how modern society subverts traditional culture through double standards. A clear example would be the kind of support that Tinga's rich neighbour receives from high government functionaries who have sworn to uphold the law of the land and faithfully serve its citizens. It demonstrates how nepotism and personal alliances can easily be used to out-manoeuvre others in one's own society. The effectiveness of the film derives from the simplicity

of Kaboré's style, his editing, camera placement, and *mise-en-scène*, recalling his concern for 'two humanities'. In effect, the first part is realised in minimalist editing as every shot, every long take, comes straight out of the camera as if unmediated. Characters are observed behaving normally as they go about their business in the realist, traditional manner typical of Satyajit Ray (*Pather Panchali*, 1955) and Ousmane Sembene (*Mandabi*, 1968). Also incorporated, however, as the pace quickens in the second half, are some elements of the here-is-the-villain-shoot-him structure that is reminiscent of Jorge Sanjine and other Latin American documentary filmmakers.[29] There is manifest interest in community and humanity (the good and bad) in the framing of a disdainful young boy as he aspires to reassert his parents' dignity by erasing the numerals painted on their wall, or an affluent couple's display of insensitivity and double standards in their intolerance to the smell of their neighbour's *soumbala*, a condiment that Tinga's wife, Napoko, prepares and sells. In actuality, this condiment is an indispensable cooking staple for both the rich and the poor, elite and illiterate.

To show how traditional culture is colliding with contemporary realities, *Zan Boko* reverses the order of traditional mores; confiscation of land goes against the tradition of Mossi culture, and to think of offering money for a piece of land is an act of betrayal. Pfaff notes that 'land was collectively owned and assigned to individuals by heads of lineages . . . Land could, traditionally, be borrowed or inherited but never sold'.[30] The words of the *griot* (oral storyteller) as he sings 'The monster has triumphed' in a local outdoor bar endorse the feelings of Tinga, who represents the majority of the underclass who are likely to be trampled on. As he tells his wife, 'What bothers me is being treated like outsiders on the land of our ancestors'. The problem of illiteracy in the film recalls *Mandabi's* theme. Because Dieng, the hero of *Mandabi*, cannot read or write (except his name, which works to his detriment), he signs his money order away to an unscrupulous relative. In *Zan Boko*, the lack of education seems to hinder Tinga's comprehension of the television debate regarding his predicament. Like Dieng, he is not stupid. Mirroring that prophetic statement at the end of *Mandabi* when Dieng says, 'We shall change all these', in the final shot of *Zan Boko*, Tinga's last statement echoes the voices of the marginalised who make up ninety percent of the population. Looking at Yabre's agonising face, he says, 'I don't understand French but it is easy to see something serious has happened. I urge you to remain true to your convictions and to yourself as a human being'.

Finzan is the second feature-length film by Sissoko, following his successful *Nyamanton* (Garbage boys, 1986), winner of a gold medal at the Mannheim Film Festival. It is a story about women and their resistance to the social systems and traditions they consider oppressive. The narrative focuses on the plight of two women: Nanyuma, a mother who is now widowed, and her niece, Fili, a socially sophisticated young woman who has not undergone the traditional clitoridectomy. Nanyuma was married for eight years to an older man (possibly as old as her father), who had two other wives and has now died. Her predicament is not yet over, since tradition demands

that she remarry, to her late husband's next of kin, Bala, the village buffoon. This obligation is ratified by the village chief despite Nanyuma's indignation. Nanyuma, however, is in love with a younger bachelor about her own age whom her family rejected as a suitor before her first marriage and who is now, once again, being denied the opportunity to marry her. She escapes to another village, taking refuge in her brother-in-law's house. This situation sets up a division amongst relatives as her brother-in-law tells her that she is obligated by custom to marry Bala, while Fili supports Nanyuma's position.

In another twist, the film shifts focus to a general emancipation theme designed to reinforce Sissoko's social critique. When a government dignitary arrives and demands that villagers surrender tons of millet to the government at a fixed price well below market value, the villagers' protests lead to the King's arrest. He is later freed when the women mobilise themselves to express their disapproval. The King's freedom in turn empowers the women to protest their own marginalisation – women's role in society and Nanyuma's plight – by threatening their husbands with a sexual boycott if their requests are not met.

Meanwhile, Nanyuma is caught and returned to her village, where she is forced to marry Bala. Her young sons, who despise this treatment of their mother, retaliate by planning retribution against Bala. In subsequent scenes laced with comedy, Bala's water is adulterated with a poisonous concentration capable of inducing diarrhoea and flatulence in order to make him believe that the gods demand that he let Nanyuma go. Other humiliating measures follow, including using Koteba 'ghost' costumes and voices to send threatening messages to frighten him. However, all these measures do not stop Bala's obsession with Nanyuma, who refuses to consummate her marriage with him. She becomes very friendly with Fili, who is soon to be accused of irreverence toward society for not having endured the required clitoridectomy. This is where the real tragedy lies. The villagers are divided and the women who support the King's position of letting tradition prevail (even though they know that there is a possibility of infection, which might ultimately cause her death) outnumber Fili's supporters. Subdued and helpless, she is forced to undergo the procedure, after which she bleeds profusely and is rushed to hospital by her father.

In the end, Nanyuma leaves the village with her youngest son, surprisingly, with no challenge. This occurrence signifies a return to sanity – a progressive synthesis between an antiquated past and demystified present, which the director uses to project a remodelled society in which women and men negotiate on an equal basis and solve their problems together.

Like his first feature, *Nyamanton*, which depicts the tragedy of children in Mali's capital city of Bamako, *Finzan* examines traditional systems and culture, vehemently denouncing the contradictions inherent in them. From the beginning of the film, one recognises the handiwork of a professional seeking to give illumined definition to film form and cinematic art. In attempting a compelling narrative style, there is no doubt here that cinematic art reinforces the strategy of

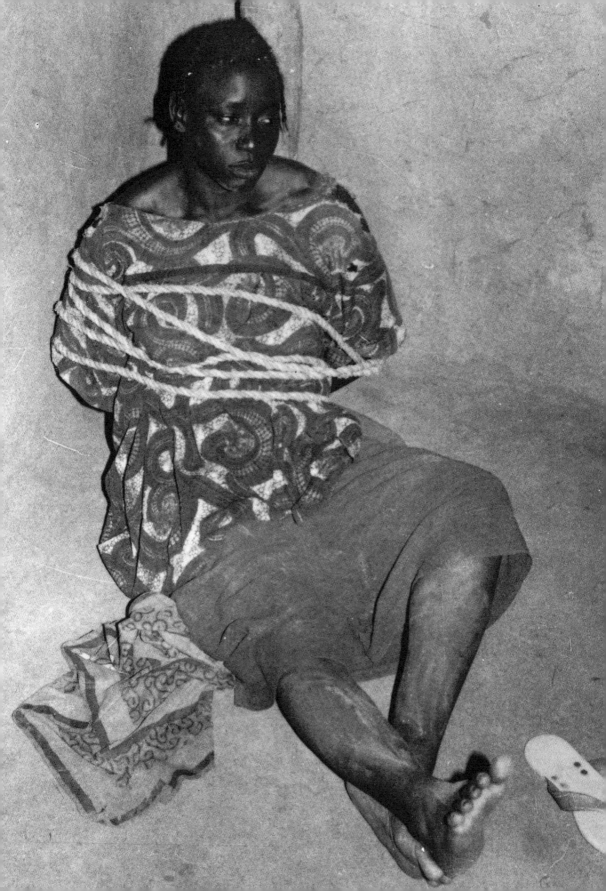

Finzan (A Dance for Heroes), Mali, 1989
dir. Cheick
Oumar Sissoko)
Film still courtesy
California Newsreel,
San Francisco

rendering explicit the cultural and the political. However, from the perspective of forging indigenous film culture respectful of African sensibility, one is forced to ask if what is presented is not some kind of structural asymmetry that tends to perpetuate the entire paradigm of cinematic representation of African cultures, as Western practices do through seeking the exotic.

The film opens with a graphic reflection on motherhood in a beautifully composed shot of two goats giving birth and straining at their tethers. This shot is followed by a catchy text in French, which announces that 'a world profile on the condition of women reveals the striking effects of double oppression. Women constitute fifty percent of the world's population, do about two-thirds of its work, receive barely ten percent of its income and own less than one percent of its property'. This statement is not merely descriptive; it also reflects the populist cry for equal justice. For anybody who has been following feminist writings, it could easily be misconstrued as a film made by a woman, or as a United Nations' documentary seeking out Third-World 'barbaric' cultures for debate. Rather, *Finzan* is a moving account of desperation told with sincerity and boldness, a film that looks at women through an empathetic male's eyes.

Although the film deals with a number of social issues, the main focus revolves around women's emancipation. One focal point is the cultural practice of clitoridectomy which, still in effect today in over twenty African countries, by United Nations' estimate, affects from twenty million to seventy million women. This practice has traditional significance in Africa, for excision was thought to be a proper way of guarding virginity as well as discouraging extramarital intercourse and an insatiable sex drive. It is important to restate that the subject of 'excision', 'female circumcision', or 'clitoridectomy', as it is variously called, is a controversial one. From the perspective of a Western cultural norm, the practice is usually denounced as genital mutilation performed by 'ethnic' cultures seen as 'barbaric' or 'anachronistic'. The practice's defenders, on the other hand, see its criticism as nothing short of racist, anti-African diatribe. It is pertinent to emphasise at this point that our reading of *Finzan* is not based on dogmatic principles. Following the same pattern of decipherment applicable in all circumstances, ours is not a matter of whether circumcision is still relevant in our present time, or whether one believes in it or not; rather, the main focus is to examine Sissoko's film style and his overall method of analysis.

In *Finzan*, Sissoko presents a critique of indigenous culture in a manner recalling the liberationist injunction to fight for freedom, a call for rebellion. I will argue that while the filmmaker presents this issue with utmost concern, his camera fails to present a detailed examination of the culture from a logical perspective that would enable us to understand how the ritual evolved. Rather, what we see is a farcical analysis that treats the subject of excision, in the words of Françoise Lionnet, 'peremptorily, in an impassioned, reductionist and/or ethnographic mode which represents the peoples who practice it as backward, misogynistic, and generally lacking in humane and compassionate inclinations'.[31]

In a scene preceding the one in which the female traditionalists mobilise to track Fili down, we are shown what appears to be callous attitudes on the part of the children who repeatedly tease Fili for not being circumcised. This parallels the brandishing of a razor by the woman assigned to perform the excision in a macabre manner reminiscent of Buñuel's *Un chien andalou* (1928), where in one of cinema's most bizarre moments, an eyeball is caught in big close-up as it is slit open. The irony here, though, is that Buñuel is a Surrealist interested in the bizarre, incongruity, shock and rejection of causality, while Sissoko is a realist who prides himself on representing African reality for the purpose of enlightenment and entertainment. He succeeds in the latter (but not necessarily in *Finzan*), his narrative drawing from the popular Koteba theatre combining slapstick comedy and satire with raucous scatological humour. Some of these devices are attempted in *Nyamanton*, and they work well, but in *Finzan* they function to distance the African spectator from the narrative, particularly in the bush scenes when the little children play tricks on Bala, or when a snake is made to crawl on his body and into his jacket before he smashes its head. Following this, Bala dances, glorifying his prowess for having killed a snake.

Regarding film and entertainment, if *Finzan* is strong in the entertainment sector, it serves to satisfy non-African spectators; it is unilluminating to Africans since the film's structure adheres to 'the new pressure to seek pleasure and fascination in the exotic'. Nor is there sustained cinematic inventiveness to suggest overt insurgency or challenge to the subjugative dominant structures.[32] Throughout the film, Bala's acting cannot go unnoticed. Although he overacts at most times, he instinctually achieves professionalism, but his performance alone is not enough to salvage the film from its amateurish style of representation.

Indeed, the question of inventiveness is so often raised by critics and filmmakers who want to emphasise either the equivalence between education and entertainment, or cultural productions reflective of genuine indigenous art and aspirations, that we must examine its premises. For example, through constructive criticism the relevance of cinematic structure can be tied to its ability to inform the viewer of important sociocultural issues such as excision, which is prone to disdain and misinterpretation. A cautious approach, rather than haphazard assemblage of reality, in my opinion, might best illuminate Africa's 'fitful process of shifting from one set of rules to the other' (from colonial and neo-colonial influences to cultural critique and changes) when 'loyalties are stretched between commandments of the Bible' (missionary influences) and 'obligations to the ancestors' (traditionalism).[33]

As Abdou Diouf, the president of Senegal stated:

Female mutilation is a subject that is taboo ... But let us not rush into the error of condemning [genital mutilations] as uncivilised and sanguinary practices. One must beware of describing what is merely an aspect of difference in culture as barbarous. In traditional Africa, sexual

mutilations evolved out of a coherent system, with its own values, beliefs, cultural and ritual conduct. They were a necessary ordeal in life because they completed the process of incorporating the child in society. These practices, however, raise a problem today because our societies are in a process of major transformation and are coming up against new sociocultural dynamic forces in which such practices have no place or appear to be relics of the past. What is therefore needed are measures to quicken their demise. The main part of this struggle will be waged by education rather than by anathema and from the inside rather than from the outside. I hope that this struggle will make women free and 'disalienated', personifying respect for the eminent dignity of life.[34]

There is ample room from this policy statement for us to agree or agree to disagree. It is interesting how Diouf challenges us with the task of handling the issues and becoming informed as never before about African social systems, beliefs, and thoughts. For Sissoko, *Finzan* 'deals

If the goal of African film practice is to formulate strategies for the production of work relevant to pan-Africanism, our concern here is to build a community of support for cultural and creative endeavours and to explore possibilities for collaboration in pan-African spirit.

with excision as an oppressive practice', but he does not 'want it to be known as a film about excision', saying that he 'made it generally as a film about women's right and struggle for freedom'.[35] Yet it is the 'mutilation' sequence, which lasts for less than fifteen minutes, that is the most powerful and talked about because of the way it was shot. In Sissoko's filming of the brutality accompanying the capture of Nanyuma and the tying together of her hands and feet with a rope that looks to be as fat and strong as that which anchors ships to the docks, the long-take, long-shot (of hands and feet) and the close-up (of the rope) lingers for an unsympathetic time.

It is true that filmmakers have to contrive an adventure, and Sissoko's automatically finds a centre of attraction – the bush and the bizarre. It could be argued that most of the scenes in the bush could have been filmed at a better location or left out entirely and the film would make better sense. To substantiate this claim, let us look at a particular sequence in which Jean Rouch's [36] influence, retrogressively appropriated, is most profound. In this sequence, after the King rules in support of Nanyuma's marriage to Bala, she tries to escape from the village by hiding in the bush. This triggers a night search by the villagers – a well-orchestrated sequence comparable to the search sequence

in Euzhan Palcy's *Rue Cases Négres* (1983) (when the whole village, led by José, played by the talented child actor Gary Cadenat, mounts a formidable search for Medouze). Villagers are seen here holding lit torches, scrambling to find Nanyuma. No definition of body contour is visible except when certain forms need to be highlighted, as when Nanyuma stops running to oil her body. The only other thing to which Sissoko draws our attention is a close-up, *chiaroscuro* in effect, of a ferocious lion growling as it charges Nanyuma and the villagers. The lion's menacing presence is felt three times: in the first and third it is visible and in the second we only hear it growling as the villagers run for their lives. This particular sequence is especially disturbing because of the deployment of retrogressive practices reminiscent of the African images proffered in melodramatic Tarzan films. Fashioning his cinematic structure after this practice is a strange, misguided judgement that subverts the director's attempt to liberate himself from the constrictive norms, canons, and myths that the mainstream media has long used to undermine Africa. It indicates a failure to deal with the burning question of an indigenous mode of African film language – something that has preoccupied African cineastes since the inception of African cinema. It also highlights the desperate question that is in the hearts of African critics and audiences alike: how to completely decolonise the image?

If the goal of African film practice is to formulate strategies for the production of work relevant to pan-Africanism, our concern here is to build a community of support for cultural and creative endeavours and to explore possibilities for collaboration in pan-African spirit. This is emblematic of the position espoused by Kwame Anthony Appiah in my second epigraph to this chapter, taken from his essay 'Is the Post- in Postmodernism the Post- in Postcolonial?' [37] regarding African art, its commodification, and interpretation. *Finzan* leads one to question what guidelines are necessary to construct a 'positive image' of Africa. By 'positive image' we mean the representation of what really matters, not that the image has to be favourable and conform to the values of the norm (hence a critique of Islam and African systems, for instance, in Ousmane Sembene's *Ceddo*, 1977). That is, 'positive' refers to the appropriateness of the method of selecting reality in a particular context. All too often, artists' affinities with specific cultures conjure immediate knowledge; sensitivity to that culture's configurations becomes instinctive. Unfortunately, this is not always the case. *Finzan* is beautifully filmed, as in the opening scenes, where composition-in-depth (deep focus in one case) is used to capture the village environment. The night sequence, while also beautifully shot, defies logic. This sequence, as in so many other scenes in this pockmarked film, is pretty bad. And if a sensible depiction of Africa means working to dismantle demeaning mainstream canons of representation, we might as well ask if *Finzan* has helped to reverse the popular assumptions perpetuated by existing forms of cinema and television. Commodification, as in the 'bi-traditionalism' discussed above, is not on a par here with African identity and sensitivity, especially the search sequence's 'Tarzan' overtones. *Finzan* is a film that no African will watch

Saaraba (Utopia),
**Senegal, 1988
(dir. Amadou Saalum Seck)
Film still courtesy
California Newsreel,
San Francisco**

and feel proud of, nor want to purchase for subsequent viewing. It is extremely popular with Western audiences, however, and widely distributed for classroom screenings as, according to one critic, 'an important new resource for studying rural sociology . . . [that] can bring to Women's Studies curricula a badly needed African perspective'.[38]

There are recent African films by aspiring African filmmakers that do not celebrate the contemptuous colonial and postcolonial messages that have worked historically to limit knowledge about Africa. Their structures may be steeped in the traditions of ethnographic *vérité*, but they do not promote the entrenchment of inferiority or the 'development of underdevelopment', in Hondo's words, but rather, a development path to artistic maturity. For, reaching a truer sense of African reality, they have been able to push art toward a celebratory role of a culture and of a life that is as warmly as it is urgently articulated. In this category are *Saaraba* (1988) by Senegal's Amadou Saalum Seck, which uses utopian motifs to demystify the illusions of independence in postcolonial Africa, and *Angano . . . Angano . . . Tales from Madagascar* (1988), co-produced by Marie-Clemencé and Cesar Paes (Madagascar/France), a highly innovative ethnographic film, brilliantly conceived and evocative, which places oral tradition specifically in its social context. As Donald Cosentino

Although *Yaaba's* storyline is basically simple, the film itself commands a universal appeal owing to the sophisticated ability of the director to unite all the essential elements operating in the film.

wrote in California Newsreel's catalogue, 'This film reveals the ever shifting, perhaps illusory, boundary between reality and myth'. The others in this section include Idrissa Ouedraogo's *Yaaba* and *Tilai* (Burkina Faso, 1989 and 1990), to which we will soon return.

Saaraba in Wolof stands for a mythical environment, equivalent to the Western idea of Utopia, supposedly free from the troubles of everyday life. Like Kaboré, Seck has a penchant for neo-realism, and like *Zan Boko*, *Saaraba* starts as an ethnographic document, changing its style to a more conventional narrative structure as it progresses. It is the ethnographic value of the first part, however, that gives the whole film its African feel. *Saaraba* recapitulates some of the themes that popularised early African films and their combative posturing. It denounces with unflinching temerity the corruption and lust of materialism and the excesses in the life-style of the older generation of Africans. In doing this, Seck foregrounds the disillusionment that has crippled Senegal's younger generation since Independence – including the director's age group – who see pre-Independence promises melting away in the postcolonial period.

Seck's first feature functions as a political critique and speaks well of African film projects that

scrutinise contemporary developments in traditional values of the first generation of African filmmakers. As we notice in *Saaraba* a craving for a personal style, we are also reminded of the future of African cinema, the new direction proposed by the African film practice of the 1980s.

Idrissa Ouedraogo, the dean of the 'new wave', citing Burkina Faso as an example, contends that films made in Africa with Africans solely in mind 'cannot generate revenue to defray production expenses. If we want [films] to be truly profitable, we have to internationalise our methods of making films. I try with the little means I have to deal with subjects concerning human beings'.[39] It is from this perspective that Ouedraogo has succeeded where many others have not broken the bondage imposed by distribution and exhibition problems. Africa and its cultures are the mainstay of his thematic convergence, in which the humanistic and the universalist interweave with the ancient and the present – probably deliberately avoiding political confrontations (and confrontations with the status quo).

In terms of universal acceptability and commercial viability, *Yaaba* is exceptional, if not unprecedented, in the history of black African cinema. It is one of the few African films that has made it to international commercial screens, and remarkably so, in box-office terms. Following its critical acclaim at Cannes (it was selected as the opening night event of the Directors' Fortnight), the film has played to large, enthusiastic audiences in Africa, Europe, Asia and the US, thus shattering the exclusion of commercial theatres that has long plagued African cinema.

Ouedraogo's next film, *Tilai*, about 'incest, revenge, crime and punishment', is the winner of the Special Jury Prize, Cannes, 1990, and also won the Grand Prize of the 12th FESPACO – the coveted Etalon de Yennega. Ouedraogo has since made another film, *A Karim na Sala* (Karim and Sala, 1991), also shown at the latter festival. Bowing to international pressure to produce another miracle following previous successes, this work failed to satisfy people's desire to see a well-polished film like *Yaaba* or *Tilai*. *A Karim's* postproduction was reportedly rushed for the 12th FESPACO's opening ceremony. It is a poorly edited film that may never be resurrected from FESPACO.

Yaaba is a deceptively simple parable, filmed in an unadorned, lucid style, deriving its plot from an African tale of the oral tradition. It is the story of two youngsters, Nopoko (the girl) and Bila (the boy), and an elderly woman. The woman is ostracised by the villagers, who accuse her of being a witch and therefore responsible for the village's misfortunes. However, the youngsters recognise that the elderly woman is often blamed for what she has not done and decide to befriend her. They nickname her Yaaba, meaning grandmother.

Yaaba exemplifies a number of important trends in contemporary African cinema.[40] It is made in a style that could be called 'elitist' and 'individualistic' – combining various comedic modes with moral nuance in a fashion that reveals the contours of a revived pan-African strategy. This strategy manifests itself in the shared consensus of the quest by African filmmakers for authentic treatment of African issues in a style that not only inscribes African identity in African films but also renders the

films competitive in the international market. The 'new' African cinema interweaves elements of melodrama, satire and comedy in a manner that attempts to satisfy the spectator's appetite for entertainment. *Yaaba* typifies this trend and its success and international acclaim exemplify the goals of the new crop of African filmmakers.

The appropriation of neo-realist techniques by Third-World filmmakers has been well documented, and Ouedraogo fuses the neo-realist penchant for eliciting polished performance from non-professionals with the African narrative tradition of the *griot*. Ordinarily, *Yaaba*'s story, in terms of cinematic storytelling, would be dismissed as too amateurish. But, as in the oral tradition, a story's interest and attraction for an audience depend on how creatively a storyteller embellishes what he has heard or taken from his own experience. Although *Yaaba*'s storyline is basically simple, the film itself commands a universal appeal owing to the sophisticated ability of the director to unite all the essential elements operating in the film. Here, bits of humour, comedy, and satire coalesce into an idiosyncratic cinematic style that highlights societal mores and those who attempt to undermine them. In terms of *mise-en-scène*, every detail is conveyed by the extraordinary framing of a static camera. In a sequence in which the camera lingers on villagers playing a traditional West African game, participants proceed in and out of frame in a fashion that unobtrusively captures the flux of traditional life. Similarly, skilful editing promotes the rhythmic progression of disparate episodes. Attention to visual detail is coupled with Francis Bebey's effective score, which makes use of indigenous string and reed instruments to heighten solemn moments (for example, Yaaba's burial) as well as carefree ones.

The film's emotional power is largely due to the choice of Yaaba as the village scapegoat. Her old age leaves her vulnerable to superstition, since elderly people are among those most suspected of being witches. This stigma does not, however, render her any less the quiet woman of wisdom that she is. Anyone familiar with African culture knows the tremendous respect accorded to elders – which is, of course, withheld from Yaaba. This respect begins in the family and is ordinarily unconditional. The aged, like the sick, for instance, are taken care of within the home, and members of the family, including the extended family, are obligated to contribute their quota. Contrary to what occurs in the West, where, for example, government welfare programmes are substituted for family care, in African society, close-knit family relations eliminate the horrors of old age. Old people are indispensable, and above all, they are loved, no matter how rich or destitute they may be. In *Yaaba*, the old woman is denied this important benefit, ostracised, and driven to despair by the villagers. Yaaba is apparently childless; although she grew up in the sophisticated caring system of African communalism, she cannot reap the benefits of an extended family, having been dismissed with ignominy. This desertion causes other members of the village community to ridicule her; in one scene we see them throwing stones at her. She survives the resulting wound and it is Nopoko and, even more, Bila, who show sensitivity to her predicament. At one point, when the children call her

Yaaba, she is elated. 'This is the first time that someone has called me Grandmother, and that makes me happy', she says, as she and Bila eat the chicken that Bila has stolen from the village to feed her. As a rule, stealing in the village, as in many other societies, contravenes ethical and moral codes. However, there is a good reason for Bila to steal the chicken for Yaaba to eat: it is out of sympathy as well as a matter of subsistence, since Yaaba is unable to trap meat for herself.

Nopoko and Bila represent the values of modern Africa and serve as a bridge between the present and the past, which is Yaaba's tumultuous environment. Here the film seems to suggest that there is need to abandon superstition and to examine critically the causes and effects of all societal circumstances before crucial judgements can be arbitrarily imposed. Yaaba's ordeal reveals that what is associated with the past is not necessarily at odds with the present; her wisdom is reincarnated in the vision of Nopoko and Bila, who in this respect represent both future and hope. This quest for future and hope is strongly entrenched in the solidarity of Bila's prophetic utterance, when, after Yaaba's house is burned down by mean-spirited villagers, we hear him say to her, 'I will build another house for you'.

In another sequence, when Bila is accosted by the village bullies (a group of youngsters about the same age as Bila and Nopoko), a fight ensues and Nopoko rushes to the aid of Bila; she is cut by a rusty knife held by one of the assailants. The cut becomes infected and she falls ill, causing her mother to fear she has tetanus. After all medical attention fails to cure Nopoko, it is the medicine of Taryam, a native doctor who is connected with Yaaba, that provides a cure for her ailment. Once again, Yaaba's wisdom prevails. Bila serves as the go-between, the link between Yaaba and the native doctor, although Nopoko's mother must hide Taryam's medicine from her husband, who does not want anything to do with the witch or her native doctor. Nopoko's recovery synthesises the film's attempt to reconcile past and future. Bila's endeavour to repudiate suspicion, superstition, and ignorance speaks of a desire for understanding between the young and the old, past and present. The temptation to disparage Yaaba's traditionalism and Taryam's values (the healer's medical roots originate from traditional culture) is offset by the fact that recourse to these ancient remedies prolongs Nopoko's and Bila's lives. Ouedraogo's respectful treatment of Taryam is part of the film's dialectic between traditional wisdom and the sometimes dubious 'progress' wrought by modernity.

In all African societies, adultery is a sin and divorce is an offence, if not taboo. Within the rural milieu of *Yaaba*, adultery and divorce are condemned, since they threaten communal solidarity and family cohesiveness. In the film, Ouedraogo displays all three, not through commentary but as plot elements meant to entertain spectators, not instruct them. Thus, when he shows us an attractive young woman, Koudi, married to Noaga, an alcoholic, who is having an affair with a local charlatan, it is not surprising that he bypasses the implication of such a taboo subject by showing her comically upbraiding her husband for being impotent. Since Noaga is unable to satisfy Koudi

sexually, a farcical transference of guilt occurs in which the promiscuous wife absolves herself of any responsibility. Yet, the beautiful woman cannot leave her husband because of the matrimonial bond consecrated in traditional doctrine. This narrative ploy is in sharp contrast to Sembene's *Xala* (1974), a film in which impotence suggests a larger political metaphor, an allegorical strategy that is absent from the more prosaic plot twists of *Yaaba*.

Stealing, bickering, gossiping, eavesdropping and juvenile mischief are portrayed, no doubt flaunting the strict moral code of a community deemed closely knit. But behavioural strictures are not the primary focus in *Yaaba*, even if the dilemma seems to extend far beyond the mere question of moral decay. Although much of the film's strength lies in its whimsical irony, Ouedraogo nonetheless does not seem to have a clear vision of the African future, and there is cause to wonder whether *Yaaba's* parabolic structural oppositions truly illuminate societal conflicts. In one sequence, for example, a quarrel breaks out between a couple, but instead of showing them fighting, in the next shot he presents a door opening and the pair in a romantic embrace. This is like saying, sarcastically, of course, 'If this is how couples fight, no one will ever cry'. In another instance, the mother of three delinquent youngsters, who constantly berates other members of the community, is shown turning a deaf ear to the misbehaviour of her own children.

In *Yaaba*, the director creates expressive rhythm through characterisation and meticulous attention to detail. The marvellous performances of the non-professional actors increase the stark realism and simplicity of the narrative, which in turn focuses attention on the film's drama. In the end, the spectator is left with the feeling that the compassionate human drama, as it unfolds in the village, where love, evil, fear, superstition, and intolerance coalesce, are revelations that only an insider can convey. For example, by making Yaaba a scapegoat, in this case accused of being a witch and therefore responsible for the evils afflicting the society, the film touches upon a subject that is crucially important for understanding African culture. In colonialist discourse, witchcraft is denigrated as 'superstition', 'demonic' and 'primitive', endemic to the 'dark continent'. Although the subject of witchcraft is used to enhance the story line, it is not used tendentiously either to valorise African tradition or to dismiss it as irrational. In this respect the film exemplifies an African sensibility in its effort to represent sensitively certain aspects of African culture.

The various episodes and segments that compose *Yaaba's* structure are seamlessly constructed. Along with the utter simplicity of the narrative pattern and careful attention to detail, Ouedraogo knows when to alternate long takes and fast cutting, silence and sound, light and dark. For example, the scene in which Bila takes food to Yaaba and discovers she has died, progresses with rapid cutting – from Bila running to inform the villagers and then returning, to the burial sequence, where the action is deliberately slowed down by the employment of a long take. The scene in which Koudi is seen wanting to have sex with Noaga, her alcoholic husband (an attempt that comes to no avail), is showered with *chiaroscuro* lighting and features an alternation between

silence and sound – reminiscent of Fritz Lang's *M* (1931) – that expedites our anticipation. Thus a static camera watches the young beauty as she struggles to arouse her husband, who is snoring loudly. When she fails to awaken him, she resigns herself to melancholy, twisting and wiggling in silence. This silence is broken momentarily by whistling from outside. When Koudi walks to the window, the camera shows her submerged in light and dark, looking out into the night, until we are made to understand that it is her lover, Razougou, signalling for attention.

The dialogue spoken throughout the film is sparse and delivered in Mooré, one of Burkina Faso's mother tongues, with English subtitles, though most people who have seen the film agree it can be understood without them. The emphasis on image over heavy-handed dialogue is increasingly common in African cinema. The multiplicity of African languages demands the breakdown of language barriers, enabling films to cut across boundaries. The desire to internationalise black African cinema in order to gain larger audiences and reap greater financial benefits currently defines the structure of the 'new' African film.

However, *Yaaba's* innovative tendencies obscure some of the flaws in this film: many sequences seem all too predictable owing to the deployment of stock characters and clichéd plot devices. *Yaaba's* admittedly diverting vignettes do not have the power to suggest the historical resonances achieved by a film such as Hondo's *Sarraounia* or the nuanced depiction of African ritual explored in Cissé's *Yeelen*; but they are clearly antipodal with Sissoko's *Finzan*.

After *Yaaba*, two African films, *La vie est belle* (Life is Rosy, 1985) by Ngangura Mweze and Benoit Lamy and *Bal poussière* (Dancing in the Dust) by Henri Duparc are distinguished by their engagement with popular culture and Africa's polyphonic rhythms, tempered with Hollywood enticements. But *La vie est belle* is not at all similar to a Hollywood movie. It is an interesting film, an unusual African film, commercial but not trivial.

It was released as a co-production involving Belgium, France, and Zaire (now the Democratic Republic of Congo). Ngangura Mweze wrote the script and was assigned a co-director by the authorities in the Belgium Ministry of Culture who provided two-thirds of the financing as a condition for co-sponsorship. The outcome of this problematic collaboration is a contemporary comedy, the roots of which are tied to the Congolese popular culture and to *commedia dell'arte* – old Congolese television programmes reminiscent of the musical Italian theatre style.

In *La vie est belle*, Zairean popular theatre and music are also used, allowing the audience to experience the Kinshasha boisterous night life. Here, a popular Zairean star, the crowd-pleasing musician, Papa Wemba, plays the protagonist, Kourou, a neophyte in the process of exploring the musical road to stardom. Although the film is a musical comedy, it is not strictly structured as an entertainment film using the African prototype of a modern city (Kinshasha) as mere decor. Rather, Kinshasha comes to exemplify many of the film's thematic preoccupations: the city as a fashion capital *à la* Paris in which we see men and women chicly dressed; the city as a boisterous music

capital continually hosting the region's hundreds of musicians, many of them the world's best, in which we find the development of new tunes and dance steps presented as routine;[41] and a city that exhibits the problems of urbanity, the entrenchment of the survival of the fittest. *La vie est belle*, like *Kukurantumi* (The Road to Accra, 1983) by King Ampaw, also set in a big city, Accra, Ghana, deals with the theme of misplaced priorities, as evidenced by the display of affluence and lust for expensive goods, such as Mercedes Benz cars, polygamy, class division, urban migration, and economic imbalance. Although the structure of the film is comedic, one can still recognise societal discrepancies as they are filtered out of joke-filled scenes that are sometimes humorous and sometimes ironic, as in the scene in which a dwarf who hawks a *kamundele* (shish kebab, in Lingala) in front of a nightclub reminds us that 'life is rosy' as he watches Kourou and his feisty girlfriend frolic on the doorstep.

Male impotence among the African bourgeoisie is also explored. However, unlike Sembene's *Xala* (1974), in which the subject is used as a caustic satire metaphorically signifying the political impotence of Senegal's ruling oligarchs while at the same time valorising the expediency of traditional medicine, *La vie est belle* uses it to induce laughter. One such moment is when Kourou's rich employer, Nvouandou, comically practices the dance steps prescribed by the traditional medicine man as a cure for his impotence. Ngangura Mweze makes the following observation on the search for a popular film form apropos of a paradigm that argues for a new way of seeing:

> The term 'commercial cinema' is quite pejorative. Let me call it 'popular cinema'. I like to make a film that many Africans come and see and feel good with. If I want to say 'commercial cinema', it means concocting stories for money, reinforcing it with sex, violence, speeding sports cars . . . That is not what interests me. Rather, to make films that are best popular with African culture . . . which will feature African problems and accomplishments at the same time. I don't feel like a teacher or a messenger of a particular idea. I am a filmmaker, as there are carpenters and bricklayers.[42]

Like *La vie est belle*, Henri Duparc's *Bal poussière* makes use of popular forms. The film is replete with entertainment that reflects emerging trends. His work, however, is being pushed toward a more bizarre, vulgar tradition, as his new film *Sixième doigt* (Sixth finger, 1991) suggests. Unfortunately, it is not only nihilistic but also reproduces much of the racial and ethnic stereotyping that African films purport to attack. When these films were shown at the 12th FESPACO, African critics, who still associate 'sexual modesty with African dignity and sexual exhibitionism with Western decadence', as Joan Rayfield puts it,[43] were very critical of the overblown sexual scenes. On the surface *Bal poussière* is a social comedy focusing specifically on polygamy, making reference to corruption and the contradictions of tradition and culture. But it cannot be

taken seriously because the issues are treated with only one thing in mind – amusement.

The focus of *Bal poussière* is a local rich man about fifty years old who is obsessed with power and calls himself Demi Dieu (Demigod). He already has five wives and wants a young school girl, Binta, played by T'Cheley Hanny of *Visages de femmes* (Faces of Women, directed by Désiré Ecaré, 1985), as his sixth wife. She is not happy to have been sent out of the city by her uncle. She meets up by chance with Demi Dieu, who falls in love at first sight and promises to marry her. He is wealthy and Binta's parents agree to Demi Dieu's proposal. As soon as she comes into the household, the rebellious Binta exposes the other more traditional wives to untraditional behaviour, such as naked bathing, splitting the family into two factions: those wearing Western-style dresses and those wearing traditional attire. Soon, Demi Dieu, who used to think with his penis, believing, according to the production note, that 'a sixth wife will only harmonise the week: a wife for every day of the week and Sunday for the one who behaves best', now knows that that is, after all, not a 'supreme reward'.

Bal poussière's photography is stunning, the acting exceptional by African film standards. The colours, composition of shots, and rhythm and pacing epitomise polished craftsmanship. It is highly entertaining, but at the expense of the changing role of African women, or women's liberation in general, although that is what it supposedly argues for. On a few occasions, the film manages a self-conscious attempt at germane social comment. For instance, at one point a prostitute who attempts to seduce a bar client is asked, 'And what about AIDS?' Similarly, the film concludes that polygamy is somehow retrogressive, since the overbearing character Demi Dieu mishandles it as he does. Binta is allowed to leave him for the man she loves – in the spirit of a liberated woman – but only when she has proved that she could not be a traditional housewife like Demi Dieu's other wives.

Duparc's structure and his method of construction become questionable in view of his cinematic voyeurism. Consider, for example, his camera's conspicuous leering at Binta's features and contours – her bouncing breasts, and in full-screen close up, her buttocks. For Western viewers, these features may be gripping and profoundly alluring, but for African critics, especially feminists, Duparc's experimental interludes are simply jaundiced, misguided and stereotypical.

Within the domain of the new African film practice, therefore, non-conformism, more than a flight from established traditions, is an inevitable transgressive mode of practice, if only to accomplish the Herculean task of getting a film widely distributed in important theatres. This has led to competition and aesthetic proliferation of enquiry into diverse filmic applications. I argue that some of the conventions used to attain this aspiration have, however, been misappropriated.

Toward the Tradition and the Centrality of the Paradigm

In an interview published in *West Africa*, Haile Gerima, the versatile Ethiopian filmmaker, who at the time was scouting for locations for his film *Sankofa* (1993), was asked to explain why 'the past continues to be such fertile soil for African filmmakers'.[44] Gerima's project explores 'the love and

conflict between an eighteenth-century African slave and her mulatto son – the product of rape by white slave traders'. The film traces this story through three regions: to the US (Louisiana), Jamaica and Ghana. 'Without the past', Gerima noted, 'there is no forward movement, so somehow we have to make peace with , and have an understanding of our past. We cannot physically go back to the past. But we have to look into the past to find out why we have come to where we are now.' [45]

The understanding of the past that Gerima is concerned with typifies the 'collective' and 'universal' ordering of African film structures manifested by the crisis of cultural assimilation imposed by colonialism and recolonisation. The recolonisation factor arises chiefly from the fact that Western media continues to develop more and more as an enterprise of acculturation, and since many African stories, long forgotten, still need to be told, there is reason to advance knowledge of Africa by exposing the ruptures and discontinuities that constitute the African experience. The priority that continues to drive the initiative is still to investigate Africa's past in order to interpret history and awaken a great cultural heritage as a challenge to racist historical myths and assumptions. How can the screen be decolonised? How can film form, content and style be developed to serve the dissemination of information? How can films contribute to a better knowledge of the African past and present? What are the priorities?

The focus of this section is to examine how the above perspectives have been reorienting African film practice over the last years towards the primary concern of constructive engagement of the African experience in narratives, which, when 'presented in the truth of their language and authenticity, become texts of real peoples', in Mudimbe's terms, rather than stereotyped, demeaning, fabricated stories as revelation. It is this kind of disinformation, 'which does not demand a knowledge of a specific social context, its culture, and language', that some African films are 'progressively replacing with concrete questions bearing upon contextual authority and the necessity of linking narratives to their cultural and intellectual conditions of possibility'. [46]

In recent African films, digging into the country's past and recontextualising it to inform the present has been indefatigably pursued with striking filmic innovations that have initiated a new phase and expanded definitions of the cinematic. In terms of creative autonomy and their themes, *Sarraounia*, *Camp de Thiaroye*, and *Heritage . . . Africa* can be seen as the precursory voice of new African alterity which, like the alternative Latin American cinemas, is closely aligned with the counter-hegemonic tendencies of 'Third Cinema'. Because the structure of the films is fused with synthesised sociohistorical and cultural information, interrogation of the production processes involves the form and content of what Mudimbe terms the style of 'Africanising' knowledge.

From a general critical perspective, therefore, these films can be seen as recoding conventional film form, bringing to it not only a new range of historical reference but also creating the type of cultural resuscitation referred to by Brazilian modernists as 'cultural anthropophagy'. The notion of cultural anthropophagy derives from Oswald de Andrade's 'utopian desire for a return to a mythical

golden age of primitive, matriarchal society, when enemies were eaten not enslaved . . . not the romantic ideal of the noble savage', but rather, as in Montaigne's cannibalism, one 'who devours enemies as a supreme act of vengeance'.[47] Simply put, cultural anthropophagy seeks to counter the cultural colonialism imposed by Western hegemony by advocating the reversal of the oppressive mechanisms used by the coloniser to subjugate colonised cultures, recycling them as 'raw material' for a new synthesis. In cultural production, this means the creation of an indigenous aesthetic that places art not only in the service of the people but also makes it answerable to their political and cultural specificities. Applied to African cinema, this means of restructuring is the integral arm with which cinematic conventions are linked with speaking in one's own voice. My analysis of *Sarraounia, Camp de Thiaroye,* and *Heritage . . . Africa* will argue that their structures reveal political consciousness indicative of a 'supreme act of vengeance', foregrounding situations and colonial atrocities long hidden.

In terms of temperament, outlook, and artistic goals, Hondo and Sembene are a study in contrasts, but their distinctive styles are united by a common ideology. This includes their unflinching interest in African issues and the rendering of cinematic structures with styles emanating from dynamic cultural polyphonic codes. Both filmmakers continue to work from pedagogical perspectives that are nonetheless gripping and emotionally resonant. Most of the time the filmmakers urge the West to acknowledge their ruinous policies toward Africa, or as one student succinctly put it in the aftermath of the Gulf War, 'their greatest crimes against humanity',[48] and implore Africans to wake up and work out lasting structures of political and economic stability.

Sarraounia is a landmark of African cinema, the most ambitious for its inventiveness, professionalism, and dedication. It took Hondo seven years to raise the three million dollars required for its production – an uphill task, and by African standards, unprecedented. The screenplay is adapted from the novel of the same title by Abdoulaye Mamani of Niger. The story recounts a true African experience during colonialism, at a time when the French colonial army was plundering its way across the western Sudan from Dakar to Rabat. According to Hondo, he was motivated to show the true 'historical value of traditional culture' by bringing to light an important period in Africa's history when Sarraounia, a Malian Queen, led a successful battle against the French colonial forces. Aside from showing 'African history in cinema honestly and objectively', the film is also a homage to African women in history, something that has always been downplayed, 'ignored or underestimated'.[49]

The structure of the film develops along two basic story lines. The first is necessary to provide information about the effects of traditional culture on national resistance and concerns the growing up of a young girl (Sarraounia) as seen from pre-adolescence to her establishment as Queen of the Aznas of Niger. During this first period, when she lives with her adoptive father, she is initiated into

mastering traditional secrets, leading her to acquire the power of a respected fierce warrior. On the other side of the story are the French forces, evil and mean-spirited foes, whose psychological warfare includes the raping of women, brutality, and annihilation. As the French forces advance, some of the Queen's detractors betray her and her prowess is tested. Determined as ever, with the help of some volunteer forces she is able to muster defences capable of restoring her people's dignity. On the eve of the attack by the French forces, a thunderstorm, believed to have come from the spiritual forces at the command of Sarraounia, strikes the French camp, throwing them into confusion as they accuse one another of desertion. This takes place while the Queen is rallying a new defence force to her side. When the invaders attack, Sarraounia's forces inflict demoralising damage, despite the enemy's powerful guns and cannons – a situation caused by Sarraounia's tactical withdrawal to the bush. The French army finally arrives at the village of Lougou, only to find it a ghost town, confusing them all the more. This disappointment leads them to become violent and greedy, and their demise comes when disheartened *tirailleurs* (African soldiers of the French colonial army) revolt, killing their white officers.

If Hondo succinctly retrieves in *Sarraounia* an essential chapter of African history, *Camp de Thiaroye*, co-directed by Sembene and Thierno Faty Sow, reveals the unfortunate legacy of French colonialism, which the latter would have preferred to remain undocumented. The film is based on an actual event, the 1944 massacre by French forces of Senegalese *tirailleurs* stationed at the camp of Thiaroye a few miles outside Dakar. The *tirailleurs* were billeted there after returning from World War II, having fought for France and now awaiting repatriation. Sembene's drama unfolds as a revelation of the unsavoury relationship between the colonising army of occupation and the colonised subject. French policy poses a double standard in regarding the *tirailleurs* as French citizens while treating them as colonised subjects, as is clearly illustrated in the film. Sembene shows that the African soldiers' demand for 'equal sacrifices', 'equal rights', and 'equal pay', with the white soldiers, is legitimate. The French authorities promised to pay the *tirailleurs'* back wages, a demobilisation allowance, and five hundred French francs each, plus civilian clothes, only to renege on these promises. A series of other insults and maltreatment by the French authorities (one injustice is the refusal to pay them at the going exchange rate) boil over, forcing the soldiers to mutiny. The *tirailleurs* seize the French commanding officer, who is later released after he promises adequate and prompt compensation. This proves to be a false assurance. In the deep of the night, after everyone is asleep, the French armoured vehicles and artillery roll into the camp, demolishing everything in sight and massacring a large number of the *tirailleurs*. This is how they are rewarded for the sacrifice of untold African lives in the service of France during World Wars I and II.

The emotional impact of the film derives from a meticulous plotting and selection of details and careful dramatisation and characterisation. It is a story told from personal experiences, which, in the director's words, 'render the film vivid' [50] – Sembene himself having fought for France in World War II

– with irrefutable credibility, its authenticity being a hallmark of a truly revisionist history.

The allegorical treatment of both *Sarraounia* and *Camp de Thiaroye*, however, would mirror the characteristics of a 'vindictive' art only if it forced France to repent and pay adequate compensation. But these films are intended to contribute knowledge of Africa's repressed history rather than incite violence or retaliation. Their revolutionary dynamics echo the nationalistic ideology of using art to scrutinise, disturb to the point of jolting consciences, and, in this case, to haunt, if possible, the propagators of today's imperialistic policies that render ineffective African and Third World struggles. Hondo's words, 'You can read my film back under the light of today',[51] underscore this concern. It is pertinent that we fast-forward at this point to Hondo's and Sembene's strategies of revelation in *Sarraounia* and *Camp de Thiaroye*.

Sarroaunia's preoccupation with historical specificities ratifies the contention of cultural theorists that it is the coloniser who 'invests the other with its terrors'. As Jonathan Rutherford has pointed out, 'It is the threat of the dissolution of self that ignites the irrational hatred and hostility as the centre struggles to assert and secure its boundaries, that construct self from not-self'.[52] As the 'barbarously cruel' French forces 'slaughter [their] way from Dakar to Rabat'[53] to assert control, it was expedient that African warriors led by Queen Sarraounia mount a formidable defence in the same way that the *tirailleurs* in *Camp de Thiaroye* did when, fed up with French insult, lying, and cheating, they were forced to mutiny. The mutiny staged here as a result of this injustice was simply to draw attention to their cause, seeking a remedy in accordance with the French policy of assimilation since they were supposedly French 'citizens'. It is not surprising, therefore, that Sembene and Hondo, both at the zenith of their creativity, would illustrate French colonial treatment of Africans with utmost pungency.

Important cinematic genre conventions determine the techniques employed. They include ethnographic methods of observation, appropriation of revolutionary Russian techniques of socialist art, avant-garde modes of production, all refurbished and fused with oral art. In *Sarraounia*, Hondo frames in long shot the Sahel landscape filled with hazy atmosphere as the camera witnesses the French colonial army under the command of Captain Voulet advance to decimate the resistance (as if the Supreme Being, frowning on the destruction about to affect her children, decides to dim the cosmic lights in the same way that flags are lowered during national calamities). In the foreground are human bodies planted in single file with only their heads above ground. Mounted soldiers are seen cutting off the exposed heads with their swords as if they are playing polo. In the following shot, four French officers stand talking as if nothing had happened. The remarkable thing about this scene is the way in which it is shot with a static camera, positioning the audience like live witnesses to the event; it traumatises as it urges the viewer to meditate on the killings.

In another scene, Hondo deviates from this long-shot positioning of the static camera as witness, to make it a 'roaming ambassador' in order to seek and find. In the scene after Sarraounia

withdraws to the bush and the disappointed French army retreats, a high-angle camera shot shows the soldiers leaving, and a pan shot reveals some wounded African *tirailleurs* on stretchers. The camera switches angles, following the movement of one of the French officers as he weaves his way through the crowd, shooting and bayoneting the wounded soldiers. One of the latter is shown in close-up as he takes his last breath. The cruelty demonstrated in these sequences ratifies the fact that the French were not interested in the lives of Africans, even those fighting for them; as far as they were concerned, the African soldiers were subhumans.

A scene that substantiates this statement occurs later in the film when the rampaging French soldiers come across a native shrine. Inside is a big mask ornamented with traditional symbols. Their African counterparts, on spying the masks, are gripped with fear. One French soldier walks fearlessly forward and removes the mask. Putting it on his face he starts to dance around, ridiculing its cultural significance. But his foolishness is only momentary: this flagrant abuse quickly ends when a shrieking cry for help is heard. His face is suddenly covered with angry insects. The next shot shows two other French officers struggling to remove the mask from his face. As they treat him, the camera reveals an African resister in the background, mercilessly tied with ropes to a stake and left unattended. This symbolic scene makes explicit the French cruelty and contempt towards African cultures. It also illustrates the director's concern to show fetishism as an authentic national culture, the mask as a 'cultural product of the people' to which traditional values are attached. (I must point out that the scene's impact would have been much more profound if there were traces of insect bites remaining when the camera moves into a close-up of the man's anguished face.)

At FESPACO 1987, where *Sarraounia* won the festival's Grand Prix, the director 'was asked whether he had not exaggerated the atrocities committed by the French soldiers, such as playing polo with the decapitated heads of the Africans. He replied that he had drawn his information from respected French histories, including [Jean] Suret-Canale'.[54] Hondo's concern for authenticity typifies what he means when he constantly reminds critics and audiences that 'every film has its own particular structure'.[55] For example, *Sarraounia* eschews the syncopated eruptive tone of Hondo's earlier film, *Soleil O* (1969) and the swift and painterly camera movement of *West Indies* (1979). In the structure, we find a deliberate relaxed use of the camera, creating a slow rhythm that leaves no detail unaccounted for. There are a few rapid camera movements, but only when the situation demands it; overall, the rhythm is calculated to make the viewers feel as if they are listening to a history lesson, narrated realistically as unmediated events instead of a fact distorted by cinematic pyrotechnics. Similarly, Hondo is careful not to depict the French solely as bad guys. He shows the contradictions forced by the resistance inside the colonial camp, and analyses the contradictions among the Africans themselves. Here, as in *Ceddo*, where Sembene posits the impotence of African traditional religions against powerful Islamic encroachment, Hondo shows Africa torn by imported structures. The abandonment of Sarraounia by the Muslim soldiers,

who detested her resistance to all foreign structures, including Islam, at a crucial time when Africa's freedom, dignity, and pride were at stake, exemplifies this stance.

Concern for Africa's freedom and dignity is also foremost in Sembene's cinematic analysis of the continent's problematic emancipation and, like Hondo, he is careful about how to put those problems on screen. In *Camp de Thiaroye*, Sembene and Sow's dramatisation of the atrocities committed by the French forces shows centuries of exploitation which, as in *Sarraounia*, can be read as mirroring today's realities. Through storytelling ingenuity, character delineation, and mastery of cinematic techniques, the film reveals characteristics already well circumscribed and established. As G. Williams puts it, 'Colonies were . . . of value only insofar as they brought material benefits to the mother country'.[56] *Camp de Thiaroye* not only shows us the processes that the colonisers used to chew away Africa to its bare bones but also the tradition that sometimes reflects the muteness of Africa in the so-called New World Order (read: New World Disorder) formed under the auspices of Pax Americana. In the film, the most well-defined signifier of this assertion comes in the form of the character of the mute soldier nicknamed Pays (Country). At the beginning of the film, it is through the experience of Pays (the viewer is told he is an ex-prisoner of a POW camp in Büchenwald) that one learns of the painful contradictions in the so-called return journey to native Senegal when Pays notices that their camp is fenced with barbed wire. This scene, filled with emotion, shows Pays, dumbfounded, as he becomes immersed in old memories. Sembene's camera lingers on him for a time, focusing tightly on his fingers as they touch the barbed wire, trembling in disbelief. One of his friends, the commanding sergeant, pacifies him, picking up some sand and sprinkling it on his fingers as he reminds him that they are in their native Senegal and not in Büchenwald. On one hand, Sembene is asking whether there is any difference between the POW camp in Germany and the camp at Thiaroye. On the other hand, Pays' muteness represents what might be seen in today's reality as a symbol of the political inertia, economic impotence, and dependency that has become a part of Africa. After watching *Camp de Thiaroye*, one is made sadly aware that France's domination of its former colonies continues unabated. Considering that France is also one of the owners of the International Monetary Fund (IMF) which, together with Africa's own mismanagement, is milking Africa dry, one cannot but question Senegal's apish loyalty in the aftermath of the 1991 American-led war against Iraq.[57]

Sembene vividly captures Senegal's tragic alliance with France through the recalcitrant attitudes of its colonial officers. Towards the end of the film is a massacre scene in which the Senegalese soldiers, who had hoped that they had secured the trust of the French commander, and therefore better treatment, are attacked. This scene is carefully staged in the usual Sembenean fashion of meticulous attention to detail. It all happens in a night scene that is beautifully lit until gun salvos punctuate the natural serenity of the sequence. In a long shot we see the movement of lights in the distance. This movement is caught by Pays, who tries, to no avail, to alert his compatriots to the

impending attack. Pays, whom his friends know is mentally deranged as a result of the war, is not taken seriously, and they joke that he is once again having a nightmare about the German concentration camp. As a column of tanks and artillery move nearer, Sembene holds his camera in a static position while witnessing what is to happen. When the attackers release an unprecedented inferno upon the camp, the camera shows only close-ups of the tanks' guns as they fire endlessly; however, the long-shots focused on the camp remain unchanged. This enables the viewer to see the Senegalese soldiers as they run for cover. The camp is burned to the ground – heightening the emotional impact that grips the spectators, who at this point are forced to place themselves in their midst. The music that runs through this sequence is carefully chosen for impact. The next scene, which takes place five hours later, is accomplished with a smooth camera pan, seeking out the dead bodies. Reminiscent of Sanjine's *Courage of the People*, the mass burial that follows is shot in medium close-up, followed by a long-shot as more bodies draped in white are thrown into a mass grave.

The French officers show no remorse or concern for their atrocities. In the scene that follows the burial, one French officer is heard telling another that the colonial minister and the government support their actions. The other asks when the new African recruits are going to be sent to France. Sembene cuts to a huge ship anchored at the dock as the recruits embark, leaving their families behind. If we read this sequence backwards in Hondo's terms, it is significant in the sense that it mirrors present realities, which is to say that if Africa continues to depend on its former colonisers, independence will remain an illusion.

Both films illuminate African history with utmost clarity without being overtly didactic. Hondo emphasises African history through precolonial and colonial images, Sembene alerts African audiences to a united search for autonomous identity. *Sarraounia* and *Camp de Thiaroye* are probably the most violent of African films, but as James Leahy rightly points out, 'Nowhere else is violence indulged for its own sake. Colonial conquest was violent and cruel'.[58]

Like *Sarraounia* and *Camp de Thiaroye*, *Heritage . . . Africa* by Ghana's Kwaw Ansah invokes historical characters and draws upon important cultural traditions to make profound statements about colonialism and Africa's struggle for freedom. This film is also among the African films that, from conception to finish, are distinguished by high levels of imagination and professionalism. The script is expertly conceived; there are marvellous performances by professional and non-professional actors alike, splendid characterisations, and good direction. Together with in-depth composition, superb editing and an intense sound track, the film highlights its own reflexivity and creates a spell-binding and suspenseful mood that is both entertaining and emotionally captivating.

Heritage tells the story of an African called Kwesi Atta Bosomefi.[59] From his rise through the scholarly and religious education of the colonial era to his subsequent elevation in the colonial administration to African district commissioner (a rarity), his identity and name change with his

values. Kwesi Atta Bosomefi becomes Quincy Arthur Bosomfield, aligning himself with his British 'counterparts' and thereby immersing himself in an atmosphere created by the 'elite', educated blacks with similar affectations. Thus, he abandons all that has real meaning to him and adopts a new culture. He undergoes a series of humiliating encounters with his estranged wife, his mother, and the jailed but unrepentant Kwame Akroma, all dealing with the system he has helped build. These are peppered with vivid recollections of his past. Finally, through the experience of a frightening and revealing dream, Bosomfield sets his foot firmly on the path to discovering his heritage.

Heritage indicts not only the educated Africans who deny their cultural past and slavishly imitate the British way of life, but also the acculturation that typifies colonial whitewashing of the people's mentality. Ansah succinctly presents this problem right from the beginning of the film, when a church scene sets the mood in an ironic sequence structured to demonstrate the involvement of Christian missionaries in the acculturation and colonising process. As worshippers gather in the church, an English priest begins to preach while his African assistant interprets and translates for the non-English-speaking members of the congregation. Seated in the audience are men in European-cut, three-piece suits and women in both traditional and European-style dresses and hats. The camera focuses on a fashionably dressed little boy, Archiebold, sitting next to his father, Quincy Bosomfield. As he doses off, his father nudges him awake, suggesting that he go outside for fresh air. A tracking shot shows young Bosomfield walking out of the church as the priest continues a sermon on compassion toward the less fortunate:

> Let us take the mentally ill or the destitute, for example, who wander about the street and pick crumbs from the refuse bins, and ask ourselves how many were born that way. Or could it be that some of these people were the very teachers who taught you and I in the class yesterday to make us rich and prominent men today? Just cast your minds back and ask yourselves if that man you met this morning or last Tuesday afternoon, collecting food from the streets . . . could it have been the same man who yesterday was good enough to be your . . .

Abruptly interrupting himself, the priest looks toward the rear of the church. The worshippers turn their heads to see what is going on. When the camera changes angles, it captures a shabbily dressed woman with a bowl of fruit on her head (the kind of woman the priest has just described). She walks down the aisle towards the altar and sits in a pew. Some worshippers, who cannot bear her stench, move further away. When the priest refuses to continue, the church wardens forcibly carry the woman out amidst her shouts of 'Leave me alone, I have come to pray'. Amplified organ music fills the void until the priest, looking up, makes the sign of the cross saying 'Let us pray', as they carry the woman out. 'Great and manifold are the blessings which almighty God the Father

of all mercies has bestowed upon the people of England when first He sent His Majesty's Royal persons to rule and reign over his subjects. Amen', 'Amen', repeats the congregation. The disturbing aspect of this sequence is not only that the priest fails to practice what he preaches by refusing to aid the mentally unstable woman, but that the concluding sermon confirms that Christianity has imposed hegemonic values in order to promote Western norms.

Heritage introduces many other sequences intended to show how Africa's cultural systems collide and disintegrate in the face of colonialism and missionary intervention. In the next scene, Ansah cuts to a highly orchestrated, frantic dance sequence of the sort misinterpreted by missionaries and colonial administrators as a 'fetish dance'. Archiebold, who has left the church, is in the midst of people watching the dancers. A distraught and furious Bosomfield is caught by the camera as he pulls his son out of the crowd, holding him by the waistband. He beats Archiebold and takes him to be disciplined by a church clergyman claiming, 'A Christian child must not watch a fetish dance'. The poor boy, humiliated in the presence of his schoolmates by a second beating, is mercilessly caned – almost naked – his underwear drenched in blood. For a Westerner, beating a little boy in such a manner constitutes barbarity and cruelty, but according to Ansah, such was the regular practice in the colonial school he attended.[60]

As Edward H. Berman notes, 'Recent studies have confirmed that missionaries disseminated education neither for its own sake nor to enable Africans to challenge colonial rule'.[61] Of the methods used to fracture traditional societies, I can only present here a few well-documented accounts from notable Africans of their missionary education. For Kenya's Oginga Odinga the missionaries were not only interested in disseminating the gospels of the Bible, they also tried to use the Word of God in order to judge African traditions. An African who followed his people's customs was condemned as heathen and anti-Christian.[62] Similarly, Nigeria's Mbonu Ojike, reflecting upon his school days in the 1920s, when the missionaries induced pupils to imitate their Western culture in every facet of life, notes that 'every good Christian must take a Western name at Baptism'. This brainwashing was so perfectly organised that 'I mocked my father's religion as "heathen", thinking his inferior to the white man's'.[63] Chinua Achebe epitomises indigenous concern to reverse the oppressive mechanism (in print and in other media) responsible for colonialist disinformation. In *Things Fall Apart*, he casts Mr Kiaga as the African missionary who rejoices when Okonkwo, the son of a traditionalist, abandons his father's house for the missionary compound by exclaiming, 'Blessed is he who forsakes his father and mother for my sake'.[64] This is in no way a simplistic critique of Christianity's contradictions. It rather proves, as in the tradition of African film practice, that history needs to be rewritten from indigenous perspectives to inform us that overzealous missionaries were never perturbed when they, in Berman's words, 'set son against father in direct violation of the fifth commandment'.[65]

If brutally beating Archiebold is atavistic, as the scene suggests, this is because Ansah wants

to substantiate the critique that he makes of colonial subjugation and the undermining of a people's culture. Archiebold becomes infected with tetanus owing to his wounds, and when he lapses into a coma, his mother, Theresa, sends his sister, Penelope, to ask Bosomfield to come home immediately. Bosomfield says he is too busy in the office and instructs his wife to give Archiebold some tablets of APC (for headaches and colds). The boy eventually dies, and it is the same English priest who officiates at his burial. This sets off a series of problems for Bosomfield; his wife abandons him, calling him a slave for neglecting his own family in order to satisfy the imperial crown.

As the narrative unfolds, Bosomfield becomes more and more restless, his loyalty to the colonial British turning to self-denial and destruction, a necessary procedure that he must undergo in order to recognise his true identity. For example, after Bosomfield's wife leaves him, he is seen at his house socialising in the company of his elite friends. When his mother arrives unannounced, instead of welcoming her into the house, he meets her by the doorstop and offers her a kitchen stool to sit on behind the house, making her look like a servant so that she will not tarnish his image. This insensitive attitude, which shows how Bosomfield has been brainwashed, illustrates the difference between traditionalist and assimilationist cultures. We only know that his traditional name is Kwesi because that is what his mother calls him. According to Ansah, his name had meaning: Kwesi means 'Sunday born'; Atta means 'a twin'; and Bosomefi means 'an illustrious ancestor has been reborn'.

After the guests are gone, Bosomfield meets his sleeping mother and asks her into the house. She is happy to see her son occupy a house in an exclusively white colonial officers' quarters (he is accepted because he has assimilated), but at the same time she is concerned about their culture. She bestows a traditional honour on him, handing over a 500-year-old heirloom, an ancestral casket that has been passed on to sons from generation to generation.

Moments after his mother leaves, Bosomfield takes the casket, the container of his family spirit, to his boss, the colonial governor, telling him that it is a special gift. Of course, the governor accepts, acknowledging that it is of an 'exquisite craftsmanship and an interesting piece of art'. The governor in turn sends the casket to England. Clearly, Bosomfield's action is one of betrayal and misplaced trust. In this action lies a political commentary that reminds the viewer of Africa's many elite sons who have betrayed their fellow citizens after ascending to their country's leadership, working only to advance the interests of the former colonial masters.

In a highly emotional sequence, after being informed about the loss of the family heirloom, Bosomfield's mother reprimands her son, giving him a lesson in traditional culture, dignity, and self-affirmation, along with one about his imminent doom. Alexandra Duah's performance here and throughout the film is outstanding. Through effective handling of cinematic conventions, this enlightening scene, with its intricate series of flashbacks, captures the mood of growing up in the 1960s and attending a colonial elementary school. A long-shot shows Bosomfield coming to

visit his mother, meeting her, and sitting down to a family *tête-à-tête*, which soon develops into a lesson for a neophyte.

Mother: "Welcome my beloved son."

Bosomfield: "How are you madam?"

Mother: "By the grace of God I am well. Have some water Kwesi."

(Bosomfield lifts a bowl of water. As he opens his mouth to drink, his mother stops him to remember tradition – to pour libation to the ancestors.)

Mother: "Remember the forefathers. Welcome my son. I trust you are taking care of the ancestral heirloom? It will forever remain your source of strength and pride."

Bosomfield: "I gave it to the Governor, my boss."

Mother: (In disbelief, heartbroken) "You have wounded my soul. You have broken my soul. You have broken your ancestral link. What happened to all the classroom education? Where is the common sense? Even your illiterate twin sister would have understood this simple message. You will never be free if you don't retrieve the heirloom. The ancestors will forever haunt you."

A series of dissolves connects images of young Bosomfield growing up, highlighting memorable shots of his mother taking him to school and caring for him. One of the shots in which the young Bosomfield holds his hand over his head, trying to touch his ear, is particularly worth mentioning: this was how the colonial administrators determined if a child was 'big' enough to go to school. If the fingers failed to reach the ear, the child had not reached school age.

From all appearances, *Heritage* is indebted to the Fanonian theory of the 'native intellectuals'. Such a figure, he states, is likely to move first into a 'blind alley' before going 'into the common paths of real life'. That is, after having 'proved that he has assimilated the culture of the occupying power', but not without expressing 'distress and difficulty', the native intellectual decides 'to make inventory of bad habits drawn from the colonial world' before turning himself 'into an awakener of the people'.[66] The major achievement of *Heritage* lies in its commitment to what Teshome Gabriel calls 'social art'. In his sincere, deep-felt respect towards treatment of theme, character, and situation, Ansah constructs a provocative, authentic, and reflective analysis of Africa beyond sociocultural parameters. In this structure, we find projected an optimistic view of Africa that suggests the possibility of a radical transformation.

As in Fanon's thesis, Bosomfield, after going through numerous problematic relationships, reaches the stage at which he begins to question his loyalties. After his son dies, he witnesses the death of another child whom he tried to save by taking him to an all-white hospital. Here he discovers the destructive impact of colonial policies that bar Africans from medical attention even at the point of death. Other problems abound, compounded by the demands of African

nationalist movements. As Nii K. Bentsi-Enchill puts it:

> Beside him stand his British colleagues who expect him to stand firm. Behind Bosomfield is the rising tide of his own conscience, first awoken by his mother's warning that until he retrieves the brass casket he shall have no rest, and spurred on by the new perception of the poverty and repression that his compatriots endure.[67]

In the end, Bosomfield is a changed man, although it is already too late. As he struggles to retrieve the heirloom in the last sequence, his demise is imminent, but he dies after common sense has prevailed – he has denounced the colonial system and secured his own heritage.

Sarraounia, Camp de Thiaroye and *Heritage . . . Africa* are African films par excellence. All of them critically examine African issues from an African perspective, and, because they dramatise the truth, there has been a general antagonism toward them.[68] The makers of these films have proved that good films can be made in Africa without resorting to clichés. The knowledge that is derived from this practice is pan-African in its spirit of recovery and in its retrieval and recontextualisation of Africa's past within Africa's present.

Notes

1 For the motivations and affectations of this ethnographic paradigm, see my article, 'Framing FESPACO: Pan-African Cinema in Context', *Afterimage*, vol. 19, no. 4 (New York: November 1991), pp. 6–9.

2 Ntongela Masilela, 'Interconnections: The African and Afro American Cinemas', *The Independent*, no. 11 (January-February 1988), pp. 14-17.

3 For example, *Yeelen* can be read as a critique of traditionalist culture (the *Komo* cult) since Mali is ninety percent Islamic and Cissé, the filmmaker, is Muslim. However, skilled in obsfucation, the film evades this primary source of influence.

4 Masilela, *op. cit.*, pp. 14–17.

5 John A. A. Ayoade, 'The Culture Debate in Africa', *The Black Scholar*, no. 20 (San Francisco: Summer – Fall 1989), pp. 2–7 illuminates and synthesises recent discourses on the subject.

6 Tony Gitten's article is published in Gladstone Yearwood (ed.), *Black Cimema Aesthetics: Issues in Independent Black Filmmaking* (Athens, Ohio: Center for Afro-American Studies, 1982), pp. 115–120.

7 Captain Thomas Sankara, cited in Joan R. Rayfield, 'FESPACO 1987: African Cinema and Cultural Identity', paper presented at meetings of Canadian Association for African Studies, Edmonton, May 1987, p. 11.

8 Sékou Touré, 'A Dialectical Approach to Culture', *The Black Scholar*, no. 1 (San Francisco: November 1969), p. 13.

9 *Ibid.*, p. 23.

10 *Ibid.*, p. 13.

11 See, for example, Françoise Pfaff's article 'The Films of Gaston Kaboré and Idrissa Ouedraogo as Anthropological Sources', in *The Society for Visual Anthropology Review* (Los Angeles: Spring 1990), pp. 50–59. Other references to this article are from the author's original copy, which she kindly made available to me before it was published; therefore, page numbers are omitted in subsequent citations.

12 See note 3.

13 Malian dialect specific to cinema, see Amadou Hampaté Bâ, 'Le dit du cinèma Africain', in *UNESCO Catalogue: Films ethnographiques sur l'Afrique noire* (Paris: UNESCO, 1967).

14 Kwame Anthony Appiah, 'Is the Post- in Postmodernism the Post- in Postcolonial?' *Critical Inquiry*, no. 17 (Chicago: Winter 1991), p. 342.

15 Kate Ezra, *Human Ideal in African Art: Bamana Figurative Sculpture* (Washington DC: National Museum of African Art, 1986), p. 15. Quoted in Rachel Hoffman, review of *Yeelen* in *African Arts*, no. 22 (Los Angeles: February 1989), p. 100.

16 Cited in Hoffman, *op. cit.*, p. 100.

17 See Cissé's interview, 'Souleymane Cissé's Light on Africa', *Black Film Review*, no. 4 (Washington DC: Fall 1988), p. 12.

18 Amie Williams, review of *Zan Boko*, in *African Arts*, vol. 23, no. 2 (Los Angeles: April 1990), p. 93.

19 See, for example, Gilbert Adair, 'The Artificial Eye: *Yeelen*', *Sight and Sound*, vol. 57, no. 4 (London: Autumn 1988), p. 284.

20 In the catalogue 'Library of African Cinema', a project of California Newsreel, distributor of *Yeelen*.

21 Abdoul Dragoss' article in the 1991 FESPACO catalogue, 'Environment: An issue which needs to be addressed by African Cinema', draws attention to the significance of the 'cosmic tree'.

22 *Black Film Review, op. cit.*, p. 15.

23 Appiah, *op. cit.*, p. 346.

24 *Ibid.*, p. 346.

25 The problem of exhibition is still a persistent one, and the sector is still foreign-dominated. Since films produced in the Francophone region during the pioneering years were financed by the French government, France also controlled the rights to distribute them. Some of the films were considered too political to be promoted in their home countries.

26 Pfaff, *op. cit.*

27 'Feature Films as Cultural Document', in Paul Hockings (ed.), *Principles of Visual Anthropology* (The Hague and Paris: Mouton, 1975), pp. 231–251, as quoted in Pfaff, *op. cit.*

28 D. Yung, *Variety* (Los Angeles: 16 November 1988), p. 23.

29 As in the process of using still photographs on screen to identify dictators or people who were responsible for unjust punishments on the society, Jorge Sanjines' *Coraje del Pueblo* (Courage of the People, 1971), Octavio Getino and Fernando Solanas' *La hora de los hornos* (Hour of the Furnaces, 1968), and Patricio Guzman's *Batalla de Chile* (Battle of Chile, 1973-78) are some of the films that employ this strategy.

30 Pfaff, *op. cit.*

31 Françoise Lionnet, 'Dissymmetry Embodied: Feminism, Universalism and the Practice of Excision', *Passages Issue 1*, no. 1 (Chicago: 1991), p. 2.

32 Ukadike, 'Framing FESPACO', *op. cit.*, pp. 6–9.

33 Blaine Harden, *Africa: Dispatches from a Fragile Continent* (New York: W. W. Norton and Company, 1990), p. 18.

34 Abdou Diouf, in Olayinde Koso-Thomas, *The Circumcision of Women: A Strategy of Eradication* (London: Zed Press, 1987), p. 27. Also quoted in Lionnet, *op. cit.*, p. 3.

35 See Pat Aufderheide's interview with Cheick Oumar Sissoko in *Black Film Review*, vol. 6, no. 2 (Washington DC: Winter 1991), p. 4.

36 For Rouch's influence on African filmmakers, see chapters two and four of my book, *Black African Cinema* (Berkeley: University of California Press, 1994). He contributed to the training of African filmmakers, including Sissoko. His numerous films about Africa are menacingly degrading.

37 Appiah, *op. cit.*

38 *Finzan* is distributed by California Newsreel. This description is contained in their catalogue *Library of African Cinema*, p. 9.

39 Pfaff, 'Africa Through African Eyes: An Interview with Idrissa Ouedraogo', *Black Film Review*, no. 4 (Washington DC: Winter 1987–88), pp. 11–12, 15.

40 Some of the information here was presented in my review of *Yaaba*, co-authored with Richard Porton in *Film Quarterly*, vol. 44, no. 3 (Berkeley: Spring 1991), pp. 54–57.

41 William Fisher provides valuable information on Kinshasha's boisterous musical life, stating that Claude Cadiou's French/Côte d'Ivoire co-production *La vie platinée* (Treichville Story, 1987), a highly successful film 'showcasing guitarist Zanzibar and his group Les Têtes Brûlées', initiated the musical comedy genre. See 'Ouagadougou: A Beacon for African Culture', *Sight and Sound*, no. 58 (London: Summer 1989), p. 172.

42 From an interview with the author in New York City in 1986.

43 Rayfield, *op. cit.*, p. 11.

44 See 'Cinema is a Weapon', interview with Haile Gerima by Kwame Karikari in *West Africa* (London: 24–30 July 1989), p. 1210.

45 *Ibid.*

46 V. Y. Mudimbe, *The Invention of Africa: Gnosis, Philosophy, and the Order of Knowledge* (Bloomington: Indiana University Press, 1988), p. 182.

47 Randal Johnson, *Cinema Novo X5* (Austin: University of Texas Press, 1984), p. 49.

48 This student referred to the wanton massacre of Iraqis and Kurds and forms of oppression reminiscent of colonialism, slavery, pogroms, the Holocaust, under the guise of 'New World Order'.

49 Med Hondo, in an interview with Amir Emery, *New African*, no. 17 (London: April 1988), p. 39.

50 Margaret A Novicki and Daphne Topouzis, 'Ousmane Sembene: Africa's Premier Cineaste', *Africa Report*, no. 35 (New York: November–December 1990), p. 67.

51 Hondo, *op. cit.*, p. 41.

52 Jonathan Rutherford, 'A Place Called Home: Identity and the Cultural Politics of Difference', in Jonathan Rutherford, (ed.), *Identity: Community, Culture, Difference* (London: Lawrence and Wishart, 1990), p. 11.

53 Rayfield, *op. cit.*, p. 6.

54 *Ibid.*

55 From an interview with Hondo conducted by this author in San Francisco at San Francisco State University, 1990.

56 G. Williams, *The Expansion of Europe in the XVIIIth Century: Overseas Rivalry, Discovery and Exploitation* (New York: Walker and Company, 1967), pp. 17–30, quoted in Mudimbe, *op. cit.*, pp. 16–17.

57 Senegal sent troops to the Gulf when it was certain they had no technology to offer Saudi Arabia or the Gulf oil states after the war. Unlike Western countries, which went in to safeguard their economic interests, it stood to lose everything. Ninety-nine soldiers were killed in an air crash when they were returning home – a number far surpassing the casualties of Britain or France, for example.

58 James Leahy, *Monthly Film Bulletin*, no. 55 (London: January 1988), p. 9.

59 This synopsis is adapted, with some adjustments, from Kwaw Ansah's production notes.

60 From an interview with the author in Ouagadougou, Burkina Faso, February 1991.

61 Edward Berman, 'African Responses to Christian Mission Education', *African Studies Review*, no.3 (Waltham, MA: December 1974), p. 527.

62 Oginga Odinga, *Not Yet Uhuru* (New York: Hill and Wang, 1967), p. 42.

63 Mbonu Ojike, *My Africa* (New York: J. Day Company, 1946), p. 55.

64 Chinua Achebe, *Things Fall Apart* (New York: Oblonsky, 1958), p. 180.

65 Berman, *op. cit.*, p. 532.

66 For the discussion of 'Native Intellectuals', see the chapter 'On National Culture' in Frantz Fanon, *The Wretched of the Earth* (New York: Grove Press, 1968), (quotation on pp. 220-23).

67 Nii K. Bentsi-Enchill, 'Black People's Burden', *West Africa* (London: 30 May 1988), p. 956.

68 All three films have been suppressed. For example, for political reasons, *Sarraounia* was prematurely withdrawn from five out of the eighty theatres in France originally scheduled to show it. *Camp de Thiaroye* was not selected for the Cannes Film Festival, and *Heritage . . . Africa* has not received wide screenings outside Africa. Films like *Finzan, Yaaba,* and *Tilai*, however, have been widely distributed.

The Modernist Experience in African Art: Visual Expressions of the Self and Cross-Cultural Aesthetics

Salah Hassan

Ibrahim El-Salahi
The Inevitable, 1984-85
Pen and ink on paper
9 panels (31.2 x 27.5 cm)
Courtesy the artist

To this day, the study of African art remains largely a Western discipline, the product of Western sensibility and an expression of Western aesthetic responses to African visual culture. This partially explains the disparity between African art as it is presented in written texts[1] and African art in reality. As argued by Jan Vansina in 1984, 'African art' is usually the label given to the visual arts of people south of the Sahara, and in particular, those of western and central Africa.[2] Perceived to be authentically less 'African', northern Africa – almost half of the continent including Egypt – has been excluded from the discourse of traditional African art history.[3] Moreover, students of African art have focused primarily on the sculpted form and its aesthetic appeal, neglecting other forms. Even when more serious students turned to the study of style and the cultural and social contexts of African art forms, they have focused primarily on the description of the function and uses of objects in an ethnographic context. Hence, their written texts, often presented in the mode of the 'ethnographic present', have expressed no concern for history, time-scale or change in African art.

This approach to African art and creativity has evolved into what Sidney Kasfir has called the 'one tribe/one style' paradigm,[4] a model of the theory that has dominated African art studies to date. It is due to this approach that African art, mostly presented as traditional masks and wooden sculpted figures, has been perceived as a product of a universal, unchanging 'tribal' essence and communal sensibility within which the creative individual remains largely anonymous and unimportant. Moreover, reading a text on African art or seeing a display of African objects in a museum or gallery, one gets the impression that 'creativity in Africa had been frozen after some genesis when the known type of icons were crafted by the hands of some hero of a founding myth'.[5] In other words, not only have scholars of African art primarily focused on the sculpted forms of limited regions, but they have egregiously neglected the contemporary experience in African art.

The following pages provide a historical and critical analysis of the modernist experience in African art. This should help in understanding and appreciating the work produced by African artists today, either in their own country or in Western centres of modernism. With the growing interest in contemporary African art forms that has become evident in the last decade, it is imperative to provide a critical evaluation of the approaches followed thus far in studying these forms, especially where applied to the works of modern African artists. The field of African art in general requires new frameworks for understanding its forms and the aesthetics that engender them. To achieve this goal, it is important first to investigate the relative neglect of contemporary forms of African art within scholarly fields of inquiry.

African Art: The Field and its Boundaries

Of all the categories of African art, modern art, especially that of Western-trained artists, has received the least attention from art historians and other scholars.[6] Most exhibitions and publications are dedicated to traditional and so-called 'classical' African art forms. Of the

intermittent and sparse exhibitions of contemporary African art mounted in Europe and North America or even in Africa from the 1960s to the 1980s, few provided critical analysis of art works or their historical and sociocultural contexts. The majority of exhibitions were mounted with poor documentation, if they were documented at all. Most Western museums still refuse to acquire or exhibit contemporary African work because it does not measure up to stereotyped standards of African art. Even after some Western museums changed their collection and acquisition strategies, making room for contemporary African or other Third-World art, the policy became: 'only as long as the contemporary art of a region bears some relation to the "traditional" art'.[7] The works of many contemporary artists from Africa and other parts of the Third World are still dismissed by many museums, galleries, and art experts in Europe and the United States as second-rate. Wolfgang Bender quotes a European museum official as saying of contemporary non-Western art:

> It seems like third-rate artwork to us because the art presented here emulates the Western tradition – this is a criterion for selection – and because it is always lagging behind, regardless of how commendable the efforts might be basically. Every comparison with the present international art scene is therefore not in its favour. It cannot escape the critical eye of the Western art world, thus it is superfluous – if I might put it so bluntly . . . It is . . . an open secret that museums have always refused to take over such displays and always managed to find a new excuse and friendly reasons to dismiss them courteously and painlessly.[8]

It has been argued that the neglect of contemporary forms in African art is due to the preoccupation of Africanists with 'traditional' art forms, or so-called 'indigenous' and 'authentic' art. Yet, in reality, this neglect has been primarily caused by the widespread misconception that contemporary African culture is a distorted copy, a mere imitation, of Western culture, and therefore lacks authenticity. Contact with Western culture is seen as a source of the decay and, indeed, the extinction, of Africa's great traditional arts.

Although colonial and postcolonial conditions in Africa have disrupted cultures rich in the visual arts, religions, oral traditions, and social and political formations, this disruption was not total, especially in the artistic and creative domains. A serious look at the contemporary African art scene contradicts assumptions about its authenticity and creative essence. Recent scholarship on contemporary African culture has demonstrated that Africa's encounter with the West has been far more complex than previously thought. In the realm of art, as argued by Susan Vogel,[9] African assimilation of Western techniques, materials, ideas and forms has been creative, selective, meaningful, and highly original. The result has been a continuous re-creation of forms and styles. In short, Africa's creative impulses remain alive and continue to contribute great works

of literature and masterpieces of visual and performing arts to the world cultural scene.

One should acknowledge an increasing interest in contemporary African art in terms of exhibitions and publications,[10] for example 'Seven Stories About Modern Art in Africa', the comprehensive show mounted at the Whitechapel Art Gallery in London as part of Africa 95, the British-based Festival of African Arts held during the Autumn of 1995. In comparison to other international biennials, the recently initiated Johannesburg Biennial of International Contemporary Art has accorded modern African art the equal status it deserves. Ulli Beier's single-handed efforts through Iwalewa Haus' exhibitions and publications has provided the German and European audience with a window onto the rich world of contemporary African art. The third 'Images of Africa' festival in Denmark, with its diverse, multiple exhibitions and activities focusing on different aspects of modern African artistic expressions, has extended attention to the Scandinavian countries, building on the Malmö Konsthall's initiative in hosting 'Seven Stories . . .' (1996). This should be saluted as an encouraging departure from the traditional approach to African art.

It must, however, be noted that the recent attentiveness by Western institutions to modern African art, and non-Western representation in general, has not, in any profound manner, altered the sense of inferiority with which those institutions have viewed the cultural production of those conveniently labelled 'other'. Nor does such attention represent a drastic change in Western institutional hegemonic strategies, which continue to view, with deep distrust, cultural practices generated outside its immediate spheres of influence. What we are witnessing is not the ultimate recognition of the plurality of history, but a return of Western grand narratives in the guise of asserting 'cultural difference', evidenced in the ideology of neo-conservatism and reactionary Western practices. The 1995 Venice Biennale and Documenta are strong manifestations of such practices. The Biennale's French artistic director, Jean Clair, decided to protect his 'pure' European territory from contamination, by failing to invite African artists. His reason? 'Because "their" notion of art is different from "ours"!' implying the self-deceiving notion that it was the West that raised the status of the image to its present point of sophistication.[11] Clair's statement is not an isolated case, but a serious reminder of an increasingly xenophobic Europe bent on combining its new consolidation of economic power through the EEC, with the protection of what it assumes to be 'pure' European traditions. The acceptance of a group of experienced and highly trained African artists into the arena of international art is seen as disruptive to the narrative of a superior Western art history.

It is true that the Western art world has learned to soften and regulate the offensive language and objectifying methodology of its ethnographic and anthropological discourses in relation to African and other non-Western cultures. However, racial determinism, the demand for the display of authenticity and spectacle, remain essential Western criteria of validation and

acceptance. The search for the unusual, the exotic, the naïve and the untrained has spurred on those art historians, critics and curators who would not otherwise express interest in African art. This is a reminder of the Africa that has always attracted Western explorers, adventurers and thrill seekers – the great white hunters of knowledge and wealth. The outcome has been the deliberate bypassing of the most proven African artists in international art arenas in favour of the kitsch, crude, and naïve products of the roadside painters who crowd the markets of African metropolises – turned overnight into so-called self-taught geniuses.[12]

The majority of the exhibitions have failed to escape Western demand for difference and exotism. A case in point is 'Towards the Year 2000' (1996), amongst several other touring exhibitions in Europe. This is a model of recent European curatorial practice driven by an alliance of mostly European curators/collectors who specialise in marketing the art of a group of untrained Francophone African artists. Their taste for and attitudes to contemporary African art is marked by a preference for the exotic, the naïve, the unusual and the crude, resulting in the creation of what they call a 'new primitivism'. Such is the binding logic of bringing together the group of artists in 'Towards the Year 2000', from Twins Seven-Seven and Chéri Samba to Takoudagba, who has become a common feature in the menu of 'new primitives' served up in recent European feasts of contemporary art. Without exception, all are known to be self-taught, untrained in a fine-art college or university. Some collectors associated with these exhibitions, such as André Magnin, are outspoken about their distaste for the art of college-educated African artists. For Magnin and similarly minded collectors, it appears to imitate European models, while the art of the untrained is thought to possess originality and an untrained African beauty.[13] One must also highlight the fact that few of the exhibitions, if any, have been curated by an African curator, art historian or specialist. This in itself is a testimony to the state of affairs in terms of African representation in the West.

Defining the Field: A Problem of Terminology

Most current scholarship on African art, pioneered by scholars and patrons of Western-trained artists in Africa,[14] has adopted a Manichean scheme, continuing to define 'contemporary' African art within the parameters set by Ulli Beier in 1961.[15] Like modern art elsewhere, 'contemporary' African art – meaning the art of Western-trained artists – is recognised as individualistically oriented rather than communally-centred.[16] It is also perceived as less subservient to dominant socioreligious structures than 'traditional' art forms. In other words, 'contemporary' art becomes a category reserved for the works of those African artists who are mostly urban-based, produce work according to the norms of Western modern art, and exhibit in galleries, museums, or foreign cultural centres.[17] These artists are to some extent internationally known, and their patrons include their governments and related institutions, foreign expatriates, and a largely Western-educated native bourgeoisie. Works produced by this category of artists are classified as 'elite', 'fine' or 'high',

as opposed to other forms referred to as 'traditional', 'tourist', 'commercial' or 'popular'. This fine or high art is contrasted to 'traditional' art as a totally separate, more intellectual, entity. In this scheme, traditional arts are perceived as consensual, communally based and created according to rigid and unchanging conventions. Such a dichotomy – problematic, simplistic and ahistorical – is inadequate for the study of contemporary African art. Today, few accept the characterisation of 'traditional' art as representing societies that are unchanging, static, closed or village-based as argued by Beier in 1969. Recent scholarship on the 'traditional' art of Africa has clearly demonstrated that it is as intellectual as the work of Western-educated artists. This traditional versus contemporary dichotomy was created by the colonising structure in Africa, and is equally rooted in the epistemological roots of African art scholarship, which is basically Eurocentric.[18] Any serious effort to define contemporary African art forms must start by examining this dichotomy and its validity.

'Traditional/Contemporary': The Dichotomy and its Implications

The confusing implications of traditional versus modern or contemporary art can best be explored by raising several related questions. How can we classify 'traditional' forms of African art that continue to be produced in Africa? Are they not contemporary art too? The dichotomy creates the illusion that forms of African art designated traditional, or studied as such, are artifacts of the past, while in reality, traditional forms of art continue to be produced today, within the burgeoning urban as well as rural sectors of Africa. Another methodological question that arises is how to classify these traditional forms? Is the designation 'neo-traditional' critical enough to distinguish such forms from either the 'plain traditional' or the new art of the educated elite? Still more relevant, is the paradoxical realisation that so-called contemporary art has in fact been in existence for more than half a century; that is to say, since at least the 1920s, if we accept the proposition that the genesis of contemporary art forms was associated with the second decade of colonial rule. Is that not a sufficient period of time to establish a tradition? Or, as some would have it, are 'traditions' more often than not actually 'invented'?

Recently, categories such as 'international', 'self-taught', 'studio-trained', 'popular', 'tourist', 'commercial' and so forth have been proposed to distinguish the different types of contemporary African artists.[19] Such classifications, however, cannot withstand rigorous analysis, and prove problematic when tested against the realities of the contemporary art scene in Africa. As propositions, they represent old wine in new bottles. African art forms are still subjected to a static system of classification and perceived as existing outside history.

The predominance of this dichotomy in the field of African art, despite the clear contradictions and paradoxes it entails, is partially due to an outdated sense of terms such as 'tradition', 'authenticity' and 'originality'. In recent scholarship, the concept of tradition is no longer viewed

in a 'naturalistic' sense as it had been previously. Students of culture and society have concluded that tradition is no longer an 'authentic' body of knowledge handed down from one generation to another with only minor alterations due to the malfunctioning of memory or skill.[20] It has been recognised that society does not treat tradition passively. It often creates its own traditions through the selection of certain historical events and heroes and even through invented pasts.[21] Although, the past is a powerful authority in culture, human societies selectively add to it, subtract from it, or mould it in their own image. The notion of tradition should be rooted in social life rather than in time alone, and tradition should not be used simply as a naming of objects, but also, and more fundamentally, as a naming process. As noted by Ben-Amos, 'the process is no longer the process of delivery, or handing down of themes, symbols or forms, but of selecting and constructing a narrative that would become part of a canon, projected into the present and from an imagined or real past'.[22] Hence, authenticity is no longer the quest for the basic essence of tradition. Accordingly, what makes a certain artifact or cultural item 'African' or 'non-African' is to a great extent dependent on how Africans themselves perceive it.

The recent debates in anthropology and in other more emergent fields have challenged conventional ways of perceiving tradition and authenticity. As James Clifford has pointed out, new definitions of authenticity (cultural, personal, artistic), no longer centred on a salvaged past, are making themselves felt.[23] Authenticity is being reconceived as hybrid creative activity in a local present. Non-Western cultural and artistic works are implicated by an interconnected world cultural system without necessarily being swamped by it. Authenticity in that sense is something produced not salvaged.

Despite newly critical perceptions of notions such as authentic, tradition and the like, the old dichotomy still persists in areas of inquiry related to African culture, art and history. The origin of this dichotomy lies in the unique history of the African continent, characterised by two of the most tragic episodes in the history of humanity – slavery and colonialism. As argued by V. Y. Mudimbe, the colonising structure has resulted in a dichotomising system with a great number of paradigmatic oppositions: 'traditional versus modern; oral versus written and printed; agrarian and customary communities versus urban and industrialised civilisations; subsistence economies versus highly productive economies'.[24] It is important to notice that 'modernity' itself is a European construct that was initially articulated while 'traditional' Africa was being colonised.

In contemporary scholarship of Africa, so much emphasis has been put on the transition from traditional to modern that the paradigm has become misleading. Between the two extremes there is, as Mudimbe has argued, an intermediate, diffused space in which social and economic events define the extent of marginality. It is the nature of this space that calls into question the dominant perception in contemporary scholarship of Africa.

It can be argued here that this condition, at least on a theoretical level, has been in part a

consequence of the anthropological discourse – a discourse in which an explicit political power was endowed with authority over a scientific knowledge and vice-versa.[25] Anthropology, as characterised recently, is a dialogue, or more accurately, a monologue, between the presumed cultural 'self' and the ethnographic 'other'. The 'other' is perceived here as static, non-changing and ahistorical, while the 'self' is viewed as universal, dynamic, changing and historical.

Towards an Alternative Dialogic Model

An alternative model for understanding and defining contemporary African art, and in fact all other forms of African art, is urgently needed. Within this model, African art forms must be perceived as expressions of a more complex African reality. Within this reality these forms can be seen as existing in one contemporary space and interacting with each other in a 'dialogic' manner. Invoking the Bakhtinian concepts of 'intertextuality' and 'dialogic' principle in relation to the study of literary genre, this dialogic relationship is assumed to exist on temporal as well as spatial and historical levels.

Crucial to this alternative model will be the investigation of the relationship between the artist, his/her art work or product, and the audience or patrons – between makers, objects and users or consumers – within each art form or tradition. As Johannes Fabian and Ilona Szombati-Fabian indicate, African art should be viewed as 'a complex process in which society articulates and communicates its consciousness of its origins, its past and its present predicament'.[26]

With this approach, we can avoid the contrastive manner in which genres or art forms are defined as separate categories in terms of what they are or what they are not. Here, each category is defined in terms of the basic relationships of intellectual production that govern the creative artistic process, which can be viewed as a communicative process. In any case, all categories must be examined carefully before being applied to the African situation.[27] Furthermore, these should be understood as analytical categories constructed by scholars for organising their material or texts. They may or may not be congruent with the culturally based notions (or, to use the language of the folklorists, 'ethnic genres'), in the mind of the actual creators (artists and audience) of the art object itself.

Understanding African Modernism and Post Modernism

To be sure, the history of modern expression defined by Western standards is relatively short in Africa and differs from one part of the continent to the other. But three factors provide important connections. One is the rise of European and Western patronage and intervention. This was characterised by the establishment of art workshops by European expatriates, mostly colonial administrators, liberal educators or missionaries.[28] A second and related factor is the establishment of formal art schools and acadamies, often fashioned on the Western art-educational model, which

can be traced to the 1940s or later. Third, and most important, is the nationalistic cultural resurgence that swept many newly independent African countries, where government patronage and interest in the arts became part of building, and in some cases, inventing, a 'national culture' and identity.[29] In the 1970s and 80s, new African art movements and initiatives emerged either in reaction to, or as a rejection of, Western schooling in art offered through workshops and art academies in Africa, or acquired by studying in the West. The basic quest of these new movements and initiatives has been to establish a more culturally rooted, self-conscious, and 'African' aesthetic expression. Rejecting the homogenising effect of Western cultural imperialism, especially its neo-primitivising and exoticising tendencies, African artists have repositioned themselves as creators of an autonomous, more global art. The net result has been the creation of new African artists, art movements, art associations and festivals, all attempting to construct new tropes of self-representation. Today, a myriad of Western and 'traditional' African influences have been synthesised, and continue to be used within a modern idiom in African art.

The search for a new identity expressed in modern forms has been the common denominator of most contemporary art movements in Africa. It is a goal shared by the majority of African artists trained in the Western tradition. Despite the postcolonial aspirations among non-Western nations and the neo-colonial ambitions of capitalism, which brought new conflicts and challenges to modernism, for the 'other', modernism remains a basic issue of debate. This should not be interpreted as the 'passive' reception of foreign influences by African people, for Africans (like other non-Western people) have long been questioning, as well as resisting, Western domination.

Such a quest for modernity as an attitude among African artists is reflected in a statement by Amir Nour, the Sudanese-born sculptor whose works were featured in an exhibition at the National Museum of African Art:

> There is nothing wrong with using technology; we need it. But the forms have to come from within the society itself – from the tradition and background we have . . . You can't have a culture isolated from the rest of the world. Cultures have always developed by being fertilised by new elements from other cultures. I mean the whole modern art movement came about because some (European) artists saw African art. And yet Moore, Picasso, Modigliani are never labelled Africanist, as I am labelled Western.[30]

Mohammed O. Khalil, another Sudanese who has lived and worked in New York City since 1967 (featured in the same exhibition), considers his work an embodiment of all his individual experiences as a human being and as an African living in New York. As he asserts, 'my roots are as close to me as my limbs'.[31] Yet he prefers to follow his own private creative intuitions rather than deliberately to portray elements of his African heritage. Khalil perceives his art as part of the

past – indeed a continuation of it – but he also affirms that there are many other influences on him, and that they are part of all of us as human beings. The views of Khalil and Nour echo the assertion of many modern African artists of their right to use all the sources and mediums available to them, defying and subverting an expectation that their art should look a certain way.

The failure to recognise the above dialogue, despite the statements articulated by African artists, is due to the prevailing dichotomies of 'modern/traditional', or 'Western modern/non-Western traditional', and all their implications. It is the failure to recognise the fact that long ago Africans and other Third-World people entered the dialogue on modernism and have challenged it on their own soil.[32] Hence, despite recent negative connotations associated with the term in Western intellectual circles, 'modern' is more suitable for such new African artistic expressions, because it symbolises the experience and practices that the art forms embody. To call it 'modern' distinguishes it from the merely contemporary; for where 'contemporary' refers to time, 'modern' refers to sensibility and style, and where 'contemporary' is a term of neutral reference, 'modern' is a term of critical judgment. Moreover, modernism in the African context, as elsewhere, entails a self-conscious attempt to break with the past and a search for new forms of expression.

The search for a new identity expressed in modern forms has been the common denominator of most contemporary art movements in Africa.

However, in defining the identity of this new art, we find differing trends. Without simplification of a rather complex process, certain perspectives can be delineated. First, there are artists who advocate rejection of Western influences and return to traditional sources. Second, we find artists whose works incorporate the latest styles, trends and techniques of contemporary Western art and thus have become a subject of criticism for rejecting their traditional culture and heritage. There are also those artists who advocate in their work a synthesis between traditional heritage and modern Western art and techniques.[33] Viewing these perspectives as part of a dialectically related process, we see that the central matters of contestation have been how 'African' are these new forms of art and to what extent has the exposure to Western art forms and ideas tainted their 'Africanness'?

Many scholars of contemporary African art have been quick to justify the preoccupation of modern African artists with the 'Africanness' of their work as a reaction to the crisis of identity faced by those artists as products of Western educational systems. In a sense, these scholars have so far dealt with the symptoms but not the causes. What they have failed to explain is why such issues have occupied a central place in the ongoing debate on modern African art.

Who is the Modern African Artist?

Today, the story of European artists such as Braque, Klee, Léger, or Picasso, seeking inspiration from African and other non-Western artistic traditions, is well known. In contrast, little is known of the journeys of African artists into Western centres of modernism, journeys that exemplify a construct that Ali Mazrui has often designated as 'counter penetration'. Not only have African artists lived in Western centres of artistic production, but they have also been in the forefront of contributing to modernism and even postmodernism. Informed by the artists' past and present predicaments, their works express differing approaches to modernity, various responses to colonialism and postcolonialism, and persistent resistance to Western hegemony. Moreover, the history of modernism, solely from a Western perspective, tends to exclude recognition not only of the plurality of cultures, but of the objects of 'high' culture produced by the 'other'.[34]

The majority of modern artists in Africa belong to the first or second generation of a Western-educated elite class that emerged in many African countries after the second decade of colonial rule. That group was small – and remains so even today – due to the limited education made available by the colonials. Many of these elites lived in colonial or postcolonial capitals and urban centres, beyond which the influence of the colonial power's culture is almost nil. Against the background of a basic colonial aim to destroy the native's culture, and to assimilate the rising minority 'lower middle-class' into its own culture, this new class felt its 'marginal' situation. It found itself caught in the middle between the masses of urban and rural workers or farmers whose culture and identity were kept intact, and their aspiration to a way of life similar to the colonial ruling class. They were prisoners of the contradictory social and cultural reality in which they lived. That 'marginality', as explained by Amilcar Cabral, constitutes 'the sociocultural drama' of the colonial elites or native 'petty bourgeoisie'.[35] In reaction to that situation, 'return-to-the-source' and other native intellectual movements began redefining their (African) identity. We should note here that 'return-to-the-source' in the realm of art and literature, or the intellectual reaction to the colonial situation in general, does not reflect an even and unified process. It ranges from total rejection of, and resistance to, the Western 'colonial' culture, to advocacy of a synthesis of the native culture and Western elements.

The development of a modern idiom in African art is closely linked to modern Africa's search for identity. Most contemporary works have apparent ties to traditional African folklore, belief systems and imagery. The only way to interpret or understand these works is in the light of the 'dual' experience of colonialism and assimilation into Western culture in Africa. They reflect the search for a new identity. This can be seen in the works of many artists who emphasise the use of local material, techniques, tools or colours, or those artists who have shown preference for urban or rural genre scenes. It can also be observed in the use by some artists of motifs and decorative elements borrowed from their countries' ancient 'traditional' arts and crafts.

In nearly all of his writings and public statements about his art, the Sudanese painter Ibrahim El-Salahi has stressed his goal in retaining 'Sudanese' motifs in his art – even if his technique may be basically Western. Upon his return from England, having studied at the Slade Art School in London in the late 1950s and early 1960s, El-Salahi found that many of the ideas he had acquired from abroad isolated him in his own country and that his work seemed meaningless and without character in Khartoum.[36] He summed up his experience and to some extent, the experience of most modern African artists, in the following statement:

I left Sudan and came back, then suddenly I started to look around and I started to look for things, for patterns. I have always been fascinated with patterns in local Sudanese handicrafts and what simple peasants were doing and carving and decorating and painting. And suddenly I think that the beauty of it came to me and hit me – it's so strong. I lived with it all my life and yet I never saw it before, until I went outside and came back, with a different outlook towards things. And this is when I started looking – just travelling all over the Sudan and looking at whatever people did – at their homes, their beds, the praying carpets, the way they put the saddles on their camels or oxen. And this fascinated me a great deal and I started just to observe and to draw. But although I said my painting now seems Sudanese in locality, in flavour, I don't deal with it in terms of locality – that it should be Sudanese art – there is no such a thing as Sudanese art. But I mean as a Sudanese individual . . . could do something. I find the colour . . . looks very much like our earth, and maybe that's why I feel it's Sudanese.[37]

The Ghanaian artist El Anatsui's use of wood burning, a traditionally known technique in African art, to make symbolic political and social statements provides evidence of this modernist urge. Magdoub Rabbah, another Sudanese artist, is known for his use of a technique that he termed 'solar engraving', the etching of beautiful low-relief engravings on hardwood boards, painted with locally made colours and dyes such as henna. Solar engraving is achieved by using commercial lenses to capture the rays of the sun into a single beam to burn the wood surface. Although Rabbah justifies the use of solar engraving, henna and wood as 'a new and cheap source of materials', all his techniques and media can be traced to traditional origins.[38]

Even works of those African artists who most closely conform to norms of the Western artistic tradition, reflect a clear relationship to their artistic heritage as Africans. The work of Skunder Boghossian, the Ethiopian artist, for example, should be viewed within such a context. Skunder uses the most diverse techniques and media from Africa and the West to enhance the power of expression in his paintings. His work entitled *Time Cycle II* (1981), offers the finest example of his innovative techniques and media experimentation combining relief with bark cloth (a local African material) and oil colour. Skunder's work – vibrant in colour and rich with symbols and motifs –

Skunder Boghossian
Time Cycle II, 1981
Embossed bark cloth
101.6 x 76.2 cm
Courtesy the artist

synthesises his country's rich and powerful traditions of wall and scroll paintings and illuminated manuscripts dating back to the eighth century, with European techniques.

The South African artist David Koloane's 'Made in South Africa' (1993), is a series of graphite drawings that forms a visual narrative. Koloane's work reflects the techniques and styles of various artists and movements. Combining animal and human forms with abstract and figurative elements, his images are dark and powerful. Koloane asserts that the work speaks of 'the tragedy of South African politics and of the endemic violence that has engulfed entire communities'. It encompasses the haunting spectre of squatter settlements, which appear on the urban landscape like 'unwanted pregnancies'. He adds that 'the apparent obsession of most South African artists with social realistic expression is an intrinsic sociopolitical statement about the tyranny of place'.[39] Therefore, the work represents the collective memory of a people trapped in a space and environment not of their choosing.

In his series of works entitled 'Africa: The New Alphabet' (1987–95), the Ethiopian artist, Wosene Kosrof has worked toward building what he calls 'a vocabulary of signs and symbols, or *fiedel* (which means language symbols in Amharic)'.[40] Creating this 'new alphabet', he says, 'is an act of storytelling for me that grows out of traditional African calligraphy, graffiti, colours, textile patterns, woodcarvings, and rituals that create a universal language of forms and meanings'. However, as he explains, 'I am not in pursuit of a readable message with my calligraphy; rather, I do paintings in which the Amharic language is incorporated as part of the aesthetic value of the whole work'. Wosene's works in this series are the best examples of his calligraphic explorations in which the aesthetic and magical qualities of language and the written word become inseparable. His style grew out of a synthesis of traditional Ethiopian calligraphy, graffiti, and colourful scroll-like patterns. Along with the traditional pan-African elements incorporated into all his works, he includes patterns that echo the rhythms of jazz. 'Jazz inspires the movements, the pacing, the silent spaces, and the moods in my works', he confirms. This is a reflection of his experience of living in the United States and his affinity with African-American culture and creative expressions.

To the uncritical eye, the sculpture of Amir Nour may appear highly abstract. Yet the geometric forms, arcs and rectangles are drawn from images of his youth in the Sudan. The domes and arches, cattle horns, calabashes and sand hills all belong to the landscape of his homeland, becoming part of his aesthetic concern and recognisable if one is familiar with the adobe architecture of northern Sudan. In some of his works, such as *Grazing at Shendi* (1969), a stainless-steel sculpture composed of 202 semi-circles of varying sizes, the shapes are more formalised and abstracted. This piece is inspired by his childhood memories of watching goats grazing on the outskirts of his home town. The arrangement of the repetitive units suggests the sloping hills and the animal's backs. The variation in their sizes gives a sense of distance.

Their polished surfaces reflect Nour's concern with light in relation to form. A dominant theme in Nour's work has been that of the gourd or calabash, which he has simplified to plain hemispheres. *Expanded Gourd* (1991) and *Split Gourd* (1991), as explained by the artist, are two works inspired by his early days watching calabash artisans in village market places 'shining their domed-shaped gourds with animal fat'.[41]

The installations of Houria Niati, an Algerian artist who has been living and working in London since 1979, shed some light on the complex experience of African artists in their confrontation with the West. Like many other Algerians of her generation, Niati spent part of her childhood under the French occupation, towards the end of the war for independence, witnessing the cruelties of the French and the heroic resistance of the Algerian people. Moving to the West in the late 1970s to study art and later on to pursue a career as an artist in London, Niati found herself in another type of confrontation with the West, this time in response to the fictionalised and exoticised images of her country and people created by Western Orientalist painters and photographers during the late nineteenth to early twentieth centuries. This new experience, plus her complex background as a woman, an Algerian of Arabo-berber heritage with Islamic influences, are all reflected in her style, and the multiple references in her work. She takes on the genres of installation and conceptual art, redefining and recreating them in a new fashion, totally unrecognisable to those who claim to have invented them. In her live performances, which often accompany her installations, Niati brings together the visual and verbal expressive elements of her culture and makes them relevant to contemporary issues and concerns. She sings traditional Algerian songs as well as Andalusian *Sha'bi* and sometimes reads English translations of her own poetry. She also uses synthesisers, sound recording, and special light effects to create a theatrical atmosphere and a vibrant magical environment of sound, body movement, and colour.

Two of her recent installations are *No to the Torture* (1982–83), deconstructing Delacroix's famous painting *The Women of Algiers* (1832), and *There is Nothing Romantic About Bringing Water From The Fountain* (1991), in which she explores Orientalist images. In this work, a soundtrack of female voices and running water accompanies several huge painted jars and plaster moulds of Niati's bare feet, placed in a circle in the centre of the gallery floor. These are surrounded by a series of paintings on canvas and paper, hanging on the wall along with a series of old photographs in the tradition of the French colonial postcards of Algeria, with images of women carrying jars and loads on their heads and shoulders. Niati's installations force the viewer to see these Western images of Algerian women as the private fantasies of their creators and consumers. In confronting the oppression of women, Niati does not limit herself to her own society, but extends her concerns to women on a global level.

The Cameroon-born, Amsterdam-based artist Angèle Essamba's black-and-white photographs are testimony to her skilful eye for composition and design. Her works, mainly

David Koloane
*Made in South Africa
Series*, 1993
Graphite and charcoal
on paper (from a
narrative frieze)
64 x 91.5 cm
Courtesy the artist and
the Goodman Gallery,
Johannesburg

Amir Nour
Grazing at Shendi, 1969
Stainless steel, 202 pieces
304 x 411 cm, variable
Courtesy the artist

focusing on Black women, are thought-provoking, visual stories combining her production abilities with a sensitivity to her African heritage. The overall theme of her work is contrast: between black and white, freedom and bondage, rich and poor, reality and fantasy. Essamba claims that through photography, she can effect unity through this contrast. The human figure plays an important role in her work, often reflecting her own background, development and contemplations on identity. Her use of cloth in the composition shows a sense of animation. Drawing on her heritage, influences, personal perspective and aesthetic style and skill, she creates intimate portrayals that provide images to which her viewers can intimately relate. Of her photographs, Essamba says, 'for me it is a hard labour of love, which tells of my world from a very different perspective. Other than the international award-winning pictures by non-Africans, my work is not of the gore, corpses and vultures of war and famine in Africa. But the images in my pictures, my work, are of things that affect anyone'.[42]

If anything is to be learned from Niati's or Essamba's work, it is how a gender-balanced perspective would be crucial to a comprehensive understanding of the modernist experience in African art.

In conclusion, the style of modern African artists, like their subject matter, is highly heterogeneous and varies according to their artistic training and the medium in which they work. Yet, regardless of the differences among their works, these artists share ideological, intellectual and formal concerns, which they seek to express through consistent and related visual devices and vocabularies in terms of style, iconography, symbolism and technique. Accordingly, we should pay special attention to the vocabulary of visual forms, colour and style used in the works of these artists as well as to the syntax and semantics that order them into final works of art. For in any work of art, ideas and programmes are translated into forms, and the quality of those forms determines their effectiveness in transmitting ideas.

It is important to examine new directions in African visual arts, especially the modernist experience. The Nigerian artist Bruce Onobrakpeya stated in 1990 that modern African art is 'growing in strength, and it has arrived. It is equal to any art being practised anywhere in the world'.[43] It is time to appreciate modern African artistic expression on its own terms. This is the way to approach the study of contemporary African art forms and the intellectual premise upon which it should be based.

This approach would offer a fresh look at modernism, and postmodernism, from an African standpoint, and at issues of cross-cultural and transnational aesthetics. It is important to emphasise the reciprocal flow of influences and traffic that has existed between Africa and the West. This would make it possible to reverse the erroneous perception of unilateral influence in which Africa and African art serve as recipients of Western culture and artistic influence, a narrative in which African artists have been projected as passive, silent, and invisible. It is also

important to see how African artists have interpreted and translated the aesthetic and social experiences of postcolonial, contemporary Africa into new idioms of artistic expression that are both related to their cultural heritage, and connected to Western modernism. This would offer a new critical perspective on 'modernism' as a concept in twentieth-century Western art history, and on cross-cultural aesthetics in general.

The many political and economic problems in Africa have denied African artists access to art material, modern techniques and facilities such as foundries and print workshops, let alone venues for exhibiting or marketing their artistic products. Some artists have responded creatively to these problems by adopting new formats and using locally found materials. For the same reasons, many artists have been deprived of participation in international exhibitions, publications and artists' gatherings, thus depriving the art world of their insight and creativity. On the other hand, many of Africa's most talented artists, voluntarily or involuntarily, have been living in major Western metropolises since the early 1940s, and some have even become integrated into established African diasporic societies in the US or Europe. Both groups are crucial to an understanding of African modernism and its responses to Western culture. Their experience provides a first-hand view of the strategies of negotiation that these artists employ in their daily confrontations with the persistent borders in an art world that continues to marginalise them, as well as questions of exile, primitivisation and 'otherisation' of African artists within the dominant cultural discourse. This is the advantage of such an open-minded approach to the contemporary experience in African art.

Finally, as stressed above, a special emphasis on gender balance would also be crucial to a comprehensive understanding of the contemporary experience in African art. Primarily, this would help redress an egregious imbalance in current scholarship on contemporary African artists, which has conspicuously omitted, or only cursorily included, women in favour of an emphasis on male artists. Most importantly, the work of African women artists living and working in Africa or in the West should be studied in order to aid understanding of the dynamic interplay of gender representation and creativity. This would also foreground the right of women artists to an equitable space in a male-dominated scene and would reaffirm the centrality of African women as creative contributors to their own societies and to the global contemporary cultural scene.

Notes

1 Mostly coffee-table-type books illustrated with beautiful photographs of art works printed on glossy paper with short and largely descriptive texts.

2 Jan Vansina, *Art History in Africa* (London: Longman, 1984), pp.1-2.

3 I should add that the debate on Egypt and its exclusion from African art studies is more complex than the artificial separation between north and sub-Saharan Africa. It was largely a product of mid-nineteenth century, Eurocentric notions about African people and their

intellectual abilities and cultures in relation to the rise of colonialism.

4 Sidney Kasfir, 'One Tribe, One Style? Paradigms in the Histiography of African Art', *History in Africa*, no. 11 (Waltham, MA: 1984), pp. 163-193.

5 Vansina, *op. cit.*, p. 4.

6 Of the few existing valuable works on contemporary African arts we can count Ulli Beier, *Contemporary Art in Africa* (London: Pall Mall Press, 1968); *Contemporary African Art*, exhibition catalogue (London: Camden Arts Centre, 1969); *Contemporary African Art*, exhibition catalogue (London: Studio International, 1970); Marshall Ward Mount, *African Art: The Years Since 1920* (Bloomington: Indiana University Press, 1973); Maude Wahlman, *Contemporary African Arts* (Chicago: The Field Museum of Natural History, 1974); Dennis Duerden, *The Invisible Present: African Art and Literature* (New York: Harper and Row, 1975); Judith von D. Miller, *Art in East Africa: A Guide to Contemporary Art* (London: Frederick Mueller, 1975); Kojo Fosu, *20th Century Art of Africa* (Zaria: Gaskiya Press Corporation, 1986); *Contemporary African Artists: Changing Tradition* (New York: Studio Museum in Harlem, 1990); Susan Vogel (ed.), *Africa Explores: 20th Century African Art* (New York: The Center for African Art, 1991); Jean Kennedy, *New Currents, Ancient Rivers: Contemporary African Artists in a Generation of Change* (Washington, DC: Smithsonian Institution Press, 1992).

7 See Wolfgang Bender, 'Modern Art to the Ethnographic Museums!', in Elizabeth Biasio, *The Hidden Reality; Three Contemporary Ethiopian Artists* (Zurich: Ethnological Museum of the University of Zurich, 1989), p. 189. He quotes a statement issued by an ethnographic museum in Berlin regarding its recent acquisition.

8 Bender, *op. cit.*, p. 185.

9 Vogel, *op cit.*

10 Examples of exhibitions and their companion volumes are 'Africa Explores: 20th Century African Art', The Center for African Art in New York (now the Museum for African Art), 1991, curated by Susan Vogel, who edited the large catalogue (*op. cit.*), which contains contributions from several scholars in the field of African arts and the humanities; 'Contemporary African Artists: Changing Tradition', The Studio Museum in Harlem, New York, 1990; 'M. O. Khalil: Etchings, Amir Nour: Sculpture', National Museum of African Art, Washington DC, 1994.

11 Salah M. Hassan and Okwui Enwezor, *New Visions: Recent Works by Six Contemporary African Artists* (Eatonville: Zora Neale Hurston National Museum of Fine Arts, 1995), p. 4.

12 *Ibid.*

13 *Ibid.*

14 See for example Wahlman, *op. cit.*; Evelyn S. Brown, *Africa's Contemporary Art and Artists* (New York: The Harmon Foundation, Inc., 1966); Frank McEwen, *New Art From Rhodesia* (Salisbury: National Gallery, 1963); Beier, *op. cit.*

15 Beier, 'Contemporary Nigerian Art', *Nigeria Magazine*, no. 60 (Lagos: 1961), pp. 27–51.

16 In some cases, 'contemporary' has been used indiscriminately to denote a wide range of African art forms – popular, commercial, tourist, fine, etc.

17 Foreign cultural centres are normally related to the embassies of Western countries, such as the French Cultural Centre, the American Centre, the British Council. They are known for their calculated involvement in the native cultural affairs of the host countries.

18 I am using 'Eurocentrism' in the sense defined by several seminal works that analyse knowledge in relation to power and power differentials. These include Edward Said, *Orientalism* (London: Routledge and Kegan Paul, 1978) and Samir Amin, *Eurocentrism* (London: Zed Press, 1989), among others.

19 For examples of such propositions see, Beier, *op. cit.*; Vogel, *op. cit.*; Fosu, *op., cit.*; Mount, *op. cit.*

20 See the comprehensive review of the concept of tradition in Dan Ben-Amos, 'The Seven Strands of Tradition', *Journal of Folklore Research*, no. 21 (Bloomington: 1984), pp. 2–3.

21 Eric Hobsbawm and Terence Ranger (eds.), *The Invention of Tradition* (Cambridge: Cambridge University Press, 1983).

22 Ben-Amos. *op. cit.*, p. 116.

23 James Clifford, 'Of Other peoples: Beyond the Salvage Paradigm', *DIA Foundation Series*, no. 19 (New York: 1987).

24 V.Y. Mudimbe, *The Invention of Africa: Gnosis, Philosophy and the Order of Knowledge* (Bloomington: Indiana University Press, 1988), p. 4.

25 Clifford, 'On Ethnographic Authority', *Representations*, (1983), pp. 1–2.

26 Johannes Fabian and Ilona Szombati-Fabian, 'Art, History and Society: Popular Painting in Shaba, Zaire', in *Studies in Anthropology of Visual Communications*, vol. 3, no. 1 (1976), p. 1-21.

27 The tripartite scheme, which has long been adopted for European studies of culture, has been uncritically applied by Africanists to African culture. It divides culture into three layers: 'traditional', 'popular', and 'elite'. As Karen Barber has argued in 'Popular Arts in Africa', *African Studies Review*, vol. 3, no. 3 (Waltham, MA:1987), p. 9. 'This simple typology has shown itself remarkably resilient and tenacious. Even when criticised, it has usually managed to resurface amidst a welter of disclaimers and qualifications; but for the most part it has survived by not being criticised, or even examined. It has simply been applied, as if its correspondence to African social reality were self-evident'.

28 Examples of such workshops are Oshogbo or Mbari Mbayo Club in Nigeria established by Ulli Beier in the 1960s, and Frank McEwen's Workshop School and the National Gallery of Salisbury in Zimbabwe (Rhodesia at the time) in 1957. See dele jegede, 'African Art Today', and Grace Stanislaus, 'Contemporary African Artists: Changing Traditions' in *Contemporary African Artists: Changing Traditions* (New York: Studio Museum in Harlem, 1990). Despite the positive aspects of European patronage and intervention, there is a point of contention that it was founded on hegemonic and paternalistic attitudes toward Africa and African artists. It is important, as jegede has attempted, to re-examine the role of the European expatriate in the light of the myth of the 'teachers who do not teach'. In reality, European expatriates and teachers introduced many techniques and styles that are European in origin, and, through certain expectations of their work, imposed limitations on the creative potential of the African artists working with them.

29 However, governmental patronage in Africa soon faded due to growing economic crises, under-development created by continued dependency on Western capitalism and the rise of neo-colonialism, among many other problems plaguing African countries today.

30 Quoted in Kennedy, *op. cit.*, pp. 113–114. See also, Sylvia Williams, *Mohammed Omer Khalil, Etching. Amir Nour, Sculpture* (Washington DC: The National Museum of African Art, 1994).

31 Salah Hassan, interview with the artist, c.1992.

32 Rasheed Araeen, 'Our Bauhaus Other's Mudhouse', *Third Text*, no. 6 (London: Spring 1989), pp. 3–14.

33 See jegede, *op. cit.*

34 Araeen, *op. cit.*

35 Amilcar Cabral, 'The Role of Culture in the Liberation Struggle', in A. Malterart and S. Siegelaub (eds.) *Communication and Class Struggle*, vol. 1 (New York: International General, 1979), p. 207.

36 Beier, *Contemporary Art in Africa, op. cit.*

37 El-Salahi, *African Arts*, (Los Angeles:1967). p. 27.

38 Solar engraving resembles the hot rod iron engraving technique used by African artists in decorating gourds or calabashes. North and East African women use henna for decorating their hands and feet, creating beautiful geometric and abstract patterns.

39 David Koloane, artist's statement published in Hassan and Enwezor, *New Visions, op. cit.*, p. 15.

40 Wosene Kosrof, artist's statement, *ibid.*, p.18.

41 Salah Hassan, *Creative Impulses/Modern Expressions: Four African Artists* (Ithaca: Ithaca Africana Studies and Herbert F. Johnson Museum, Cornell University, 1993).

42 Hassan, interview with the artist.

43 Stanislaus, *op. cit.*, p. 27.

Talk of the Town: Seydou Keïta

Manthia Diawara

**Seydou Keita, 1956-57
Courtesy CAAC - The
Pigozzi Collection, Geneva
© Keïta**

When an exhibition of Seydou Keïta's photographs opened recently in SoHo, New York, I was intrigued by a statement made by a West African colleague of mine: 'This is exactly like it was in those days. That yellow convertible, the first Cadillac in Mali, everyone remembers as belonging to Sylla, the antique dealer in Bamako. And this one, with the long tribal scars from his sideburns to his chin, must have been a Mossi soldier. The one over there's a grande dame with her fancy scarf, her gold rings alongside the strands of her cornrowed hair, her tattooed lower lip, and her gold choker necklace with a large pendant'.

To say that Keïta's portraits tell the truth about the people in Bamako, the capital city of the former French Sudan (now Mali) in the 1940s and 50s, is in fact to say that his camera made them into Bamakois. To get at this truth, which so excited my West African friend in SoHo, one must examine the relationship between Keïta's work and the myth of Bamako – to ask what was being acted out by his subjects, what they hoped to achieve by posing for his camera. Finally, there is the question as to what we see in these pictures today that so stubbornly grabs hold of our attention.

Keïta's Bamako is the Bamako at the birth of modernity in West Africa. Each one of his portraits reveals an aspect of that moment, its mythology and attendant psychology. In his attempt to create great Bamakois 'types' with his camera, Keïta participated in shaping the new image of the city, which emerged in 1946 (with the first meeting of the Francophone Congrès de Bamako) as an important French colonial centre. His studio was located not far from the train station, which served to link the city and Dakar, in turn bringing it closer to Paris, and was near another great agent of modernisation, the large market of Bamako (le Marché Rose), a trading centre that was the envy of every other West African city. There, commerce and consumption brought together villagers of various ethnic groups and redefined them as Bamakois. Other key sources of the modern experience, the central prison and the Soudan Ciné movie theatre, were landmark sites in the Bamako-Coura (the new Bamako), Keïta's neighbourhood. The proximity of his studio to the Soudan Ciné explains the impact that the cinematic, black-and-white *mise-en-scène* made on his style. The tough-guy looks and gangster-like demeanour found in his photos seem straight out of a B-movie still.

Having one's portrait taken by Keïta signified one's cosmopolitanism. It registered the fact that the sitter lived in Bamako, had seen the train station, the big market, and the central prison, and went to the movies: in short, it signified that the sitter was modern. If such urbanity was one of the enduring markers of Bamako identity, another concerned the beauty of the city's women: *A Bamako les femmes sont belles* in the words of the popular song. For women, Keïta's camera was a guarantee of beauty, fulfilling the truth of their being Bamakoise. His portraits were said to make any woman beautiful, giving her a straight, aquiline nose, emphasising her jewellery and make-up, and capturing a sense of her modernity through the attention paid to her high-heel shoes and handbag.

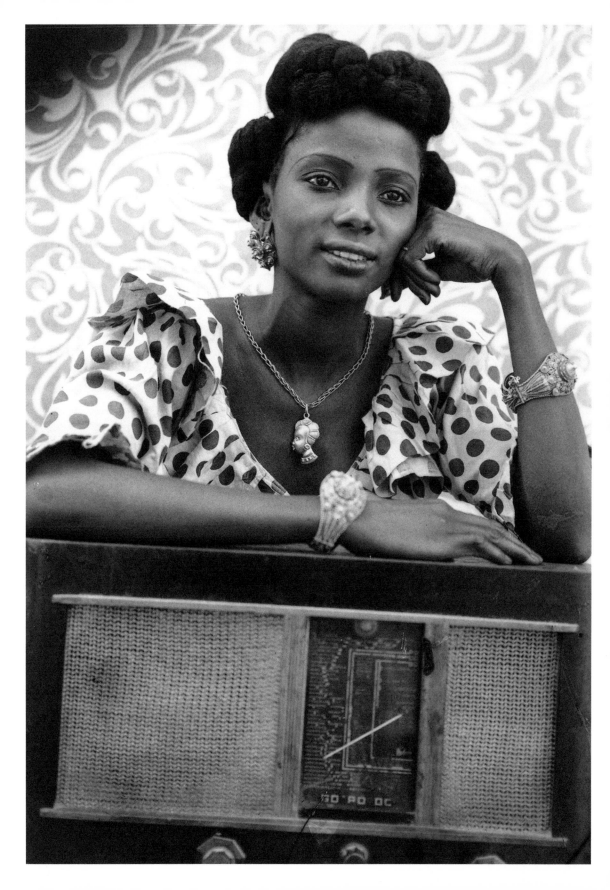

In contrast to other Bamako photographers (e.g., Sakaly in the neighbourhood of Medina Coura, and Malick Sidibé in Bagadadji), Keïta remained seriously committed to the genre of studio photography. He rigorously maintained a *mise-en-scène* that dictated the camera position and angle in relation to the subject. The decor often included such props as chairs, flowers, wristwatches, pens, radios, and a curtain in the background. The subjects, desirous of becoming Bamakois, stood, sat, or reclined for him like models in front of a painter. They always came out idealised, already belonging to the past like objects of nostalgia, and stamped as the photographer's products.

The painterly quality of Keïta's portraits derives from the way in which the subjects are absorbed by the environment of his studio. Take, for example, his portrait of two women sitting on the grass in front of his curtain backdrop with its signature arabesque patterns (all works untitled, 1950s). The two women – one wears a black dress with large white dots, the other a flower-print number – fit comfortably in this artificial landscape. They sit shoulder to shoulder as if Siamese twins, their headscarves falling in the back like foliage, revealing gold ornaments in their hair. The two mimic each other's every movement, their loose dresses spread out to cover their knees and feet. Each rests an arm on a knee, with an equal number of gold bracelets on their bared wrists as well as a single band on their respective ring fingers. Somehow, the grass surrounding the women conveys the passage of nature into the portrait, which the arabesque background and colourful dresses do nothing to negate. In fact, looking at the image, one gets the feeling of being in front of an Impressionist tableau, in which civilisation imitates nature.

Yet there is an atmosphere of excess in the portrait that derives not just from the gold ornaments and the uncanny sense that one woman is a duplicate of the other. Crucially, it is the artifice of the backdrop that prevents nature from taking over completely. The curtain reduces the depth of field by flattening the picture, and helps the artist to control the *mise-en-scène* and to frame the space. It signifies Keïta's presence and defines the women as Bamakoises enjoying a picnic. Here, as elsewhere, the curtain allows Keïta to create a sense of domesticated space, a studio effect.

No set of portraits show off the mythical beauty of the Bamakoises to better effect than those featuring a woman in a reclining pose on the bed in the studio. In one, the familiar arabesque backdrop takes on the appearance of living-room wallpaper rather than photographer's prop. The bed is covered with a checkered black-and-white blanket. Wearing a loose, flowered gown, the woman reclines with a white pillowcase under her arm, which forms an angle at the elbow to support the head. Her scarf is slightly tilted to the side to reveal her hair and earrings. The small incisions on her forehead and cheeks simultaneously register as tribal marks and beauty signs. On her neck, several strands of glass beads make her look even more desirable. What is remarkable about the portrait is not just the decor, which reveals the photographer's eye for striking arrangements (the marriage of checkered blanket, flowered dress, and arabesque

curtain). Even more arresting is the way it suggests a mistress waiting for a lover.

In fact, the portrait is as important for what it doesn't show as for what it does. Of the woman herself, we only see the face down to the neck, the forearm under the chin, the hand resting limply on the waist, and parts of the feet. The rest of the body is covered by the loose dress and the scarf. Faced with such details as the luxurious blanket, the white pillow, the dress, the beads, and the curtain, we become convinced that we are looking at an important, beautiful woman, a Bamakoise who is not just anybody. This portrait is Seydou Keïta's *Olympia*.

It's interesting that reclining on a bed was among the most popular poses for women who wanted their picture taken. This pose, which immediately registers for us an expression of contemporary leisure, indicates the subject's social status. Traditionally, this kind of portrait is associated with an unmarried woman who invites a suitor to her home, usually in the evening. The woman is sometimes pictured making tea, leaving the suitor to admire her elegance and manners. In some images in the genre, he may join her in bed. In Keïta's other portraits of young ladies, the figure typically occupies the foreground, reclining on the front side of the bed, almost on its edge, dominating everything else in the shot. Keïta's 'Olympia', however, reclines sideways on the bed, her head turned slightly toward the back, her knees obscured by the loose dress toward the front. The camera divides the space equally between an unoccupied part of the bed in the foreground, the woman in the middle ground, and the curtain in the back. It is this economy of space that is absent in similar portraits, which, for all their verisimilitude, seem cramped and deficient in the photographer's trademark control over the composition.

By the time Keïta turned to his neutral, grey backdrops in the mid-1950s, he had already photographed his masterpieces. Though the grey background of the later studio portraits signalled his commitment to realism in photographing the Bamakois, this turn in the work entailed a loss in the compositional harmony derived from the use of the patterned backdrops. But where the products of Keïta's painterly eye generally succeed as photography, particularly in the case of the earlier compositions, the subjects of the portraits, regardless of their backdrops, send us looking for stories and explanations beyond the history of the medium.

For example, one of my favourite portraits features two sisters, their arms wrapped around each other, shot against the arabesque backdrop. The girls both wear patterned dresses with ruffled shoulders. The older sister's scarf, tied under her chin, covers the back of her head down to her left ear. In the front, one can make out her hair, which is still growing after the shaving required of young girls in the Soninke ethnic group. Now old enough to have her hair braided with gold ornament, she may have covered her head to conceal her girlish hairstyle, revealing only her right ear full of gold earrings to signify her maturity (in contrast to her sister, who has only one). The younger girl's hair is shaved in the style of her ethnic group, leaving only two large swaths on her uncovered head.

The seriousness with which these two Soninke girls look at the camera speaks volumes about

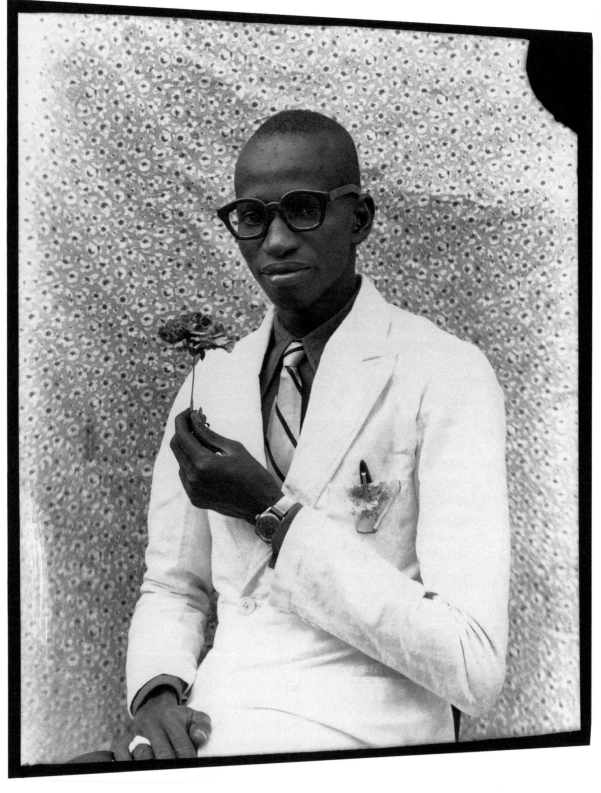

the role Keïta's camera played in giving shape to modernity at the time of its birth in Bamako. On one level, the two sisters represent ethnic influences and traditional aesthetics that are not yet assimilated into modern life in the city. The way they hold each other emphasises a complex relationship of identification. The little girl wants to be seen in the same way as her older sister, that is, a Bamakoise whose hairstyle does not identify her as a villager. The older sibling, on the other hand, leans her head against her sister's as if to offer her the Bamakoise hairdo. Both girls seem to be hiding something that Keïta's camera captures so well.

On another level, the little girl's clumsiness in front of the camera defines the awkwardness of Bamako modernity. As the modern institutions democratise the city's social relations, they also impose a *savoir-faire* that distinguishes Bamakois from villagers, an imposition that seems to extend to everyone in a generalised anxiety about how he or she is seen. To go before Keïta's lens is to pass the test of modernity, to be transformed as an urbane subject even if one has no power in the market or at the train station.

Insofar as photography offers a mirror of familiar images, stereotypes involving our own effigy, what do Seydou Keïta's portraits of Bamakois tell us today? I ask this question not only because of the excitement the portraits aroused in my West African colleague, but also because the SoHo show was very popular with sophisticated New Yorkers. The portraits give us back our individuality. In fact, I get the same feeling looking at Keïta's portraits that I get watching Chaplin's 1936 film *Modern Times*. Even though Keïta's subjects look like us, they are not us. They are our history, the history of modernity. In this sense, the portraits have the uncanny sense of representing us and not-us.

Take, for example, the man in white holding a flower in his left hand. He is wearing glasses, a necktie, a wristwatch, and, in the embroidered handkerchief pocket of his jacket, a pen – tokens of his urbanity and masculinity. He looks like a perfect Bamakois. However, the way in which he holds up the flower constitutes a punctum in the portrait, a moment in which we recognise the not-us. The flower accentuates his femininity, drawing attention to his angelic face and long thin fingers. It also calls to mind the nineteenth-century Romantic poetry of Alpohonse Lamartine, Victor Hugo, and Stéphane Mallarmé, which was taught at that time in the schools of Bamako. In fact, the man with the flower reminds me of certain Bamako schoolteachers in the 1950s who memorised Mallarmé's poetry, dressed in his dandied style, and even took themselves for him.

Elsewhere, the not-us appears to comic effect. In one portrait, three identically dressed girls are pictured with a remarkable quantity of gold rings attached to their braids and long strands of glass beads around their necks. Everything seems normal until one examines the girl on the right. Rather than simply resting an arm on the middle girl's shoulder as the one on the left does, she has one hand on her breast and the other around her waist. This unusual detail interrupts our reading of the beauty of these three Bamakoises. We say to ourselves that the hands of the girl on the right

are in the wrong place. She has not yet learned to pose in a cool and collected style – a modern style – in front of the camera. But we can empathise from a distance with this girl (who *isn't* afraid of the camera?), knowing that photographs can also catch us unaware, or unprepared, or uninhibited, and reveal the truth about us.

Keïta is caught with his own hand in the wrong place in a portrait he took of himself and a Moorish family. The portrait shows the family in the foreground: the patriarch dressed in a white gown, with his two wives sitting on either side. The wife on the left, who seems older, holds a baby in front of her. Behind the family crouches the photographer, wearing an open shirt and a felt hat and leaning over the patriarch and his younger wife on the right, with one arm on her shoulder, and the other on the shoulder of the patriarch.

This is a strange, complex portrait in many ways. In terms of composition, there's really only room in the photo for three people. When one focuses on the polygamous patriarch and his wives, it seems that Keïta's presence is what spoils the composition, that he should never have been in the picture. But when one focuses on the triangle formed by Keïta, the patriarch, and his younger wife, the wife on the left and her baby become invisible. It is interesting to note that the figure of the father is what both imagined compositions have in common. He is also the only one in the portrait not looking at the camera. This fact alone renders him more mysterious, and subject to a different interpretation depending on which composition we choose to privilege. When we look at him sitting between his two wives, who appear considerably younger than he, we put the institution of polygamy on trial. However, if we look at him at the same time with his younger wife and Keïta, it is the youth and urbanity of the photographer that we oppose to the age of the patriarch on the one hand and relate to the beauty of the wife on the other. The portrait could stand for Keïta's photography as a whole: the relationship between the two readings could stand for the two functions of his work – a decorative one that accentuates the beauty of Bamakoises and a mythological one wrapped up with modernity in West Africa. It is these dual functions – and their revelation as photographic constructions – that continue to draw us to Keïta's work.

Location and Practice

Between Worlds: Postmodernism and African Artists in the Western Metropolis

Okwui Enwezor

At the end of the century, studies of postmodernism and critical writing on questions of identity and artistic production thoroughly distance themselves from the spaces occupied by African artists in the Western metropolis. In the rare cases of contact between what so far has been identified as the 'centre' and the subaltern, the zones of enunciation are so fraught with gross misreadings and the most miserable translations of work by these artists, that it seems nothing could possibly mediate the gap that separates the two worlds. This misapprehension and misrecognition is exacerbated by a gaze that perpetually fixes the cultural production of contemporary African artists, if not in the sites of invisibility and non-existence, then on the periphery of encounters between the public and contemporary representation. This gaze reduces their artistic expression to either the aberrant production of a denativised imagination or to an inferior mimetic exercise in futility. In addressing the basis for this exclusion of African artists from the sites of normativity and the critical silence that surrounds their practice, my interest lies mostly, though not entirely, in those gaps – between worlds – where the potent signs that these artists carry from different localities are translated and ultimately transfigured through relocation into new imaginary constructs of identity, which their new places of domicile constantly deny them.

As metropolitan African artists, Iké Udé, Bili Bidjocka, Olu Oguibe and Ouattara occupy such a matrix of elision in relation to the Western postmodernist discourse. Of great interest to me is the variety of approaches, the measure of articulateness that they have employed in delineating boundaries and allegiances, modes of representation and production, which both reincorporate them into, and disunite them from, specific traditions within the realm of contemporary African cultural production. However, this discussion does not approach their work as disinherited from a progressively elusive sense of a triumphant African modernist ethic that ruptures the neo-colonial burden of the unrecuperable other. Nor does it view them as representative or exemplary models of knowledge in contemporary African cultural production, in which their individual aesthetic projects revel. They come together on these pages based on that which they represent in the hegemonic imagination: 'African artists', working in the interstices of postcoloniality in the Western metropolitan arena.

As such, I am interested in how their ineluctable presence disturbs, disrupts and problematises the postcolonial border; how their existence in the postmodern arena embodies the discontinuity of normative assumptions about originary 'authenticity' in their work. Labels, as practising cultural anthropologists know, are necessary evils. They either illuminate or they misname. The latter – in cases where the status of the sovereign narrator is accorded as the divine right of a hegemonic imperative – quite often outdistances the former, particularly where such labelling is a morphological binary that separates mere nags from thoroughbreds. Fundamentally restated along the linear parameters of the Western modernist canon (much more firmly entrenched since the 1930s, and through the era of Greenbergian American aesthetic nationalism), the pull

of hierarchy quite naturally offers the sovereign narrator unprecedented power either to contextualise or dismiss, to dissolve all edges and turn variety into an atrophied body of sameness, until the subject dissolves and vanishes. (The collapse of entire 'minority' populations into one body known as 'Black British' is but one example of this taxonomic game-playing that reductively homogenises identities while obliterating their disparate and composite social realities.)

If one were to believe the highly efficient Western critical apparatus, as it has existed within the major metropolises of the Western art world, it would seem that no African artist of consequence exists within its sphere of knowledge. To question such views remains, of course, our critical obligation; a clear opportunity for self-fashioning, self-representation, and hermeneutic recovery. On the other hand, in the crude climate of the current multicultural war, such contestation of history through recovery plays differently in the camps of two very self-interested parties. For the neo-conservatives, with their antique, crusade-flavoured, paleo-Christian fanaticism, placing the marginalised in the occulus of critical knowledge is seen not only as a travesty but also as an assault on received notions of 'quality', and more significantly, as heretical. For the self-serving liberal critical establishment, still clinging to outmoded models of Marxist liberal triumphalism, such knowledge, however truncated, represents an epiphany. It will be important to hold on to these two sets of views, because art historical and critical judgements of art and artists in the West constantly play themselves out in the well-regulated and predictable interstices where eurocentric hegemonic power-mongering meets and colonises the contributions of non-Western cultures; those cultures that, in polite euphemism, disappear into the opaque rubric of the 'other'. But more significantly, because the comets of artists whom critical amnesia wishes to narrate out of history refuse to crash in the arctic wasteland of inconsequence. Under the demanding imperialistic gaze of twentieth-century Western art history, modernism's self-arrogated centrality and exclusionism become the great totems that bear the imprimaturs of this legacy of erasure, which marginalises as it appropriates. This is an old story, yet it is one that remains relevant if only to remind us of the distasteful task of continuously questioning not only that history, but also the ethnographic paradigms that it appends to the subjects it marginalises.

In developing this text, my main concern is how to resurrect the figure of the metropolitan African artist as s/he presently exists in that less than hospitable site. I use the word 'resurrect' not only as a means of reframing the marginal status of these artists, but also to examine the constricted cultural and social space under which they have existed for so long. Because nowhere is the ethnographic trope of the 'other' more transparent, resilient, and stalwart than in the seemingly plural environment of the Western metropolis. And nowhere have we been called upon to mediate on the uses of marginality as a weapon of enclosure and exclusion, and as a critical/structural construct, more than in the site of the Western metropolis. For it is there that the cultures of the so-called margins are more visible, and dangerously more transgressive by the sheer force of their articulation of a

difference that the centre does not already own. Such transgressiveness, often commodified and reduced to spectacle, to the carnivalesque, makes the marginalised culture more nakedly vulnerable to structures that incessantly sanction its marginality, its co-option, displacement and dispersement into the centre. I am thinking here of those moments of contact when the language of the margin is appropriated and abstracted into the larger body, which denies its specificity and concreteness. This denial comes into sharp conflict with what for a decade has been postmodernism's celebration of the inherent fragmentariness, indeterminacy, contingency and so-called shifting nature of the subaltern universe. It is in this sense that the postmodern Western metropolis, with its centrifugal pull, has always, in the minds of many marginal communities, represented a site of theft, a port of dispossession. It is there that the margin comes face to face with the real threat of erasure and defacement; of being whitewashed for the intense pleasure of those who have the least interest in understanding the marginal's power to name those moments that live in what Homi Bhabha calls the 'wordless barrens' of human desire, a desire that is always denied those who have been de-authorised.

Alongside the multiple events engendered by a currently embattled multicultural discourse and by other subaltern spheres in an allegedly more inclusionist postmodernism, the importance of examining the space that African artists occupy must never be underestimated. In the 1990s – the decade that has followed the ascendancy of postmodernism as a prominent critical tool that recognises the cultural 'rights' of the 'other', but has thus far organised itself around the axis of a prime canon – a radical revision of the relationship based on the binary structure of the self/other has occurred. Not only does postmodernism position itself as a corrective to the monocular modernist meta-narrative and its privileging hierarchy (a model referred to by Hal Foster as 'neo-conservative postmodernism'), it also views its discourse – in historical terms – as one that marks a rupture in modernism's self-centred aggrandisement of the artist as author (Foster names this 'post-structuralist post-modernism').[1] Straddling this conflictive divide, postmodernism thus encodes its position as being the prime vessel through which artistic and metaphysical knowledge and meaning necessarily flow. Metaphorically, as well as literally, it casts itself as a sort of cultural relativist instrument, an all-encompassing apparatus that embodies paradigmatic border interpenetrations; one that mediates between the identity of the marginalised and its cultural dominant, the centre.

Within this notion of a transcendental postmodernism, we are told, marginalised cultures will be recuperated and recognised in a decentred re-narration of non-hegemonic discourse. Furthermore, the postulation is that the 'other's concerns at every turn of this historical rearrangement of borders will be given a 'fair hearing'. Recognition of difference, cultural hybridity, and the apparent instability of identities within post-contemporary (to borrow an absurdity from Frederic Jameson) spheres of production and representation will indeed become

semiological emblems of a post-industrial twenty-first century culture. If this sounds like a
kind of post-psychedelic love-in, the truth is that it is, albeit with a few caveats: the Swamis of
this commune are academic all-stars from various French, American, and German academies.
However, one must raise a note of caution here. For although on the surface, the radical proposition
of the Western postmodernist project seems reformist and therefore appealing, nothing so far
in its overtures – which seem too conclusive, too neatly resolved epistemologically – has given us
an inkling, as Olu Oguibe had stated, that its dominant perspective and value system will be
loosened from the authoritarian grip of a Western historicism hell-bent on shaping its definition.[2]
No matter how seductive, the disinterment and recuperation of the so-called margin into the
centre must also call for the delocalisation and decentring of the centre. The summary declaration
of decentring history consistently proffered on postmodernism's behalf, is simply not enough.
Homi Bhabha reminds us of this when he writes that in the early 1980s as

> the conceptual boundaries of the West were being busily reinscribed in a clamour of counter-
> texts – transgressive, semiotic, semanalytic, deconstructionist – none of [these texts] pushed
> those boundaries to their colonial periphery; *to that limit where the West must face a peculiarly
> displaced and decentred image of itself.*[3]

Of course that is hardly surprising, experience having taught us that decentring does not
necessarily correlate with equality.

The fact remains, however, and is always implicitly stated, that recognition of difference does
not in itself connote inclusion nor acceptance. Or as Charles Merewether pertinently asks, 'how in
this time of recognition of cultural difference, can we appeal to a universality without losing the
particularity of that difference that refuses to return us to the plural same, or the incommensurate
or irreducible polarities?'[4] Here, Merewether is enacting a vital scenario, for 'difference' as posited
and circulated through the clogged arteries of the Western postmodernist discourse, is never a
conjunctive force that impels fresh relationships, nor does it produce new and honest structures
through which novel, unencumbered knowledge and meaning can be received, tested, and shared.
'Difference', as the character in Jean-Paul Sartre's novel *Nausea* would have put it, is always located
in the limited territory of the colonised 'other', whom when rehabilitated into the 'centre', which the
West occupies, must remain thankful, until his/her usefulness expires like a transit visa. But as we
travellers who wear our badges of difference with unremitting pride on the postmodern bandwagon
have repeatedly learned, the expiration of one's visa means the termination of tolerance (an idea
that the false premise of a visa naturally disallows).

While Western modernity – and by extension postmodernity – was founded on the totalising project
of the Enlightenment, the mastery of reason over the world of spirit, it nevertheless subsists on

superstition, forever inventing ghosts to satisfy the needs and demands of its specious status of singularity. Read thus, 'difference' in the mind of Western postmodernism carries the authority of an unimpeachable fact whose continuous elaboration must again and again put to service certain bodies, not as surrogates for this phenomenon, but as representatives of the thing itself. In this charade, the authoritative figure of the subject (very much a romantic illusion of Western empiricism), exits the stage of autonomy onto one of metonym – the body of 'difference' rediscovered. It will not, however, be a waste of precious time to argue the point that such an elaboration of 'difference', which forces into service certain groups of people, de-sacralises Western postmodernism's rhetorical pretensions to plurality. Even François Lyotard's argument that postmodernism deracinates and destroys modernism's pretensions of singularity as a metanarrative, fails in the face of its ontological ellipsis.[5]

Our reading of 'difference' within this postmodernism, which Lyotard believes to have finally done in modernism, will not be greatly broadened or enhanced if we insert into its definitional zone Frederic Jameson's most instructive and decided conceptualisation of 'difference'. Jameson's Nietzschean argument is that it is 'essential to grasp postmodernism not as a style, but rather as a *cultural dominant*, a conception which allows for the presence and coexistence of a range of features'.[6] It may interest the reader to learn that the key moment of entrance into the heterogenous zones of postmodern culture is predicated on these 'different yet subordinate features' being allowed 'presence' and 'coexistence' within such a culture. In other words, they have first to be granted audience in order to speak the essential truths of their existence. One would have granted Jameson his sly manipulation of the terms of this entrance, if he had not compounded what at first could have been thought a misreading of 'difference', by stating that:

> The postmodern is, however, the force field in which very different kinds of cultural impulses – what Raymond Williams has usefully termed 'residual' and 'emergent' forms of cultural production – must make their way. If we do not achieve some general sense of a cultural dominant, then we fall back into a view of present history as sheer heterogeneity, random difference, a coexistence of a host of distinct forces whose effectivity is undecidable.[7]

As revealing and fascinating as Jameson's position might appear, even for such a highly respected critical thinker and theorist, it is not surprising nevertheless. The truth, if anyone still cares about such a metaphysical concept, remains that Western postmodernism in relation to other postmodernisms has always aimed at establishing Jameson's 'general sense of a cultural dominant'. In less subtle terms, this cultural dominant, in its periodisation, inscription, and affectivity, can be read as a culture of conquest. Its hegemony allows the West access to those modes of postmodern culture outside its immediate control while not becoming embroiled in a field that represents 'sheer heterogeneity [and] random difference'.

Oladélé Ajiboyé Bamgboyé
Homeward: Bound, 1995
(detail)
Video projection
Installation view,
Ikon Gallery
Courtesy the artist

It is within this corrupt terrain in which power, co-opted either through the means of production – a manifestation of the efficiency of capital (Foucault) – or through the means of representation – technological and digital control over information and images (Baudrillard) – is maintained and held by the West, that many African cultural producers have pitched their tent. For African artists, the Western metropolis, popularly represented as a plural environment in the contemporary imagination, is nothing but a site of displacement and dispersal, diminishment and disintegration. Additionally, a representational disruption in the material culture under which African artists live and practice also marks the Western metropolis as a site of ambivalence and longing, a site in which their faith in secular humanistic philosophies and in the inviolability of their alleged originary traditions are constantly imperiled, to the point of apostasy. This rupture has created a new migratory space that severely tests the contexts of national and diasporic borders of the new post-colony, which simultaneously speaks to a desire of place and the ambivalence of relocation.

Imprecise signals from the postmodernist establishment further throw these ambivalent social spaces into sharp relief, exposing many gaps in need of resolution. Within the realm of signification, the diasporan desire wears the impassive melancholy of exile. It is a fragmented cultural space, a place of desire that is perpetually in flux; always in the process of 'becoming', as Chike Aniakor has referred to it. Add to these the resurgent refusal of the benefits of multiculturalism from hardline American modernist reactionaries and incurable eurocentrics (Hilton Kramer, Robert Hughes, Harold Bloom, *et al.*), and we have a deck fully stacked against artists currently operating under the stained and tattered flag of difference. But these artists are hardly defenseless charity cases; they are far from being the obsequious natives who must wait for invitation to pick at left-over scraps on a dinner table long ago plundered by modernism. Through refusal to be patronised, ventriloquised, dismissed, misnamed, or miscategorised, despite the difficult conditions under which they practise, they transgress the boundaries of 'otherness': a colonial condition that a reductive postmodernist thinking constantly attempts to refashion under the polite but alien banner of 'difference'.

Writing about postmodernism's ineffectual collapse of identities into a kind of crude, hard-edged and immutable hybridity, Anthony Ilona remarks that 'the inclination here is always to seek, in the works of these artists, references to problems of nationhood, corrupt dictatorships, neo-colonialism, underdevelopment, and so on; a narrative of crises'.[8] Essentially, the mark of difference, as has been repeatedly proposed, becomes quite literally undifferentiated from this 'narrative of crises'. Within this field of representation lies an epistemic doubt as to the value of the presence of these artists in the postmodern discourse. This doubt, which also elides the composite production and contributions of these artists, is thus carried, circulated, and resold in a structurally encoded language that is disciplined by fear, ignorance and erasure. Since the implicit and adjunct banner under whose nationalistic desires the 'other' must necessarily seek

residence is a fictive construction that militates against complexity, artists who refuse sanctuary within its borders must then brace themselves for the accusation of not being 'native' enough (a charge that will normally come from eurocentrics) or for not being 'authentic' enough (a reversal that usually comes from Africanists).

These accusations make it particularly difficult to read the careers of these artists as genuine and non-derivative contributions to contemporary representation, as well as profoundly testing the critical academies that determine such matters. Claimed by no community of interest (neither in the West nor within their own cultures), these artists seem to have clearly positioned their practices within a liberatory matrix that is oppositional in nature, while at the same time refusing to allow their strategies to harden into a doctrinaire or post-histoire essentialism of the agitated 'other'. By unflinchingly engaging the entire contemporary art world, they evoke what bell hooks has named the 'Oppositional Gaze',[9] that contestatory act whereby subjects of imperialist subjugation assert their right of agency through resistance to structures of domination. By problematising the simplistic binary of the self/other relationships that tend to split down the middle issues of identity and representation, the presence of these artists marks not only an ontological ellipsis, but also questions assumptions that derive from a reading of such identity formation. And since their status as exiles ill-affords them roots in any one culture, it seems a mistake simplistically to collapse the space they occupy into a hybridised one. Their relationship to different modes of representation in and outside the West are far more complicated than the term 'hybrid' (a troubling notion that calls up images of miscegnation, mongrelisation, impurity, and inauthenticity) can explicate.

Multiplicity: The New Boundaries of Difference

In his essay 'The New Politics of Difference', Cornel West writes that the distinctive features of the new cultural politics of difference are to trash the monolithic and homogeneous in the name of diversity, multiplicity and heterogeneity; to reject the abstract, general and universal in light of the concrete, specific and particular; and to historicise, contextualise, and pluralise by highlighting the contigent, provisional, variable, tentative, shifting, and changing.[10]

Since persistent border-crossings have in many instances prevented contemporary African artists from becoming types reducible to knowledge formed by a crisis of identity, they represent the contingencies of multiplicity foregrounded by the 'new politics of difference' while still remaining anchored to specific contexts that propel them into new territories. In fact, the problem of these artists in the West is due more to their grounded, resolute identities as African artists who do not take their contemporary existence for granted through repeated forays into what Manthia Diawara has dubbed the 'Kitsch of Blackness',[11] than in their search for an identity. For them the realm of culture represents a plural universe built from a multiplicity of frames that aspire towards

the creation of new territories, towards a kind of new boundary of difference. Though the precise grounds for the enunciation of this new boundary of difference remain theoretical at best, still there are conjunctions of diverse cultural signs, in the form of quotations, appropriations, and reappropriations (which are employed in various degrees) in the works we have seen by Udé, Bidjocka, Oguibe, and Ouattara. These devices (which are hardly unique) are used less to seek resolution for a specific artistic transcendence, than to disrupt the boundaries, categories, and frames that persistently enclose them in marginal economies of production and representation. Far from the naïve simplicity that is generally ascribed to work by African artists – who must be primitivised and exoticised so as to be easily commodified, appropriated, and dismissed – the reality is that the work of artists so commodified always carries multiple content and layered meaning. They dislocate the encoded idea of an 'authentic' homogeneity, the bastard narrative of a 'native' existence that is untouched by a meditative acumen or critical nomenclature.

It is within such an entropic cultural economy (the Foucauldian heterotopia),[12] which parodies and inverts postmodernism's reification of difference, that one obtains the most useful insight into the careers of Udé, Bidjocka, Oguibe, and Ouattara. The work of these four artists and their strategies of production no longer sit easily within the rigid confines that are marked by the dichotomy between tradition and modernity. A different force impels their movement beyond the conscious stream suggested by a post-Kantian reconfiguration of the world.

How then, may one approach the bold oppositional transgressions of these postmodern artists in the face of the critical timidity that has been reluctant to recognise how African artists and artists from non-Western centres have reinvigorated the crucial debates with which we will all grapple in the next century? The temptation here will be to draw a map that delineates, in hard-edged, formal routes, such a rehabilitative project, through a labour that relentlessly reproduces the virtues of site of origin and place, and the valorisation of difference. The quest then, calls for an open-ended investigation of each artist, since their vision of the world is simply not reducible to the meagre insights that hierarchisation and categories allow. By consistently interrogating the spaces that modernism and postmodernism both occupy in the West, through the centrality of an African reality, these artists effectively disable the paradigm of colonial mimicry that can only see in their self-reconstitution the reproduction of the colonial, albeit, inferior, ideal rooted in imitation. But one thing is for sure: these are not mimic men. How can they possibly be, when their interventions in the contemporary arena (though unheralded) clearly speak otherwise? To talk then of any contemporary representation that entangles itself in the laws of a xenophobic Western art culture, which measures events in tidily marked out, straight progressions, is not only shortsighted, but also idiotic. If metropolises like Lagos and Bombay represent quintessential postmodern cities, simultaneously existing in that interface between modernity and tradition, between the present and utopia, why then do we still reduce postmodernism to poststructuralist deconstruction,

Marxist and feminist theory, Lacanian psychoanalytic themes, and the new discourses of alterity?

Clearly, what can be located and simultaneously experienced within the polymorphous and thriving urban cacophonies of Lagos and Bombay are two crystalline postmodern realities that are built on parallel ideals. The most obvious is the seemingly endless collision of high and low, alien and familiar, abject and serene, the exquisite and the torturously grotesque, a phoenix-like immanence of new cultural juggernauts, a never-ending collage of incongruities. A perfect example, where such collision can be experienced first hand, is the Jankara Market in Lagos. A sprawling, cacophonous theatre of colourful apparels and languages, Jankara Market defies the laws of order. It is a bewildering, exciting environment, a postmodern installation par excellence. In its autonomous existence as a site of cultural and mercantile exchange, where only the laws of the market apply, entire continents converge and are visibly recreated and dissolved under the dizzying pace of its domain. From one stall to another, Italian leather goods jostle for space with Hausa leather goods, freshly arrived electronic goods from Taiwan, Korea, or Hong Kong compete for space with goods from Singapore, Brazil, England, India, Senegal, Ghana, France, Cameroon and the USA. In one afternoon in this market that operates by its own rules,

In Africa today, postmodernism (whatever it finally comes to stand for) seems particularly relevant.

one touches base with virtually all the continents of the modern world. Even snow from Antarctica is rumoured to have been sighted there. It is from this debris of clashing cultures, which first anticipated what has come to be known as postmodernity, that many African artists (especially those of the post-Independence generation) find and reprocess materials and ideas for an art that possesses a critically universal language.

For these reasons, in Africa today, postmodernism (whatever it finally comes to stand for) seems particularly relevant. Despite impatience with, and resistance to, its general tenets within the African intellectual world, postmodernism nonetheless is neither misguided nor anathema to the contests that permeate issues of nationality and cultural identity in the late-capitalist economy – more on that continent than anywhere else. Facing history from the privileged perspective of a postcolonial condition, emergent nationalistic desires have produced in Africa a prism out of which emerges a disturbingly bleak picture. However, this picture is not particularly unique to Africa. It is the heritage of the entire modern world in the face of what seems like the triumph of the capitalist ideology. It appears that there is no moment in history that reflects postmodernity, its anxieties, ambivalencies and confusion better than the present historical moment. We have been witnesses to events, by which entire countries have vanished in a matter of minutes, like rabbits in a magician's hat. We have seen their fragments reconstituted into barely coherent entities that are

also on collision courses to split apart and replicate more absurd boundaries. Every map one looks at becomes an obsolete relic in the act of looking. New countries appear, old ones fall into decay and inconsequence: a cartographer's nightmare fully realised. Postmodernity then, is not just an ideology or scheme that accentuates difference and gives it the varnished allure of wholeness; it also becomes the offspring of chaos born out of the desire to reconstruct a different idea of the world. After the fall of Communism and the Berlin Wall, after the defeat of Apartheid in South Africa; after Tiannenmen Square, the Gulf War, Bosnia, Haiti; and in the wake of the obscene decadence of late capitalism, postmodernity places the world or what remains of its depleted and degraded environment, at perilous crossroads. Which way the world will proceed is a mystery, but we can rest assured that it will have multiple routes. In this sense, Thomas McEvilley's assertion that postmodernism is represented by a multivalency that makes it 'multiple-coded' seems more relevant than Charles Jencks' earlier theorisation of it as 'double-coded'.[13]

Indeed, these multiple routes lead us into and away from various sources of cultural production. But most importantly they lead us to the works of these four African artists. Beyond the interplay of social forces harvested out of the ambivalent spaces of colonialism and postcolonialism; beyond the various interpretive agencies that assume, as no longer given, questions of fixed identities and nationalistic consciousness; beyond all that, what these artists offer us in their works are provocative aesthetic and philosophical propositions. They also offer us insights formed out of highly self-conscious modes of address; an epistemological fracture built out of the relationship between text and meaning that reveals and invalidates the most sinister core of the hegemonic narrator's language.

Troubling the Water
Through astute employment and manipulation of text as a code of interrogation and disturbance, Iké Udé's conceptual photo-text work brings the engagement between the meaning of the text and the reading of the image to its most fundamental friction. This is exemplified by his installation *Cover Girl* (1994), shown at the experimental gallery space Exit Art/The First World in 1994. Nigeria-born, New York-based Udé's exquisite use of the derelict narcissism of the dandy, his theatrical playing out of the roles associated with the margin, his facility in deploying the seemingly banal texts of popular culture, are at once a disputation, a mockery of 'proper' behaviour and a disruption of its inherent fallacy. In the multimedia installation, encompassing video, a row of 'Ass Prints' hanging along the wall,[14] and a news-stand stocked with cigarettes, chewing-gum and magazines, and further augmented with such implements of beauty rites as lipsticks, combs, powders, perfumes, etc. Udé initiates an ambitious interrogation of modes of representation gleaned from magazine covers that too frequently represent a one-sided idea of beauty. But most importantly, he uses this interrogation not only to excoriate the representation

of Africa as the backwater in which the sinister lurks, but also to reclaim her as a 'site of beauty'. Though not reduced to articulating the dilemma and the diminished possibilities of mass cultural representations and the limits they impose on identity, Udé nevertheless acknowledges that yes, image is complicit in such diminishment. But he also proposes that we delve deeper into the core of the image's most resilient, structured existence through textual construction. It is through literal and metaphoric reading, he insists, that the intricate language of magazine covers reveals itself.

In *Cover Girl*, Udé replicates the very magazines that serve as models for his intervention. Meticulously disguised, he photographed himself in different personas, which he then translated into virtual magazine covers, such as *Vogue, Mademoiselle, Glamour, Town and Country*, and *Harper's Bazaar*. Undoubtedly, many viewers will feel somewhat uncomfortable with the image of Udé made up in drag. But it was not shock value that Udé meant to articulate by hi-jacking the idealised and glamourised image-machine of magazines. Nor was he pointing to the abject state of living between worlds that drag highlights. Instead, he was aiming to ironise and subvert the whole notion of gender and racial permission, as well as the self-congratulatory narcissism (of which Europeans remain the primary beneficiaries), which many popular-culture magazines celebrate. Far from taking its precedent from the performative space of the Western drag tradition, which carries a kind of repressed sexual content, Udé was instead appropriating and quoting *Adanma*, a contemporary Igbo masquerade performance genre in which men impersonate feminine characters to question and reveal certain truths about gender and difference. Writing on the fascinating exegesis of *Adanma* and the construction and regulation of gender power relations within a given community, Benjamin Hufbauer states that the performance of this masquerade 'indicates the desire of Igbo men to connect gender identity and gender politics with masquerades'[15] – which in most Western cultures would be called theatre. What is also remarkable in Udé's poseur-identity is its level of abjection, its incommensurable irresolution; its ambivalent narrative of displaced desire. Like the racialised construction of difference in Western culture, 'gender identity is perceived as dangerously fluid, [and] always in need of stabilisation'.[16] Also like race in Western culture, in *Adanma*, 'through parody femininity is criticised and then idealised, controlled...'[17] in a bid to attenuate feminine power. For Udé then, impersonation and masquerading – acting out, if you will – replicated from an African context and extended into the rigid borders of Western media empires, are willful political and subversive acts that seek to trouble notions of racial difference as much as gender difference. The will to interrogate becomes a way of decentralising the composition of identity through race or gender, making them less idealised and impervious to co-option and control.

In many instances, as presented through this organic installation, the contestation of meanings and affects that Udé brought to his project from the outset was posed from the perspective not only

of troubling those borders but also of subverting them. Udé manipulates the signs and codes of propriety and etiquette (crucial *Adanma* strategies), circulated through pop-cultural representations, for his frontal attack on issues of history, identity, and difference. At various points, he is an insouciant socialite involved in the conceit of beauty as a marker of a classist majority imperative. But at others he is an impetuous provocateur, throwing textual bombs at his intended audience – coloniser and colonised alike – by pointing out to them that their ravenous craving for the image of the 'other' as exotic object is nothing but cannibalism.

But Udé does not allow this ravenous audience the pleasure of consumption. Peopled with idealised images of beauty, with him as the interlocutor, the magazine covers are not empty spaces for vainglorious enactments of image obsession, but active discursive platforms. All the covers have textual captions that become the activators of *Cover Girl's* premise. For example, on the cover of *Town and Country*, one particularly telling caption declares, in vivid bold type, that 'The Noble Savage is Dead'. The myth of the 'Noble Savage' is a projection that officially sanctions all kinds of negative impressions (fear, horror, demonisation and degradation). Thus, declaring the 'Noble Savage' dead is a seditious act, a mutiny against hegemonic cultural authority. Not satisfied with the impact of this almost benign declaration on his viewers, Udé dug deeper into the meaning of his refusal, by portraying what might be the reaction to such a declaration, not by mere suggestion, but through assertion on the cover of British *Vogue*. His declaration, 'Hysteria Over the Death of the Noble Savage', astutely reflects the paradoxical relationship of postmodernism with the desires of the no-longer-other that creates such hysteria, as well as the critique of the British empire and its vampiric relationship to its former colonies. The fact that this declaration was placed on the cover of British *Vogue* was no mere accident. To comprehend fully what Udé was attempting requires further reading of the cover captions. The most telling pointer of his critique of empire and colonialism lies in Udé's literal burying of the empire's symbolic authority: the Queen. The declaration 'The Queen is Dead: a Song's Reality' not only puns on the punk rant of the British pop group The Smiths, but more importantly, along with 'The Noble Savage is Dead', he is marking the close of two particularly distasteful historical myths: the empire's assured superiority and the 'Noble Savage's' assumed inferiority.

The tragedy that besets identity and the longing for an actualised wholeness has come to represent Udé's entire project, especially as revealed through the lens of another magazine cover: *Condé Nast Traveller*. Recalling the violent project of slavery, the erasure of its memory, and the perpetuation of negative representations against those it marked as 'different', Udé presented three elliptically shaped diagrams of the interior of slave ships containing their human cargo. The allusion to travel, of course, is a cynical one, which calls into question the involuntary nature of that passage. It is a memory that continues to trouble the waters of the Atlantic as we repeatedly traverse its vast countenance. The consumption of the body of the 'Noble Savage' is clearly linked

to the violence of his/her co-option as commodity, entertainment, and cheap labour. As with all journeys, that depicted on the cover of *Condé Nast Traveller* is indelibly etched in our historical consciousness; it is one that still remains the seedbed of our discontent and resistance to racial stereotyping. But this journey is not administered and regulated by the image of bliss and release we obtain when we vacation in exotic locales. The image proffers no solace in the matters of self-creation, for no matter how realised, it nonetheless remains anchored to violence. Disturbingly so, because the history of self-creation in a diasporic system seems to be bound up with the violence it seeks to efface. Moreover, if realised, it offers no possibility of return, because identity constantly becomes projected into a temporal vacuum that is bound up in myth. And in many cases, as in the fantasies reproduced by magazines, in delusion. Thus, through the negation of the stereotype ('The Noble Savage is Dead'), Udé emphatically reveals to his audience that identity, however stabilised, is never a wholly fixed, immutable entity. He insists, as he did through the various personas he assumed on the magazine covers, that it is always assumed and always subtended to any notion of fixity through its denial of permanence in social construction.

Memory, Absence and Renunciation

Cameroonian-born Bili Bidjocka arrived in Paris as a twelve-year-old in 1974 and has lived there ever since. He has practised as an artist for more than a decade. Blurring the line between painting and installation, he makes tableaux-like paintings and radiant installations, so delicate in their allusive content that they can be read as apt metaphors for loss and absence, ravishment and renewal. His works possess a quiet, ponderous beauty, reminiscent of art of the most liminal kind. He transposes a postminimalist sensibility into reductive, emptied abstractions that have a charged, material urgency. Elliptical in nature, Bidjocka's paintings/objects, characterised by empty niches, and long moments of silence, call to mind the submerged and hidden gaps in which many immigrants who reside in industrialised Western countries exist. They further recall the silence shrouding the violence that constantly seeks to obliterate immigrant memories from the social fabric in these countries. Bidjocka's work is suffused with the glow of desire, yet it speaks in a hushed voice. Its narration of identity, if it can be called that, discretely recollects those figures pushed to the edges of existence within the monstrously affluent Western metropolis. These figures, like the shadows that haunt the bleak precincts of poverty and racist castigation exist in violently limited bodies.

In these subaltern figures, the 'dominant' contemporary imagination can only surmise a lack. It is through this frame of lack, through the trope of marginality, the invocation of its absence, that Bidjocka installs this figure's presence. Eschewing the modernist ideal of representation that is predicated on the image of the figure, what his paintings reveal is the body's corporeality (however

Iké Udé
Cover Girl Series, 1994-9
Photo-text
Courtesy the artist

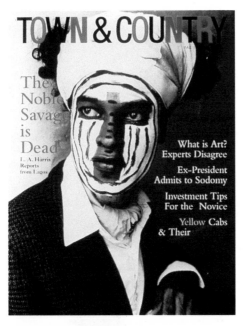

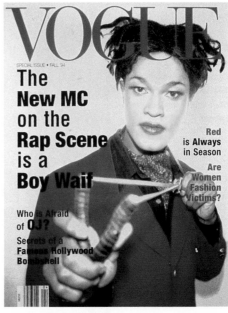

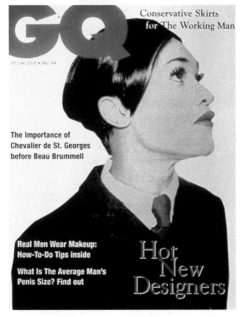

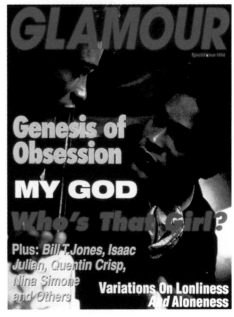

Yinka Shonibare
Diary of a Victorian Dandy:
14.00 hours, 1998
C-type print, series of five
183 x 228 cm
Commissioned by inIVA
Courtesy the artist and
Stephen Friedman Gallery,
London

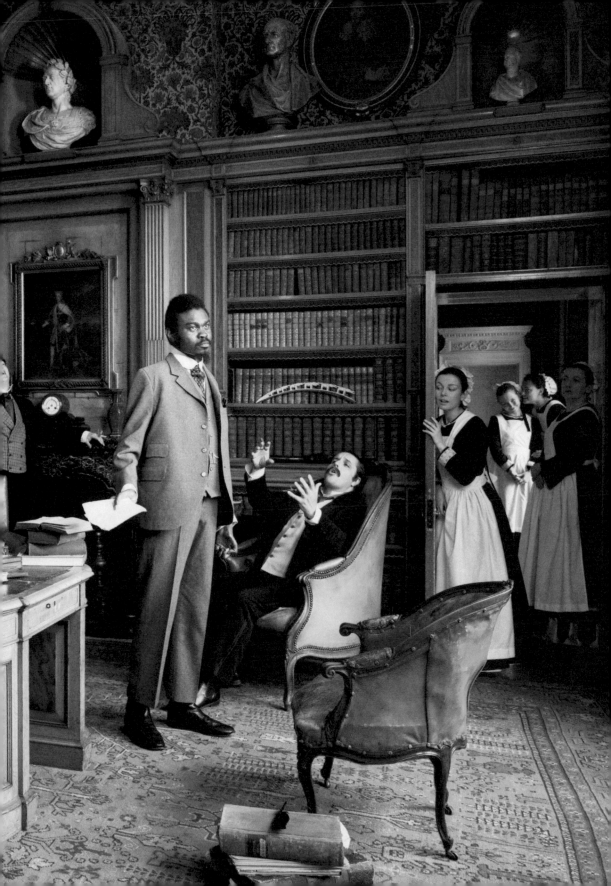

Bili Bidjocka
16,000 Holes, 1997
Garden installation,
Johannesburg Biennale
Courtesy the artist

diminished), its cognitive potential for transcendence. He uses the metaphor of empty spaces, carved out of the physical surfaces of his work, into which he places such items as a pair of rubber shoes, underwear, a simple long orange dress, plastic roses, and christmas lights to create a subdued melancholic atmosphere. The clear impression one receives through repeated viewing of these paintings, some of which are placed directly on the floor, is the sense of a memorial or an altar on which memories are propitiated. The absence of the body, for which these uninhabited items come to stand as surrogates, clearly calls in associations with physical and psychic wounds. In one of his many (one can read the meaning of anonymity in this) untitled works (1992), though the body has disappeared, its indexical presence (the memory of the body) is fully foregrounded. Like an X-Ray, the skeletal representation of a pelvis is painted on the monochrome surface of one of the niches, juxtaposed with, and faintly echoed by, a pair of underpants.

The strategy of pairing the pelvic trace with actual underwear (though disembodied), is a rhetorical device through which Bidjocka calls attention to the status of the body as primal presence, even though the painting addresses its absence. Yet the more one looks at Bidjocka's works, the less they seem to adhere to their referents in the material world or to the urgency of their charged meanings in the debased ruins of late-century capitalist economy, where, to paraphrase Oscar Wilde, people know the price of everything and the value of nothing.

This non-representational strategy in Bidjocka's work (quite distinct from abstraction), which can be traced through the phosphorescent halos that envelope the objects he hangs or places in his installations, parallels on one hand the fierce brilliance of the Congolese poet Tchicaya U'Tamsi, and on the other, the protean diffidence of Joseph Cornell's constructions. Whereas Cornell's aim was to trespass on the grounds of reality through a kind of Surrealist and absurdist trope of reconfigured realism, however, Bidjocka eschews pure representation through the sublation of any kind of identifiable facture that might lead viewers into reading things into his work. Placing an emphasis on art as a vehicle for subversion, Bidjocka not only interrogates the fallacy of racial recognition in the work of an artist, he has also remarked on the sheer impossibility of producing art that has an immediately recognisable identity. In this sense, his work reads as a deliberate effacement of evidence, a romantic penchant for self deprecation. But sustained looking produces a palpable sense of the consistent accessibility of his objects. It comes as no surprise then that Bidjocka, like Cornell in his tableaux assemblage of Surrealist ephemera, returns to the most elemental of forms and shapes: the egg. His installations utilising eggs arranged in multiple groups, on chastely subdued brownish and whitish grounds that seem lit from within and suffused with possibility, carry the poignant ethereality of a protean world, hidden, yet palpable with life, longing, and desire. This, one finds surprising and astonishing, for in the debris of so much loss, an artist like Bidjocka still finds room to dare to transcend the violence of marginality and the strictures placed on identity. The central virtue of such a stance stems less

from the Christian metaphor of suffering as transcendence, than from a more fundamental humanism, much more clearly articulated by Tchicaya U'Tamsi in a line in his epic poem *Epitome*, where his nameless protagonist insists that he must 'forget to be negro so as to forgive'.[18] Though this stance has been attacked as the romanticisation of suffering embedded in many exemplary Negritude texts, it still retains the element of refusal and renunciation (whether of misrepresentation or its violent antecedent, erasure) as willful political acts, as signifiers of loss and bereavement, resistance and renewal.

Precariously placed between Minimalism's refinement of form and its aesthetic purification and reduction of content (the apotheosis of late-modernist desexualised distance and detachment, which marginalises as it consumes the viewer's corporeal existence), Bili Bidjocka's work relentlessly refuses containment within the familiar register of racial identification. In fact, he has carefully overlayed and effaced all clues to such interpretation. It seems a fugitive act to say the least, since the last thing he wishes for is the premature termination of his interventions through a recourse to racial sentimentalisation. Fraught with this tendentious reading, which carries only the most nominal features of political signification (no 'narrative of crisis' to be read here), Bidjocka's work nonetheless leaves spaces wide enough to introduce readings of nationality, indeterminacy, and identity.

Questioning Authority

For Nigeria-born Olu Oguibe: painter, Conceptualist, poet and critic, the realm of politics is consistently inscribed within his personal and professional life. In the mid-1980s, when Oguibe was twenty-two, the great Nigerian novelist and essayist Chinua Achebe fondly dubbed him the 'Angry Young Man',[19] perhaps in reaction to his predilection for questioning power and authority through his work. Recognising the visionary restlessness of Oguibe's mind, Achebe invited him to join the editorial board of *Okike*, one of Africa's leading literary journals. What would be a great compliment for any aspiring young artist and writer, was for Oguibe, in the authoritarian environment of Nigeria's military dictatorship, more like a burden. Within this context, artists such as him, with their brutal frankness and iconoclasm, are bound to run into trouble. And he did. Hence, his quick flight out of the country and into exile in England. Oguibe is emblematic of a generation who came of age too quickly. A generation whose lives and careers were steeped in political activism, and whose presence, though sorely needed in their individual countries has been dispersed and displaced to anonymous cities and towns in the Western hemisphere.

As a cultural producer, much like the poets Christopher Okigbo of Nigeria and Jean-Joseph Rebarivielo of Madagascar, what Oguibe brings to the metropolitan space in which he practices is a grand melancholic vision. Postmodernist in outlook and sensibility, his continuous interrogations of the metropolitan arena have become emblems for his explorations into the

meanings of exile and displacement, of the place of identity in a landscape scrubbed and washed clear of any notion of human community without borders. England, as we all know, embraces a social hierarchy that rigorously maintains and polices such borders. In such a landscape, artists of his intellectual and critical makeup always face the possibility of censure for holding views contrary to official prescription. Again, true to his contestatory nature, Oguibe inevitably ran into trouble, leading to one of the most hotly debated issues of control over an artist's work by a public institution in England when the Commonwealth Institute in 1989 censored part of his one-person installation, a multi-panelled work, on the grounds that it contained obscenities. He withdrew his work, rather than bend to censorship. Such rare integrity is what makes Oguibe unique among many post-Independence African artists practising today. As such, any survey of his work requires a knowledge of these histories. For it is through such knowledge that we can adequately engage his work.

In more than a decade of practice, Oguibe has produced work that is as varied as the media he has employed. His production always seems freighted with the perpetual memory of loss, alienation, abandonment, and the violence of representations projected upon the undesirable other. Through refusal to be contained within the domain of an already predetermined boundary that unceremoniously dumps the marginalised into polite ethnic categories, Oguibe, in his own words, aims not only to problematise and transgress all notions of otherness, however embellished by postmodernism's invocation of 'difference', but also 'to pull up the rungs of hierarchy and trample the hedgerows of race'.[20] By producing work that is forever difficult and vigilant rather than celebratory, he embraces, not without romantic implications, Susan Sontag's invocation of the 'Artist as an Exemplary Sufferer'. The wound that the exile bears appears repeatedly in Oguibe's work of the last five years, through a rare and touching vulnerability. The state of displacement and dispersal inherent in the exilic existence is hardly appealing, particularly to those who must live under its unstable banner. Hence his proposal, through a multiplicity of frames and strategies of narration (installations, painting, poetry, critical practice, scholarly work, video etc.), for public debate on the status of the exilic body, a body that must remain obedient and contained within its limited status in order to survive in its already constricted borderland of desire and longing.

Oguibe dissociates himself from modernist archetypal heroism, which insistently sought resolution to the problems of representation in purified formal systems that subsumed the presence of other identities lying outside its totalising gaze. Instead, he employs a highly subjective critical apparatus to interrogate such identities, while still mediating the relationship between the dominant 'self' and the marginalised 'other', between 'citizen' and 'alien', 'nation' and 'subject'. Employing the postmodernist autobiographical trope of self-narration in an untitled installation at the Bluecoat Gallery in Liverpool (1994), Oguibe sought to bring notions of identity, usually implemented through self/other, centre/periphery, nation/subject relationships, into crisis by

hanging and roping off a heavy gilded mirror on the gallery wall. One might also read the gilded frame as Oguibe's meditation on the nature of the masterpiece, fetishised and imbued with supernatural power by both the frame and our gaze. The *Mona Lisa* in the Louvre, encased in bulletproof glass and roped off, an object of great fetish power, comes to mind. However, the power of this 'masterpiece', in its movement from one domain to another, must always be renegotiated. By vacating the frame of his masterpiece, Oguibe interrogates its assured place as an emblematic presence, as an all-encompassing visual cultural symbol.

The obvious responses to this installation call up associations with the Duchampian *laissez faire* utilitarianism of the ready-made or the Lacanian mirror stage. But in this case, rather than operating through the Lacanian trope of self-cognition whereby the split image becomes reunited in the zone of reflection, a projection of the actualised self, Oguibe uses the mirror to frame the viewer's provisional status within the domain of the all-encompassing totality that the mirror produces. The relocation of the site of interrogation is crucial in reading what he is proposing on the conditions of self/identity as being purely enmeshed only in representation. But the mirror disrupts such an association by constantly reproducing copies that can only be mediated and modified by the viewer's presence, or absence, as the case may be; a copy without a prior trace, always lacking body in its fluctuations. Cast out in such an indeterminate zone, the reproduced image is thus both real and illusionistic. This bisection of the self, a problematic that echoes the travestied binaries of the self/other, citizen/alien paradigm, is not a recapitulation to postmodernist faddism; it clearly carries the suggestion of exilic confusion, which produces the sense of disjunction and disruption more than wholeness or resolution. The mirror thus serves as a simulacral apparatus through which identity's amoebic forms ebb and rise, split and reunite.

It is not, however, lost on this writer that the signifier: the mirror, which attends such production, might in reality be lost, even on the most interested viewer. For however interested, however disciplined or empathetic the viewer, the image itself is not at all contained within the matrix of its production (the mirror) but in a migratory realm, an elsewhere that cannot guarantee the self a determinate form. Thus, Oguibe's proposal to the viewer is that the gaze, which is uncontainable within the frame of the mirror, is just as aberrational as the gaze that fixes the non-European and names him/her the 'other', the 'alien', the 'outcast'.

Clearly differentiated from Lacan's mirror stage notion, Oguibe's mirror proffers no easy answers that might lead to a shock of self-recognition or actualisation. The mirror image is always regulated through distance and indeterminacy; its roots dissolved and dispersed through many channels that lead everywhere and nowhere. The image's fluctuations run from crisis to tranquility, from memory to amnesia, remembrance to disremembrance. In short, what it introduces is the impurity of identity, thereby rendering the mirror merely a simulacral vessel, a reflective veneer beneath which lies much more troubled histories; those histories which when

appropriated through language, through the semiotics of 'difference', become irresolvably mired in both denial and self-production.

Predicated on the above, it seems clear that to survive, marginal communities – where exiles almost inevitably end up – must constantly operate in that territory of self-fashioning and production. Another untitled installation, this time at the Savannah Gallery in London (1993), forcefully addresses this condition of constant self-production. More accessible than the mirror installation, this work makes clear the never-resolved, ambivalent status of the marginalised. Appropriating an icon of late-capitalist consumerism, the shopping cart, he attached to it a miniature Union Jack and piled it with personal belongings, conjuring the severely deprived lives of those who must keep moving lest they become caught in the snares of authority. Through this installation, Oguibe institutes a commentary on the haves and have nots, on colonialism and the unresolved nature of postcolonialism, on desire and nationality, on what Homi Bhabha calls 'culture's in-between'.[21]

But Oguibe also points us to other locations, to insist that the conditions of exile are not necessarily rooted in migrancy, but can also be gleaned in the tenuous status of many Europeans:

It seems clear that to survive, marginal communities – where exiles almost inevitably end up – must constantly operate in a territory of self-fashioning and production.

Gypsies, Turks, and Bosnians come to mind. For him, Bosnia, especially, represents the ugliness and brutality that the West would rather consign to the tragedies that endlessly seem to plague places such as Africa and South America. His installation, *Requiem* (1993), at the Savannah Gallery, also universalised suffering and the violence of displacement. In this requiem for the children of Bosnia, four white dolls lie on a pedestal draped in black cloth. A sepia portrait of an anonymous young girl completes the memorial. The implication is quite clear: that Europe's charity is not only to be bestowed on its former subjects in its former colonies. In this installation, Oguibe addresses the fundamental paradox of violence as a tool of political and social emancipation, especially in Europe, under whose titular sky this century's most brutal crimes against humanity took place. Hence, the installations call for a less hypocritical approach in how we deal with the legacy of violence that seems to suffuse the relationship between the marginalised and the dominating.

Largely ignored, like many of his contemporaries, Oguibe has nonetheless shown himself to be an artist of exemplary courage, vision and humanity. He has quite correctly refused to embark on a project of neo-primitive representation, which his peculiarly postmodernist

inclination naturally rejects, and for which many critics excoriate him. His refusal, of course, is not predicated on the hubris of poststructuralist obscurantist closure, which concedes nothing through its insistence on the image's indeterminacy or its existence as a mere vessel for provocation. Instead, he attempts to search for a language whereby art of a revolutionary nature can move between the realm of aesthetic and social discourse, while still retaining the autonomy of the art object as a signifier of the larger world and without entrapping the art in interpretations that reduce its substance to a vessel for agitprop and self-indulgent victimhood. Though their conceptual nature at times makes Oguibe's installations seem like exercises in impenetrable postmodern obscurantism, their humanistic concerns and referents in the material world bring them down to a personal level, where his audience is able to experience the art as a source of self-reflection and knowledge. This participatory element clearly mediates the distance between postmodernist detachment and the audience's increasing alienation from its language and message.

Alchemical Monumentality

Ivorian-born Ouattara's paintings are perfomative venues in which African modernist aspiration and postmodernist transcendence converge. This is achieved through neo-primitivist parody, Neo-Expressionism, and the deconstruction of the sources of modernism via an ironic postmodernist consciousness. Unlike Udé or Oguibe, Ouattara is not a conscious postmodernist in the sense that the primary aim of his works is to test those boundaries where authority is constantly displaced and dispersed into other systems of knowledge; where the meaning of a social community is raised almost to the pitch of dissonance. But he is a postmodernist in the manner in which he has appropriated its sign of pastiche and composite production, its regulation of disparate cultural values and forms. What emerges is an ecstatic parody of poststructuralist signification. It is in modernist iconography, however, that Ouattara finds the most efficacious uses of the pastiche.

Given that modernism loved structures and surfaces, affect and grandiloquence, almost to the exclusion of other systems, Ouattara appropriates its essential gesture of monumentality. He also adopts its stream-of-consciousness, essentialist view of the artist as wonder-worker, as high-priest and author. He aims to examine the boundaries of the secular and the religious, alchemy and science, magic and empiricism, popular culture and canonical African classicism; above all, to examine the fundamental questions posed by the dichotomy between tradition and modernity, between Western and non-Western representation. Unlike modernist formalism, which in painting was once said to have been 'burnt to a crisp by the phenomenological stare',[22] Ouattara's work seems as if it has been wrung out and turned inside out, then reinvested with a vast array of expressive and subversive signs. In his monumental assemblages, he ranges

freely through disparate cultural landscapes and milieux, seamlessly applying a composite representation of various signs and iconographies, from the Iberian peninsula to Mexico, from Byzantine to Gondar, from Egypt to Mali, Pop to Expressionism, pop culture to pan-Africanism, high modernism to postmodernism.

Furthermore, Ouattara manipulates the frictions between modernism and postmodernism in a manner that deflects their literalist imposition of primitivism as the universal emblem of African art. If the postmodernist pastiche and its code of impure forms are veritable marriages of high and low, camp and seriousness, modern and traditional, piety and profanity, reality and simulation, all of which are mediated by technology, Ouattara like Joseph Beuys, co-opts these categories as sites onto which he can inscribe and encode a relational presence (self/other) through which he makes art that aspires to performance and magic. The danger here would be to lapse into the problematic investigation of Ouattara's work through a frame that baptises him shaman or native doctor, as many who have written about him have done. Or even through the unsettling trope of the artist as ethnographer, rummaging through the cracks of ancestry to satisfy the demands of the dominant imagination. This would be to limit talk about his work to the spectacle that its stupendous architectonics sometimes produces.

An investigation of this tendency in his work inevitably brings us to his huge tarpaulin paintings of the late 1980s, on which he placed various African sculptural objects and a flotilla of highly conscious primitivist effects. The gesture of such mimetic usage of African objects and Western-derived notions of primitivity was akin to camping out, spectacle as closure, the carnivalesque as an attempt at reclamation, through the occulus of a deterritorialised African modernism. Viewed through such a lens, these affects become, via Ouattara's use of them, subversive vessels – his Trojan Horse for infiltrating the closed quarters of Western international art.

The demand for an international presence for African artists makes clear that Ouattara's career, more than ever before, needs to be read through the internationality of his practice. There is a clear affinity between his present work and Robert Rauschenberg's early 'Combine Paintings'. In their physicality, however, in their pop-cultural graftings and appropriations, and in their illusions of three dimensionality, Ouattara's paintings/constructions need to be seen in the parallel light of the Neo-Expressionist movement of the 1980s, from the Italian Trans-avantgardists, such as Sandro Chia, Mimmo Paladino, Francesco Clemente, and Enzo Cucchi, through the New York branch, represented by Jean-Michel Basquiat (a personal friend of Ouattara), Julian Schnabel, and Keith Haring, to the ultimate champions, the post-war German Neo-Expressionists, Georg Baselitz, Markus Lupertz, A. R. Penck, and Anselm Kiefer. It is with the Germans that one can identify an international kinship for Ouattara. His primal stick figures, which populate virtual dreamscapes, easily find affinity with A. R. Penck's utilisation of such figures in his consciously primitivist *schtick*. Then there are Kiefer's overwrought,

monumental works, whose quotidian emblems can be viewed as repositories of multiple strands of historical narration. Ouattara's engagements with such historical narration, however, come from a much more vast and depopulated landscape.

Kiefer is particularly important in terms of how we frame Ouattara's stature as an international artist who engages global concerns, be it through politics or the politics of representation. Though Ouattara makes his inscriptions in full consciousness of the likes of Penck, Schnabel, Lupertz, Clemente, and Baselitz, one still understands that they are motivated by a desire that far outweighs the demands and values invested in the idea of 'authenticity' and shamanistic function – contra-Africa – necessary for his passage into the realm of 'serious' international art practitioners. Here, Kiefer's monumentality and its antinomies of decadence (whether affected or deeply felt and realised, though whispers of vicarious intent still pervade the debate around his work) brings sharply into focus Ouattara's own insistent play on scale: at once grand and compressed, open and occluded, while overlayering Kiefer's mastery and tradition with his own subjectivity.

Ouattara's *Barouah Adonais* (1992) and *Masada* (1993) can be read as counterpoints to Kiefer's *Your Golden Hair Margarete* (1981) and *Lilith's Daughters* (1991). In his relentless, almost obsessive, referencing of his country's Nazi past, Kiefer plays with the ghosts of a German nationalism run amok, inventoried and bound up in his famous, dreary, charred books. On the other hand, Ouattara, though not Jewish, by employing the Kaddish in his work, aims to discredit the kind of authority invested in works like Kiefer's. In tresspassing the boundaries of ethnicity through the appropriation of another culture's mourning rituals, Ouattara, universalises history as an experience of shared anguish and destiny. By acknowledging the pain of another's history, he also honours his own memory, Africa's memories, and the wounds suffered through colonialism's destruction of entire cultures and neo-colonialism's impingement on identity.

Lately, he has been producing work that takes its signage from architectural fragments of Africa, specifically those of old Mali. By surbordinating and enclosing the viewer within its frame, the work addresses one of the most fundamental questions of otherness: from where does its reproduction as a sign of the margin come? By whose authority do we bestow such a status? Ouattara's employment of African architecture as a nationalistic emblem, as a signifier of his cultural past and identity, seems to be saying to the viewer, 'in this brief moment of your presence before my work, you are resident within the domain of Africa: her culture, art, philosophy; her entire worldview. In short, everything you carry into this arena is mediated and processed through that singular perspective'. This marginalisation of the centre within its own domain is not a mere accident, but a conscious and tactical opposition, a refusal of otherness, a deterritorialisation of the modernist project, regardless of the consequence. The circumstances

Olu Oguibe
Requiem, 1993
Multimedia installation
with photo-image, iron-
work dresser and dolls
Courtesy the artist

of his present works are so powerfully delineated, that he has broken and extended the mould and language of painting as an objectified presence. These works no longer perform in accordance to ascribed notions of painting's formalism, its narrative structure of illusion. Rather than being paintings, they are painting-like, objects and structures relocated and painted over.

Ultimately Ouattara's paintings/constructions erode the absurd premise of the modernist hegemonic view of African painting as naïve, unsophisticated, and as less innovative than its Western parallel. In his outsized canvases, he recreates the square – neither the Greenbergian grid nor Joseph Albers' puny experiments with a form that will never contain the world it seeks to colonise – but the town square, the venue where the event between art and life, the sacred and profane, secular and religious, high and low mix to violate absurd boundaries that, in the waning years of the twentieth century, finally seem destined for dispatch into the deep grave of 'History'.

Postscript

Undeniably, the political ramifications of the invasion by the 'other' of the territories that for the entire duration of the twentieth century belonged to those who saw themselves as guardians of advanced art traditions, must not be underestimated. And these ramifications are being played out nowhere more than in the spaces, however denied, that many African artists, diasporic or otherwise, are hacking out within postmodernism while the West argues with the rest of the world about the end of 'History'.

In re-reading postmodernism and its relationship to artists such as those represented in this text, we must also turn our attention to the Africanist critical establishment, which thus far sees no benefit in engaging with, or lending its voice to, the ongoing debates around postmodernist and postcolonial discourse. Entrenchment into a dogmatic African essentialism entraps us all, and ignores the real commitment of many artists who wish to see such dogmas dismantled. Manthia Diawara cautions us against an Afrocentric essentialism that obdurately refuses to look to new texts in advancing its arguments,[23] an important point that the Africanist academia must carefully take to heart. Decreeing postmodernist discourse as irrelevant to discourse on contemporary African culture neither advances nor helps the future of African artists in a fragile global economy. Events such as the Venice Biennale, where African artists can only participate as guests of invited European countries, make it imperative that academia be vigorously challenged to open up its doors to new terrains of critical practice. Culture, though predicated on the ideal, the whole and the pure, is of course never those things. And neither are the artists upon whom the mantle of representing culture falls. Therefore, it seems ridiculous constantly to translocate contemporary African artists back to cultural milieux with which they have very little engagement. Nor should the value of their work be contingent on the display of an 'authenticity' certified, codified and ratified by an adjudicating tribunal.

This practice of ratification, which postmodernism processes, reproduces and fashions into 'difference', denies African artists a claim to subjectivity and self-narration. The complexities that enliven the contemporary condition, the contradictory and often aberrant nature of identity and memory, of race and nationality, the reckless interchangeability of either for the other – its metonymic character – within the temporal domain of contemporaneity, make the work of Udé, Bidjocka, Oguibe, and Ouattara, ever more uncontainable within one social or artistic milieu. Their presence in the domain of the Western metropolis problematises the notion of difference as a determining criterion for their inclusion within the pantheon of contemporary cultural producers.

In these widely contested terrains, in which the very notion of 'History' as constructed through hegemonic texts, seems imperiled, neo-conservative and reactionary voices have risen. Weak-willed liberals lacking the courage of their convictions have no doubt conceded the ground to the bulldozing of these cultural storm troopers, whom Jean-Michel Basquiat, were he still alive, would perhaps have called 'obnoxious conservatives'. Homi K. Bhabha reminds us of the exposure of the liberal flank, an achilles heel, no doubt, when he writes that the 'borderline negotiations of cultural difference often violate liberalism's deep commitment to representing cultural diversity as plural choice'.[24] Bhabha further argues that 'liberal discourses on multiculturalism experience the fragility of their principles of "tolerance" when they attempt to withstand the pressure of revision. In addressing the multicultural demand, they encounter the limit of their enshrined notion of "equal respect"'.[25] While Bhabha's remarks are illuminating and trenchant in their accuracy, the real enemy remains the neo-conservatives who would wish for nothing more than a return to the glory days of modernist pathos, its disdain for the culture of the 'other', and its delusional self-referentiality predicated on Europe's superiority complex. One doubts very much, however, whether artists such as Udé, Bidjocka, Oguibe, and Ouattara see the necessity to seek the Western establishment's sanction before embarking on an oppositional practice that will either change the rules of the game or shift the 'centre'.

It seems sufficiently apparent in works by many African artists that the exemplar of postmodern representation, under whose levelling authority identity might fall and become contained, is not in itself a closed shop that receives and transmits only those images that are circumstantial to the production of a positivist idea of a given society or culture. Indeed, truly to define postmodernism seems an almost futile act. Its precepts and values seem forever shifting. Its codes, digressions and constitutions, its analogues and localisation within systems whether banal or profound, immanent or dissolved into highly contested critical texts and counter-texts, excisions and exclusions, affective or enunciatory, are always in flux. Today, postmodernism would seem even more tailored to Ihab Hassan's insistence on its

indeterminacy as 'an equivocal concept, a disjunctive category, doubly modified by the impetus of the phenomenon itself and by the shifting perceptions of its critics'.[26] But approached from the perspective of how art made by these artists has functioned within its domains, how it has enlivened and given texture to contemporary representation in the metropolis (one thinks of hip-hop culture here), postmodernism becomes an ethical compass, an apparatus for interrogating both the negative and positive aspects of identity. Or put more precisely, a means of addressing identity's fragility: its temporality. Hence, productively looked at and experienced, the common purpose of a postmodern society is one that is no longer in direct opposition to the modernist project. Instead, postmodernism seeks to bypass modernism by way of its multivalent identities, and multiplicity of tongues. In the immediacy of our desires, postmodernity presupposes a shift that is neither utopic nor entropic. It persistently leads us to an elsewhere, to new terrains of possibilities, even if they are places for which we must continually fight and renegotiate, over and over again.

Notes

1 Hal Foster, *Recodings: Art, Spectacle, Cultural Politics*, (Seattle: Bay Press, 1985), p. 129.

2 See Olu Oguibe, 'A Brief Note on Internationalism', in Jean Fisher (ed.), *Global Visions: Towards a New Internationalism in the Visual Arts* (London: Kala Press in association with inIVA, 1994).

3 Homi K. Bhabha, 'The Other Question: Difference, Discrimination, and the Discourse of Colonialism', in Russell Ferguson, Martha Gever, Trinh T. Minh-ha, Cornel West (eds.), *Out There: Marginalization and Contemporary Cultures* (Cambridge, MA and New York: MIT Press and The New Museum of Contemporary Art, 1990), p. 71 (emphasis added).

4 Charles Merewether, 'The Promise of Community', in *Africus*, exhibition catalogue (Johannesburg: Johannesburg Biennale, 1995), p. 58.

5 Jean-François Lyotard, *The Postmodern Explained*, (Minneapolis: University of Minnesota Press, 1993).

6 Frederic Jameson, *Postmodernism, Or, The Cultural Logic Of Late Capitalism* (Durham, NC: Duke University Press, 1991) (emphasis added).

7 *Ibid.*

8 Anthony Ilona, 'Olu Oguibe: Recent Works', *Third Text*, no. 25 (London: Winter 1993-94), p. 87.

9 bell hooks, *Black Looks: Race and Representation*, (Boston, MA: South End Press, 1992), p. 115. The oppositional gaze is employed in this instance as a device of affirmation and for the disempowerment of hegemonic structures of reference, rather than a device of mere resistance or one used for the construction of difference.

10 Cornel West, *Keeping Faith: Philosophy and Race in America* (New York and London: Routledge, 1993), p. 3.

11 Manthia Diawara, 'Afro-Kitsch', in Gina Dent (ed.), *Black Popular Culture* (Seattle: Bay Press, 1992), p. 289.

12 Michel Foucault, quoted by Nancy Spector in 'Félix Gonzales-Torres: Travelogue', *Parkett*, no. 39 (Geneva: March 1994).

13 Thomas McEvilley, 'Fusion: Hot or Cold?', in *Fusion: West African Artists at the Venice Biennale*, exhibition catalogue (New York: Museum for African Art, 1993) p. 17.

14 Attempting to locate the source of anxieties, ambivalence, and phobias about the body and its related activities, Udé produced a group of work entitled 'Ass Prints', which sought to challenge our perceptions of certain bodily functions. He obtained the imprints by asking his 'sitters', whose buttocks he had coated with acrylic paint, to sit on a piece of heavy-duty watercolour paper. Each 'Ass Print', obtained just like a finger print, was a unique document, serving as an index of that part of the body.

15 Benjamin Hufbauer, 'Performing the Feminine:
 The Adanma Masquerade In Igboland', *TVC: Thresholds:
 Viewing Culture*, vol. 8 (Santa Barbara: University of
 California, 1994), pp. 40–41.

16 *Ibid.*

17 *Ibid.*

18 Tchicaya U'Tamsi, *Selected Poems*, trans. Gerald Moore,
 (London: Heinemann, 1970).

19 Chinua Achebe, catalogue essay for the exhibition
 'Statements', Syrian Club, Lagos, 1989.

20 Oguibe, *op. cit.*

21 Homi K. Bhabha, 'Culture's In Between', *Artforum*
 (New York: September 1993).

22 Peter Schjeldahl, Susan Rothenberg, 'United States',
 Artforum (New York: September 1993).

23 Diawara, *op. cit.*

24 Bhabha, *op. cit.*

25 *Ibid.*

26 Ihab Hassan, 'Pluralism in Postmodern Perspective',
 Critical Inquiry, vol. 12, no. 3 (Chicago: Spring 1986),
 p. 508.

Traces of Ecstasy

Rotimi Fani-Kayode

It has been my destiny to end up as an artist with a sexual taste for other young men. As a result of this, a certain distance has necessarily developed between myself and my origins. The distance is even greater as a result of my having left Africa as a refugee over twenty years ago.

On three counts I am an outsider: in matters of sexuality, in terms of geographical and cultural dislocation, and in the sense of not having become the sort of respectably married professional my parents might have hoped for. Such a position gives me a feeling of having very little to lose. It produces a sense of personal freedom from the hegemony of convention. For one who has managed to hang on to his own creativity through the crises of adolescence, and in spite of the pressures to conform, it has a liberating effect. It opens up areas of creative enquiry that might otherwise have remained forbidden. At the same time, traces of the former values remain, making it possible to take new readings on to them from an unusual vantage point. The results are bound to be disorientating.

In traditional African art, the mask does not represent a material reality: rather, the artist strives to approach a spiritual reality within it through images suggested by human and animal forms. I think photography can aspire to the same imaginative interpretations of life.

My reality is not the same as that which is often presented to us in Western photographs. As an African working in a Western medium, I try to bring out the spiritual dimension in my pictures so that concepts of 'reality' become ambiguous and are opened to reinterpretation. This requires what Yoruba priests and artists call a 'technique of ecstasy'.

Both aesthetically and ethically, I seek to translate my rage and my desire into new images that will undermine conventional perceptions and which may reveal hidden worlds. Many of the images are seen as sexually explicit – or more precisely, homosexually explicit. I make my pictures homosexual on purpose. Black men from the Third World have not previously revealed either to their own peoples or to the West a certain shocking fact: they can desire each other.

Some Western photographers have shown that they can desire Black males (albeit rather neurotically). But the exploitative mythologising of Black virility on behalf of the homosexual bourgeoisie is ultimately no different from the vulgar objectification of Africa that we know at one extreme from the work of Leni Reifenstahl and, at the other, from the 'victim' images that constantly appear in the media. It is now time for us to reappropriate such images and to transform them ritualistically into images of our own creation. For me, this involves an imaginative investigation of Blackness, maleness and sexuality, rather than more straightforward reportage.

However, this is more easily said than done. Working in a Western context, the African artist inevitably encounters racism. And since I have concentrated much of my work on male eroticism, I have also experienced homophobic reactions to it, both from the White and Black communities. Although this is disappointing on a purely human level, perhaps it also produces a kind of essential conflict through which to struggle to new visions. It is a conflict, however, between unequal

Rotimi Fani-Kayode
Sonponnoi, 1987
Black and white silver
gelatine with hand-tinting
40 x 30.5 cm
Courtesy the Artist's Estate
and Autograph, London

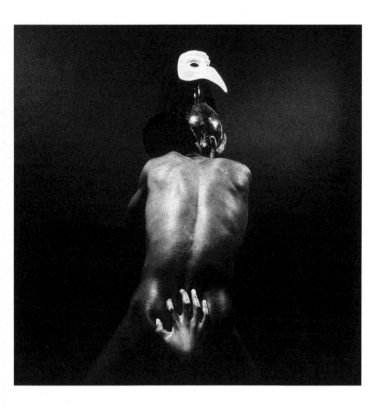

Rotimi Fani-Kayode
*Every Moment Counts
(Ecstatic Antibodies)*, 1989
Colour photograph
135 x 135 cm
Courtesy the Artist's Estate
and Autograph, London

partners and is, in that sense, one in which I remain at a disadvantage.

For this reason, I have been active in various groups, which are organised around issues of race and sexuality. For the individual, such joint activity can provide confidence and insight. For artists, it can transform and extend one's Westernised ideas – for instance, that art is a product of individual inspiration or that it must conform to certain aesthetic principles of taste, style and content. It can also have the very concrete effect of providing the means for otherwise isolated and powerless artists to show their work and to insist on being taken seriously.

An awareness of history has been of fundamental importance in the development of my creativity. The history of Africa and of the Black race has been constantly distorted. Even in Africa, my education was given in English in Christian schools, as though the language and culture of my own people, the Yoruba, were inadequate or in some way unsuitable for the healthy development of young minds. In exploring Yoruba history and civilisation, I have rediscovered and revalidated areas of my experience and understanding of the world. I see parallels now between my own work and that of the Osogbo artists in Yorubaland, who themselves have resisted the cultural subversions of neo-colonialism and who celebrate the rich secret world of our ancestors.

It remains true, however, that the great Yoruba civilisations of the past, like so many other non-European cultures, are still consigned by the West to the museums of 'primitive' art and culture.

The Yoruba cosmology, comparable in its complexities and subtleties to Greek and Oriental philosophical myth, is treated as no more than a bizarre superstition which, as if by a miracle, happened to inspire the creation of some of the most sensitive and delicate artifacts in the history of art.

Modern Yoruba art (amongst which I situate my own contributions) may now sometimes fetch high prices in the galleries of New York and Paris. It is prized for its exotic appeal. Similarly, the modern versions of Yoruba beliefs carried by the slaves to the New World have become, in their carnival form, tourist attractions. In Brazil, Haiti and other parts of the Caribbean, the earth reverberates with old Yoruba rhythms, which are now much appreciated by those jaded Western ears that are still sensitive enough to catch the spirit of the old rites. In other words, the Europeans, faced with the dogged survival of alien cultures, and as mercantile as ever they were in the days of the Trade, are now trying to sell our culture as a consumer product. I am inevitably caught up in this.

Another aspect of history – that of sexuality – has also affected me deeply. Official history has always denied the validity of erotic relationships and experiences between members of the same sex. As in the fields of politics and economics, the historians of social and sexual relations have been readily assisted in their fabrications by the Church. But in spite of all attempts by Church and State to suppress homosexuality, it is clear that enriching sexual relationships between members of the same sex have always existed. They are part of the human condition, even if the concept of sexual identity is a more recent notion.

There is a grim chapter of European history that was not drummed into me at school. I only discovered much later that the Nazis had developed the most extreme form of homophobia to have existed in modern times, and attempted to exterminate homosexuals in the concentration camps. It came not so much as a surprise but as yet another example of the long-standing European tradition of the violent suppression of otherness. It touches me just as closely as the knowledge that millions of my ancestors were killed or enslaved in order to ensure European political, economic and cultural hegemony of the world.

I see in the current attitudes of the British Government towards Black people, women, homosexuals – in short, anyone who represents otherness – a move back in the direction of the fascistic values that for a brief period in the 1960s and 70s ceased to dominate our lives. For this reason I feel it is essential to resist all attempts that discourage the expression of one's identity. In my case, my identity has been constructed from my own sense of otherness, whether cultural, racial or sexual. The three aspects are not separate within me. Photography is the tool through which I feel most confident in expressing myself. It is photography, therefore – Black, African, homosexual photography – that I must use not just as an instrument, but as a weapon if I am to resist attacks on my integrity and indeed, my existence on my own terms.

It is no surprise to find that one's work is shunned or actively discouraged by the Establishment. The homosexual bourgeoisie has been more supportive – not because it is especially noted for its championing of Black artists, but because Black ass sells almost as well as Black dick. As a result of homosexual interest I have had various portfolios printed in the gay press, and in February 1987, a book of nudes was published by GMP.[1] There has also been some attention given to my erotic work by the sort of straight galleries that receive funding from more progressive local authorities.

But in the main, both galleries and press have felt safer with my ethnic work. Occasionally they will take on board some of the less overtly threatening and outrageous pictures – in the classic liberal tradition. But Black is still only beautiful as long as it keeps within White frames of reference.

I have been more disconcerted by the response to my work from certain sections of the self-proclaimed avant garde, however. At the recent 'MiSFiTS' exhibition at Oval House (1987) (which happened to coincide with the unveiling of a plaque to commemorate the birth there of Lord Montgomery of Alamein), I was asked, along with other artists, to remove my work in case it attracted unfavourable publicity for Oval House. We refused, naturally. Unfortunately, the press were busy paying homage to Monty so the national reputation of Oval House was saved, and we were denied some free publicity. It is perhaps gratifying that the inadequacies of Oval House's Equal Opportunites Policy have since been recognised by many of its erstwhile supporters. But given the new Government ruling against local authority funding for any form of 'promotion' of homosexuality, I assume that, in any case, community organisations will no longer be allowed to show my work.

As for Africa itself, if I ever managed to get an exhibition in, say, Lagos, I suspect riots would break out. I would certainly be charged with being a purveyor of corrupt and decadent Western values.

However, sometimes I think that if I took my work into the rural areas, where life is still vigorously in touch with itself and its roots, the reception might be more constructive. Perhaps they would recognise my smallpox Gods, my transsexual priests, my images of desirable Black men in a state of sexual frenzy, or the tranquillity of communion with the spirit world. Perhaps they have far less fear of encountering the darkest of Africa's dark secrets by which some of us seek to gain access to the soul.

Notes

1 Rotimi Fani-Kayode, *Black Male/White Male*
 (London: Gay Men's Press, 1987).

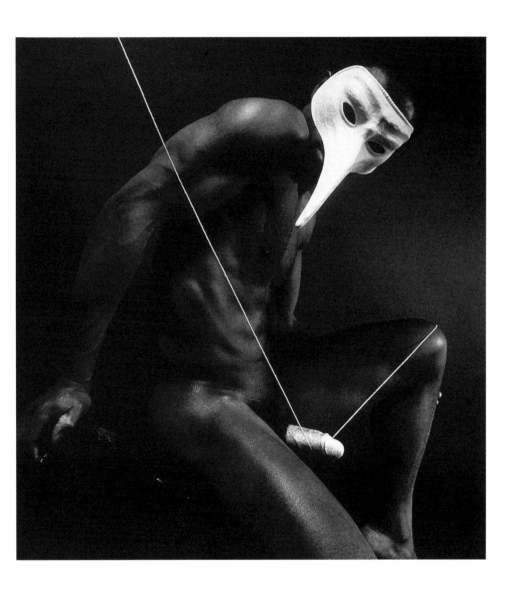

Eros & Diaspora

Kobena Mercer

Rotimi Fani-Kayode
Golden Phallus, 1989
Colour photograph
51 x 51cm
Courtesy the Artist's Estate
and Autograph, London

The erotic is a measure between the beginning of our sense of self and the chaos of our strongest feelings ... The very word erotic comes from the Greek word eros, the personification of love in all its aspects, born of chaos, and personifying creative power and harmony. Audre Lorde [1]

Pleasure is so close to ruinous waste that we refer to the moment of climax as 'little death'. Georges Bataille [2]

Rotimi Fani-Kayode created a photographic world in which the body is the focal site for an exploration of the relationship between erotic fantasy and ancestral spiritual values. In his artistic project he found the freedom to use the complexity of his experience as a resource to embark upon a journey into emotional states of being in which it is hard to tell where sexuality ends and spirituality begins. What he brought back from his travels to such nocturnal spaces are glimpses into a world illuminated by the ancient enigma of something so violent, so marvellous and so tragic as to be unrepresentable: the human experience of ecstasy.

Fani-Kayode outlined his artistic credo in 'Traces of Ecstasy', the 1988 essay that followed *Black Male/White Male*, his first published collection of photographs, brought out in 1987.[3] While many were beguiled by the multiple adjectives with which he sought to name his identity – a modern African artist, a metropolitan black gay man, a key figure in Black British photography – the irony is that Fani-Kayode's life and work were never about the comforts or securities of mere identity. His kaleidoscopic vision, filtering African and European elements through his camera's optic nerve, and his passionate pursuit of carnal visual pleasure, reveal instead a heightened encounter with the emotional reality of the flesh in which it is precisely the ego's ecstatic loss of identity that is celebrated. The body is transfigured in Fani-Kayode's pantheon of 'smallpox gods, transsexual priests and desirable black men in a state of sexual frenzy' [4] to create a new, plural beauty out of what Wilson Harris would call 'the ruined fabric of the shattered human'.[5]

Born into a prominent Nigerian family in the prelude to political independence, Fani-Kayode grew up across three continents – Africa, Europe and America – during the three decades from the 1960s to the 1980s that saw the world transformed by the emergence of the postmodern and the postcolonial. His biography was thus shaped by the characteristic diasporic experiences of migration and dislocation, of trauma and separation, and of imaginative return. Looking at how his aesthetic developed out of his response to the events that shaped his life, we can see that sexuality was central to the discovery of his artistic roots in the realm of the sacred, for the joyful affirmation of his love of life, which flows throughout the work, is testimony to the redemptive powers of eros.

Given the brevity of his life – and the sheer generosity of his prodigious output in a career that

spanned a mere six years – we can apprehend the beauty of Fani-Kayode's artistic gift by recognising the cultural mixing that constituted it. Remembering his partner and lover, Alex Hirst reveals much about how the experience of diaspora shaped Fani-Kayode's overall approach to life, and how it cut into his critical self-fashioning as an artist when he writes that:

> It is important to know that he kept faith with many of the values that his background had given him . . . Leaving Africa as an exile at the age of eleven meant that he was haunted for the rest of his life by a desire to get to grips with certain mysteries he had glimpsed there: in the traditions and beliefs of his ancestors. He tried to make sense of them in the context of a dislocated world. Brighton and school in the English countryside was obviously quite different from that of Lagos and Ibadan.[6]

From this viewpoint, we can see how diaspora entailed a rupture between 'myself and my origins', as Fani-Kayode put it,[7] opening up an abyss out of which he found the catalyst for his creativity in his commitment to same-sex passion. His paradoxical emphasis on finding one's freedom in the loss of one's origins, which are to be refound only through a journey into the body's ancestral memory, critically locates him in a space that produces 'a kind of essential conflict through which to struggle to new visions'.[8] Fani-Kayode's self-representation thus foregrounds his position as an outsider for whom such a liminal place is valued for the new practices of freedom that it makes possible.

The dynamic of rage and desire was central to Fani-Kayode's vision, and formed the mainspring of his unique aesthetic. To perceive the connections between his different roles as a transcultural animateur, we need to see how this dynamic shaped his art of photographic transfiguration, in which the body becomes a site for translation and metaphor – transporting meanings across codes of racial, cultural and sexual difference; how the camera becomes both a lamp and a mirror – emitting light into the unknown and reflecting the transience of voluptuous flesh; and how the act of representation itself shifts from the moment of documentary truth to the alchemy of the photographic darkroom.

Describing the circumstances of their life together, Hirst brings us to the body and soul of Fani-Kayode's lifework when he shares his memories of the precise point at which Fani-Kayode tapped into the sources that gave shape to his project:

> We lived in various parts of South London, marginalised, short of money and leading a life that was 'bohemian', not because we particularly wanted to but because that was how it turned out. Timi got a part-time job as a photography tutor. He had begun by then to work exclusively in black and white. This was partly to do with cutting down on expenses.

The result was far-reaching, however, in that it coincided with the start of his exploration of the relationship between erotic fantasy and ancestral spiritual values.[9]

Like the *abiku*, or spirit-child, who narrated Ben Okri's novel, *The Famished Road* (1991), Fani-Kayode was with us for only a short time. Although his work was under-recognised, because it was simply ahead of its time, and its development was cut short by his untimely death, we can see how the generosity of his vision contributed many wide-ranging responses to the transvaluation of cultural difference, which has become one of art's defining imperatives at the end of the twentieth century.

The Artist as Boundary Rider of Cultural Difference

In African traditional art, the mask does not represent a material reality; rather, the artist strives to approach a spiritual reality in it through images suggested by human and animal forms. I think photography can aspire to the same imaginative interpretations of life.
Rotimi Fani-Kayode [10]

Moving on the cusp of multiple differences, Fani-Kayode made decisive interventions at the intersection of at least three forms of cultural renascence. Although he enjoyed only one solo exhibition during his lifetime – 'Yoruba Light for Modern Living' (Riverside Studios, 1986) – his presence in numerous group shows, including 'Sacred and Profane Love' (South West Arts, 1985), 'Same Difference' (Camerawork, 1986), 'Misfits' (Oval House, 1987), 'Transatlantic Dialogues' and, with Alex Hirst, 'Bodies of Experience' (both at Camerawork, 1989), serves to outline the diversity of milieux through which his practice travelled.

As a founder member and first Chair of Autograph – the Association of Black Photographers – Fani-Kayode assumed a role that, in the ferment of the 1980s Black British arts scene, articulated the collective assertion of an autonomous agenda in the face of institutional incomprehension of the forces that were bringing about signal realignments in critical visual culture. His highly influential role in leading the break away from documentary realism, and forging new aesthetic trajectories within the constructed imagery that is also associated with his contemporaries Joy Gregory, Dave Lewis and Roshini Kempadoo, was reflected in the third issue of *Revue Noire*, December 1991. It was also evident in key issues of the journal *Ten.8*, including *Bodies of Excess* (1991) and *Critical Decade* (1992) – and in the spectacular culmination of the audio-visual anthology of black British photography, *Rencontres Au Noir*, first exhibited at the Arles Photography Festival in 1993, and subsequently shown as a video.

At the same time, Fani-Kayode's homoerotic nudes found a favourable reception in the

context of metropolitan gay culture. From his early experiments in colour photography such as the *Nude With Raffia Head-dress* (c. 1986), to the publication of *Black Male/White Male* by the Gay Men's Press,[11] Fani-Kayode was an important figure in the shifts that resulted in the flourishing queer culture of the late 1980s. He was a contributor to *Square Peg*, and a contemporary of Grace Lau, Gordon Rainsford and other lesbian and gay artists inhabiting a space influenced by such precursors as filmmaker Derek Jarman and impresario Andrew Logan. His integral involvement in the dissemination of post-liberationist gay culture was reflected in the selection of his images in the artwork for Jonathan Dollimore's ground-breaking work of queer theory, *Sexual Dissidence* (1991).[12] *Ecstatic Antibodies: Resisting the AIDS Mythology* (1990) by Tessa Boffin and Sunil Gupta,[13] is also emblazoned with *The Golden Phallus* (1989), one of Fani-Kayode's most important collaborations with Alex Hirst.

Taken together, Fani-Kayode's contributions to the transatlantic formation of a black gay cultural diaspora encapsulate his role as a migrant translator. Washington DC's black gay scene was particularly formative during his time in the US – *Black Male/White Male* was dedicated to 'Toni and the spirit of the Clubhouse, DC'. Of the three strands that weave across his body of work – portraits, nude studies and staged tableaux – his intimate portraits of poet Essex Hemphill, of activist Denis Carney, of musician Blackberri and of poetry-performance diva Assoto Saint, all speak of his involvement in the making of a vibrant transnational culture that was also being shaped by these artists, who were his friends. Along with the films of Isaac Julien, Marlon Riggs and Pratibha Parmar, or the photographs of Sunil Gupta and Lyle Ashton Harris, his work heralded the arrival of a new cultural politics of difference, which was not without its attendant public controversies.

In 1987, an image depicting the model Michael from *Black Male/White Male* was chosen for the cover of *Tongues United*, a poetry collection featuring Isaac Jackson and Dirg Aarb-Richards as well as Essex Hemphill and Assoto Saint.[14] The book became the inspiration for Marlon Riggs' breakthrough film of 1989, *Tongues Untied*, which borrowed the title in a trope of intra-diasporic translation that amplified the intertextual volume by which all cultures create themselves through acts of citation and reiteration. While enriching the literary, cinematic and photographic cultures of the Black Atlantic, Riggs' film became embroiled in the 'culture wars' when a clip was appropriated as an example of publicly unacceptable imagery by rightwing demagogue Pat Buchanan in the 1992 US Presidential elections. If this suggests that art always exceeds its author's intentions, the underlying dynamics enable us to understand why Fani-Kayode's work was itself under-recognised: because its reception was bedevilled by a superficial comparison with the photographs of Robert Mapplethorpe.

Hirst writes that Fani-Kayode's approach to his work 'was political, but it had no manifesto beyond an anarchic desire to create something . . . that would shake the established view of the

world, his own included', thus elucidating Fani-Kayode's critical perspective on what has become known as identity politics. However, the further claim that Fani-Kayode 'was not interested in being seen as a "gay" or "black" artist and especially not as a "black gay" artist' [15] seems to minimise the overdetermined character of the work's reception by different audiences, and also to side-step the subtle interplay within the work of both minoritising and universalising tendencies, which powerfully subvert the logic of mutually exclusive either/or binaries.

To see how Fani-Kayode used the hybridity of his experience as a starting point for doing something new, we should locate his specific techniques of visual interculturation in the broader art-historical context of modernism and colonialism. Here, we encounter a triangular rather than dichotomous matrix, of whose labyrinthine twists and turns Fani-Kayode was all too well aware. At the apex of this triangular relationship lies the vexed question of the mask and the historical realities that are masked by the dominant narratives of modern art in its encounter with the 'primitive'. Picasso's discovery of the aesthetic wonders of traditional African masks, fetishes and other artifacts in the storerooms of the Trocadero museum is a commonplace, but from an African point of view, such artifacts epitomised mere traditionalism and it was rather the Western

Taken together, Fani-Kayode's contributions to the transatlantic formation of a black gay cultural diaspora encapsulate his role as a migrant translator.

aesthetic of verisimilitude that inaugurated a break in African modernist consciousness.

And there is a third strand to the story, namely the shared fascination with the image of African masks among visual artists of the Harlem Renaissance. Palmer Hayden, in his *Fetisches et Fleurs* (1926); Malvin Johnson's *Self-Portrait* (1938); and Lois Mailou Jones, with her *Fetishes* (1938), each followed up on Alain Locke's 1925 essay, 'Art of the Ancestors', [16] which suggested that an alternative apprenticeship for the New Negro could be found by turning to the formal discipline of African masks, which themselves had entered into diaspora consciousness mostly through the mediums of Western museum collections and ethnographic photography.

When he announced that, 'It is now time for us to reappropriate such images and transform them ritualistically into images of our own creation' [17], Fani-Kayode spoke from his intimate knowledge of this intercultural history. Commenting on the residual dominance of modernist primitivism in the forms of ideological fixation that determined the institutional reception of his work, he delineated the complex conditions in relation to which he positioned his art.

Aware of sexuality as the hidden conduit of cultural criss-crossing between Africa and Europe, Fani-Kayode found a subversive line of flight out of the racial fetishism that dominates Western

perceptions of the black body. Because his relationship to his Yoruba sources was mediated by the ruptures of diaspora, his perspective on the body was thoroughly interpenetrated by the inseparable aspects of hybridity and homosexuality that placed him as a critical outsider to the comforts of self-same identity.

While his central interest in the body as a boundary rider between material and spiritual worlds is one shared and explored by other contemporary diaspora artists – in sculptural works such as Rene Stout's *Fetish #2* (1988), or Alison Saar's *Lazarus* (1988), and in the photographic *I-Traits* (1989) series by the Jamaican-Chinese artist, Albert Chong – it could be said that Fani-Kayode's reframing of the body owes more to the insights afforded by the subversive potential of the homoerotic. On this view, Stuart Hall's lucid observations clarify the intersticial approach by which Fani-Kayode's vision pierced into the hyphenated spaces of the in-between:

> The black male body becomes the locus for a number of intersecting planes of meaning. The hieratic, carefully ritualised posture of the figures, their central framing, the deliberate use of costume, body decoration, and *above all, masks*, reference Fani-Kayode's exploration of his Yoruba background ... Yet this 'African' plane of reference is, almost immediately, subverted by other meanings and languages. The symbolism hovers between a public or collective, and a more private and personal, set of codes.[18]

These 'other meanings and languages' come from Fani-Kayode's mastery of both mainstream Western modernism and the subcultural codes of modern gay iconography. Elements from the latter (such as cropping and posture) clearly inform his more formalistic nude studies like *Knave of Spades* (1987) or *Joining of Equal Forces* (1987), while the *mise-en-scène* in a work such as *White Bouquet* (1987) articulates a call-and-response reworking of Manet's *Olympia* (1863), which through a point-by-point reversal of the racial and gendered positions in the original composition, also reveals the light touch of Fani-Kayode's sense of humour. Viewed from behind, a white man offers flowers to a reclining black man: not only are the power relations of mistress and servant liquidated by homosexual sameness, but Olympia's defiant gesture of withholding has been subverted, or perverted rather, into an act of giving – the gift of flowers now defines the relationship between the two figures rather than the outward gaze towards the viewer that provoked the initial outrage in response to the painting.

Although the man in the pictures is often Fani-Kayode himself, the work transcends the autobiographical or confessional as his mode of framing foregrounds the 'I' of embodied experience over the 'me' of a finite self. What results in the play of condensation and displacement is the carnivalesque of the mask, highlighted in such works as *Ebo Orisa* (1987) and *Farewell to Meat (Canavale)* (1987). By de-polarising the ego's boundaries of Self and Other, the mask seeks

not to conceal an identity but to liberate heterogenous elements from the psyche and allow them to communicate with each other as the self plunges through the limit-experience of sexual pleasure into the realm of the undifferentiated – the primal chaos out of which eros emerges. As Stuart Hall continues:

> The faces are all 'masked'. In his most compelling erotic image, *Technique of Ecstasy*, the face, concentrated in desire, is finally hidden from the viewer's gaze. Fani-Kayode 'subjectifies' the black male, and black sexuality, claiming it without making it an object of contemplation and at the same time without 'personifying' it. Because the masking is not a compositional trick, but an effect drawn from another iconographical tradition, the truncation of the body condenses the visual effect, displacing it into the relation between the two figures 'at rest' with the weight, the specific gravity of concentrated sexual pleasure, without translating them into fetishes.[19]

In place of the sharply defined subject/object dichotomies that we encounter in the scopophilic force of Robert Mapplethorpe's work, in which the black body is fetishised to ward off the threat of the ego's loss of control, in Fani-Kayode's phantasia the viewer's look is cruised, caressed and seduced in the masquerade by which the protection of the gods is requested. It is the representation of such an act of propitiation that recurs across his tableaux when the converging sightlines brought to bear on the body create the sensation of 'hovering' between two worlds. In this structure of feeling we can trace what Nathaniel Mackey would call a 'fugitive aesthetic', borne of a restlessness that refuses the illusion of certainty in its search for ontological renewal.[20] Fani-Kayode's conjuring of erotic fantasy and ancestral memory thus moves us into a place that is beyond psychology – because it de-territorialises the ego's boundaries – and into a place beyond good and evil, which is to say, a somewhere other than that circumscribed by Christianity.

Communion: Love will tear us apart

> *The diagnosis does not establish the fact of our identity by the play of distinctions. It establishes that we are difference, that our reason is the difference of discourses, our history the difference of times, our selves the difference of masks. That difference, far from being the forgotten and recovered origin, is this dispersion that we are and make.*
> Michel Foucault[21]

For thinkers like George Bataille, sexuality is seen as but one route into the realm of the sacred – itself a word derived from the verb 'to sacrifice'. While religious codes seek to regulate

those human experiences that culminate in ecstatic ego-loss, in which selfhood is given up and torn apart in what could be called 'the ecstasy of communication', the disciplinary apparatus of sexuality in the modern West can be seen as a secular enterprise in which the residual elements of ancient sacrificial rites transmute into the symbolism of sado-masochism.

Following the insights of Freudian psychoanalysis as it passes 'beyond the pleasure principle' to discover the primacy of masochism as self-shattering jouissance, Leo Bersani has argued that, 'the self which the sexual shatters provides the basis on which sexuality is associated with power'.[22] The alternation of top and bottom that is ritualised *in extremis* in sado-masochism merely makes visible the subject's oscillation between self-abolition and psychic tumescence, which Bersani regards as the polar matrix of eroticism. We thus come back to the group of works bequeathed by Fani-Kayode to discover that, however hard we look, we cannot find the masochistic portrayal of the crucified body that lies at the origins of Christianity.

Although the accoutrements of sado-masochism are present in such works as *Epa Burial*, *Punishment and Reward*, and *Bondage* (all 1987), the Christian belief in the redemptive power

It may seem that in a world that has tragically condemned black men's bodies to be overburdened with more symbolic meanings than any mortal could ever hope to bear, the sacrificial offering of the cruciform body expresses a belief that freedom can be found only in death.

of pain is markedly absent from the work. The symbolism of the cruciform figures centrally in the work of numerous black male artists of the African diaspora. When we consider its recurrence, from Aaron Douglas' *The Crucifixion* (1927), through David Hammons' *Injustice Case* (1970), to the skinless, skeletal bodies that inhabit the paintings of Jean-Michel Basquiat, it may seem that in a world that has tragically condemned black men's bodies to be overburdened with more symbolic meanings than any mortal could ever hope to bear, the sacrificial offering of the cruciform body expresses a belief that freedom can be found only in death.

In his last work and testament, posthumously entitled *Communion* (1995), Fani-Kayode worked with Hirst, who died in 1994, to bring back to us a vision of redemptive renewal that is powerfully and almost unbearably charged with the feeling of having been executed in the presence of death. And yet in honouring the mortality of flesh, these visions from another world emit an aura of calm – 'the tranquility of communion with the spiritual world'[23] – that arises from the energies of the Yoruba spiritual value of *ashe*, a term that historian Robert Farris Thompson translates for us as 'cool' when he writes:

The notion of coolness in Yoruba art extends beyond representations of the act of sacrifice and acts or gestures of propitiation. So heavily charged is this concept with ideas of beauty that a fine carnelian bead or a passage of exciting drumming may be praised as 'cool'.[24]

A man masked with a bird-like visage looks out to us, his penis suspended on a piece of string. *The Golden Phallus*, which is part of the *Communion* suite, brings together each of the elements that are illuminated by the 'cool' glow of Yoruba values, which flow through the code-switching of Fani-Kayode's secular translation. The work is at once an ironic expression of how black masculinity has been weighed down within the West with the symbolic duty of being rather than merely having the phallus. As Essex Hemphill put it in his poem, *Black Machismo:*

When his big black dick
is not erect
it drags behind him,
a heavy, obtuse thing, his balls and chains
clattering, making
so much noise
I cannot hear him
even if I want to listen.[25]

It also encodes an icon of ancestral memory, which offers the antidote that preserves the possibility of beauty, for the *ororo* bird signifies the presence of Osanyin:

To the degree that we live generously and discreetly, exhibiting grace under pressure, our appearance and our acts gradually assume virtual royal power. As we become noble, fully realising the spark of creative goodness God has endowed us with – the shining *ororo* bird of thought and inspiration – we find the confidence to cope with all kinds of situations. This is *ashe*. This is character. This is mystic coolness. All one. Paradise is regained, for Yoruba art returns the idea of heaven to mankind wherever the ancient ideal attitudes are genuinely manifested.[26]

Without seeking to romanticise the issue of Fani-Kayode's complex relationship to his Yoruba origins, we can appreciate how his chosen 'techniques of ecstasy' open a portal into the universal mystery of the indissociable connection of sex and death. Numerous homosexual artists have visited this liminal place within their work, and perhaps the more relevant precursors to Fani-Kayode's exploration of the genealogies of unconscious erotic phantasy in the coils of ancestral

memories and their associated mythologies would be the Trinidad-born Geoffrey Holder, whose *Adam* (1980) reworks the Biblical narrative of Genesis. Another would be the American photographer George Platt Lynnes, whose *Birth of Dionysus* (c. 1942) derives from a reinterpretation of Greek myth in the light of his surrealist configuration of the male nude. In all three instances, it is a quest for sources of renewal that leads to the erotic, which Audre Lorde once called 'a resource within each of us that lies in a deeply female and spiritual plane, firmly rooted in the power of our unexpressed or unrecognised feeling'.[27] Invoking Eshu-Elegba, the Yoruba god of indeterminacy, Fani-Kayode shares with us the hope of rebirth that his life and his work embodied:

Esu presides here, because we should not forget him. He is the Trickster, the Lord of the Crossroads, sometimes changing the signposts to lead us astray. At every masquerade (which is now sometimes called Carnevale, a farewell to flesh for the period of fasting) he is present, showing off his phallus one minute and crouching as though to give birth the next. He mocks us as we mock ourselves in masquerade. But while our mockery is joyful, his is potentially sinister. In Haiti he is known and feared as Baron Samedi . . . And now we fear that under the influence of Esu's mischief our masquerade children will have a difficult birth or will be born sickly. Perhaps they are *abiku* – born to die. They may soon return to their friends in the spirit world, those whom they cannot forget. We see them here beneath the caul of the amniotic sac or with the umbilical cord around their neck or wrist. We see their struggle for survival in the face of great forces. Esu's phallus enters the brain as if it were an asshole. He drags birth from the womb by means of a chain gangling from his own rectum. These are examples of his 'little jokes'. These images are offered now to Esu because he presides here. It is perhaps through him that rebirth will occur.[28]

Notes

1 Audre Lorde, 'Uses of the Erotic: The Erotic as Power',
 in *Sister Outsider: Essays and Speeches* (Freedom, CA:
 The Crossings Press, 1984), p. 54.
2 Georges Bataille, *Eroticism: Death and Sensuality*
 (Erotisme: mort et sensualité) (London: John Calder,
 1962).
3 Rotimi Fani-Kayode, *Black Male/White Male*
 (London: Gay Men's Press, 1987).
4 Fani-Kayode, 'Traces of Ecstasy', *Ten.8*, vol. 2, no. 3
 (Birmingham: 1988), p. 70

5 Wilson Harris, quoted in Anne Walmsley, *The Caribbean
 Artists Movement, 1966 – 1972: A Literary and Cultural
 History* (London and Port of Spain: New Beacon, 1992),
 p. 174.
6 Alex Hirst, 'Unacceptable Behaviour: A Memoir',
 in 'Rotimi Fani-Kayode (1955 – 1989), A Retrospective',
 exhibition brochure (London: 198 Gallery, 1990),
7 Fani-Kayode, 'Traces of Ecstasy', *op. cit.*, p. 39.
8 *Ibid.*
9 Hirst, *op. cit.*
10 Fani-Kayode, 'Traces of Ecstasy', *op. cit.*, p. 38.

11 Founded by Aubrey Walters and David Fernbach, key
 activists in the UK gay liberation movement of the 1970s.

12 Jonathan Dollimore, *Sexual Dissidence: From Augustine
 to Wilde, from Freud to Foucault* (London and New York:
 Oxford University Press, 1991).

13 Teresa Boffin and Sunil Gupta (eds.), *Ecstatic Antibodies:
 Resisting the AIDS Mythology* (London: Rivers
 Oram Press, 1990).

14 Martin Humphries (ed.), *Tongues United* (London:
 Gay Men's Press, 1987).

15 Hirst, *op. cit.*

16 Alain Locke, 'Legacy of the Ancestral Arts' (1925),
 in Alain Locke (ed.), *The New Negro* (New York:
 Athanaeum, 1977).

17 Fani-Kayode, *op cit.*, p. 39.

18 Stuart Hall, in 'Rotimi Fani-Kayode (1955-1989) A
 Retrospective', *op cit.*, (emphasis added).

19 *Ibid.*

20 Nathaniel Mackey, 'Other: From Noun to Verb',
 Representations, no. 39 (Berkeley: Summer 1992).

21 Michael Foucault, *The Archeology of Knowledge*
 (L'archéologie du savoir), (London: Tavistock, 1974).

22 Leo Bersani, 'Is the Rectum a Grave?', *October*, no. 43
 (New York: Winter 1987). See also, Leo Bersani,
 The Freudian Body: Psychoanalysis and Art
 (New York: Columbia University Press, 1986).

23 Fani-Kayode, *op. cit.*, p. 38.

24 Robert Farris Thompson, 'Black Saints Go Marching In:
 Yoruba Art and Culture in the Americas', in *Flash of the
 Spirit: African and Afro-American Art & Philosophy,*
 (London: Vintage, 1983).

25 Essex Hemphill, *Ceremonies: Prose and Poetry*
 (New York: Plume, 1992), pp. 72–3.

26 Robert Farris Thompson, *op. cit.*

27 Lorde, *op. cit.*, p. 53.

28 Fani-Kayode, 'Abiku – Born to Die', in Kate Smith and
 Kate Love (eds.), *The Invisible Man*, exhibition brochure
 (London: Goldsmiths Gallery, 1988).

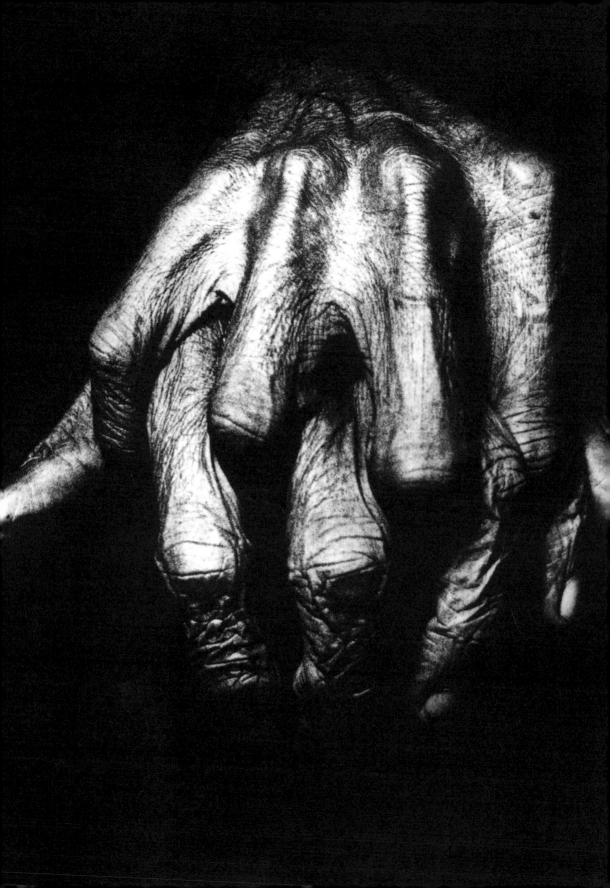

Meaning in Transit: Framing the works of Boutros, Dridi, Ennadre, Gasteli and Naji

Octavio Zaya

Of the contemporary African photographers who have been the subject of much attention and discussion in the last few years, particularly in European exhibitions and publications, the works of Nabil Boutros (Egypt), Kamel Dridi (Tunisia), Touhami Ennadre (Morocco), Jellel Gasteli (Tunisia) and Lamia Naji (Morocco) seem to prompt us to discuss them within the same frame of reference. This is not to say that their works have some kind of internal consistency that obliterates their singular modes of representation; nor that their exceptional individuations (and contradictions) readily blur into a forced unity; nor that they might together help reductively to define the purported elements of a distinctive North African gnosis (the mere fact that all of them were born in North Africa would make an inconsequential, if expedient, case for their association). But their conspicuous distance from the kinds of portraiture, cultural representation, social concerns and body politics that have brought acclaim to other contemporary African photographers in different ways, could be an excuse to group these artists. As could the relatively lyrical, sometimes metaphysical, approach of these North African photographers to their medium, or their compulsive fixation on the transience of light. That these works co-extensively shape a territory in which the predicaments, ambivalences, and discrepancies of the relationship of the relocated subject to his/her past are exposed, provides the most compelling reason to bring them together (idiosyncratic as these photographers may be). This intangible territory may variously be described as 'the place of the dream' that 'modernity has usurped' (Naji), or, as 'the intense, pure spirit of place that I associate with my Tunisian childhood' (Gasteli); as 'what lies beyond [the body's] representation, beyond its inner cry' (Ennadre), or as 'the "inner" Egypt', 'the essential, through, and in spite of, the cumbersome details of the photographic fact' (Boutros).[1]

With the exception of Lamia Naji, who still officially lives in Casablanca (although she has temporarily resided and worked in Europe and the US for long periods), all of the photographers mentioned above live in Paris. In itself, this piece of information wouldn't amount to much if we were to overlook its historico-political specificity entirely, and thus to read the work of these photographers as a fulfilment of sorts, amounting to a mythical moment of transcendence. However, such a claim would not only ignore the abstract nature of the works' relationship to transcendence, it would also be chimerical. For, in a country that has been painfully transformed into a nation of immigrants (though, as a colonial power, France was historically a nation of emigrants) and which – in the last few years – has endorsed restrictive measures towards a policy of repatriation, it is precisely the desire of these photographers for fulfilment and transcendence that produces – both in their lives and in their works – the effect of splitting. It invokes their works' potential sense of displacement in time and space, its sense of disorientation and loss, of the compulsive urge to find meaning.

In the era of globalisation and migration, while nationalism, ethnic absolutism, religious bigotry and economic backwardness are threatening Eastern Europe (against which Western Europe had

always measured itself before the collapse of Communism), the EEC has redefined immigrants from Africa and Asia as 'foreigners'. It has thereby shifted 'the problem' away from the issue of their continued arrival, to the issue of their permanent presence, and, in the process, forsaken the possibility of real and permanent exchange. Despite the increasingly multi-ethnic reality of Europe, its policies continue to respond to the idea of an ethnically pure, almost organic entity. As a result of this unresolved friction, what comes across in this Europe (which is very much intent on devising a new set of borders for and within itself), is an overwhelming sense of dislocation. The dissolution of any feeling of belonging is particularly haunting to those immigrants who have spent most of their lives in Europe, or have become its citizens. Relocated in that home, which defined and controlled their very existence for so long, these immigrants, more than just being confused and decentred, are disconnected, if not completely severed, from their origins. And this occurs not only in place and time, but also in terms of their social, economic and cultural experience.

While this is not the place to engage in a discussion of the criteria that prompted Nader Alexander Mousavizadeh to assert that, psychologically, these immigrants' 'minds have become European'[2], it seems apparent, contrary to his assertion, that immigrants are suspended between origin and destination, rather than affixed to an ontologically and epistemologically coherent domain that is distinct from that of their past. They are aliens, both in their adopted countries and in their countries of origin. As if in perpetual transit, they seem unable to procure a place that they can call their own. For these immigrants, there is no home to return to. Even if such a place does exist for them, their bond to it is ambivalent. In an insightful piece that discusses expatriation and the anxiety of the return, Olu Oguibe explains that this bond is born out of one-sided loyalty and a proclivity to possess, a desperate striving to belong, to lay claim to something that lays no claim in return. Severed from the womb and the body that bore us and hauled into the void of life and existence, we crave to attach ourselves to something, a moment, a location, an event; we crave an anchor, which we readily find in the contours of the house of our upbringing, in the streets of our childhood, in the city of our birth. But the city has a different desire and a different response, for we need the city more than the city needs us.[3]

On the one hand, the country or the city that the immigrant leaves behind – both geographically and as a site of colonial interpenetration and mediation – changes and adapts itself to the necessities of it own inhabitants. On the other, through an ongoing process of adjustment and through the concatenation of internal and external social configurations, the city poises itself to guarantee its own future. Even if distinctly African, the city that the immigrant leaves behind has continued to grapple not only with its own internal dynamics, but also with the shifting forces that are the legacy of global economic realignment: debt crises, environmental crises, political impotence and social upheaval. As Oguibe maintains:

Jellel Gasteli
*Untitled from the
White Series
(Série Blanche)*, 1994
**Gelatin silver print
on fibre paper mounted
on aluminium
120 x 120 cm (unframed)
Courtesy the artist**

The idea of our city's special love is a fiction of our own making, a necessary justification for our possessive fixation on it . . . this apprehension transforms into a romantic longing in the hold of which we are blinded to the specifics of our relationship. Everything takes on a different hue; the ugly turns unique, the trivial symbolic.[4]

Mousavizadeh believes that immigrants 'inevitably view their "home" culture through European prisms, through the language of the colonisers', that they look at their world through European eyes – 'eyes that question, suspect, often despise, and sometimes hate' that they 'see their world as the Third World' and that in this 'they bear no guilt, for it is the only set of eyes they have been given in the new world'.[5] Whatever the case may be, this dialectic of self and other has been internalised, because the immigrants experience their selves as part of the international culture and they relate to their own culture as other. In this situation, they disconnect memory from the historical experience of their places of origin when taking on the memory of their past, caught as they are in a different cultural dynamic. This is a particularly clear instance in which memory and history deviate from one another. Here, memory is disconnected from experience, often seeming to deadlock the possibility of reconciliation between the past and the present. Yet memory is inevitably engaged in an active dialogue with the outside world, and, as Gabriel Motzkin points out, while experience can modify memory, the process of memory is not purely receptive: 'The idea that a memory can be communicated assumes that memory can modify experience not only as act but also as significance'.[6]

In dealing with the work of the photographers under discussion, the 'return to the past' arises out of the dialectic of the disconnection and reciprocity between memory and experience, rather than as a result of the purported failure to accommodate themselves in a supposedly coherent system. In trying to insert the past within their lived actualities – which are shaped by the intricate interplay of repetition and change, of cohesion and disjunction, of belonging and loss – they understand their relationship with the past not as an urge to revisit a romantic and immaculate territory, but as a discontinuous practice. Though these photographers cannot entirely escape the long Western tradition that has subjected their past to an exoticising closure and which has mediated any attempt at alternative representation, and, keeping in mind the fact that they do not seem to aspire to objectivity, their work may be read as deliberately effecting a postponement of signification.

Notes

1 See 'Artists' Statements' by Nabil Boutros,
 Touhami Ennadre, Jellel Gasteli and Lamia Naji ,
 in Okwui Enwezor and Octavio Zaya, *In/Sight: African
 Photographers, 1940 to the Present*, exhibition catalogue
 (New York: Guggenheim Museum, 1996), pp. 254–275.
2 Nader Alexander Mousavizadeh, 'The Unkindness
 of Strangers', *Transition*, no. 61 (New York: Oxford
 University Press, 1993), p. 137.
3 Olu Oguibe, 'Imagined Homes, Imagined Loyalties,
 or the Uncertainty of Geographies', in Octavio Zaya
 and Anders Michelsen, *Interzones*, exhibition catalogue
 (Copenhagen: Kunstforeningen Publication, 1996)
 pp. 191–194.
4 *Ibid.*, p. 192.
5 Mousavizadeh, *op. cit.*, p. 137.
6 Gabriel Motzkin, 'Memory and Cultural Translation',
 in Sanford Budick and Wolfgang Iser (eds.),
 The Translatability of Cultures, (Palo Alto, CA: Stanford
 University Press, 1996), p. 279.

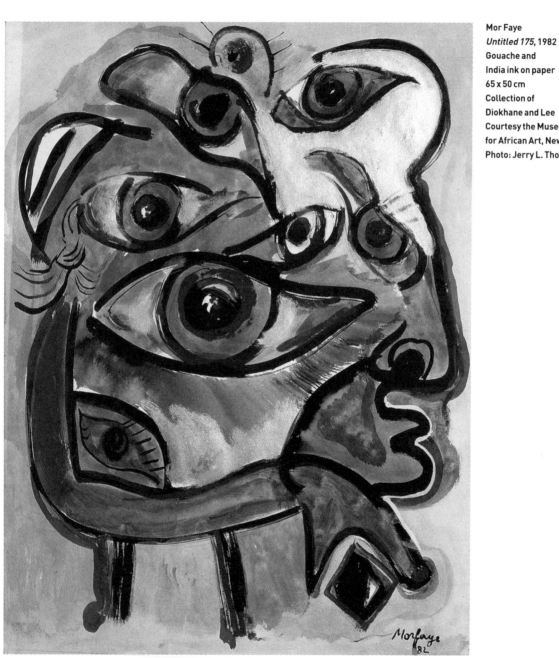

Mor Faye
Untitled 175, 1982
Gouache and
India ink on paper
65 x 50 cm
Collection of
Diokhane and Lee
Courtesy the Museum
for African Art, New York
Photo: Jerry L. Thompson

Fusion: Hot or Cold?

Thomas McEvilley

First Reversal

The first words Moustapha Dimé spoke to me in Venice this summer involved his immediate attraction, upon arriving at the airport, to the city's material foundations as substances he could reprocess in his work. Massive, weathered, waterbeaten pilings rise from the lagoon, marking the channel from the airport to the city. Their combination of power and decay – the future and the past – appealed to his sensibility.

For several years now, Dimé has made his sculptures from used materials – not used art materials, but everyday substances that had previously been involved in the societal life of Dakar, Senegal. In the importance he ascribes to the past history of these materials, Dimé's idea of art refers at least as much to reprocessing as to creation *ex nihilo*. On the one hand there is a sense of replenishment: the past is providing fuel for the future. On the other, a sense of transformation: art is transforming society, and being transformed by it. In terms of Western art ideas, Dimé's sense of involvement in community through the materials of his work could loosely be compared with Robert Smithson's idea of urban decay as the seedbed of art, or with Joseph Beuys' idea of social sculpture. 'I use material', Dimé explains, 'that leads people to be closer to their own lives'.

There is also a site-specific significance to Dimé's designs on the underpinnings of Venice – a heart city of Europe, one might argue, one of the bottom-most foundation stones on which the continent's prestige and fame depend. This jewel-box of a place, this incredible concentration of artworks, cultural artifacts, and urban icons, took hold of Dimé immediately. It might not be unreasonable to say that he wanted to remake Venice in his image, or in the image of his tradition – of Senegal and, ultimately, of Africa. Perhaps he was motivated in part by a desire to participate in Venice's artistic tradition. But his method went beyond this: in one of the many postcolonial reversals that would emerge in my conversations with four of the five West African artists who had been invited to the Venice Biennale, he wanted to remake Venice as Africa. (The fifth artist, painter Mor Faye, was included posthumously.)

Second Reversal

As Ivoirian painter Tamessir Dia and I walked along the corniche of the Giardini, the gardens that provide a permanent site for the Venice Biennale, after a three-hour interview session, he cast an eye over the sparkling surface of the water. 'As the light gets long over the lagoon and I gaze over the waters at Venice', he said, 'I try to see it as Turner would have seen it. As I walk along here, I try to image what Leonardo would have felt like as he walked these streets, what he might have worn, what might have caught his eye. What a wonderful privilege to be in the same city where Leonardo lived!'

We walked along. The water brimmed and gleamed beside us. Venice hovered like an apparition against the horizon in the distance. Dia was surprised, he told me, by the apparent degeneration of

Italian culture since the Renaissance: 'I keep looking at present-day Italians and try to compare them with the Italians of the past and wonder how they did such great things in the past. When I look around, not only are the architectural monuments extraordinary, but the paintings as well. I don't see any link between the relics of the past and what I see today. I keep wondering, are these the same people?'

This type of judgement, in which a contemporary culture is deemed to have lost the glory of its past, plays a significant role in what Edward Said has called Orientalism: the dismissal, by Westerners, of the contemporary peoples of the Third World by denigrating them in relation to their history.[1] For an African to exert such a judgement on the West is a profound reversal of the colonial relationship.

Digestion

'Digesting the West': so Susan Vogel, curator of the West African show at the Biennale, had expressed it on an earlier occasion.[2] Africa, which had been eaten before – carved into pieces and served up as a banquet entrée at the Berlin Conference of 1884-1885 – had reversed the relationship at last. This reversal seemed to crystallise in Dia's focused gaze, looking for Leonardo, or in Dimé looking at the pilings, the underpinnings of it all, the foundations of the West, and wanting not so much to assimilate himself to them as to assimilate them to himself, to honour them by reprocessing them into himself.

When Ouattara, an Ivoirian artist who has lived in New York for several years, told me he had attended a French school in Ivory Coast that had taught the history of the West, he added, without apparent resentment, 'I was interested in the West'. These Africans' interest in the West, how does it compare with the West's interest in Africa? Of course there are economic opportunities in the West, but the gaze of these artists is not the same kind of gaze that brought the West to Africa for slaves, gold and diamonds in the nineteenth century. Rather, a postcolonial gaze is involved, influenced by a sense of global interconnections. As Ouattara put it, 'My vision is not based just on a country or a continent. It refers to the cosmos'. And Ivoirian Gerard Santoni says, 'I don't think it makes sense to have a specifically African painting . . . I'm glad to see myself as part of a world tradition'.

Four Phases of Identity

Modernism – here, let's describe it loosely as the ideology behind European colonialism and imperialism – involved a conviction that all cultures would ultimately be united, because they would all be Westernised. Their differences would be ironed out through assimilation to Europe. Postmodernism has a different vision of the relationship between sameness and difference: the hope that instead of difference being submerged in sameness, sameness

and difference can somehow contain and maintain one another – that some state that might be described as a global unity can be attained without destroying the individualities of the various cultures within it.

In terms of the issue of identity, the historical process has shown four stages. First, in the pre-modern period, cultural identity was simply a given, unquestioned and unrelativised by the insistent intervention of other cultural realities. For most cultures, of course, this stage passed long ago, but it can still play a volatile and provocative role in contemporary thought as an Edenic myth of origin. Second, in the colonial or modernist period, the idea of cultural identity became a weapon or strategy used by the colonisers both to buttress their own power and to undermine the will and self-confidence of the colonised. Thus the cultural identity of the coloniser was claimed as naturally hegemonic, and that of the colonised as naturally slavish or imitative.[3] In art traditions, for example, the coloniser could dismiss the works of the colonised merely by labelling them products of an inferior cultural group.

This strategy led to two reactions among the colonised. One of them was a deliberate imitation of Western standards, an attempt to take on Western, supposedly universal identity. This was often characteristic of the earlier colonial period, before resistance had mounted. In the other, more delayed reaction, which constitutes the third stage in history's identity process, this effort was reversed; the colonised not only negated the identity of the colonisers, but also redirected their attention to the recovery of their own, perhaps abandoned, certainly altered identity. This is the phase of resistance, which leads to the end of colonialism. In Africa it is reflected in the Negritude movement, and in the pan-Africanist or Afrocentrist theory most fully articulated in the works of Cheik Anta Diop.[4] In a stunning reversal of the colonial relationship, Diop argues that Western civilisation was in fact disseminated from Africa to the Greeks, who then covered up their borrowings. Influential in Africa a generation ago, his view is now favoured almost exclusively by African-American thinkers. It is conspicuously not the attitude of the West African artists who came to Venice: 'I am not limited to African culture', Dia asserts. 'That would be absurd, it would be ridiculous for any African today to speak of Africanity or Negritude'.

On the contrary, the attitude of the Venice artists seems to represent a fourth stage. Secure in their sense of identity, formed by whatever blends of African and European influences, they want to get beyond questions of identity and difference and move into the future. (This fourth stage would seem to require the withdrawal of the colonial occupier, and thus has not yet dawned for, say, black South Africans. African-Americans too, face a somewhat different process.) Dia illustrates this stage when he denies that anxiety about colonialism or neo-colonialism is a significant thread in his consciousness. 'I never felt conflicts in that way', he says, 'I think people of my generation never had those conflicts'.[5] He notes that he and his peers were raised and often born after Independence. They approach the future not with a determination to recohere around a long-lost

identity, but with a feeling that that identity (along with the identity of the coloniser) is a thing of the past, and that the future holds new, more interesting identities for all.

Independence

Something like these latter two stages can be seen in the wake of colonialism around the world. In India, for example, artists now in their late forties and fifties were the first to express themselves as unencumbered by postcolonial anxieties.[6] In Africa, this is more characteristic of artists of thirty-five and younger, perhaps because Independence came about fifteen years sooner in India. In both cases the artists in question were raised or even born under independence, and seem to regard the problems of their parents and grandparents as history.

In the late 1950s, Frantz Fanon, Jean-Paul Sartre, and others abominated colonised individuals who would assimilate to the colonisers' culture, or would split the difference and accept a hybrid cultural identity.[7] In India, such persons were once called Gunga Dins, after the notorious Kipling poem. At the time, perhaps, to condemn those who gave up the identity they had inherited was useful in the anticolonial struggle. But what about Gunga Din's son? Or his grandson? *His* inherited identity *is* a hybrid one, and in accepting hybridisation he is not selling out his birthright but embracing it. To Indian artists I know, both the Indian and the British heritages are natural parts of themselves, much as two parents create a single offspring. Artists of fifty and under in India today tend to brush off the issue of colonialism-and-identity with some disdain, as a childish problem they have out-grown. To the Francophone West African artists in Venice, similarly, both the African and the French heritages are legitimate parts of themselves. For the most part they see the idea of restoring a precolonial identity as at best uninteresting, at worst preposterously impractical.

Image Fusion

In art-historical terms, the four stages of identity might be described like this. First, the precolonial period, in which local visual conventions are passed on in a socially functional way. This is the era of so-called 'traditional' African art. Second, the colonial period, in which the colonisers derogate the local artistic conventions. 'The highly stylised African carvings', as one scholar put it, 'were considered curiosities, at best, and evidence of the inability of Africans to represent things "as they actually are" because they were culturally or racially inferior'.[8] In place of inherited tradition, with its connection to ritual function, the Western colonisers held up to the colonised artist the vision of a non-functional, autonomous art. During this period, Third-World artists who wished to enter the international art discourse had no choice but to turn their backs on their inherited traditions and adopt a School of Paris or, later, New York School style, which would offer no clue whatever to their own ethnicity or nationality. In India, this was the route of the Bombay Progressives in 1947 and after; in Africa, of artists such as Iba N'Diaye, who developed a lush and beautiful School of Paris-

based style some fifteen years later.

In the third stage there is a nativist reaction, with the emphasis returning to some inherited tradition that is declared to have been the true one all along, if temporarily submerged by the illusory internationalism of the preceding stage. In India, this stage was marked by the so-called Neotantric painting of the generation after the Bombay Progressives; in Africa, one could point, say, to the so-called *Shona* sculpture that toured the United States a couple of years ago, with its somewhat falsified nativism and artificial references to tradition. The fourth, postcolonial phase is one in which artists self-consciously accept hybridisation and make their work reflect the various forces that have formed them as individuals. Obvious examples include the Indian works of Gulam Sheikh, with their combination of Moghul and Siennese landscape styles, or the Taiwanese ones of T. F. Chen, with their conflated quotes of *Shinto* and post-Impressionist styles.[9]

Hot or Cold?

Of course this four-stage model is not a law of nature. The conflict in Bosnia was mentioned by two of the four artists I spoke with as a horrifying spectacle: 'I didn't realise', said Dia, 'that civilised countries in Europe could do such terrible things'. 'Such terrible things' demonstrate that the third-stage emphasis on cultural identity can persist with a pathological singlemindedness, rather than being sublated into a wider arena.

But the question is: in the globalising project that seems undeniably before us all, are we going to be stuck with a slow, demanding attempt to force things together as in nuclear fusion (as in the former Yugoslavia), through a heat so great it might destroy them? Or can we – descendants of both colonisers and colonised – acknowledge the colonial karmic debt yet build from it into some more generous, less volatile geopolitical and geocultural fusion? (Or: is there anything credible in the multiculturalists' vision of a mutual good will that can arise after the postcolonial adjustment has taken place?)

Cycles

Hegel's idea that history is going somewhere isn't the only problem. Empedocles' vision of the cycles of history seems troublingly relevant, too. On that ancient model, disparate things gradually merge, under the influence of the force of sameness, until everything is one and the world is united in an Age of Love: then, as the cycle progresses, things come apart again in a gradual ascendance of the force of difference, until the world is fractured into an Age of Hate. If, at our present moment, the descendants of the previously colonised seek revenge on the descendants of the previous colonisers, the Age of Hate will be at hand in an extraordinary concentration, its outcome unforeseeable.

But the idea that a four-stage process is in play suggests otherwise. The vengeful attitude seems characteristic of the third stage – as in Fanon's *Wretched of the Earth*, published in 1961, in the

watershed years of African Independence. In at least some communities it is being succeeded by a fourth stage better characterised by Wole Soyinka's novelistic biography *Isarà* (1989), in which African and European realities mix as permeable membranes to one another.

This balance of sameness and difference underlies much of the artists' conversations. On the one hand, Dimé's creative appropriation of Venice involved a synthesising impulse, implying the idea of sameness or assimilation. On the other, it was also felt, I think, as a means to articulate himself, activating difference as well as sameness: he was looking, he explained, for elements 'that would articulate my personality . . . [that would] show myself, my own personality, what made me different from others'. His objectifying gaze at Venice, then, was premised on a view of life that assumed the primacy of sensibility and individuality – essentially a modernist view. He assumed an assertive self or subject as the primary condition for the knowing of objects. Dimé stood and gazed at Venice as a Renaissance merchant king gazed at the globe that seemed to invite his domination and appropriation. This balancing of impulses towards sameness or conflation and difference or articulation was implicitly postmodern: he was seeking a greater individuality through fusion.

History

There is a horrifying progression, a kind of Stations of the Cross, to the historical outline of the West's relationship with the rest of the world. In 1442, two years after Donatello's *David*, while Fra Angelico was working on his *Annunciation*, the first Portuguese slave ships raided sub-Saharan Africa. In 1455, as Renaissance perspective was being perfected as a means to objectify the visual realm for possible penetration into it, Pope Nicholas V granted Portugal exclusive rights to make laws and exact tribute in southern Africa, promising 'to all of those who shall be engaged in the said war, complete forgiveness of all their sins'.[10] In 1509, while Leonardo was working on the *Madonna* and *Saint Ann*, the first ship loaded with enslaved Africans moored in the Caribbean;[11] on and on the sad recital goes, reaching a kind of culmination in 1884–85, one decade before the founding of the Venice Biennale, when the European nations, at the Berlin Conference, divided Africa up like a side of beef, with hungry guests getting shares. The reversal begins to emerge in the 1950s and especially the 60s, as most of the European colonisers pull out: it involves many strange and ambivalent moments, and seems now to be reaching a kind of milestone, in the early 1990s, with such events as the appearance of West African artists at the Venice Biennale.

Art History

In a narrower focus, this reversal is significant in terms of art history, which tends to follow political history with a brief lag. In the wake of the Berlin Conference, African artworks began making their way back to Europe. In fact, 'the first examples of African art to gain public attention were the bronzes and ivories that were brought back to Europe after the sack of Benin by a British military

Moustapha Dimé
Femme Sérère (Server Woman), 1992
Bowls, mortar and pestle
145 x 49 cm
Courtesy the artist and
Museum for African Art,
New York
Photo: Jerry L. Thompson

expedition in 1897'.[12] Soon, European artists like Picasso found their visual sense challenged by the African objects that were increasingly coming into their ken, and they began to absorb some of the look of those objects into their own work, in parallel with the European nations' absorption of the actual African territories and peoples into their economies. Ironically, then, a crucial element in the birth of modernism in the visual arts was a tradition that Europeans called 'primitive'. Today, in the works of the African artists in Venice and others, that relationship is being reversed. Dia says that when he went to art school in France he was taking what belonged to him – not simply because Picasso and others had borrowed from Africa, but because his own identity is in part European, having been shaped in part by European forces. 'What happens in Europe and America', he says, 'belongs to me'. Ouattara similarly says that when he saw Picasso's African-influenced work it was like looking into a mirror, but when he saw the paintings of Goya it was also like looking into a mirror.

The Biennale

In a narrower focus still, the postcolonial reversal occurring here has a special significance in reference to the Biennale itself, as a single thread of art history. The Biennale is the type of cultural event that tends to arise when some form of capitalism is undergoing colonial expansion in pursuit of foreign markets. The cultural consequences of such an economic moment were felt in ancient Greece in the late archaic period, and again in modern Europe, when so much of the Greek experience was replayed on a larger scale.

As reflections of the increasingly dominant free-enterprise competition in both these eras, various other competitions developed, universalising the new ideology. It was at this stage in ancient Greece that artists began signing their work, which had previously been anonymous in execution and communal in meaning. It was also at this time that innovation began to be valued in art; until then, tradition had been primary. In the ancient games and competitions, which often mixed athletic and artistic events, the prizes were supposedly based on universals, and the states that competed for and won them were thereby validated as fit to pursue their domination of foreign peoples.

The Venice Biennale was founded in 1895, when the imperial centres of Europe were bonding in mutual complicity around the recent appropriations of Africa and southeast Asia. Italian troops were fighting for dominance in the Sudan that year; in fact Italy's imperial adventure in East Africa, with the dream of restoring something like the power of ancient Rome, set the background mood of the Biennale's first decades. And through most of the Biennale's first century, the institution played a role as cultural backup for colonial policy: only Western nations were invited to participate.

In ancient Greece it was the admission of a non-Greek state, the Macedonian, to a previously closed competition that marked the beginning of the end of this phase of social organisation.

Around 1990, similarly, the Biennale began showing abnormalities that coincided with changes in the society around it – with what has been called the shift from modernism to postmodernism. One sign was the sudden prominence of women: in the 1990 Biennale, Jenny Holzer represented the United States; in 1993, Louise Bourgeois represented the United States and Yayoi Kusama represented Japan. Equally historic was the invitation to two sub-Saharan African nations – Nigeria and Zimbabwe – to participate in 1990. And in 1993, Senegal, Ivory Coast and South Africa participated.

Three Souls

At the same time that the Biennale has begun to rearrange its external network in response to changes in the outside world, its internal structure has begun to shift too. The director for 1993, Achille Bonito Oliva, decreed that this year's version would not merely survey recent artwork from the various participating nations, but would be dedicated to cultural nomadism – a dominant theme of recent postmodernist discourse on shifting ideas of nationalism and identity.

The idealisation of cultural hybridisation goes back at least to the Roman poet Ennius' apparently proud remark that he had three souls because he spoke three languages. If, in the modernist period, intense nationalism led to a belief in the single, crystalline cultural identity or essence of peoples or nations, the postmodern, or postcolonial, readjustment favours the idea that human identity is composite, ambiguous and hybrid. In a complex urban society (as compared to a Neolithic village), identity is formed by a dizzying plurality of influences; any individual can be regarded as a cultural composite. But the postmodern idea of hybridisation goes beyond this, referring also to the fact that the world's populations are now increasingly on the move, settling in each other's inherited territories, where they borrow parts of each others' identities (in clothing, food, philosophy, art, athletics) or survive as embattled fortresses within alien communities. The modern media also diffuse knowledge of different cultures widely. Dimé observes that people from his home town of Louga are now 'everywhere in the world', and that he ran into some by chance in Venice.

Migrations

Similar processes of intermingling have happened many times before in the vast migratory phases that have occurred on all continents – most self-consciously or programmatically in the Alexandrian Greek period. Now, however, they seem to be becoming global and irretrievable. Whether individual cultures will lose their separate integrities or whether they will find some greater integrity from simultaneous local and global engagements is the crucial question facing the world today. Dimé expressed the paradox when he remarked, 'Even though I was born in Louga, I consider myself as a universal being'. I asked him, 'Do you ever feel tension between a universal

sense of yourself and your desire to make sure that you understand your deep roots in your own culture?' 'If I didn't succeed in keeping my own roots', he replied, 'I could never be universal because it's on that basis that I can become universal, on the basis of my own roots. Because that's how I've become what I am. The humanity that I am in the process of living today was born in my own roots'.

In the modern period, the wave of cultural nomadism that seems now to be about to crest on a global scale began with the settling of the so-called New World, societies like Canada and the United States being almost completely hybrid, the results of nomadic forces. Subsequently, the wave of colonialism in the age of imperial capitalism brought Western people into other societies around the world, and with the end of colonialism the peoples of the Third World have begun spilling back in great numbers into Western societies. This worldwide tendency toward nomadism both binds the world in a global network of associations and sunders it by the tensions of nativist reactions.

Collage

In Western art, the tendency toward self-conscious cultural hybridisation was first clearly encountered in the eras of japonisme and primitivism, both of which reflected the European intervention in the non-Western world. The assimilative or conflative tendency next asserted itself under the rubric of collage – beginning with Cubist collage (which significantly followed immediately upon the early era of primitivism) and continuing on through the present day. The discourse of collage was the forerunner to the postmodern discourse of nomadism and hybridisation. Developing intensely in the wake of the insistence on purity found in Abstract Expressionism and Colour Field painting, the stress on collage, impurity and mongrelism was both liberating and prophetic, foreshadowing impending developments in global culture.[13] In 1971, when postmodern discourse was already self-consciously underway, literary critic Ihab Hassan wrote that postmodernism 'dramatises its lack of faith in art even as it produces new works of art intended to hasten both cultural and artistic dissolution'.[14] The form of art towards which Hassan perceived a 'lack of faith' was the art of purity and wholeness – what one might call, following Derrida's 'philosophy of presence', an 'art of presence'. In place of it arose an art that was essentially critical, promoting not unity but disjunction, not integrity but mongrelism. A few years later, Hassan would characterise the postmodern as disjunctive, polymorphous, androgynous and characterised by deconstruction.

Among the more influential formulations to follow was Charles Jencks' 1981 characterisation of the postmodern as double-coded, in contrast with high Modernism, which was single-coded and based on the positing of absolute truth and absolute identity.[15] But postmodernism's relativisation of truth and identity, its arrival at a sense of slippage or displacement, really leads

beyond double coding into multiple coding. In 1982, Julia Kristeva wrote of 'the abject', meaning 'what disturbs identity, system, order. What does not respect borders, positions, rules. The in-between, the ambiguous, the composite'.[16] The emphasis on collage was revived in Frederic Jameson's 1984 assertion that postmodernist culture is characterised by pastiche[17] – by 'speech through all the masks and voices stored up in the imaginary museum of a now global culture'.[18] Gilles Deleuze and Félix Guattari in a sense completed the thought process the following year:[19] they suggest that the underlying condition for a culture of pastiche is nomadism, the movement in which individuals are uprooted from their inherited matrices, and cultures are overlaid upon one another, combined and recombined in unpredictable ways. This process amounts, in their formulation, to 'an absolute that is one with becoming itself, with process. It is the absolute of passage'.[20]

Thus postmodernism is fascinated by borders and interfaces between conflicting realities and senses of reality. It does not hold, as Modernism did, that one side of the border is right and the other side is wrong; both are understood as right in different ways, and something even more right is felt in attempting to embody both truths – even many truths ('three souls') – at one time and in one self.

The category 'cultural nomad' applies most clearly to persons who were born and raised in one culture and subsequently migrated into another; to persons who characteristically travel, and have a sense of the relativity of cultures; to people crossing boundaries in a variety of ways, including creative and professional. The situation of African artists at the Venice Biennale automatically involves a degree of nomadism, in that artworks produced in and by one culture are being exhibited and viewed in and by another on (supposedly) equal terms. The presence of these African artists in Venice itself – an overwhelmingly white demographic area – is at the heart of the postmodern moment.

The Four Stages Again

In the Modernist era, with its emphasis on sameness and identity, the confrontation between cultures was experienced as simply a choice between this and that: usually the culture of one's birth would seem the right choice. The colonial situation both reinforced and confused this assumption. Certainly, as Memmi wrote, 'even the poorest coloniser thought himself to be – and actually was – superior to the colonised'.[21] Memmi's strange parenthesis, 'and actually was', suggests the reversal of self-esteem in the colonised mind (in the second stage). But that reversal is reversed again in the reaction against colonialism (the third stage) when 'the negative myth thrust on him by the coloniser is succeeded by a positive myth about himself suggested by the colonised'.[22] The pursuit of this positive myth leads the previously colonised to 'forego the use of the coloniser's language, even if all the locks of the country turn with that key . . . He will prefer

a long period of educational mistakes to the continuance of the coloniser's school organisation . . .
He will no longer owe anything to the coloniser and will have definitely broken with him', and so on.[23]

This is the attitude of the third stage of cultural identity under colonialism. Memmi's powerful
expression of it was written in 1959, at the height of the wave of decolonisation: but with the
generation raised after the colonial period, the third-stage rage about the colonial past seems to
have given way to an alert curiosity about the future. Three of the four artists interviewed in Venice
express no ambivalence about using the French language or being shaped by the French
educational system, and the fourth acknowledges his resentment of these traits but refers to it
as a thing of the past. Dia speaks of positive aspects of the interaction between Europe and Africa
today even as he reverses the orientalising gaze. And Dimé wants to incorporate Venice into his art.
The mentality of the colonised, so brilliantly expounded by Memmi, is apparently not theirs.

Multiculturalism

As the fourth stage dawns – when the postmodern succeeds the modern – the contradictory
summonses of two or more different cultures are reconciled by the assumption that neither is true:
that no particular cultural stance has ultimate validity. At this moment the multicultural situation
can seem to highlight the absurdities of each culture, lending a certain nihilistic air to the space of
judgement. Loss and liberation can seem about equal. In other cases though, the resolution points
a more positive way: toward a feeling that each cultural form is inwardly meaningful, and that the
project of bringing them together without loss of this meaning is worth one's while. Anthony Appiah
has called such a stance the 'capacity to make use of . . . many identities without . . . any significant
conflict'.[24] Referring to a conversation with Dimé, Dia said, 'We talked to each other in Wolof;
when I go to see my relatives I speak in my own language, Bambara; when I am with a Frenchman
I speak French'. The use of French, he says, is not 'tied to any conflict'.

In this project of getting beyond simple nationalism into a new stage of multiple human identity,
the arts play a leading role, feeling out avenues of conflation and comparison. This does not mean
the adoption of some neutral international style that bleaches out cultural particularities, as it
did in the modernist period when the invitation was to abandon one's identity in order to become
Western. As the cycle shifts, the invitation is to balance one's identity with the various global
demands of the moment – such as the demand presented by the temporary hegemony of
Western technology and pop culture. Today, artists born in India, Korea, Japan, China and Turkey;
in Senegal, Zimbabwe, Zaire and Côte d'Ivoire; in Cuba, Mexico, Venezuela and Argentina,
are consciously creating styles that simultaneously honour particular cultural identities and make
gestures of mutual incorporation with the Western tradition.

This accommodation with the West is desirable not because of some hegemonic assumption
that only the Western art discourse defines the reality of art, and hence non-Western artists

should desire to be included in it. There are artists in India who are working in traditional Indian modes, and artists in China who are working in traditional Chinese modes with full satisfaction: this is part of the pluralised postmodern situation. But another part of that situation is precisely that many non-Western artists are knocking on the doors of the Western art system, seeking the advantages it offers: the increased possibility of making a living through art, access to a large, focused audience, and entrance into a lively, even agitated discourse that promises to leave its record in art-history books and museums. The sense of artistic community in the West is intensely attractive to many non-Western artists, who often work in considerable isolation in their native lands. When I asked Santoni how he thought his work would be recorded in art history, he laughed and said, 'I don't even think about that. I don't even think I am part of art history'. And when I asked Dia, 'What is your artistic community?' he replied, 'I have never confronted this question'. 'In Ivory Coast', he explained, 'there isn't much of a community of artists. Artists don't sit down together and talk about techniques or issues or anything. They live very separately'.

For these artists, freed of the colonial conflicts that confined their parents' generation, it is easy to feel a common cause with Western artists. Dimé praised Louise Bourgeois' work, which he saw

The spread of Third-World biennials – based on the Venice Biennale, but not subservient to it – is creating new centres from which entrance into the global arena can be navigated.

in Venice, as 'full of humanity. I really felt the presence of a human being. It was not just something for commerce but a kind of gift'. Ouattara praised Joseph Beuys for his interest in 'liberation through art', and he pursues in his own work the Beuysian goal of 'a synthesis of spirituality and technology – to give technology a more humane quality'. When I asked Dia if he thought that artists around the world were engaged in a kind of collaboration with one another, he replied, 'That would be wonderful'.

The doors to the global art community have long been closed and locked – partly to protect national traditions from becoming polluted by one another. Recently some have been opening in an increasing number of urban venues. The spread of Third-World biennials, for example – ultimately based on the Venice Biennale, but not necessarily subservient to it – is creating new centres from which entrance into the global arena can be navigated. In Africa, such exhibitions now occur in Cairo, Libreville, Kinshasa, Abidjan and Dakar. Pluralism, which Appiah once described as 'a fact waiting for some institutions',[25] is now amassing its institutions. Reconceived art museums and refocused international exhibitions are not the least important of them.

The value of participation in this emerging multi-branched art discourse is that contemporary

art carried out in an atmosphere of global dialogue can accomplish things that a puristically maintained native tradition cannot. Exported from within a culture to the outside world, contemporary art is a visual diplomacy that introduces the peoples of the world to one another in a type of living reality. That such an introduction cannot be perfectly lucid is not necessarily a problem. When an object produced by one culture is received in another, there is bound to be a cognitive slippage, an unintended misperception on the part of the receivers. But it is precisely this 'off' quality that offers a window of rich openness through which new options may arise on both sides.

African Postmodernists?

So, from the point of view of the West, the appearance of these five West African artists in the 1993 Venice Biennale can be seen as a signpost indicating the continued unfolding of the postmodern idea of globality. But this is not to say that these five artists are postmodernists. Seen from the point of view of Africa, or of the so-called Third World in general, their significance might seem quite different. Indeed, much of the Third World is concerned with entering modernism, not with what it sees as the oddly unnecessary concept of postmodernism. In much of the world, postmodernism is regarded as strictly a Western idea; in much of Europe it is regarded as strictly an American one. And it is no doubt true that the United States, with its specifically hybrid roots, is among the most dedicatedly postmodernist cultures. But this doesn't mean that postmodernism is only about the West, or only relevant to the West. Though postmodernism marks a shift in specifically Western attitudes, those attitudes concern the West's relationship to the rest of the world. Considering the wealth and power involved in such a shift, it is of deep relevance everywhere. Whether these African artists see themselves as postmodernists or not, the fact remains that it is the complex of changes called postmodernism that brought them to Venice.

Universals

In fact, the position these artists occupy on the continuum from pre-modernism to modernism to postmodernism is understandably mixed and fragmented – like virtually everyone else's. Insofar as they have got beyond the various issues of colonialism, neo-colonialism, and postcolonialism, they may be regarded as postmodern. Yet their ambitions as artists, and their beliefs about what the significance of artmaking might be, also involve pre-modern and modernist attitudes.

All four of these African artists seem to invoke universals as in one way or another the basis of their work. Dia, for example, perceives in art a universal element that seems to arise from a personal sense of transcultural identification with artists from radically different backgrounds, cultures, and eras, as in his exquisite curiosity about Leonardo's feelings walking the streets of Venice. Dimé's sense of the universality of art is based on Islamic religious feeling, the conviction

that God has created beauty in the world and that artworks participate in this creation. For Ouattara, the transcultural nature of art is guaranteed by the conviction that magical symbols and intentions work across lines of cultural difference – as in the similarity he has found between his initiation symbols and cabalistic imagery. And for Santoni, the universal is rooted in a lonely, intransigent individuality that sees a path-oriented isolation as fundamental to any moment of life, regardless of cultural conditions.

The Autonomous Artist

A second major sign dividing the pre-modern, the modern, and the postmodern is the definition of the artist's role in society. In pre-modern societies the artist was socially contextualised as an artisan; the Egyptian sculptor was on the same socioeconomic level as the Egyptian cobbler. With modernism, a cultural epiphenomenon of market capitalism, the fine artist gets separated from the cobbler, becoming a sensibility in competition with other sensibilities for the discovery of innovative options. Underlying this separation is a belief in the artist's connection with aesthetic and spiritual universals. The pre-modern artist, often working in religious contexts, may also have been connected with universals, but more communally – without the imperative of individual discovery.

The difference devolves upon the question of autonomy. The idea of the artist's autonomy, essential to modernism, is in part based on the idea that the artist transcends social mores, being in touch with a reality that is prior to them, that is in fact their true archetypal meaning or source. Recent Western discourse has made much of the unnaturalness of this idea, pointing out that in traditional or pre-modern (or merely non-modern) societies, the profession of artist usually isn't separated from social matrices – from craft, from religion, from communal bonding. In fact it has often been suggested that the separate and so-called autonomous role of 'artist' may be an unhealthy sign of the advancing alienation and reification of late capitalism.

My conversations in Venice do not support such thoughts, for these non-Western artists have all embraced the Western idea of the artist as following an autonomous path of self-realisation and self-expression – though one supported by communal sympathy and cultural collaboration. They all feel pretty alienated from society; but at the same time, a bond of concern with it pervades their art. In the traditional or pre-modern social setup, the artist was deeply embedded within culture, like the shoemaker. The situation of the African artists in Venice is more typically modernist: they are separated from the body of culture, even alienated from it, yet they feel themselves as its heart and soul, its essence yearning for its body, and so on. In this they recall the essentially Orphic spirituality that pervades modernism.[26]

Dimé, in the remarkable story that he tells,[27] seems to say that his life and sanity were salvaged after long travail by his full realisation of the role of autonomous artist. Furthermore,

this realisation came to him in stages not entirely unlike those that traditional mystical texts ascribe to the discovery of spirit – the ascent of Mount Carmel, say, or the penetration into the Interior Castle. As he looks back over his life now, 'I feel', he says, 'I could never have been anything but a sculptor'. Speaking of himself and other young Senegalese artists, he describes the path of art as a path of self-realisation: 'Each wanted to create his own originality, his own style'. And Santoni remarks, 'What I do is entirely personal . . . I use painting to express myself'. He sees the artist's autonomy as constituted by the irreducibility of individual sensibility, and the unquestionableness of one's solitary life-path. Action is regarded as inevitable, conditioned by the reality of one's sensing of one's path, and sufficient in its visual embodiment of that sensing. 'I am following my way, my path', he says, 'and I don't know where this path is going to take me'.

For Dia, the role of artist involves both autonomy and communality. His work penetrates realms of feeling associated with the social suffering around him; his individual selfhood catches the vibration of the communal and reflects it back, like radar signals in a visual semaphore. Thus he feels that his work, though brought into being in almost hermetic isolation, is a direct response to his community. Dimé too, while pursuing his individuality through his work, directs it at the communal distress of 'social outcasts' in Senegal. Ouattara holds to a more traditional sense of art as a magic of 'the elders'. Yet his homage to tradition is offset by deliberate multicultural mixing, and by a sense of art as future-oriented, even as a driving force in human progress, specifically in the reconciliation of technology with nature or spirit.

The pre-modern artist, contextualised as an artisan, was discouraged from pursuing a path of formal development. For the modernist artist, on the other hand, development of vision, and of that vision's formal realisation, is of the essence. Those of Dimé's boyhood friends who went into traditional woodworking may be making the same types of objects twenty years later, whereas his work has gone through several stages in a twenty-year quest. The intensity and peculiar satisfaction of such a quest suggest that it is a process of making oneself into something fuller, greater, or clearer – a kind of self-articulation. Thus the four or five stages of Dimé's sculptural practice may be seen as four or five stages of his personal quest for wholeness. All four of these artists see their work as path-oriented, as a thread they follow through their investigations of form and material, a thread leading not merely to some formal and material end, but to a combined sense of both autonomy and responsibility.

The Future

Self-consciously postmodernist art sometimes tries to function as a benign promoter of the balance of sameness and difference, as a facilitator of a certain kind of future. Sometimes it interprets the mandate of the pastiche, or the double coding, as a combination of iconic signs from different cultures, a combination that would once have been called inappropriate.

Chen and Sheikh are two artists who make this kind of conflation; the hilarious post-ironic Soviet-American pastiches of expatriate Russian Alexander Kosalopov, and the media-conscious global conflations of the Zairean artist Trigo Piula, are two more. The works of all these artists can be interpreted, in one aspect, as highly self-conscious instruments of both analysis and prophetic vision. While they analyse selfhood into various factors, they also prophesy a future in which these factors collaborate harmoniously.

The works of the five West African artists in the 1993 Venice Biennale are less self-consciously theoretical than the postmodernist pastiches of Chen, Kosalopov, Sheikh, and others who are consciously working on a synthesis of Western and non-Western modalities. But they exhibit a comparable sense of permission in regard to the attributes of other cultures as well as their own – a permission that in the modernist period was available only to the cultural agents of colonial powers.

Picasso's famous remark, haughty in its offhand imperialism, 'All I need to know about Africa is in those objects' – meaning, evidently, in the look of the objects – now represents the attitude these African artists turn back upon the Western tradition. They are adopting elements of the look of Western artworks – elements of style, iconography, and materials – from aesthetic appetite alone, not much caring about the conceptual issues or culture-specific contents that we think saturate them. When they do appreciate specific borrowed elements conceptually, these include the Western idea of the autonomous role of the artist, and along with it the belief in art as a liberating spiritual force in relation to society and its problems. Untroubled by hybridisation, armed with elements from both Africa and Europe, they are ready to move into the future.

Notes

1 Edward Said, *Orientalism* (New York: Random House, Vintage Books, 1979).

2 Susan Vogel, *et al., Africa Explores*, (New York: The Center for African Art, 1991), p. 14.

3 This one-upmanship transpired in ways analysed by Albert Memmi in his book *The Colonizer and the Colonized*, 1959 (expanded ed. Boston: Beacon Press, 1991).

4 See Ellen Conroy Kennedy (ed.), *The Négritude Poets* (New York: Thunder's Mouth Press, 1975); and Cheik Anta Diop, *The African Origin of Civilization: Myth or Reality*, trans. Mercer Cook (Chicago: Lawrence Hill Books, 1974); and *Civilisation or Barbarism: An Authentic Anthropology*, trans. Yaa-Lengi Meema Ngemi (Chicago: Lawrence Hill Books, 1991).

5 Thomas McEvilley, interview with Tamessir Dia, *Fusion: African Artists at the Venice Biennale* (New York: Museum for African Art, 1994), p. 61.

6 For more on these Indian developments, see McEvilley, 'The Common Air: Contemporary Art in India', *Artforum*, no. 24 (New York: Summer 1986), p. 10. Reprinted in an abridged version in McEvilley, *Art and Otherness: Crisis of Cultural Identity* (Kingston, NY: McPherson and Company, 1992), pp. 109–126.

7 See Frantz Fanon, *The Wretched of the Earth*, with preface by Jean-Paul Sartre, 1961 (reprinted, New York: Penguin Books, 1983).

8 William Bascom, *African Art in Cultural Perspective* (New York: W.W. Norton and Company, Inc., 1973), p.4.

9 For discussion of Gulam Sheikh's work, see McEvilley, 'The Common Air'; for T. F. Chen, see McEvilley, 'The Post-Modern Art of T. F. Chen: Images of a Global Humanity', in *T.F. Chen's Post-Modern Art: Neo-Iconography* (Tainan, Taiwan: Tainan County Cultural Center, 1991), pp. 17–22.

10 B. Davidson, *The African Slave Trade* (Boston: Little Brown, 1916), p. 55.

11 Arturo Morales Carrion, *Puerto Rico and the Non-Hispanic Caribbean* (San Juan: University of Puerto Rico, 1952), p. 5.

12 Bascom, *op. cit.*, p. 4.

13 In 1961, when the process of decolonisation was progressing headlong, Thomas Hess wrote about what he called 'impure art' in an essay entitled 'Collage as an Historical Method', in *Art News*, no. 60 (New York: November 1961), p. 70. The following year, Harriet Janis and Rudi Blesh traced the gradual ascent of collage practice through the late-modernist period in *Collage: Personalities, Concepts, Techniques* (Philadelphia and New York: Chilton, 1962). The year after that, Allan Kaprow, one of the practitioners of impure art, wrote about collage as 'impurity [meaning] a secondhand state, a mongrel', in 'Impurity', *Art News*, no. 61 (New York: January 1963), p. 31.

14 Ihab Hassan, 'POSTmodernISM: A Paracritical Bibliography', *New Literary History*, vol. 3, no. 1 (Autumn 1971), pp. 5-30.

15 Charles Jencks, 'Post-Modern Classicism – The New Synthesis', *Architectural Design*, no. 5/6 (London: 1980), and *The Language of Post-Modern Architecture* (London: Academy, 1991).

16 Julia Kristeva, *Powers of Horror: An Essay on Abjection*, trans. Leon S. Roudiez (New York: Columbia University Press, 1982), p. 4.

17 Frederic Jameson, 'Post-Modernism, Or, The Cultural Logic of Late Capitalism', *New Left Review*, no. 146 (July-August 1984), pp. 59–92.

18 Jameson, *Postmodernism, Or, The Cultural Logic of Late Capitalism* (Durham, NC: Duke University Press, 1991), p.18.

19 Gilles Deleuze and Félix Guattari, 'Nomad Art', *Art and Text*, no. 19 (Los Angeles: October-December 1985), pp. 16-24.

20 Deleuze and Guattari, *A Thousand Plateaus*, trans. Brian Massumi (Minneapolis: University of Minnestoa Press, 1987), p. 494.

21 Memmi, *op. cit.*, p. xi.

22 *Ibid.*, p. 139.

23 *Ibid.*, p. 138

24 Kwame Anthony Appiah, *In My Father's House: Africa in the Philosophy of Culture* (New York: Oxford University Press, 1992), p. ix.

25 *Ibid.*, p. 144

26 From Orpheus, by way of Pythagoras, to Plato – to whom, as Alfred North Whitehead said, all Western philosophy is a series of footnotes.

27 McEvilley, interview with Moustapha Dimé, *op. cit.*, pp. 30-49.

Negotiated Identities

In 'The Heart of Darkness'

Olu Oguibe

I

Prehistory. History. Posthistory. It is evidence of the arrogance of Occidental culture and discourse that even the concept of history should be turned into a colony whose borders, validities, structures and configurations, even life tenure, are solely and entirely decided by the West. This way history is constructed as a validating privilege, which it is the West's to grant, like United Nations' recognition, to sections, nations, moments, discourses, cultures, phenomena, realities, peoples. In the past fifty years, as Occidental individualism has grown with industrial hyperreality, it has become more and more the privilege of individual discourses and schools of thought to grant, deny, concede, and retract the right to history. Time and history, we are instructed, are no longer given. Indeed, history is to be distinguished from History, and the latter reserved for free-market civilisation, which, depending on the school of thought, would either die or triumph with it. Though they both share a belief in consolidating systematisation as a condition of historicism, Francis Fukuyama in the 1980s, and Arnold Gehlen in the immediate post-Nazi period differ on the specificities of the question. While on the one hand Fukuyama believes that the triumph of free market systematisation over regulated economies marks the end of History,[1] Gehlen and the subsequent school of post-Nazi pessimism posited that the triumph of liberal democracy over Fascism marked the end of History and the beginning of *Post-histoire*.

In both cases, what comes out very clearly, despite the fundamental differences that define and preoccupy the discourse on the fate of History, is the consignment of the rest of humanity outside the Old and New West into inconsequence. For Gehlen, who had a better and stronger sense of history and intellectual integrity than Fukuyama can claim, the entirety of humanity was victim to a universal syncretism that subverts the essence of history. For Fukuyama, this universality is to be taken for granted, although the majority of humanity is indeed, factually and historically speaking, hardly subject to liberal democracy. To a great extent, Humanity, for Fukuyama and many others, is synonymous with the Group of Seven and Eastern Europe. Under Reaganism-Thatcherism even the spatial definition of history severely retracts to the Pre-Columbian.

The contest for History is central to the struggle for a redefinition and eventual decimation of centrism and its engendering discourse. Without restituting History to other than just the Occident, or more accurately, recognising the universality of the concept of History while perhaps leaving its specific configurations to individual cultures, it is untenable and unrealistic to place such other temporal and ideological concepts as Modernism, Modernity, Contemporaneity, Development, in the arena. If Time is a colony, then nothing is free.

II

Premodernism. Modernism. Postmodernism. For the West erase Premodernism. For the rest replace with Primitivism. It is tempting to dwell on the denial of modernity to Africa or cultures

Pascale Marthine Tayou
Crazy Nomad, 1999
Mixed media installation,
Lombard-Fried Fine Arts,
New York
Courtesy the artist

other than the West. The underlying necessity to consign the rest of humanity to antiquity and atrophy so as to cast the West in the light of progress and civilisation has been sufficiently explored by scholars. If not for the continuing and pervading powers and implications of what Edward Said has described as structures of reference, it would be improper to spend time on the question. It is important to understand that while counter-centrist discourse has a responsibility to explore and expose these structures, there is an element of concessionism in tethering all discourse to the role and place of the outside. To perpetually counter a centre is to recognise it. In other words, discourse – our discourse – should begin to move in the direction of dismissing, at least in discursive terms, the concept of a centre, not by moving it, as Ngugi has suggested,[2] but by superseding it. It is in this context that any meaningful discussion of modernity and 'modernism' in Africa must be conducted, not in relation to the idea of an existing centre or a 'modernism' against which we must all find our bearings, but in recognition of the multiplicity and culture-specificity of modernisms and the plurality of centres. The history of development in African societies has metamorphosed quite considerably over the centuries, varying from the accounts of Arab scholars and adventurers as well as internal records of royalties and kingdoms, to the subversive colonialist narratives and anthropological mega-narratives. Recent times have witnessed revisions in earlier texts, and a growing willingness to admit the shortcomings of outsider narratives. Countering discourses have put history, with all its inconsistencies and vulnerabilities, back in the hands of each owning society, and shown how carefully we must tread.

III

In light of the above, the concept of an African culture, or an Africanity, which is quite often taken for granted, is equally problematic. It seems to me that we cannot discuss an African modernity or 'modernism' without agreeing first on either the fictiveness of 'Africanity' or the imperative of a plurality of 'modernisms' in Africa.

Of course, one may well be wrong here. Yet it is to be recognised that, like the entity and idea called Europe, the specificities of which are still in the making and the collective history of which dates no earlier than Napoleon – the idea of Rome and Greece is dishonest – Africa is a historical construct rather than a definitive. Many have argued, prominent among them the Afrocentrist school, the antiquity of a Black or African identity, an argument that falls flat upon examination. On the other hand, history reveals the necessity for such unifying narratives in the manufacture of cultures of affirmation and resistance. The danger in not recognising the essential fictiveness of such constructs, however, is that a certain fundamentalism, a mega-nationalism, emerges – all the more dangerous for its vagueness – which excises, elides, confiscates, imposes and distorts. Some will argue that history, after all, is perception, in other words, distortion. But if we were to accept this wholesale and without question, we would have no business trying to 'correct' history,

unless to correct is merely to reconfigure, to counter-distort.

We already recognise the dangerous potential of such fictions in the hands of the invading outsider. The spate of pseudo-scholarly interest in 'African' life, culture and art during and immediately after colonialism illustrates this. While, in the beginning, the totalising construct was employed to underline the peculiarity of the 'savage' mind and thus justify outsider intervention, it has continued to be used in justifying the changing face of that mission. From redemptive Christianity to salvage anthropology, the West has found it essential to maintain this invention. Indeed, the need seems greater now than ever before as the collapse of colonialism and the rise of contesting discourses place anthropology, the handmaid of Empire, in danger. Anthropology's crisis of relevance, coupled with characteristic Western career opportunism, has necessitated the gradual re-invention of a singular and unique Africanity worthy of the Outside Gaze. The new manufacture finds ready clients in scholars, policy makers, non-governmental and aid organisations seeking objects of charity. Unless there is a singular Africanity, distinct and doomed, how else would they justify the pity that must put them ahead and on top? If the Other has no form, the One ceases to exist. It is for this reason that recent Outsider texts on African culture remain only extensions and mild revisions of existing fictions. To undermine the idea of The African is to exterminate an entire discursive and referential system and endanger whole agendas.

IV

The history, or histories, of what we severally refer to as 'modern' or 'contemporary' 'African' art illustrates the above problems and dangers. From the point at which it became acceptable to speak of a 'history of contemporary African' art, attempts at this history have run into often unacknowledged tight corners by ducking into the safety of earlier fictions of 'Africa'. The most obvious manifestation of this is in the seeming racio-geographical delineation of the 'Africa', which, we are often told, basically refers to sub-Saharan Africa. The obvious intent of this definition, of course, is to distinguish the African from the Arab, although the spacial boundaries specified by the register, 'sub-Saharan', effectively ridicule this intent. A less apparent intent, and indeed a more important one, is to place the Arab a notch above the 'African' on the scale of cultural evolution.

It is sufficient not to question this intent here, but to point out that the signifying register proves grossly inadequate. Not only does it wholly ignore the impossibility of hard edges between cultures and societies in the region it describes, and the long history of Arab-Negro interaction, together with all the subtleties and undecidables of racial translations, indeed the impurity of designates, it equally ignores internal disparities within the so-called 'African' cultures. To play on the surface, it is never quite clear where east Africa fits on this cultural map of Africa, given not only the territorial problems of locating Somalia below the Sahara, but also of eliding Zanzibar's long history of Arabisation. In a significant sense, then, the construction of a 'sub-Saharan' Africa not

only ignores geographical inconsistencies but equally ignores accepted discursive positions in the West that not only recognise the triumph of History as the Impure but underlie the construction of Europe.

We see double standards. But that is hardly the most important point. We also find that essential tendency to ignore indigenous historical perceptions and constructs. The Outsider, whether represented by Occidental scholarship or diasporic Negro discourse, quickly establishes delineations without acknowledging the possibility that these may not be shared by those whose histories are at the centre of discourse.

On second thought, what we see are not double standards at all but a consistent referent. For, when we examine the continual construction of Europe, such discrepancies are equally apparent. The most interesting examples are the ready admission of Israel into Europe and the struggle to exclude Turkey. In other words, in the end, the use of the designate, 'sub-Saharan' in the definition of the 'African' is only a cheap ruse masking other, less innocent referents. The issue is not only race, but history as well. History as vassal.

Needless to say, white people in South Africa, Asians in Uganda, as well as other diasporic populations and communities, fall outside of this definition. In the specific case of South Africa, the settler minority, like the Europeans in Australia, has been able in the past half century to negotiate its way back into Europe. Cultural Africa, therefore, is no longer contained by that lame composite, 'sub-Saharan', which now needs a further qualifier: 'excluding white (South) Africans'. Again, how would the Outside justify its condescension to Africans, or its employment of 'The African' in the satisfaction of its need for the exotic, if Arabs, with their 'long history' of civilisation, or white (South) Africans were to be part of that construct?

On the political front, however, arguments have been stronger on the side of an all-embracing Africanity that supersedes disparities and differences and aspires towards the construction, not invention, of a new and credible Africanity. This is the position of Nkrumah's Pan-Africanism, and remains the ground argument of the Pan-African movement. Culturally, the argument is to recognise a plurality of Africanities but aspire towards the active formulation of a singular African 'identity', somewhat along the lines of Pan-Europeanism and the construction of the West.

V

For the African cultural historian, the problems here are plenty. For instance, based on the above construction of Africa, it is increasingly fashionable to begin the history of 'modern' or so-called contemporary art in Africa from the turn of the last century, that is, from the Nigerian painter, Aina Onabolu. On the other hand, earlier practitioners of 'modern' art exist in the Maghreb and Egypt, and strains of 'modernism' are discernible in the art of white South Africans from earlier than Onabolu. Also, if 'African' is a race-specific qualification, it would be proper to remember that

artists of Negro descent were practising in the contemporary styles of their time in Europe and America much earlier than the turn of the century. Where then does one locate the break with the past that the idea of a 'modernism' insinuates? In discussing 'modern' African art, does one continue to exclude half the continent? Is it realistic, otherwise, to discuss a modern culture that defies existing invented boundaries? Are there grounds in the present, that did not exist in the past, to justify a unifying discourse, or is it safer to pursue a plurality of discourses? Along what specific lines must such discourses run? Or shall we merely conclude, like Anthony Appiah, on the fictiveness of a singular cultural identity?

VI

Several other problems and questions hinge on the above. If, after all, we reject the 'sub-Saharan' qualifier, we effectively subvert a host of other qualifiers and paradigmatic premises. The 'peculiarities' and particularities attributed to 'sub-Saharan' art, which in turn sustain temporal and formalistic categorisations, become untenable. Such conveniences of Outsider scholarship as the 'problems of transition' from the 'traditional' or the 'African'

Otherisation is unavoidable, and for every One, the Other is the 'Heart of Darkness'. The West is as much the Heart of Darkness to the Rest as the latter is to the West.

to the modern, or the question of Africa's 'identity crisis' and concern over the endangerment of 'authentic' African culture, all prove very problematic indeed. If Africa is not some easily definable species or category that yields to anthropology's classifications and labels, neither are its cultural manifestations.

'Transition' from 'antiquity' to the modern ceases to amaze and exoticise or evoke voyeuristic admiration or pity because antiquity ceases to exist. The supposed distress of Africans caught in a no-man's land between Europe and their 'authentic' selves becomes a lot more difficult to locate or explicate. Ethnographic categories usually applied with ease to sequester 'African' culture into temporal boxes are no longer easy to administer. What, for instance, would we qualify as 'transitional' art in Egypt that we cannot locate in Spain? What is client-driven art within the minority community of South Africa? How easily would we lament the 'corrosive influences' of Europe on the Somali of the Northern coast?

That is to pull one leg from the stool. In strict discursive terms, of course, none of the categories, delineations and constructs mentioned above has any relevance even within the context of a delimited 'Africa', especially since none of them is ever applied in the description and study of

Europe or the West. African scholars could have bought into any of them, and indeed still do, but that is hardly the issue. The point, instead, is that such constructs that sequester specific societies and cultures and not others, emanate from less innocent structures of reference, the briefs of which are to create foils for the Occident. So we can speak about 'transitional' art in Africa, and never in Europe. We may speak of 'Township' art in Africa, or at times of 'popular art', and these would connote different forms and manifestations from those in Europe. We may qualify nearly a century of artforms in Africa as 'contemporary' while applying the same term to only a single strain of current art and discourse in Europe. We may take modernism in Europe for granted and have great difficulty in finding the same in Africa. The assimilation of Outsider culture into European art is considered the most significant revolution of its time while the same is bemoaned in Africa as a sign of the disintegration and corrosion of the native by civilisation. Or, on the other hand, Africans are to be patted on the head for making a 'successful transition' into modernity. Why, whoever thought they could emerge unscathed!

To discuss the 'problems' of modernity and modernism in Africa is simply to buy into the existing structures of reference that not only peculiarise modernity in Africa but also forbode crisis. What needs be done is to reject that peculiarisation and all those structures and ideational constructs that underlie it.

VII

To reject the exoticisation of Africa is to destroy an entire world-view, carefully and painstakingly fabricated over several centuries. This is the imperative for any meaningful appreciation of culture in Africa today, and it would be unrealistic to expect it easily from those who invented the old Africa for their convenience. It dismisses an existing discourse and signifies a reclaiming process that leaves history and the discursive territory to those who have the privileged knowledge and understanding of their societies to formulate their own discourse. This is not to suggest an exclusionist politic, but to reassert what is taken for granted by the West and terminate the ridiculous notion of the 'intimate outsider' speaking for the native. It recognises that there is always an ongoing discourse and the contemplation of life and its sociocultural manifestations is not dependent on self-appointed outsiders.

Otherisation is unavoidable, and for every One, the Other is the 'Heart of Darkness'. The West is as much the Heart of Darkness to the Rest as the latter is to the West. Invention and contemplation of the Other is a continuous process evident in all cultures and societies. But in contemplating the Other, it is necessary to exhibit modesty and admit relative handicap since the peripheral location of the contemplator precludes a complete understanding. This ineluctability is the Darkness.

Modernity as a concept is not unique. Every new epoch is modern until it is superseded by another, and this is common to all societies. Modernity equally involves, quite inescapably,

the appropriation and assimilation of novel elements. Often these are from the outside. In the past millennium the West has salvaged and scrounged from cultures far removed from the boundaries that it so desperately seeks to simulate. The notion of tradition, also, is not peculiar to any society or people, nor is the contest between the past and the present. To configure these as peculiar and curious is to be simple-minded. It is interesting, necessary even, to study and understand the details of each society's modernity, yet any such study must be free from the veils of Darkness to claim prime legitimacy. To valorise one's modernity while denying the imperative of transition in an Other is to denigrate and disparage.

The West may require an originary backwoods, the Heart of Darkness, against which to gauge its progress. Contemporary discourse hardly proves to the contrary. However, such Darkness is only a simulacrum, only a vision through our own dark glasses. In reality, there is always plenty of light in the Heart of Darkness.

Notes

1 Francis Fukuyama, 'The End of History', in *The National Interest* (Washington DC: Summer 1989); later expanded and republished as *The End of History and The Last Man* (New York: Free Press, 1992).
2 See Ngugi, *Moving the Centre: The Struggle for Cultural Freedom* (London: Heinemann, 1993).

The Identity Question:
Focus of Black South African Expression

David Koloane

I

It is evident that there is no common denominator as to what really constitutes an 'authentic' African expression. In the late nineteenth century, Africa experienced an unprecedented wave of invasions orchestrated by West European powers. The objective of the expansionist strategy was to subdivide the continent into several colonies. Christian missions from various European countries also embarked on the process of converting communities by offering salvation through the Bible. These communities were discouraged from their original forms of worship and ritual. The majority of countries in Southern Africa such as Zambia, Zimbabwe, Botswana and South Africa were at one point under British colonial rule, whilst others such as Angola and Mozambique fell under Portuguese rule. It is evident therefore that the problem of identity will to a large extent be determined by the specific type of colonial domination in a country.

Creative activity in most African communities was integral to each community's lifestyle, its mediation rituals and ceremonies. Industrialisation, which followed in the wake of colonisation in some areas, introduced the commodification of artifacts and creativity generally. The European concept of artistic excellence became essential not only as an aesthetic criterion, but as a marketing strategy as well. South Africa, which is one of the most industrialised countries in southern Africa, gradually transformed its communities to the wage-earning economy, which in turn facilitated their rapid urbanisation. Cultural activities such as sports, music, dancing and other performing arts were introduced into the gold-mining camps that house mine workers from different areas and cultural groups in Southern Africa. The state encouraged 'tribal' dancing competitions, and these proved a popular form of entertainment for the workers as well as White tourists.[1]

The promotion of sports and music, was, in a sense, a process intended to cultivate a competitive spirit based on essentially European values. The visual arts were also chaperoned into the marketplace through liberal programmes such as the Polly Street Art Centre, which was initiated in Johannesburg in 1949 and has become a historic milestone as the first visual arts programme for modern Black artists in South Africa. The Polly Street Centre was conceived as a recreation facility for Blacks employed in the city; it provided programmes in music, boxing, sewing, cooking and the visual arts. In 1962 the Centre was moved to a nearby site in Eloff Street known as the Jubilee Centre where it came under the wing of the Johannesburg City Council's cultural section. It was here that it acquired its reputation and produced some of the earliest professional Black artists.

The Polly Street programme, together with subsequent non-formal projects in the 1970s and 1980s, introduced European teaching methods, techniques, and material. Among such projects were the Federated Union of Black Arts, commonly known as the FUBA, and Funda, both in Johannesburg, and the community Art Project in Cape Town. These centres constituted alternative

institutions within Black communities, especially since, with a few exceptions, art is not catered for in Black schools.

II

In 1984, one of the most significant art exhibitions ever held in the South was mounted in Johannesburg. It was curated by Ricky Burnett under the aegis of the BMW auto manufacturing company, and later toured extensively in Germany. The work of artists from the rural North and Eastern Transvaal, encompassing the Pedi near Pietersburg to the North, the Tsonga in Gazankulu near Louis Trichardt, and the Venda near Duiwels Kloof in the East, was included for the first time in a local exhibition. Communities in these areas are among the few that still, relatively speaking, uphold traditional values. Gazankulu and Venda, for instance, are situated several miles from any major towns or cities.

The exhibition, entitled 'Tributaries', was like a revelation to the local art world. The artists from the rural areas soon became household names in suburban homes. Among them were Jackson Hlungwani, the late Nelson Mukhuba, Johannes Maswanganyi, Noria Mabaso and Phutuma Seeka.

The work of these artists was perceived as the missing link in the romantic notion that combined traces of the old with the new. A magic realm of mythology was woven around the artists and their environments by White art reviewers, researchers and spurious dealers. The fact that these artists were obviously untutored in the Western mould enhanced the abounding myth.

Jackson Hlungwani has often been referred to as a shaman artist by the South African art establishment. A fervent exponent of the Old Testament, Jackson is endowed with prodigious energy. Over the years he has erected a mammoth shrine near his home in Mbokoto, which comprises an assemblage of awesome carvings with biblical connotations, boulders, rocks and other material. He calls this shrine 'the New Jerusalem'.

Jackson has become a legend in South African art. For both art establishment and corporate business he represents the perfect Black artist, the shamanistic native providing the missing link between civilisation and primitivity. He has become the 'authentic' African artist.

III

The first conference-cum-arts festival convened to assess the role of art and artists within apartheid South Africa was in Gaborone, Botswana in 1982. It was conceived by the Medu Cultural Ensemble, which comprised exiled South African writers, musicians, painters, sculptors and sympathisers. The major liberation movements such as the African National Congress (ANC) were banned by the Nationalist government. Under the blanket bans imposed in the repressive period of the 1960s, leaders and followers alike were forced to operate underground in sympathetic

Jackson Hlungwani
Altar of God, (no date)
Metal, rocks, string,
wire, wood, yarn,
dimensions variable
Courtesy the
Johannesburg Art Gallery

neighbouring countries or overseas.

Exiled cultural representatives of various groups as well as those still operating within the country converged on Gaborone for the 1982 conference under the theme 'Culture and Resistance'. From the various seminars organised around the music, theatre, dance performances and exhibitions, it became evident that a culture of resistance had arisen in challenge to the apartheid system. The suppression of free expression and restriction of movement that epitomised the apartheid system had been translated into an overtly political expression in various art forms. Cultural and political ideas such as Black Consciousness influenced Mdali in the 1960s, a cultural formation representing music, art, drama and literature, and the Medupe writer's group during the 1970s, which comprised mostly Black writers who were hounded by security police.

In 1984 the South African defence force carried out a merciless raid in Botswana. This was supposedly aimed at ANC military bases in neighbouring states. Ironically, most of those killed in the Botswana raid were involved in cultural rather than military activities. Among them was Thami Mnyere, a graphic artist who was a key figure in convening the Culture for Resistance conference.

IV

The label 'transitional art' was introduced by academic researchers and art critics in an effort to identify a category of work that fell between mainstream expression and craft. This label covered anything from beadwork, drums, walking sticks, various forms of statuary, to wire sculpture. Seminars were convened in academic circles where papers were delivered on the subject.

Although a certain controversy ensued in art circles over the label 'transitional art', a lucrative market blossomed in commercial galleries, craft outlets and street markets for this art form. Gradually, the label, which is more suited to anthropology than to the visual arts, was indiscriminately applied to any work produced specifically by Black artists. It was also employed by those who consider themselves authorities on future developments to describe the township art that may eventually prove distinctive or characteristic of a free society. The inappropriateness of the term eventually accelerated its demise as its validity became increasingly challenged.

V

The 'Otherness' factor expected of non-Western artistic expression was, to all intents and purposes, overtly present in Venda sculpture shown at the 'Tributaries' exhibition in 1984. The highly favourable reviews generated a boom in sales for the artists.

It is curious how readily the 'ethnic' concept, as promoted by the government, has conveniently become an appropriate aesthetic classification. A parallel can be drawn between the somewhat hollow ring of the legitimation of the Bantustan policy [2] and the false echo of an 'African' mythology in 'ethnic' expression conjured by the local art, *fundi*. The irony is that it is only Black artists –

who constitute the indigenous population – who are insistently reminded at every possible occasion about their own identity, and how they should be conscious of it, by specialists who are descendants of settlers. One is reminded here of Chinua Achebe's comment about the stranger who sheds more tears than the bereaved.[3]

The expectation does not appear to apply to White artists. The fact that White artists can quote and assimilate wide and varied sources and cultures without qualm, and with no fear of being accused of appropriation or misappropriation, or of losing their identities, insinuates that Black artists lack the capacity for creative diversity.

The argument for 'identity' in the work of Black artists, therefore, is only a smokescreen for an essentially racist questioning of their abilities, very much like the argument for the 'protection' of 'Otherness' or separate cultures that lies at the heart of apartheid.

Notes

1 Luli Callinicos, *Working Life 1886-1940* (Randburg:
 Ravan Press, 1987).
2 This imposed certain areas for Black Africans,
 giving self government and eventual independence
 to each ethnic group.
3 Chinua Achebe, *Things Fall Apart*, 1958.

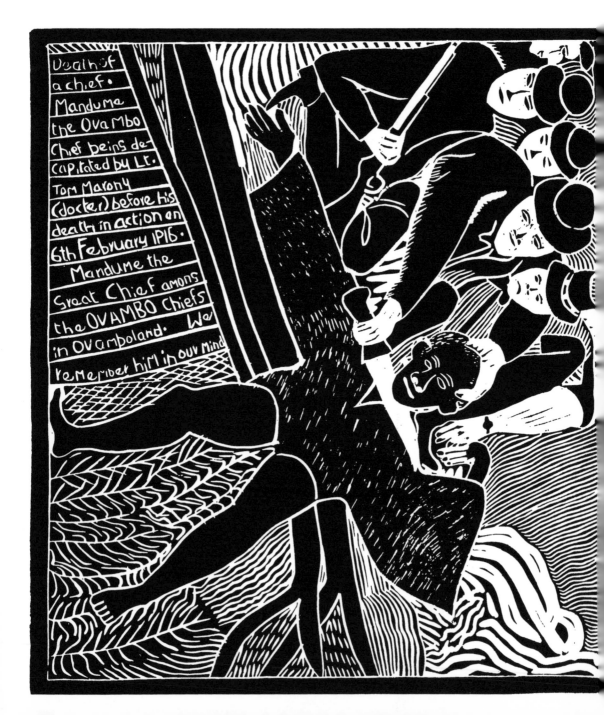

Death of a chief. Mandume the Ovambo Chief being decapitated by Lt. Tom Marony (docter) before his death in action on 6th February 1916. Mandume the great Chief among the OVAMBO Chiefs in Ovamboland. We remember him in our mind

Inversion of the Printed Image: Namibian Perspectives of John Ndevasia Muafangejo

Margo Timm

The late John Ndevasia Muafangejo (1943–1987) is a pivotal figure as the first Black Namibian to be established in the realm of gallery art.[1] He was also the first gallery artist to advocate the culture and concerns of the Black community during the era of apartheid-South African control of Namibia. His standing as a Namibian was affirmed by the achievement in his art of a humanist vision associating liberation with holistic integration and reconciliation. This insight prefigured the Namibian Constitution that was adopted upon attainment of Independence in 1990.[2]

A significant feature of Muafangejo's linocuts is the inclusion of text, which not only establishes a dialectical relationship with the image, but also facilitates interjection by the artist. In assessing his work, it is therefore essential to respect Muafangejo's recognition of the relatively arbitrary nature of signification and to acknowledge the 'voice' in the lino-text. This is of particular relevance because much of the literature on his work contains little direct commentary by the artist and a relatively limited interpretation of his intent.[3] This essay therefore initiates contextual analysis of both the image and the lino-text with selective focus on personal symbolism and sociopolitical themes.

The Formative Period: 1943–1969

The holistic manner in which Muafangejo encompasses the complexity of this period is manifest in the charting of his life in the 1976 linocut *Angolaland/South West Africa*. The lino-text traces his childhood in southern Angola in a custom-bound Kwanyama community dominated by the living memory of their last independent king, Mandume ya Ndemufayo (c. 1894–1917).[4] It then charts Muafangejo's relocation to join his family at the Anglican mission at Epinga in northern South West Africa (pre-Independent Namibia), which led to his baptism and the initiation of a Western education. Although this work depicts the formal demarcation of the colonial border that split these two realms of his experience, it is dismissed by the lino-text as artificial.

Angolaland/South West Africa also alludes to the war of liberation launched by the armed wing of the South West Africa People's Organisation (Swapo) in the northern border region in 1966.[5] The South African military force is denoted by the inclusion of an enormous elephant and gun behind an armed figure, but is not mentioned in the text. This threatening presence is counterbalanced by large black trees in the Angolan sector. Given the Kwanyama use of trees as memorials,[6] Muafangejo reconciles his Kwanyama heritage of autonomy with aspirations of liberation and in so doing relegates the colonial war to a transient phase within a greater African continuum.

Muafangejo's incorporation into the mission context is of particular significance because the Church increasingly provided a focal point for internal resistance to the injustices of apartheid and the ravages of the war. As the historian Peter Katjavivi states, 'The transformation of the churches brought with it a formidable strength of opposition to South African rule ... they [had] come full circle to join hands with the forces for social liberation in Namibia'.[7]

The precedent for Muafangejo's emergence as an artist and his dual focus on Kwanyama heritage

and Christianity was set by one of the local mission teachers, Stephen Paulus, who became his guardian and mentor. In 1967, Paulus published a text, illustrated with drawings provided by himself and Muafangejo.[8] Encompassing Christian themes and the history of the Kwanyama and related peoples (known collectively as the Ovambo), it is entitled *Epukululo Lovawambo* – 'Setting Things Straight for the Ovambo'. The foundation of Muafangejo's work had therefore been established prior to the Church's sponsorship of his art studies at the Rorke's Drift Art and Craft Centre in South Africa from late 1967 to 1969.[9]

Setting Things Straight for the Kwanyama Ovambo

Analysis of Muafangejo's works on King Mandume consistently reveals Kwanyama perspectives of their history. This is most vividly realised in one of the earliest of the prints, *Death of a Chief* (1971). This work exemplifies Muafangejo's ability to establish an exchange between the apparently simple imagery and the lino-text in order to create an iconic work, the transcendence of which is informed by the original context: 'My style is symbolic and simple. It is a teaching style . . .I use the symbols that expose the African subconscious'.[10]

Muafangejo's series on the late Kwanyama King celebrate Mandume's mythical status as a sovereign who personified the right to autonomous leadership, military might and authority over Kwanyama territory.[11] Despite successful military campaigns against the Portuguese in Angola, King Mandume was finally forced to retreat into SWA in 1915. As the Union of South Africa had just taken control of the territory, the King approached Union officials to form an alliance ensuring protection against the Portuguese. However, when it became clear to the South African authorities that King Mandume was not prepared to relinquish his sovereign authority, a military force was dispatched to either capture or kill him.[12] Official colonial accounts claim that the King was killed by Maxim machine-gun fire on 6 February 1917. The Kwanyama assert, however, that he defied the South Africans by committing suicide and was subsequently decapitated by them.[13]

In providing the Kwanyama perspective in *Death of a Chief* by depicting the decapitation of King Mandume, Muafangejo once more 'set things straight' for the Ovambo. His deliberate recourse to the graphic medium of linocut to challenge colonialist perspectives is evident in this work, which uses as source material a photograph of the South African forces posing with the body of the King. This photograph is dominated by the oppressive presence above the King of a bastion of Union forces, whose faces have been excluded from the frame. The derision flaunted by the two full figures, on their haunches by the body of the King, is rendered particularly disturbing by their shaded, anonymous faces, bringing to mind Muafangejo's later reference to the forces of the border warfare as 'Master Nobody'.[14] This image was published in the 1968 *South West Africa Annual* by a former South African policeman, who had taken part in the attack on the King.[15]

Death of a Chief can be directly linked to the publication of the photograph by Muafangejo's virtually verbatim copy of the caption. However, Muafangejo inverts the photograph in a number of ways. By rephrasing 'Mandume being treated', as 'Mandume being decapitated' the artist imposes Kwanyama

perspectives.[16] He also exposes the hitherto hidden faces as the white death masks of colonial oppression and finally, turns the tables on the colonial authority through the transformation of an 'icon' of oppression into one of imminent downfall by using the text to orient the image on to its side. In doing so, the armed figures 'above' the King appear to be about to tumble into the turbulence beneath. Yet, in turning the image, the King's status and position as the constant focal point of the work is further enhanced – as the text states, 'we remember him in our mind'. Moreover, if the lines beneath the King are interpreted as the border (as portrayed in the 1986 work *MANDUME WAS BORN A Political* [sic] *Chief of the KUANYAMATICAREA*), his body extends across the entire Kwanyama realm.[17]

Confinement and Acclaim

Despite international acclaim, Muafangejo's development as an artist was constrained by the apartheid context and the concomitant stereotypical expectations of Black art. Two central factors in the prescriptive objectification of Muafangejo were the limited nature of his education and his dependency on predominantly White patronage.

Opening a retrospective exhibition of Muafangejo's work, the South African artist David Koloane expressed regret at the inadequacy of Muafangejo's education, condemning the notion that Black artists do not require formal tuition.[18] This thinking was integral to the approach at the Rorke's Drift Arts and Crafts Centre where Muafangejo studied printmaking, painting and weaving. The provision, by the Centre, of technical assistance to facilitate the emergence of an unmediated art linked to the African heritage,[19] bore unfortunate correspondence with the objectives of Apartheid Bantu Education. These were aimed at promoting a particularly limited scope for African culture through the 'evolution' of a distinct genre of Black art based on notions of 'raw sensibility' and 'naïve rural ethnicity',[20] which entrenched the 1953 declaration by Hendrik Verwoerd, the architect of apartheid, that 'the Bantu will be taught from an early age that equality is not for them'.[21]

Accordingly, the 'fine arts' training received by Muafangejo has been 'commended' in South African literature of the apartheid era as having been shaped by emphasis on production of naïve rural art aligned with decorative crafts.[22] Indeed, the anthropologist E. J. De Jager, whose publications on Muafangejo engage these apartheid notions of African art, lauded his work as having 'all the most important qualities of "naïve" art; his style is completely unaffected and there is no endeavour towards special effects . . . [It] is narrative in nature'.[23] Furthermore, he claimed that the 'Rorke's Drift Tradition' as seen in the work of Muafangejo, represented 'rural African art in South Africa'![24]

This claim may be reflected in the selection of Muafangejo as a representative of South Africa in the São Paulo Biennale in 1971.[25] Given that the mandate to administer SWA had been terminated by the United Nations in 1966,[26] the political expediency of including a Black artist from the territory cannot be ignored.[27] Muafangejo's entry, *The Battle at Rorke's Drift* (1969), which received an award,

was nevertheless a covert critique of colonialism.[28]

It was therefore both international recognition and the blind prejudice elicited by the perceived naïvety of his work, with its focus on Kwanyama heritage, that expedited Muafangejo's entry into the elitist 'European' realms of gallery art in the apartheid context. At that time, the main focus in gallery art in SWA and parochial South Africa was on uninhabited landscape, 'a masterless land' with the people marginalised to signifiers of apartheid ethnicity, exotic addenda to the other common theme of wildlife.[29] In contrast, the progressive sectors of the Church supported artwork documenting opposition to the injustices of apartheid and promotion of the ideals of social liberty, equity and reconciliation.

Muafangejo not only had to cope with the conflicting values of this polarised, mainly White audience and the concomitant estrangement from his own community, but he also had to deal with manipulation by those purporting to act as his patrons. He expressed this in his statement, 'They help me, but they help me in the wrong way'.[30] Azaria Mbata, Muafangejo's teacher at Rorke's Drift, also wrote of the alienation and disempowerment resulting from 'Europeans [who] want to lead and leave the people they are helping outside the share of . . . creative ideas to plan for their own future'.[31]

Muafangejo's initial relationship with his benefactors can be deduced from the retrospective linocut dedicated to Bishop Winter c. 1968, *The First Bishop of Doicese* [sic] *of Namibia* (1981).[32] In this work, Muafangejo depicts himself as an inert, seeing heart, seemingly trapped in the pulpit with his soul trying to reach out in loyalty and gratitude towards the blessing bestowed by the gigantic figure of the bishop above him.[33] In contrast to the Bible held by the Bishop, the small text festooned on the heart of Muafangejo may confirm his right to ownership and interpretation of text. Although this work could refer to redemption, the disarming candour encourages a reading associating patronage with disempowerment. However, this imbalance may be countered by the irony of Muafangejo's call for redress in depicting himself as a heart, since, in accordance with Kwanyama custom, the recipient of the heart of a slaughtered ox has to host the next feast for the community.[34]

This image of patronage equated with vulnerable dependency is equally pertinent to the attitude expressed in 1981 by Olga Levinson, Muafangejo's primary benefactor in the realm of SWA gallery art, in her statement: 'He epitomised the sensitive and vulnerable man caught up in . . . circumstances beyond his control and even his understanding'.[35]

Despite some reticent recognition of social and political themes in Muafangejo's work, these were not explored in local publications. The disregard within the White sector for the realities of apartheid and its war, and the repudiation of the artist's political aspirations as a representative of the dispossessed Black community are epitomised in the statement: 'The snake was in his paradise', made in response to obvious elements of political commentary in Muafangejo's later works.[36]

In contrast, the relative objectivity of international forums allowed for greater acknowledgement of his intent. When Muafangejo exhibited in the Commonwealth Institute in London in 1983, for example, the art critic Waldemar Januszczak likened him to the German Expressionists and declared his work to

John Muafengejo
An Interview of
Cape Town University
in 1971, 1971
Linocut
33.9 x 40.1 cm
Courtesy and
© the John Muafengejo
Foundation

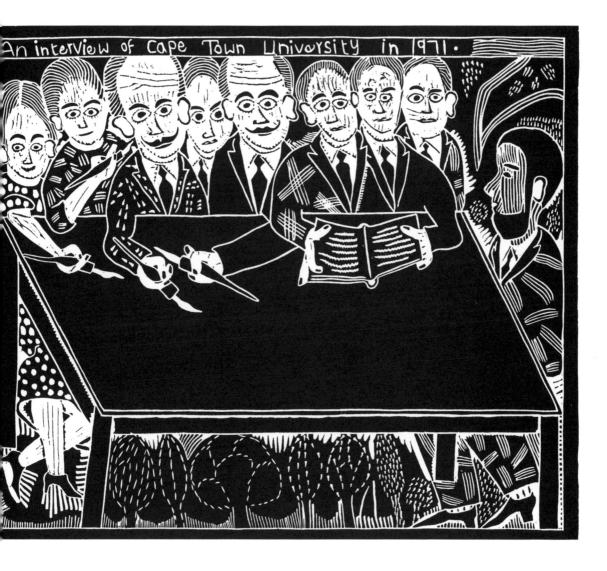

be powerfully political and a savage indictment of South Africa's involvement in Namibia. Yet even this declaration was tempered by the qualification 'almost by accident' and the designation 'primitive art'.[37]

Muafangejo's work initially had little meaning to his own community and was only to be found within the homes of the educated few.[38] Although Muafangejo's links with the White establishment aroused suspicion, it is claimed that the resultant interest in his work awakened the Black community to its significance.[39] It was only after Muafangejo moved to the capital city that he established wider Black interest in his art.[40] Whilst some considered him a traitor,[41] others perceived his commitment to both his heritage and to social change as evidence that he was acutely aware of the travesties of apartheid.[42] The interest of Black activists in his work[43] is substantiated by Theodor Ngololo's assertion that, 'Within his context of restriction – John was a freedom fighter'.[44]

Inversion of Muafangejo

Muafangejo's art includes a poignant record of artistic and personal compromise and alienation. It can be argued that his development was severely hampered by the expectation that he should fulfil preconceived formulae.

Although Muafangejo produced a number of evocative etchings and accomplished, resonant paintings (*Rorke's Drift*, 1967–69) and tapestries, these works are generally elided in the literature. They were facets of Muafangejo's talent for which there was no space within the realm of preconceptions.[45] *An Interview of Cape Town University in 1971* (1971) makes evident Muafangejo's yearning for growth and his devastation on being rejected for further study. In this work, the White interviewers are shown to be so limited by stereotyped expectation that they appear oblivious to Muafangejo himself. Their duplicity is seemingly embodied in the Janus-headed figure holding a text. The table, thrust up to confront the viewer, could denote the bureaucracy that sustained the sharp 'shard' of segregation. The marginalised and disempowered artist keeps his hands under the table that is about to crush him. The humiliation of this experience is suggested by the lines gouged in his face and person.[46]

Such personal trauma was further compounded by military attacks on Muafangejo's place of residence in northern SWA[47] and South African army raids in 1976 involving confiscation of his printing blocks, which were never to be returned.[48] These experiences forced him to move to an Anglican centre in the capital city, Windhoek, in 1977. However, even here the upheaval continued with the pressures accompanying surveillance by the police and his refusal to produce propaganda material for the colonial authorities.[49]

Muafangejo's emotional distress further escalated his stigmatisation and marginalisation. This alienation may be reflected in his recurrent self-portraits with a white face, as in *No way to go* (1973). This could, however, also denote his concurrent act of individuation in developing alternative perspectives. The artist's endeavour to retain stability in the face of the turbulence and ambiguity of his

sociopolitical milieu may be denoted by the relative solidity of the planes of the figure in contrast to the frenetic texture in the remainder of the composition.[50] Muafangejo has been quoted as follows: 'I am not a political person, it is the world which is political'.[51] This comment can be viewed in terms of Max Horkheimer's reminder that the process of knowledge involves real political will and action as well as experience and conception.[52] It was Muafangejo's ability to conceive a vision of liberation through equity and reconciliation that enabled him to transcend the constraints and contradictions of his context.

Reconciliation

Muafangejo's vision for his society is proclaimed in his *An Ark of Noah* of 1979. Noah's sons are portrayed as representing different races, united and reconciled by virtue of their faith, signified by the ark.[53] This ideal of unity within the church is celebrated in the 1980 *Activity Centre*, with its portrayal of people reaching out in 'a handshake of love and co-operation White and Black together for love and peace'.

Muafangejo's use of his art to invert the divisive destruction of apartheid is further confirmed by analysis of works celebrating the community's reconstruction of the mission infrastructure after a series of attacks. The print *Oniipa New Printing Press and Book Depot* (1975) on the inauguration of the rebuilt printing press at the Lutheran mission in Oniipa can be compared with *Oniipa Rebuilding of Printing Press* of 1981, produced to commemorate the second inauguration after the press had been bombed and rebuilt once again.[54] These works pay tribute to the resilience of the community and the Church. In the lino-text to both works, Muafangejo refers to the perpetrators of this tyranny as 'Master Nobody', whereas in the 1975 print he describes the bombing as betrayal motivated by monetary interest. Both statements are a powerful indictment of both colonialism and apartheid.

The call for equality and harmony is evident in the 1981 linocut in which the Black and White people are counterbalanced and equal in number, affirmed by the inclusion of both Kwanyama and English text. In contrast to the 1975 work, the bishop stands in humble supplication with his staff of office in one hand and an open Bible in the other. His position as one of the people is reinforced by the fine texture of his robe, which integrates him with his context. The figure standing behind the Bishop may denote the artist himself. He holds his hands in a symbolic gesture, shielding the mission against the ever-threatening army of occupation.[55]

Muafangejo's personal identification with this gesture and the link between this message of reconciliation and his Kwanyama identity may be embodied in the meaning of his name. In 1981, he formally re-incorporated his first name, Ndevasia, given to him at birth by his father, which had been replaced by John at his baptism. In Kwanyama the name Ndevasia, means 'I shield, protect and nurture them' and Muafangejo, the first name of his father, means 'you also look like me'.[56] John Ndevasia Muafangejo could thus denote his personal role as a Christian harbinger of 'protection and nurturing of recognition of equality'.[57]

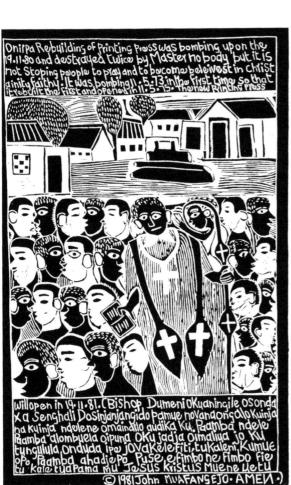

Oniipa Rebuilding of Printing Press was bombing upon the 19.11.80 and destrayed twice by Master no body but it is not Stoping people to pray and to become beleivest in christianity faithy. It was bombing 11.5.73 in the first time so that it rebuilt the first and opened in 11.5.73. the new Printing Press

Will open in 19.11.81. (Bishop Dumeni Okuaningile osonda xa Senghali Dosinjanjangido pamue novandonealo kuinja ha kuinja ndelene omaindilo audika ku, Paamba ndele Paamba alombyela oipuna oku jadja oimaliya jo ku tungulula Onduda ip jovakeletiti, tukaleni kumue opo, Paamba ahadjepo Puse efimbo ne fimbo fie tu kala tyapama mu Jesus Kristus Muene uetu

© 1981 John Muafangejo. AMEN.)

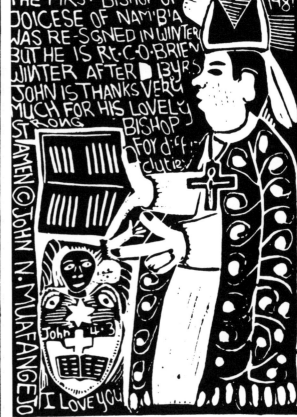

THE FIRST BISHOP OF DOICESE OF NAM'B'A WAS RE-SGNED IN WINTER BUT HE IS Rt·C·O·BRIEN WINTER AFTER 13 YRS JOHN IS THANKS VERY MUCH FOR HIS LOVELY STRONG BISHOP OF Diff Clutie. AMEN © John N. Muafangejo

John 4.3

I LOVE YOU

Far left:
John Muafengejo
Oniipa Rebuilding of
Printing Press, 1981
Linocut
45 x 30 cm
Courtesy and
© the John Muafengejo
Foundation

Left:
John Muafengejo
The First Bishop of
Doicese of Namibia,
1981 (sic)
Linocut
29.9 x 21.1 cm
Courtesy and
© the John Muafengejo
Foundation

The symbolic nature of Muafangejo's vision may be inferred through the observation that only one of the White figures in *Oniipa Rebuilding of Printing Press* is portrayed with open eyes. Muafangejo knew that his ideals could only be achieved through independence. The ongoing belief in liberation in the face of the dispossession of apartheid is alluded to in his Biblical themes of expulsion coupled with redemption, betrayal paired with resurrection. In these metaphors Muafangejo equates his own deliverance with his hopes for Namibia.

In the 1982 work, *JOSEPH'S story in Egypt* there is contention between the declaration of oppression in the lino-text and the realisation of Muafangejo's vision of liberation, empowerment and reconciliation in the image. Whereas the text recounts the sale of Joseph into slavery,[58] (as summarised in the Kwanyama statement 'They sold Joseph'), the images present a critique of the political status quo as the context for a contemporary betrayal culminating in reconciliation, liberty and empowerment.[59] Joseph, who is shown as a figure with a gigantic heart could represent Muafangejo as an embodiment of his aspirations for Namibia – a visionary figure betrayed by both White and Black brethren 'in full knowledge' of his ultimate triumph.

Yet, after his untimely death on 27 November 1987, it could be claimed that 'they sold Muafangejo'.[60] At an auction held in Windhoek in 1989 the copyright for his work, along with his collection of cancelled linoblocks, plus some 120 signed and 500 unsigned prints were sold.[61]

Although Muafangejo's personal aspirations for comprehensive reconciliation and empowerment remain largely unfulfilled, his vision has been acknowledged by the inclusion of his linocut *Live Tree* (1978) in the Namibian Independence celebrations.[62] His presence continues to be felt through the increasing recognition of the significance of his work.

Conclusion

Muafangejo's art is compelling because it demonstrates a duality of direct access facilitated by simplicity of form and the incorporation of lino-text on the one hand, and the intense multiple expression of his intent on the other. This is achieved through a choreography of dynamic exchange between the formal, figurative and con/textual components, which evokes experiential re-enactment of his personal perspectives.

In his role as the first Black Namibian gallery artist in the era of the struggle for independence from South Africa, the constraints of apartheid that so limited Muafangejo, insidiously facilitated his rise to acclaim. The works document a painful struggle to retain integrity in a maze of prejudice, acclaim, appropriation, alienation and ambiguity. Muafangejo used his art to assert the need for the artist's perspective as a 'counter-text' to the imposed text of preconceived stereotypes, calling for equity and recognition of the artist in a testimony both global and rooted in personal circumstance. He achieved this transcendence through the sophistication of his formal means and the realisation in his art of a vision associating liberty with reconciliation.

Muafangejo's inversion of apartheid, segregation and tyranny counters painful facets of the experience of the 'outsider' artist in Western hegemony. A work such as *An Interview of Cape Town University in 1971* has global pertinence in its condemnation of the prejudice and poverty of any hegemonic stance on art that precludes the 'voice' of the artist.

Notes

1 When Black art was included in exhibitions such as the 1958 'South West African Native Art and Crafts' in Cape Town, South Africa, these works were displayed as anonymous ethnographic artifacts. Although Otto Schroeder and Joshua Hoebeb initiated art classes for Black children from 1958 to the mid-1960s and these students exhibited at leading galleries, winning international competitions, this initiative could not be sustained. See my 'Namibian Art – a Re-evaluation of Craft', symposium on African Art, National Art Gallery of Namibia, Windhoek, 1993.

2 After Germany declared the territory a Protectorate in 1884, it was named German South West Africa and proclaimed a colony in 1890. During World War I (1915), the Union of South Africa conquered and annexed it. In 1920, South Africa was granted a mandate over South West Africa (SWA) by the League of Nations. After the League of Nations was dissolved and replaced by the United Nations (UN) in 1946, South Africa tried to incorporate SWA. When this was rejected by the UN, representatives of the people immediately petitioned the UN for independence. Although numerous petitions, rulings by the International Court of Justice and resolutions by the UN followed, the war of liberation launched on 26 August 1966 was central to the final attainment of Independence on 21 March 1990. See Peter H. Katjavivi, *A History of Resistance in Namibia* (London: James Currey, 1988); Joachim Pütz, Heidi Von Egidy and Perry Caplan, N*amibia Handbook and Political Who's Who*, vol. 2 (Windhoek: Magus Namibia series, 1990).

3 Whilst Theo Sundermaier's *Hoffnung für Namibia - Linolschnitte von John Ndevasia Muafangejo* (Hope for Namibia - Linocuts of John Ndevasia Muafangejo) (Bielefeld: Luther Verlag, 1991), an analysis of Biblical themes in terms of the socio-political context, is of considerable value, especially in its inclusion of Muafangejo's commentary, he focuses exclusively on the textual and figurative components. Pat Gilmour's, 'On Not Being a Political Artist', in Orde Levinson, *I was Lonelyness:* [sic] *The Complete Graphic Works*

of John Muafangejo, catalogue raisonné 1968-1987 (Cape Town: Struik, Winchester, 1992) provides an incisive reading of intent but no analysis of its embodiment in the work. Similarly, Brenda Danilowitz', 'John Muafangejo Picturing History', *African Arts*, vol. XXVI, no. 3 (Los Angeles: April 1993) focuses on the lino-text and contextualisation. In contrast, Orde Levinson (*op. cit.*) initiates an exploratory analysis of embodiment of intent, but does so in a less contextualised reading.

4 For further information on Mandume ya Ndemufayo see Patricia Hayes and Dan Haipinge (eds.), '*Healing the land': Kaulinge's History of Kwanyama* (Cologne: Rudiger Koppe verlag, 1997); Patricia Hayes, 'A History of the Ovambo of Namibia, c. 1880-1930', unpublished Ph.D. thesis, University of Cambridge, UK, 1992; Jeremy Silvester, *My Heart Tells Me That I Have Done Nothing Wrong* (Windhoek: University of Namibia, 1992).

5 See Katjavivi, *op. cit.*, p. 60.

6 This custom is documented in a series of interviews that I conducted with Rev. Philemon S. Haufiku, Muafangejo's nephew, in Windhoek on 11 March, 12 May, and 3 August 1995.

7 Peter Katjavivi, Per Fostin, Mbuende Kaire (eds.), *Church and Liberation in Namibia* (London: Pluto, 1989), pp. 14, 15.

8 Haufiku, *op. cit.* See Stephen Paulus, *Epukululo Lovawambo 2nd Edition* (Pietermaritzburg: Khanya Publications, 1970).

9 Levinson, *op. cit.*, p. 11.

10 Gavin Younge, 'John Muafangejo – Exhibition of Relief Prints 1972-1987', catalogue essay, Michaelis Gallery, University of Cape Town, 11–24 August, 1987, p. 1.

11 Muafangejo shows the King with firearms and traditional weapons. His customary dress, and that of his subjects denotes his status as a traditional leader. The only exception to this presentation of Mandume can be found in *The end of One Chief* (c. 1968), where he appears in contemporary Western dress, which serves as an inversion of a colonial photograph. For detailed analysis of this work and *Death of a Chief* see my essay 'Transpositions: The

reinterpretation of colonial photographs of the Kwanyama King Mandume ya Ndemufayo in the art of John Ndevasia Muafangejo', in Wolfram Hartmann, Jeremy Silvester and Patricia Hayes (eds.), *The Colonising Camera* (Capetown, Windhoek and Ohio: University of Cape Town Press, Out of Africa Publishers and Ohio University Press, 1998).

12 Although the King's continued engagement with his subjects in Angola was one of the reasons cited for this attack (see Silvester, *op. cit.*, p. 32), the need for Kwanyama labourers (for the mines, railways and farms) was also of major concern to the South African authorities (Katjavivi, *A History of Resistance in Namibia*, *op. cit.*, p. 18).

13 Hayes, 'A History of the Ovambo of Namibia', *op. cit.*, p. 236; Silvester, *op. cit.*, p. 32.

14 In *Oniipa New Printing Press and Book Depot* (1975) depicting the inauguaration of the new printing press in Oniipa, and in *Oniipa Rebuilding of Printing Press* (1981).

15 Sidney Bristow, 'An Old Timer Reminisces', *SWA Annual: 85-89* (Windhoek: SWA Publications, 1968), p. 87. Given the first significant armed campaign of Swapo's military People's Liberation Army of Namibia on 26 August 1966, there can be little doubt regarding the propagandist goals of 'reviving' the memory of the final 'subjugation' of the King in a publication aimed at White settlers.

16 The claim that the King was being treated by 'Lt. Tom Morony (doctor)' is unlikely, as this probably referred to Lieutenant Thomas Edward Moroney, officer in charge of the South African Mounted Rifles detachment at the Namakunde border post, who presented a sworn statement identifying the body of King Mandume in the presence of Colonel De Jager on 9 February 1917 (Windhoek: National Archives of Namibia, ADM 49 III-IV). The original caption also gave the incorrect year of King Mandume's death as 1916 instead of 1917. The reason for these inconsistencies may have been that decapitation was never mentioned in the offical report by De Jager (Hayes, *op.cit.*) and rumours of a decapitation were denied by officials of the Union of South Africa. (See letter from T. J. O'Reilly, Military Magistrate in Omaruru, to the secretary of the Protectorate, Windhoek, 24 February 1917 (Windhoek: State Archives, 47 II–IV A54 639 4).

17 *Death of a Chief* is all the more pertinent as a riposte to colonialism given that it was produced in 1971. The year was marked by widespread calls for the Independence of Namibia in response to the long-awaited International Court of Justice verdict that South Africa's occupation of Namibia was illegal (Katjavivi, *op. cit.*, pp. 65–67).

18 David Koloane, unpublished speech for opening of John Muafangejo Exhibition, Guest Artist Standard Bank Arts Festival, Johannesburg Art Gallery, 28 July 1988.

19 Stephen Sack, 'The Rorke's Drift Art and Craft Centre', 1992, in Levinson, *op. cit.*, p. 343.

20 S. R. Dent, Foreword, in J. W. Grossert, *Art and Craft for Africans: A Manual for Art and Craft Teachers* (Pietermaritzburg: Shuter & Shooter, 1957), p. 9.

21 Justin Ellis, *A Future for Namibia. Education, Repression and Liberation in Namibia* (London: World University Service, 1984), p. 21.

22 Rhoda Rosen, 'Art History and Myth Making in South Africa: The example of Azaria Mbatha', exhibition handout, Standard Bank National Arts Festival, 1993.

23 E. J. De Jager, 'African Art in South Africa: The Rorke's Drift tradition with special reference to Azaria Mbatha and John Muafangejo', *Fort Hare Papers*, vol. 9 (Alice: November 1988), p. 75.

24 *Ibid.*, p. 70.

25 Levinson, *op. cit.*, p. 393.

26 Katjavivi, *op. cit.*, p. 58.

27 Similarly, one could query the circumstances of Muafangejo's joint prize with Norman Catherine for his 1976 *Angolaland/South West Africa*, at the 2nd South African Republic Festival Exhibition in 1981, (Levinson, *op. cit.*), which was boycotted by a number of artists on the grounds of its *de facto* 'celebration' of apartheid rule.

28 This linocut was based on a nineteenth-century engraving in the *Illustrated London News*, which showed the battle between Zulu fighters and a small contingent of British soldiers surviving inside a barricade (Gilmour, *op. cit.*, p. 323). The principal of Rorke's Drift ordered Muafangejo to destroy this block 'because it was too political'. (Interview with Muafangejo by Olga Levinson in May 1987, as cited by Gilmour, *op. cit.*, pp. 323–324.)

29 On page 4 of his *Art in South-West Africa* (Pretoria: J. P. van der Walt & Seun (edms) Bpk, 1978), (which includes a brief mention of Muafangejo), Nico Roos describes the eurocentric art of SWA as essentially nineteenth century. For a critique, see my 'Nambian Art', *op. cit.*, pp. 4–5. A more inclusive overview has been provided in Adelheid Lilienthal, *Art in Namibia* (Windhoek: National Art Gallery of Namibia, 1997).

30 Haufiku, *op. cit.*

31 Rosen, *op. cit.*, p. 7.

32 Bishop Colin Winter of the Anglican Church was Bishop of 'Damaraland' (SWA) from 1968 to 1972. After Muafangejo

completed his studies, Winter assisted him in establishing a studio and employed him as an art teacher at St Mary's mission school in Odibo (Muafangejo: The text of the linocut *Zimbabwe House*, 1975). The contradiction between the lino-text description of Winter as the First Bishop of the diocese of Namibia and Muafangejo's 1975 work *Three Bishops of Damaraland*, which acknowledges Winter's actual title and role as the 'second' bishop, may serve to acknowledge his contribution to sociopolitical change in Namibia.

33 In my view, the linocut evokes the prejudice evident in Rev. Placide Tempels' ontological Bantu philosophy of 1969 that 'the natural aspiration of the Bantu soul was . . . to be able to take some part in our superior force', Placide Tempels, *Bantu Philosophy*, English trans. (Paris: Presence Africaine, 1969) and in William Blake's poem *The Little Black Boy* (1789): 'I am black . . . but O my soul is white', M.L. Rosenthal (ed.), *Poetry in English: An Anthology* (Oxford: Oxford University Press, 1987), p. 486. Although the two early etchings, *Jesus with his Disciples* (1969) (where a bishop represents Jesus) and *The Bishop* (1969) also present an imposing figure, which may denote Winter, the 1985 linocut *Bishop O. B. Winter with Peter Kachavivi*, portrays Winter as a humble man committed to working with the Namibian people. Together in exile, in an ambience of equity and shared purpose, Katjavivi and Winter 'clear the ground' by sweeping autumn leaves.

34 Haufiku, *op. cit.*; Theodor Ngololo, a former close friend of Muafangejo at St Mary's mission, Odibo, whom I interviewed in Windhoek, with translation by Elia Ilimali, on 1 April 1995.

35 Olga Levinson, 'The Life and Art of John Muafangejo – The Moving Story of an Artist in Troubled Times', *SWA Annual* (Windhoek: SWA Publications, 1981), pp. 107–110.

36 Pedro A. Vorster, 'The End of an Enigma' (Windhoek: *Windhoek Observer*, Saturday 5 December 1987), p. 42. This statement was selected because it is so revealing of the status quo. It was made in oblique reference to Muafangejo's 1968 work *Adam and Eva*. Writing under the pseudonym Deutromite (Orde Levinson, *op. cit.*, p. 403), Vorster made a significant contribution to the understanding of Muafangejo as an artist in his newspaper articles, which resonated with extensive quotation of Muafangejo based on interviews that commenced in 1985.

37 Waldemar Januszczak, 'Commonwealth Institute', (London: *The Guardian*, Tuesday 17 May 1983), p. 11. This critique is one of the most progressive in Muafangejo's

career. Nevertheless, a more comprehensive overview is warranted, particularly with regard to inclusion of Muafangejo in publications in Finland and Sweden.

38 Haufiku, *op. cit.*; Ngololo, *op. cit.*; Veronica Shindinge, Muafangejo's close associate from the Lutheran church, interviewed by Pinehas Shipena in Oshakati for the UNAM Kwanyama History and Culture Project, 20 December 1996.

39 Haufiku, *op. cit.*

40 *Ibid.*

41 Shindinge, *op. cit.*

42 Ottilie Mwookwandje Kayofa, fellow student when Muafangejo was artist-in-residence at Rorke's Drift in 1974, interviewed by Wilhelmina Mpingana Shikomba, Ohangwena region, for the UNAM Kwanyama History and Culture Project on 15 February 1997.

43 Pedro A. Vorster, 'Talent: he understood the call but he was wounded by the spear of time' (Windhoek: *Windhoek Observer*, 12 August 1989), p. 70.

44 Ngololo, *op. cit.*

45 In her critique of South African perceptions of Azaria Mbata, who, having taught him at Rorke's Drift, was a seminal influence on Muafangejo, Rosen (*op. cit.*) places emphasis on the perpetuation of apartheid preconceptions about Mbata as a rural African artist.

46 This interpretation is strengthened by the emphasis placed on the separation between the table legs and the feet of the White woman in the interview panel. Although marginalised, she is free to 'move'. The broken outline of the trees under the table may be a reference to the location of the art school, but could also be interpreted as suggestive of growth, which will in time overturn the rigidity of the system.

47 Muafangejo may have tried to counter emotional instability in the linocut *Zimbabwe House* (1975), where the art provides a forum for personal testimony. In this torrent of text, he locates his loneliness, anxiety and consequent accusations of madness within a comprehensive overview of his life, which achieves resolution in the philosophy that 'There are just two great human needs: Light on the Mystery of life and Life for the Mastery of life'.

48 Haufiku, *op. cit.*

49 *Ibid.*; Shindinge, *op. cit.*

50 This allusion to movement and instability could also be pertinent to Shindinge's description (*op. cit.*) of a period in which Muafangejo was constantly moving from one town to the next in an attempt to escape police surveillance.

51 Younge, *op. cit.*, p. 1.

52 This statement, quoted from Max Horkheimer's inaugural lecture as director of the Frankfurt School in 1931, appears in Horkheimer's *Sozial Philosophische Studien* (Frankfurt: Fischer Taschenbuch Verlag, 1972).

53 Following Sundermaier, *op. cit.*, p. 28, this work also served to counter rhetoric that appropriated the biblical text on Noah's sons as a justification of apartheid. The claim was based on the supposition that descendants of the three sons, Ham, Shem and Japheth, formed separate races of peoples. Accordingly, in the interests of apartheid ideology, the curse of servitude placed by Noah on Canaan, the son of Ham (*Genesis*, chapter 9, verse 25) was perceived as a justification for the subjugation of Black peoples.

54 Bishop Auala of the Evangelical Lutheran Ovambo-Kavango church held the South African armed forces responsible for the bombing of the printing press at Oniipa on 11 May 1973. He attributed this to the criticism in the church newsletter *Omukwetu* (Friend) of South African attempts to impose an 'Ovamboland' election in order to enforce the apartheid Bantustan policy of nominally independent homelands in the north (Katjavivi, *op. cit.*, p. 75). The second attack took place on 19 November 1980.

55 The 1981 linocut, *Anglican Seminary Blown Up* (which laments the third attack on the St Mary's mission at Odibo), extends the symbolism to affirm a bond between Christianity and customary belief. The Kwanyama text implores Pamba (the ancient term for God) to send Kalunga, the supreme being (the term adopted by missionaries in reference to God) to watch over them, as designated by the enormous eye above the mission. (Peter Mbenzi, lecturer in Ndonga and authority on Kwanyama, whom I interviewed in Windhoek on 30 November 1995.)

56 Haufiku, *op. cit.*

57 Muafangejo's use of the meaning of his name to denote the intention of a work is also evident in the 1986 work, *Swakopmund*, which depicts the coastal resort of its title using vibrant abstract motifs, in which his name is given in the lino-text as Muangejo. This can be translated as 'You also belong to me' (Mbenzi, *op. cit.*). Muafangejo's claim to shared ownership of this White-dominated settler town and original harbour for German South West Africa, confirmed his status as a Namibian as opposed to the continued assumption within the conservative majority of the pre-Independence White sector that Black Namibians were migrant labourers who belonged in the designated 'homelands'.

58 Genesis, chapter 37, verses 23–36.

59 *Ibid.*, chapter 47, verses 5–10. In this work the depiction of Black and White faces in a row of 'traditional' houses divided by upright spears could be a reference to the divisive attempts to establish a South African-friendly, pseudo-independent state composed of ethnically based second-tier governments achieved via 'elections' excluding Swapo (Pütz, *et al.*, *op. cit.*, p. 25), as possibly denoted by the blank area in the space allocated for a face on the far left. The final register depicts the scene in Genesis 47 in which Joseph, the liberated slave who has become governor of Egypt, having become reconciled with his brothers, introduces his father Jacob to the pharaoh.

60 Although the death certificate (A08100, entry no. 401/1987919) declares Muafangejo to have died from pneumonia, there were newspaper reports that he suffered a heart attack (Anonymous, 'Kunstenaar se werk baie werd na dood' (Artists's work of great value after death) (Windhoek: *Die Republikein*, 3 December 1987), p. 4.

61 Ian McLaren, 'PUBLIC AUCTION, Estate Late John Muafangejo' (Windhoek: [Advertisement in] *Die Republikein*, 3 October 1989), p. 9. Muafangejo's will left 80% of his estate to his mother (or in the event of her death, to his siblings) and 20% for a trust to be administered by the Anglican church 'to train an artist from Namibia', (Windhoek: Estate No. 123/88, Master of the High Court, 1988).

62 Gilmour, *op. cit.*, p. 324. In 1989 the SWA Arts Association initiated a small arts workshop called the John Muafangejo Art Centre in Katutura, Windhoek. This was re-launched in 1994 as a fully fledged informal art centre providing studio space and training for Namibian artists without access to formal art education. (Annaleen Eins, Director of the National Art Gallery of Namibia, whom I interviewed in Windhoek on 2 September 1997.)

About Face: Aspects of Art History and Identity in South African Visual Culture

Colin Richards

. . . to represent someone or . . . something has become an endeavour as complex and as problematic as an asymptote, with consequences for certainty and decideability as fraught with difficulties as can be imagined. [In addition] the notion [of] the colonised . . . presents its own brand of volatility. Edward W. Said [1]

Visions

Impossibly overshadowing colonialism, the apartheid vision has ensured that even to speak *about* cultural others – let alone speak *for* them – is to risk reproducing its repressive regimes. In writing here I cannot represent other voices, but if I do it is only by default.

Given an apartheid vision, we might also speak of an 'apartheid gaze'. Like other gazes it colonises. It regulates meaning; it interrogates, maims and murders. While race monopolises this gaze, it incorporates other exploitative visions – like classism, sexism and ethnic prejudice. It will survive the laws that bolster it and outlive our generation. Colluding with other oppressive visions in Western ocularcentrism,[2] this gaze reveals the naked eye of Western scopophilia. Spotted with blindness, it produces its own field of discriminations. While totalitarian, the apartheid gaze is not total. Its culture spawns a counter-culture. Its pseudo-traditions are confronted by 'other' traditions. In facing down apartheid culture, the culture of resistance has often only been able to glance at a more imaginative future out of the corner of its eye. It has had little choice. Its struggle has mostly been to create conditions for creativity. It has seldom created those conditions itself. The challenge now is how to begin to realise what has only been glimpsed through fissures in the finally declining white nationalist hegemony. This process has begun. While the cultural struggle continues across a broad front, its terms appear to be shifting: shifting from the demands of combat to those of self-definition, from strategies of boycott and confrontation to those of critical engagement. Some fleeting (and non-mystifying!) signs of this have been noticeable since the early 1980s, perhaps even before, although these have been frail and difficult to sustain.

Albie Sachs' recent plea, from within and to the broad liberation movement, for cultural openness and critical introspection signals this shift.[3] Speaking to a Swedish audience not long ago, he had this to say:

You [Swedes] know who you are. Perhaps your artists have to explore underneath all your certainties, dig away at false consciousness. We South Africans fight against real consciousness, apartheid consciousness, we know what we struggle against . . . But we don't know who we ourselves are. What does it mean to be a South African? The artists, more than anyone, can help us discover ourselves.[4]

For Sachs, culture and identity interweave: 'Culture is a very deep thing. It's about who we are. It's what we mean when we say we are South Africans'.[5]

Penny Siopis
Exhibit: Ex Africa, 1990
Collage, oil, screenprint,
perspex and found objects
126.2 x 124.5 cm
Collection of
Johannesburg Art Gallery
Courtesy the artist
Photo: Jean Bundit

Sue Williamson
*For Thirty Years Next
To His Heart*, 1990
Colour laser prints in
hand-made frames
(49 in total)
196 x 262 cm
Courtesy the artist

Nationalism

An obvious dynamic in this (re)constructing of selves and others is nationalism. Notions of nation-building permeate cultural rhetoric across time and the political spectrum: from Mangaliso (Robert) Sobukwe's pan-Africanism[6] to the African National Congress' (ANC) humanistic cultural pluralism,[7] from F. W. de Klerk's 'new' South Africa[8] to Andries Treurnicht's 'old' South Africa. All in one place at one time.

It is hardly surprising that uncomfortably similar rhetoric sometimes articulates the cultural visions of those otherwise in radical and even violent opposition. For example, the tag 'unity in diversity' found in a recent article in *Mayibuye* (the journal of the ANC) – titled 'Culture: the Antidote to Apartheid'[9] – recalls the self-same slogan of the controversial Republic Festival of 1981. At that time, the Apartheid State's cultural celebration of its hegemony was heavily contested by those only now beginning to emerge from its long shadow.

Both the struggle for liberation and the maintenance of the status quo is often cast in terms of nationalism. Ethnicity, like nationalism, clearly involves achieving political goals – getting and keeping power, mobilising a following 'through the idiom of cultural commonness and difference'.[10] Tribal constructs play a powerful part in both.[11] The Apartheid vision of white Afrikaner nationalism has segregated ethnic groups' 'self-determining' into nationhood. African nationalism has flatly challenged this.

Ploughing the waves of the sea is probably easier than finding common ground in conflicting nationalisms within South Africa. Powerful, if imaginary, 'nationhood' often betokens wishful thinking. As E. J. Hobsbawm observes:

where ideologies are in conflict, the appeal to the imagined community of the nation appears to have defeated all challengers. What else but the solidarity of an imaginary 'us' against the symbolic 'them' would have launched Argentina and Britain into a crazy war for some South Atlantic bog and rough pasture?[12]

Hobsbawm's characterisation of nationalist movements of the late twentieth century as 'essentially negative', 'divisive' or 'defensive reactions'[13] may relate more to the disintegrating Apartheid State than to the South Africa to be. Does nationalism provide useful leverage in the process of cultural democratisation? Is there a South African nation at all?[14] Currently, South Africa does not have an integrated border. If we did, it would still be the one drawn in by colonialism. Within our borders, the material and symbolic conditions for open exchange between black and white are effectively absent. We still know little about each other beyond the narrow roles that history has cast for us. How is all this registered in visual imagery?

Narrating History: Historiography

The path to knowing the South African past, like the present, divides and multiplies.[15]
Historiography is itself a *present* site of struggle.[16] As V. Y. Mudimbe has it, history is legend,
'an invention of the present'.[17]

Historiography doubtless plays a role at many levels in the construction of a South African
cultural identity. Going the way of available historical narratives we find a discordant clash of voices:
indigenous, settler, liberal, British, Afrikaans, radical. Some are patently nationalist, some not.
Predictably, it is only white Afrikaans nationalist historiography that has extruded a tight-fitting
graphic imagery. Quintessential here are the works of artist W. H. Coetzer, perhaps most
programmatically codified in his illustrated book, *My Kwas Vertal* (My Brush Tells, 1947). In it,
Coetzer pictures the chosen, the unchosen (other 'groups'), and their conflicts. And, in our land of
myths,[18] Coetzer charts that most heavily mythologised and significant of themes – the land itself.

For the rest, ideology and image indulge in more diffuse and eccentric relations. For instance,
British settler visions of the land encoded in landscape painting may be less ideologically advertent
but they still bear the colonial imprimatur. I will return to this later.

The dynamic between visual image and historiography works in the other direction – images as a
(re)source for historiography are beginning to be recognised. This partly relates to a changing notion
of what stands for admissible evidence in the court of history. Luli Callinicos, in her introduction to
the catalogue for an exhibition of 1991 titled *Art and the Media* notes:

> Until very recently, the only historical evidence that scholars took seriously was the written
> word. Partly responsible for this was the monopoly that European culture held for centuries
> over the production of printed documents. In Europe and its colonies, it was more likely that the
> deeds and utterances of the rich and powerful would be immortalised in official documents,
> newspapers and parliamentary proceedings. The lives, struggles and opinions of ordinary men
> and women – often illiterate – were for the most part officially ignored if not suppressed.
> Reconstructions of the past in the form of popular memory, oral testimony, storytelling or
> graphic art were held to be unreliable because they were facile or fanciful. What was
> overlooked was that the printed evidence can be as biased as a conversation – perspectives
> differ according to one's position in society.[19]

Legendary History: In the Beginning

Beginnings are stressed in narrating, not least in historical storytelling. An emphatic statement
about origins betrays a desire to control history. When history begins is crucial. The idea that San
Rock art is 'prehistoric' projects it beyond (before or outside) 'our' history.[20] From here, a familiar
plot ensues, a plot that sets the holy alliance of history–culture–civilisation against the calamitous

combination of pre-history–nature–primitive. This plot manufactures identities and otherness as suspect as they are endemic to Western culture.[21] The plot thickens in the representation of African culture cheek-by-jowl with dinosaurs in the museum-like ambience of Natural History, as opposed to Cultural History, the privileged domain reserved for white settler cultures.[22]

Colonial Grahamstown was a frontier town. It still is, currently the site of a major national cultural festival. It was here that Barbara Masekela made the first significant cultural interventions for the African National Congress after its unbanning.[23] In this town's Natural History Museum we find a section called 'Peoples from Africa'. This is (naturally) reserved for black people. (In my childhood black people were often called *naturelle* – naturals – in Afrikaans.) A simulated cave houses a number of recessed displays. One is headed 'Rock Paintings – pictures from prehistoric times'. All are within a stone's throw of the dinosaur exhibit – *Bradysaurus Baini et al.*

Moving on we find this bare-faced proposition in the 'South Africa 1700 . . .' display: 'When the Dutch arrived in Table Bay, it marked the end of the prehistoric period and the beginning of history in our country'. Copied crudely in white paint on an otherwise largely vacant map are two almost unrecognisable 'rock paintings' – a gesture to the presence of these 'makers' of history, white settlers. For more of these makers we are forced to leave the realm of Natural History and relocate to the 1820 Settlers Memorial Museum next door. This story is told over and over again in the museums of the Western world.

Colonialism took and kept black people out of history. It was, after all, that great European, Hegel, who said 'Africa has no History'.[24] For poet, critic and (at the time of writing) Head of the ANC's Department of Arts Culture (DAC), Mongane (Wally) Serote:

> We have [as a people] been denied our right to make culture and history as free people. Yet, as we struggle against oppression, and as we defend and fight for freedom, so we enter history, and as human beings we redefine and create culture.[25]

The return of the oppressed has now taken place with a vengeance. Serote is precise about dates; for him the 1987 CASA Conference in Amsterdam marks the people's return to history.[26] In 1991 this return is irreversible. The struggle continues.

Fissures: Symbolic Violence

Present identity, tradition (history) and representation collided forcefully in a photographic exhibition held in 1990 at the Market Gallery in downtown Johannesburg. Organised by the respected journal *Staffrider*, the exhibition was opened by the then head of the DAC of the ANC, Barbara Masekela. The photographer in question was Steven Hilton-Barber. The exhibition generated a widely reported controversy.[27] Deep feelings were aroused, finding their most open expression in the angry, pained

comments in the visitors book. Some forty-seven employees of the Market Complex, including well-known actor/director John Kani, signed a petition headed by this statement:

> We . . . hereby state our objection to the exhibition of photographs of the initiation ceremony of African males. We see it as an invasion of a sacred African tradition, which has for centuries been private. We demand the removal of these photographs from public view.

Adding insult to injury, the images appeared in the mass-circulation *Sunday Star Magazine*,[28] under the rather predictable rubric 'Rites of Passage'. This publication coincided with the opening. The display was closed when the photographs were stolen.[29] The controversy was debated in a public panel discussion held at the Market Theatre on 12 December 1990.[30] The following were some of the main issues raised:

Violating cultural privacy: the photographs were held to be an invasive record of a ritual held sacred by a living community. This is not a simple matter. Hilton-Barber stated that permission to photograph the ceremony 'was granted by the principal of the school, on condition that I had been circumcised. This was the only condition attached to my access to the ceremony . . . Both the initiates and the elders were aware of my presence and my purpose.[31] Vusi Ngidi, spokesperson for the workers, suggested that the broad community structures, like the Congress of Traditional Leaders of South Africa should have been consulted.[32]

(Re)presenting 'others' as barbaric, insensate, objects: this objectification is common in photographic practice, and crosses another powerful but dubious Western cultural tradition, namely representing the contemporary 'other' as specimen – primitive, timeless, or at any rate, ahistorical, before our time, and exotic.

Asserting Tribal identity: this was especially problematic given the public metropolitan setting. As such, the exhibition was considered misplaced and ill-timed given the broad political climate. Tribalism has often been an historically divisive force in the general quest for (black) national unity. According to Ngidi: 'We are in a political crisis of transition, the pictures encourage tribalism . . . The social-minded artist should not work with tribalist images for now, it may be relevant, but the time is not right. Maybe in ten or twenty years'.[33]

Double standards on nudity: this involved questions of pornography, sexism and racial mockery. The show was said to exploit racist attitudes towards nakedness. Noteworthy here is the fact that showing bare-breasted 'traditional' women on postcards is still widespread in South Africa. The same cannot be said for white women. Or, for that matter, as one report pointed out, white boys undergoing initiation at an Afrikaans University.[34]

All these points open onto deeper, more intractable questions: who ultimately holds the rights to cultural material, its appropriation, representation and dissemination? This particular form of

production and publication (the art exhibition) begs questions of broader cultural practices. The appropriation and display of imagery of any source – living or dead – is now a naturalised routine of a good deal of Western artistic behaviour. This routine – the symptom of a sort of vicarious vitalism – is itself one of the beloved spectacles of international postmodernism. The assumed rootlessness of cultural signs motivates postmodern celebrations of every shade.

The casualty here is historical specificity and all this might mean. The value to South African artists and cultural workers of modelling local practices on international postmodernists, feeding off the image-bloated corpse of their own and 'other' cultures, is debatable. Moreover, addiction to absolute freedom of expression suggests that anything may be pictured and published. In South Africa this 'freedom' is, as elsewhere, largely conditioned by the needs of the dominant order. While infringing the right of a culture to self-protection, the rights of an arguably naive, if well-intentioned, well-placed individual – 'I have attempted to act with integrity and with a sense of responsibility and sincerity' [35] – to picture whatever s/he considers worthwhile are upheld.

Turning on questions of censorship and freedom of expression, this continues a heated debate in the larger cultural domain. Editor of *Staffrider*, Andries Olifant, considers the controversy evidence of 'a society where much still remains to be done before freedom of expression and the right to criticism become common values'. [36]

Framed

Which evaluative frameworks legitimately apply here? Can the different implied frameworks be reconciled? The photographer insisted that he was a 'documentary photographer and not a cultural anthropologist'. [37] In asserting that the work be assessed on its quality as photography – 'the standard of my photography' – the photographer seems to privilege an autonomous aesthetic realm over all others. Different criteria might be derived elsewhere, not least, politically conscious ethnographic practice. [38]

However, the photographer is also at pains to institute another dimension of value – that of the document: 'It was my concern that this ritual should be documented, not only to add to the growing photographic cultural heritage of our country, but to help educate, enlighten and broaden understanding of different cultural practices'. [39] The photographs thus constitute evidence, facts appropriate to the historical record. [40] Aesthetic contemplation (as it is commonly understood) is not called for here, for it may undercut the documentary status of the work. I am reminded of Walter Benjamin's comment about Jean-Eugène-Auguste Atget's photographs of the depopulated streets of Paris, which 'become standard evidence for historical occurrences, and acquire a hidden political significance. They demand a specific kind of approach; free-floating contemplation is not appropriate to them'. [41]

Hilton-Barber insists on this function: 'My photographs are a factual documentation of a

particular cultural practice and I attempted to record this ritual as accurately as possible'.[42] Interpretation of this 'factual' record apparently involves 'the question of perception',[43] not of the photographer, but of others. The contextual implications, ethical or otherwise, are seemingly outside the concern of the photographer.

Speaking of 'allowing the situation to speak for itself',[44] or referring to the 'photographs themselves', or 'factual documentation',[45] Hilton-Barber appears to hold that the act of photographing is somehow value-free. Further, that photographs give unmediated access to the reality they purport to show. If true, this seriously misunderstands and underestimates the power of context and the admittedly complex question of mediation. It is a power in which judgement and choice is unavoidable. Hilton-Barber himself acknowledges that one 'of the most enduring problems faced by documentary photographers is that of the distance between themselves and their subjects'.[46] This distance – and the judgement it necessarily occasions – is foregrounded when we consider this statement made by the photographer in the public debate: 'I attempted to document a *basically authoritarian* situation in a way that would allow the situation to speak for itself'.[47] Value-judgement is clearly implied by the stressed words. It is perhaps understandable that these

The value to South African artists of modelling local practices on international postmodernists, feeding off the image-bloated corpse of their own and 'other' cultures, is debatable.

two words were dropped from the phrase when the piece was published in *Staffrider*.

This implied transparency and value freedom – both in documentary 'facts' (photographic evidence) and the absolute autonomy and exclusive relevance of 'aesthetic' criteria (good photography) – face the challenge of the actual power relations that structure the larger social domain in South Africa. An ethnological point of view may make this political dimension clearer. We might, for example, consider an exhibition at the Peabody Museum, Harvard University, held in 1986, 'From Site to Sight: Anthropology, Photography and the Power of the Image', which addressed, sometimes rather tentatively, this and related issues. There Melissa Banta and Curtis Hinsley argue that: 'Intimacy always carries with it the burden of respect and responsibility . . . and photographic intimacy, which involves the special exposure of human lives, adds a special need for sensitivity'.[48]

This 'exposure' is played out in the image-text relationship in interesting ways. It is noteworthy that the captions to Hilton Barber's photographs – which might be said to anchor and direct the meaning of the image[49] – shifted given the context of display. In the initial context – the exhibition – the trivialisation of deeply felt private cultural practices appears to have stemmed from an implied equation of art with entertainment. In this, the public art gallery is felt to be the space of light relief,

of escape, of quick sensation. This perception would have been strengthened by the *Sunday Star Magazine* article, the second context. Such magazines divert readers on a dull day. As indicated, the photographer's response to the controversy – 'In Good Photographic Faith' – was later published, with images, in *Staffrider*. This constitutes a third context, arguably the most sober. Some textual shifts between these different contexts are worth noting. In the exhibition, one figure was captioned, 'The initiates eating *pap* and *maroga* (porridge and spinach)'. In the *Sunday Star Magazine* this caption was included within the image field with the addition of 'They must "close the anus" while eating'. When reproduced in *Staffrider* (after controversy erupted) that caption is reduced to 'Eating'. We might ponder the reasons for these shifts.

Striking, too, in the published apologia is the dropping of three images that show frontal nudity, including the image on the *Sunday Star Magazine* cover. These, with the editing out of the patently value-laden words mentioned above, suggest increased consciousness of the power inscribed in photographic practice.

We might take special heed of Banta and Hinsley's words in a chapter aptly titled 'The eyes that look back at us' (recalling the image on *Sunday Star Magazine*'s cover):

In a fragile, politically splintered world, we need to see each other clearly . . . photography wields more power than ever before and carries heavier ethical burdens. Because the ethical issues are not inherent in the technology itself but derive from its uses, the impact of photography depends less on the camera than on the person standing behind it.[50]

In their original publication and exhibition these photographs were clearly felt by the workers to be a form of symbolic violence.[51] Loaded pictures, they represent 'tribe' as wildlife – fair game for the dominant culture. This species of cultural trophy-hunting is a familiar cultural pastime in the neo-colonies.

Look Again

Looking at 'others' also informed a recent project (1990) by Cape Town artist Sue Williamson. Part of Williamson's intention, like Hilton-Barber's, was to record. Here the object is itself a record of sorts:

For Thirty Years Next to His Heart is a record of every page of Ncithakalo John Ngesi's passbook, issued to him on 20 October 1955, and carried in the inside pocket of his jacket every single day until the day in 1990 when he gave it to me.[52]

Here, socially constructed identity – a named person identified by a *dompas* (passbook) – and history fuse differently. Whatever its particular difficulties this seems a more considered and politically visible approach. Williamson states:

It's gone now, part of our recent historical past. Future generations may find it difficult to comprehend the power the passbook had over the lives of black South Africans, but that power was complete. No passbook, no rights . . . [This work presents] the record of one man's life, as prescribed by the State.[53]

Williamson also installed metal trunks in the gallery of the kind that migrant workers use to store and transport their earthly possessions. Here, the artist wished to develop 'the idea of baggage which has to be carried through life, and loads, and identifying labels and time passing, and journeys'.[54] This work points to the changing relationships between lived history and visual art that have begun to mark both historiography and visual culture in South Africa in new ways. The graphic dimension of History now motivates critiques arising from within the dominant discourses. History Painting proper, and popular (mis)representations, are in fact answering 'other' emerging historical narratives. This work usually seeks a more self-critical relationship to the politics of representation and the representation of politics. Some artists do this by simple juxtaposition of terms in cultural shorthand, while others invoke a rather more searching look.

In her *Exhibit: Ex Africa* (1990), Penny Siopis collages and overpaints 'generic' history pictures culled from various sources, including history text-books – the images 'We were brought up on . . . stereotyped images of colonised and colonisers. Our textbook stories were illustrated by them and we copied them for our history projects'.[55] Buried in and interleaved between these layers of 'copied' repeated representations are identifiable historical figures – some well known, some not. Perhaps most trenchant are the representations of Saartjie Baartman, the so-called 'Hottentot Venus'. From around 1810, Saartjie Baartman's abused body became the screen for a spectacular compound of pseudo-scientific and popular projections – blends of bitter racial and gender prejudice.[56] Her body, her story, is paradigmatic of the scopic savagery of Western looking at 'others'. Hers was a journey to the heart of 'civil' darkness, a cultured world.

In *Exhibit: Ex Africa*, half-innocent, half-covered (by an actual Victorian apron, *objet trouvé*), the edenic 'natural' habitat of the likes of Saartjie Baartman is repeated *ad nauseum*, despoiled by cliché in an intolerable history. The apron recalls Saartjie's 'veil of shame'.[57]

(Re)visions: Looking Further

That history and visual culture are finding new relationships is the achievement of the broader struggle in and outside the country. There were significant cultural events outside South Africa in the 1980s, which amongst other things, sought to shift and consolidate cultural power within the country.[58] A revisionary impulse is now visible and voluble in South Africa, having first registered its presence in the dark days of the 1980s, the decade of emergency.[59] This impulse finds expression in a wide variety of national cultural activities and events: exhibitions, art history conferences,

publications, festivals, national art competitions. Many of these directly address the question of identity.

In 1987, a conference of the South African Association of Art Historians saw its task as addressing the issue of 'Re-writing the Art and Architectural History of Southern Africa'.[60] The number of books published on South African visual culture, ranging from the cultural work of the Khoisan to contemporary art, increases year by year. These publications are often avowedly revisionary, attempting to rewrite, as well as fill the gaps in, the already written.[61] The number of comprehensive catalogues for major 'revisionary' exhibitions is also a manifestation of this tendency.

The modes of selecting and judging many of the major national competitions have also been challenged by progressive movements with varying degrees of success. These challenges address a broad range of issues, from including judges more representative of all the communities in South Africa, to deeper questions of values.[62] Identity lies at the heart of many of these challenges.

Fusion: Here and Now

Many of these exhibitions have been motivated by the need to achieve something 'truly' South African.[63] For some, this has been a relatively simple matter of extending the canonisation of names to include the appropriate quota of 'others' (blacks, women). For others, a more radical structural alteration is necessary to give substance to concepts and relationships more congenial to the emerging culture. Incidentally, it would be wrong to assume that work produced by black and non-black artists was never 'integrated' in the sense of being seen together. The gone-but-not-forgotten immorality act (1950) left some forms of intercourse alone.

Naturally, in order to interfere better elsewhere. In 1971, the Minister of Health, Dr Carel de Wet insisted, 'Contact across the colour line is welcome so long as the motive for contact is the greater separation of the races'.[64]

Interesting here was the Pretoria Art Museum's, 'Looking at Our Own: Africa in the Art of Southern Africa', (*N Blik Op Die Eie: Afrika in Die Kuns Van Suider-Afrika*, 20 June – 15 August 1990). The dominant cultural categories are still 'groups' articulated in the language of apartheid. In that respect, this 'pluralist' show proved to be more backward-looking than looking back at history.

Most revisionary exhibitions have been mainstream events, well-documented and often lionised by artworld cognoscenti. Distinctly off-mainstream was a more modest exhibition in 1989, called 'South African Mail Art – A View From the Inside', which engaged issues of race, class and gender identity. It also consciously identified itself with the liberation struggle inside and outside the country.[65] As it was to travel abroad, this exhibition was organised within the terms of the selective cultural boycott. It was supported by the UN Special Committee Against Apartheid and received the support of many progressive cultural structures within the country.

The organisers invited women from town and countryside to submit a postcard communicating

Willem Boshoff
Blind Alphabet Project,
1995
Installation view, São
Paulo Biennale, 1995
Mixed media,
dimensions variable
Courtesy the artist

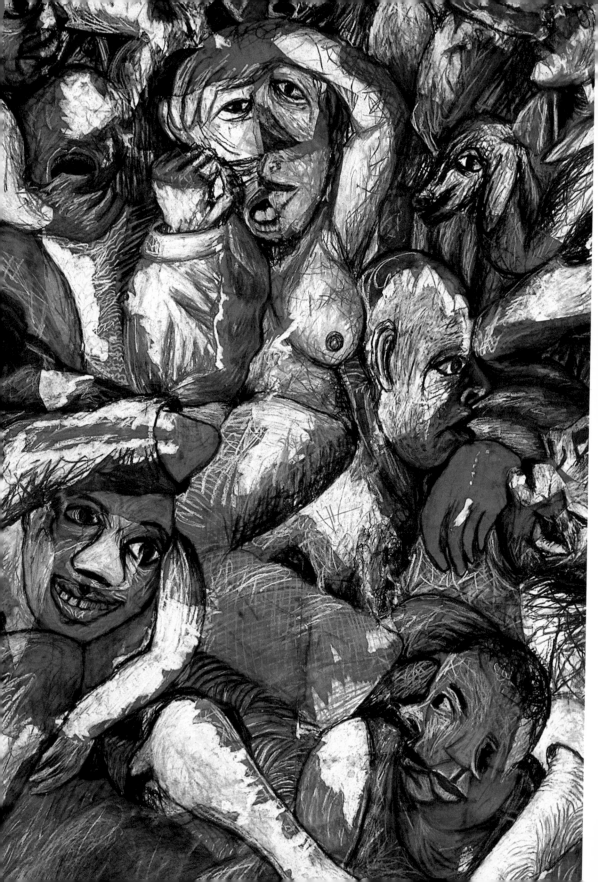

Helen Mmakgabo
Mmapula Sebidi
Where is my Home?
The Mischief of
Township, 1988
Pastel and
collage on paper
200 x 147 cm
Courtesy the artist
Photo: Athol Franz

their experience of being in South Africa in 1989. Any form of expression by individuals or collectives was welcome. Some card-making workshops were organised with community cultural workers, relatives of maximum security prisoners held at Robben Island and other prisons, children in the townships, and women in the rural areas. All work received was exhibited.[66] The only condition was the signing of an anti-apartheid pledge:

We reject apartheid in all its forms. We pledge to work for the formation of a free and democratic culture in South Africa. We recognise that such a culture can come into being only with the removal of all forms of economic, political, social and educational oppression, including all discrimination based on race, sex and age.

In many respects the exhibition echoed the project of British feminists in the late 1970s, emphasising communication, broad creative rights, the power of the collective.

Some important questions were aired during the process. Tensions between gender, race and class oppression inevitably surfaced. While recognising that the notion of 'shared oppression' ('all women') glosses over the specificities of the oppression of working class black women, solidarity across these boundaries was considered an important strategy by the organisers and many participants. Nevertheless, the organisers did feel that uncritical imports of European or internationalist ideologies of gender oppression may result in its force being lost in the local setting – being either irrelevant or considered yet another form of neo-colonialism.[67] Some critics saw separatism as sexist and questioned the value of a gender-specific exhibition against sexism. For the organisers, the reality of gender-specific oppression called for gender-specific action, at least as a start. This facilitated solidarity and challenged that oppression.

Inevitably, questions of value were also raised. Were received notions of art and aesthetic value appropriate to local cultural expressions, for instance, 'peoples' culture'?[68] These questions involve debates about craft, available symbolic and material resources, primarily educational opportunities, access to equipment and facilities, and the state of usable, community-based visual traditions.[69]

Such debates have boiled over into mainstream art events; for example, the Grahamstown Festival of the Arts, held at the 1820 Settlers Monument, once called 'the English equivalent of the Voortrekker monument' by Nadine Gordimer.[70] Festival Young Artist awards were made to two black women – Helen Mmakgoba Mmapula Sebidi in 1989 and Bonnie Ntshalin Tshali (with Fee Halsted-Berning) in 1990. Are these awards simply gestures, instances of what Gayatri Chakravorty Spivak cautions against – the putative centre welcoming 'selective inhabitants of the margin in order to better exclude the margin'?[71] Even amidst such questioning, these awards are to some degree the fruit of critical interventions on the part of the excluded or marginalised majority. History (tradition)

and identity figure prominently in Sebidi's work. She comments on her *The Child's Mother Holds the Sharp Side of the Knife (Mangwana Otshara Thipa Kabhaleng*, 1989):

> I see a woman chained, pulling her tradition . . . In African tradition they say it is the woman who holds the sharp side of the knife. Here, woman is holding the knife in this way and is saying – this is what I have to do, and it's my way.[72]

The imaginative effort here is to express the uncomfortably different identities of the rural and urban woman worker. Sebidi grew up in a rural environment and came to town as a domestic servant before taking up art.

As already noted, it was at Grahamstown that the ANC's Barbara Masekela made a controversial intervention in 1990. A strategic involvement of the sort in which she engaged remains a matter of continuing debate. Resisting co-option, risking legitimising exclusive cultural events parading as inclusive, while challenging and re-appropriating existing cultural forums and resources to advance democratic, free culture remains one of the major challenges facing South African artists and cultural workers.

Clearly, visual culture has a contribution to make in the coming phase of social reconstruction. From the point of view of the ANC, the desired outcome of these interventions is 'a strong and proud South African identity'.[73] A strong identity requires a sense of place.

Land(e)scape

A lack of exactly this sense of place has probably always unsettled settler culture. This appears nowhere more evident than in attitudes to the land. Writer J. M. Coetzee argues that one persistent settler vision sees the land as 'vast, empty, silent [and]. . . unchanged'. This vision signals 'a failure to imagine a peopled landscape, an inability to conceive a society in South Africa in which there is a place for the self . . . a failure of the historical imagination'.[74] Underpinning this vision are two different conceptions of wilderness: one is linked to British colonialism with its obsessions with the border between order and disorder, culture and barbarity; the other with Afrikaner isolationism, which saw land as refuge, the mythically privatised place of purge, purification and promise.[75]

Landscape painting, in the tradition of white nationalist mythology, with its historical mystifications, has now largely degenerated into a sub-genre of designer cosmos. Coetzee's pressing question remains important: 'Is there a language in which the people of European identity, or if not European identity then of a highly problematic South African-Colonial identity, can speak to Africa and be spoken to by Africa?'[76]

Some white artists still try and deal with questions of land, place and identity. Indirect and allegorical, Clive van den Berg's Faustian images present idyll and purgatory in collision. Here, unidentifiable earth is distended with promise as bad faith, with an unrepresentable history, all scourged and graced by metropolitan desires.

More direct, is 'field painting' – abstract painting by black artists – which perhaps suggests a wholly different set of relationships. Most commonly experienced in a collective workshop format out of doors, this genre may point to a more relaxed, rooted and expanded sense of place. The major contemporary force here is the Thupelo Art Project, based in Johannesburg, whose aim, according to David Koloane 'is to create opportunities for genuine self exploration amongst artists'.[77] The project's aesthetic and material roots lie in a somewhat strident, American-oriented and supported high modernism refracted through local conditions.[78] Amidst much (white) critical worrying about the historical relationship between Abstract Expressionism, the Cold War and American imperialism in contemporary South Africa, some black artists have asserted their right to paint in this tradition. Or, as they would have it, make this tradition work for them.

Koloane resists the criticisms of the practice, which for him suggest white prejudice about black identity:

[Critics] would seem to propagate a view that the naïve and somewhat crude ethnic identity of black artists has to be maintained regardless. Creative experience is not perceived by them as a long-term and varied process leading towards maturity. It is regarded, rather, as a quick-solve formula devised to establish an identity in the art market or even a political affinity.[79]

Fusion: Other Times, Other Places

This attempt to clear a place within immediate political pressures bespeaks another art-cultural trend that attempts to shift focus from physical to metaphysical place. These are usually 'synthetic', eclectic, allegedly transcendental visions responding to a strong redemptive impulse that runs through South African visual culture. In promising deliverance from 'politics', most of these efforts require much aura-management and entrepreneurial skills on the part of promoters and their charges.

Here artists seek – with uneven results – to reveal or develop new (re)visionary places from which to speak, new languages with which to speak, a new identity.[80] One of the more compelling of these is the sculptor and religious leader Jackson Hlungwani. Aggrey Klaaste, editor of the *Sowetan* newspaper, speaks of Hlungwani as:

An elite, a mystic [who] . . . cannot be dismissed [but] should not simply be indulged. What meaning does he have in these testing times? He crosses many cultural barriers yet he has found a unique identity . . . Hlungwani reminds us of our essential humanity, which is both unique and dynamic.[81]

For his part, Hlungwani is explicit: 'All these people in this country must become one nation . . . I do my job to try to show people about a new world where we can be united'.[82]

Identity figures prominently in one of the very few books devoted to an individual black artist. Titled *Durant Sihlali: Discovering my True Identity*,[83] the book catalogues the radical transformation of Durant Sihlali's work from 'sociohistorical documentation' to 'the realm of self-exploration'.[84] Travel, like exile, sharpens identity. Sihlali's journey to France in 1986, according to Koloane, proved to be 'not only a physical experience [but] . . . paradoxically also a journey to the interior of [his] ethnic origin conceived through visions of his tribal lore'.[85] Koloane speaks of the 'potent ethnic presence' of these works. Historical irony also finds a place in this identity:

The large painting pieces . . . explore the paraphernalia of unorthodox objects collaged on the respective pieces. These include hollow riverbank reeds, a mirror disc, cut-away calabashes, tribal fighting sticks, a letter-carrying stick with a letter to President Botha attached to its forked end. These sticks were used to deliver their master's/mistress' letters by '*kaffir*' messengers during the colonial era.[86]

Sihlali himself refers to a psycho-history of dreams and premonitions as the well-spring of his art. In these works, he responds to spiritual demands mediated through his ancestors;

All the while my contact with the *Idlozi* had found expression in my art. But I did not show these paintings to gallery owners. While I was being dictated to by ancestors, the gallery owners were being governed by commercial whims and white people's perceptions of black art.[87]

There is here, perhaps, a false opposition between what we might call political relevance and religious feeling. Relevance perhaps relates more or less to immediate political tensions. In some quarters, the relatively unambiguous registering of these tensions in creative work has seemed a precondition of value.[88] Religious feeling is often displaced or considered mystifying in this scenario. The historical moment of this sterile confrontation seems to be passing. The political question of relevance has been a source of irritation for some black artists. Against the demand 'that the artist's work should align itself with a certain cause or purpose, affecting his community', David Koloane insists that 'creative expression is not determined or induced by events external to the demands of creative experience. Potential . . . can only develop via a journey of exploration and via other cultures, techniques and self-discovery'.[89]

This account clearly bears the mark of humanistic individualism and pluralism, primary strands of the dominant but not uncontested aesthetic ideology in contemporary South African visual art discourse.

Durant Sihlali
The Fire Place, c.1987
Acrylic, wood, paper, wire, clay
116.5 x 167 cm
Courtesy the artist
Photo: Natasha Christopher

Durant Sihlali
The Messenger, c.1986
Acrylic on wood
130 x 66.5 x 34.5 cm
Private Collection
Courtesy the artist

Identity Within and Without History

The apartheid gaze has placed identity beyond context and history. Identity has been fixed by 'nature', backed by God. Every identity – worker, woman, African, Zulu, Afrikaner – is prefixed by a static ethno-nationalist category. This fixation has maimed and crippled our cultural life. That the identity may be dynamic has been foreclosed. That people might choose different identities in different situations has been denied. The cruel economies of the apartheid vision have dissected identity, inflating its alienated fragments into a grotesque wholeness.

W. Beinart (according to John Sharp) showed that 'people's experience of "class" or "nation"' is often mediated by, and reached through, the other ways in which they define themselves'.[90] However real, such changeability may not always be comforting. Identity, fixed or fluid, can be a matter of life and death in times of emergency. Recent conflicts in South Africa are tragic testimony of this.

Conclusion

The power of culture in South Africa lies in the vital bond between symbol and substance, the imagined and the material. Ideals mix with blood. It is a volatile power. The sanitising aesthetic distance so characteristic of Western aesthetic discourse does not have, in the African sun, the easy life it might promise elsewhere.

The challenge for us is whether we can harvest this power according to needs other than those of the interrogator's room, the wounded crowd, the dusty backstreet, the isolated studio.

Our task is to uncover our history and recover our traditions, to straighten distortions, to make the negative positive; to do this with those who have been absent for so long – exiled, jailed, and marginalised. To do this in memory of those who cannot return.

Notes

1 Edward Said, 'Representing the Colonised: Anthropology's Interlocutors', *Critical Inquiry*, vol. 15, no. 2 (Chicago: Winter 1989, pp. 206–207). See also Said's comments, 'In the Shadow of the West: An Interview with Edward Said', Phil Mariani and Jonathan Crary, in Russell Fergusen, William Olander, Marcia Tucker and Karen Fiss (eds.), *Discourses: Conversations in Postmodern Art and Culture* (New York and Cambridge, MA: The New Museum of Contemporary Art and MIT Press, 1990). For 'dialogues' on these issues see also, Gayatri Chakravorty Spivak, *The Post-Colonial Critic: Interviews, Strategies, Dialogues* (New York: Routledge, 1990).

2 Hal Foster (ed.), *Vision and Visuality* (Seattle: Bay Press, 1988).

3 Albie Sachs, 'Preparing Ourselves for Freedom', in Ingrid de Kok and Karen Press (eds.), *Spring is Rebellious: Arguments about Cultural Freedom by Albie Sachs and Respondents* (Cape Town: Buchu Books, 1990), pp. 19-29. Most respondents endorsed Sachs' call for tolerance and cultural self-criticality, but many resisted the implied aesthetic poverty of products of the culture of resistance.

4 *Ibid.*, p. 146.

5 Sachs, 'Kindling a Culture of Debate', *Mayibuye*, vol. 1, no. 2 (Lusaka: 1990), pp. 42–44.

6 As an idea, nation-building has a potent pedigree. See the various writings of Aggrey Klaaste, editor of the *Sowetan*, a local black-run newspaper. Long before that, it flourished in the ideological folds of Mangaliso (Robert) Sobukwe's pan-Africanism. See his 'The State of the Nation' address, reproduced in Aquino de Braganca and Immanuel Wallerstein (eds.), *The African Liberation Reader: Documents of the National Liberation Movements*, vol. 2: The National Liberation Movements (London: Zed Press), pp. 47–52, especially pp. 48, 50.

7 Barbara Masekela, 'Culture in the New South Africa', *Contact*, vol. 2, no. 14 (Grahamstown: November 1990), pp. 4–16, especially p. 16. See also 'Preamble and Resolutions of the DASA Conference' in Campschreur and Duvendal (eds.), *Casa, Culture in Another South Africa* (London: Zed Books, 1989), p. 216; and a recent proposal by a cultural worker for a Culture Charter; CS, 'Culture: The Antidote to Apartheid', *Mayibuye*, vol. 1, no. 3 (Lusaka: 1990), pp. 60–63.

8 In his speech at the opening of parliament in 1990 President F. W. de Klerk co-opted the venerable concept of nation-building. For the State's general cultural position see the Department of National Education, *Culture: Arts Conference of 29 April 1988. Speeches and Discussions* (Pretoria: The Government Printer, 1988).

9 CS, 'Culture: the Antidote to Apartheid', *Mayibuye*, vol. 1, no. 3 (Lusaka: 1990), pp. 60–63.

10 John Sharp, 'Ethnic Group and Nation: The Apartheid Vision in South Africa', in Emile Bonnzaier and John Sharp (eds.), *South African Keywords, The Uses and Abuses of Political Concepts* (Cape Town: David Philip, 1988), p. 80.

11 On ethnicity and tribalism see *ibid.*, and Leroy Vail (ed.), *The Creation of Tribalism in Southern Africa* (London and Berkeley: James Currey and University of California Press, 1989).

12 E. J. Hobsbawm, *Nation and Nationalism Since 1780: Programme, Myth, Reality* (Cambridge: Cambridge University Press, 1990), p. 163.

13 *Ibid.*, p. 166.

14 James Barber, 'Is There a South African Nation?', occasional publication, *Jan Smuts Memorial Lecture* (Johannesburg: The South African Institute of International Affairs, 1987).

15 For a useful review of current issues in radical historiography, see 'History from South Africa', *Radical History Review*, vol. 46, no. 7 (New York: Winter 1990). See also, Christopher Saunders, *The Making of the South African Past: Major Historians on Race and Class* (Cape Town: David Philip, 1988); and Ken Smith, *The Changing Past: Trends in South African Historical Writing* (Johannesburg: Southern Book Publishers, 1988).

16 According to Ken Smith, *ibid.*, p. 2, 'charges of presentism could . . . well be brought against all the schools of history discussed in this book'.

17 V. Y. Mudimbe, *The Invention of Africa: Gnosis, Philosophy, and the Order of Knowledge* (Bloomington: Indiana University Press, 1988), p. 195.

18 See Marianne Cornevin, *Apartheid: Power and Historical Falsification* (Paris: UNESCO, 1980); and Jay Naidoo, *Tracking Down Historical Myths: Eight South African Cases* (Johannesburg: Ad Donker, 1989).

19 Luli Callinicos, 'Representing "people's history"' in *Art and the Media*, exhibition catalogue (Witwatersrand: Gertrude Posel Gallery, University of Witwatersrand, 1991), p. 1. For accounts of how history and art might relate, see Dierdre Beddow, *Discovering Women's History: A Practical Manual* (London: Pandora Press, 1983); Guy Brett, *Through Our Own Eyes: Popular Art and Modern History* (London: GMP, 1986); Robert I. Rotberg and Theodore K. Rab, *Art and History: Images and their Meaning* (Cambridge: Cambridge University Press, 1986); Peter Paret, *Art as History: Episodes in the Culture and Politics of Nineteenth-Century Germany* (Princeton: Princeton University Press), 1988.

20 See, for instance, Cranmer Kenrick Cooke, *Rock Art of Southern Africa* (Cape Town: Books of Africa, 1969); A. R. Wilcox, *The Drakensburg Bushmen and Their Art* (Natal: Drakensburg Publications, 1984).

21 As Marianna Torgovnick (once more) reminds us, a 'savage' heart beats within the 'civil' breast. For every ostensibly noble line in the fabric of 'civilised' identity there weaves a 'primitive' warp. See her *Gone Primitive: Savage Intellects, Modern Lives* (Chicago: University of Chicago Press, 1990). Torgovnick argues that the 'primitive' has constantly functioned as a precondition and supplement for the Western sense of self. See Abigail Soloman-Godeau, 'The Primitivism Problem', *Art in America* (New York: February 1991), pp. 42, 43, 45. See also Sally Price, *Primitive Art in Civilised Places*, (Chicago: University of Chicago Press, 1989).

22 Manhire Royden, Tony Parkington and John Yates, *Pictures from the Past: A History of the Interpretation of*

Rock Paintings and Engravings of Southern Africa
(Pietermaritzburg: Centaur Publications, 1990).

23 Masekela's speech was reprinted in full as 'Culture in the New South Africa' in *Contact*, vol. 2, no. 14 (November 1990), pp. 4–16. An edited version, titled 'We Art Not Returning Empty-Handed' was published in *Die Suid-Afrikaan*, no. 28 (Stellenbosch: August 1990), pp. 38–40.

24 Robert Young, *White Mythologies: Writing History and the West* (London: Routledge, 1990), p. 2.

25 Mongane Serote, 'Post-Sharpeville Poetry: A Poet's View', in *On the Horizon* (Fordsburg: COSAW, 1988), p. 4.

26 Serote, 'Now We Enter History', in Wellem Campschreur and Joost Duvendal (eds.), CASA, *Culture in Another South Africa* (London: Zed Books, 1989), pp. 13–17.

27 See John Van Zyl, 'Sacredness of Ritual Violated', *The Star TONIGHT* (Johannesburg: Wednesday 5 December 1990) and 'Ethnography: seeing it in perspective', *The Star TONIGHT* (Johannesburg: Wednesday 19 December 1990); Ivor Powell, 'Vitriolic row over nude photos', *Weekly Mail* (Johannesburg: 14–19 December 1990); Shareen Singh, 'Remove "disrespectful" photos, demand workers', *The Star* (Johannesburg: Friday 14 December 1990); Phangisile Mtshali, 'Pictures of boys ritual spark row', *Sowetan* (Johannesburg: Friday 7 December 1990); Andrea Vinassa, 'Inisiasiefoto's – Vrae Oor Etieck', *Vrye Weekblad* ('Initiation Photos – Questions of Ethics', *Sunday Times*), (Johannesburg: 30 November 1990); 'The case of the missing pictures', *City Press* (Johannesburg: 16 December 1990); 'Controversial photos disappear', *The Star* (Johannesburg: Monday 17 December 1990); 'Naked-rite pics stolen: theatre', *Citizen* (Johannesburg: Tuesday 18 December 1990).

28 *Sunday Star Magazine*, (Johannesburg: 25 November 1990), pp. 8-13.

29 Opening on Sunday 25 November 1990 the show was originally set to end on 18 January 1991. The press release issued by the Market Galleries noted that twenty photographs were stolen on Friday 14 December between 22.30 and 01.00 hrs. The captions for the photographs were vandalised between 12.00 and 13.30 hrs on 17 December. The matter was reported to the police.

30 Steven Hilton-Barber presented a response entitled 'In Good Photographic Faith'. An edited version of this was later published under the same title in *Staffrider*, vol. 9, no. 3 (Johannesburg: 1991), pp. 34–39. Unless otherwise stated, I quote from the published version.

31 Market Panel Discussion, unpublished presentation,

12 December 1990, p. 3. This was edited out of the published version, where only the simple statement – 'I had permission to photograph the ceremony and publish the photographs' – remains, *ibid.*, p. 38.

32 From a draft report by Jonathan Rees, *Sapa* (Johannesburg: 13 December 1990).

33 *Ibid.*

34 See Vinassa, 'Inisiasiefoto's – Vrae Oor Etieck', *Vrye Weekblad* (Johannesburg: 30 November 1990), pp. B1, B3.

35 Hilton-Barber, *op. cit.*

36 'Comment', *Staffrider, op. cit.*

37 Hilton-Barber, *op. cit.*

38 On the often competing ethics of aesthetics, art, anthropology and ethnography, see R. M. Gramly, 'Art and Anthropology on a Sliding Scale', in *Art/Artifact*, exhibition catalogue (New York: The Center for African Art and Prestel Verlag, 1988). See also James Clifford and George E. Marcus (eds.), *Writing Culture: The Poetics and Politics of Ethnography* (Berkeley: University of California Press, 1986).

39 Hilton-Barber, *op. cit.*, p. 36.

40 Also a historico-political matter. See John Tagg, *The Burden of Representation: Essays on Photographies and Histories* (London: Macmillan, 1988).

41 Walter Benjamin, 'The Work of Art in the Age of Mechanical Reproduction', *Illuminations* (Glasgow: Collins, 1973), p. 228.

42 Hilton-Barber, *op. cit.*, p. 39.

43 *Ibid.*

44 *Ibid.*, p.38.

45 *Ibid.*, p. 39.

46 *Ibid.*, p. 36.

47 *Ibid.*, p. 38, (emphasis added).

48 Hinsley and Banta, *From Site to Sight: Anthropology, Photography, and the Power of the Image* (Cambridge, MA: Peabody Museum Press, 1986), p. 125.

49 Roland Barthes, 'Rhetoric of the Image', *Image Music Text* (New York: Hill and Wang), 1977.

50 Hinsley and Banta, *op. cit.*, p. 127.

51 See Pierre Bourdieu, 'Symbolic Power', *Critique of Anthropology*, no. 4 (London: 1979) for his concept, involving the imposition of specific meanings, categories and ideas in thought and communication.

52 Sue Williamson, 'Dompas' in *Art and the Media*, *op. cit.*, p. 43.

53 *Ibid.*

54 *Ibid.*

55 Sue Williamson, *Resistance Art in South Africa* (Cape Town and London: David Philip and the Catholic Institute for International Relations, 1989), p. 20.

56 Sander L. Gilman, 'Black Bodies, White Bodies: Toward an Iconography of Female Sexuality in Late Nineteenth-Century Art, Medicine, and Literature', *Critical Inquiry,* vol. 12, no. 1 (Chicago: Autumn 1985), pp. 204-242; Stephen J. Gould, 'The Hottentot Venus', *The Flamingo's Smile: Reflections in Natural History* (London: Pelikan, 1985), pp. 291–305; Barbara Buntman, 'White Men See Black Women', 'Proceedings, First Conference of the South African Association of Art Historians' (Transvaal: March 1990); Hugh Honour, *The Image of the Black in Western Art*, vol. 4, part 2: *From the American Revolution to World War 1* (Cambridge, MA: Harvard University Press, 1989).

57 Interview with the artist.

58 Some major festivals of resistance were: 'Culture and Resistance', organised by the Medu Cultural Ensemble, Gaberone, July 1982; 'The Cultural Voice of Resistance', Dutch and South African Artists Against Apartheid, Amsterdam, December 1982; 'Culture in Another South Africa', the C. A. S. A. Foundation and the Anti-Apartheid Movement, Amsterdam, Netherlands, 14-19 December 1987; the *Zabalaza* festival held in London in July 1990 is the most recent event outside South Africa.

59 For details concerning the various states of emergency, see *Subverting Apartheid: Education, Information and Culture under Emergency Rule*, I. D. A. F. Fact Paper on Southern Africa, no. 17 (London: International Defence and Aid Fund, 1990).

60 The conference was held in the Department of Fine Arts, University of Stellenbosch, 10–12 December 1987.

61 Matsemela Manaka, *Echoes of African Art* (Johannesburg: Skotaville, 1987); Gavin Younge, *Art of the South African Townships* (London: Thames and Hudson, 1988); Sue Williamson, *Resistance Art in South Africa*, (London and Cape Town: David Philip and Catholic Institute for International Relations, 1989); Anitra Nettleton and David Hammond-Tooke, *African Art in Southern Africa/From Tradition to Township*, (Johannesburg: Ad Donker, 1989); David J. Lewis-Williams and Thomas Dowson, *Images of Power: Understanding Bushman Rock Art* (Johannesburg: Southern Book Publishers, 1989); Manhire Royden, Tony Parkington and John Yates,

Pictures from the Past: A History of the Interpretation of Rock Paintings and Engravings of Southern Africa (Pietermaritzburg: Centaur Publications, 1990).

62 These include the Cape Town Triennial (Rembrandt Van Rijn Art Foundation), The Vita Art Now Awards (A. A. Mutual Life), The Standard Bank National Drawing Competition (Standard Bank).

63 The major example here was the 1985 *Tributaries* exhibition, curated by Ricky Burnett and sponsored by BMW (South Africa). See catalogue, *Tributaries: A View of Contemporary South African Art* (Quellen und Stromungen: Eine Austellung zeitgenossischer sudafrikanischer Kunst, 1985). The work was shown in Johannesburg for a short time before touring to Europe, primarily Germany and Austria. More recent was the Johannesburg Art Gallery's *The Neglected Tradition. Toward a New History of South African Art (1930-1988)*, curated by Steven Sack (1988). A third was the recent *Art from South Africa* show, curated by David Elliott, Museum of Modern Art, Oxford (1990-1991). See *Art From South Africa*, exhibition catalogue (Oxford: Museum of Modern Art, 1990).

64 Quoted in Ben Maclennan, *Apartheid: The Lighter Side* (Plumstead and Cape Town: Chameleon Press in association with Carrefour), p. 83.

65 Penny Siopis, 'Some Thoughts on Women Representing Women', paper given at 'Proceedings', *op. cit.*

66 Local exhibitions took place in the Joseph Sone Auditorium, Cape Town on 11 January and the Johannesburg Art Foundation on 13 January . The work was exhibited abroad at the SOHO 20 Gallery, New York, from 30 January – 17 February, where it formed part of the Women's Caucus for Art conference 'Shifting Power', 1990.

67 Siopis, *op. cit.*, p. 45.

68 See *Staffrider*, vol. 8, nos. 3 & 4 (Johannesburg: 1989), which is devoted to Worker Culture.

69 Siopis, *op. cit.*, pp. 48-49.

70 Masekela, *op. cit.*, pp. 38-40.

71 Gayatri Chakravorty Spivak, *In Other Worlds: Essays in Cultural Politics* (New York: Methuen, 1987), p. 107.

72 Marion Arnold, 'Helen Mmakgoba Mmapula Sebidi: "The Sharp Side of the Knife"', exhibition catalogue, Standard Bank Young Artists Award 1989 (Grahamstown: Standard Bank Foundation, 1989), p. 14.

73 C. S., 'Culture: The Antidote to Apartheid', *Mayibuye*, vol. 1, no. 3 (Lusaka: 1990), pp. 60–63.

74 J. M. Coetzee, 'Introduction', *White Writing: On the
 Culture of Letters in South Africa* (New Haven: Radix in
 association with Yale University Press, 1988), pp. 7–8.

75 *Ibid.*, 'The Picturesque, the Sublime, and the South
 African Landscape', pp. 49-50.

76 *Ibid.*, 'Introduction', pp. 7–8.

77 David Koloane, 'The Thupelo Art Project',
 Art from South Africa, op. cit., p. 84.

78 Koloane's position owes something to the somewhat
 Greenbergian modernism of the late Bill Ainslie,
 friend and mentor. See Avril Herber, in *Conversations.
 Some People, Some Place, Some Time, South Africa*
 (Johannesburg: Bateleur Press, 1979), pp. 104–110.

79 Koloane, *op. cit.*, p. 84.

80 Colin Richards, 'Desperately Seeking Africa' in *Art
 From South Africa, op. cit.*

81 Aggri Klaaste, 'An Intriguing Encounter', in *Jekiseni
 Hlungwani Xagani: An Exhibition*, exhibition catalogue
 (Johannesburg: 1989), pp. 25–26. The show was curated
 by Ricky Burnett and exhibited at a temporary space in
 Johannesburg, 1990.

82 'Towering Exhibitions', *The Sowetan* (Johannesburg:
 Monday 29 November 1989), p. 15.

83 Durant Sihlali, *Durant Sihlali: Discovering my
 True Identity* (Skotaville: Braamfontein, 1989),
 catalogue for Sihlali's solo exhibition held at FUBA
 Gallery, Johannesburg, September 1987.

84 *Ibid.*, p. iii.

85 *Ibid.*

86 *Ibid.*, p. iv.

87 *Ibid.*, p. vi.

88 See de Kok and Press, *op. cit.*

89 Sihlali, *op. cit.*, p. iv.

90 Sharp, *op. cit.*, 1988, pp. 97–98.

Jane Alexander
The Butcher Boys, 1985-86
Plaster, bone, horn,
oil, paint, wood
128.5 x 213.5 x 88.5 cm
Courtesy the artist and
South Africa National
Gallery, Cape Town

Reframing the Black Subject:
Ideology and Fantasy in Contemporary
South African Representation
Okwui Enwezor

I

In the house next door to mine in a suburb of Johannesburg, my Afrikaner neighbour makes it a duty every weekend and on public holidays to hoist on his flag pole the blue, white and orange colours of the old South African nation. Like all symbols of nationalistic identification, this flag raises extreme emotions – either of mortification or nostalgia. It has become rare to find a South African of any race who is not either a staunch supporter of the African National Congress or an anti-apartheid activist, and my new neighbours have made it very clear on which side of the ideological plane their allegiances lie. It seems nothing has changed for these people and thousands of others like them, who still persistently dream of the return of the old nation. Nostalgia, cleansed of poisonous memories, endures, and is thus justified in its almost fatalistic clinging to a relic of racism. In many ways, this defiant use of an old nationalist symbol, with its undisguised, terrifying history, is nothing new or unique. It has companions in the recent Fascist revivalism that has engulfed Europe in the aftermath of the Cold War, with the return of swastikas and Nazi symbolism, and in the more enduring history of the Confederacy flag in the southern United States.

Reading this image in the uneasy light that illuminates South Africa's return to the ranks of the modern nations, the flag display reveals, and at the same time masks, certain anxieties around the transition from apartheid to a representative, tolerant, liberal democracy. As I write this, I am listening to the wind snap the stiff cloth and colours of the fading flag. I am fascinated by that sound, by the rituality of my South African companion's forlorn hope. The flag is an ideological prop of longing, the lost dream of a fallen nation whose haunted past is very much part of the present, a sentinel that echoes the ambivalence and the desires of both the new South African nation, and the fantasy of a time fading fast with the bleached tricolour of the old flag. However optimistic one may sound in articulating the new South Africa, we must constantly remind ourselves that while nations may disappear, the ideologies that feed and sustain them, and which form the foundational basis of their creation, are more difficult to eradicate. For they are imaginatively reconstituted through the use of the surplus resources of their enduring myths as banners to rally adherents.

Thus in late 1996, two years after the legal fall of apartheid, it is hardly revealing to observe that racism and racial suspicion endure as rampant realities of the new South African state. We can hear it in the resplendent, undisguised accent of those anxious voices who still await the return of the owl of Minerva, bearing the news that the experiment was a failure: the 'natives' are simply ill-prepared to run a functioning, well-oiled state. In pointing out the above, I am less interested in the fraught political context out of which these issues arise than I am in using the questions they raise to examine issues of representation in a culture that has lived for generations with racist stereotypes as a prevailing attitude. To sketch out the image fully, I want to begin with two

analogous depictions that run synchronously through the histories of both the United States of America and of South Africa: *baas* and *massa*; *kaffir* and *nigger*; The Hottentot and the auction block; Jim Crow and apartheid.

The uncanny resemblance of these characterisations is not an accident. For they are both founded on blackness as anathema to the discourse of whiteness; whiteness as a resource out of which the trope of nationality and citizenship is constructed, and everything else that is prior is negated, defaced, marginalised, colonised. By thinking analogously of the two systems of whiteness as official policy, and as a mechanism of bureaucratic normality, I want to extrapolate from the cultural text of the United States a commentary on the fascinating usage in post-apartheid representation of the African body as subject and prop in both the political and cultural expressions of the 'New South Africa'.

This retrieval of the black figure from the debased image-bank of the former apartheid state is not surprising. Nor is it necessarily new; it is parcelled in the experience of a 'nation' emerging from one of the most traumatic events of the twentieth century: the long, terrible, insomniac night of apartheid. Dialectically, what one encounters within this scripted and representational presence is a nation seeking a new identity, and thus new images, new geographies, boundaries with which to ballast its strategic and mythological unity as what has come to be known as the 'Rainbow Nation', a term coined by Desmond Tutu to describe the multicultural population of South Africa. To put it bluntly, such a search is clearly related to how whiteness and its privileges are presently conceived, interpreted, translated and used to access the code of a disturbed sense of South African nationality. Thus to examine the charged descriptive detail of what strikes at the mortal heart of the 'New South Africa' – multilingual, and hopefully, multivocal – is to keen one's ears to the new uses and revindication of whiteness (in subdued and barely registered forms) as an idiom of cultural identity, that is, as a renewed and authoritative presence in the country's iconographic text.

II

Although today the word 'identity' has lost discursive currency, especially as multicultural and postcolonial discourse come under persistent academic attack, it would seem that South Africa has arrived belatedly at such contestations. This belatedness could be attributed to its rearguard position *vis-à-vis* identity, which up until recently, had been bound to the archaic formulation of whiteness as a nationalistic desire.

To be WHITE is in many senses an ideological fantasy. In discursive terms, it is a fantasy framed in the old mode of nationalist address (pursued with brutal efficiency by old apartheid ideologues); it is the arena in which all kinds of ideological longings converge, and are recovered in terms of a specific sociopolitical agenda and historical formation. Such an agenda and formation have often been replayed in the charged territory of racial pathologies, the kind that

Benedict Anderson in *Imagined Communities* described as 'the magic to turn chance into destiny'.[1] This in turn is invested with symbolic signs and positive values of origin, space, and a sense of who occupies that space, who owns it, who lords over it, and for whose benefit it is worked. In the specific example of South Africa, as in the American model, the identity of whiteness binds itself to the exclusionary politics of national discourse. Who is included or excluded from that body politic and on what grounds is their admittance or exclusion ratified?

Until recently in South Africa, as with Germany's *jus sanguinis* ethnic policy, citizenship (nationality) was a special animus that carried the Calvinist symbol of whiteness. For it not only declaimed belonging from the position of exclusion, it effectively rendered millions of the indigenous population *persona non grata*. Under such definition, to challenge the sanctity of whiteness, to represent it adversely, either in writing or image-making, to question the Calvinist ethic of racial purity on which it is founded, is to court terrible reprisals (brutal beatings, ban orders, jail, solitary confinement, exile, death) or to be cast out of the inner sanctum of the *broederbond*. And nowhere is the ideology of this racial fundamentalism in the shaping of national identity more potently manifested than in the arena of sports and visual arts. These are modes of culture that, according to Edward Said, occupy the realm of pleasure and leisure, coarsened by brutal exclusion and primitive racial determinism.[2]

For years, because they were neither citizens nor persons with a national affiliation, black South Africans were not offered the opportunity to participate in the corporate body of national sports, let alone to represent such a body or speak on its behalf. Sports had simply become a purified zone, the hallowed ground upon which white supremacist impulse traded its currency. In art, the museums of South Africa, in their attempt to redress the imbalances of the past, are paying the price for their past neglect of work by African artists, excluded from their collections. Because of this neglect, a process of gobbling up any work of art made by 'black' artists has intensified within both public and private institutions in the last ten years. But since the pragmatic value of everything that defines the old South Africa was derived from the interregnum of white nationalism and black resistance – in terms of popular iconography, art, literature, language and religion – it goes without saying that the birthright of utterances that spoke authentically about the nation, rendered the exactitude of its character, probed its borders and alleviated its insecurity, drew it into the light through all kinds of signifying devices (which included speaking on behalf of the 'native'), ultimately belonged to the white interlocutor.

III

But what is it, exactly, that makes whiteness such an exorbitant space of subjectivity, as the unimpeachable and irrefutable testimony of the knowledge of the colonised native? One could hazard – though this might imply an essentialist projection or even a prejudicial marking – that

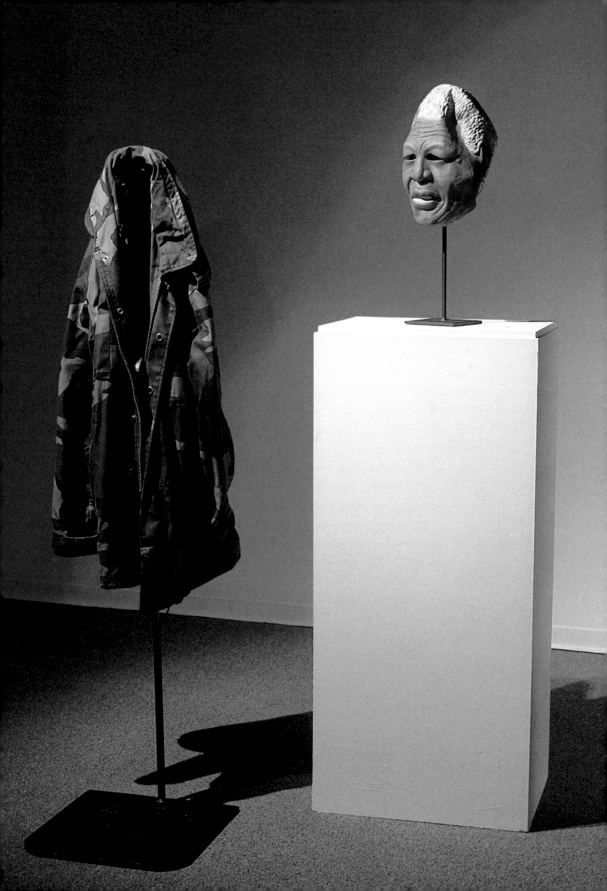

Kendell Geers
Title Withheld
(Out of Africa), 1997
Installation,
dimensions variable
Courtesy the USF
Contemporary Art
Museum, Tampa, Florida
Photo: Peter Foe

the tropes of whiteness can be related to what Claire Kahane, following psychoanalytic theory, has called 'object relations theory'. She writes that object relations theory assumes that from birth, the infant engages in formative relationships with objects – entities perceived as separate from the self, either whole persons or parts of the body, either existing in the external world or internalised as mental representations.[3]

Is this, then, how the Other is invented and assigned his place on the margins of the nation, in the wilderness of incommensurability? The Hottentot Venus, whose supposedly horrendous-looking vagina is now preserved in formaldehyde in a museum in France, and the black man on the auction block, as objects of denigration, become props of this ideological fantasy, the degenerative sketch from which whiteness stages its purity. These two historical scenes in which the black body has been tendered as display, reproduce the abject as a sign of black identification. Thus, the Hottentot Venus and the black man on the auction block signal a kind of black–genitalia abjection, products of a white masochist enjoyment of black sexuality in its most debased form.

Although today these are thought of as things of the past, in reality they remain perversely lodged in popular culture, films, novels and art. In films, the fantasy is of the menacing black criminal or prostitute. In contemporary art, we have Robert Mapplethorpe to thank for furthering the illusion of the black body as an object of enjoyment and spectacle, in short, for helping restore it to an aesthetic state of grace .

Olu Oguibe has noted that 'the introduction of digitalisation in our time has sanitised erasure and transformed it into a messless act, and the object of the obliterative act now disappears together with the evidence of its own excision, making erasure an act without trace'.[4] These obliterative acts are constantly played out in the resurgence of the black subject as a popular image in all forms of representation in contemporary South Africa.

In the post-apartheid moment of national reconciliation, reconstruction and unification, we have heard much of the militant black subject who wants to change everything and remake the nation in the illusory image of black identity. Conversely, another enduring popular image has emerged of the sulking white subject who harbours fantasies of an ethnic white *volkstaat*, and failing that, either emigrates to Australia or stays behind to complain bitterly about how things have changed. These images represent the polar axes around which the terms of transition are being negotiated. But they are both founded on the basis that notions of whiteness have constituted the terms of national identity and citizenship, and must now either be amended or attenuated and deconstructed in order to reconstitute the new image of the nation as something neither white nor black, but 'a rainbow of multiple reflections'. Hence, to speak through the territory of both the old and new South African nation and the intersection of black and white subjectivity within their iconographic lexicon, might it be possible to begin with the question of the abject, so as to delineate what binds the subject of the nation to both its object of desire,

its internal unity, its frame of stability, and to that which disturbs it, calls it into question, sets it adrift?

As part of the experience of apartheid, the primal symptom of whiteness was always in relation to that broad category in which large groups of people were reproduced in the image of the abject, defined by Julia Kristeva as that which 'disturbs identity, system, order . . . does not respect borders, positions, rules'.[5] Frantz Fanon relates this to that moment when a white child shrinks in horror and terror into her mother's arms, pointing to a black man in a public space as some kind of defilement, a mark of excess, an abscess sprung fresh in the temporal imagination. 'Look, a Negro', screamed the child.[6] Here, the Negro becomes an object of fetishistic fascination and disturbance to both the spatial and temporal order. There is a demand both for the repression of his presence and for his objectification, so as to mark out the divide that separates his polluting presence from the stable environment of whiteness: the enclosed suburbia in which he is forever a stranger, a visitor. Within South Africa, the Pass Laws, Separate Amenities Act, Bantu Education Act, Group Areas Act and so forth, were the mechanisms employed to cleanse territories, coveted by whites, of the scourge of blackness. This schematic trace of the abject as a transgressor of borders and rules is especially disturbing because the abject seems so wholly reproduced in the image of the criminal, the fugitive, the trespasser. This point was necessary in the construction of South African identity, regimented as it was in a colour-coded system of appreciation, value and worth, of which the ideological fantasy of whiteness becomes the marker against which everything is measured, whether as resistance or aspiration.

The racism that instituted and structured apartheid can be said to have been first accommodated by what Edward Said has described in his elaborate study of Orientalism as an ontological and epistemological distinction between the settler population and the indigenous populations.[7] These distinctions, which lie at the root of the colonial project, worked on the premise of two inventions: one, the ontological description of the native as devoid of history, and two, the epistemological description of the native as devoid of knowledge and subjectivity. On each account, the colonial territory grows more expansive as the imaginary map, drawn from the two distinctions, opens further a corporate body of interests in which the native now exists in direct competition for resources – material, history, representation – which culminates in resistance and sets in motion the process of decolonisation.

But for this sense of competition to grow into an ideological struggle, it must first be imagined as imperilling either the profitable position of the settler or putting at even greater risk the interests and benefits that accrue from his superiority – that is to say, his race, language, culture, knowledge, history, or the authority with which he narrates history – in short, whiteness. This is the crucial point at which African subjectivity and white interests seem to intersect in the contest

of the meaning of identity in post-apartheid South Africa. It appears that the struggle for this meaning hinges on who controls the representational intentionality of the body politic, especially its archive of images, both symbolic and literal.

IV

The colonised man is an envious man. And this the settler knows very well; when their glances meet he ascertains bitterly, always on the defensive, 'They want to take our place'. It is true, for there is no native who does not dream at least once a day of setting himself up in the settler's place.[8]

Fanon's astute observation of the Manichean universe inhabited by the opposing factions of black and white, and the competing narratives of the native and settler, bears some unadorned truths and demands attention, if at least cursorily. Surely the black South African is envious of the position of the white South African, who has always deigned, and regarded it as natural, to speak on his behalf, for his presence, history, sociopolitical position and place within South Africa. Surely the colonised man is an envious man. For he wants to write his own history, to retrieve his own body from the distortive proclivities of white representation. Even though on this account, he is no less willing to succumb to certain ideals of ethnicity, to ideological fantasies of blackness in order to tell his story.

It doesn't matter under which guise it is told (whether it is in the recuperation of the mythological essence of the omnipotent King Shaka as a noble warrior fighting colonial incursions on territories that belong rightfully to Africans) as long as it connects with some atavistic sense of destiny. In other words, he wants to take the place of the settler. And he is no more willing to give up that dream than the settler is willing to concede that key ideological position. For in their historical relationship, the settler always feigns to know his native better than the native knows himself. It is this crucial position that the white South African, which has always been in control of how the eyes perceive the African, is not yet ready to give up. Hence, in recent South African representation, the ideological battle seems to be over the control of the black body, its frame of analysis, the projection site in which its image is refreshed with the new insight of a suddenly untroubled social relation. But according to Fanon the two zones are opposed.

V

If, as Stuart Hall suggested, 'identities are the names we give to the different ways we are positioned by, and position ourselves in, the narratives of the past',[9] what happens when suddenly the narratives of white representation of Africans are challenged by a black counter-narrative?

It is no secret that in the aftermath of emancipation it is precisely the terrain of the 'narratives of the past' that is the most fiercely contested. As we all know, during half a millennium of European presence in South Africa, the spectres, the haunted and historic memory, the glow, the consciousness, the metaphorical speech of European identity has stood solidly on a nationalism of white supremacist ideology. In the faded glory of the fallen apartheid republic, workaday speech signals a desire still unfulfilled, a speech currently being unlearned in the space of representation, and within the transitional haze of political and social transformation. If no articulate voices have been heard in this din, it should not be surprising, particularly if one listens within earshot of the contrapuntal narrative of the 'native's' agitation to be heard, and the hardened habit of the settler not to listen. At present an impasse exists.

Two years after the official demise of apartheid, Nelson Mandela and the majority of South Africans – black and white – have tried to achieve nothing less than the reinvention of their once-divided country, a new South African identity attempting to shed the wool of its racist past. The drive is for the emergence of a new nation, from one that lived in isolation and mutual suspicion, in competition and as adversaries, to one today described as the last miracle of the century. Part of the formidable repertoire of images with which the nation has attempted to heal itself is framed in the iconographic technicolour of the 'Rainbow Nation'. One's understanding of the 'Rainbow Nation' has less to do with its mythic dimensions, the uneasy air of ambivalence that visits its every invocation, than with the pragmatic politics of reconstruction that it seeks to articulate: a reborn nationalism. But no one in full honesty believes the 'Rainbow Nation' to be a long-term project. Rather, it is a project of accommodation, of armistice, in the absence of which, competition between the various members could again erupt into civil strife. Along this thinking, Rob Nixon has noted that 'much the strongest current of nationalism in South Africa – that represented by the ANC – is inclusive, nonracial, and premised on a conciliatory unity, not an enforced ethnic homogeneity'.[10] But the critics of the 'Rainbow Nation' easily ignore this fact.[11] In this regard, one casts an uneasy glance in the direction of KwaZulu Natal, where the cauldron of Zulu nationalism bubbles.

On this note, I want to suggest that nationalism – whether framed in the sectional rhetoric of Zulu nationalism, in the *volkstaat* of Afrikaner nationalism, in the settler colony belief in generic whiteness as an essential way of being, or in blackness as a revolutionary discourse of decolonisation – has always been an inextricable reality that frames South African identity. There is no better way to acknowledge this sense of factionalism than in the different responses to the concept of the 'Rainbow Nation', particularly that of a white community that suddenly finds itself a minority, and potentially, the underling of its former African vassals. And nowhere has this recent resistance been more fierce than in a representational terrain still dominated by highly literate, but nonetheless unreflexive white cultural practitioners, unblinkingly intent on

representing black subjectivity at the margins of cultural and aesthetic discourse. Unmoored from what they have always known – that is, the unquestioned privilege of whiteness from which everything is refracted – the Rainbow now seems a motley reflection of images alien to the old sensibility. Very simply, the Rainbow either opposes or seems antagonistic to whiteness. The Rainbow as what 'disturbs identity, system, order. What does not respect borders, positions, rules' has made artistic practice a volatile and transgressive act of realpolitik, for it has suddenly made South Africans clearly aware of how different, culturally, ethnically and linguistically they are as a 'nation'. No longer tenable is that hardened position of binaries – black/white, settler/native, coloniser/colonised.

VI

This calls into question what images in a decolonising South Africa should look like, who has the right to use them, and what the authorising narrative ought to be. If decolonisation is, as Fanon noted, 'the meeting of two forces opposed to each other by their very nature' [12] – and one might add, linked by mutual suspicion – is it possible to suggest that the recent conference amongst

What exactly is it about the 'Rainbow Nation', barely two years into reunification, that makes Afrikaners so uneasy in terms of their prospects as an ethnic minority in South Africa?

Afrikaner intellectuals in Stellenbosch, Western Cape, in a bid to form an organisation that will promote Afrikaans language and culture, could be linked to an opposition to the 'Rainbow Nation'? Some of their derisive, perhaps even naïve, mockery of the 'Rainbow Nation', on the level of an ideological promotion of a wounded whiteness, could be seen as separatism in disguise. At least, it seems to suggest that. Judging from the recent convulsive events around the world, this kind of nationalism has persistently made its bid by invoking a certain particularity, by investing its images with a sense of uniqueness, a manifest destiny without which the desire and destiny of the national entity withers. To be potent, the object of nationalist discourse has to see itself as endangered, on the brink of extinction, in need of special protection and reparation.

This is what some of my black South African colleagues found so disturbing about the Stellenbosch conference. Not least because some of its most prominent advocates, such as the writer Breyten Breytenbach, have strong liberal credentials in the Leftist politics of South Africa, and were staunch anti-apartheid activists. Even so, the Stellenbosch conference was not a display of unanimity on the meaning of what ostensibly may be perceived as Afrikaner chauvinism rearing its ugly head again. Some of the attendees of the conference, such as the poet Antjie Krog

– who has written brilliantly and movingly in the *Weekly Mail & Guardian* about the harrowing testimonies to the Truth and Reconciliation Committee, chronicling past human rights abuses during the political struggle against apartheid – were uneasy about the implications of such a gathering, and made an attempt to distance themselves from any suggestion of reviving Afrikaner nationalism.

To encounter this debate as it unfolds in the disjunctive, uneasy peace of the 'New South Africa' is to admit the unfinished business of the transformation of the apartheid state and the huge task of decolonisation. It is also to acknowledge the fragility of the post-apartheid nation. For here, the question that could be asked of the Stellenbosch colloquium is: what exactly is it about the 'Rainbow Nation', barely two years into reunification, that makes Afrikaners so uneasy in terms of their prospects as an ethnic minority in South Africa? Is this response – the inability of a once-dominant white culture to deal with its diminished role and sense of superior entitlement in the cultural and political life of the nation – a preamble to a resurgent Afrikaner nationalism, caught so well in the shadow of the Voortrekker monument in Pretoria? Can one assume that such a colloquium, however well meaning, is not a pretext for the rallying of the troops below from above? [13]

I want to return to how today this fantasy of whiteness again images the black subject in the old, warped frame of the apartheid era as lacking, at the liminal point of defeat. That is, his story, as spoken through the transitional identity of post-apartheid contemporary representations, is narrated in the past tense, as if the narrators want to stop history; as if everything about the black subject resides only in his pre-linguistic period, in the residue of his diminished state as subject, prior to his act of speech, fixed in his eternal silence. Of course these narratives are cleverly couched in a manner that appears to recover the essence of a black subjectivity suppressed during apartheid.

While the Stellenbosch conferees measure, within listening distance of the nation, the mythological space of the 'Rainbow Nation', the site from which Mandela's daydream takes its *fait accompli* attempts to steer a different course, a course in which all ethnicities are recognised as 'equal', perforce of the recently ratified constitution. Could one even suggest that in participating in what is seen as a chest-thumping projection of the robust characteristics of Afrikaner speech and subjectivity during a difficult period of reconciliation, the conference was not only ill-advised, but arrogant? And in the face of testimonies of horrible apartheid crimes made to the Truth and Reconciliation Committee that was set up to investigate the murderous policy of the old regime, does this portend a larger lack of sensitivity and accountability to victims of Afrikaner domination? In mounting a drive to promote Afrikaans in such a short space of time, in a volatile period of reconciliation, could these intellectuals be accused of lapsing into a form of amnesia and disavowal of historical memory, characteristic of the holocaust deniers in post-Nazi

Germany? And finally, could this drive for the promotion of Afrikaans as special and endangered be seen as a need to shore up and maintain the dominance of a minority Afrikaner culture? Are some of these progressive white intellectuals still clinging to that old image of the 'native' entrapped in muteness?

VII

Perhaps there is a difference between what the colloquium staged, and what the artist attempts when employing the image of the African subject in order to come to terms with South Africa's past, present and future. But why am I unconvinced by the remonstrative gestures of those artists who sentimentalise African images, who persist with those images that are devoid of conflict, depicting the quietly suffering but still noble African? Since he can't speak for himself, he is spoken for. I want to believe in the sincerity of these gestures, to think that the whiteness of the artists is beside the point.

And, even more strongly, I want to believe that there is no continuation of that old business, which nevertheless still persists, of serving up African culture as spectacle and source of reassuring, harmless entertainment. But my faith is forbiddingly racked by doubt. We easily deceive ourselves, believing that the dividing line of racial discourse is not as baited as it once was. Today, the spectacles of yesterday have returned. The most resourceful and formidable examples of this kind of representation have recently made their appearance in the booming South African tourist industry. In what are described as 'Cultural Villages' throughout South Africa, so-called old African customs are being staged for mostly white audiences, in exclusive holiday resorts. In Lesedi Cultural Village in Guateng Province, tourists have their choice of which African fantasy they may sample. Depending on your taste, you might choose Zulu dancing, in which pot-bellied. ferocious-looking men in leopard skins prance and stamp around a bright burning fire, in a performative, ethnographic Surrealism. Or you can partake in an authentic Xhosa, Pedi or Sotho domestic scene, replete with the visible iconographical marks of those cultures. In this retrieval of African customs from a besmirched ethnographic cupboard, only those aspects of African culture that entertain are presented. Such are the images of Africans that are beginning to enter the archival bank of the new South African nation.

Of all such cultural villages, Kagga Gamma, a space that does double duty as a game park in the Western Cape, is perhaps the most primitive. At Kagga Gamma, the so-called endangered Bushman has been reinvested as entertainment and put on display. His brief? To put in a performance daily, which could live up to, or approximate, colonial fantasies of his nomadic hunter-gatherer past. For a little more than a subsistence wage, he is given a leather loin cloth, bows and arrows and in full view of the paying guests at Kagga Gamma, performs the task that defines that aspect of his 'authentic' past.

A headline in a New York Times article in early 1996, which reported on Kagga Gamma, captured the tragedy of this form of representation. It read: 'Endangered Bushman Finds Refuge in a Game Park'.

VIII

Even after the fall of apartheid, the temptation to retrieve the 'native' in his full ethnic regalia remains, evidenced in representations that attempt to address the notion of difference and otherness in these images. While the primary intention of these works may be as critique, the irony is that the artists who embark on them often end up uncritically seduced by their fascination for the abject and docile bodies of African men, women and children. Homi Bhabha captures this well when he writes that:

An important feature of colonial discourse is its dependence on the concept of 'fixity' in the ideological construction of otherness. Fixity, as the sign of cultural/historical/racial difference in the discourse of colonialism, is a paradoxical mode of representation: it connotes rigidity and an unchanging order as well as disorder, degeneracy and daemonic repetition. Likewise, the stereotype, which is its major discursive strategy, is a form of knowledge and identification that vacillates between what is always 'in place', already known, and something that must be anxiously repeated.[14]

This anxious repetition finds itself inscribed again and again in the almost obsessive usage of old photographic images of Africans or in the ethnographic tourist postcards depicting near-naked African women in a state of colonial arrest. The resulting work is redolent of a time past, if not one quite vanished. But it is the over-familiarity, and brazen usage of the photographs, many of which were undoubtedly found in curio shops, that attracts one's attention. The subjects, it seems, are attractive because of their anonymity and existence at the margins of history. They have no names, thus they pose the least emotional or ethical threat, and the distance between them and the artist offers a gratifying contextual licence to do with the images as one chooses.

Thus Penny Siopis turns the ubiquitous ethnographic postcard of 'native' women into large Cibachrome prints, then paints over them and drapes them with assorted paraphernalia, syringes, medical catheters, etc. The surfaces of the large photographs have been worked on for effect, some parts highlighting and other parts covering or erasing certain tell-tale and problematic areas, an effect that recalls what Olu Oguibe has called 'the scarred page'.[15] By sentimentalising her images, Siopis turns them into over-aestheticised vessels for pleasurable consumption, untroubled and available. The images are rendered as banal texts, sources of art. A turn-of-the-century photograph of a doleful-looking boy in a suit and hat

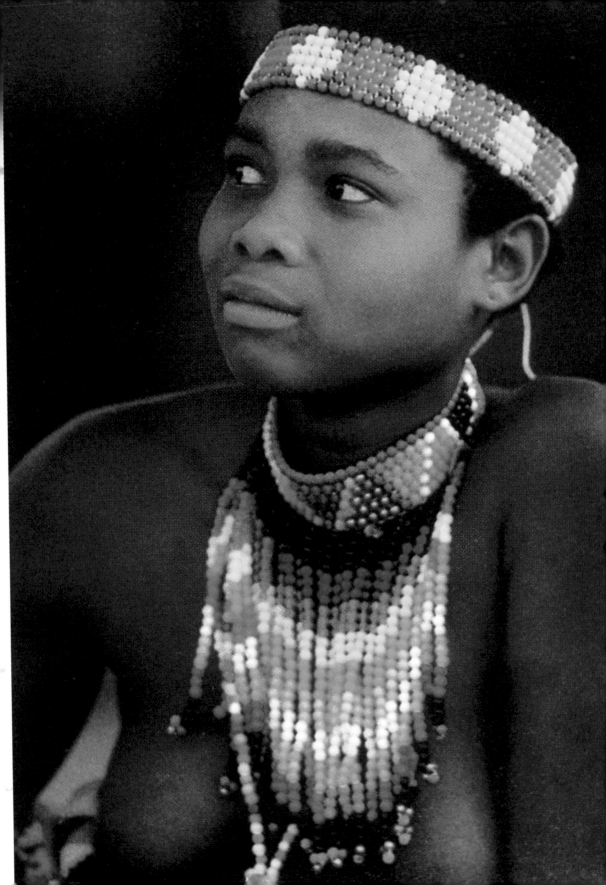

carrying an ostrich egg is one such image, which appears in Siopis' extensive incursions into this arena of racialised representation. The image has been recoloured blue and decorated with vertical borders of baby shoes. It is pure visual candy. The work says very little about the photograph, or who the little boy is, or about the artist's relationship to the image. Instead, what we are given is an aesthetic that reveals a curious ambivalence towards its subject as a social being, and towards the historical impediments that frame his reception within this strategic restaging of African identity through the ghostly outline of his faded form.

Along the same lines, Wayne Barker puts such images on display at the Johannesburg Art Gallery as indigenes, foils to the young artist Piet Pienaar's more revealing critique of identity, stereotype and essentialism. Gunther Herbst appropriates them as kitsch ethnographic symbols of the 'native's' Western desire.

On the obverse side of this discourse is photographer Santu Mofokeng's ongoing project *Black Photo Album/Look at Me: 1890-1950s* (1995), a meditation on black desire and what it means to be black under colonial domination. Rather than making aesthetic interventions on the images to prove a point as author, he has instead, except for restoring the images, left them as they were. In this sensitive recovery of the private history of black families during the colonial period and that leading up to the early stages of apartheid, Mofokeng has ostensibly upset the apple-cart, in turn redeploying the archival images of black identity for the recovery of historical memory. By emphasising the historicity of the subjects who occupy the site of his exhaustive study, Mofokeng has painstakingly searched out the often elusive biographies of the sitters and their families. Their names form part of the larger task in what these images suggest for future usage. Perhaps it is best to use Mofokeng's own words:

> These are images that urban black working and middle-class families in South Africa had commissioned, requested or tacitly sanctioned. They have been left behind by dead relatives, where they sometimes hang on obscure parlour walls in the townships. In some families they are coveted as treasures, displacing totems in discursive narratives about identity, lineage, and personality. And because, to some people, photographs contain the 'shadow' of the subject, they are carefully guarded from the ill-will of witches and enemies . . . If the images are not unique, the individuals in them are . . . When we look at them we believe them, for they tell us a little about how these people imagined themselves. We see these images in terms determined by the subjects themselves, for they have them as their own.[16]

What is evident is Mofokeng's insistence that the subject be seen as a person possessing a history, identity and desire. However, it must be understood that far from drawing a positivist sketch of noble Africans, Mofokeng is attempting to tease out an often-elusive sense of black

complexity in racialised discourse. Cast neither in the splintered light of deformity, nor in the pathos of a curative nostalgia, his project provides us with at least one of the ways in which an ethical sense of African agency can be used imaginatively.

Willie Bester's multimedia constructions carry the liminal images of the fight against apartheid with a brutal realism that situates the black body in the realm of political struggle and social resistance. He fashions a critique in which the black subject is able to speak, to threaten, to be angry, unbowed within the temporal and spatial history of South Africa. On the other hand, Lien Botha memorialises that body's absence by fragmenting it. In her installation, *Krotoa's Room* (1996), she squares it into a close-up of Krotoa's sad eyes and mouth: simply an 'authentic' image of suffering. Botha lights votive candles to the eternalisation of the object position of black people in South African history, signing her images, perhaps unknowingly, with the pure mark of the mute African, on whose behalf the metaphoricity, rather than the commensurability of the African subjectivity, is pleaded for by another, by a surrogate voice. Botha's use of the black image recasts another stereotype, of the eternally grateful, eternally noble native, who, despite the most horrendous deprivation and dehumanisation, is incapable of hurting a fly.

To represent the black subject as Bester does, in the midst of his violent struggle for emancipation from servitude and denigration, is to pick up another slur, which is his enduring image as the uppity nigger, the smart-alecky *kaffir*, the rebellious native, the runaway, the maroon, the terrorist. It is this sense of radicality that made the preacher in Ralph Ellison's first novel *Invisible Man* defiantly declare, 'Black is . . . black ain't'. The dominant trope and discursive address of the black subject by these artists is predicated on their overdetermined sense of familiarity with African identity – a sense of themselves thoroughly evoked by what Susan Vogel, when to her eternal damnation, she referred to European curators and ethnographers as 'intimate outsiders'.[17] The black subject, however, continues to elude the primary task of such discourse, which seeks the normalisation of the power role of whiteness through the historicising of black desire.

IX

Such a position of power was evident in the much-discussed exhibition 'Miscast: Negotiating the Presence of the Bushmen', curated by the artist Pipa Skotness at the National Gallery of South Africa in Cape Town in April 1996. The show, according to Skotness, was mounted to reveal the horrors suffered by the 'Bushmen' in southern Africa at the hands of white settlers and Africans alike. Skotness assigned herself the role of historian, perhaps even custodian, of 'Bushman' history. Not one African was invited to join more than fifteen white contributors to the catalogue, to comment on a history in which Africans themselves are implicated. And neither was there a section in which the 'Bushman' was called upon to testify on his own behalf. Instead, we heard his

'voice' only through the anecdotal voiceover of the white anthropologists commissioned to carry out the research, which Skotness believed to be great material for exhibition in an art museum. As James Clifford has observed, 'one increasingly common way to manifest the collaborative production of ethnographic knowledge is to quote regularly and at length from informants . . . Quotations are always staged by the quoter and tend to serve merely as examples or confirming testimonies'.[18]

It is not, however, the paternalistic framing of the 'Bushman' as a gentle, misunderstood creature hunted to extinction, in a commentary embellished by what Clifford calls 'redemptive modes of textualisation', that disturbs. It is Skotness' attempt to make out of this history an artistic project.

Accompanying this creative exercise in curatorship was an attempt to stage authenticity through the metonymic presence of objects. Skotness ransacked various ethnographic storerooms, coming up with musical instruments, bows and arrows, bits of ethnic paraphernalia such as bead work, old colonial photographs and ancient cameras (placed all around the room, surveillance style), anthropological documents, dissecting instruments in illuminated glass cabinets, and numerous shelves bearing cardboard boxes of concealed information on ethnographic expeditions (at least that's what the captions on the boxes suggested). She even had moulds of the dismembered body parts of the 'Bushmen' cast in wax and displayed on pedestals.

Along two huge walls, she constructed a gridded mural of photo-collages of the 'Bushmen', in which she had interspersed and juxtaposed the photographs of various white people. Perhaps the most interesting aspect of this was the disjunction it created between the white subjects and the 'Bushmen'. Many of the photographs of the 'Bushmen' gave one the eerie feeling of looking at police mug-shots of criminals or condemned people. But what staged this disjunction so dramatically was the contrast between the totally at ease white faces and the forbiddingly morbid black ones. This did not so much blur the line between the hunter and hunted, between the coloniser and colonised, as it highlighted it, with quite surprising perversity.

Unaware, perhaps, of this perversity, Skotness was escorted by these images into the charnel house of an entirely submerged social history of photographic representation, the archive as a signpost pointing to how difference and otherness are constructed through photographic practice. For what we were confronted with in the panels were two socially constructed positions of knowledge in pitched battle: the white man and the 'Bushman'. But Skotness' exhibition 'contains subordinate, territorialised archives: archives whose semantic interdependence is normally obscured by the "coherence" and "mutual exclusivity" of the social groups registered within each'.[19] As one wandered through the rooms, bludgeoned by a didactic relativism that at times seemed an act of ironic self-mockery, I was forced to ask what this exhibition was all about. What was the exhibition actually saying, and to whom was it addressing its message?

Certainly not to the 'Bushmen' who, to the surprise of the curator and the institution, upset the cart by rejecting the message of the exhibition.

Part of the reason for this rejection was their refusal to recognise the body casts as forming any kind of knowledge of their history or world. But most especially it was the linoleum flooring, which Skotness had commissioned, embossed with photographic likenesses of their images. Invited as special guests to the exhibition opening, the 'Bushmen' were horrified at the sight of their images embossed on the linoleum carpet and refused to walk on it. That we as viewers were invited – and in some cases acquiesced – literally to trample the abject figure of the 'Bushman', was most disturbing. But it was the 'Bushmen's' complete rejection of the carpet that was the most memorable and damning event of the exhibition, effectively vitiating Skotness' attempt to serve as the sympathetic interlocutor of their history, indeed as their historian.

If we hold on to this critique, we will observe how Skotness as curator of this postmodern ethnography took the role of a dilettante, neither ethnographer nor historian, neither member of the clan nor confidante, nor 'intimate outsider'. In her obsessive attempt to raise emotional hackles (as if all we need do is think about the 'Bushman' with our hearts rather than our heads), she neglected to take into account that her voice as the authority of history might indeed be contested by the very people she was attempting to recuperate. It is indicative of the ethical blinkers familiar to all redemptive colonial errands that her allegedly exhaustive consultation with the 'Bushman' community failed to alert her to the potential violation they may feel in the face of her work. For in reproducing this diapositive image of blackness, in which the historical memory of the 'Bushman' was desacralised and appropriated for a kind of colonialist exegesis, Skotness repeated the act of arrest of the native subject at the moment of his fall.

The refusal by the 'Bushmen' to assist in the production of a distorted view of their history indicates certain stances of oppositionality that are sometimes enacted by repressed groups in the face of misrepresentation. To bell hooks, the African American experience of repression under slavery had produced 'an overwhelming longing to look, a rebellious desire, an appositional gaze. By courageously looking [they] defiantly declared: "Not only will I stare, I want my look to change reality". Even in the worst circumstances of domination, the ability to manipulate one's gaze in the face of structures of domination that would contain it, opens up the possibility of agency'.[20] It was this failure to contain the gaze of the 'Bushman', that caused the discomfort still reverberating in the halls of the South African National Gallery.

It would seem that Skotness, as is often the case with white representations of African history, had assumed that as spectators we all see the same thing, and thus believe that our gazes are constituted and therefore affirmed and defined by the same regime of looking. Such an assumption is not only simplistic, but reductive as well. As Manthia Diawara has suggested, under such a position, 'the dominant reading compels the Black spectator to identify with racist

inscription of Black character'.[21] Difficulty and anxiety arise when the gaze of the black spectator is accounted for, and ends up challenging representations that the white community might have deemed irrefutably conclusive. Therefore, when looking at white representations of African identity, we must allow that positions of spectatorship be recognised, particularly in a racist society, as always conditioned by the economy of racialised interpretation, as well as desire.

It is the non-recognition of the place of the black spectator as an affirmed and enabled participant in the act of looking that burdens the work of the young artist Candice Breitz. In her 'Rainbow Series' (1995), a body of work reminiscent of Hannah Hoch's photomontages, particularly the ethnography series from around 1919, Breitz explores the tension that exists in the discursive territory of the 'Rainbow Nation', as rendered in the pornographic depiction of white women and the doubly coded depiction of the black female body, framed by both pornographic and ethnographic desire.

Breitz stages this *mise-en-scène* through that most inimitable form of hybridity – collage – the errant pastiche of irresolvable miscegenation. She began by pulling images of white women

Not even gender could so suddenly bind together black and white women's bodies as equal partners against patriarchy in post-apartheid South Africa.

from the pages of porn magazines. These she cut, ripped and collaged with stereotypical images of bare-breasted and bare-footed black South African women in 'ethnic' garb (Ndebele blankets, beaded aprons and jewellery and brass leg ornaments), taken from those tourist postcards familiar to safari trippers. These crude joinings, some of which conflate the bodies of pre-pubescent black children with those of leering, sexually exposed white women, are meant to enact an analogy of equal relationship and compatibility at the site of representation: the equation of colonial ethnographic capture of the black body with the pornographic capture of white women. For example, the body of a young smiling girl, with barely sprouting breasts, carrying a large pumpkin on her head was collaged on the faceless body of a squatting white woman wearing nothing but white shoes and socks and baring her vagina.

Another particularly striking image is a photograph of a ghostly, pale Breitz reclining, odalisque-style, like Manet's Olympia, holding a cardboard cut-out of a black woman's face, which partially frames and conceals her face. It is interesting that Breitz is represented full figured, while the black woman is rendered as a mask, a simulacrum to white feminine subjectivity. What are we to make of this degenerate form of African womanhood – without body,

without name, the image of an image – except to see it as an object with which white femininity acquires its fullest enjoyment as subject? And what is it that Breitz is saying here that is of real interest to the African woman? Is she saying that this woman lives in the same temporal zone as the white woman? That they are both on the same level, as naïve victims of masculine violence?

The props of Breitz' argument begin to wobble exactly on this level. She simply cannot tell us just what makes these images congruent, as forms of a charged and cohesive discourse of race, femininity, ethnography, pornography, the 'Rainbow Nation', and the complex web of entanglements that further undermine her thesis. A discursive absurdity, the images are often spliced and scanned through the computer to produce large, seductive Cibachrome photographic prints. It seems that she is just too much in a hurry to show both her unimpeachable feminist credentials and her equally enlightened liberal sympathy towards the much-abused African woman. Despite her effort to prove irrefutably that the bodies she uses for her misguided narrative do indeed cohere, and do indeed accuse and reproach Mandela's 'Rainbow Nation', the black body speaking through Fanon's ghost arrives with a jarring retort: 'You came too late, much too late. There will always be a world – a white world – between you and us'.[22]

While such a Manichean scheme might irritate, what Fanon seems to be saying – either missed or ignored by Breitz – is the fact that not even gender could so suddenly bind together black and white women's bodies as equal partners against patriarchy in post-apartheid South Africa. For white women must first recognise their own complicity in constructing the African subject. The vehement responses to this work by African women in South Africa and in the United States bear this out. The measure of this opposition to an all-knowing, non-complicit whiteness in South Africa is written within the dialectic of an empowered black feminine presence in the 'New South Africa'. What white representation disavows or disallows, through what Toni Morrison has called 'the stressed absence', black women aim to reify through a questioning and empowered voice. Perhaps to some ears the ring of hostility in the obliterative act (whiting out, ghosting, decapitation, etc.), the unwelcome overfamiliarity, bordering on ownership of the black body, the smug lecturing of those who have severely borne the sentence of these kinds of titillating attentions, might seem too harsh.

The 'Rainbow Series' has been critically praised by the white establishment, dismissing the protestations of African viewers as reactionary, childish and hysterical. Such praise, however, blissfully ignores that in Breitz' need to valorise and shift emphasis to the recognition of difference as the most plausible counteractive force to the homogenisation of South African identity by the 'Rainbow Nation' ideology, her work neglects the fact that, under apartheid, white women fought against African women. These critics fail to address the vast chasm that still separates black women from white women in South Africa, socially, economically, and in

access to educational opportunities. They have either looked askance at, or peremptorily dismissed, the objections of African women and the traumatic experiences of violation that images such as Breitz's series re-enacts for them, and which has been tendered for public display and consumption in the plush living rooms of white collectors. Perhaps one should neglect, as not being of critical importance, the comment of a black South African woman friend, who commented, rather ruefully at Breitz' exhibition 'is this the way they still see us?'. To understand this comment, it is important to note that white women metaphorically sodomised and pornographicised black women by using their bodies as functional objects of labour, as domestic workers, as maids and nannies and wet nurses.

However, in issuing this injunction against Breitz' questionable representation of black women, one must not dismiss it merely by casting it in the ethical swamp of colonial mimicry, nor simply damn it as another form of racist stereotype masquerading as liberal civilising mission. Bhabha provides a cogent example of how one may think of work of this nature:

> To judge the stereotyped image on the basis of a prior normativity is to dismiss it, not to displace it, which is only possible by engaging with its effectivity, with the repertoire of positions of power and resistance, domination and dependence that constructs colonial identification subject (both coloniser and colonised).[23]

Is it possible to read this situation as a glaring lapse, or is Breitz constructing a strategic discourse of whiteness? Surely one must allow that the subjectivity and desire of white women is attached and close to white patriarchy and its desubjectivisation of both black men and women. Even in her submissive position, the white woman still does colonial errands that denigrate black men and women, partly as a member of the tribe, partly to make the white fathers of the Broederbond happy.

My mind is called to attention here by an anecdote from bell hooks that encapsulates the sense of a narrative in which the black subject remains vividly etched on the margin, and is made secondary to white female desire. She relates an account that appeared in the newspaper *USA Today*, which reads: 'The Jefferson County Commission voted not to remove a courthouse mural of a white female plantation owner, looming over black men picking cotton'.[24] She notes that the subject of the mural relates to how white femininity performs within white patriarchy to further marginalise the black subject in an act of incestuous impulse: 'No doubt the white woman in this mural is . . . doing it for daddy; performing an act of domination [of the black body] that she hopes will win his approval and love'.

This act of 'doing it for daddy', which hooks also refers to as the search by white women within patriarchy 'to find ultimate pleasure, satisfaction, and fulfilment in the act of performance

and submission',[25] is a crucial disjunctive element not at all accounted for in Breitz' work. Read in the shadow of this discourse, Freud's question, 'What does woman want?', and Fanon's archly patriarchal counter, 'What does the black man want?' loom large. For in each instance, it is the black woman that is disavowed, lodged in the lowest register of articulation. This aspect fascinates me, for the intersection of Freud and Fanon's questions as a description of the black woman's utter otherness could be transferred to the kind of attention devoted to bisecting, colouring, whiting, ghosting out, morphing, collaging of the black figure within the field of representation. These acts seem to have the common desire of enacting fantasies of whiteness, in which the black figure again returns for mediation as an anathema, as a hollow presence: seen and unseen.

X

Despite the sincerity of the artists who have brazenly maintained a relationship in their work with the black body, there is a certain over-determination that accompanies their gestures. They seem to neglect the fact that the black form is as much a grotesque bearer of traumatised experiences as it is the abject vessel of race as a point of differentiation. More than alerting us to how the stereotype fixes its objects of desire in that freeze-frame of realism, as prior knowledge, the work of these artists exacerbates the stereotype by replaying it, perhaps unconsciously, as if it had always been factual. The problem with this kind of work is that it is so fixed on the body that it neglects to account for the more crucial psychic split that positions black and white bodies in polarities of worth and value. By seeking to merge them, albeit forcibly, and taking as licence the fact of their whiteness, they repeat that act of surrogacy that emphasises the subject's muteness and silence, while embellishing their own positions as the voices of reality, as the vocal integers of truth.

While this attention, which has grown out of the need to sate white liberal conscience in a fragile post-apartheid culture, persists, African artists have conversely adopted a contrary attitude towards the same body. There is very little usage of that figure in their work. Instead, we encounter it as a suppressed presence, abstracted and exorbitantly coded with the semiotic speech of *détournement*, a kind of shift of emphasis from its representational 'realness' to a metaphorical search for its lost form.

But in pointing out some of these problems, are we not fetishising identity as something that wholly belongs to and can be used only by a particular group? And am I not again reiterating that postcolonial litany of the wounded black subject, caught in the mesh of white, European displacement, who must again be either protected or spoken for? The fact that I am an African does not in itself absolve me from this quandary. Despite such dilemmas, what will be the implication of remaining silent on the matter? In proposing a re-examination of certain facts lodged in the iconographical heart of South Africa, in a delimited forum of whiteness as a nation unto itself,

should we not also admit that it is the reappropriation of blackness by Africans as a nationalistic emblem, as a fantasy of the coherence of African identity, that has set up the appositional measures against the 'Rainbow Nation'?

I remain sceptical of there being a possible resolution to the problems raised by these issues. I question the wisdom of enacting any kind of representational corrective through a recourse to 'positive' images of blackness. For identity must never be turned into a copyright; an antinomy in which ethnicity through group reckoning stages its authenticities and retains exclusive user rights to its images. To do so would be to fetishise identity, to render it into a totem, a token of mythology, an ideological fantasy. Moreover, we would miss the vital lessons that inform the complex motives of usage and the reasons why we resist such use of images. The predicament into which one is thrown, then, is how to imagine identity in the present tense of South Africa's transitional reshaping and reconstitution of its reality; between authenticity and stereotype. For everything seems haunted by this paradoxical affirmation of origin and disavowal of past histories. Within all that, what needs interrogation is usage of any fixed meaning of blackness as an ideology of authenticity, or whiteness as a surplus enjoyment of superiority. Whatever the orientation, whatever the signifying strategies of usage, either to mask whiteness or to valorise falsely an atrophied and immobile black identity, we would do well to heed Aimé Césaire's refusal to fix blackness in any stable meaning. Césaire, in his seminal epic poem *Cahier d'un retour au pays natal* (Notebook of a Return to my Native Land), wrote in some of its most moving lines:

my negritude is neither tower nor cathedral
it takes root in the red flesh of the soil
it takes root in the ardent flesh of the sky

What Césaire is articulating here, far from being a fantasy of blackness, is a proposition of heterogeneity, in which he casts aside all those fantasies that fetishise blackness in such a way that it loses its human dimension. 'My negritude is neither tower nor cathedral', 'Black is . . . black ain't': are there any more succinct ways to begin the delimitation of those fantasies that mark the black subject as abject, than to start with these two ideas of unfixed blackness, burgeoning into the expansive site of heterogeneity? I want to end with this question, because the relationship of the white or black artist to the black body is indeed paradoxical. And the less anxiously repeated the image, the better the opportunity to find an ethical ground to use its index as a form of discursive address, for radical revision, as well as to unsettle the apparatus of power that employs it as a structurally codified narrative of dysfunction.

Notes

1 Benedict Anderson, *Imagined Communities* (London: Verso, 1991).

2 Edward Said, *Culture and Imperialism* (London: Vintage, 1994).

3 Claire Kahane, 'Object Relations Theory', in *Feminism and Psychoanalysis: A Critical Dictionary* (Oxford: Basil Blackwell, 1992), p 284, quoted by David Sibley in *Geographies of Exclusion: Society and Difference in the West* (London and New York: Routledge, 1996), p. 5.

4 Olu Oguibe, 'Art, Identity, Boundaries', *Nka: Journal of Contemporary African Art* (New York: Fall/Winter 1995), p 26.

5 Julia Kristeva, *Powers of Horror: An Essay on Abjection*, trans. Leon S. Roudiez (New York: Columbia University Press, 1982), p 4.

6 Frantz Fanon, *Black Skin, White Masks*, trans. Charles Markmann (New York: Grove Press, 1967), p. 112.

7 Edward Said, *Orientalism* (London: Routledge and Kegan Paul Ltd, 1978).

8 Frantz Fanon, *The Wretched of the Earth*, trans. Constance Farrington (New York: Grove Press, 1963), p 39.

9 Stuart Hall, 'Cultural Identity and Cinematic Representation', *Framework*, no. 36 (1989), p. 70.

10 Rob Nixon, 'Of Balkans and Bantustans', *Transition*, no. 60 (New York: Oxford University Press, 1993), p. 25.

11 While on the surface, the challenges to the 'Rainbow Nation' as a unitary polity might seem like a defence of pluralism, difference and heterogeneity, in reality they seem to recast a neo-conservative stance that echoes the divisive Bantustan policy of separate development of the apartheid regime. For what the critics fear and have failed to admit, at least explicitly, are the prospects for whiteness in an overwhelmingly 'black' South African country. Hence, the maintenance of ethnic, racial and linguistic faultlines seem the best check against an encroaching Africanisation of South Africa. In fact, the extreme right wing have seized on such arguments and fears of Africanisation to demand an outright white Bantustan (homeland) for Afrikaners, and the Inkatha Freedom Party has adopted the neo-biologism of Zulu ethnicity to make an appeal for what its leader Mangosuthu Buthelezi has dubbed the 'Yugoslav option' or KwaZulu. See Rob Nixon's brilliant essay (*ibid.*) for a more in-depth study of these contestations.

12 Fanon, *Wretched of the Earth*, *op. cit.*, p. 36.

13 This issue was echoed by Mahmood Mamdani, the Tanzania-born Chair of the Department of African Studies at the University of Cape Town. In the discussions that surrounded the conference, Mamdani asked whether the desire to form an organisation to promote Afrikaans was not an attempt 'by the privileged but displaced section to recruit foot soldiers from its less fortunate cultural cousin to strengthen a bid to retain some privileges and regain others?'. Neville Alexander, one of the speakers, also placed himself at a distance from the nationalistic intonation carried by aspects of the conference by insisting that 'if people want to form this kind movement to protect a specific language, they must accept the consequences'. But the entire debate, as it relates to the concept of the 'Rainbow Nation' with equal access for all cultures, was phrased most effectively by Antjie Krof who stated 'that if this meant standing shoulder to shoulder with Afrikaners whose motives were anti-government, anti-ANC, anti-truth commission and anti-nation building, then she would have none of it'. All quotes taken from Chris Barron, 'Afrikaans takes a wary step into the future', *Sunday Times* (8 December 1996), p. 8.

14 Homi Bhabha, *Location of Culture* (New York and London: Routledge, 1994), p. 66.

15 Olu Oguibe, 'Art, Identity, Boundaries', *Nka: Journal of Contemporary African Art* (New York: Fall/Winter 1995), p. 26.

16 Santu Mofokeng, 'Black Photo Album/Look at Me: 1890-1950s', *Nka: Journal of Contemporary African Art*, (New York: Spring 1996), p. 54.

17 Susan Vogel, *Africa Explores: 20th Century African Art*, exhibition catalogue (New York: The Center for African Art, 1991), p. 10.

18 James Clifford, *The Predicament of Culture: Twentieth Century Ethnography, Literature and Art* (Cambridge: Harvard University Press, 1988), p. 50.

19 Allan Sekula, 'The Body and the Archive', in Richard Bolton (ed.), *The Contest of Meaning: Critical Histories of Photography* (Cambridge, MA: MIT Press, 1989), p. 347.

20 bell hooks, 'The Oppositional Gaze: Black Female Spectators', in Manthia Diawara (ed.), *Black American Cinema* (London: Routledge, 1993), pp. 288-289.

21 Manthia Diawara, 'Black Spectatorship: Problems of Identification and Resistance', in *ibid.*, p. 213.

22 Fanon, *The Wretched of the Earth*, *op. cit.*

23 Bhabha, *op. cit.*

24 bell hooks, 'Doing it for Daddy', in Maurice Berger, Brian Wallis and Simon Watson (eds.) *Constructing Masculinity* (New York: Routledge, 1996), p 99.

25 *Ibid.*

The Carapace That Failed:
Ousmane Sembene's *Xala* (1974)

Laura Mulvey

The film language of 'Xala' can be constructed on the model of an African poetic form called
'sem-enna-worq', which literally means 'wax and gold'. The term refers to the 'lost wax'
process in which a goldsmith creates a wax form, casts a clay mould around it, then drains
out the wax and pours in pure molten gold to form the valued object. Applied to poetics, the
concept acknowledges two levels of interpretation, distinct in theory and representation.
Such poetic form aims to attain maximum ideas with minimum words. 'Wax' refers to the
most obvious and superficial meaning, whereas the 'gold' embedded in the art work offers
the 'true' meaning, which may be inaccessible unless one understands the nuances of folk
culture. Teshome H. Gabriel [1]

This quotation succinctly illuminates the intense interest that recent African cinema holds for
any film theory concerned with the 'hieroglyphic' tradition, and potential, of cinema. The catch-all
phrase 'hieroglyph' is useful in that it evokes three processes: a code of composition – the
encapsulation, that is, of an idea in an image that is on the verge of writing; a mode of address that
asks an audience to apply its ability to decipher the poetics of the 'screen script'; and, finally, the
work of criticism as a means of articulating the poetics that an audience recognises, but leaves
implicit. My critical perspective cannot include the 'nuances of folk-culture' or, indeed, other
important aspects of African culture and history, but attempts to present *Xala*'s significance for
film theory beyond its immediate cultural context. While as a critic, I would like to fulfill the third
deciphering function, that of 'articulation', my critical process does not aspire to go beyond making
explicit the work of the first two hieroglyphic processes, that is, the 'screen script' and its mode of
address to an audience. African cinema should no longer be seen as a 'developing' cinema. It has
already made an original and significant contribution to contemporary film and its cumulative
history and aesthetics. Ironically, or appropriately, this is particularly so as interesting cinema in
the West seems to lapse into decline.

The germinal ground in which the African cinema developed in the postcolonial period was
Francophone sub-Sahara, above all in Senegal and Mali, and first of all, with Ousmane Sembene.
Geographically, this area has its own cultural traditions dating back to the old Mande Empire,
founded by Sundiata in the eleventh century, and which revived in resistence to French colonialism,
as the Dyula Revolution, under Samoury Toure in the late nineteenth century. It was not until
Independence in 1960, when the French were abandoning most of their African colonies in the
hope of holding on to Algeria, that the conditions for an African cinema came into being. Sembene's
work, first as a writer, then as a filmmaker, crosses the 1960 divide and is also divided by it.
During the 1950s, Sembene had made his name as an African novelist, writing, of course, in
French. His first novel, *Le Docker Noir* (The Black Docker, 1956), was written while working in the
docks and as a union organiser in Marseille. *Les Bouts de Bois de Dieu* (God's Bits of Wood) was

published in 1960 (after a number of others), based on his experiences during the famous 1947–48 strike on the Bamako-Dakar railway. Then, in 1961, immediately after Senegal achieved Independence, he went to the Soviet Union to study at the Moscow Film School and his first short film, *Borom Sarret*, was shown at the Tours film festival in 1963. *La Noire de ...* (Black Girl), released in 1966, was the first full-length feature from the sub-Sahara.

Sembene's novels were written during the period in which African poets, novelists, Marxist theorists and intellectuals in Paris were grouped around the journal *Prèsence Africaine*. Sembene was critical of the Negritude [2] movement with which they were identified. He considered the concept to be irrelevant to the popular resistence that grew into the independence movement. He identified himself with, and was part of, the anticolonial struggle in Senegal rather than intellectual circles in Paris. While he wrote novels in French during the colonial period, the cinema offered Sembene a means of contact with popular traditions. His films are directed towards the cultural needs of the ordinary people, who had no access either to French language or to traditions of written culture:

> Often the worker or the peasant don't have time to pause on the details of their daily lives; they live them and do not have time to tie them down. The filmmaker, though, can link one detail to another to put a story together. There is no longer a traditional story-teller in our days and I think the cinema can replace him. [3]

This last observation is characteristic of Sembene's commitment to promoting and transforming traditional culture, to using the technological developments of Western society in the interests of African culture. Sembene was more interested in finding a dialectical relationship between the two cultures than in an uncritical nostalgia for precolonial pure African-ness. This position is underlined by his background as a worker and his Marxism.

The cinema can speak across the divisions created by oral tradition and written language and is, therefore, a perfect mechanism for a cultural dialectic. It can perpetuate an oral cultural tradition as the spoken language plays a major role in cinema; and it can bring oral traditions into the modernity of the postcolonial. Sembene himself was the son of a fisherman and self-educated into French literacy. His own Wolof language, like the Mandinke, had no written equivalent. In the social structure of the Mande tradition, the task of maintaining and creating oral culture evolved onto a specific social grouping, the *griots*, dependent on the nobility in precolonial times. They functioned as the repository of historical memory, traditionally that of the kings and their families, and as creators, among other things, of poetry and music. African culture has had to negotiate a contemporary *modus vivendi* between writing in French, its own traditional oral forms and the facts of postcolonial cultural life. While the figure of the *griot* may evoke the oral culture of the precolonial

past, he (and, sometimes, she) spoke primarily to an elite. Economically and politically, the cinema had to address a mass audience in postcolonial Africa.

In Sembene's film *Xala* (1974) the question of language is at the political centre of the drama. The economic division between the indigenous entrepreneurial elite and the impoverished people is reflected in a division between French and Wolof. The elite use French to communicate among themselves and as their official language. They speak Wolof only across class and gender lines and treat it as inferior and archaic. In the novel *Xala* (published by Heinemann Books as part of their African Writers series in 1976), which Sembene wrote up from his script while searching for funds for the film, the young people on the Left have developed a written equivalent for the Wolof language and are publishing a journal in their native language for the first time. In the film, Sembene sets up a parallel between two figures, who are quite marginal to the story but significant for its politics. One is a young student selling the new journal; the other is a peasant, robbed of his village's savings, which he had brought to town to buy seed. Both get caught in the police round-up of beggars that forms the film's central tableau and become integrated into the beggar community. Any moves towards cultural and economic advance and self-sufficiency from the people themselves are dashed in the polarisation between the entrepreneurial elite and the underclass it creates.

Although the cinema has often been evoked in continuity with the *griot* tradition, there are important points of difference, besides those of class. The oral tradition of the *griot* was based on verbal language. The cinema sets up a dialectic between what is said and what is shown. One can undercut, or play off, the other. In *Xala*, Sembene uses the language of cinema to create a poetics of politics. He gives visibility to the forms, as opposed to the content, of social contradiction and then, through the forms, illuminates the content. He forges links between underlying structures, or formations, and the symptoms they produce on the surface, stamped, as it were, onto everyday existence, across all classes. This is an aesthetic that depends on making visible those aspects of economic and political structure that are either invisible or repressed in articulated language. It is a cinema of what cannot be said. Underlying structures mark the lives of the ruling elite as well as the people, and as the story unfolds, signs and symptoms signal an insistent return of the repressed. The repression is both political, of the people by the ruling elite, and psychoanalytic, of the ruling elite by their relation to Frenchness, its consequent phobias and fetishisms. The two spheres become increasingly interlinked throughout the course of the film. While Sembene's analysis of signs is always historical and, in the last resort, materialist, he also acknowledges the place of sexuality and the structure of the psyche in the symptomology of neo-colonialism. There are shades of Frantz Fanon's *Black Skin, White Masks* (1967).

Xala is set in Senegal after Independence, when the presence of the colonial power is concealed behind a façade of self-government. The story's premise is that Independence politics had become inextricably compromised with colonial financial structures. The opening, pre-credit, sequence of

Xala shows a crowd celebrating as a group of African businessmen expel the French from the Chamber of Commerce and take control of their own economy. The people in the crowd are depicted in such a way as to evoke 'African-ness', with bare breasts, dancing and drums. These connotative images never appear again in the film; thereafter, the characters' clothes and appearance are appropriate for the Islamic sub-Sahara. The businessmen are dressed in loose shirts and trousers made of 'African' type materials. They appear at the top of the steps, ejecting a few objects that evoke the colonising culture (including a bust of Marie-Antoinette). The camera is placed at the bottom of the steps. As the men turn to go into the building, the camera dips slightly to change its angle and the steps suddenly resemble a stage on which a performance has just taken place. When the camera joins the men back in the Chamber, they are dressed in the dark European business suits that they will wear for the rest of the film. While the crowds still celebrate, a posse of police arrive and, under the command of one of the recently expelled Frenchmen, push the people back from the central space in front of the Chamber of Commerce, literally enacting the process of domination and repression. The other two Frenchmen then enter the Chamber and place an attaché case in front of each African businessman. The cases are full of money. The two men step backwards with the silent subservience they maintain, as 'advisers', for the rest of the film. The sequence closes as El Hadji Abdou Kader Beye invites his colleagues to the wedding party celebrating his marriage to a third wife. All the speeches are in French.

I have chosen the word 'carapace' to evoke the central poetic and political themes in *Xala* in order to convey an image of vulnerable flesh covered by a protecting shell. The carapace doubles as a mask behind which the ruling elite camouflages itself, adopting the clothes, language and behaviour of its former colonial masters. The carapace also evokes the social structure of neo-colonialism. The entrepreneurial bourgeoisie live the life of an upper-crust, floating and parasitical on the lives of the people. In *Xala* the carapace conceals not simply vulnerable flesh, but flesh that is wounded by class exploitation. Whereas a scab indicates that a wound has developed its own organic means of protection, the carapace of neo-colonialism denies and disavows the wound and prevents healing. The elite encase themselves in expensive Western cars, while the beggars' bodies are crippled by deformed or missing limbs. Concealed corruption at the top of the social hierarchy manifests itself on the wounded bodies of the dispossesed. During the course of the film's story, the gap between the two groups, the beggars and the elite, narrows until the final scene, which brings them together. The central character of the film is El Hadji, a member of the entrepreneurial elite, who finds he is impotent when he marries his third wife. A tension then runs through the film between the vulnerability of his body, his failed erection, on one side, and on the other his outward carapace made up of European props. In the end, his sexual vulnerability has brought him to realise that the carapace has failed and he exposes his own naked body for the beggars to cover in spit in their ritual of humiliation and salvation.

Xala, Senegal, 1974
(dir. Ousmane Sembene)
Film still courtesy the
British Film Institute,
London

During a climactic scene just before the end of the film, El Hadji is being hounded out of the Chamber of Commerce by his equally corrupt colleagues. His most vindictive antagonist seizes his attaché case and opens it to find it empty except for the magic object with which El Hadji had attempted to ward off the curse of impotence, the *xala*, that had afflicted him. His enemy holds it up for public ridicule. El Hadji seizes it and waves it defiantly in the faces of the others, shouting 'This is the true fetish, not the fetishism of technology'. At this moment, Sembene brings into the open the theoretical theme of his film, that is, the different discourses of fetishism. Up until that point, these had been woven into the story implicitly, creating the complex semiotic system that makes special demands on the spectator's reading powers. Suddenly, the three strands are condensed together in one object. The object acts simultaneously as a signifier of religious belief that pre-dates Islam and colonialism, as a signifier, in the context of the story, of El Hadji's sexual impotence, and as it is enclosed, concealed, in the attaché case, a key signifier of financial corruption and the commodity fetishism that corruption breeds.

Sembene weaves a series of reflections on fetishism across the film. As something in which a meaning and a value are invested beyond or beside its actual meaning and value, a fetish demands the willing surrender of knowledge to belief. The fetishist over-rates his object, and ignoring the common-sense value attributed to it by society, secretly attaches mysterious powers to it. But, however intensely invested, this secret belief is vulnerable, acknowledging, even more secretly, what it simultaneously disavows. For an individual, the fetish object may be invested with private magical or sexual significance, but distortions of value and attributions of inappropriate meaning may also be shared by social groups in a kind of collective fantasy. The fetish thus acts, either individually or collectively, as a sign, signalling the intervention of fantasy into the normal course of the reality principle. The intervention of fantasy signals a point of anxiety that cannot face the possibility of knowledge, and in the process of avoiding it, erects a belief in an object that, in turn, denies knowledge of its actual value. While supporting the suspension of disbelief, the fetish also materialises the unspeakable, the disavowed, the repressed.

The cinema, too, appropriates objects, turns them into images and wraps them in connotations and resonances that are either collectively understood, or acquire specific significance within the context of a particular story. Sembene makes use of the language of cinema, its hieroglyphic or pictographic possibilities, and creates a text that is about the meaning of objects and objects as symptoms. His use of cinematic rhetoric is the key to *Xala*. The form of the film engages the spectators' ability to read the signs that emanate from colonialism and its neo-colonialist off-spring. And, because the film shows an African ruling elite accepting and appropriating the fetishisms of European capitalism, it allows a double reading. As a comedy of fetishistic manners *Xala* uses signs, objects and the rhetoric of cinema to allow its audience direct engagement with, and access to solving, the enigmas represented on the screen. But *Xala* also sets off a kind of chain

reaction of theoretical reflections on fetishism, linking together otherwise diverse ideas, and highlighting the age-old function of fetishism as a conduit for the to and fro of cultural and economic exchange between Europe and Africa.

I

There is a double temporality hidden in Sembene's use of the discourses of fetishism in *Xala*. Behind, or besides, the thematic strands of the story, lies another, extra-diegetic, history. This history, quite appropriately, is not visible in the film. But any consideration of fetishism in Senegal today raises 'ghosts' from the past. These are reminders that the word first came into existence in the proto-colonial exchanges, beginning in the mid-fifteenth century, between Portuguese merchant traders and the inhabitants of the West African coast, part of which is now known as Senegal. Sembene depicts an entrepreneurial, pre-capitalist economy in contemporary Senegal and the film is about the function, within that economy, of fetishised objects as signifiers of unequal exchange. The film inevitably draws the attention of anyone interested in the history of the concept of fetishism to its origins in that earlier period of pre-capitalist, mercantile, economic exchange.

Before analysing the theme of fetishism in the film itself, I would like to use it as an excuse to raise some of these ghosts and make some introductory points about the history of the concept of fetishism. Marcel Mauss first pronounced the epitaph on the anthropological use of the word 'fetishism' as a compromised relic of nineteenth-century imperialist ethnography:

> When the history of the science of religions and ethnography comes to be written, the undeserved and fortuitous role played by concepts such as fetishism in theoretical and descriptive works will be considered astonishing. The concept represents nothing but an enormous misunderstanding between two cultures, the African and the European, and is based purely on a blind obeisance to colonial usage.[4]

The recent revival of interest in the origins of the term 'fetishism' has drawn attention to its conceptual contribution to the European polarisation between primitive and civilised thought and its consequent moral and intellectual justifications for imperialism. In other words, the concept of fetishism cannot be dismissed because of its compromised place in exploitative exchange and imperialist ethnography. On the contrary, the concept and its history can throw light on the 'enormous misunderstandings' between Europe and Africa.

William Pietz has discussed the origins of both the word and the concept in a series of articles in the journal *Res*.[5] He shows how the word emerged in the cross-cultural encounter between West African and European Christian cultures in the sixteenth and seventeenth centuries. It was a 'novel word that appeared as a response to an unprecedented type of situation',[6] of relations between

'cultures so radically different as to be mutually incomprehensible'.[7] Pietz argues that the term bears witness to its own history. To reject the term completely, as purely and simply a relic of colonialism and imperialist anthropology, is to ignore its historical specificity and the cultural implications that go with it. Pietz demonstrates that fetishism is a debased derivation of the Portuguese *fetiço*, which means 'witchcraft', in turn derived from the Latin *facticium* which means 'artificial', something made up to look like something else. *Feitiço* was generally applied by the Portuguese to beliefs and practices that they neither could nor would interpret, but encountered in their commercial relations. In the pidgin of middlemen, who settled in West Africa and became the *soi-disant* experts on native customs, the word became *fetisso*. Pietz notes: 'It brought a wide array of African objects and practices under a category that, for all its misrepresentation of cultural facts, enabled the formation of more or less non-coercive commercial relations between members of bewilderingly different cultures.'[8]

The lore and practices that developed around the concept of the *fetisso* was then inherited, wholesale and to a second degree, by the Dutch traders who arrived on the West Coast in the very late sixteenth century and had gradually ejected the Portuguese by 1641. The Dutch Calvinists

The European extrapolation of the concept of fetishism, the fetishisation of 'fetishism', seems like an enormous blindfold – one that was necessary to justify the colonisation of Africans.

brought the Reformation's deep, anxious hatred of the superstitious and idolatrous practices of Catholicism. To them, the idolatry of the Portuguese and the fetishism of the Africans were six of one and half a dozen of the other. It was the Dutch merchants of this period, Pieter Marees and William Bosman in particular, who wrote down their experience and observation of African customs. Pietz argues that the implications of the concept 'fetishism' took shape during this period. It was during the late seventeenth century, with West African trade efficiently organised by the Dutch East India Company, that conceptual problems of value began to be theorised as a problematic concerning the capacity of the material object to embody value. The concept of fetishism as an inappropriate attribution of value to an object, emerged alongside, and in conjunction with, the emergent articulation of the commodity form. It was, for instance, during the second part of the seventeenth century that William Petty, an influence on Adam Smith and described by Marx as 'the father of Political Economy and to some extent the founder of statistics' was evolving an early version of the labour theory of value.[9] At the point when trade in commodities became a 'market', not only did the question of attribution of value become crucial, but also how value could be marked by a shared and recognised 'general equivalent'. A coinage

with value – money – represented in quantities of silver and gold, translated value into something that could represent the same for everyone involved in the process of commercial exchange. The abstract, symbolic nature of the money form seemed, to the European mind, to emerge from the same thought processes that could conceptualise the abstract, symbolic nature of God.

To the European traders, the Africans' attribution of talismanic and prophylactic powers to inanimate objects was the basis for their false economic valuation of material objects. They would exchange gold for what the Europeans considered to be worthless 'trifles'. Overestimation, of the trifles, on the one hand, underestimation, of the standard value of gold, on the other, blocked 'natural reason' and 'rational market activity'. Although there were examples of a proto-money form in Africa at the time (iron bars, for instance, in Senegambia), although a developed network of commercial trade and exchange existed between sub-Saharan Africa and the Arab north, although Islam, a religion of monotheism and the written word, had spread into Africa, European observations only confirmed their preconceptions. At the same time, the *fetisso* became deeply imbricated in commercial relations. It was the practice to guarantee transactions by getting Africans to take 'fetish oaths', which, while ensuring the efficacy of the transactions, also seemed to confirm the innately superstitious nature of the indigenous people.

> For the European merchant, the *fetisso* posed a double problem, a double perversion. First, the status of commercially valuable objects as *fetissos* complicated his ability to acquire them as commodities and seemed to distort their relative exchange value. This often led to transactions with an exceptionally high rate of profit, but it also caused difficulties since the locals regarded the desired objects in a personal, social, or religious register rather than an economic one. Second, to effect economic transactions, merchants had to accept the preliminary swearing of oaths upon *fetissos* – a perversion of the natural processes of economic negotiation and legal contract. Desiring a clean economic interaction, seventeenth-century merchants unhappily found themselves entering into social relations and quasi-religious ceremonies that should have been irrelevant to the conduct of trade were it not for the perverse superstitions of their trade partners. The general theory of fetishism that emerged in the eighteenth century was determined by the problematic specific to this novel historical situation.[10]

The beliefs and practices surrounding *fetissos* were described, exotically and derogatorily, by travellers, merchants and priests above all, during the seventeenth and early eighteenth centuries, culminating in the publication of William Bosman's *New and Accurate Account of the Coast of Guinea* in 1704. It was this descriptive work that was used as the basis for President de Brosse's general theorisation of fetishism published in 1760. De Brosse used the concept of fetishism to

describe the culture of Africa as essentially childish and to show that 'what is today the religion of African negroes and other barbarians, was once upon a time the religion of the ancients, everywhere on earth'.[11] De Brosse's account of fetishism influenced some thinkers of the Enlightenment period and the concept of fetishism began to become integrated into intellectual discourse. Pietz comments: 'This sanctioning power through magical belief and violent emotion was understood to take the place of the rational institutional sanctions that empowered the legal systems of European states . . . social order was dependent on psychological facts rather than political principles'.[12]

It is in this sense that the concept and discourse of fetishism has itself played an important part in justifying the colonisation, exploitation and oppression of Africa. The European extrapolation of the concept of fetishism, the fetishisation of 'fetishism', seems like an enormous blindfold – one that was necessary to justify the colonisation of African people. Auguste Comte took one stage further de Brosse's theory that fetishism constituted an infancy in the history of human spiritual belief, a moment through which, once upon a time, all religions have passed. Comte argued that the lack of priests as intermediaries and the personal and domestic nature of the cults blocked the development of belief in an invisible, abstract godhead:

> It is above all a belief in the invisibility of the gods and their essential distinction from the bodies under their discipline, that must determine, in the polytheistic period, the rapid and significant development of a true priesthood, able to acquire a high social authority, constituting, in a permanent and ordered manner, an indispensable intermediary between the worshipper and his god. Fetishism, on the other hand, does not involve this inevitable intervention, and thus tends to prolong indefinitely the infancy of social organisation, which must depend, for its first step, on the distinctive formation of a class of speculative thinkers, that is to say, a priesthood.[13]

Jean Pouillon argues that Hegel, however, saw the fetishism of the African not as a stage on the path towards civilisation, but as inherent: the 'African' being unable to 'move beyond a first antithesis between man and nature'. From the perspective of this logic, colonisation and civilisation become synonymous. Pouillon comments: 'Fetishism leads nowhere and the colonisers may have a clean conscience'.[14]

The concept of the fetish provided an antinomy for the rational thought of the Enlightenment. It gives a new form and historic twist to the long-standing and familiar spirit/body and abstraction/materiality polarisations. It coincides with the iconoclastic purification of Christianity from the trappings of idolatrous Catholicism, in which a return to the Old Testament and the precedent of the Jewish, monotheistic rejection of Egyptian iconology was influential.

Pietz emphasises that the coming into being of the concept of the fetish was necessarily in conjunction with 'the emergent articulation of the ideology of the commodity form'.[15] As W. J. Mitchell points out, 'If Adam Smith is Moses he is also Martin Luther'.[16] It was this discourse of fetishism ('the mist enveloped regions of the religious world') that Marx turned back onto his own society and that Freud used to define the furthest limits of the psyche's credulity. Both analogies gave the concept of the fetish a new pertinence, turning it away from its anthropological roots towards questions of signification. The fetish raises questions of meaning quite apart from its constructed antinomy with abstraction. It epitomises the human ability to project value onto a material object, repress the fact that the projection has taken place, and then interpret the object as the autonomous source of that value. The process becomes invisible; as the object acquires exchange value, its historical specificity drops into obscurity. The enigma, then, challenges the historian or analyst. The fetish is a sign rather than an idea and it can be analysed semiologically rather than philosophically. This process is central to *Xala*.

II

The film opens with El Hadji collecting his two other wives to go to the party. The elder, Adja Awa Astou, is traditional and religious. In Sembene's imagination, 'He got his first wife before becoming a somebody'. The second, Oumi N'Doye, is Westernised and mercenary. Sembene says 'Along with his economic and social development, he takes a second who corresponds, so to speak, to a second historical phase'. Awa's daughter Rama, who stands up to her father throughout the film, synthesises progressive elements in both African and Western cultures. She has posters of Amilcar Cabral and Charlie Chaplin in her room; she dresses in African style and rides a motor scooter; she is a student at the University and she will only speak Wolof. N'gone, El Hadji's new wife, is dressed for a white, Western wedding and her face is covered with a bridal veil. Sembene says: 'The third, his daughter's age but without her mind, is only there for his self-esteem'. Then, on the wedding night, El Hadji finds he is impotent. During the rest of the film he tries to work out who could have cursed him and visits two marabouts to find a cure. Unable to sustain the cost of three households and the lavish wedding, his financial affairs unravel until he is finally expelled from the Chamber of Commerce.

The central enigma in *Xala* cannot be deciphered until the very last scene, when the beggars, who, at the beginning of the film are marginal to the story and gradually come to occupy its centre, invade El Hadji's house. Then the different clues that have been signalled by Sembene throughout the film fall into place and complete the picture. El Hadji does not function as a knowing narrator and the only character with whom the spectator is given any identification, personally and ideologically, is Rama, who plays only a small, though important, part in the film. El Hadji is a didactic hero. He is made into an example, rather as Brecht makes an example out of Mother

Courage. He only engages sympathy through the disaster he has brought upon himself, and, like a tragic hero of the cathartic theatre, he is literally stripped to nakedness. On a more significant level, he cannot command the narration because he is unable to understand his own history. The audience are thus deprived of the safety and security of a hero who will guide them through events, and provide them with an appropriate moral perspective. At the end, the spectator realises that the film itself has held the clues to the enigma of El Hadji's *xala*, and these linked images and figurations can, retrospectively, be deciphered. Sembene's cinema demands a spectator who is actively engaged with reading and interpreting the sounds and images unrolling on the screen.

There are certain parallels between *Xala*'s narrational strategy, constructed around a central enigma, and that of Orson Welles' *Citizen Kane* (1941). Both films also tell the story of a man's relationship to money, fetishised objects and sexuality. In *Citizen Kane*, the audience's investigation of the enigma is conducted by a surrogate, the journalist, Thompson. However, he is unable to see or interpret the clues contained in the visual discourse of the film. The pieces finally fall into place when the camera allows the audience a privileged look at the little sled as it is thrown on the flames. Thompson cannot see how these signifiers link together like the rings of a chain and mark the movement of associated ideas, objects and images that map out the process of displacement. The camera, or rather the rhetoric of the cinema, assumes the position of master narrator, and directly addresses the audience.

As in *Xala*, the audience of *Citizen Kane* then has to think back over the whole course of the film to translate the 'sensitive areas', retrospectively, and solve the enigma by deciphering the sliding of the signifiers. Just as the glass snow-storm allows a 'reference back' to the log-cabin, so the name on the sled at the end of the film returns the missing signified to the enigma, seeming to halt and restore order to the slippage of the signifiers. But the signified 'Rosebud' then sets off on another journey, as a signifier for the lost mother and a memorial to that loss. As Jacques Lacan points out in his essay 'Agency of the Letter in the Unconscious',[17] a signifier's ability to suggest multiple signifieds creates the leap of association that allows the unconscious mind to displace one idea onto another. Where the conscious mind has set up an impenetrable wall of censorship, the unconscious disguises its ideas through displacement, but not so completely that the link between the original idea and the disguised idea will be lost. Psychoanalysis tries to trace the process backwards, following the links and deciphering the clues in reverse, restoring the links between the signifiers lodged, but indecipherable, in the conscious mind to the unconscious idea they represent. Similarly, describing the language of dreams, Freud used the image of a rebus and compared dream interpretation to the decipherment of the clues in a pictogram.[18]

In *Xala*, the visual coding of ideas is even more marked and further emphasised by the absence of a surrogate narrator. This mode of cinematic address is perfectly suited to the film's subject matter: fetishism. El Hadji and his colleagues have lost touch with their own history and society

through adopting Frenchness as a sign of superior class position. There is an unbridgeable gap between the elite's own origins, the condition of the people and their present masquerade of Westernised, commodity culture. The gap is demonstrated by the elite's use of French, rather than Wolof, and safeguarded by a fetishisation of European objects. These things, like, for instance, El Hadji's Mercedes, are the literal materials of the carapace, his defence against political and economic reality, and the outward manifestations of a corruption that sucks the life blood of the people. When the Mercedes is repossessed, Modu, the chauffeur, carries a wooden stool as he guides his employer along the street. The stool is like a shrunken, or wizened version of the proud object of display. It is a trace of, or a memorial to, the Mercedes and its meaning for El Hadji. Because Modu has been so closely identified with the car and its welfare, his presence links the two objects ironically together. Sembene consistently links people with things; things substitute for people or for each other; things acquire associations and resonances that weave like threads of meaning through the film. At the same time, he raises the issue of substitution and exchange in a social and economic sphere. The marabout who cures El Hadji's *xala*, Sereen Mada, restores it when the cheque that El Hadji gave him in payment is bounced by the bank.

As the members of the Chamber of Commerce arrive at El Hadji's wedding party, the camera is positioned so that, as each man walks past, his attaché case is framed in close-up. On the outside, the attaché case is emblematic of the power of the international business community, but inside, as only the audience can know, is the secret evidence of corruption and collaboration with the old colonial masters. While seeming to be signs of power and authority, the attaché cases represent the real impotence of the entrepreneurial elite in relation to neo-colonialism. Once the film has established these associations, the image of the attaché case evokes them whenever it appears. So that when El Hadji walks dejectedly away, carrying his attaché case, from N'gone's house after his failed wedding night, he seems to be bowed down with a double impotence. And, in his final confrontation with his colleagues, his case is empty apart from the fetish given to him by the phoney marabout. The failed fetish is found in the place formerly occupied by the colonialists' banknotes.

Although the particular discourse of sexuality on which Freud's theory of fetishism depends cannot be imposed carelessly on another culture, Sembene's juxtaposition of the psychosexual with the socioeconomic is explicit. He uses the sexual as the point of fissure, or weakness, in the system of economic fetishism. El Hadji's impotence is a symptom of something else, a sign of the eruption of the unconscious onto the body itself. In Freud, the fetish enables the psyche to live with castration anxiety; it contributes to the ego's mechanisms of defence; it keeps the truth that the conscious mind represses, concealed. When the fetish fails to function effectively, the symptoms it holds in check start to surface. In *Xala*, the fragile carapace collapses under pressure from class politics and economics but these pressures are expressed through, and latch on to, sexuality, working on the body's vulnerability to the psyche. For Sembene, class politics determine events

over and above sexuality. Sexuality plays its part in the drama as the site of the symptom, the first sign of a return of the repressed. In his representation of repression, Sembene makes full use of the *double entendre* that can condense its political and psychoanalytic connotations.

The morning after the wedding, El Hadji's secretary opens his shop. Modu delivers El Hadji in the Mercedes. El Hadji asks his secretary to telephone the President of the Chamber of Commerce who immediately comes over to see him. Interspersed with, and separate from these events, the beggars are slowly gathering, taking up their usual positions outside in the street. As the local women empty their slops into the drain outside the shop, the secretary runs out with her disinfectant spray to ward off infection. As El Hadji's car appears, so do the beggars and their music; as the president's car appears, so do the cripples. In the back office, El Hadji tells the President about the *xala*. The President reacts with horror saying 'Who? Who could have done this to you?' At that moment the beggars' music drifts into the room. El Hadji gets up from his chair without answering and goes through to the front office and closes the window. He asks the President to call the police and remove this 'human refuse', adding that 'it's bad for tourism'. The police arrive, and under the direction of their French commander, load the beggars and cripples into a lorry and drive them out of town. They are left miles away, in the middle of nowhere, and start their slow, painful trek back into town.

When watching this scene, the spectator cannot but be conscious of a figuration of 'repression'. The President orders that the beggars be removed from sight and from consciousness. Their return then figures a 'return of the repressed'. To the mutilated limbs of the cripples is now added a baton wound on the head of the boy who guides the blind man and whom Modu employs to clean the car. The repression is both physical and social and the bodies of the beggars are symptoms of social and economic injustice. But this scene also contains a clue to the enigma, to the source of the *xala*, suggesting that it is in El Hadji's social and historical position. This other, psychic, dimension is not revealed until the final scene in the film, when El Hadji's fall is complete. Oumi has left him; N'gone's *Badyen* (her father's sister) has repudiated the marriag; his cheque to the marabout has bounced so that the *xala* has returned, his bank has refused to extend his loans, and his colleagues have voted unanimously to expel him from the Chamber of Commerce for embezzling thirty tons of rice destined for the country people. As Modu takes him to Awa's house, he tells El Hadji that the blind man can cure the *xala*. The scene builds up to the final revelation as the beggars invade the house under the blind man's leadership. While some of the beggars loot the kitchen, the blind man sits, as it were, in judgement. He says to El Hadji: 'Do you recognise me? . . . Our story goes back a long way'. He tells how El Hadji had taken his clan's land:

What I have become is your fault. You appropriated our inheritance. You falsified our names and we were expropriated. I was thrown in prison. I am of the Beye family. Now I will get my

revenge. I arranged your *xala*. If you want to be a man you will undress nude in front of everyone. We will spit on you.

It was this first act of expropriation that had set El Hadji on the road towards entrepreneurial success and had taken him from the country to the town, away from loyalty to family to individualism, from traditional modes of inheritance to falsified, written legal documents, away from the continuity of his own history into a charade of Frenchness. His failure to recognise the beggar indicates that he had covered his tracks by 'forgetting'. But when the President asked who had cursed him, his response was to shut out the sound of the beggar's song. This gesture signified both an acknowledgement of the truth and the need, quickly, to re-enact its repression.

During the final scene with the beggars, the tailor's dummy with N'gone's wedding veil, returned contemptuously to El Hadji by the *Badyen*, stands clearly visible in the corner. The presence of these objects sets off a chain of associations that run back through the film as the links between them begin to emerge. N'gone acts as a pivot between the two fetishistic systems: the economic and the sexual. She is woman as commodity, woman as fetish and woman as consumer of commodities.

Sembene's use of the concept of fetishism is Marxist *and* Freudian. The interest of the film lies in its inextricable intermeshing of the two.

N'gone's marriage to El Hadji was based on exchange. At the wedding, his gifts are displayed, including, most prominently, a car key. The car, which stands on the back of a truck, decked out with ribbons, outside the gate of the villa, is El Hadji's present to her in exchange for her virginity. As he leaves the villa after his unconsummated wedding night, he stops by the car and touches it mournfully, so that it seems to substitute for N'gone's unattainable sexuality. The car's fetishistic quality, its elevation out of ordinary use, the ribbons, is displaced onto her figure. She is first seen concealed behind her wedding veil, packaged like a valuable commodity, and she speaks only once throughout the film. To emphasise this 'thing-ness' and 'to-be-looked-at-ness', Sembene places her next to a large, nude but tasteful photograph of herself as the *Badyen* prepares her for her wedding night. As she is undressed and her wedding veil placed on the tailor's dummy, the camera pans up from her naked back to her body in the photograph. In a later scene, the same camera movement reiterates this juxtaposition.

N'gone's fetishised erotic appearance contrasts with Oumi's immediate, vital, demanding and corporeal sexuality. N'gone is image and commodity and, half concealed behind the wedding veil, she evokes the double nature of commodity fetishism. The commodity, in order to circulate and

realise the capital invested in it, must seduce its consumer and, in its very seductiveness –
its 'packagedness' – disguise the secret of its origins. That is, the inherent unglamorousness
of the production process should be invisible and, most of all, class relations, the extraction of
surplus value, must be concealed by seductive surface. N'gone's image as fetish evokes the
processes of veiling, disguise and substitution necessary to commodity fetishism and it is
perhaps significant that when El Hadji, temporarily cured of his *xala* by Sereen Mada, goes
triumphantly to his new bride, she has her period and is 'not available'. Her perfect surface
is tarnished by menstrual blood. Although the depiction of N'gone suggests links with the
appearance and circulation of the commodity under capitalism, the story is taking place in a
non-industrialised and 'under-developed' country. The money El Hadji needed to acquire her
as commodity, in the specific economic conditions of neo-colonialism, came from financial
corruption and exploitative entrepreneurial capitalism. He paid for the wedding and N'gone's
gifts by embezzling and illegally selling the quota of rice intended for the country people.
The secret corruption is displaced onto the little car that N'gone will receive in exchange for her
virginity. The car's fetishistic qualities are displaced onto N'gone for whom a photograph and a
tailor's dummy become substitutes and metaphors.

Marx evolved his theory of commodity fetishism in the process of developing his theory of value.
The problem that Marx perceived to be at stake in the theory of value is connected to the question
of visibility and invisibility of labour power and of value. Here, the question of materiality and
abstraction returns, in the context of a capitalist system of thought that Marx can show to be
deeply imbricated with fetishism, its phobic other. For W. J. Mitchell:

> Marx's turning the rhetoric of iconoclasm on its principal users was a brilliant tactical
> manoeuvre; given nineteenth-century Europe's obsession with primitive, oriental, 'fetishistic'
> cultures that were the prime object of imperialist expansion, one can hardly imagine a more
> effective rhetorical move.[19]

Marx identified commodity fetishism as emerging out of the gap between a belief in the
commodity as its own autochthonous source of value, and knowledge of its true source in
human labour. This gap is finally papered over and disguised under capitalism, as the labour
market necessary for mass industrial production can only function by transforming individual
labour power into abstract and generalised wage labour. The commodity's glamour, verging
on sex appeal, seals these complicated processes into a fixation on seeing, believing and not
understanding.

Money, the means of expression of value as a symbolic equivalent, is comparable, Marx said,
to language. The disavowal characteristic of fetishism is due to misunderstandings of the complex

stages inherent in an abstract, symbolic system and the political need to disavow the worker's labour power as source of the commodity's value. Just as a religious believer refuses to accept the human origin of his object (either physical or abstract) of worship, so capitalism refuses to accept that value originates in the labour of the working class. The more abstract the process, the more utterly fundamental is the denial of human origin. While belief in a fetish may be obviously a disavowal of its intractable materiality, belief in an abstract god creates a gap between man and spirit that is harder to materialise. 'A commodity is therefore a mysterious thing, because in it, the social character of men's labour appears to them as an objective character stamped on the product of that labour.' [20] It was at this point that Marx invoked, in a famous phrase 'the mist enveloped regions of the religious world' where 'the productions of the human brain appear as independent beings endowed with life and entering into relations both with one another and the human race'. He continues:

> value does not stalk about with a label describing what it is. It is value that converts every product into a social hieroglyphic ... The determination of the magnitude of value by labour time is therefore a secret, hidden in the apparent fluctuations of the relative values of commodities ... it is the ultimate money form of the world of commodities that actually conceals instead of disclosing the social character of private labour and the social relations between the individual producers. [21]

The hieroglyph of value is like *trompe l'oeil*. It appears on the surface to be intrinsic to its commodity but, with a move to another perspective, from the visible to the theoretical, its structure may be made accessible to knowledge. The commodity thus seals its enigmatic self-sufficiency behind a masquerade, a surface that disavows both the structure of value and its origin in working-class labour. Instead, it is inscribed with a different kind of semiotic, one that is directed towards the market place, which further disguises, or papers over, the semiotic that originated in its production. Baudrillard argues in 'The Political Economy of the Sign' [22] that, increasingly in the consumer societies of advanced capitalism, both the object form (use value) and the commodity form (exchange value) are transfigured into sign value. This is partly the function of advertising, which is expert in the creation of sign values, weaving an intricate web of connotation, as Roland Barthes describes in his analysis of the Panzani advertisement in the essay 'The Rhetoric of the Image'. [23] Baudrillard then argues that spending, or perhaps one should say 'shopping', elevates the commodity form into sign value, so that the economic is then transfigured into sign systems, and economic power becomes visibly transmuted into the trappings of social privilege. Consumer objects can then create needs in advance of the consumer's awareness of a need, bearing out Marx's point that 'production not only produces

goods but it produces people to consume them and corresponding needs'.[24]

The circulation of European commodities in a society of the kind depicted in *Xala*, caricatures and exaggerates the commodity fetishism inherent in capitalism. Rather than representing an enigma that may be deciphered, politically and theoretically, to reveal its place in the historical and economic order of things, the commodity's ties with history have been effectively severed. The chain of displacements that construct the concept of value are attenuated to the point that all connection with the source of value, basic to fetishism, are irredeemably lost in the movement from capitalism to colonialism. Floating freely outside its own economy, the gulf between luxury objects monopolised by a Third-World elite and the labour power of the working class in the producing country seems vast. Belief in the commodity's supposedly self-generated value does not demand the process of disavowal on which it depends at home so that it can live out its myth as an object of cult. In *Xala*, Sembene uses the neo-colonial economy to show the capitalist commodity 'super fetishised'. Modu, for instance, only puts imported bottled water into the Mercedes. These things take on pure 'sign value' (as Baudrillard would put it). However, the objects enable another process of disavowal. Sembene suggests that these fetishised objects seal the repression of history and of class and colonial politics under the rhetoric of nationhood. His use of the concept of fetishism is not an exact theoretical working through of the Marxist or Freudian concepts of fetishism, however; it is Marxist *and* Freudian. The interest of the film lies in its inextricable intermeshing of the two.

In the final images of the film, its class and psychoanalytic themes are suddenly polarised into a new pattern. Sembene invokes horror of the body and its materiality through the desperate and degraded condition of the beggars and cripples. As El Hadji is denounced by the blind man, their wounds and their missing limbs demonstrate the political fact that financial corruption and profit are manifested on the bodies of the poor. The Western objects that the entrepreneurial elite fetishise inflict not impotence but castration on those they impoverish. The wounded body, the source of horror in the Freudian concept of castration anxiety, returns in the wounded bodies of the beggars and the hunger of the peasants. These bodies break through the barriers maintained by the French language and symbolised, for instance, by El Hadji's cult of Evian water. The otherness of Africa that horrified the Europeans is perpetuated into a real horror for the ordinary people by colonialism, and grotesquely more so, by the irresponsible greed of the new ruling class.

For Freud, the site of castration anxiety is the mother's body. For Julia Kristeva, the mother's body is the site of abjection. The child's relation to its mother was a time without boundaries and a time when the body and its fluids were not a source of disgust. For Kristeva, the ego defines itself by a demarcation of its limits through mastering its waste and separating itself from those of the mother. It establishes itself as an individual, in its oneness.[25] This concept of individualism is, it has been extensively argued, a crucial basis for the ideology of entrepreneurial capitalism. And, as has also been extensively argued, the residue of disgust, bodily waste, are the matter of

ritual. In the last moments of *Xala*, the beggars take their revenge on El Hadji in a role reversal of power and humiliation. As El Hadji stands naked, in front of his wife and daughter, the beggars crowd around and spit on him. This is the price that the blind man exacts for lifting the *xala*. And as the scene seems to continue beyond endurance, the film ends with a freeze-frame.

Sembene's film opens with the theatre of politics, moves through a ceremonial celebration of marriage, closes with a ritual of rebirth. The prophylactic rituals of fetishised manhood fail, both financially and sexually. Teshome Gabriel comments:

> The spitting on El Hadji helps reincorporate him into the people's fold. In other words, the ritual becomes a folk method of purgation which makes El Hadji a literal incarnation of all members of the class or group that spit on him and consequently reintegrates him into folk society.[26]

In submitting to the body, and to everything that fetishism disavows, psychic and political, El Hadji signals a lifting of amnesia and an acceptance of history. The freeze frame resur-erects a man, whole through community, stripped of the trappings of colonialism and fetishised individualism.

Gabriel draws attention to a scene between El Hadji and Rama in which words, emblems and the film image weave an intricate pattern of meanings at different levels of visibility:

> Before Rama stands up to walk out of the frame Sembene makes us take note, once again, of the map of Africa behind her. We notice too that the colour of the map reflects the exact same colours of Rama's traditional *boubou*, native costume – blue, purple, green and yellow – and it is not divided into boundaries and states. It denotes pan-Africanism:
> *El Hadji:* "My child, do you need anything?"
> (He searches in his wallet.)
> *Rama:* "Just my mother's happiness."
> (She walks out of frame as the camera lingers on the map.)

What Sembene is saying here is quite direct and no longer inaccessible. On one level Rama shows concern for her mother ... On another level ... her concern becomes not only her maternal mother, but 'Mother Africa'. This notion carries an extended meaning when we observe the shot of El Hadji – to his side we see a huge colonial map of Africa. The 'wax' and the 'gold' are posited jointly by a single instance of composition. Two realities fight to command the frame, but finally the 'gold' meaning leaps out and breaks the boundaries of the screen.[27]

Notes

1 Teshome H. Gabriel, 'Xala: Cinema of Wax and Gold',
 in Peter Stevens (ed.), Jump Cut: Hollywood, Politics
 and Counter Culture (Toronto: Between the Lines, 1985),
 p. 335.

2 According to Noureddine Ghali: 'The concept of
 "Negritude" was developed by a group of French-
 speaking black intellectuals studying in Paris during
 the 1930s and 1940s, among them Leopold Senghor,
 later to be the first president of Senegal after colonial rule.
 It denoted a view of black people as particularly gifted in
 the art of immediate living, of sensual experience, of
 physical skill and prowess, all of which belonged to them
 by birthright. It was an attempt at the time to combat the
 racist view of African civilisation as a null quality, and the
 ideology that French colonial rule was providing otherwise
 worthless culture-less beings with the opportunity to
 assimilate themselves to French culture . . . Sembene
 is one of the many later African writers who have
 criticised the concept vigorously, among other things
 for underpinning the view that the European contribution
 to global culture is to be technological and rational,
 while Africa can continue in economic disarray because
 it is happy just "being".' 'An Interview with Ousmane
 Sembene', in J. Downing (ed.), Film and Politics in the
 Third World (Brooklyn: Autonomedia, 1987), p. 52.

3 Ghali, ibid., p. 46.

4 Marcel Mauss, Oeuvres 2 (Paris: Eds de Minuit, 1969),
 p. 245 (my translation).

5 William Pietz, 'The Problem of the Fetish', Part 1, Res,
 no. 9 (Cambridge, MA: Peabody Museum, Harvard
 University, Spring 1985), pp. 5–17; Part 2 in Res, no. 13
 (Spring 1987), pp. 23–46; Part 3a in Res, no. 16
 (Autumn 1988), pp. 105–24.

6 Pietz, op. cit., Part 1, p. 6.

7 Pietz, op. cit., Part 2, p. 21.

8 Ibid., p. 23.

9 Karl Marx, Capital, vol. 1 (Moscow: Foreign
 Language Publishing House, 1965), pp. 272–3.

10 Pietz, op. cit.

11 'Du aille des dieux fètiches' in Objects du fètichisme,
 Nouvelle revue de psychanalyse, no. 2 (Paris: Autumn
 1970), p. 132.

12 Pietz, op. cit., Part 2, p. 44.

13 From Auguste Compte, Cours de philosophie positive,
 extracted in J.B. Pontalis (ed.), Objets du Fètichisme:
 Nouvelle revue de psychanalyse, no. 2 (Paris: Autumn
 1970), p. 134.

14 Jean Pouillon, 'Fètiches sans Fètishisme', in
 J. B. Pontalis, op. cit. (Le fètichisme ne debouche sur rien
 et les colonialisateurs pourront avoir bonne conscience.)

15 Pietz, op. cit., Part 1, p. 7.

16 W. J. Mitchell, Iconology: Image, Text, Ideology
 (Chicago: Chicago University Press, 1986), p. 200.

17 J. Lacan, Ecrits: A Selection (London: Tavistock
 Publications, 1977).

18 Sigmund Freud, The Interpretation of Dreams, standard
 edition, vol. 5 (London: Hogarth Press, 1957), pp. 177-178.

19 Mitchell, op.cit., p. 205.

20 Marx, op. cit., p. 72.

21 Ibid., pp. 74–75.

22 Jean Baudrillard, For a Critique of the Political
 Economy of the Sign (St. Louis: Telos Press, 1981).

23 Roland Barthes, Image, Music, Text (New York:
 Hill and Wang, 1977).

24 Marx, op. cit., p. 73.

25 Julia Kristeva, The Powers of Horror
 (New York: Columbia University Press, 1982).

26 T. Gabriel, op. cit., p. 340.

27 Ibid.

Reference

Notes on Authors

Kwame Anthony Appiah is Professor of Afro-American Studies and Philosophy at Harvard University and author of *In My Father's House: Africa in the Philosophy of Culture* (Oxford University Press), *Assertions and Conditionals* (Cambridge University Press), *For Truth in Semantics* (Blackwells) and *Necessary Questions* (Prentice-Hall). He is also a co-editor, with Henry Louis Gates Jr., of an encyclopedia of *Africa and the African Diaspora* (Civitas, Perseus).

'The Postcolonial and the Postmodern' was previously published as chapter seven of *In My Father's House: Africa in the Philosophy of Culture* (New York: Oxford University Press, 1993), pp. 137–157.

Manthia Diawara is Professor of Film and Comparative Literature and Director of Africana Studies at New York University. He is author of *In Search of Africa* (Harvard University Press) and the film *Rouch in Reverse* (1995).

'Talk of the Town' was originally published in *Artforum* (New York: February 1998), pp. 64–71.

Ima Ebong has worked as exhibitions co-ordinator for The Center for African Art in New York where she worked on such exhibitions as 'Art/artifact, Africa and the Renaissance' and 'Yoruba: Nine Centuries of African Art and Thought'. She has conducted research on contemporary art in West Africa and is a contributing author to *Africa Explores* (The Center for African Art).

'Negritude: Between Mask and Flag – Senegalese Cultural Ideology and the Ecole de Dakar' was first published in Susan Vogel (ed.), *Africa Explores* (New York: The Center for African Art, 1991), pp. 198–209.

Okwui Enwezor is the Artistic Director of Documenta XI, Kassel, Germany in 2002 and is Adjunct Curator of Contemporary Art at the Art Institute of Chicago. He was the Artistic Director of the 2nd Johannesburg Biennial, South Africa in 1997 and has curated and co-curated a range of exhibitions internationally, including 'In/Sight: African Photographers, 1940-Present' (Guggenheim Museum, New York, 1996). He is the publisher and founding editor of *Nka: Journal of Contemporary African Art*, and has written for *Frieze*, *Third Text*, *Atlantica*, *International Review of African American Art* and *Flash Art*, in addition to authoring several catalogue essays.

'Between Worlds: Postmodernism and African Artists in the Western Metropolis' was previously published in *Atlantica*, no.12 (Gran Canaria: 1995-96), pp. 119–133. An earlier version of 'Reframing the Black Subject: Ideology and Fantasy in Contemporary South African Representation' was published in the exhibition catalogue for 'Contemporary Art from South Africa', Riksutstillinger, Oslo, 1997 and in *Third Text*, no. 40 (London: Autumn 1997), pp. 21–40.

Rotimi Fani-Kayode (1955-1989) was an influential British photographer and founding chair of Autograph, the Association of Black British Photographers, London. Regarded as the most accomplished British gay photographer of his generation, he was the author of *Black Male/White Male* (Gay Men's Press).

'Traces of Ecstasy' first appeared in *Ten.8: Critical Decade*, vol. 2, no. 3 (Birmingham: Spring 1992), pp. 64–71.

Salah Hassan is Assistant Professor of African and African Diaspora Art History and Visual Culture at the Africana Studies and Research Center, Cornell University. He is author of *Gendered Visions: The Art of Contemporary Africana Women Artists* (Africa World Press) and is co-editor, with Philip Altbach, of *The Muse of Modernity: Essays on Culture as Development in Africa* (Africa World Press). He has also curated major international art exhibitions including 'Modernities and Memories, 1997 Venice Biennale' and 'Seven Stories About Modern Art in Africa', Whitechapel Art Gallery, London, 1995.

'The Modernist Experience in African Art: Visual Expressions of the Self and Cross-Cultural Aesthetics' was originally published in *Nka: Journal of Contemporary African Art*, no. 2 (New York: Spring/Summer 1995), pp. 30–33.

Sidney Kasfir is Associate Professor of Art History at Emory University, and edited the volume *West African Masks and Cultural Systems* (Musée Royale de l'Afrique Centrale). She has written extensively on African art and has published essays in the journals *African Arts* and *Transition*, among others. Her most recent book is *Contemporary African Art* (Thames and Hudson).

'African Art and Authenticity: A Text with a Shadow' was originally published in *African Arts*, vol. 25, no. 2 (Los Angeles: April 1992), pp. 40–53, 96–97.

David Koloane is one of South Africa's leading artists and a well-known international curator and critic. He has contributed critical commentary to several books and journals including *Seven Stories about Modern Art in Africa* (Whitechapel Art Gallery) and *Third Text*. He is a member of the South Africa National Arts Council and co-director of the Fordsburg Artists' Studios, also known as the Bag Factory, in South Africa.

'The Identity Question: Focus on Black South African Expression' was first published in *Third Text*, no.23 (London: Summer 1993), pp. 99–102.

Thomas McEvilley is Professor of Art History at Rice University and a recipient of the 1993 College Art Association Frank Jewett Mather award for distinction in art criticism. He has written hundreds of books, catalogue essays and articles on contemporary art and culture, as well as cultural history. These include *Art and Otherness: Crisis of Cultural Identity* (McPherson), *The Exile's Return: Towards a Redefinition of Painting for the Post-Modern Age* (Cambridge University Press) and most recently, *Sculpture in the Age of Doubt* (Allworth Press).

'Fusion: Hot or Cold?' was first published in his *Fusion: West African Artists at the Venice Biennale* (New York/Munich: Museum for African Art and Prestel, 1993), pp. 9–23.

Kobena Mercer is the author of *Welcome to the Jungle: New Positions in Black Cultural Studies* (Routledge), the editor of *Black Film/British Cinema* (ICA) and co-editor (with filmmaker Isaac Julien) of *Screen*. He has lectured and written widely on the visual arts of the African diaspora and is currently Research Fellow, Society for the Humanities, Cornell University.

'Eros & Diaspora' was previously published in *Rotimi Fani-Kayode and Alex Hirst: Photographs* (Paris/London: Editions Revue Noire and Autograph, 1996), pp. 108-121.

V. Y. Mudimbe is the William R. Kenan Jr. Professor of French, Comparative Literature and Classics at Stanford University and Distinguished Research Professor in The Literature Program at Duke University. He is the author of more than two dozen books, including works of philosophy, philology, linguistics, sociology, poetry and fiction; among them are: *The Idea of Africa*, *The Invention of Africa: Gnosis, Philosophy and the Order of Knowledge* (both Indiana University Press), *Parables and Fables: Exegesis, Textuality and Politics in Central Africa* (University of Wisconsin Press) and The *Surreptitious Speech: Presence Africaine and the Politics of Otherness 1947-1987* (University of Chicago Press).

This edited version of '*Reprendre*: Enunciations and Strategies in Contemporary African Arts' was previously published in Susan Vogel (ed.), *Africa Explores* (New York: The Center for African Art, 1991), pp. 276–287; the complete version was published in V.Y. Mudimbe, *The Idea of Africa* (Indiana/London: Indiana University Press and James Currey, 1994), pp. 154–204.

Laura Mulvey is Professor of Film and Media Studies at Birkbeck College, University of London. She is the author of *Visual and Other Pleasures* (Macmillan) and *Fetishism and Curiosity* (British Film Institute). She has also co-directed six films with Peter Wollen.

Earlier versions of 'The Carapace That Failed: Ousmane Sembene's *Xala*, 1974' were published in *Third Text*, no.16/17 (London: Autumn/Winter 1991), pp. 19-37 and in Laura Mulvey, *Fetishism and Curiosity* (London: British Film Institute, 1996), pp. 118-136.

Everlyn Nicodemus is an artist and critic whose contributions have appeared in a number of journals and books, including *Third Text*, *Nka: Journal of Contemporary African Art*, *Global Visions: Towards a New Internationalism in the Visual Arts* (Kala Press/inIVA), and *Seven Stories about Modern Art from Africa* (Whitechapel Art Gallery).

'Bourdieu out of Europe?' previously appeared in *Third Text*, no. 30 (London: Spring 1995), pp. 3–12.

Olu Oguibe has taught at the Universities of London, Illinois at Chicago and South Florida, Tampa, where he held the Stuart Golding Endowed Chair in African Art. He is an editor of *Nka: Journal of Contemporary African Art* and author of many books including *Uzo Egonu: An African Artist in the West* (Kala Press).

'Art, Identity, Boundaries' was originally delivered as a lecture at the forum 'Art, Identity, Boundaries' in Rome, Italy in July 1995; the complete version was previously published in *Nka: Journal of Contemporary African Art*, no.3 (New York: Fall/Winter 1995), pp. 26–33. 'In the "Heart of Darkness"' was previously published in *Third Text*, no.23 (London: Summer 1993), pp. 3–8.

Chika Okeke is an artist, curator and critic. He has curated exhibitions for the Whitechapel Art Gallery, London and for the First Johannesburg Biennial in 1995, among other venues, and has written extensively on contemporary Nigerian art. He is the author of *Fante* and *Kongo* (both The Rosen Publishing Group).

'The Quest for a Nigerian Art: Or a Story of Art from Zaria to Nsukka' is a revised version of an essay entitled 'The Quest: from Zaria to Nsukka', which was first published in *Seven Stories: About Modern Art in Africa* (London: Whitechapel Art Gallery, 1995), pp. 38-74.

John Picton is Reader in African Art at the University of London and former head of the Department of Art and Archaeology at the School of Oriental and African Studies. Picton previously worked for the Nigerian government, Department of Antiquities and the British Museum. His research interests and publications cover Yoruba and Benin (Edo) sculpture, masquerade, textile history and twentieth-century developments in African visual practice.

An edited version of 'In Vogue, or The Flavour of the Month: The New Way to Wear Black' was previously published in *Third Text*, no.23 (London: Summer 1993), pp. 89–99.

Colin Richards is an artist and Associate Professor of Fine Art at the University of Witwatersrand, Johannesburg. He has lectured widely on South African art criticism, practice and theory, and has published several critical essays in *Third Text* and *Atlantica*, among other journals, as well as in *Random Access: On Crisis and its Metaphors* (Rivers Oram Press) and *Art Criticism and Africa* (Saffron Books).

'About Face: Aspects of Art History and Identity in South African Visual Culture' first appeared in *Third Text*, no.16/17 (London: Autumn/Winter 1991), pp. 101–134.

Margo Timm is co-ordinator of History of Art and lecturer of African and Namibian art at the University of Namibia, Windhoek. She is currently engaged in Ph.D. research on John Ndevasia Muafangejo.

An earlier version of 'Inversion of the Printed Image: Namibian Perspectives of John Muafengejo' was published in *Nka: Journal of Contemporary African Art*, no.4 (New York: Spring 1996), pp. 40-44.

N. Frank Ukadike is Associate Professor of Film and African and African Diaspora Studies at Tulane University in New Orleans. He is the author of *Black African Cinema* (University of California Press) and the forthcoming book, *A Questioning Cinema: Conversations with Black African Filmmakers*.

'New Developments in Black African Cinema' is chapter five of his *Black African Cinema* (Berkeley: University of California Press, 1994), pp. 246-303.

Octavio Zaya was the founding editor of the Spanish international art journal, *Balcon*, and currently edits *Atlantica*. Zaya has published widely on contemporary art and his writings appear regularly in *Flash Art* and *Nka: Journal of Contemporary African Art*, as well as numerous magazines and newspapers. Zaya is also an international curator whose credits include exhibitions for museums in Madrid, Prato, Helsinki, Seville and Copenhagen, as well as the Guggenheim Museum in New York.

'Meaning in Transit: Framing the Works of Boutros, Dridi, Ennadre, Gasteli and Naji' was first published in *Nka: Journal of Contemporary African Art*, no.5 (New York: Fall 1996), pp. 50–53.

Index

FIERCE
CONVERSATIONS

Achieving Success at Work & in Life,
One Conversation at a Time

SUSAN SCOTT

PIATKUS

PIATKUS

First published in the US in 2002 by Viking Penguin
First published in Great Britain in 2002 by Piatkus
This revised and updated edition first published in the US 2017 by Berkley
This revised and updated edition first published in Great Britain in 2017 by Piatkus

9 10 8

A CIP catalogue record for this book
is available from the British Library.

Grateful acknowledgment is made for permission to reprint "This Sane Idea" from
The Gift: Poems by Hafiz, translated by Daniel Ladinsky (Penguin Books). Copyright ©
Daniel Ladinsky, 1999. Reprinted by permission of the author.

Accountability ladder drawing on page 157 copyright © Senn-Delaney Leadership
Consulting Group, LLC. All rights reserved.

ISBN 978-0-349-41736-3

Printed and bound in Great Britain by
Clays Ltd, Elcograf S.p.A.

Papers used by Piatkus are from well-managed forests
and other responsible sources.

MIX
Paper from
responsible sources
FSC
www.fsc.org FSC® C104740

Piatkus
An imprint of
Little, Brown Book Group
Carmelite House
50 Victoria Embankment
London EC4Y 0DZ

An Hachette UK Company
www.hachette.co.uk

www.littlebrown.co.uk

This book is dedicated to the Fierce staff, who work brilliantly every day to transform the conversations central to our clients' success, and to friends and family, whose conversations are simply the best.

CONTENTS

FOREWORD

by Ken Blanchard

The notion that our lives succeed or fail one conversation at a time is at once commonsensical and revolutionary. It is commonsensical because all of us have had conversations that, for better or worse, profoundly altered our professional or personal lives. It is revolutionary because a course on conversations won't be found in an MBA curriculum. Yet who among us hasn't spent time and energy cleaning up the aftermath of a significant but failed conversation? Who among us hasn't recognized, perhaps too late, that a client was frustrated or a loved one wounded because we failed to engage in the conversations that were needed? By the same token, most of us have left a successful conversation clicking our heels at the outcome, eagerly anticipating the next one.

While success is often measured by an accumulation of titles, acquisitions, and the financial bottom line, little or no attention is paid to the power of each conversation to move us toward or away from our stated business and life goals. No longer. Susan Scott set out to help us change our lives—one conversation at a time.

If you don't have time to read the whole book, it's a mistake. But

since God didn't make junk and you are unconditionally loved, I will hold back on a One Minute Reprimand. And as a humanist, I will go one step further and give you the essence of this powerful book. Here's what it says:

Our lives succeed or fail gradually, then suddenly, one conversation at a time. While no single conversation is guaranteed to change the trajectory of a career, a business, a marriage, or a life, any single conversation can. The conversation is the relationship.

This book will help you gain the insight and skills to make every conversation count. Are you ready?

INTRODUCTION
The Idea of Fierce

When you think of a fierce conversation, think passion, integrity, authenticity, collaboration. Think cultural transformation.

Think leadership.

When she was seven, my niece, Margot, called to announce that she had just had an apostrophe. "You know, an idea with shiny lights around it." She meant "epiphany," but I've always liked the idea of having apostrophes, and my hope is that as you read this book, you will enjoy an apostrophe, at the very least a semicolon, maybe even an exclamation point about the connection between conversations and your success and happiness, about the connection between conversations and leadership. I want you to get really good at fierce conversations, but before we go into the "how"—the 7 Principles—it's important that you understand "why."

Picture a kaleidoscope. Do you remember the first time you held one up to the light and turned it? When one piece inside the kaleidoscope shifted, the entire picture changed, and once that happened, you couldn't dial back to the picture you had before. The three ideas I want to share with you in this introduction have been like kaleidoscopic pieces that, when they shifted, changed my view of the world and of myself in the world and, therefore, what is required of me. Once my

view—my understanding—shifted, it wasn't possible to return to conversations as I'd known them.

Idea #1

My first "apostrophe" arrived courtesy of Ernest Hemingway. In *The Sun Also Rises*, a character drinking with friends in a bar is asked, "How did you go bankrupt?" He answers, "Gradually, then suddenly." At the time I read this, I had been running think tanks for chief executives for thirteen years and had had more than ten thousand hours of conversations with industry leaders worldwide. I thought back over important events in the lives of my clients. A piece within my kaleidoscope dropped. Our careers, our companies, our relationships, and indeed our very lives succeed or fail, gradually, then suddenly, one conversation at a time.

On the failing side, sometimes the questions were: How did we manage to lose our biggest customer—the one that counted for 20 percent of our net profit? How did I lose my most valued employee, for whom I had great plans? How did I lose the cohesiveness of my team? Why are we experiencing turnover, turf wars, rumors, departments not cooperating with one another, unengaged employees, long-overdue reports and projects, strategic plans that still aren't off the ground? Why do we have so many reasons and excuses for things not being different or better than they are?

> Our careers, our companies, our relationships, and indeed our very lives succeed or fail, gradually, then suddenly, one conversation at a time.

And on a personal note: How did I lose an eighteen-year marriage that I was not prepared to lose? How did I lose my job? How is it that I find myself in a company, a role, a relationship, a life from which I've absented my spirit? How did I lose my way? How did I get *here*?

Once the members of my CEO groups reflected on the path that led them to a disappointing or difficult point and place in time, they remembered, often in vivid detail, the conversations that set things in motion, ensuring that they would end up exactly where they found them-

selves. They lost that customer, that employee, the cohesiveness of their team, their marriage, their joy—one failed or one missing conversation at a time. In fact, it was often the missing conversations for which they were paying the greatest price, the conversations they avoided for days, weeks, months, even years that caused the most devastation.

So many times I've heard people say, "I knew our strategy wasn't working, but no one was willing to tell our CEO. No one wanted to lose their job." Or, "I knew that customer was unhappy, but I didn't have the guts to come right out and ask." Or, "We never addressed the real issue, never came to terms with reality." Or, "My wife and I never stated our needs. In the end, there were so many things we needed to talk about, the wheels came off the cart."

On the positive side, *here* was pretty amazing when a company finally landed that huge customer, the one their competition would kill for. Or successfully recruited a valuable new employee. Or a leader discovered that her team was committed to her at a deep level. Or a team blew their goals out of the water. Or a couple celebrated another happy year of marriage.

They got to these good places in their lives, these amazing achievements, these satisfying career paths, these terrific relationships, gradually, then suddenly, one *successful* conversation at a time. And they were determined to ensure the quality of their ongoing conversations with the people central to their success and happiness.

Imagine you are standing on a game board—the game of life. *Your* life. How did you arrive at this square on the board, with all of your current results—professional and personal—spread out in front of you, some you like and some you don't? You arrived here one conversation at a time. And when you project yourself into an ideal future, how will you get from here to there? Same way you got here. One conversation at a time.

But What Is a "Fierce" Conversation?

Most people would agree that conversations are important, that, if some conversations fail, it's a big fail! But why "fierce"? Doesn't "fierce" suggest menacing, cruel, barbarous, threatening? Sounds like raised voices,

frowns, blood on the floor, no fun at all. In *Roget's Thesaurus,* however, the word "fierce" has the following synonyms: robust, intense, strong, powerful, passionate, eager, unbridled, uncurbed, untamed.

In its simplest form, a fierce conversation is one in which we come out from behind ourselves into the conversation and make it real. This book was constructed as an imaginary conversation with you, the reader, with me doing most of the talking, being as real with you as I know how to do, and you doing most of the listening. *Sorry about that part.*

Fierce conversations have four objectives, which we'll cover in depth throughout this book, along with the meaning of "real":

1. Interrogate reality

2. Provoke learning

3. Tackle our toughest challenges

4. Enrich relationships

The fourth objective—enrich relationships—points to the next kaleidoscopic piece.

Idea #2

Years ago I heard Yorkshire-born poet and author David Whyte speak at a conference. David spoke of the young man, newly married, who is often frustrated, even a little irritated, that his lovely spouse, to whom he has pledged his troth and with whom he hopes to spend the rest of his life, seemingly wants to talk—yet again—about the same thing they just talked about last night, last weekend. The topic? The quality of their relationship. He wonders, "Why are we talking about this again? I thought we settled this. Could we just have one huge conversation about our relationship and then coast for a year or two?" Apparently not, because here she is again.

Around age forty-two, if he's been paying attention, David suggested, it dawns on him. David smiled. He was forty-two and married.

"This ongoing conversation I have been having with my wife is not about the relationship. The conversation *is* the relationship."

The conversation *is* the relationship.

To say that this landed with me would be an understatement. The idea was simple, even obvious, but I had missed the formula. Apostrophe #2.

Conversation = Relationship

As the idea dropped, my internal kaleidoscope shifted. I had just left a long-term marriage and was deeply sad. I felt David was talking just to me and learned later that all four hundred people in the room, most of whom were men, felt the same way. We all had a strong desire to run out into the parking lot and phone home.

If you recognize that there may be something to this, that the conversation *is* the relationship, then if the conversation stops, or if we add another topic to the list of things we just can't talk about because it would wreck another meeting, another weekend, all of the possibilities for the relationship become smaller and the possibilities for the individuals in the relationship become smaller as well, until one day we overhear ourselves in midsentence, making ourselves quite small, behaving as if we're just the space around our shoes, engaged in yet another three-minute conversation so empty of meaning it crackles.

This is a seriously big deal. Our most valuable currency is not money. Nor is it intelligence, attractiveness, fluency in three-letter acronyms, or the ability to write code or analyze a P&O statement. Our most valuable currency is relationship. Emotional capital.

In 2002 the Nobel Prize for economics was awarded to Daniel Kahneman, a psychology professor at Princeton. Why, you might ask, would the global economics community award the Nobel Prize to a psychologist? Because Kahneman's studies proved beyond any doubt that we behave emotionally first, rationally second. No matter how logical we claim to be, our emotions are the most powerful factor in how we respond and interact with others. This is not a girl thing. It's not a cultural thing. This is the human condition, and the implications are significant. And costly, if we don't get this right.

Several years ago I was contacted by a company widely respected for its legendary international business-consulting services. They wanted my help. They were spending millions developing solutions for prospective clients. The price tag for these solutions was many millions. Some approached a billion. After much preparation and expense, they would present their solutions. The prospective clients would thank them. And hire the other guys. This had become a trend, which they needed to reverse!

Part of my investigation involved attending a two-day sales training session for about two hundred of their new recruits. After each training segment, teams of two bright-eyed, killer-smart young men (and a few women) would meet with an individual posing as a potential client and make their pitch. The "clients" had been given scripts. Questions, objections, hurdles, concerns to bring up. After observing the training sessions, I sat in on several of the final client meetings. New employees had been instructed to close the deal. Clients had been instructed to start the meeting by introducing a new wrinkle in the deal.

"Hey, guys, before we begin, I should let you know some breaking news. We've just been acquired by ABC (large, well-known) company. It will be announced publicly tomorrow. None of us knows what this will mean for us, but I imagine that within ninety days, some of us will be gone. In fact, I could be gone. So we're all a little distracted today."

There was a pause, and then one of the salespeople asked, "So, will this delay the decision on our proposal?" My heart almost stopped. This had been an opportunity to demonstrate empathy, concern, support, but although these young men had been advised to connect with their clients, nowhere in the training had they been taught what "connect" means, *how* to accomplish it, or *why* it is essential. In fact, many people (most, in fact):

a) Don't fully understand or appreciate *what* "connect" means, beyond Facebook, online tweeting, following, linking, etc.

b) Don't see *why* they should connect with colleagues and customers beyond "How are you?" "I'm fine," and whatever minimal amount of effort it takes to get through the meeting or make the sale.

c) Don't know *how* to connect with people at a deep level and are a little freaked out at the thought, equating the experience of "con-

necting" to holding on to both ends of a jumper cable and turning the key in the ignition.

When the session ended, the "client" gave them feedback. He asked, "If you came home and your wife was weeping in the kitchen, would the first thing out of your mouth be, 'Does this mean dinner will be late?'"

I was reminded of Gore Vidal's comment about Mary McCarthy. He described her as "uncorrupted by compassion."

After observing the sales training, I spoke with prospective clients who had hired the other guys. The answer was clear. The firm was failing to win new engagements because clients liked the competition better. Their prospective clients' reasoning had nothing to do with the competition's solutions or pricing. They liked the people at the competition better. They enjoyed the relationships they had begun to form there. They felt a connection.

It became clear that this brilliant but faltering firm's greatest opportunity lay in extending their relationships with their clients beyond price, beyond brilliant proposals, and engaging them not only intellectually, but on an emotional level as well. This became their next frontier, where significant gains in market share could be made.

Increasing their "smarts" by 25 percent (hiring smart people with the right degrees, the right pedigree) was not translating into 25 percent revenue growth. Albert Einstein understood this. He said, "We should take care not to make the intellect our god; it has, of course, powerful muscles, but no personality. It cannot lead; it can only serve."

> We should take care not to make the intellect our god; it has, of course, powerful muscles, but no personality. It cannot lead; it can only serve.

Today people are making very different choices about where they want to work and where they want to spend their money. If a company has a relationship with its employees based primarily on an exchange of time and talent for a paycheck, that company becomes résumé padding for talented employees on their way to bigger and better things instead of the place where they decide to grow their careers. By the same token, if a company has a relationship with its customers based

primarily on price, those "loyal" customers are gone as soon as the competition offers something similar for less.

Assuming a company's product or service is worthwhile and their pricing is reasonable, it's the quality of their relationships that determines whether they gain customers or lose them, whether they retain great employees or lose them. Relationships are the great differentiator. As venture capitalist John Doerr put it, "The moment of truth is when you ask, 'Are these the people I want to be in trouble with for the next five, ten, fifteen years of my life?' Because as you build a new business, one thing's for sure: You'll get in trouble."

Let's translate that to you, your career, and your organization.

The next frontier for exponential growth, the place you will find a new and sustainable competitive edge, lies in the area of human connectivity—internally with staff and externally with your marketplace. Human connectivity occurs or fails to occur one conversation at a time. In every conversation, meeting, or e-mail we are accumulating or losing emotional capital, building relationships we enjoy or endure with colleagues, bosses, customers, and vendors. In fact, life is about making connections, most importantly, a deep connection with people; otherwise, we do not know what it means to be human.

In case the concept of human connectivity is unclear, I asked hundreds of people how they would define human connectivity. I heard:

- practicing empathy

- being understanding

- being transparent

- asking fact-finding questions, showing curiosity

- paying attention to the whole being

- having compassion once you know the story

- being yourself, authentic, genuine

- going deep yourself, showing vulnerability

- having an open mind

- not pushing your own personal agenda

- being clear and direct, no sugarcoating

- responding appropriately

- breaking down us versus them

- acknowledging human imperfection and human experience

I asked what emotions people associate with human connectivity:

- positivity

- comforting

- scary

- belonging

- vulnerable

- rewarding

- special/unique

- different with each individual

- safe

And what human connectivity sounds like:

- calm, open dialogue

- patience

- no yelling

- laughter

- commonality

And what it looks like:

- a river that grows into a larger force, carving its path

- not superficial, no masks

- not at arm's length

- when you go to someone's house, kick off your shoes, curl up on the couch, help yourself; not prim and proper

Why have so few companies mastered the ability to connect at a deep level with their employees and their customers? Because to many leaders, the responses above seem inappropriate in the world of business, and because when companies are at a tough crossroads, most leaders review measurable goals, economic indicators, cash-flow projections, process and procedures—clinging to the quantitative aspects of performance in an effort to understand what is going wrong. Staggering amounts of money are dedicated to reviewing basic business processes while employees long for one galvanizing conversation that will explain the situation and get everyone back on track. Just one. I know. I've talked with thousands of these employees.

It is the unusual leader who turns his or her attention to the conversations within the company, and yet our leverage point, our fulcrum, is the conversation in which we are engaged at any given moment in time. A leader's job is to engineer epiphanies through conversations that reveal we are capable of original thought. Intelligent, spirited conversations that provide clarity and impetus for change. In fact, in addition to the usual list of desirable leadership characteristics, I suggest that leadership should be defined in terms of relationship and taught and measured in terms of the capacity to connect with colleagues and customers at a deep level.

Our tag line at Fierce is—"any conversation can." Why? Because we've seen over and over that while no single conversation is

While no single conversation is guaranteed to change the trajectory of a career, a company, a relationship, or a life, any single conversation can.

guaranteed to change the trajectory of a career, a company, a relationship, or a life, any single conversation can.

Idea #3

Have you ever left a meeting only to discover that apparently, we were all just in the same different meeting? Or sent a perfectly innocent e-mail or text and been appalled to learn how it was received? It seems one of the most common outcomes of communication is *mis*understanding. Why? All conversations are with myself, and sometimes they involve other people.

> **All conversations are with myself, and sometimes they involve other people.**

This is true in the sense that we all unconsciously, automatically put our own interpretation or spin on the words of others. No matter what a person says, we decide what he or she *really* means by it and then we operate as if our interpretation, our "story" is true, without checking it out. He said this. You heard that. You intended one thing; however, the recipient of your message gave your words a tone, an intent, a meaning that never even crossed your mind.

How many times have you said to someone, "I wish we had recorded that conversation because it would prove that I *never* said . . ." or "I *did* say . . ."? Each of you was convinced your interpretation was the right one. There are not enough emojis in the world to ensure that your e-mails and texts are "heard" in the way you intend.

> **There are not enough emojis in the world to ensure that your e-mails and texts are "heard" in the way you intend.**

We are constantly interpreting everything we hear others say. And constantly being interpreted in turn. Studies have shown that misinterpretations cost companies many millions each year. And they are serious stumbling blocks for relationships.

It is not difficult to understand how misunderstandings and conversational flybys occur, given that each of us experiences life through our unique context—the filter we will look at in chapter one, consisting of our strongly held opinions, beliefs, and attitudes, which have been shaped

and reinforced over a lifetime, and became "truths" at some point in our lives. Our context shapes the internal conversation we are having with ourselves all day, every day. We couldn't stop it if we wanted to.

William Jennings Bryan wrote, "Two people in a conversation amount to four people talking. The four are what one person says, what he really wanted to say, what his listener heard, and what he thought he heard." Spending time with those who misinterpret us in almost every conversation will cause relationships to stall or end. On the other hand, what about *our* possible misinterpretations, the context through which we filter everything we hear?

For now, just consider that all of us are interpreting everything we hear or read all the time and are often getting it wrong. An important goal of this book is that you will learn how to put that conversation with self to work in a positive way.

To review the three ideas:

1. Our careers, our companies, our relationships, and our very lives succeed or fail, gradually, then suddenly, one conversation at a time.

2. The conversation *is* the relationship.

3. All conversations are with myself, and sometimes they involve other people.

Have You Met "The Man"?

The goal of this book is to transform the conversations central to your success. Transformation: It's a big word.

I remember going with my daughter Jennifer to Dixie's BBQ for lunch. Dixie's has the best BBQ in western Washington. Ask anyone. It's official. The proprietor visits each table and asks, "Have you met 'The Man'?" "The Man" is the seriously hot hot sauce for which Dixie's is famous.

"Lay it on us," we said. Within seconds, two women of reasonably professional demeanor were transformed into bleary-eyed, runny-nosed, red-blotched, mascara-streaked, ugly-faced, broken-down, beggin'-for-mercy, cryin'-for-Mama, fixin'-to-die, hiccupping lumps of humanity. Of humility. There was no way out but through. Sans dignity.

And if you've never heard a grown child of yours whisper, "Help me," it's unnerving, let me tell you. Particularly when you yourself expect your last vision to be the ceiling of a BBQ shack in Bellevue, Washington.

Outside in the parking lot, still gasping, there were three things for which I had a new appreciation:

1. The line "I once was blind, but now I see."

2. If your mouth is on fire, do not attempt to quench it with soda pop.

3. Not all transformation is pleasant.

I have met "The Man," lived to tell about it, and most of the lining of my mouth has regenerated. If it's instant transformation you're after, go to Dixie's BBQ. Don't say I didn't warn you. A less painful, though no less difficult, step would be to transform how you bring yourself and others into a conversation and out of a conversation. That's what "fierce" is about. That's what you'll explore in this book, so let's talk about the transformations you can reasonably expect when you and your team engage in fierce conversations.

From X to Y: What Fierce Transforms

(X) Before Fierce	(Y) After Fierce
Low levels of inclusion and diversity. Employees are there for the paycheck. Decisions are made without appropriate input, which often falls short of brilliant.	High levels of inclusion and diversity. Employees are invested in the company's success. Additional input results in better decisions.
Anonymous performance reviews once or twice a year. Employees are confused, shocked, angry, unclear.	Employees receive frequent face-to-face feedback so they always know how they are doing and trust that they are on track to succeed.
Focus on activities. On reasons why it is not possible to reach individual or collective goals. Stalled initiatives.	Focus on results. Deep-seated accountability. Initiatives executed.

(X) Before Fierce	(Y) After Fierce
Beating around the bush, dancing around the subject, skirting the issues. No one and nothing changes.	Naming and addressing the issues truthfully and effectively. Impetus for change.
An us-versus-them, me-versus-you culture. Politics, turf wars, competition for resources and attentions.	High levels of alignment, collaboration, partnership at all levels throughout the organization and the healthier financial performance that goes with it.
Leaders overwhelmed by the complexity of their tasks. Everything is a priority.	The timely resolution of periodic leadership challenges. Clear priorities.
Leaders micromanaging versus leading. No grassroots leadership development.	Improvement in leadership effectiveness, development of quality "bench" to fill future leadership positions.
A relationship with customers based solely on price. Difficulty maintaining margins.	A relationship with customers that extends beyond price. Customers are engaged on an emotional level.
Original thinking is happening elsewhere. Sleepwalking through the manual.	Shared enthusiasm for agility, continued learning and epiphanies; shared standard of performance.
A culture of terminal "niceness." Avoiding or working around problem employees. Tolerating mediocrity.	Effectively confronting attitudinal, performance, or behavioral issues. Enhanced employee capacity to serve as effective agents for strategic success.

These transformations aren't easy or simple and won't happen overnight, but they are worth the time and the conversations needed to shift from one to the other. No matter what situation you are in, transformation is possible and necessary because what we want from "leadership" today is quite different from what we wanted not that long ago. Here is a breakdown illustrating those differences:

Ye Olde Leadership Model	New Leadership Model
Directing and telling	Really asking, really listening, then directing, in that order
Feedback-free, development-free zone; little, if any personal growth	Feedback-rich, development-rich zone; ongoing personal development
Delegating, abdicating, holding people accountable	Delegating, coaching, modeling accountability, holding people able
High task/low relationship and the culture of compliance that goes with it	High task/high relationship and the culture of passionate engagement that goes with it
Silos and fiefdoms; competing for resources; not good at partnering	Sharing resources, collaborating, partnering across functions in service of the organization's goals
Information-starved, need-to-know culture	Open, transparent, inclusive culture
Business as usual	Original thinking, going further, taking risks, agile, innovative
Imposing leaders' view of reality/ issues	Exploring multiple, competing realities

As you may have deduced, I am not neutral. Whether it's transforming a company into a great place to work, improving customer-renewal rates, increasing employee engagement, enhancing cross-boundary collaboration, or providing leadership development and the healthier financial performance that goes with it, success—or failure—occurs one conversation at a time.

Conversations are the work of the leaders and the workhorses of the company. After all, business is fundamentally an extended conversation with employees, customers, and the unknown future emerging around us. *What* gets talked about in a company, *how* it gets talked about, and *who* is invited to the conversation determine what will happen or won't happen. Conversations provide clarity or confusion, invite cross-boundary

collaboration and cooperation, or add concertina wire to the walls between well-defended fiefdoms. They inspire us to tackle our toughest challenges or stop us dead in our tracks, making us wonder why we bothered to get out of bed this morning.

It's time to change the conversation.

Consequently, our work with each client begins by putting into place a foundation—four conversational models that become workhorses for an organization.

- **Team Conversations:** Engage individuals and teams in frictionless debates that interrogate the status quo and ignite dialogue around clarifying goals, solving problems, evaluating opportunities, and designing strategies, resulting in excellent decisions for the organization, enthusiastically implemented.

- **Coaching Conversations:** Engage individuals and teams in conversations that increase clarity, improve understanding, and provide impetus for action and for change when needed, resulting in increased feelings of loyalty and teamwork, professional development, the advancement of projects, and accelerated results.

- **Delegation Conversations:** Clarify responsibilities and raise the level of personal accountability, ensuring that each employee has a clear path of development, action plans are implemented, deadlines are met, goals are achieved, and leaders are free to take on more complex responsibilities.

- **Confrontation Conversations:** Engage individuals and teams in conversations that successfully resolve attitudinal, performance, or behavioral issues by naming and addressing tough challenges.

This book will help you master and implement all four models, integrating them into your leadership style and strengthening and transforming your team and organization for the better over time.

Note: Do try this at home.

My Own Journey

For thirteen years, I worked with corporate leaders through the auspices of Vistage International, an organization dedicated to increasing the effectiveness and enhancing the lives of CEOs. Thousands of CEOs worldwide meet for a full day each month with twelve to sixteen of their peers to advise one another on their most pressing issues. They also meet monthly with someone like myself to focus on topics from their businesses and their personal lives—from budgets, strategies, acquisitions, personnel, and profitability (or the lack thereof) to faltering marriages, health issues, or kids who are upside down.

Twelve conversations over the course of a year with each CEO. Since time is a CEO's most precious commodity, it was essential that our time together be qualitatively different from time spent with others. Each conversation needed to accomplish something useful. My success, and that of my peers, depended on our ability to engage leaders in conversations that provoked clarity, insight, and action.

In the beginning, a fair number of my conversations were less than fierce. They were somewhat useful, but we remained in relatively familiar, safe territory. Some, I confess, were pathetic. No guts, no glory. I wimped out. Either I didn't have it in me that day, or I looked at the expression on my Vistage member's face and took pity. I don't remember those conversations. They had no lasting impact. And I am certain my Vistage members would say the same.

The fierce conversations I remember. The topics, the emotions, the expressions on our faces. It was as if, together, we created a force field by asking the questions, by saying the words out loud. Things happened as a result of those conversations.

When people asked me what I did, I told them that I ran think tanks for corporate leaders and worked with them one-to-one. That was the elevator speech. What I really did was extend an intimate invitation to my clients, that of conversation. And my job was to make each conversation as real as possible.

As my practice of robust conversations became increasingly compelling

to me, I imagined that I was turning into a conversational cartographer, mapping a way toward deepening authenticity for myself and for those who wanted to join me. The CEOs with whom I worked became increasingly candid, and with that candor came a growing sense of personal freedom, vitality, and effectiveness. The most successful leaders were invariably determined to engage in an ongoing, honest conversation with themselves, paying fierce attention to their work and lives, resulting in a high level of personal authenticity, ferocious integrity, emotional honesty, and a greater capacity to hold true to their vision and enroll others in it.

My colleagues worldwide asked me to provide training on what I was doing, to pass along the skills needed for these conversations about which I had become so passionate. This required me to articulate for myself the approach I was developing.

In January 1999, I ran a "fierce" workshop attended by sixteen extraordinary individuals from seven countries. There was no role-playing. No one pretended to be someone else. No one worked on an imaginary issue. It was all *real* play. The participants engaged in conversations as themselves, using real, current, significant issues as the focus for our practice sessions. And we did not shy away from emotions. Following one of the exercises, a colleague from Newcastle on Tyne, England, had tears in his eyes.

"I've longed for conversations like this all my life," he said, "but I didn't know they were possible. I don't think I can settle for anything less going forward."

Attendees e-mailed others about the impact of the workshop, about how they were applying the principles and using the tools they had learned, and about the results they were enjoying with their clients, colleagues, and family members. Word spread and the demand grew. Each subsequent workshop had a waiting list, and each workshop went deeper. Corporate clients invited me to work with their key executives to foster "fierce" dialogue within their companies.

I recognized that my travel schedule had gotten out of hand when I sat down in my seat at the Sydney Opera House and reached for my seat belt. But my work with clients around the world has been worth it. We were exploring core principles, which, when embraced, dramatically changed lives, one conversation at a time. Fierce conversations are about

moral courage, clear requests, and taking action. *Fierce* is an attitude. A skill set. A mind-set. A way of life. A way of leading. A strategy for getting things done.

Many times I've heard words to this effect: "Your work has profoundly improved our leadership team's ability to tackle and resolve tough challenges. The practical tools allow leaders to become fierce agents for positive change." Or this: "You've helped me engage my workforce in moving the company to a position of competitive superiority!" Or this: "A fierce conversation is like the first parachute jump from an airplane. In anticipation, you perspire and your mouth goes dry. Once you've left the plane, it's an adrenaline rush that is indescribable." Or this: "This weekend my wife and I had the best conversation we've had in ten years. It feels like falling in love all over again."

This book began as informal class notes requested by workshop attendees. As the significance of what we were addressing became increasingly clear, people asked for more material. As a result of constant urging from clients and colleagues—"Write this down. This is life-changing stuff!"—I began to assemble my notes, to put on paper what I'd been practicing for more than a decade. The following pages emerged as a road map for each reader's highly individual journey.

The first edition of *Fierce Conversations* has been translated into many languages, including Braille, which makes me very happy. I offer this revised edition because I've learned a great deal in the intervening years and have paid attention to what is and isn't working within organizations today. It is clear that the "fierce" approach to conversations has become increasingly relevant. Now more than ever before, the principles and practices of "fierce" are needed.

Getting Started

Whether you intend to maintain positive results in your life or turn things around when times are tough (a client recently told me he felt like Wile E. Coyote after sprinting off a cliff in pursuit of the Road Runner, as he realizes he is about to become a puff of dust on the canyon floor), considering all of the conversations you need to have could feel a

bit daunting, so consider what the American author E. L. Doctorow said about writing: "It's like driving a car at night. You can only see as far as your headlights illuminate, but you can make the whole trip that way, you see." It's the same with conversations, so I'd like you to simply take the next phase of your career, your life *one conversation at a time,* beginning with the person who next stands in front of you. Perhaps there are very few conversations in between you and what you desire.

Here is what I'd like you to do: Begin listening to yourself as you've never listened before. Begin to overhear yourself avoiding the topic, changing the subject, holding back, telling little lies (and big ones), being imprecise in your language, being uninteresting even to yourself. And at least once *today,* when something inside you says, "This is an opportunity to be fierce," stop for a moment, take a deep breath, then come out from behind yourself into the conversation and make it real. Say something that is true for you. My friend Ed Brown sometimes stops in midsentence and says, "What I just said isn't quite right. Let me see if I can get closer to what I really want to say." I listen intently to the next words he speaks.

Recognize that a careful conversation is a failed conversation because it merely postpones the conversation that wants and needs to take place. Don't linger on the edges. Small confusions are easy to clear up and can lull you into thinking you've addressed your subject in a comprehensive way. Instead, ask yourself: What is the deepest issue in this confusion, that element that has caused less-than-spectacular results? Speak toward that issue, with firmness and concentration.

> A careful conversation is a failed conversation because it merely postpones the conversation that wants and needs to take place.

Epiphanies aren't granted to those who are sleepwalking through the manual or who pitch a self-serving agenda. Instead, epiphanies seek out those who give the purity of their attention to the next words. Let's engage ourselves there and tell the truth as much as we can. There is something deep within us that responds to those who level with us, who don't suggest our compromises for us. By the time you have finished this book, you may try to say something trivial and find that you can't do it. You must speak directly to the heart of the issue.

Pushing our own limits can be exhilarating. Our edge can be a growing edge that we hone and sharpen like a blade. Or it can be an edge from which we topple, like a cliff. The fall won't kill us. Avoiding the topic could.

When you come out from behind yourself into a conversation and make it real, whatever happens from there will happen. It could go well or it could be bumpy, but at least you will have taken the plunge. You will have said at least one real thing today, one thing that was real for you. And something will have been set in motion, and you will have grown from that moment, even if it isn't immediately apparent.

I will support you chapter by chapter by telling you true stories about fierce conversations that caused shifts in internal kaleidoscopes, both personal and professional, for me and for my clients. I will tell you about a sixty-second fierce conversation that changed a friend's life. I will delve deeper into what fierce conversations are and what they aren't. Why they're so rare. Why you would want to have them. How to have them. Once you master the courage and the skills and begin to enjoy the benefits of fierce conversations, they will become a way of life.

The way of *your* life.

The ongoing success of this book since its first publication underscores a genuine hunger for conversations that build our world of meaning. Conversations during which we connect with colleagues and customers, speaking in human voices—our own voices. Conversations during which we touch one another in some way.

We resent being talked to. We'd rather be talked *with*. So will all of the experts and the terminally self-absorbed please leave the room and close the door behind you so that we can get started here? Thank you.

PRINCIPLE 1

Master the Courage to Interrogate Reality

*It ain't what you don't know that gets you into trouble.
It's what you know for sure that just ain't so.*

—Mark Twain

No plan survives its collision with reality. The problem is, reality has an irritating habit of shifting at work and at home, seriously complicating our favorite fantasies. And while you may not like reality, you cannot successfully argue with it. Reality generally wins, whether it's the reality of

> **No plan survives its collision with reality.**

the marketplace, the reality of a spouse's changing needs, or the reality of our own physical or emotional well-being.

In Elizabeth George's novel *A Banquet of Consequences*, we meet a man named Charlie. "His own life had ground to a halt, so it was difficult to take in the reality that for everyone else, the struggle went on. That's what it was, he'd decided. An eternal struggle to come to terms with realities that shifted from day to day. One day you were going about your business, secure in the illusion that you had arrived at the exact point for which you'd been aiming. The next day, you found yourself on a runaway train about to derail. He had known this was possible, of course . . . but the level at which he knew it was the level at which he applied it to other people and not to himself."

Things change. The world changes. You and I change. Business colleagues, life partners, friends, customers. We are all changing all the time. As Lillian Hellman wrote, "People change and forget to tell one another." Not only do we neglect to share this with others, but we are skilled at masking it to ourselves. It's no wonder things go sideways and relationships disintegrate.

Sometimes *here* just happens. Following the high-tech carnage, crashing economies, corporate layoffs, and terrorist attacks of 2001—which altered our individual and collective realities in a heartbeat—it would have been easy to conclude that life had grown too unpredictable, that there was nothing to do but hang on and muddle through as best you could. But we are resilient and over time we recovered. And then the world was confronted with ISIS, more companies were found to have put financial gain ahead of customer safety and well-being, governments went bankrupt, and the 2016 political debate in the United States left voters confused, frustrated, disgusted, frightened, and angry. An us-versus-them mentality created a wider divide than ever before. I found myself muttering my mother's trademark comment, "What fresh hell is this?"

This is nothing new. In February 2002, Robert Kaiser and David Ottaway wrote an article for the *Washington Post* about the fragility of U.S.-Saudi ties. Brent Scowcroft, national security adviser to the first President Bush, is quoted as saying, "Have we [the United States and Saudi Arabia] understood each other particularly well? . . . Probably not. And I think, in a sense, we probably avoid talking about the things that are the real problems between us because it's a very polite relationship. We don't get all that much below the surface."

The image that comes to mind is waterskiing: It's loads of fun and you can get a tan, but putting on an oxygen tank and going below the surface in full scuba gear is an entirely different experience. I've got nothing against small talk—waterskiing—on certain occasions, but if we really want to get it right, whatever "it" is, we have to explore what is underneath in the sometimes murky depths of a conversation, a company, a relationship.

One thing's for sure. For companies, the traditional practice of an-

nual strategic planning sessions is a thing of the past. It no longer works for a company's executive team to spend two days on retreat, determine their goals, roll out an action plan, and call it a year. Team members must reconvene quarterly to address the question "What has changed since last we met?" As a company president recently admitted, "I'd like to get a firm grasp on reality, but somebody keeps moving it." The American economist Thomas Sowell said, "It takes considerable knowledge just to realize the extent of your own ignorance." It's humbling—that's for sure. The best we can hope for, to quote business consultant Robert Bridges, is "the masterful administration of the unforeseen." Stuff happens. Internally. Externally. Some you can affect. Some you can't.

> **I'd like to get a firm grasp on reality, but somebody keeps moving it.**

Life Is Curly

From working closely with corporate leaders, I know very well how quickly reality can change. The customer responsible for a significant piece of your business files for bankruptcy. Valuable employees are recruited away from you. Your competition comes out with a great new whiz-bang product that you are not prepared to match or beat. New technology renders your product or service obsolete. The economy goes upside down. *You* go upside down, lost in the complexity of your organization's goals and challenges. And yet there is no stopping, no taking time off, no shirking of responsibilities.

I began my second book, *Fierce Leadership: A Bold Alternative to the Worst "Best" Practices of Business Today* (which could have been titled *A Complete Guide to the Fricking Obvious*) with this memo:

MEMO TO LEADERS

Congratulations. You are a leader. It's a heavy load, but someone has to do it. The primary focus of your organization is growth. To help in this regard, it is your duty to lead change, manage and motivate a multigenerational workforce, and execute initiatives that

impact the top line and the bottom line while delivering short-term results. You must demonstrate agility, speed, inclusiveness, strategic acumen, and innovation, manage uncertainty and risk, and mitigate the impacts of globalization, offshoring, a recession, global warming, and the price of oil, etc., etc., etc. If you fail, Darkness will cover the earth, the stock value will plummet, and chaos will reign.

Hence, a few suggestions:

The memo continues with ten suggestions for leaders. If you want to hear them and enjoy a laugh, take a break and watch my TED Talk: The Case for Radical Transparency.

The point is, leadership demands all we've got and then some, even when a shift in reality provides great opportunities. Perhaps you suddenly landed that huge customer you've been pursuing but never believed you'd get, whose expectations you are unequipped to meet. In the last quarter of 2001, the owner of a crab fishery in the Bering Sea scrambled to fulfill twice the normal orders for crabmeat from his customers in Japan. Why the demand? Following the September 11 terrorist attack, many Japanese canceled their travel plans and stayed home. And while they were home, they ate a lot of crab! Few of us would have foreseen a link between terrorism and the consumption of crab.

It would seem companies are stressed either because their sales are too low or because their sales are too high. As individuals, we are stressed either because we don't have enough of the things we want or because we have all of the things we want. We are either shedding or acquiring; either way, happiness eludes us.

Or perhaps you realize that you're operating at a new level of effectiveness in a particular area of your life. Life feels like your favorite class at school, with a rush of learning every day. You've received a promotion or you've fallen in love with a wonderful person. Whatever it is, something spectacular has happened and you don't want to blow it. It feels like acing a final exam and winning the lottery on the same day—exhilarating and a touch frightening. You've been given a valuable gift—a thrilling new reality—and you know it! And in some corner of your heart, a loving voice suggests, "Listen up, bucko. You'd better make some serious changes or you're gonna blow this deal!"

Let's face it. The world will not be managed. Life is curly. Don't try
to straighten it out. In this chapter I will in-
troduce you to two conversational models
that do a bang-up job of interrogating real-
ity: the Beach Ball approach and Mineral

> **Life is curly. Don't try to straighten it out.**

Rights. We'll begin with the Beach Ball approach, which transforms
typical "meetings" into intelligent, spirited conversations.

Beach Ball Reality

If you are running an organization or an area within an organization,
you will find yourself continually thwarted in your best efforts to ac-
complish the goals of the "team" unless reality is regularly and thor-
oughly examined. *You know this.* Describing reality, however, can get
complicated. Let me show you what I mean.

Imagine that you are the CEO of a global company whose org chart
looks something like this:

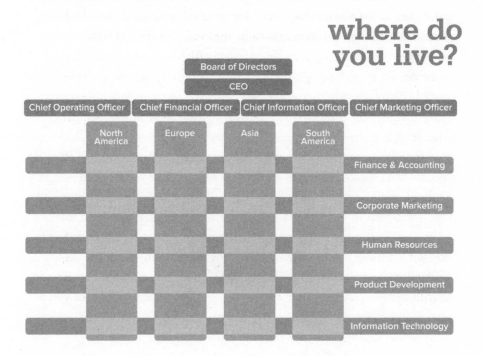

You send a question out to your senior execs worldwide. Something like: "Given the resources available to us, where should we focus them?" Or "What topic should we prioritize during our next strategy session?"

Depending on where they live in the organization, you wouldn't expect to get the same answer from everyone. The Chief Information Officer in Asia would understandably have different priorities than the head of HR in North America. As well they should. And what matters to each of them is important! Years ago, I was privileged to speak at an event with Madeleine Albright. During Q&A, she was asked, "If you could give all of the world leaders one piece of advice, what would it be?" She responded, "I'd tell them that what matters anywhere, matters everywhere."

I loved her response. And it's certainly true within a company of *any* size. What matters anywhere in a company matters everywhere in a company. Or should.

What matters anywhere in a company matters everywhere in a company.

To simplify, think of your company as a beach ball. Picture the beach ball as having a red stripe, a green stripe, a yellow stripe, a blue stripe, an orange stripe, a white stripe. Everyone in your organization is standing on a different stripe on the corporate beach ball and is experiencing reality from that perspective.

Imagine that you're standing on the blue stripe. The blue stripe is where you live, every day, day after day. If someone asks you what color your company is, you look down around your feet and say, "My company is blue."

How do you know? You're surrounded by blue. You open a drawer and it's full of blue. You pick up the phone and listen to blue. You walk down the hall and smell blue. Every day you eat, drink, and breathe blue. From where you stand, the company is as blue as it gets. *Cobalt blue,* to be precise.

So here you are in a meeting, laying out your strategy to launch an exciting new project. And, of course, you're explaining that this strategy is brilliant because it takes into consideration the blueness of the company.

Your CFO listens intently. Her brow is furrowed. She lives on the red stripe. All day she's up to her armpits in red. Cash flow is tight. She takes a deep breath and ventures, "I'm excited about this project, but when I hear you describe our company as blue, I wonder if you've studied the latest cash-flow projection. I'm dealing with a lot of red these days. Can we talk about this?"

While many leaders do not welcome opposing views, you are highly evolved, so you respond, "Okay. Put that red on the table and let's take a look at it." And the debate is on. Blue, red, blue, red, blue, red.

Meanwhile, your director of manufacturing is starting to squirm. He lives on the green stripe. He is thinking, "Man, oh, man. The timing on this project couldn't be worse, but every time I share concerns I am viewed as a naysayer. Besides, it's nearly lunchtime and no one will thank me for complicating this conversation even further."

Your VP of engineering, who lives on the yellow stripe, has a strongly held, differing opinion, but his experience has taught him that differences of opinion lead to raised voices and strong emotions, after which someone shuts down, having been bullied into silence by the loudest voices. In his experience, for some people *win/win* translates to *I win. I win again.* And the last time he stuck his toe over the line with a controversial idea, the most vocal member of the team shot it off. So this key executive, who is privy to

Win/win translates to I win. I win again.

useful information, pulls off an amazing feat. He shrinks his subatomic particles and disappears.

This *is* possible, you know. Think about all the times a meeting has ended and you found yourself trying to remember if an invitee was present. He was; he just made himself invisible. Some people are extraordinarily talented at this. They may be brilliant, but disappointingly (and irritatingly), they neither fish nor cut bait. They are neither hot nor cold. They are the people on your corporate beach ball who appear to be, at best, politely indifferent and, at worst, completely unconcerned about the decisions being made.

The Corporate Nod

The ability to hide out at meetings was so prevalent at one company I worked with that the behavior eventually got a name. Picture a leader holding forth from one end of the boardroom table. She is espousing the cleverness of the current strategy. Like all good leaders, at some point she offers an opportunity for others to respond. Something like "So what do you think?"

It gets quiet around the table. Unnaturally quiet. Like the quiet before a tornado, when birds fall silent and not a leaf stirs and a bilious sky warns of an approaching storm. Around the table, eyes fall. Each individual practices the art of personal stealth technology, attempting to drop beneath the leader's radar screen. At one point the leader calls on some poor bloke who is less skilled at vanishing than his team members.

"Jim, what do you think of the plan?"

Jim gets that look on his face like a cat occupied in the litter box—sort of far away as if to indicate that he is not really here and neither are you. The leader waits Jim out. Jim has to do something.

Jim nods. His head moves up and down as he gazes fixedly at a spot on the boardroom table.

The leader smiles.

"And what about you, Elaine?" the leader persists.

Elaine steps into the litter box. Head down. Eyes averted. She nods.

And so forth around the table, as the leader scans the room.

The Corporate Nod.

Satisfied, the leader concludes, "Good. We launch on Monday."

In the funnies, characters' thought bubbles float overhead, capturing the unfiltered notions bobbing about in their heads. We love the *Dilbert* comic strip because the characters actually say what they're thinking, and it's often what we have thought ourselves. If we could read the thought bubbles floating over the heads of people sitting around the boardroom table, the very people charged with implementing the strategy, we might see: "There's no way we can do that! This is crazy!" Or "This sucker is going down. Time to dust off my résumé." Or "Wonder if my family would notice if I bought a ticket to Barbados and disappeared."

We don't know what people are thinking unless they tell us. And even then, there's no guarantee they're telling us what they really think. Yet, if asked, most people want to hear the truth, even if it is unpalatable.

> **Most people want to hear the truth, even if it is unpalatable.**

A friend who is a high-level executive, intimidating to many, recently promoted a courageous employee who walked into his office with a large bucket of sand and poured it on the rug. "What the hell are you doing?" demanded my friend.

The employee replied, "I just figured I'd make it easier for you to bury your head in the sand on the topic I keep bringing up and you keep avoiding."

You can be assured this employee would not have taken such a bold and risky step if he were not convinced that the company was about to embark on a road to ruin. After a sleepless night, he had determined that he owed it to himself, his colleagues, his customers, and his leader to either make himself heard or leave the organization. He told his boss, "Everyone's in-basket and out-basket are full, but I'm concerned we're avoiding the *too hard* basket."

The conversation following this outrageous act interrogated reality, provoked learning, tackled a tough challenge, and enriched the relationship. It is no small thing that, as a result, the company made the change needed to avoid a potential disaster.

If you're in a similar situation, I don't advise you to buy a bucket of sand. However, do recognize that there is something within us that

> **There is something within us that responds deeply to people who level with us.**

responds deeply to people who level with us, who do not pamper us or suggest our compromises for us but, instead, describe reality so simply and compellingly that the truth seems inevitable, and we cannot help but recognize it.

And if you are the boss who deserves a bucket of sand, you may have been defending yourself with the complaint: "I pump out energy and it's unilateral. Nothing comes back." Perhaps you are not allowing it to come back.

Taking Stock

The Corporate Nod shows up in living rooms as well as boardrooms. Companies and marriages derail temporarily or permanently because people don't say what they are really thinking. No one really asks. No one really answers.

Ask yourself . . .

- What are my goals when I converse with people? What kinds of things do I usually discuss? Are there other topics that would be more important given what's actually going on?

- How often do I find myself—just to be polite—saying things I don't mean?

- How many meetings have I sat in where I knew the real issues were not being discussed? And what about the conversations in my marriage? What issues are we avoiding?

- If I were guaranteed honest responses to any three questions, whom would I question and what would I ask?

- What has been the economical, emotional, and intellectual cost to the company of not identifying and tackling the real issues?

What has been the cost to my marriage? What has been the cost to *me*?

- When was the last time *I* said what I really thought and felt?

- What are the leaders in my organization pretending not to know? What are members of my family pretending not to know? What am I pretending not to know?

- How certain am I that my team members are deeply committed to the same vision? How certain am I that my life partner is deeply committed to the vision I hold for our future?

- If nothing changes regarding the outcomes of the conversations within my organization, what are the implications for my own success and career? for my department? for key customers? for the organization's future? What about my marriage? If nothing changes, what are the implications for us as a couple? for me?

- What is the conversation I've been unable to have with senior executives, with my colleagues, with my direct reports, with my customers, with my life partner, and most important, with *myself*, with my own aspirations, that, if I *were* able to have, might make the difference, might change everything?

Are My Truths in the Way?

It would be a gross oversimplification to suggest that each of us simply needs to tell the truth. Will Schutz, who taught seminars on honesty for decades, suggested that truth is the grand simplifier, that relationships and organizations are simplified, energized, and clarified when they exist in an atmosphere of truth. Yet Schutz acknowledged that truth, itself, is far from simple and, I will add, not always welcomed. I came across this comment overheard at a Washington, DC, bar: "Truth is like poetry. And most people f—king hate poetry." Or, as author Flannery O'Connor suggested, "You shall know the truth, and the truth shall make you odd."

Pause for a moment and think about the truth. How do we even know someone is telling the truth? Perhaps a better question is: What is the truth, and does anybody own it? What each of us believes to be true simply reflects our views about reality. Our stripe on the beach ball, if you will. When reality changes (and when doesn't it?) and when we ignore competing realities (the red, green, and yellow stripes), if we dig in our heels regarding a familiar or favored reality, we may fail. Perhaps what we thought was the truth is no longer the truth in today's environment.

> **Truth is like poetry. And most people f—king hate poetry.**

> **Perhaps what we thought was the truth is no longer the truth in today's environment.**

The question isn't whether your beliefs are right or wrong. Most of us can defend our beliefs up one side of the room and down the other. We can give examples, all kinds of proof, tell elaborate stories that back up what we believe to be the truth because we've been there, done that, and have the data and the scars to prove it. And we are often adept at creating a compelling reality distortion field to prove ourselves right, even though our potentially flawed or incomplete version of reality may be causing pain.

It's an important concept to grapple with, our internal filters, our context. It has to do with Idea #3 that I shared in the introduction. All conversations are with myself and sometimes they involve other people. When we were children, we absorbed the beliefs, opinions, and attitudes of our parents and teachers. As young adults, we took on those of our employers, our colleagues. At some point, our beliefs morphed into truths. In *The Love Song of Miss Queenie Hennessy* by Rachel Joyce, a character reflects, "Perhaps I took my mother more literally than she intended, but I applied her rule to my life; after all, we are all searching for them, the rules. We pick them up from the strangest places, and if they appear once, we can live a whole lifetime by them, regardless of the unhappiness and difficulty they may later bring."

The question to ask, if you can find the courage, is: Are my beliefs working for me, for my company, for my team, for my family? How are

my beliefs shaping my life, my career, my relationships? Are they getting the results I want, the results others want? Am I and are others happy as a result of my beliefs, my "truths"? Have any of my strongly held beliefs resulted in a negative "suddenly"? What truths am I adopting because I agree with them and what truths am I deflecting or ignoring because they don't fit with my world view?

Our context determines how we experience the content of our lives. In fact, I'll go so far as to say that *your* context is running your life. Quite simply, your context influences your behavior and your behavior produces your results.

For example, if I believe that someone in my company is a jerk who doesn't wish me well, I will put the worst possible interpretation on any

e-mails that person sends me, reading bluntness and rudeness where I might read efficiency in correspondence with others. The relationship is doomed. If I believe that life is a struggle, I will behave in ways guaranteed to prove myself right and even to deepen and prolong the struggle. And what are my beliefs about my job? How do I view the work that I do? If I am a bricklayer, am I laying bricks, building a wall, or building a cathedral? Same job description, tools, salary, benefits, et cetera, yet totally different experiences of the work, different narratives, different contexts, different outcomes.

Our context determines how we experience the content of our lives.

To show you what I mean, look at the chart below and check the beliefs you hold. Don't check what you think you ought to check. Check the beliefs that you *really* hold. There will probably be checks in both columns.

❑ Disclosing my real thoughts and feelings is risky.	❑ Disclosing what I really think and feel frees up energy and expands possibilities.
❑ Most people can't handle the truth, so it's better not to say anything.	❑ Though I have trouble handling the truth sometimes, I'll keep telling it and inviting it from others.
❑ It's important that I convince others that my point of view is correct.	❑ Exploring multiple points of view will lead to better decisions.
❑ I will gain approval and promotions by exchanging my personal identity for my organization's identity.	❑ My personal identity will be expanded as my colleagues and I exchange diverse points of view.
❑ Reality can't be changed. There's no point in fighting it.	❑ Perhaps we can change reality with thoughtful conversations.
❑ As an expert, my job is to dispense advice.	❑ My job is to involve people in the problems and strategies affecting them.

❑ I'll keep my mouth shut; this is a job for the experts.

❑ My point of view is as valid as anyone else's.

❑ I need to ignore what I'm feeling in my gut; just put my head down and do my job.

❑ I know what I know, and what I know, I need to act on.

Let's say that you and many others in your organization hold the belief that disclosing your thoughts and feelings is risky. That is understandable and is certainly a commonly held belief. It's just that, if that's what you believe, when your boss asks you what you think, you'll duck and dodge, give the answer you think he or she wants to hear or claim not to have any opinion whatsoever. Where does that leave you? Nowhere different than you were before, and you certainly haven't distinguished yourself as a "high potential" in your organization. If you're the boss, stuck in ye olde leadership style, it leaves you pleased that you have so many employees who suck up to you.

If you go down the list of beliefs and ask yourself how people holding those beliefs will behave, you will recognize the beliefs that will produce the behavior and the results you hope for as well as those that need shifting. I would label the column on the left "negative" and the ones on the right "positive" not because the beliefs are right or wrong, but because they produce negative or positive results for you as an individual and for your organization.

I could suggest that if you recognize that a belief you hold isn't working all that well, now would be a good time to shift your belief to something that will produce better results. Just change your internal operating system. Reboot! Right! I'm the first to admit that wouldn't be easy on a good day, much less when you're stressed and/or struggling. Besides, no one likes to be wrong about his or her beliefs, and it takes guts to admit we may have been wrong about someone or something.

British writer W. Somerset Maugham wrote of a character, "Like all weak men he laid an exaggerated stress on not changing one's mind." We do have a right, at times an obligation, to change our beliefs, though the longer we've held on to them, the harder it is to admit they haven't served us, or anyone else, for a very long time.

Circling back to beliefs that govern our conversations and cause us to misinterpret others, there is a responsibility here: to be clear, to check for meaning, and, most important, to examine the context in which we experience our conversations. Cardinal Newman said, "We can believe what we choose. We are answerable for what we choose to believe." If your goal is evolution, work on changing your behavior; if your goal is revolution, work on changing your context.

We can believe what we choose. We are answerable for what we choose to believe.

How often are we putting a negative spin on someone's words that doesn't belong there? How often are we misinterpreting what people say to us?

Joseph Pine, author of *The Experience Economy*, suggests, "The experience of being understood, versus interpreted, is so compelling you can charge admission." There is a universal longing to be known, to be understood. Unfortunately, the experience is rare.

The experience of being understood, versus interpreted, is so compelling you can charge admission.

During fierce conversations, people don't cling to their positions as the undeniable truth. Instead, they consider their views as hypotheses to be explored and tested against others. While we may find it easier to stick with the reality we've defined by operating, most of the time, from one color stripe on the beach ball, our competitive advantage is to learn from our changing realities and respond quickly. If we entertain multiple realities, we create possibilities that did not exist for us before.

Who owns the truth about what color *your* company is?

The answer? *Every single person in your company*, including the entry-level service representative and the guy on the loading dock, owns a piece of the truth about what color your company is. The operative word is "piece." No one, not even the CEO, owns the entire truth, because no one can be in all places at all times.

And, of course, this applies to our personal relationships. Each of us owns a piece of the truth about what's going on in our relationships, and so does our partner, so do our kids, and I wouldn't be surprised if the dog had a suggestion or two he'd like to offer.

Multiple, competing realities existing simultaneously: This is true *and* this is true *and* this is true. As Anne Lamott writes, "Reality is unforgivingly complex."

Since there is no *the* truth in any business, the question is "What is the best *a* truth for today?" We are more likely to discover the

> Reality is unforgivingly complex.

truth we most need to understand today by demonstrating that everyone has a place at the corporate table. That all voices are welcome. That no matter what our area of expertise, each of us has insights and ideas about other aspects of the organization, and while each of us may know a better way for the company to do something, none of us knows more than the sum of everyone's ideas.

> Since there is no *the* truth in any business, the question is "What is the best *a* truth for today?"

My friend Tom Seeberger, who has led many fierce trainings, recently said, "Thought leadership is a team sport." So true! In addition to diversity as we normally think of it, we need diversity of thought; otherwise it's almost impossible to demolish the ensconced. Fierce conversations are a marvelous cure for excessive certitude. In other words, whatever you're sure of, don't be.

> Fierce conversations are a marvelous cure for excessive certitude.

Later in this chapter I will introduce you to a powerful conversational model for interrogating reality with anyone on any topic. But first, be reminded that one of the goals in a fierce conversation is to get everyone's reality out on the table, so it can be interrogated. *Everyone's!*

Many a corporate leader has groaned upon considering this point. "I've got a business to run. Taking the time to interrogate everyone's piece of the truth about what color the company is could take forever!"

Not always. I've had fierce conversations that lasted only a few seconds (more about those later). But it's true, fierce conversations often do take time.

The problem is, not having them takes *longer.*

> Fierce conversations often do take time. The problem is, not having them takes *longer.*

Most leaders have learned from experience that until the multiple, sometimes conflicting, realities of key individuals and constituents

have been acknowledged and explored, implementing a plan can be a decidedly tentative endeavor. To the degree that you resist or disallow the exploration of differing realities in your workplace, you will spend time, money, energy, and emotion cleaning up the aftermath of plans quietly but effectively torpedoed by individuals who resent the fact that their experience, opinions, and strongly held beliefs are apparently of little interest to the organization.

A leader's job is to *get* it right for the organization, not to *be* right. And this requires Beach Ball meetings that are clear, compelling, focused, energized. A Beach Ball meeting isn't always about solving problems. It can be about exciting things—a new opportunity, a key decision, a strategy that will help you achieve your goals.

> A leader's job is to *get* it right for the organization, not to *be* right.

There are four stages of interrogating reality using the Beach Ball model. The first is to prepare for the meeting by identifying the issue. The second is deciding who should be part of the conversation. The third is facilitating the conversation by inviting input from every person in the room.

Let's look at the first—preparing for the meeting by identifying the issue.

1. Preparing an Issue for Discussion

Pat Murray suggests, "The problem named is the problem solved." It is crucial to spend time in the problem-naming part of the exercise *before* the meeting! We've all been invited to meetings that dragged on and on while we wondered what the topic was and texted under the table or checked our e-mail. I know from experience that high-performing teams get frustrated when they feel they are doing the work a colleague should have done beforehand. They like it short, clear, and simple. They like to hit the ground running.

> The problem named is the problem solved.

Unfortunately, in meetings, after half an hour or so of sincerely attempting to help someone who has misnamed the issue, most

people find it difficult to muster the energy and attention needed to shift gears and stay engaged.

To help you get clear about the issue, create an issue preparation form like the one below as an essential part of your preparation for a meeting. It's the form that the CEOs in my think tanks always filled out before they brought an issue to their peers, but anyone and everyone who asks for a meeting should do this. It's the form our leaders at Fierce use when we meet with our advisory board. It prevents an incoherent or incomplete explanation of the topic on the table. Additionally, attendees appreciate good use of their time. At the top of the appreciation list is the accurate identification of the problem.

ISSUE PREPARATION FORM TEMPLATE

The Issue Is:
Be concise. In one or two sentences, get to the heart of the problem. Is it a challenge, opportunity, decision, strategy, or recurring problem?

It Is Significant Because:
What's at stake? How does this affect dollars, income, people, products, services, customers, or other relevant factors? What is the future impact if the issue is not resolved?

My Ideal Outcome Is:
What specific results do I/we want? In other words, assuming we get this right, what good things will occur? What, who will be affected?

Relevant Background Information:
Summarize with bulleted points: How, when, why, and where did the issue start? Who are the key players? Which forces are at work? What is the issue's current status?

What I/We Have Done up to This Point:
What steps, successful or unsuccessful, have been taken so far?

The Option I Am Considering:
What options am I considering? What option would I choose if I had to decide right now, without input from the group?

The Help I Want from the Group Is:
What I want from the group: Tell me what I'm missing. What are you seeing that I may not be seeing? Suggest alternative solutions, consequences I may have missed, where to find more information, critique of the current plan.

An alternative approach is to withhold your ideas until others have shared theirs; however, I find that conversations are best launched when there is a well-defined idea offered as a jumping-off place for everyone's thinking and discussion. When we hear someone in a leadership role say, "I want to hear what you have to say before I tell you what I'm thinking," everyone wonders, "What's the right answer?" The conversation becomes cautious as they fish for clues as to the leader's thinking. So put your answer out there right from the get-go. If you don't have a proposal to fix the problem, say so. Simply identify the issue and proceed.

2. Send the Invitation and Expectations

I'll say it again. *What* gets talked about in a company, *how* it gets talked about, and *who* gets invited to the conversation determines what will happen. And what *won't* happen. You get to decide *what* to talk about. The Beach Ball approach is the *"how"* part. Once you've filled out your issue preparation form, think about *who* should attend the meeting.

What **gets talked about in a company, *how* it gets talked about, and *who* gets invited to the conversation determines what will happen. And what *won't* happen.**

No one person has all the answers in your organization, and you can probably predict your team members' views on the topic, so don't just invite the usual suspects. Who else should attend? It isn't always helpful to exclusively look to the persons with the most

experience. Additionally, look to the persons with the best vantage point: Who is standing right at the juncture where things are happening? Who has the fifty-yard-line seat on the action? That person isn't always the designated leader. Also, who stands squarely downstream and, therefore, will be impacted by any decisions you make? Who is the customer, internal or external?

A few years ago, after a great deal of arm-twisting on my part, two actual customers were invited to a Beach Ball meeting focused on a company's plans to expand their offerings. After listening intently, both customers said that while they would be happy to benefit from the expanded offerings, they would not be interested in paying for them, as their priorities lay elsewhere. They then told my client what they *really* wanted from them, why they wanted it, and what they were prepared to pay to get it. Rather useful input, wouldn't you say?

So depending on the topic for the meeting, who has a perspective that you need to understand before making a decision? Err on the side of inclusion, rather than exclusion.

Send out the invitation, let them know the topic—the decision to make, strategy to design, problem to solve, or opportunity to evaluate—why it is significant (see the first **Err on the side of inclusion, rather than exclusion.** two items on the issue preparation form), and that you want them to come prepared to share their perspectives on the topic.

If you'd like them to review material before the meeting, send it with the invitation. Make it clear that you want them to come to the meeting having already reviewed the material, prepared to share their perspectives. Do not begin a meeting by asking people to read something. That's the best way I know to kill the energy and flatline everyone's thinking.

Let them know you will begin the meeting on time. And do so. Don't wait for latecomers. Some companies are so accustomed to meetings that don't start on time, attendees don't even bother to leave their offices until they think most have assembled. If this is habitual in your organization, break the habit.

3. During the Meeting

Thank everyone for coming. After all, they are busy and you have asked for their time and their brain cells. Ask them to close any laptops, mute cell phones, and put down their pens. Tell them you want this to be a conversation, during which everyone is looking at and listening to whoever is talking. No note taking. This will frustrate those who love to write everything down, but they'll survive and will hear more than they would if they'd been taking notes.

Talk them through your issue preparation form, then pass out copies to everyone. In that order. You want them looking at you when you take them through it, not reading.

Note: Do a bang-up job on item 2. "It is significant because if nothing changes, this is what is likely to occur." Bullet points. The prices we'll pay. This will happen. This will happen. This will happen.

The last part—"The Help I Want from the Group Is"—is key. Let them know you are inviting them to influence you and, therefore, the outcome of the meeting. Let them know that you want to know what they're seeing that you may not be seeing or that is different from what you're seeing. Let them know that you want them to help prevent the future you described if nothing changes. Let them know that at the close of the meeting, you will ask each of them to make a recommendation based on what has been shared. This will get their attention, and anyone who had planned to daydream will abandon that plan.

Once you've walked them through your issue prep form, which shouldn't take you longer than five minutes max, open it up for clarifying questions. I suggest allowing about fifteen minutes for questions, then shift to soliciting their ideas and suggestions. More than fifteen minutes of questions is hard to take for people brimming with ideas they want to share. Besides, endless questions can be a strategy to avoid making suggestions. Some people never feel they have all the information they need. You might say, "Let's move from questions to answers. What are your thoughts on the topic?"

Your job at this point is to (a) shut up and listen and (b) make sure

you hear from everyone in the room. No one gets a pass. Ask for push-back. For example: "I shared what I feel is the right way to go, the right course of action, and I suspect some of you may see it differently. If you do, I'd like to hear it. I know that my enthusiasm may make it hard to challenge me, but my job is to make the best possible decisions for the organization, not to persuade you of my viewpoint. So please speak up." This is an unusual and highly appealing way to begin a meeting.

At Sundance, Robert Redford begins meetings by saying, "I am inviting you to influence me. I want to be different when this meeting is over." Who wouldn't respond to an invitation like that? People will open up when you publicly, openly, and actively encourage them to share opposing views, showing that you are open to rational influence.

Pay attention to who speaks up, and before you move to the final step, call on every individual at the table who hasn't said anything. "Sarah, what are your thoughts?" "Mike, what's your perspective on this?"

Note: I imagine some of you, over the course of your careers, have found yourselves with a team member who, like a character in Charles Baxter's *The Feast of Love,* adopted an attitude of "lethal neutrality and immobility." No matter how sincerely and graciously you invite such people to share their views, they decline the invitation. Yet, because of their position and power in the organization, until they are on board, they stand squarely in the way of progress, like the tree that a drunk driver swerves into: "It kills you just by standing there." In chapter four, you will learn a model for confronting such behavior with courage and skill.

The point here is that the only wrong answers in a Beach Ball meeting are, "I don't know," to which you would respond, "What would it be if you *did* know?" and "I don't have anything to add," to which you would respond, "What would you add if you *did* have something to add?" Watch your tone of voice here. Be sincere, interested. This way it becomes clear to everyone that they don't get to come to a Beach Ball meeting and hide out. They are there to listen, think, contribute. Otherwise, why do you need them?

At times I've used other, more colorful words to encourage reluctant team members to challenge one another's thinking. "Tie a lure onto your line—a belief, an opinion, a provocative question—then chuck it into the stream and see what bites! If we are to build something other than loose-change relationships with one another, give us something to sink our teeth into and challenge our thinking."

> Tie a lure onto your line—a belief, an opinion, a provocative question—then chuck it into the stream and see what bites!

A caution: When someone takes you up on your invitation to challenge your strongly held opinion, resist the temptation to immediately defend your idea. So often I've observed teams respond to what appeared to be a sincere invitation, only to be shot down by a leader's knee-jerk attempt to build a stronger case. You've seen this happen, have probably done it yourself. A leader asks for input and someone screws their courage to the sticking point and says, "Well, I'm concerned about . . ." To which the leader replies, "I hear you, Jim, but . . ." Thus ensuring that no one else bothers to share what they're really thinking because to everyone in the room, it feels as if the leader is saying, "Apparently you haven't grasped the brilliance of my thinking. Let me explain it to you one more time." Or "Fooled you! I'm not really asking. My mind is already made up." Or simply, "You're wrong!"

Don't be that person! Approach this conversation as Einstein did, with "thoroughly conscious ignorance." Get genuinely curious. Ask them to say more.

4. Wrapping Up the Conversation

Once you've heard from everyone in the room, hand out paper and pens and ask them to write down what they would do if they were in your shoes. No side talking. Then go around the room and have each person read aloud what they wrote. No more discussion. Just say, "Thank you."

I love this part. It puts everyone in the shoes of a leader, having to take a stand for an action, a decision, based on what was discussed and suggested. It's a taste of leadership for everyone at the table.

Close the meeting by saying, "This is what I've heard you say." And then let them know what you heard. You don't need to quote them verbatim, but they will appreciate that you did, indeed, hear them. Ask, "Did I miss anything?" They'll let you know if you did.

Ask them to sign their names to their suggestions and hand them to you so that you can follow up with them if you need to.

Finally, thank them again for their time and intelligence. Let them know that you value their input and feel better prepared to get it right for the organization (or the department).

Following the meeting, once you have made your decision, let them know what it is.

Thus, the sequence in interrogating reality is:

1. Fill out the issue prep form.

2. Invite those whose input will be important to the issue, let them know what the topic will be, why it is significant, and that you look forward to learning their perspective.

3. Once the team is assembled, quickly take them through the issue form and let them know which way you're leaning.

4. Invite competing perspectives (this is obviously the longest part of the meeting). Probe. Be curious.

5. Ask them to write down: Given everything we've explored together, what would you do if you were in my shoes? (Or simply, what would you advise?) Then ask everyone to read their suggestions aloud. No discussion. Just say, "Thank you."

6. Tell them what you heard, collect their ideas with signatures, and thank them for their input.

What's the payoff for interrogating multiple realities? Besides being better prepared to get it right, whatever "it" is, people learn to think. Many so-called learning organizations don't provide opportunities for real thinking. Meetings are just thinly veiled attempts to persuade others to agree with a leader's conclusions. In the novel *Five Rivers Met on*

a Wooded Plain, by Barney Norris, a character says, "It wasn't a real conversation, just the batting of a ball of words from one mouth to the other." Real thinking occurs only when everyone is engaged in exploring differing viewpoints. Without true collaboration we have the problems resulting from noninclusion, the illusion of inclusion, and "the loudest get heard." And we all know what those get us.

You may shift your position as the conversation unfolds. In fact, consider yourself fortunate if you do. When reality is thoroughly interrogated, participants often walk out of the meeting with ideas that no single individual had walking in. We sometimes discover that we have merely been operating out of the kitchen and living room of our organization, not noticing the highway out front.

I remember quite a few CEO think tank meetings when a CEO would present options A, B, and C, leaning toward option C, and the group would come up with option Q, which no one person would have ever figured out all by themselves. Innovation! You can't mandate it, so you have to create an environment in which it can emerge, unfold.

At times, mastering the courage to interrogate reality has allowed an organization to pull back from the brink of ruin. As Émile Chartier noted, "Nothing is more dangerous than an idea, when it's the only one you have."

> "Nothing is more dangerous than an idea, when it's the only one you have."

Very importantly, interrogating reality allows you to generate internal commitment to a decision. People buy into it, even if they don't necessarily agree with it, because their perspective was sought out and valued and because they genuinely understand the thinking that went into the decision.

Avoid Laying Blame

If we can agree that reality is complex, we can probably also agree that the path by which we arrived at our current reality—all the *who, what, when, where,* and *why* that guaranteed we'd end up with the poor results on our plates today—is equally complicated. How do we talk about

that? How do we talk about our mistakes and failures without shutting people down, without putting everyone on the defensive?

Here's a thought for your consideration: "In any situation, the person who can most accurately describe reality without laying blame will emerge as the leader, whether designated or not."

Author Edwin Friedman said that. Easy to say, hard to do, and yet one of the secrets of success in conversation is to be able to disagree without being disagreeable.

> In any situation, the person who can most accurately describe reality without laying blame will emerge as the leader, whether designated or not.

Most people point the finger. *He* did it. *She* did it. *They* did it. Or didn't do it. Such faultfinding invariably provokes all of our defense mechanisms, thus slamming the door on the possibility of frictionless debate and resolution.

I witnessed the aftermath of such dynamics when a new CEO was appointed to lead a company out of a difficult period. I knew quite a few people who worked for the organization. The new CEO, Roger, had a tough job on his hands. Employees had become disillusioned by the behavior of his predecessor. Roger attempted to turn the tide with an ironfisted style of leadership. It seemed to many that Roger was unwilling to listen to advice and that, in fact, those who challenged his course were considered enemies.

The talk in the hallways and private offices was grim. Another failure of leadership seemed inevitable. Many withdrew their support from Roger, and he received the unfortunate nickname "dead man walking."

At an informal staff gathering in the lunchroom, as several employees recounted Roger's latest missteps, one employee, Elizabeth, said, "I am troubled at what we are doing here. I've been guilty of bashing Roger, and I'm sitting here feeling ashamed. Guiding the organization at this time would be a difficult job for anyone. Morale is in the tank, revenues are sliding, customers are complaining, and Roger is trying to lead us through this morass and out the other side. I wonder what we could do to support him."

Another employee responded, "Come on, Elizabeth. Nobody can talk to Roger. He won't listen to us."

Elizabeth said, "Then how can we make ourselves the kind of people he *will* listen to? Maybe we need to change our approach. And how well do we understand his current strategy?"

The mood shifted around the table as individuals contemplated the possibilities and began to offer suggestions. Elizabeth asked for a meeting with Roger the next day and began their conversation with these words: "I am here for two reasons. First, to apologize for my criticism of you behind your back and for my lack of support. I realize that my attitude has been a hindrance, and I want you to know that I've got a greatly improved attitude today. I'd like to help you in any way I can. Second, I'd like to suggest a meeting with the staff. As our leader, you need our support and I'd like you to receive it. Some potentially good ideas have been withheld from you because of fear of reprisal. I hope you'll entertain them and also share with the staff as many details as possible about your strategy for this coming year and the thinking behind it. I believe this could serve as a turning point for all of us and for the company."

Over the next few months, Elizabeth emerged as a highly respected agent for positive change in her organization.

No More "Buts"

Throughout this book, you will gain many tools that will help you explore profound and provocative territory around reality in your workplace and in your life. To help you improve at describing reality without laying blame, a simple and effective shift you can make is to remove the word "but" from your vocabulary and substitute the word "and." "I like what you've done here, but . . ." will be better received if you say, "I like what you've done here, and . . ."

Remove the word "but" from your vocabulary and substitute the word "and."

For example, in a conversation with an employee, this is how things typically go:

I know you want more time to complete the project, but the deadline is looming. You want me to help out in Boston, but I have only a small window in which to make some critical things happen in Seattle. I'd like to help you, but I have no easy choices right now. You seem stressed, but I need you to deliver this project on time with minimal involvement on my part.

Most people are shocked to discover how many times they use the word "but" during the course of a day. At a workshop in Dallas, Rob Brown, a CEO whose company builds an astonishing quantity of pulpits and lecterns, suggested that "yes, but . . ." is an acronym for "your evaluation superlative; behold underlying truth."

If you substituted "and" every time you would ordinarily use the word "but," the conversation might go like this:

> **Most people are shocked to discover how many times they use the word "but" during the course of a day.**

I know you want more time to complete the project and the deadline is looming. You want me to help out in Boston, and I have only a small window in which to make some critical things happen in Seattle. I'd like to help you, and I have no easy choices right now. You seem stressed, and yet I need you to deliver this project on time with minimal involvement on my part.

In other words, this is true, and this is true as well. It doesn't lessen the employee's challenge, but it feels better, doesn't it? To both parties. Multiple realities are not competing. They just exist. You own a piece of the truth, and so do I. Let's figure out what to do. *(Yes, I used the word "but" in this paragraph. Sometimes it's okay. The challenge is to recognize when "but" might shut someone down.)*

Assignment

Over the next twenty-four hours, practice describing reality accurately, without laying blame, at home and in your workplace.

To help with this assignment, catch yourself whenever you are about to say "but" and replace it with "and." You may struggle with this assignment, and that's where the learning is—in the struggle. Get good at this and your leadership, your career will gain momentum, aliveness. At home, well, things will gentle down. Family members will open up.

Participate fully in conversations, whether you're the boss or not. After all, your version of reality is as good as anybody's. Keep in mind that reality can never be absolute and that it isn't something that is handed to us. Clarity develops as we thoughtfully consider all aspects of a topic.

Your version of reality is as good as anybody's.

To encourage colleagues to voice their views candidly, you might explain the beach ball analogy and say, "You can count on me to tell you what I think and feel and how I've arrived at my perspectives. I invite you to do the same, especially if you disagree with my view. Our differing perspectives are invaluable. After all, our goal is to make the best possible decisions for the company, not to be right about our individual points of view."

At a recent gathering of key employees from all points on the globe, a corporate client passed out beach balls with one of the four focuses for the year printed on four stripes: financial accountability, speed, new technology, innovation. He instructed everyone, "As we implement our action plan, we need to regularly interrogate reality from these perspectives. Sometimes they will compete; however, we must be advocates for each stripe on our corporate beach ball. Speak boldly on behalf of your stripe."

Above all, as you describe reality from your perspective, do not lay blame. Each time you describe reality accurately, *without laying blame,* you create a kind of force field around yourself—one that feels good to others—and as you make the subtle change of deleting the word "but"

from your vocabulary, you'll notice the change in the tone and the outcome of your conversations.

I want to turn now to a second conversational approach that is aces at interrogating reality. It can be used with a team or one-to-one. It's my Swiss Army knife. I will introduce it in this chapter and go through it in depth later in the book.

The Fish Rots from the Head

John Tompkins, the CEO of a Russian-owned commercial fishing fleet, looks like a seawall against which many a ship has been wrecked. He is six foot six. He has girth. He looks solid. He smiles warmly as he greets me in the reception area of his company. I think I notice a slight limp and, like a fool, glance to see if he has a peg leg. As we shake hands, I think, if we were choosing sides, I'd want to be on his team.

John had called me in to help him prepare for a meeting with fifty-five key employees—forty Russian, Czech, Norwegian, Australian, and American vessel personnel, and fifteen land-based staff members in operations, sales, marketing, accounting, and human relations.

On the phone John had said they had a few challenges, some things he hoped to resolve while everyone was in town during shipyard, the repair and refitting of ships. I'd been recommended. Could I help?

A week later, I sink into the leather sofa in John's office, accept a glass of water, and ask him what the issues are.

"There are two," John says. "The first is that there isn't enough communication between the vessel personnel and the office staff."

John's nautical-themed office is beautifully appointed, and I struggle not to be distracted by the weird and wonderful items on the walls, shelves, and desk. There's a massive hunk of twisted metal that must represent a bad day or an expensive trip. Maps of fishing waters. A Chihuly glass sculpture resembling an anemone.

"The vessel personnel catch and process fish. That's their job. Here in the office it's our job to support the vessels. When something breaks on one of the vessels, if they don't have the extra part they need, we get

it to them. If someone gets sick, we get them off the ship and replace them. It's critical that vessel and office personnel stay current regarding performance—how much fish each vessel has caught, how crew members are doing. Based on results, we move our vessels to different fishing waters or replace crew members. The problem is, nobody is talking to anybody else."

"Why?"

"The vessel staff doesn't feel supported by the office staff. The office staff doesn't feel appreciated by the vessel staff."

"Keep talking."

"The vessel crew are out there busting their butts to catch fish. If they don't catch fish, none of us would have a job. They're frustrated at the way the office staff treat them. They feel the people in the office don't value what they do or understand how hard the work is. Meanwhile, the office staff are convinced the vessel personnel think they just sit around smoking cigars."

"Okay. What's the second issue?"

John takes a deep breath and looks at the floor.

This one's closer to home, I imagine. *And close to the bone. Looks like this one hurts.*

"I've got two talented guys, Ken and Rick, handling operations. Rick helped me get the company started, so when I hired Ken and put him in charge, Rick was angry. I had my reasons. Rick is a hothead. Ken's better at working through issues with people, thinking through how things should be handled. I thought Rick would get over it, but it's been a year and he's still angry and he's found a million ways to sabotage Ken. He's even been caught in some lies."

I raise my eyebrows. John shrugs. "I know. You're wondering why he's still here."

"I'm wondering if you have considered making him available to industry."

John chuckles. "That's good."

"The latest euphemism."

John shakes his head. "Rick's too good to lose."

"Now I'm thinking you get what you tolerate."

John nods, grimacing.

"Sounds like you've got an integrity outage here," I say, "unless, of course, lying is one of your corporate values."

John frowns and nods. "I need to talk to him. I *will* talk to him."

"Does the thought of that conversation nauseate you?"

John smiles wanly. "Yeah."

"Well, it's a serious issue, but we'll come back to it later. Anything else?"

"No. That's it. That's enough!"

I ask permission to talk with people in the office and on the vessels. Confidentially. "Sure," he says, "but most of them don't speak English."

I also ask to meet with several key customers and vendors.

We hire an interpreter, Vasily, who signs a confidentiality agreement and drives with me to the shipyard.

Gulls and oystercatchers cry overhead. This is December. A cool, erratic wind is blowing, but there is no musical pinging of lines against masts. The sounds here are different from those of a marina. These ships are huge, larger than the Parthenon. Heavy metal. The vessels sit solidly in the water, monoliths 345 feet long and sixty-five feet wide, built to house and sustain 165 people for as long as six months.

Vasily and I gaze up the sloped sides of the vessel on which we will have our first interview. I wonder what would happen to the water level if the vessels were magically lifted. We begin the climb up and up and up to the deck. Vasily is breathing hard. My imitation of Long John Silver—"Avast there, matey. Har, har, har"—does not amuse him. Perhaps he thinks I've choked on something and is turning away in consideration of my feminine dignity.

Let's Meet in the Field

One of my favorite quotes is from Rumi, a thirteenth-century Sufi poet: "Out beyond ideas of wrongdoing and rightdoing, there is a field. I'll meet you there."

This is the field in which I prefer to converse, a field where we do our best to suspend judgment, where we walk and talk with one

> **Out beyond ideas of wrongdoing and rightdoing, there is a field. I'll meet you there.**

another, where learning may be provoked. In very challenging situations, I have to remind myself, "Stay in the field!"

I didn't talk about Rumi's field on the fishing vessels. Hard to translate into Russian! However, because most of the time I imagine I'm conversing in the field where judgment is suspended, often about ten to fifteen minutes into a conversation, people will say, "I can't believe I'm telling you this." When this happens I often respond, "I am privileged to hear it." And to myself, *I can't believe you're telling me this either!*

With the vessel crew it was "I vas not goink to tell you nutting, but mebbe I trust." I learned a lot of great phrases. "The fish rots from the head." This is true. The bread crumbs always lead to the CEO. Or in this case, the fishmaster.

The bread crumbs always lead to the CEO.

The stories rolled out. Here is some of what I learned.

- If you go fishing with a bunch of your buddies, what do you hope will happen? *You hope* you *catch the biggest fish, the most fish.* The captain and crew of fishing boats want bragging rights. After all, they have their reputations in the industry and significant personal income at stake.

- What if you go fishing with people you don't like? *You conceal your pleasure when they don't catch fish, and you give them lousy advice.* All of the vessels were competing with one another. When they found good waters, the fishmasters on each vessel would withhold information about their location.

- Ken and Rick each favored a particular vessel—different ones—and they fought to make sure their favorite vessel got the best equipment, soonest, so it could catch the most fish. Ken and Rick's competition had spread to all vessel personnel on those two vessels. The two vessels and all hands were at war.

- The other vessels felt like ugly stepchildren, operationally adrift.

- During shipyard, when the crew was in town, an HR director debriefed the vessel crew, who felt she was actively trolling for gossip. When she heard dirt on someone, she would later let slip

to the accused person what was said and who had said it. The crew dreaded their interviews with her at the end of the season. They called her names I won't repeat. They vowed not to tell her anything.

- There are rules about drinking and fraternization on factory trawlers, but all the vessels held impressive quantities of booze. One fishmaster drank and fraternized at a decidedly intimate level with several of the galley workers. HR knew it, but his vessel caught more fish than anyone anywhere, so everybody looked the other way.

- The vessel crew broke their backs to catch fish. And they were good at it. If they didn't catch fish, the office staff wouldn't have a "cushy" office to come to every day. Add to that the hardship of the work itself, plus being away from their families for months, cooped up in the bowels of a floating tin can. And there are no guarantees. If they caught fish, they made money. If they didn't catch fish, they didn't make money, at least not enough to compensate for the hardship. It is a tough life. Granted, they chose it, but they would be a lot happier if they felt the office staff appreciated what they did, what they endured. Just getting decent movies to watch on board seemed an impossibility.

- The office staff resented living on call day and night during fishing season to support vessel personnel who wouldn't send in reports or return calls. Meanwhile, they were trying to sell a product. If they didn't sell the product at a good price, the company didn't turn a profit. The office staff needed to know how the vessels were doing out there—the quantity and quality of the catch. They needed reports. Accurate reports. Because of the competition between Ken and Rick, some of the reports were greatly exaggerated.

These stories were familiar. I recalled working with a company that manufactured machinery used in commercial kitchens. Their machines kept breaking down. Customers were angry. Engineering was convinced

no one in the organization appreciated the impossibility of fixing the problems with the machines in the time frame demanded. The engineers were frustrated with customers, whom they described as demanding and unreasonable. The sales staff were demoralized over their failure to close lucrative deals with prospective customers who had heard about product problems. Customer service was burned out—angry, bordering on hostile: "What are you guys promising out there that we can't deliver?" The president was spending all his time visiting international customers and trying to keep them from canceling orders for new machines. He had no life. His wife was issuing ultimatums. His children missed him . . .

Back to the ships.

Did I mention that most of the crew did not speak English?

A day and a half in the office reveals the same stories told on the vessels. Everyone is aware of Ken and Rick's rivalry and its consequences, including Ken and Rick.

As I share my discoveries with John, he leans forward with his head in his hands and stares morosely at the carpet. When I describe a particularly colorful detail of what is happening and the outcomes, John groans softly.

We talk about the good things—the loyalty to John, the company's reputation in the industry, customer loyalty despite current frustrations, the talent of his staff in the office and on the vessels. We digest it all.

I finally say, "Some of this stuff is not pretty."

Deep sigh.

I venture, "Why do I have a feeling that none of this is news—that you've been pretending not to know a lot of stuff?"

Deeper sigh. Long silence. John addresses his first comment to the floor.

"I hate conflict." Another sigh. Then he looks me in the eye and says, "It's important to me to be liked."

I smile. "You're in excellent company."

As the facilitator, I will ensure that the scheduled meeting with employees takes place within important guidelines. However, tackling these issues will not be easy for John, so after I've gotten a picture of what is going on with him, I move to the conversation model I developed and

use more often than any other with clients. It is extraordinarily powerful and wonderfully fierce, and one with which you will become intimately familiar. It is used by coaches worldwide, those who coach inside and outside of organizations. I use it with John because it is essential that we review what is at stake for John and his company, what is to be gained or lost based on what he chooses to confront or ignore. And I want *him* to clarify what needs to happen, rather than rely on me for advice.

Mineral Rights

Years ago this model was named "Mineral Rights" by workshop participants. Someone suggested, "If you're drilling for water, it's better to drill one hundred-foot well than one hundred one-foot wells. This conversation goes deep!" Another participant responded, "This conversation is drilling for gold!"

> **If you're drilling for water, it's better to drill one hundred-foot well than one hundred one-foot wells.**

Mineral Rights is my version of "The Man," the hot sauce I mentioned in the introduction that removed several layers of the lining of my mouth. A form of leadership at its most powerful. Mineral Rights interrogates reality by mining for increased clarity, improved understanding, and impetus for change.

This conversation breaks the mold and is not for the faint of heart. I think it's time you met, but first let's take a look at three less effective common coaching models:

- Coach as Advice Giver

Several problems with this model. A coach—with his or her unique history, experience, ideas, suggestions, and particular brilliance—will not have the "right" answers or solutions for every topic that comes up. Also, if the person you are coaching expects you to tell him or her what to do, that's a heavy load, and when it turns out that your suggestion didn't work, they can say, "It's not my fault. I did what you suggested and it backfired!" Besides, think about how resistant most of us are to acting on other people's advice. We are far more likely to act on our own

ideas. During a Mineral Rights conversation, your goal is to provoke self-generated insight, and you won't give advice until the very end, *after* they've suggested the steps they will take. And by that time you may not need to advise them at all. Home run!

- Coaching Checklist

This is the one that got me in trouble in the early days. I'd take notes while my coachees told me what was going on and what they were planning to do. At the next meeting, I'd ask them what had happened from my notes, how things were going, and what they were planning to do next. The assumption I made was that they knew what we should focus on. And I learned that while most coachees *did* know what we should focus on, they didn't always want to go there. At least, not today. Even during conversations that began with a clear focus ("We need to talk about *this!*"), it was easy to get sidetracked onto rabbit trails. Typically, we began on one topic, quickly veered off course, and ended up somewhat lost and frustrated, having made little progress on the main issue. An important part of a coach's job is to juggle the frivolous with the significant. The challenge is telling them apart.

For example, if you've read *Beowulf,* then you know that while Grendel was a terror, his mother was far worse. Here's the short version:

> In Denmark lived King Hrothgar, beloved by many. His men enjoyed evenings at the mead hall. Drinking, telling stories, singing songs. One night the door burst open and a creature called Grendel burst into the room and dismembered several men before dragging one of them, screaming, out into the night. This put quite a damper on the party, but it was a real high for Grendel, who returned the very next night. Though the men were armed and ready, they couldn't defeat him. More carnage. Lucky for Hrothgar, Beowulf, a traveling hero-for-hire, showed up the next day looking for work. Hrothgar offered Beowulf anything he wanted if he would slay Grendel. After hearing how many men Grendel had killed, Beowulf was a little worried, but in true hero fashion, decided to give it a go. When Grendel returned for his third deadly raid on the mead hall,

the horrific battle was on. Beowulf barely survived but finally managed to tear off one of Grendel's arms and the creature fled into the night, howling and bleeding profusely from his fatal wound. Everyone celebrated, Beowulf was rewarded many treasures, including the prettiest wench in the land, and the parties resumed. Imagine everyone's horror when a few nights later, in the darkest hour, the door to the mead hall came off its hinges and filling the doorway was Grendel's mother. She was far bigger and badder than Grendel and she was seriously pissed. Many more men died that night. Clearly Beowulf's job wasn't over, so he headed out to the grassy marshes and boggy swamps, where Grendel's mother lived, finally arriving at a black lake where he watched as wild dogs pursued a stag to the water's edge. Rather than go into the black water, the stag stopped on the edge of the lake and was taken down by the dogs. The problem was, Grendel's mother lived in a cave beneath the lake. Beowulf had serious misgivings about this assignment, but what's a hero to do? Beowulf removed his heavy armor and swam down, down, down, into the lake, to the cave, where he discovered Grendel's mother sleeping. When he raised his sword to kill her, she awoke, his sword disintegrated, and he stood before her with empty hands as she attacked. Just when he was about to take his last breath, his fingers found the handle of a dagger on the floor of the cave, which he drove into her throat, killing her.

By the way, they made this into a movie with Angelina Jolie as Grendel's mother. *I don't think so!* But here's the learning for those of us who coach or mentor. Are you and your coachee dinking around with Grendel, or a series of Grendels, while Grendel's mother is alive and well and about to cause serious damage? Your goal as coach is to find out if Grendel has a mother and it's unlikely that you'll find her on the surface. You'll have to go into the conversational lake, beneath the surface, where few are eager to go. And once you're there, all of the coaching techniques you've learned may not help you. Best to go in with empty hands and use what you find when you arrive.

The Mineral Rights questions are you with empty hands searching

for what is truly needed. Your checklist may not reveal Grendel's mother, but Mineral Rights will smoke her out if she is lurking nearby.

- All Head, No Heart

I have worked with lots of great people who live primarily in their heads. They are reasonable; they explain what they are going to do and why. It makes perfect sense. And then they don't follow through. This is almost always because they haven't gotten in touch with the emotions they feel around this issue. And they won't unless *you* ask them. Remember Daniel Kahneman's finding that people—*that would be you and me*—act first for emotional reasons, second for rational reasons. This is not biased toward gender or ethnicity. It is the human condition. Emotions give the lit match something to ignite. During a Mineral Rights conversation, you are building a bonfire by asking about emotions four times throughout the conversation. This may seem inappropriate, unprofessional, and downright uncomfortable to old-school coaches, but if you skip this part, it's as if your coachee is sitting in a race car that has no fuel, in no danger of going anywhere. Besides, where in our lives did we learn that we should never feel uncomfortable or cause anyone else to feel uncomfortable? Certainly you want to do no harm, but sometimes a coaching conversation should be provocative. There is gold in them thar uncomfortable hills.

There is gold in them thar uncomfortable hills.

Whether you are an independent coach or an internal leader coach, your product, if you will, is coachees who have been transformed in some meaningful way as a result of the work that you do with them. Your goal may be to increase their effectiveness and enhance their lives, but all coaching conversations are not equal. Mineral Rights will help you drill down deep on a topic by asking your colleague, customer, boss, direct report, spouse, child, or friend a series of questions. This is not a dentist's painful drilling sans Novocain; it's a natural exploration of an important issue, helping your coachee interrogate reality in such a way that he or she is mobilized to take potent action on tough challenges.

Taking action is key. I don't know about you, but I develop com-

passion fatigue with coachees who complain about the same issue over and over and don't do what is needed to fix it. The well has run dry and I'm all outta love.

My friend Charlotte Thompson, a psychotherapist in the UK, provided a marvelous visual in a recent e-mail. "I had an interesting image come into my head the other day of me as a dust truck, trundling along, and people just throwing black bags of rubbish into the back, which I have to go and sort through. I think there is something about understanding that I'll help with the recycling but, no, this is their rubbish and therefore primarily their responsibility to sort. I don't think I have to finger through the egg yolk and old bacon to get to the recyclable material. Don't mind helping but not doing it all perhaps." I love this!

In a Mineral Rights conversation your coachee sorts through the rubbish, does the heavy lifting throughout the conversation and leaves the conversation with clarity and commitment to action so that you won't need to have the same conversation the next time you meet.

My Mineral Rights conversation with John—the owner of the fishing company—took about an hour. Following is an abbreviated version of the conversation.

ss: *Of the issues we've uncovered, which one is most important, the issue that when it's resolved, will give you the greatest return on investment of whatever time, energy, dollars you allocate to it?*

JOHN: *(unhesitating)* The competition between Ken and Rick.

ss: *Summarize for me the current impact of this competition.*

JOHN: The problems between Ken and Rick translate to competition between vessels and go directly to the bottom line. When a favored vessel ends up with better equipment than the others, it performs better. The others are struggling to do their best with marginal equipment.

ss: *Keep talking.*

JOHN: Well, on top of some vessels having lousy equipment, the fishmasters are actually giving one another wrong information about where

the fish are, all because of this competition thing. This makes me crazy.

SS: *Crazy . . .*

JOHN: It makes me nuts! We're all supposed to be working together—all our people, all the vessels—but because Rick and Ken have got this power struggle going on, I've got one ship doing great while the others are still trying to *find* the fish, much less catch them!

SS: *Who else is being impacted? What else?*

JOHN: Morale is the lowest it's ever been. Key personnel are threatening to leave. I've got some great talent here, and I don't want to lose them. I can't afford to.

SS: *How is it impacting the company?*

JOHN: We're not as profitable as we should be, as we could be. Frankly, I'm fed up.

SS: *You're fed up. Talk to me about what you're feeling, how this is impacting you . . .*

JOHN: When grown men, highly skilled . . . act like children, it's . . .

SS: (I wait . . .)

JOHN: . . . beyond frustrating. It's maddening. These are well-paid professionals. I take good care of them. When they dig in their heels over who's got the shiniest toys, who's got the most clout, when they sneak around pulling off all kinds of devious bullshit to see whose vessel can catch the most fish . . . *(John leans back, looks up at the ceiling, then slumps forward.)* We are one company. Many ships, one company. If they can't see that . . .

SS: *What are you feeling?*

JOHN: *(silence, then . . .)* Betrayed. I feel betrayed.

SS: *Imagine that it's six months from now, a year from now, and nothing has changed. What are the implications?*

JOHN: *(groans)* I'd have to fire myself, say to hell with it.

SS: *What's at stake for you to lose or gain?*

JOHN: Millions of dollars. Pleasure in the work. Self-esteem. Physical health. *(We explore specifics.)*

SS: *When you contemplate that scenario, what do you feel?*

JOHN: Exhausted but determined. I can't let this continue.

SS: *What are you doing that is keeping this situation exactly the way it is?*

JOHN: *(frowns)* I don't understand. I don't know.

SS: *What would it be if you did know?*

JOHN: *(Smiles, frowns, thinks. I wait. After a long silence, he sits up straight and looks directly at me.)* I haven't outlined clear consequences if Ken and Rick's rivalry continues.

SS: *Say more.*

JOHN: They probably feel safe. My guess is they doubt I'd pull the trigger on those consequences and fire one of them if they can't work together.

SS: *Are they right?*

JOHN: No. *(long silence)* No. *(another long silence)* If this doesn't stop, one of them will have to go.

SS: *John, let's shift gears. Let's imagine you have tackled this head-on and the issue is resolved—completely, brilliantly. Ken and Rick are working together, rather than competing with each other. What difference will that make?*

JOHN: All the difference!

SS: *For example . . .*

JOHN: If Ken and Rick put their heads together and collaborated—they're both geniuses at this—all the vessels would be equally well equipped. Good fishing grounds would be shared. Everybody would catch

more fish, which translates into better profitability for the company, better pay for the crew, better morale. Happier times for all of us.

ss: *What else?*

JOHN: Well, obviously, higher profits would allow us to upgrade equipment, expand the fleet. As they say, all ships would rise. And I'd sleep better. I wouldn't be thinking of selling the whole damn thing.

ss: *When you consider those outcomes—better profitability, improved morale, sleeping better—what do you feel?*

JOHN: Hope.

ss: *Say more.*

JOHN: I love this business. I'd love to stay in the game. Things would be a lot more fun around here. I wouldn't feel like the Lone Ranger.

ss: *Given everything we've talked about, what's the next most potent step you can take to improve this issue prior to the company meeting?*

JOHN: Talk to Ken and Rick individually and together. One more time.

ss: *What's going to differentiate this from previous conversations you've had with Ken and Rick?*

JOHN: That's where you come in. *(I agree to prepare him for that talk.)*

ss: *What's going to get in your way?*

JOHN: My need to be liked, which translates into rarely making clear requests—in this case, requirements, not requests. With consequences attached.

ss: *What about the other issues? Possible bribery in Vladivostok? Fraternization? Drinking? What difference will it make when those issues are resolved?* (We go through them one by one.) *What exactly are you committed to do and when?*

JOHN: Talk to Ken and Rick on Monday.

ss: *What's your ideal outcome?*

JOHN: They stop competing and work as a team. I don't lose either one of them.

SS: *If the competition continues, what action are you prepared to take?*

JOHN: Fire the sons of bitches! Sell the company. Move to Tahiti.

SS: *Let's craft a conversation that will lessen the possibility of those outcomes, at least in the near future. I feel strongly that our goal is to retain both Ken and Rick.* (It is Friday and John wants time to prepare. We agree to work over the weekend on the phone.)

On Monday John talks with Ken and Rick separately, then together. I meet with John and his six key executives on Tuesday to debrief them about the findings from my interviews with crew, office staff, customers, and vendors. Although there are no surprises, it is eerily quiet as the words float in the air above the boardroom table.

Ken and Rick apologize to the executive team for the damage their rivalry has caused. I am impressed. It takes a big person. From my talks with Rick, I suspect that he is in no immediate danger of overhauling his hardwired manipulative nature. He has a certain charm, however, and is exceptional at his job. I see how valuable he is to the company. John will circle back to issues with Rick later.

I remind the executive team that "fierce" does not mean barbarous, menacing, or cruel. "Fierce" means powerful, strong, unbridled, unrestrained, robust. It means coming out from behind ourselves into the conversation and making it real. There will be no blood on the floor. No violence. I talk about the purposes of fierce conversations. Interrogate reality. Provoke learning. Tackle tough challenges. Enrich relationships.

I coach them regarding their roles in our upcoming session, especially John, Ken, and Rick. I answer questions, turning most of the questions back to the executives to answer for themselves. I tell them, "The answers are in the room. If they aren't, we have the wrong people. You are the right people. You have the answers."

> The answers are in the room.

A week later, John, two interpreters (they spell each other; we wear them out), forty vessel personnel, and fifteen office staffers file into a

large room. The seats fill in from the back. Arms are tightly crossed against massive chests. When we begin, I suspect there will be skid marks across the floor from heels dug in.

My conversation with John was a Mineral Rights conversation. Now it was time for a Beach Ball conversation with everyone assembled. I lay out the issues without mincing words. They are stunned as John and I describe what is really going on, naming each of the issues without putting pillows around them. I remind myself to breathe.

The interpreters struggle to find the words in Russian. I hope they are close to what I want to convey. I say that we will confront the real issues, that "confront" does not mean argue or beat up. "Confront" means search for the truth, that "honesty" means full disclosure to myself and others, with good intent.

"Honesty" means full disclosure to myself and others, with good intent.

I tell them that we are going to take on the biggest, smelliest, ugliest, nastiest issue first so we will find out what we are made of, and go from there.

We begin by addressing the rivalry between Ken and Rick. We experience our first moment of truth when Ken stands, faces everyone, and says, "I *have* shown favorites among our vessels. I admit it. It's unacceptable and I apologize. It's stopping now."

Ken waits quietly as fifty-four people digest what he has said. The turning point comes when Richard, a highly regarded engineer whose vessel, *Clearwater*, is the one Ken has favored with equipment and supplies, stands and admits, "It's put some of us in a difficult position, Ken. On the one hand, I appreciate what you've done for the *Clearwater*, but it's made it hard to help out the guys on the other vessels and that's what we're supposed to do."

Ken looks as if he's been kicked in the gut. Richard is one of Ken's most valuable employees. Ken shakes his head. This is not easy. The interpreters trade places. It's been only one hour and the first interpreter looks pale.

Rick stands. "Some of you know I've been . . . I haven't felt good about . . . Hell, you all know I wanted Ken's job. I've made no bones about that. But that wasn't your problem. I made it your problem. Shouldn't have happened. Gonna fix it."

The attendees begin to show up authentically, honestly. Some defend their behavior; others reveal the amazing grace of those who engage without defense. They set the bar for the rest of us.

Chris, a deckhand from Australia, shows us the way. He is passionate about fishing and about his love for the work, for his mates. He is angry that so much damage has been done to morale. We ask for suggestions as to how to begin to turn this around. Chris offers ideas, then faces John and says, "Good on ya, mate, for having this meetin'."

Through it all, John is impeccable. As we tackle additional issues, he asks questions, and when he asks, he's really asking. He listens thoughtfully, offers the perspective that only he can offer, answers questions. And when he answers questions, he really answers them, doesn't duck them. No shuck and jive. I see why they respect him and watch their respect deepen.

Things happened as a result of the session. The fishmaster who was drinking and fraternizing was made available to industry. The vessel he had captained continued to catch the most fish. Rick wasn't sure he could accept the changes he'd have to make. He resigned to take another job, was gone for one week, and then asked to return. John took him back. Rick returned *slightly* humbled. Ken and Rick still engaged in minor power struggles, but the struggles were less visible to the larger community. Vessel favoritism was stopped dead in its tracks. Communication among vessels became timely and accurate. All vessels caught fish. Reports were accurate. The HR director still had a fatal attraction to gossip, but she stopped leaking it to crew members. Morale improved.

Following the meeting with the fifty-five employees, John and I met monthly to continue our fierce conversations about his work and what was next for him. When I asked John if I could use his company as a case study on the benefits of the Beach Ball approach, he said, "I'd be honored. I'm proud of my company and what we've accomplished." He has a right to be.

Though John's story concerns a unique industry, the issues are similar to those in many organizations—high-tech, low-tech, no-tech. Competition for titles and bragging rights among individuals and teams. Lack of appreciation for others' realities. Competition for scarce resources. Tolerance of the ineffective or harmful behavior of a high performer. Or

of entrenched victims, who feel, *He did it to me. She did it to me. They did it to me. It's not my fault. Not my problem.*

Ground Truth

Several years ago I was introduced to the military term "ground truth," which refers to what's actually happening on the ground versus the official tactics. One of the challenges worth going after in any organization—be it a company or a marriage—is getting to ground truth.

Seems to me you have to get at ground truth before you can turn anything around. John Tompkins mastered the courage to interrogate reality in his organization, to get at ground truth. Publicly. No hidden agenda.

What is ground truth in your organization? Every day companies falter and fail because the difference between ground truth and the "official truth" is significant. The official truth is available for general circulation and is viewed by most team members as propaganda.

You have to get at ground truth before you can turn anything around.

Ground truth is discussed around the watercooler, in the bathrooms, and in the parking lot, but is seldom offered for public consumption and rarely shows up when you need it most—when the entire team is assembled to discuss how to introduce a new product or to analyze the loss of a valuable customer and figure out how to prevent it from happening again.

I recently talked with a friend who attends the kinds of high-level political meetings you read about in thrillers. He reminded me that politicians are adept at navigating within the sizable gap between ground truth and official truth. Everyone is careful, guarded. No one admits to vulnerability, to failure, that they are not the center of the universe, that they are not in control.

My friend went on to say that the China Policy, a China-focused policy analysis and strategic advisory firm, is referred to as "the China policy of ambiguity." All communications on the topic are oblique and soft. Nothing anyone says has any meat on the bones. Trying to enforce

anything would be like trying to nail Jell-O to the wall.

Trying to enforce anything would be like trying to nail Jell-O to the wall.

In June 2001, when President Bush attended a meeting with European leaders to discuss global warming, Jacques Beltran, a military affairs expert at the French Institute for International Relations in Paris, was widely quoted, describing the talks as full of backslapping bonhomie, yet on matters of substance, they were "the polite dialogue of the deaf."

I recall my attempt to have a meaningful conversation with a local politician during a dinner party. Trying to engage him was like trying to sculpt air. There was nothing there, no discernible human being with whom to converse.

Following the September 11 attack on America, dialogue got real in a hurry. It had to. Buildings had literally come to the ground, and now we had to come to the ground as well. To ground truths. Individuals all over the world began to understand that, in a very real sense, the progress of the world depends on the progress of each individual human being now. Leadership must be for the world, rather than being an appeasement of individuals with special interests.

John Tompkins's *official* truth had been that the competition between his two highly capable operations executives was invisible to the rest of the organization. He had convinced himself that a little creative tension between his two top leaders and his fishing vessels could be tolerated. Meanwhile, *ground* truth was inflicting significant harm on a daily basis.

What conversation can we have with one another to help our collective understanding of ground truths?

Let's examine current reality. What has changed since last we met? Where are we succeeding? Where are we failing? What have we learned in the last few months? If nothing changes, what are the implications? What is required of us now?

Each of us needs honest answers to these questions, in the workplace and at home. We can begin by identifying the official truths in our companies and in our relationships that conflict with ground truth.

Assignment

Before you read further, stop for a moment and have a quiet conversation with yourself. Are there differences between official truths and ground truths in your workplace? in your personal relationships? in your life? If so, write them down. The following examples may help you get started:

- My company's official truth is that our goal is to be world-class in everything we do. Ground truth is that many of us are embarrassed by frequent blunders that have not been acknowledged or addressed.

- The official truth in my marriage is that we are happy, that everything is fine. Ground truth is that we've been avoiding significant issues. If we fail to resolve them, our marriage could fail.

- The official truth in my life is that I am on track to be successful. Ground truth is that my job is unfulfilling. I am just going through the motions.

Fierce conversations with yourself, such as these, are not for the faint of heart. They require courage, from the French word *coeur*, meaning "heart." They are conversations during which you're likely to overhear yourself saying things you didn't know you knew, or didn't want to know.

We each have our own sense of the reality of any situation, our own truths. These "truths" can be far removed from reality and often cause our conversations to travel the same ground over and over and over again.

I am reminded of the story of the man who visits a Zen master. The man asks, "What truths can you teach me?" The master replies, "Do you like tea?" The man nods his head, and the master pours him a cup of tea. The cup fills and the tea spills. Still the master pours. The man, of course, protests, and the master responds, "Return to me when you are empty." The lesson here is that we need to

Return to me when you are empty.

empty ourselves of our preconceived beliefs in order to be open to a broader, more complex reality.

During fierce conversations we are more likely to get all our answers questioned than the other way around. Before we can learn, we must unlearn. We must empty the cup by temporarily setting aside our opinions and being open and willing to explore competing ideas.

Official truths in my workplace:

Ground truths in my workplace:

Official truths in my personal relationships:

Ground truths in my personal relationships:

Official truths in my life:

Ground truths in my life:

Getting Real with Yourself

How do the realities we've explored for companies apply to you as an individual?

A useful question is "What are my skills and talents, and are there gaps between those talents and what I am bringing to the job market, to my career, and to my personal relationships?"

In Studs Terkel's book *Working,* a young woman named Nora describes her excitement when she landed her first real job after college. It was for a large, well-known company, and she was intent on bringing everything she was and everything she had learned to the task at hand. The problem was, her coworkers made it clear in subtle and not-so-subtle ways that if she brought everything she had to the task, she would wreck the curve for everyone else.

Nora said—and this is the part I remember so vividly, the part that

went through me like a chill—"Within a few weeks, as I was driving to work I psyched myself down for a job that was too small for me. Within a month, I had absented my spirit from my work."

Absented my spirit.

What a price to pay, both for Nora and for her company. No one does herself (or her company) any favors by staying in a job in which there is very little of her alive. Perhaps your current job isn't the right place for you and you know it. Perhaps it is asking only a small fraction of what you are capable of delivering, and every attempt to deliver more has been denied. Perhaps your job requires you to deliver results that hold little interest for you or that are beyond your capabilities.

Maybe you've been telling yourself that it's not so bad where you are. That while it may not be your dream job, you've gotten used to it. That it's actually kind of comfortable here. You've got a salary and benefits and a place to go five days a week. After all, you've got only fifteen years until retirement. You can hang on until then, for the sake of keeping a roof over your family's heads.

What happens in your gut when you hear yourself thinking this way?

Meanwhile, you have dreams of breaking free, of a different career altogether. In fact, there are days when you'd rather write, read, walk, sculpt, teach, work in a paint store, drive a forklift, sell seashells on the seashore—do anything except the job to which you are currently attached.

One of my colleagues, Pat Murray, suggests, "If you want to see someone in real pain, watch someone who knows who he is and defaults on it on a regular basis."

> If you want to see someone in real pain, watch someone who knows who he is and defaults on it on a regular basis.

If there is no joy in Mudville when you contemplate your job, if you live only for weekends, you are in real pain. Yet often the companies we work for are the right companies, and the problem is that we are in the wrong place in the company or underutilized in our job. Perhaps a fierce conversation with coworkers can open doors to new, more satisfying challenges.

However, if your job is no longer appropriate or sufficient for you and the situation cannot be remedied unless you were to become a dif-

ferent human being entirely, it's time to leave. You can't afford to sit there like a possum in the headlights, or you may end up as the critter *du jour* at a roadside tavern.

It may be time to screw your courage to the sticking place and *fire yourself.* Make yourself available to industry. Make yourself available to whatever is out there with your name on it. Ask yourself:

What activities have my heart?

What am I called to do?

And if you're still hesitating, ask yourself:

Is the personal cost I'm paying really worth it?

One of the rules of engagement for companies, couples, and individuals who are practicing the principles of fierce conversations is that while no one has to change, everyone has to have the conversation. When the conversation is real, the change occurs before the conversation has ended. Insights about who we are and what we really want and need are already at work, rearranging our interior furniture, cleaning our internal closet of unnecessary clutter, revealing the way we must go.

And what if the path with your name on it requires a radical upheaval of life as you know it? What if you recognize that, to step into a more pleasing life, you must change career direction entirely? You may be thinking, "If I do what I really want to do, I will make less money. How would my family feel about simplifying our lifestyle, cutting back on expenditures? What would people think? After all, everyone thinks I'm successful where I am."

> When the conversation is real, the change occurs before the conversation has ended.

My response to such concerns is addressed by a definition of success that has served me well for many years: I am successful to the degree that who I am and what I live are in alignment. I am doing the right work, with the right people, for the right reasons.

In getting to this place of alignment, one thing is clear: The quality

of our lives is largely determined by the quality of the questions we ask ourselves—and the quality of our answers.

Answered thoughtfully and candidly, the right questions offer the possibility of a life that is much more than a satisfactory compromise. As a leader you must answer the right questions for yourself first, and then for the company. Erik Erikson wrote, "There are certain individuals who, in the process of resolving their own inner conflicts, become paradigms for broader groups."

What are the right questions? They are the big questions that define your ideal future:

Where am I going?

Why am I going there?

Who is going with me?

How am I going to get there?

Am I realizing my full potential?

Am I fully extended in my capabilities?

Is there value and fulfillment in my work today?

What unmet needs am I moved and positioned to meet?

The biggest barrier to addressing such questions is fear of the journey— fear of discovering who we are or the impermanence of who we are. Yet these questions are compelling because they lead to an eminently desirable outcome: They enable deep, positive personal change. They open up possibilities not previously accessible.

Companies, teams, families, and communities have been changed by individuals who have arrived at compelling clarity about the trajectories of their corporate and personal lives, having wrestled these questions to the ground. Our answers provide the context through which we

experience the content of our lives. How do you build this internal context? Articulate the highest and best contribution your company, your family, and your life can make.

We'll take a closer look at several of these questions in chapter two. In this chapter, you've begun to focus on *your* reality, on what color the beach ball is from your perspective. You've engaged in a fierce conversation with yourself about your life's focus and that of your company and your career.

In subsequent chapters, you will gain skills in drawing out your colleagues', customers', and life partner's views of reality. You will learn how to really ask—in such a way that people really respond. You'll learn how to engage others in conversations resulting in greater clarity, intimacy, understanding, and impetus for change, bringing you closer together no matter how far apart your current realities and hopes for the future seem today.

A REFRESHER . . .

- Regularly interrogating reality in your workplace is the cornerstone of great leadership, healthy cultures, intelligent strategies, and wholehearted execution. What has changed? Does the plan still make sense? If not, what is required of you? of others?

- Since everyone owns a piece of the truth about reality, consider whose realities should be explored before important decisions are made.

- Avoid blame by modifying your language. Replace the word "but" with "and."

- If Grendel's mother is out there, take her on!

PRINCIPLE 2

Come Out from Behind Yourself into the Conversation and Make It Real

Authenticity is not something you have;
it is something you choose.

Y ou are an original, an utterly unique human being. You cannot have the life you want, make the decisions you want, or be the leader you are capable of being until your actions represent an authentic expression of who you really are, or who you wish to become. The same is true within an organization.

Every organization wants to feel it's having a real conversation with its employees, its customers, its territory, and with the unknown future that is emerging around it. Each individual within an organization wants to have conversations that build his world of meaning.

In the context of fierce conversations, this requires that you pay attention to Woody Allen's first rule of enlightenment: "SHOW UP!"

You must deliberately, purposely come out from behind yourself into the conversation and make it real—at least *your* part of it.

But aren't most people pretty real during a conversation?

I wish I could answer with a resounding "Yes!" but even when you are committed to authenticity, it can be surprisingly difficult.

In news reports, we often read that someone was "speaking on condition of anonymity." A near-pathological anonymity and inauthenticity

are the stuff of many lives. A friend whose mother had recently died said, "My mother never shared her dark days, her troubles with me. I don't feel I really knew her." How real are any of us if we do not share our dark days with those closest to us, if we do not claim our failures as well as our successes?

If you listened in on conversations with employees, learned their views of their organization's strategy, and then watched them reverse their positions in the presence of higher-ups, or if you tuned in to the internal anguish of someone in a troubled marriage and heard him or her respond "Nothing's wrong" to an inquiring spouse, you might conclude, as did Martin Amis, that "we are out there on the cutting edge of the uncontroversial."

While many are afraid of "real," it is the unreal conversations that should scare us to death. Whoever said talk is cheap was mistaken. Unreal conversations are incredibly expensive for organizations and for individuals. I have witnessed this up close and personal during my work with CEOs.

Some things are difficult to talk about because the "fix" won't be easy but, as I've said before, if a problem exists, it exists whether we talk about it or not. In fact, as Carl Jung said, "What we do not make conscious emerges later as fate." Amen to that!

What we do not make conscious emerges later as fate.

Fate caught up with one of my favorite CEOs who waited too long to address a major shift within his industry. The lesson I learned is that ineffectiveness can be stealthy. It doesn't always come right out and smack you in the face. Few people are eager to confess what's really going on if it will reflect badly on them. Let me tell you about Jim.

How Many T-shirts Does One Person Need?

Early in my tenure of working with top executives, I experienced a stunning end to a meeting with Jim, the owner and president of a company that printed art on T-shirts, which were then sold in retail stores nationwide.

Jim and I had filled almost two hours reviewing the progress on his to-do list from our previous session and identifying his priorities for the upcoming month. We had talked about the purchase of a new screen-printing machine, strategies to increase sales, improvements in communications among top executives, Jim's negotiations with a talented but difficult designer. We had talked about a recurring theme: Jim's struggles to balance work and family. And, as often happened, we spoke briefly about a shared love—fly-fishing—and Jim's latest fly-fishing jaunt with his best friend.

It had been easy to fill two hours with agenda items, and I was about to walk out the door of Jim's office thinking I had done my job. In reality, we had merely been water-skiing. With ten minutes left in our session, Jim fell silent and leaned back in his chair. Finally, he said, "What if everyone who buys the kind of T-shirts we produce has all the T-shirts they need?"

I got a chill. "What do you mean?"

Jim continued. "Well, think about it. How many T-shirts do you have?"

"A drawerful. Around ten, fifteen, maybe twenty. You gave me most of them."

"How many of those did you buy?"

I thought about it. "Probably seven or eight."

"When did you last buy one of our T-shirts or a T-shirt of any kind?"

"Maybe two years ago."

"Where?"

"In Maui on Front Street."

"But you've been to Maui since then, haven't you?"

"Yes.

"Did you buy T-shirts the last time you went?"

"Um, no."

"Why not?"

"Well, mostly I wear T-shirts on vacation, and since I have so many T-shirts, I just packed the ones I already had."

"Have you bought T-shirts as gifts for the family?"

"Yes, sometimes."

"But not this last trip?"

"Well, everyone has plenty of T-shirts, just like I do. Besides, they like to choose their own—different tastes, you know what I mean."

"Exactly."

I felt the air being sucked out of the room. This was what we should have been talking about for the last two hours and now it was time for me to leave. Another client was expecting me.

Jim said quietly, "I suspect that the world of fashion is moving away from what we manufacture toward stuff we don't manufacture."

"Jim, why haven't we been talking about this since I walked in the door?"

Jim sighed. "It's not something I want to think about, much less talk about, but avoiding it is no longer an option. I suspect our flat sales aren't just a short-term dip. I think we've got trouble."

In the remaining minutes, I assured Jim that I would carve out time on the agenda for him to put this in front of his peers at the group meeting the next week. I handed him a copy of the issue preparation form introduced in chapter one and we got to work. But we had waited too long. Gradually, then suddenly, one missing conversation at a time, one less-than-fierce conversation at a time, Jim's business hit the skids. Six months later, he sold what was left of his company and walked away with just the shirt on his back.

His fellow CEOs and I were horrified that we had let this happen on our watch. I fell on the sword. After all, it was my responsibility to surface the most important issues of my members, get them on the table, and do it in time to fix anything that was breaking or broken. I vowed that I would never ever let what happened to Jim happen to anyone else. That I would make sure to surface and tackle the toughest issues the moment they arose, would sniff them out if I had a reluctant client or colleague. No more negative "suddenlys."

This is why I developed the Mineral Rights model I want you to master, and it has served me well ever since.

Not being real and not inviting others to be real and listening to them when they are cost Jim his company. It can also cost companies its best employees. One company president I worked with was known to stop candid input in its tracks with the pronouncement "Howard, I do not consider that a career-enhancing response." Howard knew it was time to move on.

Fortunately, few leaders exhibit such exaggerated violations of the general rules of communication, however, greed, hubris, or just plain cowardice can cause leaders to duck and dodge the truth, even though history has proved that secrecy is unsustainable, that the truth will eventually surface. I wonder how many employees at Volkswagen and Mitsubishi, aware of falsified diesel emissions tests, or at Takata, whose exploding air bags caused grave injuries and deaths, discovered that when they expressed concerns, the "truth" was not welcome.

In our significant relationships, in the workplace, and in our conversations with ourselves, we'd like to tell the truth. We'd like to be able to successfully tackle the topic that's keeping us stuck or at odds with one another, but the task is often too hard and we don't know how to avoid the all-too-familiar outcome of talks gone south. Besides, we've learned to live with it. Why wreck another meeting with our colleagues, or another weekend with our life partner, trying to resolve the tough issues or answer the big questions? We're tired and just want peace in the land.

The problem is, whether you are running an organization, a team within an organization, or your life, you are required to be responsive to your world. And that response often requires change. We effect change by coming out from behind ourselves, into our conversations, and making them real, even if it is difficult or it's not always pleasant. Authenticity is not something you have—it's something you choose.

Authenticity is not something you have—it's something you choose.

In Henry David Thoreau's *Walden,* written during his year in a one-room cabin with few possessions, is this quote: "The cost of a thing is the amount of what I will call *life* that is required to be exchanged for it, immediately or in the long run." He was talking about the bigger house, and all the stuff we buy that ends up owning us, keeping us awake at night. Amen to that! Let's substitute the word "practice" for "thing."

The cost of a practice is the amount of time, energy and dollars that must be exchanged for it, immediately or in the long run.

There is a direct link between our practices and our results, and in my work with leaders and their teams, the practice that when it is missing costs

us the most and when it is present makes the greatest difference is the courage to seek and speak the truth(s) confronting us every day of our lives.

Courage is a noun that shows up as a verb. We recognize it by what people say and do. We do what frightens us, even in the face of perceived or real personal risk: The man who ran into a house that was fully engulfed in flames to save a neighbor whom he barely knew. We demonstrate strength in the face of pain or grief: The hiker trapped beneath a boulder who escaped by cutting off his own arm with a Swiss Army knife. No anesthetic.

While we recognize courage in once-in-a-lifetime, go-down-in-history heroic deeds, it is far more powerful as a daily practice. Though *you* might have run into that burning house, your courage may be failing you where it counts most—in your day-to-day interactions with the people who are central to your success and happiness.

Why Courage Fails Us

Courageous acts, whether played out in the global media or in a meeting room, are fueled by strong emotion. We don't attempt to vanish off the radar screen in a meeting because we lack heart. We have plenty of heart, strong emotions. The problem is that our primary emotion may be fear.

How many times have you told someone what you thought he or she wanted to hear, rather than what you were really thinking? Painted a false, rosy version of reality, glossing over problems or pretending they simply didn't exist? Tossed out the ceremonial first lie?

The desire to keep our jobs, our good standing with our boss and colleagues, overrides the impulse to disclose that, in our view, the latest plan is a really bad idea. *What fresh hell is this?*

Telling it like it is, speaking the ground truth as opposed to the official party line (which we know to be bogus) is no one's notion of a good time. It's so upsetting, alarming, and risky that we're willing to place a for-sale sign on our integrity to avoid it. We've all witnessed a kind of violence—a lost promotion, raise, or place at the table—visited on those who've spoken their hearts and minds, and it is raw.

You know how it goes. Someone speaks the truth out loud, in the

presence of leaders, and soon it is difficult to breathe. Tension fills the room. The leader stiffens, gives everyone the look, sweeps the room with it. There's lots of fidgeting and darting eyes, until finally, the leader speaks solemnly, saying, as if speaking to a carrier of dengue fever: "I'm aware of these concerns, John (Jane, Larry, Linda). We've got it covered."

Translated: "What part of 'team player' did you not understand!"

So what do we do? We practice withholding what we really think and feel, which costs us big-time. Meetings produce more nothing than something. Ideas die without a funeral or proper burial. Conclusions are reached at the point when everyone stops thinking, which is often short of brilliant. Communication is primarily from the leader to everyone else. No point in telling our leaders what we're actually dealing with every day, since to do so would not be a career-enhancing move.

And this is a shame because our first thoughts, unfiltered, uncensored, are usually onto something, yet all too often the courage to capture and voice them fails us.

The Fierce Alternative

The practice that must take center stage today is radical transparency. Human beings are hardwired to solve problems and are usually successful when they address the real problems, the root causes of whatever challenges they're encountering.

Coming out from behind yourself into your conversations—pushing aside inhibitions and those negative voices in your head that are telling you that what you have to say is not valuable, won't be welcomed—and making them real is especially important when things have gone sideways, when your organization or your team or you yourself have come under public scrutiny.

Rumors, criticisms, anonymous blasts in public forums. You made a well-regarded employee available to industry—but there is a backlash. *Why didn't we throw a going-away party?* You know what was going on behind the curtain and the sooner you said good-bye to that person, the

better for everyone, but what do you disclose to those clamoring for an explanation? Or there is a false rumor about your company—*The company is being sold.* You have no idea who started the rumor or why and it isn't true. Should you address this? If so, how? And what about inaccurate, anonymous posts in public forums by disgruntled former or current employees? *The executives receive huge bonuses.* Not true.

Where, when, and how should you respond? How do you motivate employees, keep them focused, and keep them, period?

Of course, the short answer is—tell the truth, admit to mistakes, reveal your plan. Since problems rarely solve themselves, let's talk about it. Sounds straightforward, but telling the truth, simply and courageously, doesn't always solve the problem because of challenges all truth-tellers face.

1. The "truth" is complicated. Leaders can't be aware firsthand of every broken or limping segment of an organization. What don't you know? Who does know? Are you sure you've got the whole picture? Have employees withheld what they know in fear of retribution?

2. Even if you lay it all out for everyone to see, some will reject your version. As a friend said to me, "I have my truth and you have yours, but my truth is truer than yours." We've pitched our tent on our truths and plan to camp there indefinitely even if we've camped on stony ground. There is this tiny factory inside us that produces horror stories. Human nature is strange in that many prefer tragedy to comedy, Sturm und Drang to blue skies, melodrama to documentary. And even if you say "I take that back" or "That's not what I meant," it won't help. The story others have manufactured is out there and it's never going to shift.

3. Human nature is also hardwired to lie, to protect itself at all costs, including putting a for-sale sign on its integrity. Sadly, this is what many employees expect of leaders, so why should they believe you? Lie to us once, stretch the truth, or gloss over unsavory truths, painting a rosy picture that we know to be bogus, and we're onto you.

So what do you do if your organization is under scrutiny?

- Keep telling the truth and inviting it from others. The level of candor in your organization depends on *your* level of candor every day.

- Own up to mistakes. Don't say, "Mistakes were made." That's a duck and dodge. Fess up to any blunders that have your name on them.

- Lay out your conclusions, your solutions, your strategy and invite input from all points on the compass and all of the stripes on the beach ball.

- Keep employees current and make yourself available for impromptu conversations. It will take more than one meeting, one e-mail to settle the dust. But, as I've said before, while no single conversation is guaranteed to change the trajectory of your organization, any single conversation can. You don't know if the person asking "Do you have a minute" could trigger one of those conversations.

- Stay calm and grounded. Unless your organization has engaged in wholesale, massive deception, this storm is temporary. Issues heat up and cool down.

- Remain open and available to those who don't believe you or who may have helped spread rumors. Gradually, then suddenly, one conversation at a time, you can regain their trust.

And what if your company did something unethical or careless that caused harm and now it's out there in the world? Think banking practices that brought the U.S. economy to its knees. Think emissions cheating, toxic chemicals, faulty air bags. Think law enforcement behaving badly. Or something terrible and unintended occurred through no conscious involvement or intent on the part of your company. Think E. coli.

The same advice stands. Tell the truth, lay out the plan, invite input.

In *The Horse Whisperer*, Robert Redford's character says, "Knowing something's easy. Saying it out loud is the hard part." Most importantly,

fess up to anything you did or didn't do that contributed to the problem. If you did something you knew was deeply wrong, admit it and resign. Do what my mother instructed my siblings and me to do. "Go to your room and think about your sins." Think long and hard. Clean up your act. You may need to start over. Somewhere else.

A few years ago, while I was working with top execs, an environmental disaster involving their company occurred. When I asked if they had taken the specific action that would have discovered and averted the disaster, after a long silence, the CEO said that they had. I learned later that he was lying. In fact, he was being coached how not to tell the truth in preparation for his appearance before a U.S. Senate panel. It didn't go well. He and his executive team ended up contemplating the ashes of their downsized opportunities.

Leadership is not a title; it's a practice, as is transparency. Don't just talk about transparency. *Be* transparent. As I've said before, there is something within us that responds to those who level with us, who don't suggest our compromises for us. Rumors blow over. Disgruntled employees move on. Your job is to navigate the riddle of leadership—the uneven terrain, the unpredictable weather and the narrow margin of approval by which you retain the right to lead. Strong leaders know that things will improve only by coming to grips with how bad things are and how they got that way, building a good plan, and staying the course—one conversation at a time.

> There is something within us that responds to those who level with us, who don't suggest our compromises for us.

Weak leaders want agreement. Strong leaders want the truth. They tell the truth as they understand it and encourage those they lead to tell them the whole truth, paint the whole picture, even if it's ugly, unpleasant, not what we wish it to be. Because only then can we put our best efforts forward to fix what needs fixing.

If you are a leader, your job is to accomplish the goals of your organization. How will you do that in today's workplace? In large part, you will do it by making every conversation you have as real as possible. The first frontier is finding our own courage.

> Weak leaders want agreement. Strong leaders want the truth.

Many work teams have a list of undiscussables: issues they avoid broaching at all costs in order to preserve relationships, keep the meeting short, stay out of trouble. In reality, relationships, teams, and the companies they work for steadily deteriorate for lack of the very conversations they so carefully avoid. Those hard questions and controversial topics are the very ones that need to be discussed in order to move the company forward. It's difficult to raise the bar if it has remained low over a period of years, and that's what keeps many of us stuck.

A few years ago, I was privileged to help a company kick off the introduction of fierce conversations to their leaders in Europe. The meeting was in a former "gentlemen's club" in London. The first thing the attendees saw when they walked in was a poster with the question "What are our mokitas?"—a Papua New Guinea word for that which everyone knows and no one will speak of: the elephant in the room. As they walked down the hall toward the meeting room, there were more posters suggesting topics guaranteed to provoke high emotions, competing perspectives, and fierce debate. There was a blow-up elephant in the meeting room. The managing director said, "This elephant may look cute and friendly, but he's a problem!"

The managing director was convinced that until these topics were aired and resolved, the European division of the company was in no danger of achieving their goals.

They talked, courageously and skillfully, for two days.

I can practically hear you groaning. *I don't have time for a two-day meeting. Nobody on my team does.* And sotto voce: *And even if we did, no one would disclose what they really think and feel.*

As I've suggested earlier, *not* having meetings like this will take you longer. Initiatives may stall. People will likely offer valid excuses to explain disappointing results. Engagement will diminish. The competition may already be surpassing you and poaching your best people. Even though you lowered your price, customers are still leaving. Margins are shrinking. And *you* are not sleeping well at night.

Time is not the issue. The issue is what gets talked about in your company.

In London, two days of radically transparent conversations resulted

in increased clarity, accountability, collaboration, and partnership across the leadership team, which translated directly to the top and bottom lines.

If you would like to see more courage in *your* organization, model courage yourself. Ask:

- What is the most important thing we should be talking about?

- What are our mokitas, those elephants in the room that we are ignoring?

Radical transparency can be scary—but it rocks. It is for those who are not interested in living a guarded, careful life and are quickly bored in the company of those who are. It is for those who would choose a fierce conversation, a fierce relationship, a fierce life over the alternative, any day.

Radical transparency can be scary—but it rocks.

Being real is not the risk. The real risk is that:

I will be known.
I will be seen.
I will be changed.

Think about it. What are the conversations you've been unable or unwilling to have—with your boss, colleague, employee, customer; with your partner, parent, child; or with yourself—that, if you were able to have them, might change everything? Contemplating some of those conversations may increase your blood pressure, but as Ray Bradbury suggested, "Go to the edge of the cliff and jump off. Build your wings on the way down."

One of the most interesting phenomena I've noticed, personally and in others, is our ability *not* to know what we aren't ready to face. I'd like you to meet my friend Alice.

Alice and Gary

A sixty-second fierce conversation startled Alice into *showing up* and changing her life.

After graduating from college, Alice married a fine person. Gary was in law school, and Alice taught in a high school. Halfway through law school, Gary realized he had gotten into law for all the wrong reasons—recognition, status, income, his parents' approval. His romanticized version of what it would be like to attend law school did not match the reality. In fact, he found that he didn't enjoy his classes and had no real calling for law, so he dropped out and joined Alice in teaching. At the time, Alice defended Gary to his disappointed parents and particularly to his mother, who pulled Alice aside and said, "You'll see. He's never finished anything he started."

When the military draft was about to intervene in their lives, Gary joined the air force. Alice stopped teaching to follow him from base to base and begin a family. After a few years, however, a yearning to farm possessed Gary, so when his stint in the military ended, he and Alice moved to the Midwest, where Gary helped his parents with their small farm, intending to do more as his parents aged.

As the reality of what it took to run a farm became increasingly clear, Gary became restless once again. His idealized, Norman Rockwellian view of farming did not match up with the reality of endless chores, long days, and meager income. Gary began to toy with the notion of teaching at a university, envisioning himself happily immersed in academia. So the family, which now included two young boys, moved to Oregon, where Gary had been offered a scholarship to complete the degrees necessary to launch the next phase of his career.

Three years into the program, Alice discovered that Gary had not attended classes for more than a year. Instead, he had been slipping back into the house after their sons had gone to school and Alice had left for work. Gary had derailed professionally again. He was, by this time, understandably embarrassed. He admitted that he had found himself disinterested in academia but that he didn't know what he really wanted to do, and he suggested that the best plan for the foreseeable future was

for him to remain at home, handling the cooking and cleaning, running the endless errands required of a busy family, and most important, being there when the boys got home from school. He assured Alice that he would be happy as a house husband. Alice was dubious but acquiesced. It was nice not to have to go to the grocery store and to come home after work and smell dinner cooking.

At the time, Gary and Alice attended a Sunday school for couples in their thirties. About a year into their new arrangement, the topic in Sunday school was the role of the woman in a marriage. The discussion leader read passages from the Bible that suggested women should be at home filling jars with oil, weaving cloth, and putting up olives. Alice stood up and gave an impassioned speech about how, while that may have made sense when the Bible was written, things were different now. Women had many options available to them, and, as everyone knew, though Gary and Alice had reversed the traditional roles, they were deeply happy. Alice got a standing ovation and sat down feeling pleased with others' response to what she had said.

As Alice walked out of the room on her way to the eleven o'clock service, the husband of one of her friends came up, put his arm around her shoulders, and whispered, "I love you a bunch, but with all due respect, you are full of shit!"

Alice stared, openmouthed, as he continued. "This isn't working for you, Alice. You hate the whole arrangement, and you have lost respect for Gary. What are you pretending not to know?"

What are you pretending not to know?

In that instant, and not a moment before, Alice knew that he was right, not because reversals of antiquated gender roles are impossible—they're not—but because of the reality of the life she was living.

Had Alice really not known what she was feeling? Some people might find that difficult to believe. But until that moment, Alice had been unconscious of her true feelings. She had successfully swept them under the rug. In the movie *The Madness of King George,* a character says to the king, "You seem yourself, Majesty." King George responds, "I have always been myself, even when I was sick, but now it seems I've developed a talent for seeming to be myself."

Both Alice and Gary had seemed to be themselves. But now, as Alice thought about it, she imagined that Gary was probably as unaware and as unhappy as she was. They were both suppressing emotions too painful to examine. Talking about their feelings might force an outcome for which they were not prepared. It took one comment from a friend who must have been paying fierce attention to the intent beneath Alice's words, to her body language—the slant of her back, held too proudly perhaps—to put her in touch with reality.

Six months later, after many impassioned conversations, Alice and Gary realized that it is possible to love someone and not love your life together.

Gary returned to the Midwest, while Alice and her sons remained in Oregon. Gary has since remarried and is enjoying a satisfying career as a high school teacher and football coach. Alice's career continues to thrive, and she is dating someone with whom she feels deeply compatible.

To this day, Alice wonders how long she and Gary might have trudged along, pretending not to know how deeply off-kilter their marriage was. She is grateful to the man who took the risk to deliver a badly needed message to her—unfiltered and to the point. That is not to say you should go around critiquing the marriages of others, but this story shows the power of one open and truthful conversation.

Healthy Selfishness

Perhaps you've had an experience similar to Alice's, when a new understanding reared up like a tsunami, startling and disturbing—and undeniable. Perhaps in time you discovered the gift in the message and wondered how you managed to suppress your real feelings from yourself and others for so long.

Even individuals who wield significant power at times withhold their real thoughts and feelings from those central to their success and happiness. It has much to do with an underlying impulse to survive by gaining the approval and support of others (boss, customers, coworkers, investors, family members) who we imagine hold the keys to the warehouse wherein is kept everything we want and need. To ensure that such power brokers are

on our team, we aim to please. While the desire to please is not a flaw, at crucial crossroads we sometimes go too far. *Way* too far. When faced with a so-called "moment of truth," we find ourselves chucking the truth over the fence or tucking it behind the drapes in exchange for a trinket of approval.

What's that behind the curtain, you ask? Oh, nothing important (just my entire identity). May I refill your wineglass?

Some fear that becoming authentic is a form of selfishness, and unknowingly limit the possibilities for their careers or within their relationships, feeling it's inappropriate to put their own interests first. After all, what would people think?

During a workshop, Lauren, a delightful woman in her forties, described the unsettling experience of awaking one morning *unrecognizable to herself.* Having spent a lifetime accommodating the needs and desires of so many others, both at work and at home, she had developed amnesia about who she was and what it was she had wanted to do with her life when she was younger and all the possibilities seemed so vast.

At another workshop, a participant said, "I always drive carefully when there's someone important with me in the car." It took her a moment to understand why everyone in the room was gasping.

Do you think you shouldn't need the help, encouragement, and support that you give to others? What else do you think?

"I shouldn't need to be told that I am loved."

"It's not fair to insist on quality time with my partner; after all, he/she is so busy with work."

"I really need to talk this issue through with my boss, but she has different priorities."

Successful relationships require that all parties view getting their core needs met as being legitimate. You won't articulate your needs to yourself, much less to your work team or life partner, until and unless you see getting your needs met as a reasonable expectation. So pry the permission door open just far enough to consider

> **Successful relationships require that all parties view getting their core needs met as being legitimate.**

that you have a right to clarify your position, state your view of reality, and ask for what you want.

I'm not suggesting any of this is easy. There's always a risk. A magnet on my refrigerator door says: "They would have passed a pleasant evening had shit not gotten real." I hope that doesn't offend you. I laugh every time I see it.

Coming out from behind yourself is part of the search, whether born of panic or courage, for that highly personalized rapture of feeling completely yourself, happy in your own skin. It is a reach for authenticity—a process of individuation—when you cease to compare yourself with others and choose, instead, to live *your* life. It is an opportunity to raise the bar on the experience of your life. It is a deepening of integrity—when who you are and what you live are brought into alignment. No more damping down your soul's deepest longings in order to get approval from others. As André Gide wrote, "It is better to fail at your own life than succeed at someone else's."

Authenticity is a powerful attractor. The singer James Taylor has said, "I am myself for a living." When we free our true selves and release our unique energy, others recognize it and respond. It is as if we have set ourselves ablaze. Others are attracted to the warmth and add their logs to the fire.

> It is better to fail at your own life than succeed at someone else's.

The principal job at hand is to intertwine addressing your current business and personal issues with self-exploration and personal development, building a bridge between yourself as a person and yourself as a professional. The assignments in this chapter are designed to help you ground yourself in original thought and potent action, in work that breaks you open and devastates your habitual self. Parts of your habitual self serve you wonderfully, while others stand squarely in the way of your happiness and success. Do you know which are which?

The Good News and the Bad News

My colleagues at Vistage often say, "We advertise for CEOs, and human beings show up." For example, the visionary who founded the company

often lacks the attention to detail needed to run the business on a daily basis. The parent who always kisses a child's hurt to make it better may fail when it's time to teach the child to identify and solve the source of the pain.

The good news and the bad news are the same news. The news is: Our companies, our relationships, and our lives are mirrors accurately reflecting us back to ourselves. The results with which we are pleased reflect parts of ourselves that are working well. The results that disappoint and displease us reflect aspects of ourselves—beliefs, behaviors—that simply aren't working.

> Our companies, our relationships, and our lives are mirrors accurately reflecting us back to ourselves.

Douglas Stone, author of *Difficult Conversations,* suggests, "To say of someone 'He died with his identity intact' is not a compliment." When our idealized views of ourselves are set in stone, despite evidence that there's an imperfection or two (or three), the people in our lives have little recourse other than to work around our flaws or to leave. We can see an organization or a department or a relationship with clarity only when we look ourselves full in the face.

> To say of someone "He died with his identity intact" is not a compliment.

In workshops, I ask participants, "Barring all else, what is one word or phrase that absolutely describes you?" Before you read on, take a moment and do this for yourself. What is a word or phrase that unfailingly describes *you?*

Write it down: _____

Stephen, a workshop participant, recently declared with great conviction, "The word is 'focus.' Everyone who knows me will tell you that I'm focused on what's important and on getting it done."

After all the participants have shared their words, I suggest, "Think of times and situations when you are exactly the opposite of this." Some insist, "I'm never the opposite."

When pressed to identify a time when he is not focused, Stephen realized that, while he is extraordinarily focused in his job, many weekends are given over to aimless activities. "I'm just hanging out, slumped in a chair, watching TV, eating chips. I'm not focused on quality time with my wife or achieving personal goals. I told myself I was going to

pick up a guitar I haven't touched in years. It's still in the closet missing two strings."

My accountant recently asked me to sign a paper that would allow her to act on my behalf when I am "in absentia." I laughed. After all, a word that describes me, at least most of the time, is "present." But it got me thinking. When am I not present? With whom? When I am tired. When something else is pressing on my thoughts. At times like these, I have to forcibly reel myself back to the present. I'm not always successful.

The purpose of this exercise is to help us recognize the multiple realities about how each of us shows up in the world, not just when we're at our best.

If we are to develop as leaders, as human beings, our very identities (primal things) must become fluid. For example, is it a fact that you are fair-minded, good-hearted, and generous of spirit? Okay. Have you ever wished, just for a moment, that something bad would happen to someone who has wronged you? Well, that's true about you too. It's neither good nor bad. It's just what is.

One of the most painful realizations upon reaching forty or fifty or sixty can be that you have *no* discernible identity, that somehow your identity has been compromised. It's not that your credit card or social security number was stolen or that your email was hacked. It's that an internal voice is whispering, insisting, "This isn't you. This isn't enough of you. Parts of you are failing to show up."

In Steve Tesich's novel *Karoo,* Saul Karoo admits, "It occurred to me that I wasn't a human being anymore. Probably hadn't been for some time. I was a loose cannon, whose spin and charge and direction could be reversed at any moment by forces outside myself."

It is through such humbling insights into ourselves that we come to know, reshape, and trust the self we may then offer to others. It takes courage to look at ourselves unflinchingly in the mirror called our lives. Sometimes what we see isn't particularly attractive. The truth will set you free—but first it may piss you off!

The truth will set you free—but first it may piss you off!

Meet Thom.

You'd Like Thom

Everyone likes Thom Porro, a member of a group of key executives that I chaired in Seattle for many years. He is funny, good-natured, candid, authentic, and skilled at putting his finger on the source of any issue under discussion. Thom's metabolism is the envy of everyone. He appears not to have one ounce of fat on him. *Yes, we hate him for that.* His mind is equally lean and mean.

Don Aubrey, another member of the group, introduced Thom to mountain climbing. Don was all grins as Thom made trip after trip to REI, Seattle's famous everything-you-could-ever-need-to-do-anything-outdoors store, eventually buying every piece of climbing gear known to man and spending as much time as his wife would tolerate learning the sport. In fact, just before his and Don's planned climb of Mount Rainier, Thom had spent thirteen days climbing in Alaska.

The four-person climbing party had purposefully split up. Don and J.J., an experienced female climber, got a four-hour head start. They planned to reach base camp, recuperate, and greet Thom and Mike, the climb leader, with a hot meal. At about ten o'clock in the morning, halfway to base camp, Don and J.J. came to a glacier where bamboo poles marked the recommended route around a crevasse.

A snowbridge offered an enticingly direct, shorter route to base camp. The snowbridge seemed solid. However, after Don carefully examined the dark crevasse, the path marked by the poles was clearly the wiser choice. He and J.J. took the longer route. When they arrived at base camp it was sunny and clear. A gorgeous day.

Thom and the leader arrived at the glacier at about two in the afternoon. They sat in the snow and retrieved sandwiches from their packs. Thom glanced toward the crevasse, then at the bamboo poles. Thom and Mike had discussed route options, and Thom was to take the lead on this section of the climb. He gulped down the last of his meal, turned to Mike, and said, "I vote for the snowbridge."

Thom moved quickly, without roping up. A cardinal sin in mountain climbing! As Mike stood to shoulder his pack, he was horrified to see the top of Thom's head disappearing as the snowbridge collapsed beneath him.

As Thom fell, he glanced off the ice walls, breaking something with each hit. A rib. The cheekbone supporting his left eye. Another rib. An ankle. Another rib. With each collision with the icy walls of the crevasse, Thom wondered, "Is this the one that's going to break my neck? Is this my last moment of consciousness?"

Thom fell the equivalent of seven stories. If he had not landed on a three-foot-wide ledge of ice, he would still be down there. It took a rescue crew hours to get him out of the deep, narrow icebox. Each pull on the rope sent showers of snow down the crevasse. It was feared that a large chunk would dislodge and finish Thom off.

When Don and J.J. heard about the accident on their radio, it was too late to get back down the mountain, so it was the next day before they could retrace their steps. On the way down the mountain, Don photographed the crevasse. He and J.J. stopped at a one-hour photo developing shop and got the film developed. When they walked into Thom's hospital room, the first thing Thom said was, "That snowbridge looked solid!"

This was your basic moment of truth. The executives in Don and Thom's group have had many a fierce conversation over the years, and this seemed like a prime candidate for another one. Don took a deep breath and said, "You look like hell, buddy. I'm awful glad you're alive. But that snowbridge did not look solid. It was risky enough at ten in the morning. Look at this photo. You got there four hours later. Four more hours of melting in full sun. What the hell were you pretending not to know?"

Thom did look awful. Since one of his eyeballs was hanging disconcertingly low in its socket, he could barely see the photos. He squinted and moved the photos farther from and closer to his face, attempting to focus. After about a minute Thom became abnormally still. Not at all like our familiar, attention-deficited friend. After a long silence, he murmured, "God almighty. What *was* I pretending not to know?"

At a meeting two months later, Thom hobbled in for a session with the group. We insisted on a blow-by-blow account of the entire misadventure, which was sobering and graphic to the point of inducing nausea and a keen desire to rush home and kiss our children. After Thom had answered all of our questions, he shared his insight. "Well, now I know what a fierce conversation is. I had the fiercest one of my life while plummeting into a crevasse. It was brief—but memorable!"

We all laughed as Thom continued. "Lying in the hospital forced me to be still and think about some things. I saw that the way I approached that crevasse is pretty much the way I live my life. One foot after the other. Head down. Don't look up. Don't ask for help. Don't listen to advice. No time. Just move. Now, now, now. Rope up? Sorry, too busy. Got things to do."

We nodded. We knew Thom and we knew ourselves. Most of us weren't much different.

Then Thom added quietly, "It almost cost me my life."

While most of us don't behave in ways that put our lives at risk, without realizing it we often put our careers and our relationships at risk at the conference table or the kitchen table, by operating much of the time like Thom. By not paying attention to what others are really saying or asking. Not even to our own words. Instead, we string meaningless words together, all the while complaining that today seems an awful lot like yesterday.

A Nervous Breakthrough

I remember Beth, a woman who attended one of my workshops several years ago. It was January. The class was held in the visitors' center of the Washington Park Arboretum. The wintry view out the windows put us all in a reflective mood. Beth had been quiet, lost in thought for the better part of the day. At one point I said, "Beth, will you let us in on your thoughts?"

She answered quietly, in a soft Southern accent. "I've been thinking about my life." We waited. Beth barely took a breath during the following stream of consciousness:

> When I was first married, I was right on time with the biological clock, which set the pattern of correctness and timely dutifulness and the predictability of a marriage that lasted fourteen years, kids, two of them, of course, divorce, a second marriage which was a disaster because, like everyone who divorces after fourteen or eighteen or twenty-two years, you're crazy as a loon, only you don't know it and you think you've learned so much and now you know what you really want or at least what you don't want, and then this man shows up who tells you you're the one he's been looking for forever, and your

body wakes up and you feel attractive and valued and excited about life again, and so what if he's a lot younger than you and even though all your friends and all the books and articles warn you that it's too soon, that you need at least a year or two to figure things out and date several people, what's the rush, et cetera, you're so caught up in the look in his eyes and, besides, he seems to know what he's doing and it just feels so good to be in love or in lust again that you go ahead and marry him and then it takes a week or two, maybe a month, to figure out that you blew it, all your friends and books and articles were right, I mean, he doesn't even know the words to your favorite songs, but then it takes a year or two to finally give up and get out and then you finally meet someone right for you and you marry him and settle into your life together and you don't see it coming one morning two weeks before Christmas when you're reading the newspaper over a cup of coffee and you are in your nice home with your nice husband and you are suddenly terrified that your life will continue exactly as it is until the day you die and you realize you better put your seat belt on because lunacy is sitting in the corner behind the Christmas tree, and it just irritates the hell out of me that all this is part of the schedule, you know, all that midlife crisis stuff, and I'm right on time as usual. I'm a compulsive punctual.

There was a stunned silence, and then Beth chuckled. "Y'all can laugh. I think I'm having a nervous breakthrough." We roared with appreciation for an authentic kindred spirit. What Beth did was show up to herself.

The following assignments will help you show up to yourself, as boldly as Beth and Thom. They will require you to be daring, but let's face it: You've tried prudent planning long enough. It's time to show up in 3-D, cinematic, wide-screen, surround sound to yourself. Even, perhaps, to overhear yourself saying things *you didn't know you knew.* It is highly likely that your own learning will be provoked.

First, you will do a gut check on how you feel about your life today. Next, you'll describe key aspects of the future you desire. Third, given the gap between your current reality and your ideal future, you'll identify the

conversations you need to have with others. Finally, before you have conversations with anyone else, you'll have one with yourself about an issue that is troubling you.

What are the rewards for coming out from behind yourself into the following conversations and making them real? You will find yourself abandoning the safety of confusion (confusion and safety are illusions, anyway) for the juice and motivation of clarity. You will nurture your own deepening dissolution and the emergence of healthier, more effective qualities and behaviors. Your desire to influence or control others will be balanced with a willingness to surrender. As a result, you will move toward what you desire—happier relationships, personal freedom, professional accomplishment, a life that simply fits you better. A lot better. The experience of being awake, alive, and free.

Assignment 1

Annie Dillard wrote, "How we spend our days is how we spend our lives." How are you spending your days, your life? Write down how you feel about yourself, your life, and

> **How we spend our days is how we spend our lives.**

your work—several words or phrases that capture your thoughts and emotions.

MYSELF _____

MY LIFE _____

MY WORK _____

Assignment 2

Write your personal stump speech. There are several forms of stump speeches. One of my favorites is Kevin Costner's memorable "I believe" speech to Susan Sarandon in the movie *Bull Durham*. Most women

recall the line: "I believe in long, slow, deep, soft, wet kisses that last three days . . ." *Ahem. Moving right along . . .*

In chapter six, if you are a leader of a company or a team within a company, you will write your corporate stump speech. For *your* stump speech, I suggest you take a broad perspective. You'll answer four questions: Where am I going? Why am I going there? Who is going with me? How will I get there?

It helps to pull back from your life and look at it as if you're the screenwriter, director, producer, and star. What's the plot? What's the story? What do you want more than anything? What's the conflict? What's the ideal ending? You can't always foresee the interesting side trips you may take, but where are you headed? A trajectory and destination are essential for clarity, even though you will make course corrections throughout your life, as wisdom and maturity broaden your perspective and scrub that last shred of inauthenticity off you. But for now, where you are today, take a stand for the ideal future you envision.

This exercise requires and deserves time. Ideally, a personal retreat. At a minimum, several hours. Your living room will work just fine— though, if possible, I suggest that you get out of your everyday environment. A change in your literal horizon will boost your ability to see new horizons for your life and career.

This fierce conversation with oneself during which we revisit our personal stump speech has become so valuable to me through the years that I go to considerable lengths to ensure the quality of that conversation. Each September, I take a long walk—typically five to seven days— *alone.* The purpose of my September walks is to revisit, reclarify, and recommit to what my soul desires.

One of my favorite walks was through the Yorkshire Dales in England. It was late afternoon of the first day before the chatter in my head began to quiet down. By day two, I felt completely alive, overcome by the beauty of the territory. Most of day three was spent on the high moors. My only companions were sheep, rabbits, and curlews. Midafternoon, I climbed atop a stone outcropping to enjoy my lunch and drink in the view.

Before following the footpath that would take me down into a village for the evening, I invited a fierce conversation with myself: "Am I

on the right path? Is the life I'm living an authentic expression of who I am, of who I wish to become? Is there anything I am pretending not to know? What is next for me?" I got answers.

In the late afternoon I descended from the high moors into a church-yard. It had been blue sky and warm sun all day and I had drunk all of the water I'd carried with me, so I asked a man who was working on the landscaping if it was okay for me to go into the church and fill my water bottle. He looked me up and down and then said, "From the looks of you, love, 'twere me, I'd go to the pub and have meself a pint." (Did you know that there is often a pub across the street from churches in the UK? How convenient!)

The pub was dark and cool. I said to the bartender, "I'd like something cold and strong." A customer said, "Give her a Black Sheep."

Heaven!

That evening, on my bedside table in a cozy inn, I found the book *Watership Down,* which I had read to my daughters years ago. It was delightful to reread parts of this favorite book, reacquainting myself with Hazel and Fiver and the peculiar language of rabbits. I was deeply happy. On this night, outside my window, three stars soaking up twilight lit the way forward. And I was certain of the path.

Why is it so important to spend time conversing with ourselves? Because *all conversations are with myself, and sometimes they involve other people.* This is incredibly important to understand. Embracing this insight changes the way we relate to and interact with everyone in our lives. I may think I see you as you are, but in truth, I see you as *I am.* I see you through my own highly individualized context. The implications are staggering, and not the least of them is this: *The issues in my life are rarely about you. They are almost always about me.*

This means that I cannot come out from behind myself into conversations with others and make them real until I know who *I am* and what I intend to do with my life. Each of us must first answer the question "Where am I going?" before we can address the question "Who is going with me?" It is essential not to get those out of order.

> I may think I see you as you are, but in truth, I see you as *I am.*

The September following the walk in the Yorkshire Dales, you would

have found me in the Swiss Alps. This past September, I walked the Cotswolds in England, 102 magical miles of footpaths. When I am alone, in nature, my life automatically properly reprioritizes itself. I return—to my family, to my company, and to myself—refreshed. Clear and clean.

Whether you end up spending four hours at home or manage to get away for a day or two, your work, your relationships, and your life will begin to be transformed as a result of addressing these questions. We bring into our lives whatever it is that we have the most clarity about. The trouble is, most of us have a great deal of clarity about what it is we *don't* want. So guess what we get!

Clarify what you want and don't allow your inner critic to edit your answers to the following questions. Set reality considerations aside. Just write whatever comes to mind. If you hear yourself answering "I don't know" to any of the questions, ask yourself, "What would it be if I *did* know?"

STUMP SPEECH

- Where am I going?

- Why am I going there?

- Who is going with me?

- How will I get there?

Assignment 3

Now that you've written your personal stump speech, you're ready to list the fierce conversations you need to have with others. They may be the conversations you've been assiduously avoiding for months or years. Some of them may be about the undiscussables in your life—the topics that you and others have been avoiding at home or at work, the topics that need to be addressed and resolved in order for you to move forward. You won't address them quite yet, but it's time to identify them.

Write down the name of each person and a sentence or two about the topic for the conversation. For example:

- Bob (my boss): My career ambitions, in particular, my desire to prove myself a worthy candidate for the position of VP of operations.

- Jane (my wife): We're both so busy. We haven't spent much time together or had many laughs lately. I'm worried that our relationship is becoming stale. How do we resolve the challenges of our busy lives and create quality time together?

- Alison (my direct report): Her performance has really slipped. I no longer feel I can rely on her to get things done. The stakes are high for her, for me, for our department. I'd like to resolve this.

- Jeff (my son): I don't think he knows how proud I am of him, how much I love him. I want to tell him and schedule something special to do together.

FIERCE CONVERSATIONS I NEED TO HAVE . . .

PERSON _____ TOPIC _____

PERSON _____ TOPIC _____

PERSON _____ TOPIC _____

PERSON _____ TOPIC _____

Assignment 4

In chapter one, you were introduced to the Mineral Rights conversation that I had with John Tompkins. In chapter three, you will learn how to take someone else through Mineral Rights, but for now I'd like you to have it with yourself. I'm asking you to take on the issue that is troubling you the most, perhaps the one that you least want to face, the one you

sense may require courage you're not sure you have. You will need an hour. Alone. Uninterrupted.

In preparation, identify your single most pressing issue, something that is currently going on in your professional or personal life that you want and need to resolve. In workshops, participants' issues cover a wide range . . .

- Our strategic plan looks good on paper, but it's not being implemented. We're headed for a bad day.

- I'm failing in my job. I'm afraid I'm going to be fired.

- My marriage is stagnant. My partner and I are housemates, not lovers.

- I'm overweight. If I don't make a change, my health will suffer.

- I suspect our sales manager has a drinking problem. I hear stories about what happens on the road. I've asked him about them, but he makes light of them. I just heard another story—from a customer.

- My daughter may be doing drugs. I know she'll deny it.

- My job pays well, but when I imagine myself doing this for another ten years, well, just take me out back and shoot me now.

- I'm successful in my work, but my personal relationships keep failing.

To the degree that you are fierce with yourself—passionate, real, unbridled, uncensored—a Mineral Rights conversation will help you explore issues by mining for greater clarity, improved understanding, and impetus for change. It will shine a bright light on that issue of yours, the one growling in the dungeon, and you'll live to tell about it.

So now it's time to begin. Write down your response to each of the following questions. Do not edit your responses. Just write.

Step 1: Identify your most pressing issue.

The issue that I most need to resolve is:

Step 2: Clarify the issue.

What's going on?

How long has this been going on?

How bad are things?

Step 3: Determine the current impact.

How is this issue currently impacting my career, the success of my team, my marriage?

What results are currently being produced by this situation?

How is this issue currently impacting me?

When I consider the impact on myself and others, what are my emotions?

Step 4: Determine the future implications.

If nothing changes, what's likely to happen?

What's at stake for others relative to this issue?

What's at stake for me?

When I consider these possible outcomes, what are my emotions?

Step 5: Examine your personal contribution to this issue.

What is my contribution to this issue? (How have I contributed to the problem?)

Step 6: Describe the ideal outcome.

When this issue is resolved, what difference will that make?

When this issue is resolved, what results will others enjoy?

When this issue is resolved, what results will I enjoy?

When I imagine this resolution, what are my emotions?

Step 7: Commit to action.

What is the most potent step I could take to move this issue toward resolution?

What's going to attempt to get in my way, and how will I get past it?

When will I take this step?

Contract with Yourself . . .

During this fierce conversation with myself, I've identified a potent step to take to begin to resolve this issue. I have chosen the date by which I will take this step. There will be other steps, perhaps many of them. This is the first. I commit to taking it.

_____ _____

action *today's date*

Now take a break. Walk around. Breathe. Breathing is good.

Take It Personally

A final note: The phrases "Don't take this personally" and "Don't take yourself so seriously" are misguided suggestions. Do take it personally; do take yourself seriously. The opposite of "So what?" is to take it personally! Work is deeply personal. Leading is intensely personal. Ultimately, everything is personal, assuming you've addressed the questions . . .

Who am I?

What price am I willing to pay to be that?

This is your life. I hope it has its hilarious moments; however, this is serious business—or what's the point? If you don't take it seriously, there won't be enough of you here. The results you're experiencing and

the emotions roiling within you are direct results of how you are show-ing up to yourself and others. All day. Every day.

What about making it personal at home but keeping a politically strategic distance at work? If that is the model, we ultimately absent our spirit from our work. Then we come home and complain about it all. *My boss is an idiot. Our customers are unreasonable. My colleagues aren't pulling their weight.* Whoever awaits our arrival at home receives the brunt of all our angst and anger.

There is no workable separation of selves at work and at home. We are ourselves all over the place, and it is this real self that is felt and experienced at a deeply personal level by ourselves and everyone on the receiving end of us, whether we acknowledge it or not. In *Traveling Mercies,* Anne Lamott writes, "Everything is usually so masked or per-fumed or disguised in the world, and it's so touching when you get to see something real and human . . . no matter how neurotic the members [of the group], how deeply annoying or dull . . . when people have seen you at your worst, you don't have to put on the mask as much. And that gives us license to try on that radical hat of liberation, the hat of self-acceptance."

A REFRESHER . . .

- In each conversation you have at work and at home, come out from behind yourself, into the conversation, and make it real.

- When you offer up your true self, others will recognize it and respond.

- Your body will manifest the pictures your mind sends to it, so clarify where you want to go with your life in 3-D, cinematic, wide-screen, surround sound.

- If you overhear yourself saying, "I don't know," ask yourself, "What would it be if I did know?"

- Take yourself seriously. Take your life personally. Otherwise, there won't be enough of *you* here.

PRINCIPLE 3

Be Here, Prepared to Be Nowhere Else

> *The experience of being understood, versus interpreted, is so compelling, you can charge admission.*
>
> —B. Joseph Pine II, *The Experience Economy*

There is a profound difference between having a title, a job description, or a marriage license and being someone to whom people commit at the deepest level. If we wish to accomplish great things in our organizations and in our lives, then we must come to terms with a basic human need: Humans share a universal longing to be known and, being known, to be loved, valued, respected. Being known is at the top of the list.

In *The Nightingale* by Kristin Hannah, a character thinks, "I always thought it was what I wanted: to be loved and admired. Now I think perhaps I'd like to be known."

Psychologist Jeffrey Bernstein believes that understanding is more important than love, especially when it comes to intimate relationships. He writes, "As a psychologist for more than twenty-five years I can tell you that I have never had an adult look back at her childhood and complain that her parents were too understanding. And similarly, I have met many divorced people who still love each other, but yet they never really understood each other."

I suspect that one of the reasons couples don't understand each other is because when there are disagreements, one or both leave the room. "My husband and I never fight," a friend told me. "Not with each other or with anyone else."

I replied, "I'm sorry to hear that."

How can you see someone if there is never anything about that person that puzzles or irritates you?

When our conversations with others disregard the core need of being understood, our lives can seem like an ongoing, exhausting struggle to influence others to do what we want them to do, to rise to their potential, to accomplish the goals of the organization or of the relationship. We persuade, cajole, manipulate, and issue directives. Nothing changes. Deadlines are missed. The scenery is boring. People and relationships are on automatic pilot.

Consider this passage in *The Fifth Discipline Fieldbook*, edited by Peter Senge:

> *Among the tribes of northern Natal in South Africa, the most common Zulu greeting is the expression: "Sawubona." It literally means, "I see you." The reply is "Ngikhona," or "I am here." The order of the exchange is important: Until you see me, I do not exist. It's as if, when you see me, you bring me into existence.*

Sawubona. Only when we genuinely see the people who are important to us can we hope to succeed as agents for positive change.

Having misread many individuals throughout our lifetime, however, we often find that discovering someone else's authentic self can be complicated by our increasing cynicism. In Philip Roth's *The Human Stain*, a character suggests, "By a certain age, one's mistrust is so exquisitely refined that one is unwilling to believe anybody." Or to *know* anyone. Or to get too close.

Discovering someone else's authentic self can be complicated by our increasing cynicism.

Yet we must learn to rebuild the links that connect people and that provide an effective antidote to cynicism and disaffection. We must

transform the way we speak, the way we ask, the way we listen. How do we get to know another person? How do we get past "How are you? I'm fine."

By really asking and really listening. By being with someone, even if only for a brief moment, prepared to be nowhere else.

I worked for a man who did this beautifully.

Fred Timberlake

When I was sixteen, I got a summer job as an assistant to Fred Timberlake, head of sales and marketing at Cook Paint and Varnish in Kansas City, Missouri. I could type a hundred words a minute and, as this was before computers, I sat at an IBM Selectric, the metal ball of type twirling furiously. During my second week on the job, the Selectric suddenly froze, and I looked up, shocked to see Mr. Timberlake holding the cord after having pulled the plug from the outlet. He was smiling. He handed me a sheet of paper.

"What do you think of this advertising layout?"

I glanced at the layout, then looked behind me, certain that there must be someone else from whom Mr. Timberlake was expecting intelligent input. But there was no one there, and Mr. Timberlake was still standing in front of me, waiting for a response. The expression on his face, his posture, and the full-stop silence encompassing my desk and seemingly everything within miles persuaded me that he was really asking. I studied the advertising layout. It featured a stack of paint cans with colorful graphics, paint spilling from each can.

My impulse was to shrug and say, "I don't know. I don't have any experience in advertising." However, I had the impression that Mr. Timberlake anticipated my response with genuine interest. I didn't want to disappoint my boss, so I thought hard.

"Well, my mom thought about painting our living room for a long time, but she couldn't make up her mind what color to use. Then she saw a photograph in a magazine of a really pretty room with walls painted a color she liked, and she went right out that day and bought paint. I think the picture helped her imagine what our living room

could look like. Maybe if you showed a pretty room with walls painted a great color, it would give people the courage to go buy some paint."

Mr. Timberlake listened as I spoke. When I stopped, he stood quietly for a moment, then said, "Thank you, Susan. I'm sending this back to the drawing board."

Throughout that summer, whenever my Selectric froze, I would smile and prepare to answer another of Mr. Timberlake's questions. In his presence, I became a bigger human being. Every person who worked for Fred Timberlake would have followed him anywhere.

It's amazing how this seemingly small thing—simply paying fierce attention to another, really asking, really listening, even during a brief conversation— can evoke such a wholehearted response. A Chinese proverb says, "When a question is posed ceremoniously, the universe responds." When someone *really* asks, we really answer. And, somehow, both of us are validated.

> **When a question is posed ceremoniously, the universe responds.**

Think for a moment about the kind of attention you bring to your conversations. While someone is talking, where are your thoughts? When you are face-to-face, do you look at the individual in front of you or do your eyes roam the room in a sort of perpetual surveillance? While you're talking with someone on your phone, do you scan your e-mails? And can you tell when someone else is scanning his?

The assignment in this chapter will help you learn to be with someone, prepared to be nowhere else. You've done important work in the first two chapters. You've written your stump speech and listed others with whom you need to have important conversations. You've had a fierce conversation with yourself using the Mineral Rights model.

The first question you answered in your stump speech was "Where am I going?" You can't answer the second question—"Who is going with me?"—until you know who that someone is.

Do I want this person as a member of my team? As a client? Am I eager to commit to this relationship? Do I really know this person?

By the end of this chapter you'll be ready to have a fierce conversation with someone else, a conversation that will be significantly differentiated from others you have had. You'll explore an important issue by

asking questions and listening carefully to your partner's responses. Anyone with whom you have this conversation will go away from it having enjoyed your complete attention and feeling known by you—a rare and wonderful thing.

The One-to-One

One of the most difficult decisions I've ever made was to stop chairing my group of Seattle CEOs in order to free up more time for writing and speaking. For thirteen years I had a fifty-yard-line seat on some of the most interesting lives in town.

Each month, sixteen noncompeting CEOs spent a day together. At times I would bring in an outside expert for the morning, someone who would engage the group in an intimate dialogue guaranteed to provoke learning. In the afternoon, we focused on the most pressing issues of three or four of the members.

- In this competitive economy, how can I attract top talent?

- What customer-relationship management system is the best fit for my company?

- What is your evaluation of this potential acquisition?

- How can we build our brand?

I loved those days and looked forward to the interaction of the group. They were genuinely glad to be together, focused on their businesses in the company of peers with no agenda other than to help one another succeed. Once an issue was introduced, we mined for the group gold and struck rich veins by posing hard questions.

The other interaction each month—the one-to-one—was in some ways more satisfying to me than the group sessions. I've talked about these conversations already. This was a member's time alone with me and mine with him or her.

I knew, because my clients had told me in ways I could not discount,

that these fierce conversations meant as much to them as to me. Reality was interrogated, learning was provoked, the tough issues were tackled, and our relationship was enhanced.

During the gorgeous days of summer and fall, several members preferred to get out of their offices and meet me at Green Lake. It took an hour to walk around the lake. Two strolls around Green Lake provided just enough time to cover everything going on in the CEO's corporate and personal life. I once made the mistake of scheduling three Green Lake sessions on the same day. During six trips around the lake, the conversations were so riveting that I didn't feel a thing until the next morning when I leapt out of bed and my legs almost buckled beneath me.

Here's the thing I most want you to understand: I had little or no experience in such diverse businesses as rapid prototyping, software development, fine art supplies, public accounting, coffee, and commercial construction. What I *did* have was fierce affection for each of my clients, genuine curiosity about the topic of the moment, an insatiable appetite for learning, and a fierce resolve to be with each individual, prepared to be nowhere else.

This set of characteristics translates to personal relationships as well. For relationships to move forward and upward, you must have fierce affection for the other person. You must have genuine curiosity about what is going on with that person at any given time. You must have an insatiable appetite for learning more every day about who he or she is and where he or she wants to go and how this does or does not mesh with who you are and where you want to go. And all of this is helped significantly by your willingness to occasionally set aside all of the topics ping-ponging inside your own head and simply be with this other person, here and now.

> For relationships to move forward and upward, you must have fierce affection for the other person.

Perhaps you have a creeping foreboding that, in some instances, all this getting to know someone, all this *being present* stuff, involves listening endlessly to someone telling you more than you ever wanted to know about a series of boring topics. All the gory details about who did what to whom.

This would not work for me or for most people I know. Few of us

are blessed with unending patience or the ability to demonstrate genuine interest in every individual or issue that crosses our paths. This is certainly true of anyone heading up an organization, or a team within an organization tasked to pull off miracles in a short time frame—which is what the business world requires of us daily. Time that busy people have set aside to talk with anybody about anything is time not to be taken lightly. Something needs to be set in motion as a result of their time with others. Every conversation has to count.

If this sounds like you, or like you in certain situations, then be comforted by the following . . .

Yes, the conversation *is* the relationship. One conversation at a time, you are building, destroying, or flatlining your relationships. It is possible, however, to create high-intimacy, low-maintenance relationships—one relatively *brief* conversation at a time. If that sounds good to you, read on.

Getting Past "How Are You?"

Somewhere in our histories, most of us have come across an individual who remains a cipher to us. A coworker who seems to be wrapped in Teflon, carrying a shield. A relative with whom you always end up in some kind of misunderstanding. No matter how much you try, you don't seem to be able to connect with that person in any meaningful way. You're not sure where he or she is coming from, and the feeling is probably mutual. You've been tempted to say, "I've been hanging out with you for years, and I still don't know who you are or what you want." And sotto voce, *Frankly, I've lost interest.*

The problem does not always lie in a lack of time together. Almost every busy parent has felt guilty about not spending enough time with his or her child. Most couples express concern that they have not been spending as much time with their mates as they feel they should. Most leaders suspect that things would go more smoothly if they spent more time with the individuals on their leadership team and that they, in turn, should do the same with the people who report to them. So we carve out the time, sometimes grudgingly.

A parent sits down to talk with a child. A couple gets a babysitter and goes out to dinner. A leader schedules a meeting with a direct report. What happens? Not much. Just space, uncomfortable space, stretching out in front of you. Many do not make it past "How are you?" "I'm fine."

Many of us have imagined saying, "By the way, I only have three days to live," or "I robbed a bank, and I'm running away with the bartender at Trudy's Tavern," just to see if anyone would notice.

Kathleen de Burca, the central character in *My Dream of You* by Nuala O'Faolain, describes a missed conversation with a companion escorting her to an awards ceremony, who tells her not to be nervous. Kathleen replies, "I'm not nervous in public." She then shares her interior dialogue with the reader.

"This was an invitation to ask me what I meant, and for me to tell him about being afraid of the people I knew, not the people I didn't know, and for him to tell me what he felt, and so on. But he didn't know how to talk that kind of talk."

When people are not paying attention, not really engaged, there are many missed opportunities to clamber out of the usual conversational box and talk about something interesting and memorable. However, while most people think the problem lies with others, what if there is something else at work here? What if *you're* the problem? What if you're so unengaged or unengaging that nobody hears you, nobody really listens to you, nobody really responds to you?

Perhaps you're too polite. Or too self-conscious. Or too self-absorbed. Or too politically correct. Or too cautious. The net result? Unconsciously, we end our conversations as soon as we initiate them, too afraid of what we might say or hear.

> Unconsciously, we end our conversations as soon as we initiate them, too afraid of what we might say or hear.

In the workplace, this translates into the typical exchange:

"How's the project going?"

"Great."

"Everything working out?"

"You bet."

"Good. That's what I like to hear."

No one's really asking. No one's really listening.

"Have a good day?"

"Yeah. You?"

"Sure."

"Hmmm."

Even

"I'm dying."

"That's nice."

No one engages; nothing changes.

So what do we do about this? For starters, being with someone prepared to be nowhere else takes courage. It's unlikely any of us will really ask, unless and until we are prepared to really hear the response and respond in turn, addressing a potentially difficult or complex topic authentically with someone, here and now.

Where do we get the courage? In part, simply by recognizing that if you chicken out now, you'll pay the price later. Recognizing that if you or someone else feels a conversation is needed, it is. If a sensitive or significant topic comes up unbidden, seize the moment. Those conversations you listed in chapter two need to take place. They're important to your success and happiness and, I would venture to guess, to other people's success and happiness as well.

Avoiding or postponing a conversation, downplaying its importance, or trying to bluff your way through it only delays or accelerates a very bad day.

If you chicken out now, you'll pay the price later.

If you or someone else feels a conversation is needed, it is.

A reminder here: So often people forget that one of the fiercest conversations any of us can have is to tell someone how important he or she is in our lives, how much we value and love that person. For many people, that is more difficult than bringing up a concern. If none of the conversations you listed in chapter two involves letting someone know what he or she means to you or to your organization, go back and add a conversation.

Now let's focus on one of the basics of being present—eye contact. So simple and yet so difficult.

Soft Eyes and Ears

Many people make little real contact during a conversation. Not even eye contact. A vivid experience I had of this was with Mark, a high-level leader of a global organization. Mark had invited me to talk about fierce conversations with his executive staff during a two-day retreat. When I arrived at the site, I met with Mark to review the ideal outcomes from my time with his team and to find out how things were going so far.

Mark didn't look at me. During my conversation with Mark, no matter which one of us was talking, he simply did not look at me. Eventually I said, "While we've been talking, I've noticed you haven't looked at me."

Mark smiled, glanced at me, then looked away and responded, "I haven't decided if I like you yet."

"So until you've made up your mind whether or not you like me, you will withhold eye contact?"

He smiled again. "That's what I do."

"Do you do this with new members of your executive team? For whatever period of time it takes you to decide whether or not you like them . . . you withhold eye contact?"

"That's right."

"Well, I feel it acutely, this withholding of yourself, of your approval, and I'm puzzled. You invited me here to produce a result you say you want. It seems we should be collaborating. I'd like to feel you are joining me in this conversation, and it would help if you'd look at me while we talk."

Mark was looking at me now. Not smiling. I wondered if he would stand up and say, "We're done. You're outta here." But instead, he thought for a moment and then said, "Okay, let's work."

"One more thing," I offered. "If you are not looking at the people on your team when you're talking with them, be aware that they may feel they're invisible to you. Devalued. I don't imagine that's what you want."

Half an hour later, as Mark introduced me, he said, "Susan practices what she preaches. I know. She told me I had lousy eye contact and that it didn't feel very good. So I'm going to work on that."

Fifty people smiled and nodded.

I do not, however, recommend maintaining *maniacal* eye contact during your conversations. Many of us have wanted to back away from an avid individual whose eyes seemed to drill through us and out the other side. What I do recommend are "soft eyes," which I learned about years ago when I lived in Japan and studied karate.

During the last half hour of each session, everyone formed a circle around one individual and could attack the person in the center of the circle from any direction at any time, with no warning. When I was the vulnerable individual in the center, I initially strained to see everyone, my eyes darting from person to person, whirling and turning so that I wouldn't miss anything. I often ended up felled, not by someone behind me but by someone right in front of me. It seemed that the harder I tried to see, the more I missed.

The sensei taught us that if instead of trying to focus on any one thing, we softened our eyes and allowed the world to come to us, we would see a great deal more. We would catch subtle motion. Our peripheral vision would become acute. This was true. Over time, we developed the proverbial eyes in the backs of our heads. And it was effortless.

> We may succeed in hearing every word yet miss the message altogether.

The same thing happens with our listening. We may succeed in hearing every word yet miss the message altogether.

A great example of me missing important messages was at a business meeting in Tokyo. I noticed a young

woman writing continuously. Following the meeting, I commented that it was good to have someone capturing everything that was said.

"Oh, she wasn't writing down what was said," a colleague explained. "She was writing down what was *not* said."

"But she never stopped writing the entire time!"

My companion simply smiled.

In conversations, soft eyes and soft ears allow a partner to come to you, to communicate to you. It is not about being clever or having degrees in a particular field. It's about being genuinely interested, really asking, and paying fierce attention to the response. Or the lack of response.

Years later, when I worked for a search firm, someone asked me how I could bear to interview people all day. It was as if this person felt that interviews with job candidates couldn't be interesting, that somehow they must all be alike. The question astounded me. I almost always lost myself in those interviews.

Sometimes a colleague would later ask, "Was she the one with the pink piping around the collar of her jacket?" Or, "He wore glasses and had a beard, right?" I could never remember.

Who cares if the guy has a beard! He is a delightful, interesting human being who raises basil as a hobby, makes incredible pesto. I don't remember what color his eyes are, but I do know that he has an eye for detail, incredible organization skills, and a wonderfully wry sense of humor. I think he'd be successful with several of our clients. And who notices piping, for God's sake?

More recently, I worked with a woman who had incredible hands. I could listen to her through isolated hand movements. At first I felt self-conscious focusing on her hands, but they had so much to say. At one point, I told her that her hands were wonderfully expressive. She looked at her hands a moment and said, "This morning I put on my coat and my mother's hands came out the sleeves."

There is so much more to listen to than words. Listen to the whole person.

How Aren't You?

For many people, the answer to the question "What's the opposite of
talking?" is "Waiting to talk." Many think that
not speaking when someone is talking is the

**Hearing people's words is
only the beginning.**

same as listening. Hearing people's words is
only the beginning. Do you also hear their
fears? their intentions? their aspirations? In the words of the thirteenth-
century Sufi poet Rumi:

> *Reach your long hands out*
> *to another door, beyond where*
> *you go on the street, the street*
> *where everyone says, "how are you?"*
> *And no one says how aren't you?*

At a recent workshop in Florida, I asked a participant named David
to come to the front of the room to talk about a problem he'd like to
solve. I asked a third of the participants to listen for content, a third for
emotion, and a third for intent. David spoke about his ongoing struggle
with his weight. He discussed his concerns about how his health might
suffer if he didn't get on top of this issue, how he didn't feel good in his
clothes, how important it was for him to start eating better and exercis-
ing, how long he had been struggling with this issue.

After a few minutes, I stopped David and asked each group to tell
him what they had "heard." The content group fed his words back to him
almost verbatim. David nodded. The emotion group picked up on his
frustration, embarrassment, and helplessness. David acknowledged all
of this. The group listening for intent delivered the blow: "You aren't
going to do anything about this. Right now, it's all just words." David
blanched and disagreed with their assessment. On the very next break,
he helped himself to brownies.

David had given us the usual rhetoric that most of us hear and even
say ourselves when trying to lose weight: "I've got to get a handle on
this. I'm going to watch what I eat and start exercising."

When we listen beyond words for intent, for the scaffolding on which a story hangs, clarity and character emerge. We need to listen this way to ourselves, not just to others.

When we listen beyond words for intent, for the scaffolding on which a story hangs, clarity and character emerge.

The Samurai Game

I got a unique perspective on being present years ago when I did some training for an organization called Sports Mind. It was marvelous preparation for the work I would soon be doing with leaders. Three facilitators and a high ropes team took work teams out into the boonies for four days of weird and wonderful stuff. We climbed poles and leapt for trapeze swings, zip-lined across rivers, and walked beams fifty feet off the ground. The most controversial activity was the Samurai Game, played on the third night. When I went through the training myself, before I became one of the facilitators, I remember being prepared for the Samurai Game.

We were told, "Go spend an hour alone, in silence. When you return to this room, enter it as a samurai—in silence."

An hour later, as about sixty other participants and I sat on the floor, ready to learn the rules of the game, I sensed an intense, impassioned spirit in myself and others. It was as if each of us had experienced a "walk-in" by the ghost of a samurai from long ago. The facilitator, who had adopted the unnervingly stern visage of a Fate of War, gave us plenty to think about.

"How would a samurai sit?" he asked in a deep voice.

We straightened our spines.

"As I give you the rules of the game, how would a samurai listen?"

Every synapse and neuron went on alert.

For the next four hours, we were caught up body and soul in the game, which seemed not so much a game as a vivid and utterly compelling reality. While we were never in danger of physical harm, many battles, such as rock, paper, scissors, or holding one's arms up until the point of exhaustion, or standing on one leg in the "crane" position, were won or lost on the battlefield. Many samurai were "killed," and the battlefield became littered with bodies. Occasionally, the Fate of War would halt the battle long enough for the two armies to drag off their "dead."

My army's Daimyo, the equivalent of a CEO, repeatedly sent me to fight challenging battles. I brought to the game everything I had learned about centering and focus. While other battles raged around me, I fought with fierce attention. Silently, I summoned strength and communicated my will to defeat each opponent. In one particularly arduous battle, compassion for my opponent caused me to will her to endure. In my head and heart, I upheld both of us. The battle was a draw.

Amazed, I remained standing until the end, humbled and inspired by the power of being completely present and attentive to everything that was happening. The concept of changing my life by merely paying fierce attention to it had become entirely real to me. I was paying attention not as a means to an end—to be liked or to make another person feel liked or understood—but as a new way of experiencing myself and others. I felt utterly calm, clear, and alive. I felt like, as my colleague James Newton, founder of Newton Learning, would say, "an unanxious presence in an anxious world."

Given the topic of this book, the obvious question is: How would you approach a conversation if you were a samurai? I doubt you'd be checking your phone for texts or e-mails.

Preparing for Your Assignment

Now you're ready to have a wonderfully fierce conversation with someone at work and someone at home. A powerful aid to being here, prepared to be nowhere else, is your old friend Mineral Rights. Before you take the leap, I want to provide answers to some frequently asked questions.

FAQ

How should I frame these kinds of one-to-ones and set expectations with my direct reports?
This is your uninterrupted time with the people who are important to the success of your company or your team. They will rise or fall accord-

ing to your expectations. If you always create and drive the agenda, that will become everyone's expectation. Additionally, you may be missing something important. Set the stage by telling the individual ahead of time:

> *When we meet tomorrow, I want to explore with you whatever you feel most deserves our attention, so I will begin by asking, "What is the most important thing you and I should be talking about?" I will rely on you to tell me. If the thought of bringing up an issue makes you anxious, that's a signal you need to bring it up. I am not going to preempt your agenda with my own. If I need to talk with you about something else, I'll tag it onto the end or plan another conversation with you.*

Won't some people be suspicious? Might some people get the deer-in-the-headlights look?

Yes, and that's okay. If they press you for reasons why you should meet, just say: "You're important to me, to the team, to this project. We owe it to ourselves to stay current on where we're going, what's happening, and what's needed." If someone protests, possibly insecure lest he or she overlooks what you want to talk about, stand your ground: "I hold you able to identify the most important thing we should be focusing on together." I can guarantee that serious thought will be given to the topic.

What if someone doesn't put his or her finger on the topic I feel is most important?

If someone wants to discuss what to you seems like an organizational hangnail, bite your tongue and explore the topic. Why? Because if you asked that person what he or she deemed most important and that person told you and you then disregard it and place your own agenda on the table instead, you have essentially just said that when you asked, you weren't really asking. That this was just an exercise of smoke and mirrors. *If it's important to that person,*

> Observe an individual whose pressing topic is overridden or dismissed by others, and you will likely see that person explode or disappear.

then it's important. So go there. Observe an individual whose pressing topic is overridden or dismissed by others, and you will likely see that person explode or disappear. If you're the boss, it's unlikely he or she will explode in front of you; instead, the explosion will be saved for colleagues at the watercooler or a poor, unsuspecting partner later that night. With you, the individual will smile and nod and endure the conversation, and little that's useful will have occurred. If over time an individual persists in avoiding the topics that need to be addressed, you have a different issue. Then it will be up to you to put an issue on the table for exploration.

What are some reasonable goals and outcomes for such one-to-ones?
Each Mineral Rights conversation will be productive and memorable. Each will move important issues down the field. Each will develop the leadership capabilities of your team members and, at home, maturity in your children, closeness with your lover. Each will accomplish the goals of any and all fierce conversations:

- *Reality will be interrogated.* You'll stay current regarding ground truth. You won't be blindsided by surprises down the road. You will peel off the proverbial layers of the onion and get to the heart of the issue.

- *Learning will be provoked.* Yours and others'. In fact, you and your partner are likely to learn much more during a Mineral Rights conversation than you've learned in other "meetings."

- *People will be mobilized to tackle the tough challenges.* People solve the problems and seize the opportunities that they themselves have named. They will leave this conversation with a sense of accountability for their understanding of the conversation, for their ownership of the outcomes, and for any action that has their name on it.

- *The relationship will be enriched.* One of the greatest gifts you can give another is the purity of your attention. Not your advice! Mineral Rights requires that you hold your ideas about what needs

to be done until your partner has had an opportunity to formulate his or her own solutions.

How often should the one-to-ones be held? How long should they last?

That depends. In the workplace, if someone is new, more often. If someone is experienced and proven, less often. Flexibility is important, but I recommend that the optimum schedule is once a month for one hour. If that thought buckles your knees, you may have too many direct reports. Twelve times a year, ask each of your key people to explore his or her most important issues with you. In a personal relationship, you may want to do this more often, certainly whenever you sense something is up.

What are some process tips and techniques that will make the one-to-ones more effective?

Mineral Rights is a seven-step process that will guide you through a scintillating conversation from beginning to end. Just as important as following the process, however, is checking your belief system. What you believe to be true about people affects how you lead and partner with them. For example, I worked with a client, Mike, who continually complained about the incompetence of his executive staff, "They wait for me to come up with the answers." On the rare occasions when they did have answers, it seemed the answers were inadequate. Mike unconsciously broadcast his beliefs—*I am the only one here who is capable of intelligent thought*—to everyone who worked for him. So Mike got to be right about his belief. What do you expect of the people on your team? From the members of your family? How are your expectations affecting their behavior?

Why is it essential during Mineral Rights to ask about someone's emotions?

Emotions serve as the gasoline that propels us into action. As I've said before, if you don't ask what someone is feeling, it's as if you leave that person sitting in an exquisite car—one that he or she could take apart and put together blindfolded—with no gasoline in the tank, which means this car is in no danger of going anywhere. I have listened to

Emotions serve as the gasoline that propels us into action.

executives, friends, and relatives describe in detail the current disturbing results and future implications if an issue doesn't get resolved . . . even though they clearly have no intention of doing anything about it in this lifetime. Not until they explore emotions do they truly get in touch with the price they are paying. Then, and only then, does the lit match have something to ignite.

What are the most common mistakes made during one-to-ones?

1. *Doing most of the talking.* Don't. It's that simple. Really ask, and then really listen. What happens if it gets really quiet? Take a deep breath and wait. Useful thinking takes place during silence. As long as you're talking, you're not learning anything you didn't know already.

2. *Taking the problem away from someone.* No matter how skilled someone is at giving the problem back to you, don't take it. If someone asks for your opinion, say, "I'll share my thoughts with you before we end our conversation, but right now, let's keep exploring yours."

3. *Not inquiring about emotions.* For some people, asking what someone is feeling is an unnatural act. If this is true for you, do it anyway and learn from the experience. If you fail to inquire about and surface emotions, you'll notice that nothing much changes as a result of your conversations because no heat has been generated. *Note:* Don't ask, "How does that make you feel?" Nothing *makes* us feel anything. We feel what we feel for a gazillion reasons too complicated to fathom. Ask, "What are you feeling?"

4. *Delivering unclear messages, unclear coaching, and unclear instructions.* Ideally, you will deliver few or no messages, coaching, or instructions; however, if you do have something to add, do it clearly and succinctly. If you have a request, make sure your partner hears and understands it. Don't leave it open for interpretation.

5. *Canceling the meeting.* Don't do it unless someone dies—like you. You said these meetings were important. Are they or aren't they? Your actions will tell the story. This meeting with you should be considered inviolate.

6. *Allowing interruptions.* Turn off or mute your cell phone. You cannot be here, prepared to be nowhere else, when you are interrupted by beeps, buzzes, and bells. If you're conducting a one-to-one on the phone, don't put someone on hold to take another call. Not only is it disrespectful, but when you return to the conversation something will have been lost and may or may not be regained. The tone, the sound, the timbre, the welling emotion. If you want to engage in fierce conversations, if you don't want to waste your conversational time or that of the person on the other end of the line, do not allow interruptions of any kind.

> You cannot be here, prepared to be nowhere else, when you are interrupted by beeps, buzzes, and bells.

7. *Running out of time.* Every Mineral Rights conversation concludes with clarity about the next most important step. If that next step needs to be another conversation, schedule it; however, in many cases you won't need to because of a wonderful phenomenon that's part of Mineral Rights conversations: The conversation hasn't ended just because the *conversation* has ended. During a Mineral Rights conversation, things are set in motion. For the person who just walked out of your office, an internal conversation is ongoing. It gets people thinking because what the two of you set in motion deserves fierce attention.

> The conversation hasn't ended just because the *conversation* has ended.

8. *Moving too quickly from question to question.* Your job is to slow the conversation down so it can discover what it really wants and needs to be about.

> Your job is to slow the conversation down so it can discover what it really wants and needs to be about.

9. *Assuming your one-to-ones are effective.* I know someone who periodically opens a one-to-one by giving his clients a form. He says, "When you looked at today's schedule and noticed our meeting, what was your immediate reaction? Pick one." The form has seven choices:

- Okay, no big deal.

- Oh no, two hours wasted!

- Should I cancel and reschedule?

- Maybe I can shorten this today.

- Great! I need to talk about _____.

- Great, a few moments of sanity.

- Other _____

Is he guaranteed a candid response? That depends on how he has handled feedback in the past.

Assignment

Schedule a one-to-one with someone at work *and* someone at home. Choose a person who you sense is struggling with an issue. Speak and think of it as a conversation rather than a meeting. Use Mineral Rights as your model. Before you begin, ask yourself, "What do I need to do to be fully present? What are all the things I am thinking about that could interfere with my being here, prepared to be nowhere else? What beliefs am I holding that could be in the way of really asking and really listening?"

You'll begin by asking, "What is the most important thing you and I should talk about today?" Give your colleague or partner some time to consider what you've asked. Don't help the person out. Don't get itchy during the silence and try to help with, "For example, you said you weren't sure if John is going to work out. Maybe we should talk about

that." Or, "Last weekend we didn't have much time together and you seemed upset. Do you want to talk about that?"

Let them decide! And if anyone ever responds with "I don't know," your reply should be, "What would it be if you did know?" This

> **When you can do nothing, what can you do?**

question was inspired by the Zen koan "When you can do nothing, what can you do?"

Ask the question. And wait.

Below, take a moment to revisit the Mineral Rights model. Before having your conversations, however, I recommend that you read the rest of this chapter.

MINERAL RIGHTS: A SIMPLIFIED VERSION

1. What is the most important thing you and I should be talking about?

2. Describe the issue. What's going on relative to _____?

3. How is this currently impacting you? Who or what else is being impacted? The emphasis is on the word "current," so keep your partner focused on current impact and results. Ask, "What else?" at least three times. Probe feelings. When you consider these impacts, what do you feel? Let's say they respond, "I feel frustrated." Say, "Frustrated. Say more about that."

4. If nothing changes, what are the implications? You could say, "Imagine it is a year later and nothing has changed. What is likely to happen?" Ask, "What else?" "What's likely to happen for you?" Probe feelings. When you consider those possible outcomes, what do you feel?

5. How have you helped create this issue or situation? If someone says, "I don't know," then ask the question with which you've become familiar by now, "What would it be if you did know?" Don't comment on the response other than to say, "That's useful to recognize." Don't agree with them and pile on criticism. Move on.

6. What is the ideal outcome? When this is resolved, what difference will that make? Ask, "What else?" Probe feelings. When you contemplate these possibilities, what do you feel?

7. What's the most potent step you can take to begin to resolve this issue? What exactly are you committed to do and when? When should I follow up with you?

Debrief

As you practice Mineral Rights and Principle 3—Be Here, Prepared to Be Nowhere Else—it is helpful to debrief yourself after each conversation. Ask yourself:

- Was I genuinely curious about this person and his or her reality?

- Did I work to understand what color the corporate or relationship beach ball is from where he or she stands?

- Did I slow the conversation down and really probe?

- Did emotions get expressed, as well as issues and solutions?

- Did I ask this person to say more about any emotions they expressed?

- What parts of me failed to show up?

- Who did the most talking? "Me" is the wrong answer.

Over the many years that I've taught and worked with Mineral Rights, I've seen amazing results and conversations that have unfailingly delved into rich territory.

The following list of additional questions has also provided useful openings to memorable conversations. As you deepen your understanding of the seven principles of fierce conversations, you will gain considerable skill in asking these questions and in responding to the answers. But no harm will come from beginning to try them out. The risk is that you will hear things you have been pretending not to know.

Additional Good Questions

You will rarely need to ask anything other than the first question of Mineral Rights to launch a highly useful conversation. It is always comforting, however, to have a few other questions in your back pocket. Here are some of my favorites.

1. What has become clear since we last met?

2. What is the area that, if you made an improvement, would give you and others the greatest return on time, energy, and dollars invested?

3. What is currently impossible to do that, if it were possible, would change everything?

4. What are you trying to make happen in the next three months?

5. What's the most important decision you're facing? What's keeping you from making it?

6. What topic are you hoping I won't bring up?

7. What area under your responsibility are you most satisfied with? least satisfied with?

8. What part of your responsibilities are you avoiding right now?

9. Who are your strongest employees? What are you doing to ensure that they're happy and motivated?

10. Who are your weakest employees? What is your plan for them?

11. What conversations are you avoiding right now?

12. What do you wish you had more time to do?

13. What things are you doing that you would like to stop doing or delegate to someone else?

14. If you were hired to consult with our company, what would you advise?

15. If you were competing against our company, what would you do?

16. What threatens your peace? What threatens the business? your health? your personal fulfillment?

How would *you* answer these questions? How might your teammates answer them? Questions 14 and 15 are particularly effective in inviting a reluctant individual to open up and share his or her ideas.

A Secret Rule

I give myself a secret rule during all Mineral Rights conversations. In fact, when I demonstrate a Mineral Rights conversation with a volunteer, I give the following instructions to those observing:

> *During this conversation, please write down two things:*
> *First, see if you can identify the secret rule I give myself in order to accomplish the goals of the conversation, which are to interrogate reality, provoke learning, tackle tough issues, and enrich the relationship.*
> *Second, note any questions you would have wanted to ask our volunteer if you were having this conversation with him or her.*

Throughout the conversation, observers write lots of questions, many of which could have been useful. In trying to identify my secret rule, they note "techniques" (I put the word techniques in quotation marks because when you master the courage and skill required for fierce conversations, you no longer consider any part of your behavior to be a technique; everything you do is natural and vital) such as these:

- You helped him identify and focus on the real issue.

- You didn't get sidetracked by rabbit trails.

- You took him deeper and deeper into the issue until you found the core.

- You maintained eye contact; your eyes never left his face.

- You weren't distracted by anything else going on in the room.

- You mirrored his body language. *(While I don't do this deliberately, sometimes it just happens.)*

- When he got emotional, you didn't rescue him.

- You nodded and made sympathetic sounds indicating empathy.

- You didn't offer advice, even when the solution seemed obvious.

- You used silence powerfully.

All of these are accurate observations; however, rarely does anyone recognize that my secret rule is . . . *questions only.*

Until the person I am with has answered the question in Step 7— *What do you see as the next most potent step you need to take?*—I do not allow myself to make a declarative statement. No cheating. No leading questions such as "Have you considered trying . . . ?"

You will be mightily tested. Most people don't do well here. What most of us do when someone says, "I have this issue, or I have this problem," is jump in with: I have this solution, or I have this point of view about your issue. We are eager to show what we know, to demonstrate our value to our coworkers, clients, and family members. So we leap in with suggestions, stories about our experience, quotes from the latest articles on business. After all, we want to be helpful! And we don't notice that our companion's eyes have glazed over.

A common experience you've no doubt had is the conversation that begins with you telling someone about something you are grappling with and before you've even finished the story, the other person says, "I know what you mean. About three years ago . . ." And they're off and running. In a matter of seconds, this conversation shifted from being about the coachee to being about the coach.

When that occurs, what happens to your interest level? How do you feel about the person who is now regaling you with his or her story? Not good, right? And let's face it: You've done this yourself. We all have.

Don't take the conversation away from others and fill the air with your stories.

If my "voice" seems to have taken on a bit of an edge here, you're not imagining it. This practice of taking the conversation away from other people and making it about ourselves goes on all day, every day, and is a huge relationship killer and a waste of time. Nothing useful happens here. Even if your story is riveting, don't tell it until your companion has answered question 7 (What's your next step?), by which time you may conclude that the story you wanted to tell is not relevant.

The point here is to draw others out with good questions and incredible listening on your part. If you can't do this, it's unlikely that you will build deep relationships. So leave your expert, storyteller, fix-it hat at the door. Come into the conversation with empty hands. Bring nothing but yourself.

> **Come into the conversation with empty hands.**

It is likely that your boss, valued customer, key employee, or family member will come away from this conversation feeling furthered in his or her life somehow, sensing that his or her world of meaning has been expanded, and most decidedly looking forward to another conversation with you.

A few days ago one of our trainers took a close friend through Mineral Rights. He sent her this text: "I was knotted and inert and now feel untangled and light. Thank you!" Not bad for a single conversation.

A fierce conversation is not about holding forth on your point of view, but about provoking learning by sitting with someone side by side and jointly interrogating reality. The goal is to expand the conversation rather than narrow it. Questions are much more effective than answers in provoking learning.

And even when you're not using Mineral Rights, at least once a day, let a conversation truly be about someone else.

Mole Whacking

I'd like to conclude this chapter with a marvelously useful method of ensuring that your direct reports will choose well when they tell you

what they would like to talk about during a Mineral Rights conversation. This requires that I tell you about my brother, Sam.

In our teens, Sam and I had Saturday chores to attend to before we could do as we pleased. Sam's responsibility was to tackle the mole problem in our yard. Each Saturday morning Sam would look out the window and heave a sigh. Our yard was mole central. Dozens of trails ended in large mounds of freshly turned dirt.

Resolute, Sam would head out the door to do battle. Sometimes he would use the hose, shoving it as far down into the burrows as possible. There would soon be rivulets of water running throughout the yard. Another approach was to stuff foul-smelling smoke bombs into the burrows, after which our yard resembled a fantastic galactic landscape riddled with active volcanoes spewing toxic fumes. And then there were traps. In one battle plan, a mole would trigger the trap, whereupon it would be skewered. I didn't like to think about that one.

Sam devoted many Saturday mornings to mole whacking. He took his job seriously. However, when the day came for him to move out on his own, Sam admitted that the only dead mole he ever saw had clearly died of old age.

Many years later, Sam called me and said, "Suze, you won't believe it. I was at the hardware store standing in line behind a guy with a big bag of something that had a skull and crossbones on it. I asked him what it was for and he said, 'The mole problem.' So I asked him, 'How do you get that stuff down into the burrows?' And he said, 'Oh, it's not for the moles. You sprinkle it on the grass and it kills the grubs that the moles eat.'" (Pretty sure this was environmentally irresponsible, but we didn't know much at the time.)

There was a moment of silence on the line, and then I overheard a faint: "Damn!"

As I chuckled, Sam continued. "If I had gone after the grubs, I could have spent Saturdays riding my bicycle. The thing is, I'm still whacking moles. It's what I do all day at work. And I'm good at it, an enthusiastic and capable mole whacker. Almost every morning I wake up weighed down with the items on my lengthy to-do list. So I come to work early, determined to make progress, to get that one thing that's nagging me handled, only to find someone leaning in the doorway of my office, holding a mole, saying, 'We've got a problem, boss.'

"'Okay,' I say. 'Put that problem on my desk and let me take a whack at it.' Half an hour or an hour later, that person drags the mole out of the office. Just when I think, 'Now I'll focus on my top priority,' the phone rings and it's somebody else who essentially says, 'Boss, I got a mole here I need to run by you.' By four in the afternoon, when the last sorry mole has been carted out of my office, I'm running on fumes. I couldn't have an original thought if my life depended on it, and I still haven't tackled item number one on my own to-do list. This is the stuff of my days. And this is a problem!"

Sound familiar? Behind one mole is another one. For many of us, mole whacking seems to be the stuff of our professional lives. And let's face it: In a way, mole whacking is kind of fun. It's satisfying when people turn to you to whack moles for them. After all, you've gotten this far in your career because you're known for your mole-whacking skills. You are a world-class mole whacker! Besides, if you are no longer a mole whacker, who would you be? What would you do?

So we continue whacking moles and by midafternoon we are exhausted, having expended precious energy flailing around on the periphery, in the margins, rather than identifying and tackling core issues: the grubs that attract the moles.

What's important to understand is that leaders devoted to mole whacking are frozen in place professionally, as are the people who report to them. They aren't spending enough time on the issues with their name on them and those who report to them aren't growing because they've gotten into the habit of asking their boss to do all the thinking. They're both stuck.

Whenever we work diligently, and possibly brilliantly, to advise others concerning decisions in which they are involved, their internal reaction may well be "This is great. She's doing the work, coming up with all the ideas. I'm off the hook. And if her idea bombs, well, it wasn't mine, so I'll still look good. The bonus is, I'm not putting myself or my own ideas at risk. I get to stay safe."

This conscious or unconscious internal response is incredibly expensive both for the organization and for the individual. Trying to build leaders by regularly exposing them to your brilliance guarantees a lack of development. You will not have allowed anyone around you to show

up with solutions outside the reach of your own personal headlights. If your employees believe their job is to do what you tell them, you're sunk.

If your employees believe their job is to do what you tell them, you're sunk.

Make it your job as a leader to give up mole whacking and take up grub hunting—stop wasting energy on small problems, instead look for the overarching challenges in your company that allow these small problems to happen in the first place. Implementing the Decision Tree outlined below will help you accomplish this important transition.

The Decision Tree

When employees have clarity about which decisions are truly theirs, personal accountability increases. They know what they "own" and want to get it right. And what they "own" is no longer a mole *you* need to whack, which is a very good thing.

To provide clarity for me when I was promoted to a management role in my late twenties, Jeanne Knutzen, the president of the company I worked for, took me through this exercise. She drew a rough sketch of a tree and said:

> *Think of our company as a green and growing tree that bears fruit. In order to ensure its ongoing health, countless decisions are made daily, weekly, monthly. Right now in your development, you have a good history of making decisions in these areas [we reviewed those areas]. So let's think of these areas as leaf-level decisions. Make them, act on them, don't tell me what you did. Let's make it our goal to move more decisions out to the leaf level. That's how you and I will both know you're developing as a leader and increasing your value to the company. After all, anything that's a leaf for you does not require my attention, which frees me up to focus on other things.*

She pointed to her sketch of the tree and explained four categories of decisions.

Leaf Decisions:

Make the decision. Act on it. Do not report the action you took.

Branch Decisions:

Make the decision. Act on it. Report the action you took daily, weekly, or monthly, as appropriate.

Trunk Decisions:

Make the decision. Report your decision *before* you take action.

Root Decisions:

Make the decision jointly, with input from many people, perhaps from a Beach Ball conversation. These are the decisions that, if poorly made and implemented, could cause major harm to the organization.

Here's a visual . . .

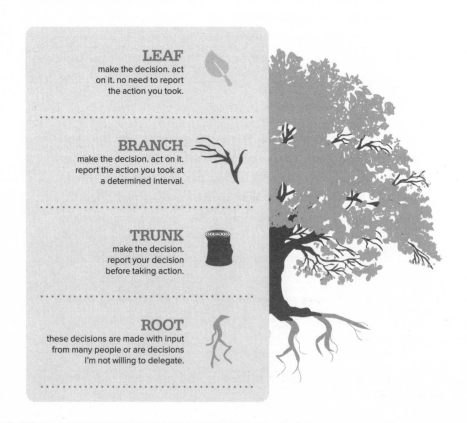

LEAF
make the decision. act on it. no need to report the action you took.

BRANCH
make the decision. act on it. report the action you took at a determined interval.

TRUNK
make the decision. report your decision before taking action.

ROOT
these decisions are made with input from many people or are decisions I'm not willing to delegate.

The analogy of root, trunk, branch, and leaf decisions indicates the degree of potential harm or good to the organization as action is taken at each level. A trunk decision isn't necessarily more important than a leaf decision. Poor decisions at any level can hurt an organization, but if you unwittingly yank a leaf off a tree, the tree won't die. A leaf decision will not kill the tree if it is poorly made and executed. A wrong action at the root level, however, can cause tremendous damage.

As an independent person who does not enjoy having someone looking over my shoulder, I thought I had died and gone to heaven when the Decision Tree clarified my professional development path. I knew I was progressing when I found myself making more and more decisions without Jeanne's input.

The goal of the Decision Tree is fourfold:

1. To identify clearly which categories decisions and actions fall into, so that an employee knows exactly where he or she has the authority to make decisions and take action.

2. To provide employees with a clear upward path of professional development. Progress is made when decisions are moved from root to trunk to branch to leaf. As an employee demonstrates a track record of making good decisions in the trunk category, for example, it will be satisfying to both the employee and the person to whom she reports when those decisions can be moved to the branch category.

3. To raise the level of personal accountability without needing to say (or worse, threaten), "I'm holding you accountable."

4. To assist companies in consciously developing grassroots leadership within their organizations, freeing up executives to take on more challenging responsibilities themselves. A direct outcome of using the Decision Tree is that learning is provoked—one of the purposes of a fierce conversation.

This is a great way to tell people where they are free to play and how they can grow, providing frequent opportunities for them to bring their own brilliance to the fore.

Best of all, if you follow the Decision Tree model, members of your team will take on more responsibilities and your own to-do list will shrink.

She who has the shortest to-do list wins.

And in case you haven't noticed, she who has the shortest to-do list wins. At a GE plant, managers were told, "You have six months to teach everyone who reports to you to get along without you." The goal was to free up managers' time so they could tackle emerging opportunities. Marvelous. Give people information and a goal; let them figure it out. The Decision Tree will help you do this.

I particularly celebrate when a leader at Fierce is ready to take on trunk-level decisions because:

1. They don't come to me until they've thought something through, done the research, and formulated the decision they favor. It can be hard to break the habit of people wandering into my office, wanting to spend time with me thinking out loud, but if the topic/decision is at the trunk level, I can say, "This is a trunk-level decision for you, so though I love you very much, go away and come back when you've made your decision."

2. This frees me up to focus on my own top priorities.

3. I hold our leaders able, versus accountable. (In *Fierce Leadership* I devoted a chapter to the worst "best" practice of holding people accountable.)

4. No action is taken on the decision until it's been run by me, so I don't worry that something bad could happen. While I find that 90 percent of trunk decisions by my leadership team are right on, these are decisions I want to learn about before they're executed. And it's time for serious celebration when a trunk decision is moved to branch or leaf.

Of course, this means that you will need to look at the things you've been doing and assign the moles you've been whacking to others at appropriate levels on the Decision Tree, so that you can focus on the grubs, the really important issues. You may have to give up doing some

of your favorite things, things you do that are important that they be done well.

Assignment

Answer these questions:

- Given your deliverables to the organization, what would be the best use of your time?

- What activities or responsibilities are no longer the best use of you?

- To whom would you like to give these activities and responsibilities?

- At what level? Leaf, branch, trunk?

- By when?

- How much of your time will this free up?

Assignment

Put the Decision Tree to work as a delegation and leadership-development tool for your team. If you have a teenager at home, use it with him or her as well.

To get this started, explain the Decision Tree to your direct reports. Ask each of them to pay attention over the next thirty days to all of the decisions that fall within their responsibilities and to categorize them where they feel they belong—leaf, branch, trunk, or root. Review their conclusions and reach agreement about where each kind of decision falls on the Decision Tree. Remind everyone that the goal is to move more and more decisions out to the leaf level. This is the leadership-development path. Following this agreement, adhere to the boundaries and agreements required. For example, if someone comes to you for help

in making a decision that falls within the trunk category, say, "Come back to me when you've made your decision. Then we'll talk."

Additional Assignments

During the coming week, focus on one conversation at a time. *One at a time.* And be there, in each of those conversations, prepared to be no-where else.

If you create the space, if you offer the invitation, what happens will be new and fresh, and if you are not attached to a specific result, it cannot be a disappointment. You will learn much more about the value of nonattachment in chapter five.

The rare and valuable gift you can give to others this week, and I hope for many weeks and years to come, is to be fully present in the moment. It helps me to remember a cartoon I once saw that shows a wizard sitting behind his desk. A big clock is behind him and each hour says NOW.

NOW. NOW. NOW. NOW.

What time is it? Now. Even your memories are experienced *now.*

Now is the only time you have. What are

What are you dragging into your conversations on your back?

you dragging into your conversations on your back? Put it down. It will wait for you. When you are present in the moment, allowing each conversation to be brand-new, you will be sur-prised. You will find more of the other person. You will find more of yourself.

A REFRESHER . . .

- Whether at home or at work, whether for five minutes or for an hour, give your partner the purity of your attention.

- Take the pulse of the relationship by really asking and really listening.

- Come into the conversation with a beginner's mind. Bring nothing but yourself.

- Use the secret rule: No advice or declarative statements. Questions only.

- Use the Decision Tree to provide your direct reports with clear decision-making boundaries and thresholds and free yourself up to focus on your own priorities.

PRINCIPLE 4

Tackle Your Toughest Challenge Today

The need for change bulldozed a road down the center of my mind.

—Maya Angelou

Burnout happens, not because we're trying to solve problems, but because we've been trying to solve the same problem over and over. Hand in hand with the courage to interrogate reality comes the courage to bring to the surface and confront your toughest personal and professional issues, which often involve an individual whose attitude, behavior, or performance is a problem.

> Burnout happens, not because we're trying to solve problems, but because we've been trying to solve the same problem over and over.

I smiled at a passage in *A Banquet of Consequences* by Elizabeth George: "If Barbara can't find it in herself to work not only as a member of a team but also as an individual whose responsibilities carry the weight of certain behavioural requirements, then she needs to find another line of employment. Frankly, I can come up with several but most of them have to do with sheep and the Falkland Islands and my guess is that lacks a certain appeal."

It is possible that the emperor is, indeed, sans clothing, that a sacred

cow must be shot, that identities will unravel, that forms will break down, that there will be a period of free fall. It is also possible that a conversational free fall is what is needed to help you turn the relationship corner.

"Tell me again," I hear you ask, "exactly why I would put myself through this. Why would I subject myself and others to discomfort, given everything that's on our plate?"

Because what's on the other side of your most frustrating relationships is worth it: relief, success, health, freedom from stress, happiness, a high-performing team, a fulfilling personal relationship.

And because of what's in store for you if you continue to avoid addressing and resolving the tough issues. Think confronting an executive about his or her behavior could be costly? Consider the cost of a good headhunter when this person is finally made available to industry. Think confronting an emotional issue with a life partner is too risky? Ask your divorced friends how long it took for them to regain their sanity. Think this glitch in the organization, caused in part because of someone's mismanagement or ineffective leadership style, is too complex or sensitive to solve? Ask someone whose company failed which of its competitors is still standing and why.

The Undiscussables

Some things are much more difficult to talk about than others. Many business groups and family members operate with an unspoken rule book, including a list of undiscussables, topics that are too risky to bring up. *After all, your last attempt netted you two weeks as the corporate pariah. Or you ended up sleeping on the couch.*

Some topics on the undiscussables list are in the form of quid pro quo agreements. Without discussing it, everyone instinctively understands the deal that has been struck.

- I won't mention your bungling of the Ross account if you won't bring up how many people have left my team.

- I won't complain about how often you miss deadlines if you won't point out that I've missed a few myself.

- I won't yell at you about the credit card bill if you won't go ballistic when I buy a Harley.

- I won't mention your drinking if you don't talk about my weight.

Sometimes we avoid saying what needs to be said because we're sure there will be consequences.

- Are you crazy? Say that to him and he'll hand you your head on a platter!

- She's on a rampage, disappointed with the team. The team's fine. She's the problem. But if anybody tries to tell her that, there will be hell to pay.

You Get What You Tolerate

In addition to the kind of organizational issues that come up in a Mineral Rights conversation, let's take a look at a reality every organization must regularly examine: "What are the skills, attitudes, and talents of our employees, and are there gaps between those resources and what our market demands?"

Several years ago, I sat in on a meeting of managing directors in Edinburgh, Scotland. Once I got past my enchantment with the brogue and could pay attention to the issues being discussed, my thought was: "They have the same issues as the CEOs in Seattle. And London. And Indianapolis. And Sydney. And Chicago. And Vancouver." The common thread—*people.*

When solving problems, producing results, or addressing strategy, we invariably turn to the performance of individual employees. *Do we have the talented people we need to successfully deliver our product or service to our customers?* It's been interesting to note that the vast majority of leaders with whom I have worked—who for the most part are fairly well grounded

in reality—tend to hold out hope that marginal employees will magically transform themselves overnight into high performers.

I don't know about you, but I have not yet witnessed a spontaneous recovery from incompetence. Or a bad attitude. As a leader, you get what you tolerate. I'm reminded of a frustrated client who finally told an employee, "I'm not here to evaluate your performance. I'm here to locate it."

> **I have not yet witnessed a spontaneous recovery from incompetence.**

> **As a leader, you get what you tolerate.**

What's needed is a fierce conversation, perhaps a series of them, followed by relentless follow-through and ongoing support. While some people can't be saved, many can. Most people will comply with clear requests. Perhaps the fierce question leaders need to ask themselves is: "Were my employees dead when I hired them, or did I kill them?"

Have you communicated clearly not only the results but also the behavior that you want? What about attitude? Herb Kelleher, cofounder and former CEO of Southwest Airlines, famously said, "We are prepared, including legally, to fire you for a bad attitude."

Southwest Airlines employees are rarely accused of sleepwalking through the manual; instead, they are known for bringing a playfulness and individuality to their work. How does an airline get this behavior out of its employees? By clearly communicating what is expected and parting company with those who don't meet the bar.

During all of my conversations with Peter Schutz, former president of Porsche, his message was consistent: "Hire attitude. Train skill." Peter was successful in large part because he was clear about the attitude he was looking for at Porsche. The key question is "What attitudes will lead to success in our company?" Follow-up questions are, "To what degree do our employees exhibit these attitudes?" and "To what degree am I and other leaders exhibiting these attitudes?"

In my work with leaders and their teams, I've discovered that a universal talent is the ability to avoid conversations about attitude, behavior, or poor performance. "I take the high road" is often an excuse for not tackling the issue. It is far better to take the *direct* road. Granted, revealing painful truths—our own or others'—is tough. Upon contemplating

a needed confrontation with an individual who, when challenged, had a history of becoming defensive, emotional, and irrational, one client said, "I've always dreamed of selling seashells on the seashore. Maybe it's not too late."

"I take the high road" is often an excuse for not tackling the issue.

If your stomach flips at the thought of confronting someone's behavior, you're in excellent company. It is far less threatening to talk about declining sales than to look straight into someone's baby blues or browns and address the specific behavior that may be causing the decline. Instead, we talk with others over lunch and by the coffeepot about the person whose behavior is driving us mad. It's called triangulating. Person A bonds with person B over their mutual loathing of person C.

Person A bonds with person B over their mutual loathing of person C.

James Newton shared a unique point of view on critiquing others behind their backs. He asked, "How do you housebreak a puppy? Put it in a crate. What's the one thing a dog won't do in its crate? Poop. I sure wish human beings were as smart." Complaining to anyone other than the person with whom you have a problem is like soiling your own crate. If you really want to resolve the issue, go directly to the source and confront the person's behavior one-to-one, in private.

Understandably, many of us fear confrontation because it hasn't gone well in the past. All attempts to date have failed miserably. We don't know how to make it better this time, and the stakes are fairly high. We sense that a monster is lurking in the bushes and today is not the day we are prepared to take it on. Or this is not the hill on which we're prepared to die. Our fears may include:

- A confrontation could escalate the problem rather than resolve it.

- I could be rejected.

- I could lose the relationship.

- Confronting the behavior could force an outcome for which I am not prepared.

- I could incur retaliation.

- I could be laughed at or not taken seriously.

- The cure could be worse than the disease.

- I could be met with irrationality or emotional outbursts.

- I might hurt his or her feelings.

- I could discover that I am part of the problem.

Yet the results of not confronting a problem include:

- The problem could escalate rather than be resolved.

- I could be rejected.

- I could lose the relationship.

- I could lose my job.

- Emotions could escalate until someone blows up.

You get the drift.

The very outcomes we fear if we confront someone's behavior are practically guaranteed to show up if we don't. It will just take longer, and the results will likely occur at the worst possible moment, when we are least expecting it, with a huge price tag attached, and will possibly appear on YouTube.

Repositioning *Confront*

When most people think of confrontation, they picture angry faces, clenched teeth, roiling emotions. This is because of their context about confrontation. For example, let's imagine you believe that dogs are dangerous. The door opens, and a dog walks in and heads toward you. You are afraid. The dog didn't scare you. Your belief scared you. While I don't expect anyone to wake up in the morning thinking, "Oh boy, I get to

confront someone today!", I do want to recast the whole notion of confrontation.

Last fall, on a train from Salisbury to London, I was talking with a young couple sitting opposite me. I shared that I was teaching a session on how to confront and, at the same time, enrich the relationship with the person they're confronting. I mentioned that the word "conversation" was derived from the Latin *"conversare,"* which means an exchange of ideas and sentiments, and that it had occurred to me that the meaning of the Spanish word *"con"* is "with." Therefore, the word "confront" could mean "to be *with* someone, *in front* of something." The young woman said, "My father doesn't have conversations. He has *versations.* I gave up trying to have a conversation with him long ago."

I laughed and winced at this insight, wondering what her father would feel if he heard her words. *Conversation* and *confrontation* both begin with the idea of *with.* The "fierce" version of confrontation is not firing at someone from across the room, but rather sitting side by side, looking at the issue together.

> My father doesn't have conversations. He has *versations.*

If you think about it, all confrontation is a search for the truth, a two-person Beach Ball conversation. Each of us owns a piece of the truth, and neither of us owns all of it.

Before we address how to confront someone whose behavior, attitude, or performance has become intolerable, let's talk about how to possibly avoid this conversation altogether by giving and receiving feedback, face-to-face, staying current with one another 365 days a year.

The Value of Feedback

That promotion you received was not a miraculous event. You earned it one job well done after another. One successful conversation at a time. You are aware of the many things you did over time to get where you are. On the other hand, if your career is lagging or if you've ever been terminated, you probably recognize in your heart of hearts that you

arrived at that negative "suddenly" one poor job after another, one failed or missing conversation at a time. The sad thing is, many people are shocked when they don't get a promotion or are terminated because they truly had not realized things were so bad.

One thing's for sure. When a negative suddenly arrives, we are instantly ON ALERT. It's a bad day if we thought we were doing fine and suddenly learn that our boss, coworkers, or customers see it differently. Now you've got our attention.

> **When a negative suddenly arrives, we are instantly ON ALERT.**

Imagine what it would be like if, rather than waiting six to twelve months for a formal performance review to learn how you're doing ("Wow! I am really excited about my performance appraisal today!" said no one ever.), you knew at all times how you were doing in the eyes of your boss, your colleagues, even your customers, staying wide awake during "gradually." There would be no negative "suddenlys." You'd always be clear about what you were doing well, what you could do even better, and any potentially significant roadblocks to your success. This is the goal and the outcome of feedback and, with it, the end of the performance review as we've known it.

> **"Wow! I am really excited about my performance appraisal today!" said no one ever.**

Sadly, some leaders are still clueless. At Fierce, Nicholas Nelson told me about a former employer, "My last position mirrored some of the worst practices you've talked about. For example, during my six-month performance review, we were asked to rate ourselves, then have our management rate us. The first stage of self-evaluation was when the floor fell out from underneath me. After submitting my review to HR, I was told that I rated myself too high. I pushed back and told them this is how I felt about myself. Second round, same thing. HR said I couldn't submit my review until I brought my score down. Again a pushback. Then the COO e-mailed me saying that even he didn't rate himself as high as I did and I needed to use 'his scores' as a guide on how to rate myself. This went on and on as you could imagine. And when it came time for them to rate me, my immediate supervisor tasked delivering the results to me to a junior level manager and refused to discuss any questions I

had about his report. Talk about making a guy feel good, right? This was just the tip of the iceberg with this company."

Since the first edition of this book was published, a marvelous sea change is under way in the world of performance management. Savvy organizations are shifting the landscape of performance reviews, turning them into face-to-face conversations, some of which are initiated and led by employees. No more anonymous comments and rankings! Instead of chasing metrics, employees are focused on true growth and development. Makes me very happy, although it isn't happening everywhere. I had a conversation with a client this morning about this very topic in preparation for a keynote I will be giving next week. She asked me not to say anything to the thousand attendees about the changes that I'm seeing and recommending because her company would never invite their four hundred thousand employees to decide what gets discussed regarding their performance.

Ah, well, it's a great company that could be even greater. Sea changes don't happen overnight. Crowley Maritime Corporation—a family-owned, third-generation, 125-year-old marine solutions, energy, and logistics services company—is supplementing year-end performance reviews with midyear, employee-driven conversations. Crowley's instructions to employees are:

You decide what to discuss. You schedule the meeting. You lead the conversation.

Crowley suggests that employees choose two or more of the following topics, some of which are from Gallup's Q12 employee engagement index, for their midyear conversations and provides tips for supervisors to listen well and coach employees.

Employees May Share	Supervisors Listen for
I believe I am paid to . . . To help achieve my goals, I measure progress by . . .	Listen to your employee's understanding of what he or she is paid to do compared to what you think or expect.
The things that distract me or get in the way of meeting the responsibilities are . . .	Listen for obvious issues that seem to get in the way of this person doing his or her work better.

Employees May Share	Supervisors Listen for
In the last six months, I've felt conflicted about priorities when . . .	Listen for when and how you need to provide clear expectations about priorities.
The parts of my current role that energize me are . . .	Listen for how close of a fit this person is for their role. Consider adjustments you can make that would better motivate and develop this employee.
I feel my job is important when . . . I add value to our team and customers by . . .	Listen if this employee knows his or her value to the team, organization, and customers. Think of what you can do to make it easy for this employee to maximize his or her individual contributions.
The best recognition I ever received was . . . It was the best because . . .	Listen to the types of recognition that would be meaningful for this employee. Consider timing and how (e.g., public vs. private) this employee prefers to be recognized.

In addition to these statements, Crowley encourages employees to choose at least two questions to ask, such as:

1. Which aspect of my role is most important to the department's strategy?

2. Where could I redirect my focus?

3. When do you seek my expertise? How can I be even more helpful?

4. How do you think we complement each other as partners?

5. What value do I personally bring to my internal and external customers?

6. When do you see me at my best?

The employee-driven midyear conversations are new for Crowley. Going into them, Jennifer Church, director of organizational development at Crowley Maritime, told me, "Not everyone was initially convinced that this midyear conversation was a good idea. There was some reluctance from skeptics." Now that the conversations have been completed, Suz Michel, vice president of organizational development and change leadership, shared, "We will know more when we survey the organization. Right now I have quite a few e-mails where people said that they absolutely loved it. We haven't received any feedback, from supervisors or employees, that folks dislike the process."

Crowley will solicit feedback on what worked and what could work better and will continue to refine what they do and how they do it. And of course, the midyear conversation will not replace ongoing feedback.

The question I put to everyone reading this book is—why has Crowley Maritime turned this important performance conversation over to their employees? Because ultimately, employees are responsible for their own performance, for their own career progression. Or failure to progress. Crowley Maritime's high performance culture focuses on what the company, teams, and individuals should be doing, at all levels of the organization, in order to preserve forward momentum.

I think what some employees might miss is the word "individuals." Yes, your supervisor wants you to succeed, to grow and thrive professionally. But don't sit passively, hoping your boss intuits where you want to go in your career and sees to it that you get there. In case you hadn't noticed, no one, not even your mother, cares as much about your success as you do and this is why feedback is essential. Crowley suggests, "You are the person with the greatest investment in your own development. You have a unique insight about your talents and strengths and how you can best leverage those within your group or company." It's important that you believe in yourself, advocate for yourself, and that you are clear about how others view you. When you get feedback, you need to own the results and then, as Senn Delaney's accountability ladder indicates, "get on with it"!

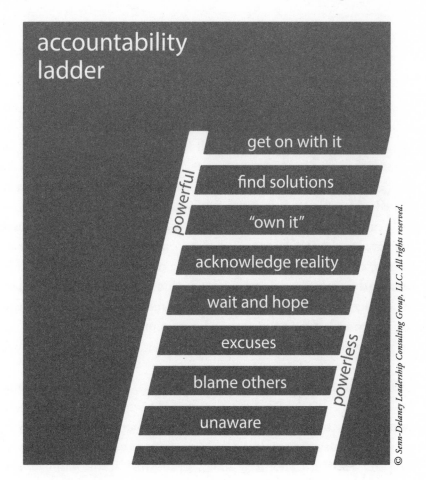

accountability
ladder

get on with it

find solutions

powerful

"own it"

acknowledge reality

wait and hope

excuses

powerless

blame others

unaware

When I consider Crowley Maritime's midyear conversation and ongoing feedback to employees, I am reminded that while no single conversation is guaranteed to change the trajectory of a career, a company, a relationship, or a life—any single conversation can.

It might help to think of feedback as a series of waypoints to keep you headed in the right direction. If you don't receive feedback and adjust accordingly, you may find yourself off track and on your way to a negative "suddenly."

Careerwise, my trajectory was not a straight line through space. It looked more like a winding map, with one-way streets and stop signs . . .

. . . with plenty of help, aka "feedback," along the way, some wel-comed and some resented, even rejected, for example being told by a male executive that I wasn't being promoted into the all-male executive suite because I wanted it too much. Looking back, I see that all of it was helpful, even comments that came from a place of sexism or prejudice, because they helped me understand the mind-sets around me and helped me change minds or change the game. Reality was interrogated, learn-ing was provoked, and I took the next steps on my journey.

Definition of Fierce Feedback

Fierce feedback is a conversation in which we have the opportunity to see what we may not see. It is a small conversation during which much happens. Feedback *done well* allows us to grow, learn, improve, and become more effective in how we work, play, interact, and achieve re-sults because it shines a light into an area we hadn't noticed before. It might be an area in which we excel, an area about which we are clueless, an area we had noticed and didn't wish to acknowledge, or an area we had acknowledged and were unwilling to change because we didn't fully understand what was at stake.

Fierce feedback is a conversation in which we have the opportunity to see what we may not see.

I want to emphasize that feedback should be *face-to-face*. In my second book, *Fierce Leadership, A Bold Alternative to the Worst "Best" Practices of Business Today*, I devoted the first chapter to the hor-rific (in my opinion) practice of anonymous feedback. Here's a brief excerpt:

Feedback is invaluable. It's the anonymous part that gets us in trouble. We're like Woody Allen, who said, "I'm not afraid of death. I just don't want to be in the room when it happens."

It starts early in our impressionable lives—this attraction to anonymity. This hiding. So it's no wonder that, although most organizations *profess* to value openness, transparency, trust, respect *(yeah, yeah, yeah)*, when there are invaluable opportunities for candor, we send in our friend, good old underpaid, overworked "Anonymous," to slip the feedback over the transom and run like hell.

I discovered an ally regarding my view of this "best practice" in Kevin Kelly, the editor of *Wired* and the author of *Cool Tools*. Each year, the scientific foundation called Edge Foundation asks dozens of scientists one provocative question. In response to the question—What is Your Dangerous Idea?—Kevin suggested the idea: "More anonymity is good." He wrote: "

Fancy algorithms and cool technology make true anonymity in mediated environments more possible today than ever before . . . however, in every system I have seen where anonymity becomes common, the system fails. Anonymity is like a rare-earth metal . . . a necessary ingredient in keeping a cell alive, but the amount needed is a mere hard-to-measure trace. In larger doses these heavy metals are some of the most toxic substances. In vanishingly small doses, it's good for the system by enabling the occasional whistle-blower or persecuted fringe. But if anonymity is present in any significant quantity, it will poison the system . . . Trust requires persistent identity. In the end, the more trust, the better. Like all toxins, anonymity should be kept as close to zero as possible."

> Like all toxins, anonymity should be kept as close to zero as possible.

Well said! Just look at the most common definitions of "anonymous" in dictionaries.

a.non.y.mous
adjective
* not identified by name; of unknown name: *an anonymous phone call*

*having no outstanding, individual, or unusual features; unremarkable or impersonal: *a faceless, anonymous group*
*used in names of support groups for addicts of a substance or behavior to indicate the confidentiality maintained among members of the group: *Alcoholics Anonymous, Debtors Anonymous*

In what universe would anonymous feedback, anonymous *anything*, be considered a best practice? No one I know wishes to be unremarkable, impersonal, faceless, or unknown—and it would be difficult to argue that anonymity enriches relationships or strengthens connection with others. The fact is that anonymous feedback rarely creates real or lasting impetus for change, which is crazy because the whole idea is to encourage professional growth.

> In what universe would anonymous feedback, anonymous *anything*, be considered a best practice?

Most commercials for the latest, greatest drugs include the warning that side effects can include loss of vision, muscle spasms, internal bleeding, uncontrolled barking (okay, maybe not that), and sudden death. The warning for anonymous feedback should read: "Not to be used within organizations that value honesty, transparency, or openness or by anyone who views 'authenticity' as a desirable character trait. Side effects can include a culture of terminal niceness, avoiding or working around problem employees, tolerating mediocrity, beating around the bush, dancing around the subject, skirting the issues. If you experience rapidly deteriorating relationships or have difficulty maintaining eye contact with others, call your doctor immediately as these may indicate a serious problem and could become permanent."

You are better than this. So are the people around you. So let's get good at this thing called feedback. Giving it, asking for it, receiving it, face-to-face. Through these conversations, you can:

- Get your manager's perspective on how to achieve your goals

- Set priorities

- Realign goals and expectations according to business changes

- Share what you're most proud of and what makes you passionate about work

- Discuss obstacles or barriers you encounter

- Talk about what you appreciate and what you need from your supervisor

- Talk about a skill you want to gain or a role to which you aspire

- Gain awareness about performance or attitudinal shifts that need to be made

Sounds important, right? Then why isn't this happening as often as it should? It's our context that causes us to hesitate. It seems we don't give feedback because:

- We connect "feedback" with criticism, forgetting that feedback can be positive.

- We are worried about how it will be received.

- We don't want to hurt people's feelings.

- We've been given little or no feedback ourselves, so it doesn't occur to us to expect or provide it.

- We don't care enough about the person to offer guidance.

- We don't know how to give feedback in a way that it lands, is helpful, useful, and enriches the relationship.

- We think people already know how they're doing.

- We haven't been asked for feedback . . . which brings us to . . .

We don't ask for feedback because:

- We expect "feedback" to be negative.

- We are afraid we might not like what we hear.

- It doesn't occur to us to ask for feedback.

- We think we're doing great.

- We are pretty sure we are not doing well and hope to avoid confirmation.

- We think we can tell how we're doing by the expression on others' faces or other cues.

While all of this is understandable, it is also puzzling because if I asked you what you would want your boss to do if he/she thought you were doing a great job, you would say, "Tell me!" Right? And if I asked what you would want your boss to do if he/she thought you were doing a poor job, you would say (at least I *think* you would say), "Tell me!" Even if it would be hard to hear. You can't fix a problem you don't know about!

So how and when should feedback be given? This chart may be useful in determining which situations warrant a confrontation, which I'll address later in this chapter, and which simply require some feedback:

Feedback	Confrontation
It's never happened before and I don't think they were aware they did it.	There is a pattern of similar behavior. I've said something and nothing is changing or it is not changing quickly enough.
I see a pattern that could become a problem later on for the person and feel compelled to share it with them so that they have an opportunity to course correct.	The individual has done something and even once is too much.
Happened once—I do not necessarily have an expectation they change, but rather I want to make sure they see it from my perspective.	Keeps happening and now it is affecting our relationship, ability to work effectively together, and/or our results.

Feedback	Confrontation
A mistake was made and it's important to share insights on what could have been done better.	Mistakes keep being made and there is an underlying issue that needs to be corrected to prevent further, unanticipated mistakes.

Giving Feedback

Feedback should be easy to give, but it rarely is. When we recognize that we need to give feedback to others, especially giving feedback "up" (to our boss, for example), it can feel dangerous. *Might I be made available to industry if I give my boss this feedback?* The most important thing to consider if you feel uncomfortable giving feedback is that you need to make effectiveness more important than comfort.

Feedback, like all fierce conversations, is a conversation in which we come out from behind ourselves, into the conversation, and make it real; therefore, interrogating reality is an essential part of feedback. There are multiple, competing realities about someone's performance, behavior, or attitude. Before giving feedback, contemplate *your* reality. Is your interpretation of what you saw or heard accurate, or could there be a different interpretation?

As I said in the previous chapter, we make up stories about people and then behave as if our stories are true. On the one hand we can celebrate the creativity of our imagination. On the other hand, we can look at disasters that resulted from getting it wrong. The point is, we can make ourselves believe anything that suits us, even if it only suits us because it proves us right about something that makes us miserable.

> **We make up stories about people and then behave as if our stories are true.**

Oh, the Stories We Tell . . .

Have you ever given feedback about something that happened differently from the way the other person saw it? I have.

I am in a meeting with colleagues. Jane begins to share her idea about an upcoming project and a colleague, Steve, leans back in his chair and yawns. When Jane asks if anyone has questions during the meeting about this idea, Steve stays silent and doesn't make eye contact with Jane. Based on this observation, I've decided to give Steve feedback on his overtly rude behavior. After I tell him what I observed and that he was being rude, he tells me that he liked Jane's idea. This does not match my opinion, belief or attitude about what I witnessed. I don't believe him . . .

He explains that he had no questions because Jane presented her idea thoroughly.

This, too, does not match my opinion, belief or attitude about what I witnessed. I don't believe him . . . Besides, I heard from someone else at that meeting that Steve didn't seem to like Jane's idea because they saw him roll his eyes when she was presenting her plan. This makes perfect sense to me because I knew this all along! I knew I was right!!

But could there have been some other explanation for Steve's behavior? As you will discover, the mistake I made was, "If I can see it, surely you can see it too and there is only one possible interpretation!" I made assumptions based on my observations and assumed that my interpretation was rock solid. I mean, after all, I am intelligent, insightful. I assumed my perspective was the truth rather than just my perspective.

Maybe I should have begun this conversation by simply describing what I observed from a factual perspective, rather than labeling his behavior rude and assigning meaning to his actions. Then letting him tell me what was going on. The following guidelines may be useful.

Begin the conversation by providing some context for this feedback. *When, where, what.* Then ask for their perspective. The trajectory of constructive feedback goes something like this:

"I want to give you the benefit of something I saw that you may not have seen. In the meeting this morning, I observed . . . What was going on?"

For example . . .

WHEN AND WHERE?

Describe the situation that took place that is prompting the feedback. *When* did it happen? *Where* did it happen? This allows the other person to begin to visualize the time and place you are referring to.

> *"Yesterday in the team meeting . . ."*
>
> *"Last time we went to lunch together . . ."*
>
> *"When you were presenting your plan at the board meeting last week . . ."*

WHAT?

What did you see? Describe what happened or what they did just like a video camera would capture it, without using loaded words. *What* did they do or say that you feel is important to give them feedback about? *What* did you observe?

> *". . . you appeared to be focused on something else while Jane was talking about her project. When I asked you a question, you weren't able to answer it and asked to have it repeated."*
>
> *". . . you took a call during lunch while I was talking with you."*
>
> *". . . I noticed you used some tentative language, such as 'kind of' and 'sort of.'"*

After you set the stage with the subject you want to talk about, *before* you share your interpretation of their behavior, ask what their perception is.

Let's imagine Jan is the person who used tentative language. She may already know it didn't go well and may have a perspective about her behavior, actions or results that is more insightful than yours. Certainly, it helps Jan save face if she already knows. This is your opportunity to allow her to process and, in a sense, give herself feedback before you launch into yours. This allows you to confirm Jan's self-feedback

and/or for you to learn more about the situation than you knew coming into this conversation.

But what if Jan doesn't seem to know what you're talking about or didn't see the problem? Now it's time to briefly (let me emphasize "briefly") describe the impact for her, for you, and/or others. *Why* you are having this conversation with Jan. Why this is important. The implications of this behavior. This is an important part of this conversation and one that often gets left out. You are letting Jan know why you were compelled to talk with her about this. You could say . . .

"At times, it appeared as though you weren't certain about your ideas and presentation. You are talented and your ideas are terrific. You've shared your career goals with me. Using more definitive language will help you appear to be more confident and allow others to hear and appreciate your ideas more fully."

What about Steve, who yawned and rolled his eyes in a meeting when someone was speaking? You could say, "This gave the impression to me and possibly to others at the table that you were not interested in Jane's project or in the meeting. It is important for me that we treat each other with respect. I have been careful to make sure our meetings are interactive and I have been mindful of making certain they are short and to the point. I was surprised that you seemed to be distracted and not fully present at the meeting or listening to Jane."

Or the person who took a call when he was talking with you.

"It felt to me, in that moment, that this call was more important than our face-to-face conversation. I was bothered by your decision to take the call while we were talking because I value the little time we get to spend together."

EXPLORE.

Before you say more, explore their point of view about what you just shared. It can be as simple as asking, "Can you tell me what was going on?" They may give you a perfectly reasonable answer, which lets you know it's not a problem that's likely to occur again. *I learned that Steve was asleep on his feet because he and his wife had been up all night with their colicky newborn.* Or they may acknowledge the misstep and apologize. On the other hand, they may be shocked or surprised, even angry.

They may be triggered by your feedback and move into a "fight or flight" reaction and deny, defend, or deflect.

- They may **deny** it happened. This is not uncommon when someone doesn't realize something that they did. We may learn about something we said or did and have no recollection of it. For example: "I was paying attention in the meeting. I don't know what you are talking about."

- They may **defend** their perspective or point of view by justifying why they did what they did. Listen carefully. This is often a place where *your* learning can be provoked. For example: "I had a call to make after the meeting that was really important, so I felt I had to mentally prepare for that instead."

- They may **deflect** in order to change the subject or get the focus off of them. For example: "I was no more distracted in that meeting than anyone else."

Try hard not to go there with them—don't argue or try to prove that your perception and point of view are the correct ones! Instead, if you are faced with someone who is denying, defending, or deflecting, continue to ask questions and discuss openly the impact of the issue at hand for the person, for the team, and/or for the organization.

Even when our interpretation of what we observed is correct, how we deliver the feedback doesn't always land well. We've all heard, "Feedback is a gift." This is often true, and yet most of us have received feedback that felt more like a bad mood looking for a place to land. Or it felt like undeserved criticism—the opposite of a gift. If you are the gift giver, there are questions to ask yourself before you proceed:

If I were to receive this "gift," what might I feel? Is this the right gift, the best gift, or the right timing for this gift? All good things to ponder to ensure your feedback is well received . . . and not returned to the store or even "regifted" to *you* perhaps.

What is my intention? An objective of every fierce conversation is to enrich the relationship. With this in mind, is your feedback valid, honest, well timed, and focused on helping the other person improve? Or, are you giving this feedback to show how right you are and how wrong they are? If you received this feedback, would it feel like a gift, or an attack?

Am I making assumptions about this person and their abilities, decisions and/or behaviors that might be incorrect, off base? What are the facts of the situation as you know them? Where would you find out more if you need to, prior to having this conversation? If you are unsure, or can't know for certain until you talk with this person, then frame your feedback as a perception rather than a fact.

Have I set realistic goals with this person? Am I asking for something that is not realistically possible? Tunku Abdul Rahman Putra wrote, "Some people think that as soon as you plant a tree, it must bear fruit. We must allow it to grow a bit." If the time frame or goals are not realistic, your feedback has the potential to be detrimental and create an environment where people are not able to feel effective and engaged on the job. For example, if you have insisted that you approve all the final drafts of a project, but you have been in back-to-back meetings or out of the office for the last several days and an assignment is late, is it realistic to give feedback on the tardiness of the project? Or, could you just acknowledge that the deadline should change or an alternative approval method needs to be explored for the future to allow others to get on with their work when you are tied up?

Have I laid out my expectations in clear and direct terms? Are you consistent in your expectations? Are you giving feedback today about something you gave a different direction for yesterday? Did you give vague instructions with the assumption that they should know what you were asking? If so, you can still give feedback; just make certain you acknowledge that you did not give clear expectations. I have a tendency to mess up here. When I tell someone I'd like something to be done ASAP, I mean TODAY. But they could interpret ASAP to mean as soon as they can get around to it, given their To-Do list, which could be a week from today.

The receiver is ultimately in control here. You may do everything well, respectfully and thoughtfully, and they may hear or perceive something you had not intended or did not mean. Or they just might not agree with you. This is why diving into exploration and the desire to fully understand their perceptions, thoughts, and feelings is essential.

As you wrap up the conversation, determine what, if anything, needs to change (on both your parts, if appropriate). Paraphrase and check perceptions to be sure you are leaving the discussion on the same page.

It may seem that this would be a long conversation, but it usually isn't unless the person to whom you're giving feedback is in complete denial about what they did and/or why it's important enough to merit feedback. If that's the case, hang in there, take a deep breath, and ask questions!

Receiving Feedback

Receiving feedback gracefully is one of the hardest things to do. We want to be liked. We want to appear as though we are competent in everything we do. When we learn we have behaviors that need correcting, it often takes us by surprise and can be difficult to hear.

For example, have you ever received a gift that made you wonder what the gift giver was thinking when they purchased it for you? I'll never forget opening the Christmas present my mother mailed to me when I was a young mother. My family watched as I lifted the lid of the box. My smile turned to confusion. In a quavering voice, one of my daughters asked, "What is it?" I wondered if we'd need to feed it, hang it on the wall, or return it with a note. *Did you mean to send me a box of compost?* Turns out it was a sweater, hand-knitted by my mother, unique in the world. It resembled a nest of twigs, leaves, and various detritus from the forest floor. It was oversized, camouflaged. I could have camped out in it. The only person who I could imagine wearing it is my favorite wizard, Radagast the Brown from *The Lord of the Rings*, whose hair is literally a bird's nest. I never wore it in public but came to love it because my mother made it.

Feedback can be like that. I think at times we all receive feedback that doesn't resonate with us right away. *I'm not like that!* Sometimes the

feedback can be off the mark. *I am REALLY not like that!* Other times we receive a gift that we never would have bought for ourselves and it turns out to be one of the best gifts we receive. I confess that it often takes me a while to recognize the truth in feedback I've received. I may be appalled and offended in the beginning, yet over time I see the value.

Even when the delivery is off-putting, the question to ask yourself is, "Have I ever received feedback like this before and ignored it? Maybe there is something to this 'gift' that I need to take a second look at."

You, the receiver of feedback, are in the "driver's seat" regarding whether you will hear, believe, incorporate feedback, and even thank the person for talking with you, or stash it in the trash as undeserved or unimportant.

Think about a time when you received feedback you weren't expecting. What did you feel in the moment? Angry, offended, surprised, unjustly accused, unfairly judged, afraid of where this conversation was going?

We take feedback personally, because it *is* personal. When someone giving us feedback says, "It's just business," we know that's not the case because our work identities are intertwined with ourselves, the whole person. We feel vulnerable—almost like a clam without a shell. And we often clam up. Ego is a powerful thing. When we are given feedback we were not expecting or that may be embarrassing for us, our ego can prevent us from hearing this feedback or assimilating it in order to make changes. So let's focus on how to receive feedback.

> We take feedback personally, because it *is* personal. When someone giving us feedback says, "It's just business," we know that's not the case because our work identities are intertwined with ourselves, the whole person. We feel vulnerable—almost like a clam without a shell.

Receiving feedback effectively doesn't mean you have to believe every bit of the feedback you receive. Instead, receiving feedback effectively means you enter into the conversation and explore the feedback together, with an open mind. By staying present and asking questions, we are truly tackling a tough challenge in the moment. We can enrich the relationship by leaning in, getting curious, and asking clarifying questions so that we more fully understand the feedback.

This is often surprising for the feedback giver and creates a positive cycle of giving and receiving feedback between both of you.

But receiving unsolicited feedback can be tricky. It's much easier to be prepared when we solicit the feedback, much harder when it arrives uninvited. If you have advance notice, come prepared. If you have data or information that you can use to explain or support your perspective, bring it. Focus on leaning into the feedback and come with a curious frame of mind. Listen carefully, without interrupting, to what is being said (and how it's being said). If it feels too general, vague, or inaccurate:

- **Ask for clarification and examples.** *Can you provide the specific details that led to this feedback? When did it happen? Where did it happen?*

- **Explore the feedback giver's perspective.** Don't just assume you understand exactly what they mean when they tell you something. *How did you interpret what happened?*

- **Listen to the specifics in the feedback.** What is the giver trying to convey? Is this a current situation, or has the giver been sitting on the feedback for a while?

- **Let them finish their thoughts.** Work to not get defensive. Focus on trying to understand.

- **Check your context.** Are you making assumptions about the other person and their motives? If you feel there is a motive, check it out. *Can you clarify your goals for this conversation?*

- **Present your thoughts without defense or blame.** Use data and facts, if possible. Offer your perspective with an intent to enrich the relationship while coming out from behind yourself into the conversation and making it real.

- **Take responsibility for the impact.** Even if the impact was not your intention, accept your part in it. Apologize if needed and appropriate.

- **If you get triggered, admit it.** You can ask to stop the conversation and come back to it later if you need time to calm down and collect your thoughts.

- **Paraphrase what you heard and discussed.** Clearly articulate what you have learned from the feedback. You don't have to decide anything right now—just listen. If you need time to process the feedback, let them know and make certain you follow up. Sincerely thank them for giving you the feedback, if you are able.

- **Commit to action in the areas you wish to change and ask for support.**

People who respond well to feedback tend to be looked upon favorably within their organizations—they are judged to have higher emotional intelligence and seem to be genuinely interested in learning and improving. These are welcomed traits in any organization. The bottom line is, most people's perceptions of themselves and how they come across often look very different from how they are actually received and perceived by others. If you want to work harmoniously with people around you, learn to receive feedback with curiosity, grace, and gratitude.

What If You're the Boss?

The higher up you are in the organization, the more removed you are from receiving regular feedback about how you are doing. In fact, many leaders think that because they've been promoted, they must be "fully formed." Hardly. If you operate in a feedback-free zone, you may be unaware of how your leadership style is affecting your teams and the organization. This is why many leaders are surprised, even shocked by the feedback they receive on a 360-degree anonymous feedback survey. They may wish people had told them how they felt, but early in life we learn not to criticize our parents, our teachers, our bosses. We are hardwired this way. So, if you are asking your employees for feedback—you are asking them to go against their "wiring," so to speak. Realize this is

a lot for them to overcome. Your employees may be testing the water for quite some time until you've shown them through your words, tone of voice, and actions that you really do want to hear what they have to say. As a leader, you have one chance to get this right. If you push back or get defensive, chances are you may never get feedback again. Your job is to remain curious and grateful for whatever you get in order to pave the way for more meaningful feedback once trust has been built.

Here are suggestions for how to go about it:

Define the scope. What specifically do you want feedback about and why?

> *Example: "What feedback do you have for me that will help me become more effective in how I lead our team meetings?" or "What feedback do you have for me that will help me improve how I work with you and your team on this project?"*

Be prepared to listen and learn. Don't ask if you are hoping the person will only give you positive feedback. Realize you may not get the truth, the whole truth, and nothing but the truth. Listen for what is not being said. People may dip their toe into the water to make certain it will be "swimmable." Don't shoot it off.

Remain curious. Ask questions and paraphrase for clarification. Explore the feedback giver's perceptions without getting defensive. Ask for clarification, if need be, in order to more fully understand. For example:

> *"Is there anything about the way I lead the team that is getting in the way of us achieving even better results?"*

If you find yourself getting triggered, let them know and immediately thank them for their candor. For example:

> *"Wow, I wasn't expecting to hear that. I am quite surprised by this. Thank you for sharing it with me. I will have to take some time to process it."*

Demonstrate a willingness to consider. Don't defend yourself. If you want feedback you must accept what others tell you as their perception, their context of you and the situation. You obviously don't have to do anything with the feedback. But if you ask for feedback and do nothing, it's often worse than had you not asked for feedback at all. It feels like the illusion of inclusion.

Say thank you. Giving you feedback feels like a dangerous and risky thing for the person you are asking. Recognize the difficulty and thank them for their courage. Show your gratitude even for the smallest bit of feedback. This will more likely bring better, clearer, and more direct feedback in the future.

Follow up. Set up a method to follow up if necessary. Check back in on your progress to be sure you are still on track.

> *"I know what I need to do. Please let me know how I'm doing going forward. Okay?"*

Assignment

Take a few minutes to reflect and answer the following questions:

- From whom on your team would you most like to receive feedback and why?

- What specific feedback would you like to receive? How are you hoping that feedback will benefit you, your work, your results?

- Who would you least like to receive feedback from on your team? Why? What are you afraid you might hear from them?

- How soon can you schedule these feedback conversations?

Giving Positive Feedback

If your recognition program occurs once or twice a month and is called a paycheck, your relationships are likely diminishing one missing conversation at a time. Feedback can and often should be *positive*, reinforcing behaviors and attitudes that lead to success.

Think about a time when someone gave *you* positive feedback.

> *"I was impressed with the way you responded to those who challenged your thinking in the meeting this morning. You weren't defensive. You didn't interrupt or make a face. You answered questions and explained your thinking. Grace under fire. Well done!"*

> *"I overheard you talking with a customer who was upset. At first I thought we might lose that customer, but you handled it so well, I don't think we will and that's a big deal."*

> *"Kyle told me you took the time to help him prepare his presentation for the meeting tomorrow. It's great that you did that and I've noticed that you are always willing to chip in when needed. Consequently, I suspect people in your department would do anything you asked of them. I hope that feels as good to you as it does to me."*

Pretty terrific, right? And you were probably intent on doing more of the same, so if you haven't praised anyone lately, get on it! If it occurs to you that *you* haven't received any positive feedback for a long time, ask for it. While asking for positive feedback may seem awkward, have fun with it. "To ensure that I'm prioritizing my activities correctly, what's the one thing I am doing or have done that you value the most?" Once you get an answer, ask, "Tell me more! What else?" You'll both smile.

As a leader, part of your job is to consistently let people know what they are doing well to reinforce those positive behaviors and to build emotional capital.

Positive feedback makes work more enjoyable and more productive. It should be given freely and regularly by all members of an organization

or team. With that said, there is no replacement for the positive feedback of a leader—it carries a lot more weight and has the ability to leave a long-lasting, positive emotional wake.

Before you give positive feedback, make sure you can clearly articulate the specifics of the feedback. Like constructive feedback, it shouldn't be vague. Begin just as you did when delivering constructive feedback: by setting the stage.

When and Where? Describe the situation that took place that is prompting the feedback. For example: "I was impressed with how prepared you were in today's presentation."

This helps set context and allows the receiver to understand the situation that prompted this feedback.

What? Describe the actions with plenty of details.

> *For example: "You came to the meeting with your agenda polished and ready to present, and you also came prepared to answer questions that weren't on the agenda. I especially appreciated how you handled Robin's pushback about the timeline. You were calm and genuinely seemed pleased that she asked the question. I could tell she was happy with the answer you gave."*

Why? Describe the impact and significance for you and others and the potential impact for them.

> *For example: "Your thoroughness and the way you responded to comments and questions reflected well on you and on our department. I am happy to have you on my team."*

Giving positive feedback consistently and meaningfully to colleagues and peers will help you build and maintain an effective team and a stronger working relationship because it reinforces what they are doing that is working. Practice makes perfect.

Just Say Thank You

This is really all you need to know about receiving positive feedback. You will get more of it if you learn to just say thank you. If you want to get really fancy, you can say, "Thank you. That means a lot to me. I appreciate hearing that."

What you should not do: Downplay the feedback. "Oh, that's no big deal. I was just doing my job." Or be sarcastic in your response. "So, you finally noticed that I am a rock star!"

Feedback, whether formal or informal, allows us to share our impressions, to learn where we are being highly effective and where we are missing the mark. Feedback allows us to learn how we are being perceived by others and where we may have room to alter that perception. Feedback is an essential conversation.

When It's Time to Confront

If you've given someone feedback several times *and* their behavior, performance, or attitude is still problematic *and* you have looked long and hard at yourself *and* you are very clear that while you may not be perfect, this issue is "not about me, it's you!", it's time to have a more serious conversation, one during which the problematic employee will come face-to-face with what's at stake. A serious wake-up call, if you like.

Keep in mind that a confrontation is still a conversation. In Spanish, *"con"* means "with." "To confront" means being *with* someone, in front of something. In this case, in front of a behavior or performance or attitude that isn't working. It's an exchange of perspectives and sentiment. The image I hold when confronting someone is that we both have flashlights and a magnifying glass, prepared to explore the issue. I'll begin by shining a light on what I'm seeing and then I want you to look closely and reveal what you're seeing.

Ideally, this conversation is face-to-face, with no desk or furniture of any kind between you. If that's not possible—for example, you're in Dublin and they're in Prague—then use technology that allows you to

see each other. Next best is voice only. Dead worst is e-mail. Do not confront via e-mail! If you do, you might as well get out a bucket and mop because you'll have a toxic-waste spill to clean up. When we confront over e-mail, the person on the receiving end almost always "hears" a tone and intent that didn't exist for us. And they will probably pile on a longer list of messages that they feel we are really saying and what's really behind it. It gets very ugly very fast, and once someone has latched onto their "story," they're stickin' to it. We wonder why the fiery explosion when the e-mail only said . . .

Consider the following real-life incident from *T&D* magazine.

A CEO who thought he saw too few parked cars early and late in the day blasted an angry e-mail to four hundred managers. He complained that the employees weren't working enough hours. An employee forwarded the CEO's e-mail outside the company, and it was posted on Yahoo.com. Stock market analysts and investors found out and were concerned that negative events at the company were behind such an angry message from the CEO.

The *New York Times* picked up the story.

The company's stock price fell 22 percent, from U.S. $44 to $34, in just three days.

That CEO learned a lesson the hard way. Plan your messages instead of sending out impulsive e-mails. His thoughtless action not only harmed his reputation as a leader but also severely affected his company's profitability. A two-minute reader-analysis process could have helped him avoid that catastrophe.

You may not be the CEO of your company, but if you imagine there is the possibility that something in an e-mail you're planning to send could be misinterpreted, don't send it!

When confronting, your obligation is to describe reality from your perspective and then invite your partner to describe reality from his or her point of view. Like feedback, it's a Beach Ball conversation with only two stripes. Your invitation will take only about sixty memorable seconds. But before we go there, think of that conversation out there with your name on it, the one that every subatomic particle in your body would prefer to avoid. Who is it with and what is the topic? Write it down.

PERSON _____ TOPIC _____

Here are some examples to give you an idea of the types of conversations this assignment is for:

Boss: *We're in no danger of innovation because in every meeting, my boss does all the talking and shuts down anyone who disagrees with him.*

Customer: *Working with this particular customer is always unpleasant and difficult. Their demands are unreasonable. We may need to part company.*

Work team: *Our strategic plan looks good on paper, but we as a team are missing critical deadlines.*

Manager: *A manager's employee is causing intolerable problems.*

Employee: *An employee has a reputation for starting and spreading rumors that are unfounded.*

Colleague: *A colleague has a pattern of taking credit for others' work.*

Spouse: *My husband's commitment to work seems stronger than his commitment to our marriage.*

Teenager: *I suspect my young daughter may be sexually active.*

Friend: *I am concerned that my friend may have a drinking problem.*

A few years ago, following a talk I gave, I had a "fireside chat" with a dozen individuals. One of them was wondering how to approach the first bullet above with the CEO of his company. "We're in no danger of innovation because in every meeting, he does all the talking and shuts down anyone who disagrees with him." He wanted to know what he should say. I suggested, "How about saying what you just said, that you are concerned the company isn't innovating because in meetings he's doing all the talking and shutting down those who disagree with him?"

It got real quiet. "Just say it like that?"

"Yes. Of course, it should be just the two of you in the room. This is not something you'd say in front of others."

"He might blow his top!"

"He might, which is why you should prepare your opening statement. Read chapter four. It will help you create a compelling invitation for him to talk with you about this in a civilized manner, though there are no guarantees."

Another man present said, "I don't like my wife."

We waited. He continued. "She's mean. She's mean to me, to our children. I just don't think I can live the rest of my life with her. But how can I talk with her about this? What should I say?"

I replied, "How about saying what you just said? It was clear and to the point. I understand this may seem harsh, but it's best to get to the point quickly and convey what's at stake. Otherwise, you may not have her full attention. Before you do, read chapter four."

After that, as each person brought up a conversation they were dreading, everyone laughed and said, "Chapter four!"

Before I walk you through a model for having this conversation and coming away from it having enriched the relationship, with all your body parts intact, consider the case of Sam and Jackie.

Sam and Jackie

This is not my brother, the mole whacker, but a different Sam, the CEO of a software company who had the following problem to solve.

Sam is a thoughtful leader and a truly good human being who was beaming when I walked into his office for our monthly one-to-one. He reported that he had successfully recruited Jackie, known in the software industry as a miracle worker with a reputation for never missing a deadline. Jackie had agreed to head up Sam's software development team for the eight months Sam estimated it would take to move the latest version of their software from the stage of development in which they were struggling to the marketplace. As a freelancer, once the project was completed, Jackie would take on a different assignment elsewhere.

Sam's company runs neck and neck with its competitors in an attempt to introduce the newest, slickest versions of their products to the marketplace, and Sam felt, "With Jackie heading up the team, we'll hit our target delivery date. Getting her is a real coup. She had lots of options, including working with one of our competitors. But she chose us and she starts tomorrow. This is too good to be true!"

A mere thirty days later, Sam groaned when I asked, "What is the most important thing you and I should be talking about today?"

"If you ever hear me say that something is too good to be true, kick me."

"What's happened?"

"About a week after Jackie came on board, a member of the software development team and I pulled into the parking lot at the same time, so I asked him how things were going. He said things were a little tense. I asked him what he meant, and he told me that the day before, he had been in Jackie's office asking her questions, and she had said, 'I don't have time for private tutoring sessions. Work this out on your own time.' He told me that in her first week with the team, this seemed to be typical of how Jackie dealt with people. Of course, I was sure they'd get through this. After all, they're all adults, professionals in their fields. I assumed this was just a bump in the road."

Sam sighed deeply.

I prompted, "More like a land mine . . ."

"Yeah. A week later, Sarah passed me in the hall and said, 'Guess you heard about the meeting.' 'What meeting?' I asked. She told me that the software team had met, and at one point, they were all stumped. Seems there's a glitch in the software and nobody knows how to resolve it. So they were just sitting there, looking at a diagram Jackie had drawn on the flip chart, when suddenly Jackie ripped the page off the flip chart, crumpled it up, and pitched it over her shoulder. She said, 'I thought you guys were better than this. This team is beneath my expectations.' And she walked out the door. Left them all sitting there."

"Yikes."

"And you know what really frustrates me? I still didn't do anything."

"Sam, what were you . . . ?"

Sam smiled ruefully, as he finished my sentence: ". . . pretending not

to know? Well, I couldn't believe that someone with Jackie's impressive résumé could turn out to be a jerk, so I clung to the fantasy that somehow this would all go away and they'd play nice. Besides, if we end up having to terminate Jackie, we'll definitely miss our deadline!"

"And the coup de grâce?"

"Delivered this morning by Peter (Sam's first employee, his alter ego, and the single individual besides Sam who most influences the culture of the company). This morning he came into my office, closed the door, and said that something had happened that I needed to know about."

"Sounds ominous."

"Yeah. My thought was embezzling, sexual harassment, industrial espionage."

"And the winner was . . ."

"Jackie. Peter admitted that he gets calls from headhunters from time to time but that he never takes those calls, never listens to the pitch. He told me that yesterday he got a call and this time he listened. He scheduled a meeting with the recruiter."

The look on my face mirrored Sam's.

Sam continued. "He told me that he had canceled the meeting and that he doesn't want to leave. Of course, I asked him what was going on, and he said, 'The thought of working with Jackie for another seven months is not a good one. She's brilliant, no question. But she's got some seriously sharp edges, and people are getting hurt. I doubt I'm the only person wondering if I can endure the next seven months.'"

Sam sighed. "I've got to talk to her. Today."

Before I walk you through the model Sam and I used to prepare him for his talk with Jackie, imagine you are Sam. Let's assume you don't want to fire Jackie, at least not yet. Ideally, you'd like to save the relationship. What might you say or ask to open the conversation with her? The first sixty seconds are key. Before reading on, take a moment to think about common errors we've all made in confronting behavior.

Error 1: So, How's It Going?

When I tell workshop participants the story about Sam and ask how they would open the conversation with Jackie, someone always suggests that Sam should begin by asking, "So, Jackie, how are things going?"

Many of us have been a part of such confrontations: "How do you feel you're doing here in the company?" Or, "How would you rate your performance?"

Openings like this are disrespectful and dishonest. Plus, you're not fooling anyone. The minute you ask how someone thinks he or she is doing, the internal reaction is likely, "Well, apparently not as good as I'd hoped."

Imagine you are Jackie. The CEO comes into your office, sits down, and asks, "So, Jackie, how are things going?" What might you instantly suspect? *Something's up.* After all, you already know things aren't going that smoothly. It's your team. You were there. You are also a person with darn good radar. You sense your boss has a hidden agenda.

Most of us can smell hidden agendas a mile away, and we don't like them. In our shared histories, "How are things going?" has almost always been a lead-in to bad news, negative feedback. So what do we do? If you were Jackie, you might have responded, "Things are going great! There's a little creative tension, but that's to be expected and we're working through it." Sound familiar? Now where is the conversation? Nowhere useful, that's for sure.

Most people determine to bluff their way through a veiled confrontation for as long as possible. Some are very good at it! Don't provide the opportunity. If what you really want to say is "Your job is on the line," then say that. Clearly, cleanly, and calmly.

Error 2: The Oreo Cookie

Well, how about the time-honored Oreo cookie approach? You know the Oreo cookie—two chocolate layers with cream filling. Many of us have been advised to begin a confrontation with a compliment, then slip

in the real message—the filling—then tidy up with another compliment or some words of encouragement.

"You did a really good job on the Adams report . . ." Then *splat,* the criticism, the negative feedback. ". . . but you've come in late almost every day this week and you were out two days last week. Work is piling up and people are complaining." Ending with "I'm counting on you. You're a terrific person with much to offer."

Most of us have either done this or had it done to us. And we don't realize the downside of this approach, which is that people get downright paranoid as soon as someone in authority says, "You did a good job on . . ." We're waiting for the "but," the equivalent of the sugarcoated spitball. The popularity of the Oreo cookie approach, known in Australia as the "shit sandwich," causes many people to break out in a sweat anytime they are paid a compliment. We say something nice and wonder why others seem to be bracing themselves for a blow.

People deserve better than this. Even if they haven't asked for it, each of us has an obligation to provide clear, straight messages. People deserve to know exactly what is required of them, how and on what criteria they will be judged (including attitude), and how they are doing. When you praise someone, keep that conversation separate, focused, and clear. Don't use praise as a lead-in to a confrontation.

Error 3: Too Many Pillows

A third approach is to soften the message in order to lessen the impact and avoid hurting anyone's feelings. It's a good thing, part of our human nature, to want to avoid inflicting pain. I remember wishing I could line the road with pillows when my daughters were learning to ride their bicycles. The trouble is, sometimes we put so many pillows around a message that the message gets lost altogether. We will have worked up a sweat and expended all of that emotional energy for nothing. Our employee, partner, or child may walk away thinking he or she has just had another casual chat with us.

Jeanne, the owner of the firm of which I was vice president, was the ideal boss for me. I always enjoyed our conversations, but following one of our meetings, I had an uneasy feeling, so I called her and said, "I enjoyed

our time together today; however, I have the sense that there is something you want me to start doing or stop doing that I may have missed."

"I thought I made it clear that I want you to . . ."

I no longer recall the details, but I had managed not to hear her message. It reminded me of Peter Falk's line in the movie *Murder by Death*: "This can only mean one thing, and I don't have a clue what that is."

This can only mean one thing, and I don't have a clue what that is.

Fortunately, Jeanne and I could both laugh as I admitted, "I often miss subtleties and I'm downright lousy at interpreting. If there is something you want me to do, get out a two-by-four and hit me alongside the head. Just tell me."

Replace pillows with clear requests.

A secondary point here is that while we often tell ourselves we are softening the message so as not to hurt someone else's feelings, we are really trying to protect ourselves. We don't want to deal with our own emotions, much less someone else's. So we wait for the right moment, when the other person is in the right mood, with the right music playing in the background and the stars are properly aligned. This is often a long wait. Odds are, we may never have the conversation.

Error 4: Writing the Script

Many of us have a tendency to script in our minds what we think someone else will do or say if we bring up a certain topic. Certainly, if we have a history with someone at home or at work, it is natural to anticipate his or her reaction. It is also a problem.

If I play out, like a movie in my mind, what I will say and then what you will probably say, there is little possibility for improvisation, little opportunity for new behaviors or responses on either side. I've got us both in a conversational box. An old one, well earned and understandable, but a box all the same. No hope for surprise.

When we script what others will say and do prior to a conversation, we can be so locked into the responses we're expecting that when someone responds differently, we do not notice.

She may not seem angry right now, but inside I bet she's seething. I know how she is.

Or we steel ourselves for the anticipated response, and, in so doing, our own words come out as metallic, cold, or menacing.

Our bodies manifest the pictures our minds send to them, so pay fierce attention to the negative scenario you are running in your mind. It just might come true. If what you intend instead is a frictionless debate, one that furthers the relationship, then hold that scenario as a possibility. That, too, just might come true.

Error 5: Machine Gun Nelly

Unfortunately we are all familiar with the person who confronts with heavy artillery. This individual is so terrorized by the notion of confrontation that he gets his adrenaline flowing, then runs into the room and hurls the message with vitriol or vengeance. He so fears the negative response he has scripted in his mind ahead of time that he skips anticipated defensive maneuvers and heads directly to the offense, which is offensive!

This is the bully, who is, of course, terrified of the other person's response. So terrified that once the message is delivered, this person ducks and runs, without surveying the extent of the damage inflicted. Perhaps you are guilty of this yourself. If so, the model that follows will help you tremendously, and in chapter six, you will gain additional skill and grace in the art of delivering a message without the load.

We've all made these errors. It seems we're so uncomfortable with the whole notion of confrontation that we either build up a head of steam, burst through the door, hurl our words across the table, and then bolt, or we soften our message to the point that the other person leaves the conversation thinking we've just had a lovely chat. When we hurl and bolt, we damage the relationship. When we soften and protect, the message is lost and it's unlikely anything will change and only one person is aware that the relationship is deteriorating.

Delivering a difficult message clearly, cleanly, and succinctly is essential. In organizations where leaders have developed the courage and skills required to stay current and to communicate honestly with co-workers regarding behavior issues, there is far less stress and there are considerably fewer concerns about lawsuits. But there are even more benefits to confronting with courage and skill.

In January 2016, after interviewing clients of Fierce, Dana Wilkie, an online manager/editor at SHRM (Society for Human Resource Management), wrote an article titled: "No More Mr. Nice Guy: Workplace 'Front Stabbing' Gains Steam." It reads in part:

> *Companies turn to "radical candor" to address poor performance, bad behavior, productivity, and more. They call it "fierce conversation," "frontstabbing," "radical candor," or even a "mokita." "It" is an emerging HR trend that encourages blunt, even brutally honest feedback at work—from employee to employee, supervisor to employee, and employee to supervisor. . . . And as for ignoring the elephant in the room because it's too uncomfortable to talk about? Time to face the beast.*
>
> *Kendall Hawkins, senior manager of talent at Kalypso, a consulting firm, embraced "radical candor" when she discovered that employees were shocked by the feedback they'd get during annual performance reviews. "They were hearing things they'd never heard before."*
>
> *Wendy Finlason Seymour, a talent management executive at the Canadian offices of staffing firm Randstad Holding NV, wanted to improve employee engagement and turnover in her Toronto office.*

Hawkins recognized that no one was going to get better unless they received candid feedback about how they were doing. Finlason Seymore recognized that withholding feedback for fear of the response was not helping people or enriching relationships. Both companies called Fierce.

At Kalypso, feedback now gets to individuals in the moment. After training 170 leaders at Ranstad, workers are more satisfied with their

leaders and feel they have a voice in the organization. Turnover has been reduced by 25 percent.

Makes me happy, though I'm not fond of the word "stabbing" or of the often-used phrase "brutally honest." There is nothing brutal about a fierce conversation. No blood on the floor. Might people be initially put off or embarrassed when a problem of attitude or behavior or performance is brought to their attention? Yes. Might they become defensive, even angry at first? Yes. Is there a guarantee that if we give one another feedback things will get better? No. No one *has* to change, but without a conversation, you can be assured there will be no change. What I have found is that when the conversation is real, the change occurs before the conversation is over.

Don't put this conversation off. Remember that the title of this chapter is "Tackle Your Toughest Challenge Today" when you're tired of limping and decide to remove the stone from your shoe. If you need to confront someone's behavior, come straight at the issue. Get right to the point. Say what you have to say in sixty seconds, then immediately extend an invitation to your partner to respond.

> **Come straight at the issue. Get right to the point.**

Sixty seconds? That's not enough time to express all the angst that's been building up inside me. Not enough time to tell the long story I've told and retold myself, plus all the gory details. Not nearly enough time to unleash the emotional diatribe I've rehearsed in my mind.

But oh, how powerful it is when your opening statement has been prepared and delivered with skill and grace and the invitation to your partner to participate wholeheartedly and thoughtfully in the conversation is compelling. It's highly likely that the relationship will be enriched in the process.

I've broken down confrontation into three distinct parts: opening statement, interaction, and resolution. Let's look at the all-important opening statement phase of a confrontation. Later I will tell you what happened during Sam's interaction and resolution with Jackie. And what happened after that.

OPENING STATEMENT

Preparation of your opening statement is essential. Write down your opening statement and practice saying it. *Out loud.* If you just rehearse it in your head, when the curtain goes up you may be appalled at the words that actually come out of your mouth. There are seven components to an opening statement:

1. Name the issue.

2. Select a specific example that illustrates the behavior or situation you want to change.

3. Describe your emotions about this issue.

4. Clarify what is at stake.

5. Identify your contribution to this problem.

6. Indicate your wish to resolve the issue.

7. Invite your partner to respond.

You have sixty seconds to do it all. Let's take these components one at a time.

1. Name the issue. As in a Beach Ball conversation, the problem named is the problem solved. Name the issue that is causing the problem and the area the behavior is impacting. If you have multiple issues with someone, ask yourself what's at the core, what's the theme, the commonality of all or most of your concerns and frustrations with this individual. Do the thinking to identify and name the central issue; otherwise, the conversation will lack essential focus and you'll both end up lost and frustrated. Your invitation should begin with these words: "I want to talk with you about the effect X is having on Y." Notice "I *want* to talk *with* you . . ." versus "I *need* to talk *to* you . . ." There is a huge difference between "want . . . with" and "need . . . to." Our defenses go up when

> **"I *want* to talk *with* you . . ." versus "I *need* to talk *to* you . . ."**

someone says, "I need to talk to you." We suspect they're unhappy about something and since they plan to talk to us, not with us, we assume we're expected to shut up and listen. When you say that you want to talk with someone, in the first three seconds, you've indicated the emotional tone with which you're approaching this conversation. It's friendly, open, a conversation, an exchange. You'll fill in the X and Y of course. For example, after thinking about everything that had occurred, Sam began his opening statement with these words: "Jackie, I want to talk with you about the effect your leadership style is having on the team."

2. Select a specific example that illustrates the behavior or situation you want to change. Since you've got only sixty seconds for your entire opening statement, this example must be succinct. No long stories. Besides, if you've ever been on the receiving end of someone who went on and on citing all the details about whatever you did that upset her, at some point either your eyes glazed over, you shut down, or you began building your defense. By the time she came up for air, you were loaded for bear. So keep this short. Must you have an example? Absolutely. When someone is upset or disappointed with us but can't think of a specific example that illustrates what is irritating him, his case loses credibility and is easy to dismiss. Take the time to think of an example that hits the nail on the head. Let's stay with Sam. For example: "I learned that when a member of your team was asking questions, you told him you didn't have time for private tutoring sessions and that he should work it out on his own time. I also learned that during a meeting with the team, you tore a page off the flip chart, wadded it up, threw it on the floor, said that this team was beneath your expectations, and left the room."

3. Describe your emotions about this issue. Why do this? Telling someone what emotion his or her behavior evokes in you is intimate and disarming. You are letting the person know that you are affected. Contrary to popular opinion, I believe it actually has quite an impact to say, quietly, "I am angry," if anger is what you feel. Just don't demonstrate it by shouting and balling your fists! Perhaps you are concerned, worried, sad, frightened, or frustrated. Name the emotions that are true for you.

For example, Sam's words were brief yet personal: "I'm deeply concerned and fearful of the possible consequences." Note: I advise not saying that you're disappointed. "Disappointed" sounds parental and demeaning. Plus, it doesn't carry any heat.

4. Clarify what is at stake. In other words, why is this important? Whether providing feedback or confronting, we owe it to the person to make sure they understand what prices are being paid and what's likely to occur if nothing changes. What do you believe is at stake for the individual whose behavior you are confronting? What is at stake for yourself, for others, for the customer, for the team, for the organization, for the family? What is at stake for the relationship? Use the words *at stake*. Those words have an emotional impact. Heads will raise and eyes will lock when you say, "This is what I believe is at stake." Talk about this calmly and quietly. What you say during a confrontation should not be delivered in a threatening manner, but simply as a clarification of why this is important. For example, Sam said: "There is a great deal at stake regarding how successful you and your team are in getting this product to the marketplace by or ahead of the deadline. If you fail, our competition will likely introduce their product to the market first, which would damage us on many levels. Our reputation as a product leader is at stake, as well as our professional pride, keeping promises we've made to our customers, and considerable financial gain. Additionally and importantly, a long-term employee has considered leaving the company rather than work with you. I am not prepared to lose good people. Right now, your team is avoiding you whenever possible because they don't want to incur your wrath. Perhaps there's little or nothing at stake for you, Jackie. If it doesn't work out, you can undoubtedly get another job quickly, but for us the stakes are high." Notice that Sam signaled that if it didn't work out, Jackie would have to leave. In some situations, it is best to just come out and say, "Your job is at stake."

5. Identify your contribution to this problem. This is your answer to the question "How have I behaved in ways guaranteed to produce or influence the very results with which I am unhappy?" Before we con-

front another's behavior, it is essential that we first look at our own noses. No long confession is needed here. With sixty seconds, you couldn't do that if you wanted to. What is appropriate here is a brief acknowledgment that you recognize any role you may have played in creating the problem and that you intend to do something about it.

I have often realized, to my chagrin, that my primary contribution is in not communicating clear expectations from the outset of a relationship or project. For a new member of the team, this should include the behavior that is valued in our culture, for example. How we treat each other, how we interact with clients . . . This may seem obvious, but the majority of problems I see in both professional and personal relationships are due to a lack of clear expectations of all parties, and the rest are due to a lack of accountability regarding expectations. As you think about behaviors you wish to confront, you may see that most missteps are ones you could have anticipated. By being clear up front regarding which behaviors and results are acceptable and which are not, you can avoid many problems, and you'll have a simpler task if you need to go back and remind a coworker or family member of the expectations he or she agreed to when the relationship began. For example, you might say: "I have contributed to this problem by not clarifying priorities and due dates with you. I want to correct that." Or: "I've contributed to this problem by not letting you know months ago how upset I was. Instead, I withdrew, and consequently, our relationship deteriorated even further. For that, I am sorry." If you believe you did not contribute in any way to the problem, leave this part out. Sam recognized that he should have dealt with this sooner. He noted: "My role in creating a growing rift between you and your team members is that I did not bring it to your attention earlier and when you joined us I did not make you aware of our values, including how we interact with one another."

6. Indicate your wish to resolve the issue. Use the word "resolve." It shows that there is no firing squad waiting outside the door. This is not a termination or an ending. In fact, when this model is used to confront a behavior or issue, more relationships are saved than ended. To say, "This is what I want to resolve" communicates good intent on your part. Additionally, you should restate the issue. That way you will have come

full circle, beginning and ending with absolute clarity about the topic on the table. Sam said, for example: "This is what I want to resolve with you, Jackie—the effect your leadership style is having on the team."

7. Invite your partner to respond. When our own behavior has been confronted, it may have felt as if a court found us guilty and we've simply been called in to learn the date and manner of our execution. In this model, however, there has been no attack. Instead, there has been an extraordinarily clear and succinct statement describing the reality of this particular behavior or issue from one person's point of view. We have been reassured that the intent is to resolve the issue. Now the invitation is offered for us to join the conversation. And the conversation has barely begun. For example: "I want to understand what is happening from your perspective. Please talk to me about what's going on with you and the team."

I imagine some of you are thinking, "This all sounds well and good, but you don't know Ed (or Shirley or Mark or Elaine)! There's a serious issue I need to discuss with him, but I can tell you right now, he won't play fair or nice. How do I influence such a person to come out from behind himself into the conversation and make it real?"

Ask him to. Ask her to. And make your part of it real. That's all you can do.

All conversations are with myself—and sometimes they involve other people.

This idea can be tough to come to terms with, yet it is essential that you grapple with it; otherwise, while you may understand the importance of conversations, you may find yourself holding back because of common concerns we hear in our workshops.

The most popular reason for not confronting a particular individual is: "They can't handle it." Other familiar versions go something like: "They'll get defensive." "They'll be hurt." "They won't talk about it." "They'll blame others." "They'll blame me." "They'll get emotional, irrational, angry, illogical." And sotto voce: "They'll get even!"

Countless corporate teams and families are held hostage by a single dysfunctional human being who has got the entire tribe cowed into avoiding the topics that need addressing. Such a person teaches us: *If*

you dare to bring up this topic or talk to me about things I'd rather not face, you'll be sorry. It won't be pretty. Even though we recognize that we've got to address this issue, we still hear ourselves saying, "He can't handle it. He isn't ready."

Fierce conversations cannot be dependent on how others respond.

What most people confess is that it's we ourselves who can't handle it, aren't ready, lack the courage. It is critical to recognize that *someone* has to handle it or nothing will change. That someone is *you*. Fierce conversations cannot be dependent on how others respond.

If you know something must change, then know that it is *you* who must change it.

If your life succeeds or fails one conversation at a time, and if the conversation is the relationship, ensuring that these conversations take place is up to you. In other words, if you know something must change, then know that it is *you* who must change it. Your job is to extend the invitation. What if the invitation is declined? Extend it again. And again. My experience is that when the invitation is extended with grace and skill, it will be accepted, even by those you have almost given up on.

Importantly, if you've extended many invitations and someone still won't play, you have a decision to make. Is this person, this relationship worth the continued emotional, intellectual, and financial prices you're paying, or is it time to bid them adieu?

If there is someone in your life who has consistently refused to have the conversation that is desperately needed, you might preface your opening statement by saying something like "No one owns the entire truth about [the topic], including me. I would like for the two of us to interrogate reality, side by side, as if we are walking down some stairs, one at a time. If it gets scary, we can sit down on a step until we're ready to continue. Imagine that we both have flashlights to illuminate the issue. Both of us might see something new. Both of us may gain perspective. If we have this conversation in Rumi's field—out beyond ideas of wrongdoing and rightdoing—we may both learn something."

If someone came to you and spoke words like this, then used the model we've explored to address a problematic behavior or situation in

which you are a key player, how would you respond? Yes, you might wonder if that someone has taken his or her meditation practice a little too far, but I bet it would get your attention. I have used these and similar words to prepare the way to address or help others address a highly charged issue. Use different words, if you like, but do find the words.

I often ask work teams, "On a scale of one to ten, at what level would you like to be confronted—ten being told straight, no holds barred, what someone thinks or feels—about something you have said or done?"

Surprisingly, most team members say, "Nine or ten." Recently, a team member suggested, "I think I could handle ten on Mondays, nine on Tuesdays, eight on Wednesdays, seven on Thursdays, and six on Fridays. I don't want to go into a weekend stressed." When I then ask, "At what level do you feel you are currently being confronted?" the answer is usually, "About a three, maybe four." We profess to have more courage than our colleagues give us credit for.

We can have the conversations needed to create the results we say we want in our lives, or we can have all of our reasons why we can't have those conversations. But we can't have both. Reasons or results. We get to choose. Which would you rather have?

Staying current regarding issues that are troubling or perplexing us enriches and simplifies our relationships. Neither of us has to

Reasons or results. We get to choose.

try to figure out what the other person really thinks and feels—an altogether exhausting and futile endeavor anyway.

Sam's opening statement took about forty-five minutes to prepare and practice. It covered all the bases, avoided common errors, and took about sixty seconds to say. When you put all the pieces together, Sam's opening statement went like this:

> *Jackie, I want to talk with you about the effect your leadership style is having on the team. I learned that when John asked you questions, you told him you didn't have time for private tutoring sessions and that during a meeting with the team, you wadded up a page from the flip chart, threw it on the floor, said that this team*

*was beneath your expectations, and left the room. I'm deeply con-
cerned and fearful of the possible consequences. There is a great deal
at stake regarding how successful you and your team are in getting
this product to the marketplace by or ahead of the deadline. If you
fail, our competition will introduce their product to the market
first, which would damage us on many levels. Our reputation as
a product leader is at stake, as well as our professional pride, keep-
ing promises we've made to our customers, and considerable finan-
cial gain. Additionally and importantly, a long-term employee has
considered leaving the company rather than work with you. I am
not prepared to lose good people. Perhaps there's little or nothing at
stake for you, Jackie. If it doesn't work out, you can undoubtedly
get another job quickly, but for us the stakes are high. My role in
creating a growing rift between you and others is that I did not
bring this to your attention earlier and I didn't share with you the
behaviors we value in working together. This is what I want to
resolve with you, Jackie, the effect your leadership style is having
on the team. I want to understand what is happening from your
perspective. Please talk to me about what's going on with you and
the team.*

If we were to simplify Sam's conversation with Jackie, essentially,
the flow would go like this:

*Several individuals on your team are having a difficult time with
you. Let me give you some examples of what I've been hearing. This
is what I'm feeling and what I believe is at stake. I recognize my
contribution to this outcome. So that we can begin to resolve this
issue, give me your take on the situation.*

Let's return to the confrontation model and then learn what hap-
pened following Sam's opening statement. Once you've said your open-
ing statement, it's time to stop talking and start listening.

INTERACTION

8. Inquire into your partner's views. It is here that the bulk of the conversation takes place. This is where reality will most certainly be interrogated. If your partner says something with which you violently disagree, resist the temptation to build a stronger case. Simply listen so that your own learning may be provoked. Ask questions. Dig for full understanding. Use paraphrasing and perception checks; don't be satisfied with what's on the surface. For example: "Please say more about this. I see it quite differently, so I'd like to understand your thinking, how you came to this conclusion." And/or: "May I tell you what I'm hearing? I want to make sure I've understood you."

We are often severely tested during the interaction phase. You will likely encounter the same avoidance strategies people use when receiving feedback: Deny, defend, deflect. It is not easy to contain your emotions during an interaction with someone whose comments or behavior makes you want to leap over the desk or through the Ethernet and strangle him.

When we struggle to wrap our minds around a partner's alternative reality, it's helpful to recall that in all conversations, including confrontations, we are all interpreting what is said through our own highly individualized filters. Rather than jump back in and start talking as soon as your partner says something you feel is off base, focus on examining your partner's reality and his or her filters. It may help to give yourself the secret rule of Mineral Rights. Questions only.

Finally, when your partner knows that you fully understand and acknowledge his or her view of reality, move toward resolution, which includes an agreement about what is to happen next.

RESOLUTION

Throughout the interaction phase of confrontation, reality is interrogated, learning is provoked, and relationships are enriched, if for no other reason than having gained clarity about one another's perspectives on the topic. Now it's time to come to an agreement about what happens

next. After all, you said your intent was to resolve the issue, and the following questions will help you accomplish this:

9. What have we learned? *Where are we now? Has anything been left unsaid that needs saying? What is needed for resolution? How can we move forward from here, given our new understanding?*

How do you end the conversation?

10. Make an agreement and determine how you will hold each other responsible for keeping it. Though I was not present during Sam's conversation with Jackie, from his later account, it's clear that Sam did a number of things really well. First, he kept in mind the four purposes of a fierce conversation:

1. Interrogate reality. *After his opening statement, Sam made it clear that he was genuinely interested in what reality looked like from where Jackie stood.*

2. Provoke learning. *There is no surer way to shut down a conversation than to come into it with an entrenched position. Sam was open to learning, willing to be influenced by Jackie.*

3. Tackle tough challenges. *It was time.*

4. Enrich relationships. *Sam intended that, even if the relationship with Jackie ended, there would be no blood on the floor.*

The interaction phase certainly contains potential quagmires. Often when we let someone know that others have complained, the person whose behavior we are confronting will attempt to justify the behavior by going into details about who said what to whom. If they try good old deny, defend, deflect, don't get trapped here. You wouldn't have decided it was time to have this conversation if you knew of only one complaint or negative result. Remember, you're driving this conversation. Don't let them take the steering wheel away from you.

For example, as soon as Sam extended the invitation to Jackie to

offer her perspective, she responded, "If people were upset, it would have been nice if they had come to me." Sam was prepared for such an attempt at deflection, and he replied, "We're here to talk about the effect your leadership style is having on the team, Jackie. What's going on from where you sit?"

During the interaction part of the confrontation, Sam gave himself the rule to make no declarative statements until he couldn't stand it anymore and then for a while longer. He pitched his tent on questions. Eventually two things happened. Jackie figured out that she was not going to be shot at dawn. She also saw that there was no place to hide. Sam could not be seduced onto rabbit trails. Whenever Jackie headed off into the bushes, Sam brought her back. Sometimes he just quietly said, "Let's return to the topic of your leadership style, Jackie." And she reluctantly came back.

In the course of their conversation, Jackie settled down and became thoughtful, less defensive, and Sam learned what was going on for Jackie. There was, indeed, a glitch in the software that no one, including Jackie, had yet been able to resolve. No one on the team had experience with this particular problem and Jackie's concern was palpable. She had a reputation for never missing a deadline, and now she had a critical problem that had no resolution at hand. Naturally, she feared this project might tarnish her reputation. Most of us have heard the phrase "Where there is anger, there is fear." Not that it made everything okay, but Sam began to understand the edge to most of Jackie's comments.

In moving toward resolution, Sam acknowledged, "I misdiagnosed the capabilities of the team. I thought we had the talent needed on this project, and clearly we don't. Do you know anyone who has the experience we need?"

"Yes. I know exactly the person. I don't know if he's available, but he could help."

"Well, it blows the budget, but I'm willing to get someone else on board. Will you call and find out if he's available?"

"Yes, of course."

"Now tell me what you are willing to do to resolve the issues regarding your leadership of your team."

Perhaps because their interaction had been productive and even pleasant, Jackie attempted to minimize her role in the problem. "Oh, we'll be fine. I'm sure the team will get used to me."

It was at this point that Sam's particular genius was revealed. I share this with you because there is a great lesson here.

Sam sat quietly for a moment, then said, "That isn't enough, Jackie. There are going to have to be some changes on your part. Tell me something. Have you ever received feedback like this anywhere else in your life?"

Jackie sat back in her chair. Her face reddened and she looked away. At last, she murmured, "As a matter of fact, yes, I have."

Sam waited a moment, then continued. "Jackie, you don't have to change your leadership style. You don't have to change, period. Nobody does. You will need to make some changes to stay here, and if you aren't willing to do that, you will leave, get on with your life, and possibly get this same feedback down the road. If that's your decision, then so be it. I'll have another problem to solve—replacing you—but I'll solve it. On the other hand, you could decide that this is as good a time and place as any to take yourself on. Because that's what we're talking about. Taking yourself on. Going inside with clippers and a soldering iron and doing some internal rewiring. That's a lot to ask of anyone, and you may not be willing or able to do that right now. I see this as an important choice point for you, so I'd like to meet with you at eight tomorrow morning and learn your decision. If you are willing to make some alterations in your leadership style, I'll help you, coach you. If you aren't, we'll part company, no hard feelings."

The next morning Jackie looked like something the cat had dragged in. She'd clearly had a bad night, but she said, "I made the call to the person I told you about and he's available. He's coming on board in two weeks. And, Sam, I want to stay. I don't know how it will go, but I'd like to make it work. It's an exciting project, the people on the team are good, and this is where I want to be."

"That's wonderful, Jackie. I'm really glad. Okay, let's get to work."

Thus, Sam began coaching Jackie. He didn't attempt to change her essential nature. He just took it step-by-step, asking a lot of questions. The first was "What's your next meeting? Who is it with and what do you want to accomplish?"

Jackie grimaced and said, "This is the part where you're going to

suggest that I apologize to John and the others on the team. I hate this. I'm lousy at apologies, but I'll do it."

They both laughed.

Seven months later, right on schedule, Jackie and the team rolled out a product that blew the competition out of the water. During the launch party, which I attended, the team was brimming with appreciation and congratulations. "I learned a lot from you. It's been great working together." The team said these things. Jackie said these things. All were sincere. Jackie is a snowboarder, so the team gave her a snowboard with the code name of the product stenciled on it. Before leaving, Jackie pulled Sam into his office.

When they returned, Sam took me aside and told me what had happened. His eyes were shining.

"Sam," Jackie had said, "there's something I want to tell you." She was clearly struggling with her emotions. "You know that conversation we had a while ago? You know the one I mean?"

"Yes, I think I do," Sam replied.

"Well, that conversation"—Jackie looked at Sam and her eyes filled with tears—"that conversation saved my marriage. I was behaving with my husband the same way I was behaving with my team and he was almost out the door. So I owe you, Sam, big-time. If you ever need me, please call me and I'll find a way to get here. That's a promise."

Sam and Jackie have since worked together on another project. It has been wonderful to see the pleasure they take in their professional relationship, and it has been a privilege to see a talented woman add compassion and considerable grace to her brilliance.

What was Sam's genius? Recognizing that when someone has a behavior at work that is causing a problem, it is inevitably showing up elsewhere in his or her life, causing similar problems.

Perhaps you've bought into the premise that we respond differently depending on whom we are with, that our work and home personas are really quite different. Perhaps you pay fierce attention to conversations at work but slip into a conversational coma at home, convinced there's nothing new, interesting, or energizing to discuss, preferring the company of the remote control. Perhaps you leave your warmth, playfulness, and authenticity at home and prop up an automaton at your desk at

work, afraid to let your authentic self show up lest you be judged as poor fodder for the corporate feast. Perhaps you've told yourself that conversations at work are unavoidably and substantially different from conversations at home. That that's just the way it has to be.

This is not true.

Each of us must discard the notion that we respond differently depending on whom we're with and that our work and home conversations are really quite different.

When you squeeze an orange, what comes out of it? Orange juice. Why? Because that's what's inside it. The orange doesn't care whether it's on a boardroom table or beside the kitchen sink. It doesn't leak orange juice at home and tomato juice at work.

When we get squeezed—*when things aren't going well for us*—what comes out of us? Whatever's inside us. To pretend that what's going on in our personal lives can be boxed, taped shut, and left in the garage while we are at work is hogwash. It seeps in everywhere. Who we are is who we are, all over the place. So if your conversations at work are yielding disappointing results, I'd be willing to bet you're getting similar results at home. The principles and skills needed to engage in conversations that produce celebratory results in the workplace are exactly the same principles and skills that produce celebratory results at home.

When we confront behavior with courage and skill, we are offering a gift. *This behavior is hurtful. This is the result it is producing. This is what's at stake.* And sotto voce: *Where else is this behavior showing up in your life, and what results is it producing?*

> **Where else is this behavior showing up in your life, and what results is it producing?**

Assignment

Think about the fierce conversations you identified earlier. For those that have to do with problematic behavior, prepare your opening statement by writing down exactly what you will say below.

1. Name the issue: *I want to talk with you about the effect* . . .

2. Select a specific example that illustrates the behavior or situation you want to change: *For example* . . .

3. Describe your emotions about this issue: *I feel* . . .

4. Clarify what is at stake: *I want to share with you what is at stake* . . .

5. Identify your contribution to this problem: *I recognize my contribution to this issue in that* . . .

6. Indicate your wish to resolve the issue: *I want to resolve this issue, the effect that (x is having on y)* . . .

7. Invite your partner to respond: *I want to learn your perspective. What's going on from where you sit?*

Once you're satisfied with a final draft, practice your opening statement until you own the words. Until the words come out straight, clean, and clear. Until you know the ground on which you stand. Have the

conversation with the person you wish to address as soon as possible. You can do this!

With courage and practice, your discomfort in confronting difficult but important issues will lessen over time. The goal is for you to become and remain current with the important people in your life. No more recycled tears. No recurring anger.

Life is short, and with some people, it feels way too long.

And what if your best efforts fail? There may be someone in your life who, in spite of multiple invitations from you, simply cannot, will not have the conversation that wants and needs to take place. You have a decision to make. Life is short, and with some people, it feels way too long.

If it's an employee, make them available to industry. If it's a love interest, say good-bye. When one of my friends broke up with her boyfriend, she explained, "I opened my home and he walked in with muddy boots." She was speaking metaphorically, of course, but I've never forgotten the image her words evoked.

A REFRESHER . . .

- Stay current by exchanging feedback 365 days a year.

- Do it face-to-face whenever possible.

- Give it as soon as possible after something occurs.

- Saying thank you can ensure that feedback continues.

- Remember to praise.

- When you need to confront someone, your sixty-second opening statement must be clear and compelling.

- Do it today.

PRINCIPLE 5
Obey Your Instincts

*It is only with the heart that one can see rightly; what
is essential is invisible to the eye.*

—Antoine de Saint-Exupéry, *The Little Prince*

"You know before you know, of course. You are bending over the dryer, pulling out the still-warm sheets, and the knowledge walks up your backbone. You stare at the man you love and you are staring at nothing: he is gone before he is gone."

This is the opening paragraph of Elizabeth Berg's novel *Open House*.

Do you recall a moment when a realization walked up your backbone? You knew before you knew. It was not your imagination. Each of us is equipped with exquisite calibration that allows us to sense when there's a storm brewing, snow coming down, an unexpected blizzard. Thunder rolls across your mind. Lightning flickers. Static and noise. And the scent of rain. It's going to rain. Hard.

There is a point where fact-finding and research accomplish nothing. Sometimes we just have to ask ourselves, "Is it right or wrong, yes or no, right or left?" And we know. A businessperson takes a deep breath and commits funds to a vision. Lovers let go of the past and commit to the present, or recognize that they are fundamentally wrong for each other and say good-bye. Our radar works perfectly. It is the operator who is in question. We are too often like a character in Colm Tóibín's

novel *Brooklyn*: "She thinks and notices and reflects with considerable force, but then she doesn't act on her intelligence."

Kim Murphy, a reporter for the *Los Angeles Times,* wrote an article about the search for grizzly bears in the Bitterroot region of Montana. Murphy reported that "Brian Huntington, a researcher for the Great Grizzly Search who has spent most of the summers of his life in the woods . . . has learned to trust the hair on the back of his neck. He feels it rise when he's walking down a trail, and he stops. 'Don't think it's probably your imagination,' he says. 'It's probably not.'"

Things don't always make sense—they just are. There are things our gut knows long before our intellect catches on. In *The Good Gut: Taking Control of Your Weight, Your Mood, and Your Long-Term Health*, authors Justin Sonnenburg and Erica Sonnenburg assert:

> **There are things our gut knows long before our intellect catches on.**

"A primal connection exists between our brain and our gut. We often talk about a 'gut feeling' when we meet someone for the first time. We're told to 'trust our gut instinct' when making a difficult decision or that it's 'gut check time' when faced with a situation that tests our nerve and determination. This mind-gut connection is not just metaphorical. Our brain and gut are connected by an extensive network of neurons and a highway of chemicals and hormones that constantly provide feedback about how hungry we are, whether or not we're experiencing stress . . . That sinking feeling in the pit of your stomach after looking at your postholiday credit card bill is a vivid example of the brain-gut connection at work. You're stressed and your gut knows it—immediately."

In addition to the neurons in our gut, every day, all day, our personal intelligence agent is sending us messages. We hear them in our heads, feel them in our guts, discern them in our hearts. They come to us while we're sleeping. Albert Einstein had his best ideas in the morning while shaving.

On a purely practical level, you will save money and avoid headaches by using your radar to recognize scams. Just this week I became aware of three incidents in the few square blocks near my office. Our bookkeeper, Christina, got an e-mail from me instructing her to wire $32,500

to a bank account in Dubai. She e-mailed back, asking for the details so she could categorize it properly. I responded that I wasn't near my desk, so couldn't give the details to her at that moment and that I wanted her to go ahead and process it. It didn't feel right to Christina. She called me. My e-mail had been spoofed. We blocked the sender and reported it to the attorney general.

Last week a Seattle company sent $15,000 to a similar account in the Middle East. The e-mail appeared to have been from the CEO and it went to the right person in their organization who would handle something like that. She didn't check with the CEO, just followed instructions. The company is out $15,000. She was reprimanded and feels awful about what she did.

An employee's friend followed e-mailed instructions from the president of her company to provide him with the 401(k) information for all employees. She spent hours gathering the data and then sent it to the president. The e-mail wasn't from him, of course, but she didn't check. Now everyone's data has been compromised. She lost her job.

I wonder if either of these employees had a twinge of doubt, a question, a gut instinct that they ignored. *It didn't feel right.*

Don't just trust your instincts. *Obey* them. What is, is. And what is must be acted upon. This instinctual wisdom is readily available to all of us. Tune in. Pay attention.

I'm Trying to Concentrate!

How does an intelligent human being make poor decisions? When President Kennedy got the idea to invade Cuba, only one person, Arthur M. Schlesinger Jr., questioned this decision; however, other advisers talked Schlesinger out of bringing up his concerns. The invasion was a disaster. The "team" got caught in the type of thinking best illustrated by a well-loved Winnie-the-Pooh story.

Winnie the Pooh and Piglet are walking together. They walk in a circle, heads down, examining the ground. All of a sudden Pooh says something like, "Look, Piglet. Tracks. Two other creatures were on this path not too long ago." They walk in a circle for a bit longer, and Pooh

declares, "More tracks, Piglet. Where do you suppose everybody is going?" They continue walking in the circle and Pooh says, "Wow, look at this! There are so many paw prints, something exciting must be going on. We're definitely not alone."

Before we know it, we're off and running, heads down, going in circles, following a well-trodden path. Perhaps if we looked up and around, we'd become acutely aware of a different reality, an alternate route that would take us someplace more valuable, someplace we've never been before.

Obeying your instincts requires that you listen to your own internal voice, acknowledge your internal reference point, rather than rush to embrace the myriad references and voices of others. Most of us allow ourselves to be influenced or persuaded that the voice within us is mistaken, flawed, at best a distraction. And if we are intent on gaining others' approval, we are quick to discard our insights, commanding the voice inside us, "Shut up and go to your room," and yet it is important to be true to the instincts that make you *you*, as opposed to anyone else.

> It is important to be true to the instincts that make you *you*, as opposed to anyone else.

In fierce conversations there is neither a struggle for approval nor an attempt to persuade. There is, instead, an interchange of ideas and sentiments, during which you pay attention to and disclose your inner thoughts while inviting others to do the same.

Our thoughts, wonderings, unexplained memories, and yes, suspicions speak to our oldest neurons and synapses. We know things. We sense things. We don't know how or why we know things. We just do. For example, as you read this chapter, I encourage you to pay attention to the connections you're making in your mind between what I'm suggesting and your own life. Go beyond the words I've written and pay attention to what you're thinking and feeling as you read them.

This is what I want you to do in your conversations. Principle 5 asks you to obey your instincts. In this chapter, you will practice becoming intuitively aware of the thoughts and feelings of the most important people in your life. You will learn how to employ this phenomenon called *instinct*, often unexpected and inexplicable, to provide explosive insight, thus greatly enriching the quality and outcomes of your conversations.

You will learn to obey your instincts while inviting others with differing views to challenge your thinking. You will continually check in with your inner reference point and disclose what you find there, with no concerns about approval or control, either yours or that of others.

If you have ever felt lost in a conversation—who hasn't?—it may be because you were so focused on the literal words that you were ignoring the clues all around you. Examine more than surface evidence. Resist automatically accepting what you see at face value. There is value in paying fierce attention to our instincts, which are readily available to us 24/7.

But how do we tap into that terrific resource? What can we do when we're in the middle of a conversation or a meeting and we find ourselves distracted by our thoughts? After all, we've been advised to pay attention to the people we're with, so we attempt to cordon off those pesky insights we keep getting from somewhere north of the Pleiades. We consider them suspect and are careful not to disclose them, ending up like the central character in Steve Tesich's novel *Karoo,* who says, "My insights were many. I was full of penetrating insights. But they led to nothing except an ever-growing private collection."

How we enter our conversations is how we emerge from them. Holding back, not paying attention, disengaged, half-asleep. Or available, present, engaged, awake. If we're to be the latter, as you learned in chapter four, we need to listen for more than content. We need to listen for emotion and intent, as well.

> **How we enter our conversations is how we emerge from them.**

In *Crossing the Unknown Sea,* David Whyte writes, "In the surface conversation of our colleague we listen for the undercurrent; the persistent tug and ebb that tells us she is actually going in the opposite direction to her speech."

The Left-Hand Column

Take a moment and think back to your conversations during the last thirty days. Revisit sitting with your coworkers, your boss, your customers, your lover, your child, your friend. As you listened to each individual, what did you think but not say? What were your thoughts about

What did you think but not say?

these thoughts? What did you do with those thoughts? Did you think, "I need to say something here, but I don't know what it is"? Or did you know you needed to say something, yet acted inconsistently with that impulse?

In the interest of fierce conversations, what is really needed here is a reality check of some kind, a conversation about your conversation.

How is it possible to have a conversation about a conversation? We can do it only if we first acknowledge that we are carrying on a private, internal conversation.

But how do we find out what we are thinking? This sounds obvious,

Sometimes we don't know what we think until we hear ourselves say it aloud.

but it isn't. Sometimes we don't know what we think until we hear ourselves say it aloud. Sometimes we believe that our internal conversation is in the way of our being present, so we try to push it away. Being 100 percent present means being present for everything that is occurring in that moment. It's like a split-screen TV:

Private Thoughts	Public Thoughts
What you think *Not visible/audible*	*What you say* *Visible/audible*
"You're crazy. We can't do that."	"Sure. No problem."
"People are scared to death of you. There's no way they will tell you the truth."	"What does your staff think?"
Belief: Don't show what you feel.	Behavior: The Corporate Nod

We filter our private conversations, making public only what we assume will get us what we want. When we keep important thoughts private, our ability to learn and to make good decisions is reduced.

Our dilemma is: Keep it private (in other words, be diplomatic) and prevent ourselves and others from learning, or, say it, knowing that we might upset someone or make ourselves vulnerable. Yet unconsciously,

most people are asking us to visit the "edge" or frontier with them. To go there, we may need to change how we think in the first place. What if we drilled down, hit oil, decided what's rich and what's junk, refined it, and used it?

To do this, we need to value our instincts as a resource. In addition to paying attention to the person, we must also pay attention to and value the messages we're receiving from ourselves. This approach, developed by Chris Argyris and Donald Schön, was first presented in their book *Theory in Practice*. It has come to be known as the "left-hand column."

Essentially, you can think of your brain as split into left-hand, middle, and right-hand columns.

Private Thoughts	Neutral Zone	Public Thoughts
What you think and feel but don't say	You are aware of what you think and feel without attachment.	What you see and hear. What is shared and known.
Assumptions and judgments. Your private view	You don't claim it's right or special. It just is. And you want to share it to see if it brings insight to the conversation.	

There was a time in my life when I considered my left-hand column to be a royal pain. All those distracting private thoughts. All those crazy notions that derailed the conversation:

"Why are we talking about this? This isn't the real issue."

"I've lost the thread of this conversation. I'm completely disoriented."

"He says the plan's on track, but I sense an undercurrent of fear."

"She says everything is fine. I don't think she really believes that."

In fact, attending to my left-hand column is, at times, like writing. In Patricia Hampl's essay "Memory and Imagination," she writes, "I sit

before a yellow legal pad, and the long page of the preceding two paragraphs is a jumble of crossed-out lines, false starts, confused order. A mess. The mess of my mind trying to find out what it wants to say. This is a writer's frantic, grabby mind, not the poised mind of a reader ready to be edified or entertained."

Then years ago I read about Dr. O. Carl Simonton, whose clinic in California had an amazing cure rate for supposedly incurable cancer victims. Early in his medical career, Simonton noticed that patients given the same dose of radiation for similar cancers had different outcomes. When he looked into why, he concluded that people who had a more positive attitude generally lived longer and had fewer side effects. Simonton went on to popularize the mind-body connection in fighting cancer, focusing on how our beliefs, attitudes, lifestyle choices, spiritual and psychological perspectives can dramatically affect our health, the course of our disease, and our overall well-being.

Simonton encouraged his patients to listen carefully to their personal insights about what they needed to do. Most important, he urged his patients to take action on those insights as soon as it was humanly possible. He said something like, "Those messages are from you to you. They are from the part of you that knows what is needed to help you get better. If you ignore those messages, eventually you'll stop getting them. The part of you that offers insights will say, 'No use telling her. She doesn't listen.'"

If you ignore those messages, eventually you'll stop getting them.

This got my attention, and I resolved to get better at putting my instincts to work as the powerful tools that they are. I began starting my day with a brief, quiet time, which concludes with the question "Is there a message for me?" A message often presents itself.

Several years ago, at a time when I was trying to make multiple things happen in my personal and professional life, I asked if there was a message and was startled at the vehemence with which the message arrived. Two words, quite clear: BE STILL.

I recall my response. *What do you mean, be still?* And the immediate answer: *What part of BE STILL don't you understand?*

I got the message. For many months, "BE STILL" became a personal

mantra, pulling me back from the brink of wrong action on numerous occasions.

Still, to this day, during my early-morning quiet time, it takes a while for the stillness to arrive. Thoughts swarm.

"I need to call so-and-so. Respond to e-mails. Write the keynote talk. Call the accountant. Review the goals. Update the action plan."

I am reminded of Holly Hunter's character in the movie *Always*, who dreams grocery shopping lists. *Kitty litter, potato chips, milk.* Like many individuals running organizations and living full lives, I dream to-do lists. During my morning meditation, it is often all I can do not to rush from the chair and hurl myself into a flurry of activity. Yet, over and over, I have discovered that a rush to action can be counterproductive. When I am still, underlying truths surface, pointing me toward the right action. Stillness has become a discipline.

What needs to be my focus for today? The theme for today's endeavors? Is there a message from me to me? These conversations with myself, during which a nugget of gold is revealed amid the rubble, have become invaluable.

I remember a time when I faced a difficult decision. It involved leaving a particular corporate client whose president had an ongoing integrity outage that he refused to correct. Not surprisingly, he encountered the same problems over and over, yet insisted on pointing the finger elsewhere. In addition, I wondered if he had attention deficit disorder. His son had been diagnosed with this challenge, and I was aware that it could be inherited. He declined to investigate this possibility, even as our conversations raced from one incomplete thought or issue to the next with no resolution, no clarity, no conclusions. Our conversations were maddeningly unfocused, circuitous, and confusing.

I became keenly aware that our conversations were visits to competing ethical systems and that despite my best efforts at helping him frame a topic for discussion and remain, at least for a while, within the boundaries of one topic at a time, and despite having confronted behavior that was **Our conversations were visits to competing ethical systems.** at odds with the company's stated values, our work together was unsuccessful and deeply frustrating for both of us.

The voices inside my head urged, "You are not the right person to help this individual. You are only a phase on the way to someplace more useful for him. Get out of the way, so someone else can step in."

I realized that it was I who had an integrity outage. My behavior did not match what I said was important, my values. My emotional fatigue was understandable. I had not been present with or attentive to myself. One part of me was urging me to cease my work with this client, and the other part of me was countering, "Yes, but . . ." In disregarding my instincts, I essentially had been telling myself that I didn't exist 50 percent of the time.

I met with my client that day and told him what I'd been feeling. I spoke of his integrity outage, which I could no longer look past, and also of my concern that he might have attention deficit disorder, which contributed to his inability to communicate effectively. I told him that, based on results, I wasn't the right resource for him, and that I felt we should stop working together. He said, "I've been expecting this. I've been thinking about some of the things you've said. Maybe I do need to get tested for ADD." I noted that he didn't say anything about correcting the integrity outage, so I thanked him for having allowed me into his confidence, pointed him toward the resources we both felt could be useful, wished him all good things going forward, shook his hand, and left, feeling energized, grounded, and determined to pay fierce attention to that ongoing conversation we all have with ourselves.

And what about the many thoughts we have as we listen to friends, colleagues, kids, spouses, customers? For some time now, as I have practiced Principle 3—Be Here, Prepared to Be Nowhere Else—I have attempted to capture and share elusive thoughts and emotions. During a fierce conversation, my role is not to say what is easy to say or what we all can say, but to say what we have been unable to say. I try to pay attention to things that may pass unobserved by others and bring them out into the open. One of the most valuable things any of us can do is find a way to say the things that can't be said.

One of the most valuable things any of us can do is find a way to say the things that can't be said.

Trapping Furtive Truths

The left-hand column—the one that is filled with your personal thoughts—will assist you in this process. You will pull your thoughts from the dim corners where they would prefer to hide. You will bring them into the light, catch them in midflight.

This is how it's done.

Listen to both sides of your brain as if you were hearing two conversations at the same time. One conversation is the literal conversation that is visible, audible. The other conversation is the one going on inside your head—what you are thinking and feeling.

Bring some of your private thoughts and feelings into the neutral zone by noticing them without attachment. They aren't right or wrong. They just exist. Become interested in them as phenomena in the world, as if they were interesting shells you found on the beach. When you are ready you can bring these thoughts into the public conversation. If you like, you can use these words: "While you were speaking I had a thought that I would like to check out with you . . ."

This is called "perception checking." It lets your partner in on what you have been thinking and feeling, but it doesn't invite defensiveness because you didn't interject your thoughts as the capital-T Truth.

Another approach is to ask a question to open up a willingness on another person's part. For example, you might ask, "Would you like to hear something I'm feeling (or thinking or wondering) right now?" Then, assuming your partner is willing and interested, share your thought.

Here's an example of how the left-hand column works.

David and Ron

I was listening to a client named David talk about the disappearance of his twenty-year-old son, Ron. Ron had fallen in with a bad crowd and had been expelled from high school in his junior year. Ron refused to return to school and scorned all offers of counseling. He continued to live with his parents but had become increasingly abusive to his mother

and, on one occasion, had threatened her physically. In addition, Ron got into numerous messes, fights, and predicaments, all the while remaining adamant that none of it was his fault.

David intervened to shield his wife from Ron's abuse, to bail him out of his latest problem, and to influence him to change his ways. After yet another blowup between Ron and his parents, Ron packed up and headed out. No one had heard from him for several months.

David was disturbed by his feelings of relief. "Is it normal to feel this way?" he asked. "I mean, we've done everything we could, and at this point, frankly, Katie and I are glad to have our home back, our lives back. But shouldn't I feel more concern about Ron's whereabouts? Should I be doing more than I am to try to find my son?"

Throughout David's detailed description of all that he had endured at Ron's hands, and his admission of relief that his son was gone, I noticed that his voice was absolutely flat. Although David used emotional words, he didn't seem to be feeling emotion himself. He sat slumped in his chair, his face and body devoid of animation.

While listening to David, I tuned in to an impression that hinted at itself, then grew stronger the longer he talked. The impression was of someone enveloped in a dense fogbank, to the point of near invisibility. Even to himself.

This impression persisted, so at a pause, when David seemed to be thinking about all he had said, I offered my personal left-hand column to David for his consideration: "As I have been listening to you, I've had a sense of you inside a fogbank, as if you were invisible, perhaps even to yourself. Does that impression make any sense to you?"

He sat quietly and seemed to examine the space in front of him. Then he said, "You know, that is what it feels like. I can't see anything clearly right now. That's interesting. It's almost as if I'm running blind. I'm afraid I'm going to walk off a cliff."

I said, "As you've been telling me about Ron and Katie and all that the three of you have been through, you seem emotionally flat, as if you had been drugged and were unable to feel anything."

His response was instantaneous. "You're right. It's as if I've been anesthetized."

"How long have you felt this way?"

David thought awhile, then said, "I think it started coming on the year Ron was expelled, when we had one knock-down, drag-out after another. It was horrible. Katie and I had no time or energy for ourselves. Everything was about Ron. Trying to help him, clean up after him."

As our conversation continued, David realized that, like many who have been in a war zone for an extended time period, in order to survive, he had desensitized himself to the awfulness of his situation. The trouble was, he had numbed himself to the point of somnambulism. His work and his relationship with Katie were suffering as a result. David concluded that a useful step would be to seek the help of a professional therapist to work through how best to help his son, while staying energized and engaged in his own life.

It takes a certain fearlessness to make your private thoughts public. But if what you're thinking makes you squirm and wish to wriggle away, you are probably onto something. In David's case, it was rewarding that my internal musing helped him recognize what he was experiencing and what he might do to help himself.

Can Our Instincts Get Us in Trouble?

Our instincts are not always correct. There have certainly been times when I managed to possess an incorrect but fervent understanding of an issue. And sometimes I've found myself just plain lost. I have no idea what a conversation is even pretending to be about. At times like that, I have sometimes said, "I'm as confused as you appear to be. How do we dig out of here?"

It's not our thoughts or feelings that get us into trouble. It's not our disclosures that cause distress. It's our attachment to them, our belief that we are right. I want to emphasize the importance of releasing any attachment to our thoughts and interpretations as the *truth*. Even so, I would rather err on the side of checking out my instincts than passing them over for fear that I could be wrong or that I might offend someone.

I have at times said to new clients, "I will tell you what I'm thinking, sensing, wondering. I will push you to make decisions or to take actions on important issues. I am on your side. I will go too far, and when I do, you must stop me."

I will go too far, and when I do, you must stop me.

We deservedly get into trouble when we ascribe motives or when we determine the "truth" thirty seconds into a conversation and inject our opinion, under the misapprehension that we are on track, that we know what is really going on. We are guaranteed to offend others when we present our impressions and interpretations as the truth.

Recently our head of training sent an e-mail to our contract trainers explaining that due to changes in some states' legal requirements governing when someone is considered an employee or truly independent, they would need to incorporate and become an S or a C Corp if they weren't already. The e-mail asked that they confirm their status within thirty days, so that we could continue booking them. Most trainers responded, fine, no problem. Some were already S Corps. Some said making the change would be a hassle but they understood and would do it.

One went ballistic.

It took at least six hours over two days trying to correct his misinterpretation of the e-mail. He had become attached to the story he

It was as if a whacked-out tour guide had hijacked his brain.

had told himself about our true intent, which was that we no longer wanted to use him and that we were going to cancel all sessions for which he was already booked. I wondered why he would want to believe what he'd told himself. It was as if a whacked-out tour guide had hijacked his brain, taking him somewhere I couldn't imagine he wanted to go.

What Are We Winning?

Insisting on clinging to our beliefs, on convincing ourselves we're right in the face of evidence to the contrary, can have enormous consequences, and not just in the workplace.

Jim Sorensen, a master facilitator with Fierce, told me a true story. Jim was preparing to leave Seattle to lead a training session for one of our clients and asked his wife, Brenda, to take care of something for him while he was gone. He emphasized that it was critically important and she assured him she'd get it done.

"Promise?"

"Promise!"

When he returned home and asked about it, Brenda gulped, apologized, and admitted she had forgotten. In disbelief, Jim began to rage.

"I can't believe this! You promised you'd handle it!"

"I know. I'm really sorry. I . . ."

He cut her off, furious. "If you loved me, you could not possibly have forgotten to do something this important to me!"

"Jim, I feel awful. Things just got crazy busy and . . ."

He cut her off again. "There is NO excuse! Someone who loves me would not forget to do something that important after they promised they'd do it!"

"Jim, please, I'm really sorry. I love you and . . ."

"I don't want to hear it. I told you this was critical! If you loved me, you would have kept your promise."

Brenda stood very still, then quietly asked, "Jim, what do you win if you win this argument?"

And it hit him. If Jim won this argument, he would have convinced himself that his wife didn't love him. Nothing could have been further from the truth and he knew it.

Sometimes when we're right, our only prize is a sour taste in our mouth, sadness, a negative view of humanity, anger, stress. What *are* we winning?

Few people appreciate being told, "What you are really saying is . . ." or "What this really means is . . ." followed by a message, motive, or meaning that could not be further from the truth. It feels like a violation, like trying to play tennis with someone who refuses to stay on his or her side of the net. The left-hand column is about how to stay on your side of the net without violating someone else, but still playing a really great game of tennis.

A friend recounted a conversation that marked the beginning of the

end of her marriage, during which she told her husband, "You misinterpret me completely, consistently. I wear one face and you have given me another that is dark, malevolent. You ascribe to me thoughts, feelings, motives that are not mine. You miss me entirely."

I recall listening to someone recount a conversation we had both witnessed and wondering, "It's amazing that he interpreted it that way. After all, we were both at the scene of the 'crime.' Wonder where he got his story."

In addition to what we think we heard someone say, we must decide what to do when our left-hand column sends a consistent message over and over again: "Something is not right here. Something is going on. Somehow, I sense that there is more to this than meets the eye"?

You may feel awkward as you begin to experiment with your left-hand column, offering your private thoughts to others for their consideration. We often speak of "feeling our way." To let your feeling lead you is not a bad tactic during a conversation.

Trouble Paying Attention

Phillip and I had met monthly for a year, usually on Monday mornings. Phillip is sociable, shares my macabre sense of humor, laughs easily, and is wonderfully candid concerning his shortcomings as a leader. During the second year of our relationship, I couldn't help noticing the increasingly visible veins in Phillip's nose and cheeks. He often looked sleep-deprived, his eyes red-rimmed and puffy.

Occasionally, I ventured a comment. "You look a little ragged this morning."

"Yeah, party last night. Got to bed around two. Great time."

And so it went.

In subsequent meetings, I became more and more distracted by my concerns over Phillip's appearance. It was difficult for me to pay attention to his comments about the issues in his company when I found myself wondering if he had begun drinking heavily. I was stuck. Should I bring it up? How could I bring it up? How do you ask someone, "Do you have a drinking problem?" That's not the kind of thing one brings

up out of the blue. Or is it? And who am I to venture a guess? And sotto voce, my left-hand column insisted, "You've got to say something."

As I got into my car following another session with Phillip, I sat for a moment, confronted by my cowardice. *You say you care for this person. Do you really? If he has become a heavy drinker, perhaps an alcoholic, it's not only affecting his health, but it's affecting his marriage and his ability to be the great leader he aspires to be. You've got to ask him about this.* I resolved to share my concern when it seemed appropriate.

As soon as I walked into Phillip's office for our next meeting, I knew it would be impossible to concentrate on anything he had to say. He looked decidedly hungover.

"Bad night?" I asked.

"What? Oh, yeah. I got together with some friends this weekend."

The moment of truth. I screwed my courage to the sticking place.

"Phillip, it's going to be difficult for me to focus on business issues today unless I share with you a growing concern of mine."

Phillip paused, smiling quizzically. "Okay, shoot."

"It's not that easy. I'm worried that you'll be put off by what I want to ask you, so I want you to know that I'm prepared to be dead wrong about this."

Phillip's smile faded.

"We always meet on Monday mornings, after the weekend, and, well, frankly, you usually look like hell." Phillip frowned. I took a deep breath and continued. "A couple of times I've asked you about it, and you tell me about another party with your friends, staying up late. You always laugh it off."

By this time, neither of us was eager to hear the next words I would speak out loud. The brief silence between us was hard at work, and my heart was in my throat. I spoke as gently as I knew how.

"I may be way off base, and I know you'll tell me if I am. It's just that I find myself wondering if the way you look on Monday mornings is about more than good times with your friends. I worry that perhaps you have a drinking problem, that perhaps you are an alcoholic."

Phillip had lost his sleepy look. His face flushed. He snorted. "I can't believe it! I tell you about my friends, a few parties, and you take it to this."

I barely resisted the impulse to apologize, withdraw my observation,

discount my concern. Instead, I waited. Phillip pushed his chair away from his desk. I could virtually hear the tension in the room—an electric whine. I was in the electric chair and was about to become toast.

Phillip's words were measured, his jaw clenched. He looked me squarely in the face and said, "One. I do not have a drinking problem. Two. I will never mention my friends and our parties again." He took a long breath. "Now can we get on with our meeting? I have some things I want to run by you."

Again, I fought off the impulse to apologize and instead said, "Yes, okay, let's move on."

At a meeting with Phillip six months later, I began with the first question from Mineral Rights: "What is the most important thing you and I should be talking about today?"

Phillip sat quietly a moment, then said, "My drinking problem."

Finding Out What You Know

When we habitually disregard instincts that suggest we're not talking about the real issue and enter our conversations with a goal of being careful or "nice," we are inhibited, and all possibilities of intimacy, connection, and resolution are held at bay. It also doesn't work to enter a conversation with a goal of being poised, clever, instructive. You can get that on any street corner.

Simply put, we are too careful. Too nice. It's hard for me to imagine a worse sentiment expressed at a funeral than "She was so nice." Actually, "She always played it safe," would be even worse. A marriage, a career, a life with no controversy is nothing to be proud of. Unless you are a member of the royal family, opportunities are earned rather than bestowed. You cannot hope for accolades without being willing to bear the scars required to win them.

A marriage, a career, a life with no controversy is nothing to be proud of.

A fierce conversation is courageous, original, and varied in its choices. The heart, the guardian of intuition with its unsettling intentions, is the boss; its commands are ours to obey. At least, they are mine to obey.

I love this passage from *Martin Marten*, by Brian Doyle.

It turns out that having a conversation with someone you like and respect is harder as you go deeper, isn't that so? Conversations are easy on the surface, where there's just chaffing and chatter and burble and comment and opinion and observation and mere witticism or power play, but the more you talk about real things, the harder it gets, for any number of reasons. For one thing, we are not such good listeners as we think we are, and for another, everyone in the end is more than a little afraid of saying bluntly and clearly what they really think and feel—partly because we are nervous about how it will be received and partly because once you say something true and deep and real, it's been said; it's out of your heart and out of your mouth and loose in the world, and you cannot take it back and lock it up secret again, which is, to be honest, terrifying . . .

The wrong words . . . will make (someone) huddle back inside herself nor is silence an option for silence will itself be a comment reeking of shock or disapproval. And again the reply must be crafted in such a manner that (we) continue to think aloud; in so many ways, this is what friends are for—to allow you to speak freely, to speak yourself towards some clarity of heart, to think aloud and thrash toward being able to say what it is you feel, for the chasm between what you feel and what you can articulate is vast and wide. And this is not even to mention how very often what we say has nothing whatsoever to do with what we truly feel.

It still comes as a shock to realize that I don't speak about what I know. I speak in order to find out what I know. Often the real trouble is that the conversation hasn't been allowed to find its subject; it isn't yet about what it wants to be about. But everything shifts when we entertain private thoughts that drop clues like bread crumbs along the conversational path.

Another quote from *Martin Marten*: "You know how when you are going one way in the river, and you stick your paddle in and hold it in the right spot for a second, and the whole boat turns?"

Having practically grown up in a canoe, I do know. What strikes me is that conversations can be like this. After countless fierce conversations, I am still touched to realize that the person with whom I am talking wishes to be discovered by a reflective self who is listening carefully in order to understand and make sense of this maze of words concealing the heart of the story.

Obeying our instincts and offering them up to a colleague or loved one is like putting a paddle in the conversational waters at the right time, the right spot. It allows both of us to know things we could not know otherwise. Together, we begin to see what this conversation wants to be about, where it wants to go, and how to make it pulsingly real. One disclosure, one offering from our left-hand column at a time.

We select something to bring into the public conversation. We put something forth, then something else, and so on, to the conclusion of the conversation. What we select is not necessarily the truth, not even *a* truth sometimes. However, the thoughts or questions we dare to share may assist the conversation in going where it needs to go. The function of our left-hand column is intensely personal and surprisingly revelatory. One dip of the paddle can point the conversation toward a worthy destination.

What Is Appropriate?

There are differences of opinion about what is appropriate territory for conversations, given one's area of expertise. I am not a therapist or a physician, so when I encounter things that are beyond my ken, I refer people to a professional. However, none of us needs a license to be a fellow human being or a friend. We don't need a degree to be present. It is not my intent or goal to advise anyone. My job is to take my expert hat off, leave it out in the hall, and come into the conversation and just be available. And pay attention to my instincts.

None of us needs a license to be a fellow human being or a friend.

We all know how easy it is to get into conversational hot water when we shoot from the hip and say whatever comes to mind. It's a very different experience to obey our instincts after having gained skill and

practice in interrogating reality, in showing up authentically, in giving others the purity of our attention, and in confronting issues with courage and compassion. Since the conversation is the relationship, there is now a broad and rich context in which to offer our thoughts for others' consideration.

And what if your instincts occasionally miss the target?

Consider this possibility: Your confusion is an asset; in fact, your search for clarity may blaze a path for others. In working to express what you do not understand—but long to understand—you invite the kind of conversations for which others are searching. If you begin to wonder what others will think of you, you won't be able to pursue original avenues.

> **Your confusion is an asset; in fact, your search for clarity may blaze a path for others.**

There's something else I'd like you to consider, an area where it's vital that you obey your instincts.

Psychoneuroimmunology

When it comes to profitability, keeping our businesses healthy and growing, we must determine whether the assumptions on which our organization was built and is being run match current reality.

What kind of assumptions? Assumptions about markets, about customers and competitors, about values, beliefs, and behavior, about technology and its dynamics, about the organization's strengths and weaknesses—even assumptions about what the company gets paid to do.

These assumptions are what acclaimed management consultant Peter Drucker would call the company's "theory of the business," and they need to be regularly and rigorously interrogated. To test these assumptions, organizations must interrogate two realities at once—engaging in two ongoing fierce conversations. The first has to do with the organization's values. The question posed is "What values do we stand for, and are there gaps between these values and how we actually behave?" Remember John Tompkins, the CEO of the fishing company? When I asked him to share with me the core values on which his organization was founded, he paused, then admitted, "We've never declared them."

No wonder John's organization was floundering. The corporate soul reflects shared values. *Or the lack of them.* Embedded in the reasons we get

The corporate soul reflects shared values.

out of bed every day and in every action that we take as individuals are *our* values. A value is a tightly held belief (as opposed to a vague notion) upon which a person or organization acts by choice. It is an enduring belief that one way of behaving is personally, professionally, spiritually, or socially preferable to an opposing way of behaving.

In considering your values and any gaps that might exist between those values and your behavior, there is more at stake in interrogating this particular reality than most of us realize.

Psychoneuroimmunology is a field in which medical physicians and quantum physicists have met, shaken hands, and engaged in a startling conversation. It is the study of the interaction between psychological processes—our thoughts and minds—and the nervous and immune systems of the human body—our biology. In other words, it seems you and I have the ability to strengthen or weaken our own immune systems. No doubt Dr. Simonton would agree. What's surprising is that, though a healthy diet and an exercise regimen are important, the strength of our immune systems has more to do with the degree of integrity with which we live our lives.

Does psychoneuroimmunology suggest that if you get sick, you're a bad person? No. Bad things happen to good people. Maybe you just caught a bug. Maybe you inherited a troublesome gene. However, if you feel a creeping, deadening depression, a malaise, as if you are merely drifting, bumping into the bank in a rudderless boat, held in the current of the particular river you are in, if you are tired and listless much of the time, if you sense something's off . . . then do an integrity scan.

Ask yourself, "What values do I stand for, and are there gaps between these values and how I actually behave?" In fact, if you are depressed, it may be because you have repressed some important truths from yourself. Truths *about* yourself.

Integrity requires alignment of our values—the core beliefs and behaviors that we have claimed are important to us—and our actions. So if, for example, you say that you value time with your family members

yet haven't spent much time with them lately, you are, by your own definition, out of integrity. If you have taken the stand that fidelity in a marriage is essential and you're cheating on your spouse, you're out of integrity. If you tell yourself that honesty is important, yet you frequently bend the truth in an attempt to stay out of trouble or get what you want, you are out of integrity.

Remember the concept of "ground truth"? All too often there is a difference between stated values and ground truth.

Most of us don't go around consciously violating our values; nor do we spend our days obsessively checking: "Okay, am I in or out of integrity?" However, if your behavior contradicts your values, *your body knows,* and you pay a price at a cellular level. Over time, depending on the severity of the integrity outage and how long it's been going on, your immune system will weaken, leaving you increasingly vulnerable to illness.

> If your behavior contradicts your values, *your body knows.*

Each individual has an immune system. Each marriage has an immune system. So does every organization. What happens when promises to customers are broken? When employees are feuding? When there are conflicts of interest involving large sums of money? Do we admit that there are defects in our products? That we've lied about emission tests?

If behaviors within an organization are not in alignment with the values described so prettily in the mission statement, the company's immune system is weak, rendering it vulnerable when opportunities to get sick come along. When a company takes a blow, if the corporate immune system is weak, things can go south in a heartbeat.

> When a company takes a blow, if the corporate immune system is weak, things can go south in a heartbeat.

It's a sad fact about our culture that a politician can earn more votes by talking about his values than he can by practicing them.

And what happens in your marriage during a tough time? What integrity outages are causing or contributing to a bad patch? Do you support each other through the difficult times, or do the wheels come off the cart?

Pay attention here. When bad things happen at work or at home, if

our corporate or personal immune systems are weak, it's likely that things will worsen. On the other hand, when bad things happen and our immune systems are strong, our defense system can kick in and return us to health.

What if we know we're out of integrity and do nothing about it? If we continue to ignore the part of us that says, *This is wrong. This is not right for us, for me,* we're playing Russian roulette with our physical, emotional, spiritual, and financial health. Sadly for many, we have only to watch the news to learn of another example of corporate psychoneuroimmunology at its most devastating.

Assignment

Conduct an integrity scan. In preparation for your integrity scan, you must first clarify your values. It won't do to spout the values that have been suggested to you by others, even by those whom you admire. The question is "What are *your* values?"

A value I have identified for myself is *passionate engagement*. Looking back on personal and professional peaks and valleys, I find that I do the best work and enjoy my life most when my passions are thoroughly engaged. *Authenticity* is another core value for me. Just the sound of the word creates a thrumming in my bones. But I have to say—and I am being judgmental here—lots of people seem to love the word "authenticity," but my experience of some is that they wouldn't know authenticity if it ran over them.

When I work with clients, there is often a sense of personal discovery when the right words spring to mind. One woman in a workshop regained her fierce resolve to take a class in writing once she realized her life had fallen into a routine that had dulled her sense of aliveness. "I am too comfortable. I haven't learned anything new in a long time. I've always said that a lifetime of learning is one of my core values, yet I'm in a rut in just about every area of my life. No wonder I'm so bored."

Look for the words that speak to you, that wake you up. Don't worry about what anyone thinks of your list of values. This is *your* life. You and only you decide.

This is *your* life. You and only you decide.

The conversation that follows is one of the most important conversations you will ever have with yourself. It requires that you obey your instincts and deserves annual revisits.

PERSONAL INTEGRITY SCAN

Clarify and write down your core values. Pay attention to each word you consider. Maybe there's only one word or phrase that rings true for you. That's fine. Write it down.

My Core Values

Now run an integrity scan.

Is my behavior out of alignment with my values in the workplace? in my personal relationship? in my life? Are there integrity outages? If so, where and what are they?

Integrity outage in my workplace:

What must I do to clean it up?

When am I going to do this?

Integrity outage in my personal relationship:

What must I do to clean it up?

When am I going to do this?

Integrity outage in my life:

What must I do to clean it up?

When am I going to do this?

CORPORATE INTEGRITY SCAN

If you are a leader in an organization, invite your team to conduct a corporate integrity scan. In preparation, review your company's vision or mission statement. Does it include clearly stated values? Is it compelling? Most mission statements sound the same, containing such sentiments as:

> *We will be the premier provider of [insert your product or service here] in [geographic territory]. We will exceed our customers' expectations, provide growth opportunities for our employees, and ensure a reasonable return for our shareholders.*

Boring! There is no vitality in such statements, and unless I'm a shareholder, who cares? The language doesn't provide us with anything we can sink our emotional teeth into. It doesn't compel us to take action, doesn't motivate us to get out of our warm beds on cold, rainy days and go into the office to tackle a job, some parts of which are not fun.

I subscribe to the idea that you want your convictions to come up out of the work and out of the people doing the work, not have them imposed on people by upper management. That you have to trust the act of involving all your employees in scanning their brains and hearts and guts to represent whatever beliefs and values they have. You cannot impose those beliefs and values on people by twisting and banging and rewarding and sanctioning and inspiring and motivating and hanging

your imposition on the wall, no matter how noble a statement you have conceived, because if you do, you become a propagandist and you spend your corporate life's energy attempting to push, pull, and persuade rather than get on with the business of your business, whatever it may be.

People yearn to be connected to something of substance. They are oriented to values. *How shall I live my life so that it means something more than a brief flash of biological existence soon to disappear forever?*

> **People yearn to be connected to something of substance.**

This is especially true for all those who assess their lives and are not satisfied. Few employees are content with a merely contractual relationship in which they exchange their time and skills for a paycheck, then go home to spend their paychecks on what their lives are really about. Most care deeply about the reputation and values of the companies they work for and would like to feel that their ability to live up to those values in their organization matters.

A compelling vision, including shared values, is not just an idea. It is, rather, a force in people's hearts, a force of impressive power. It may be inspired by an idea, but once it goes further, if it is compelling enough to acquire the support of more than one person, then it is no longer an abstraction. It is palpable. People begin to see it as if it exists. Few, if any, forces in human affairs are as powerful as

> **Few, if any, forces in human affairs are as powerful as shared vision.**

shared vision. And mission. Clarity about how we operate around here.

For example, if your company is competing for talent—and what company isn't?—you may well be reviewing your company's policy around parental leave right about now. Gotta keep up with Amazon, Facebook, Microsoft, right? But what's best for *your* organization? What makes sense given your number of employees, your bottom line, your values?

In Seattle, nontech companies like Fierce cannot compete with the high-tech giants who are our neighbors and who provide signing bonuses, high salaries, gourmet food, free beer and wine, health clubs, and doggy day care. Pretty seductive. But there is an interesting phenomenon happening within the "war for talent." It is not uncommon for someone

who has left their company for a higher salary and generous benefits to realize within weeks that they were happier where they were.

I concur with *Fast Company*'s prediction: "Mission Will Trump Money," and so if entitlement rears its head during negotiations about perks or policies, I would confront it head-on. The risk is that some will be offended, a risk leaders must be willing to take. I have shared with our employees:

> *My job is to take care of you. Your job is to take care of our customers. Our customers' job, so to speak, is to take care of our bottom line. In taking care of you, I must also consider what is healthy for our company. I certainly don't blame you for wishing we had a well-equipped gym, day care, and a gourmet chef on site. It would be lovely for all of us and unsustainable for our company, so I encourage you to revisit why you are here, how you feel about what we do, your job here, the people around you. At some point in our lives, most of us recognize that true happiness and deep satisfaction come to us because we are lending our talents, our intelligence, and our hearts to an organization whose mission and vision we embrace, working alongside people for whom we have respect and genuine affection. The sooner we lay down our burden of unrealistic expectations, which the world will never completely satisfy since, really, that is not the world's obligation, we will be far more content.*

Might some people leave? Yes, and that's okay. The tribe that is "fierce" is there because of *why* we do what we do, and that makes all the difference. So what should a vision include? The best kind of vision statement answers four questions:

1. **Why are we here?** The answer to this question must get beyond identifying the product you manufacture or the service you provide; it must answer the challenge "So what?" In other words, what do we do for our customers that matters to them? Consider the compelling response of a telecommunications company: "Our work brings the human family closer together."

2. **What is our ideal relationship with one another?** How would we describe the best possible relationship we could envision with everyone inside the organization? More compelling than "trust and respect" are specific, actionable values such as: "We want consistency between our plans and our actions. To disagree without fear. Each person to be connected with the final product. Freedom to fail; people are shot only for not trying."

3. **What is our ideal relationship with our customers?** Consider such responses as: "We act as partners with our customers. We encourage them to teach us how to do business with them. Our customers leave us feeling understood. We understand the impact of our actions on our customers."

4. **What contribution do we wish to make to the local or global community?** What impact do we wish to make in the larger community in which we are visible, beyond our customers? What do we want to be known for? Examples: "We give our unconditional commitment to enhance the quality of life and human growth," and "We are committed to fulfilling our ethical and social responsibilities."

If your vision statement needs rewriting, involve as many employees, customers, and strategic partners as possible in doing so. Periodically review it with your coworkers and ask, "Where are we off?" If an integrity outage becomes clear, discuss what needs to be done to correct it. Develop a plan that includes specific actions and dates by which they will be taken. Thank the team for their candid responses. Conclude your integrity scan by identifying where the company's behavior is in alignment with its values. Ask the team, "Where are we on . . . ?" Thank them for their contributions to the company's alignment of values and behaviors and let them know what it means personally to you, their leader.

Assignment

During your conversations today, pay fierce attention to what you are thinking and feeling. Notice what interests you that is not being addressed; notice the questions you'd like to ask; notice the observations your inner voice is urging you to share. Remember that what you are thinking and feeling is not right or wrong. Your thoughts are simply your thoughts. From time to time, choose one to bring into the public conversation. Invite your partner to explore it with you. In doing so, you give the conversation an opportunity to go deeper. Be courageous in your conversations today. Look for the deepest issue that engages or troubles you. Familiarity with the unknown and with the fluidity of the world is essential. Don't swerve away from it. Speak your way toward it. Paddle!

Look for the deepest issue that engages or troubles you.

A REFRESHER . . .

- A careful conversation is a failed conversation.

- During each conversation, listen for more than content. Listen for emotion and intent as well.

- Act on your instincts rather than passing them over for fear that you could be wrong or that you might offend someone.

- Watch what happens to the conversation when you do this.

- Invite your partners to do the same.

PRINCIPLE 6

Take Responsibility for Your Emotional Wake

There are people who take the heart out of you and there are people who put it back.

—Elizabeth David

For a leader, there is no trivial comment. As a result of something you don't even remember saying years ago, someone who was looking to you for guidance and approval could still be in therapy! Or as a result of something you said years ago, someone is grateful to you to this day. Each time we speak, each time we send an e-mail or text, we leave an emotional wake. We soothe panic attacks or cause them, leave people feeling charred or uplifted. Our individual wakes are larger than we know.

For a leader, there is no trivial comment.

An emotional wake is what you remember after I'm gone. What you feel. The aftermath, aftertaste, or afterglow.

If we are capable of living our lives at times unconscious of what others are feeling, imagine how easy it is to toss off comments, blithely unaware of our emotional wake's effect on others. There is a toll for such unconsciousness. In the business world, even a brief hallway comment can cause

An emotional wake is what you remember after I'm gone.

resentment, misunderstandings, plane wrecks. The wake of our comments is amplified when others put their personal spin on everything we say. This is something that we all do. It's one of the biggest, baddest causes of misunderstanding, hurt feelings, and frustrating relationships.

For example, we may have innocently asked Johnny how he was doing on such-and-such, only to learn that Johnny went directly to his colleagues and said, "I can't help you with this now. Other things are more important to the boss, so I've got to focus on those this week." Everyone sulks.

One of my friends frequently struggles to resolve fights with her husband. She never remembers what he says, just how she feels when he says it. Later, he is angry at her withdrawal. "This is stupid. I didn't say anything worth barricading yourself in here all day!"

Yes, you did, she thinks, *but I can't tell you what it was. I just know that I got the message. What you said. How you said it. Tone of voice. Sarcasm, I think it was. The look on your face. The long-suffering husband. Your back was half-turned to me. Dismissal.*

She feels this in her bones. Angry words crouch behind her teeth, ready and willing. He sees the flash in her eyes and knows to stop, then pretends later that this is silly. *Silly woman, upset for no reason.*

"He says I'm his tuning fork," she told me. "His image of grounded, intelligent energy. He values my intelligence, but he doesn't reach for me. Doesn't touch me."

When she tried to say these words to her husband, her fear and anger triggered both of them and they added another topic to their list of undiscussables, and yet their mask of civility was wearing thin.

After one of their fights, my friend called her husband on his cell phone, hoping for some hint of clarity or resolution. Their connection kept going in and out, and there was a lot of static on the line. My friend kept shouting, "Are you there? Can you hear me?" Later, she realized it was a perfect metaphor for their four-year inability to communicate about the topic of commitment to their relationship. Their constant sniping at each other reminded me of a Bulgarian proverb: "If you wish to drown yourself, do not torture yourself

If you wish to drown yourself, do not torture yourself with shallow water.

with shallow water." And of a passage from *The Miniaturist*: "This is not a conversation, it is Agnes sending out darts and watching them pierce."

This marriage failed. Slowly. Surely. What was needed was a series of fierce conversations, during which each of them took responsibility for his and her emotional wake.

After they separated, I ran into her husband, a man whose sense of humor I had always enjoyed. He said, "Every time I go back to the house, she has two more black trash bags filled with my stuff. The other day I saw a black trash bag in the backseat of a friend's car. 'Wife throw you out?' I asked. And he said, 'Yes. How did you know?' Black trash bags. Dead giveaway."

Funny, and sad. *What were the messages these two people were unable to deliver or hear that might have saved the marriage?*

James Newton, CEO of Newton Learning, makes his home at the foot of San Diego Bay, where all of the houses have docks. The speed limit in the bay is five knots. Once in a while, some cowboy rips through the area and rocks all of the boats, knocking them up against the docks. The person might not have done this on purpose; however, if a boater is thoughtless and causes damage, he is responsible for it. The water cops will make sure he pays for any damage caused by his wake. Yes, the other boats should have bumpers; still, each boater is required to take responsibility for his wake.

The question is not "Can he boat in those waters?" Of course he can. The question is "At what speed?"

I love the scene in the movie *Office Space* when a consultant hired to downsize the company asks an employee:

"What would you say you do here?"

"Well, look, I ALREADY TOLD YOU! I deal with the @#%!$ customers so the engineers don't have to! I have people skills! I am GOOD at dealing with people! Can't you understand that!? What is WRONG with YOU PEOPLE?"

If you can relate to this sentiment, you can appreciate how challenging it is to live up to the vow of becoming more conscious of the effect of our words on others. It's hard to see ourselves as others see us. It's hard to acknowledge that our offhand comments are sometimes

Our offhand comments are sometimes powerful diminishments.

powerful diminishments. We can imagine what they must think and experience when they are with us, but we often misread things and make assumptions. *Yes, I raised my voice or made a face, but he's a big boy. He can handle it.*

Some people decide not to say anything at all to certain "sensitive types." They believe the problem is out there. With him, with her. Yet, though a "problem" often belongs to both parties, since you and I have little control over how others will react, the most effective position to take is to focus on our own actions. There was a period in my life in which I was unconscious of the wake I was leaving during my conversations with others. I received the feedback that while my message was right on, my delivery left a lot to be desired. My thought was: *If I'm too strong for some people, that's their problem.* That was me not getting it. That was me dismissing all the comments my classmates had written in my yearbook when I graduated from high school. "Suze, you are the sweetest girl in the world." "To Sweet Sue . . . ," etc. I didn't want to be sweet. I wanted to be dangerous!

Finally, as an adult, after yet another negative outcome, I recognized that the constant in all those failed conversations and disappointing results was me. I recognized that "fight or flight" were not my only options. I also recognized that when I restricted my responses to what I knew that I knew, bombarding people with my extraordinary, well-stocked vocabulary, I was putting people off rather than bringing them close.

Our emotional wake determines the story that is told about each of us.

A leader's long-term performance is profoundly affected by the long-term spin the organization puts on him or her. Our emotional wake determines the story that is told about each of us in the organization. It's the story that's told when we're not in the room. It's the story that will be told about us after we're gone. It can be a wonderful story that makes us smile or a painful story with a tragic ending. The fact is, we are what we leave behind.

We are what we leave behind.

Now, of course, I am happy to be described as sweet, but not sickly sweet, not

saccharine. I do my best to say what I want to say in a way that delivers the message without the load. What is *your* story? How would you like to be interpreted? What is the legacy you want to leave? If the people in your organization could tell one story about you, what would you want it to be? What is the message you wish to deliver to *your* customers? What wake do you wish to leave following each conversation with colleagues and family members? What is your ongoing dialogue with all those essential to your success?

Many of the great leaders with whom I have worked sustain a love affair with their work and their lives. They place their attention at the service of deep, long-term concepts and convictions in the workplace and the home. They possess a groundedness that comes from having wrestled core problems to the ground and lived to tell about it. They have become sensitized to the effect they have on others, increasingly aware of the wake caused by their words and actions. They have said to themselves, in one way or another, "This is my problem, my challenge, my opportunity. From this day forward, I will take responsibility for my emotional wake." Their perspective and goals have shifted as they recognized that leadership must be for the world.

Leadership must be for the world.

A CEO who was frustrated with the results of his attempts to communicate with his executives mused . . .

> *What I get to say is not what I want to say,*
> *is not what they listen to,*
> *is not what they hear,*
> *is not what they understand,*
> *is not what they remember when I'm gone.*
> What do I want them to remember when I'm gone?
> *I need to say that, and only that . . . clearly!*

What do you want them to remember when you're gone? Are you saying it . . . clearly?

What do you want them to remember when you're gone?

Your Stump Speech

If you are a leader, taking responsibility for your emotional wake requires that you are clear not only about where *you* want to go and where you want your team or organization to go, but *how* you want to get there. In what spirit? Adhering to what practices, what values? In addition to a compelling vision (why do we exist?, etc.), it helps to have a stump speech—the speech you are prepared to give anytime, anywhere, to anyone who asks or who looks the least bit confused. Your stump speech must be powerful, clear, and reflective of your organization's values.

> *Where are we going?*
>
> *Why are we going there?*
>
> *Who is going with us?*
>
> *How are we going to get there?*

Here is the stump speech I wrote when I founded Fierce, before I had any employees.

WHERE ARE WE GOING?

We are dedicated to transforming the conversations central to our clients' success. Our long-term goal is to help change the world, one conversation at a time.

WHY ARE WE GOING THERE?

We are not neutral. We believe that:

- What gets talked about in an organization and *how* it gets talked about determine what will happen. And what won't happen.

- While no single conversation is guaranteed to change the trajectory of a career, a business, a relationship, or a life, any single conversation can.

- Leadership should be defined in terms of relationship and taught and measured in terms of the capacity to connect with colleagues and customers at a deep level.

WHO IS GOING WITH US?

At Fierce, there is no bench. Consequently, we attract and retain partners and staff who bring organizational expertise, personal depth, and fierce resolve to all of our endeavors. Each of us is dedicated to living the "Fierce" brand every day.

HOW ARE WE GOING TO GET THERE?

By working with clients whom we enjoy and respect and for whom we can make a significant and unique contribution. By focusing on performance and sustainability. By developing leaders who are globally competent and competitive. By continually earning our reputation as the international leader of executive education focused on skillful, courageous dialogue.

WHAT ARE OUR CORE VALUES?

Living the brand requires that each of us lives a life of ever-deepening *authenticity, passion* for the work, *freedom* to obey one's instinct while working without a net, *collaboration* so that we may continually learn and improve, *courage* to live the principles every day, *grace* that comes from ongoing personal transformation, and genuine *affection* for and an *emotional connection* with our customers and with one another. Our touch is light, our interventions are gentle, our approach is fair, and our egos are checked at the door. Without being intrusive, we provide follow-up, follow-through, and ongoing support. In addition to making a positive impact on this planet and on the robust growth, health, and

ongoing relevance of Fierce Inc., our primary goal is captured in the following quote:

> *If you ever listen to Sinatra sing, it sounds as if he's singing directly to you. That was Sinatra's great skill, and that's what we try to achieve in our business. We want to connect with people on a human level—to touch them in some way.*
> —George Forrester Colony, Forrester Research

Great leaders share their stump speeches with their teams and with their customers, not only to convey a clear and compelling story but also to leave a positive emotional wake. My stump speech has been helpful in conveying what, why, who, and how to each person who has joined our tribe.

Assignment

If you lead an organization or a team within an organization, write your corporate stump speech with that team in mind. Antoine de Saint-Exupéry wrote, "If you want to build a ship, don't gather your people and ask them to provide wood, prepare tools, assign tasks. Call them together and raise in their minds the longing for the endless sea." I long to fulfill Fierce's mission and vision, to transform the way we talk with one another, everywhere on this planet.

Andy and Roger

A negative emotional wake is not caused exclusively by thoughtless or unkind comments. It is created at times by a lack of appreciative comments. For example, my meetings with clients always end with the question "Given everything we've talked about, what's at the top of your to-do list for the next thirty days?" I follow up on that at the next meeting.

During a meeting with a client whose long and impressive history

of successes was legendary, I got so caught up in the topic for the meeting that I forgot to ask him about his to-do list for the preceding thirty days. I began to wrap up the meeting, and he could see I was about to leave. He said, "Hey, wait a minute. Aren't you going to ask me what I got done in the last thirty days? I wanna brag."

I had forgotten that people at all levels in the corporate world, even those at the very top, deserve to be recognized for their good qualities and accomplishments.

Who deserves *your* praise? Who needs to know you care? Who needs to be told that you love him? How soon can you say it?

Andy is a gentleman's gentleman, a consummate professional, and a world-class negotiator. Most people who know Andy want to be just like him when they grow up.

I walked into Andy's office for our monthly meeting to find him distraught. His first words were, "Roger resigned." Roger was Andy's heir apparent. Andy had great plans for Roger. He continued. "He took another job that's a complete dead end for him."

"But why?" I asked.

Andy shook his head. "He saw me move other people around in the organization and assumed I didn't have a plan for him, assumed he was being passed over because I didn't think highly of him."

"But you had great plans for him. How could he not have known that?"

"I felt it was best not to promise him anything. You never know what's going to happen. I planned to promote him in time—soon, actually—but felt that it wouldn't be politically correct if I told him what I had in mind."

"Can you save him?"

"I tried, believe me, but his pride is involved. He won't budge. A year from now, he'll be miserable."

We sat quietly, Andy with his head in his hands. After a while, I ventured a question: "Maybe it's too soon to know, but what have you learned from this?"

Andy's eyes glistened. "I didn't tell him I loved him. I thought he knew."

Appreciation, praise.
Unfiltered, unqualified.
There is so little of it
going around.

Appreciation, praise. Unfiltered, unqualified. There is so little of it going around.

While it might not have been appropriate for Andy to lay out the details of what he had in mind for Roger—after all, reality can and does shift—it was appalling to Andy to realize that Roger really did not know that Andy held him in high regard.

Tellmetellmetellmetellme

In the movie *Always,* there is a scene in which Richard Dreyfuss's character, Pete, a pilot who specializes in firefighting, has given Holly Hunter's character, Dorinda, a beautiful dress for her birthday. Very feminine and girly. Dorinda puts it on and makes a grand entrance down the stairs of a bar to the whistles of all the men, who line up for a chance to dance with her.

Later, alone with Pete, Dorinda pleads, "Tell me you love me. Tellmetellmetellmetellme. TELL ME!"

He doesn't, of course, until days later. As he is about to take off for an unexpected emergency, Dorinda cycles madly down the tarmac, climbs up onto the airplane, hugs him fiercely, then climbs down and starts pedaling away. In that moment, he is struck by his feelings and shouts toward her retreating back, "I love you!" She cannot hear him over the roar of the engines. He shrugs, taxis off, and dies moments later in an explosion.

That may seem a bit sappy, this notion of "you could die today, so who haven't you hugged?" Yet it's a real possibility that you and I could check out anytime with no advance notice. So could others in your life.

A taxi driver in San Francisco recently told me, "It's just never been in the cards for me to have a close, loving relationship with my parents in person. We got along from a distance but never when we were together. Things started getting better a few years ago. I visited and it went well; we had a good conversation, and I thought, 'Finally, it's possible.' I was planning another visit when my dad died. Now my mom is really sick. She's not going to last much longer. I can't change the past, but I

thought I could change the future. I didn't know there wasn't going to be one."

Michael and Joe

Michael, a friend and colleague, told me about his college-age son, Joe. Michael loved Joe deeply yet didn't currently feel connected to him, didn't feel that their conversations had heft or meaning. Michael decided that he needed to go down the conversational staircase with Joe no matter what they might discover in the basement, so he invited Joe to lunch and told him what he was feeling.

Joe asked, "How long have you felt this way—not connected?"

To his surprise, Michael heard himself answer, "Since you were in the third grade."

Joe gulped. "That's a long time, Dad."

Michael thought about that time, so long ago. "When you started third grade, you didn't want to go to school. So every morning I would play catch with you. I'd throw the ball toward school, and you'd run out to catch the ball, then throw it back. Each throw would take us closer to school. Finally, we'd be out front and I'd roll the ball through the door. You'd run in the door, pick up the ball, wave at me, and disappear. The next year you were fine with school and in the years since then you seem to know where you want to go and how you want to get there. I'm very, very proud of you. It's just, well, I wish you still needed me. We don't talk much anymore."

As Michael shared this memory, both he and Joe were surprised by their emotions. Neither had known what he would find at the bottom of the stairs. But both were willing to go there.

It took a moment for Michael to continue. Finally, he said quietly, "What I just admitted to you and to myself makes me very sad."

Over the next hour, father and son found their way back to each other and created a plan to stay engaged. Following Michael's conversation with Joe, he realized there was another person in his life from whom he felt disconnected: his wife.

When we spend a lifetime curbing our anger, our sadness, or our

When we spend a lifetime curbing our anger, our sadness, or our frustration for fear of offending others, in the process we curb our joy.

frustration for fear of offending others, in the process we curb our joy. We cannot find the words to name what we love, who we love, and why we love them. We lose the ability to express deep and genuine appreciation. Healthy relationships require appreciation *and* confrontation. How can we really know someone if there is never a misunderstanding that invites exploration, never a disagreement that merits examination, never anger that reveals an unacknowledged fear? Rather than tell someone, "I value you, but I am angry with you," replace it with the deeper truth of "I value you *and* I am angry with you." Or "I love you *and* I feel disconnected from you."

Who needs to hear from you? Who needs to know what you appreciate about him? If there is any possibility that people don't know how much you value them, there's a conversation that needs to occur.

In the business world, confrontation, criticism, and even anger are more socially acceptable than expressions of appreciation. That's too bad, because appreciation is a truly value-creating activity. Sometimes the fiercest thing that needs saying is "Thank you. I admire how you handled that. You're important in my life. You're important to this organization."

Who needs to hear from you?

And wouldn't it mean more if you named a specific quality, behavior, or trait that you appreciate in someone? For example, as I've suggested before, "You're doing a good job" leaves a feeble wake compared with telling someone, "I overheard you handle that upset customer on the phone. It sounded like you were able to calm him down and really help him. I was impressed by your professionalism." Despite Dorinda's plea in *Always,* don't just tell people that you love them. Tell them *why* you love them and what it is about them that you love. Specifically. You go first.

They Just Don't Understand

Following a talk I gave in Orange County recently, one man said, "I am completely understood at work, but my wife doesn't understand anything about me. Not one single thing." His frustration was apparent.

I asked, "Do you understand your wife?"

It got really quiet.

It is possible that both individuals in this marriage are self-absorbed and strong-willed. I could envision a clash of wills at home that this man does not encounter at work, where he holds a leadership position. I wondered about his statement of being understood at work. I had the feeling that to him, a "fierce" conversation looked like him giving orders—"Bruce, you take that hill. Sally, you take this one"—or expressing his displeasure at marginal performance with a raised eyebrow and a tug at the cuffs of his Armani turtleneck. I wondered how his employees and his wife would answer the question "Does he understand you?"

The very next week at a workshop in San Francisco, following a practice session on Mineral Rights, a participant, Mike, protested, "But this isn't a conversation; it's an interview! I don't want to interview my employees. I want them to hear what I'm telling them!" Later in the workshop Mike talked about how frustrated he was with one of the people who reported to him. "This guy doesn't listen. I talk and I talk, and he just doesn't get it."

There's a theme here—this unfortunate context around the meaning of the word "conversation." I see it all the time. Frequently, the context is: *I'll talk, you listen. We'll have had a good conversation when you finally understand me and admit that I'm right.*

This definition of "conversation" will not serve you. In fact, it can be fatal to both professional and personal relationships.

We'd all like to be understood, yet very few feel understood. We talked about this in chapter three. The question I want to revisit with you is "Who is responsible for providing this *understanding* we all crave so much?"

How about me? How about you?

Who is responsible for providing this *understanding* we all crave so much?

When the Relationship Is on the Line

Sometimes individuals in a relationship have created such a negative emotional wake that one or both participants are ready to pull the plug. Even at that stage, fierce conversations can turn things around—and it requires going back to basics.

Before any of us can answer the question "Do I want this relationship at work or at home?" we must accomplish two things.

First, our own lives must be working. In other words, we must have had the fierce conversations with ourselves that are necessary to sort out our own lives, to answer the big questions in chapter two: *Where am I going? Why am I going there? Who is going with me? How am I going to get there?* And following these conversations, we need to step onto the path and remain on it for longer than a week or a month. Otherwise, when we are unhappy, we will have difficulty determining the source. It's easy to assume someone else is the source of our angst and that we'd be happier if that person were no longer in our professional or personal lives; however, the problem may lie much closer to home.

Second, we must give to others what we most want to receive. Do you want to be with others who leave behind a positive emotional wake? Then leave one yourself. Do you long to be understood? Then focus on understanding others. Do you want to have a place at the corporate table where your ideas will be welcomed? Then welcome the ideas of the person who most confounds and irritates you. Do you want your life partner to listen to you the way he or she did when you were first falling in love? Then plan an evening during which you will focus entirely on listening to your loved one. Do you want to be able to discuss difficult issues without experiencing someone else's defensiveness and wrath, without unkind, thoughtless comments that leave you drowning in a negative emotional wake? Well, it's highly unlikely any of this will happen until you go first. And one day doesn't count. You must extend to others what you want to receive. It begins with you.

> **You must extend to others what you want to receive. It begins with you.**

People express and receive love in different ways. Read *The 5 Love*

Languages by Gary Chapman. Find out what language your spouse understands. Is it quality time? Words of affirmation? Gifts? Thoughtful acts? Physical touch? Whatever the language is, learn it and speak it.

In difficult moments, ask, "What would love do?" And do it. Do not give up. Live what you are intent on learning.

Here's where the magic comes in. A funny thing happens between people when one of them is really asking and really listening versus constantly interrupting with his or her own agenda and ascribing negative meanings to everything the other says. And when this person who is really listening operates from a well-built and well-stocked personal base camp—when what he or she lives is an authentic expression of who that person is or wishes to become—the invitation to come out from behind oneself into the conversation and make it real is often accepted. And once that happens, the armor begins to fall away, piece by piece, and we see, beneath the armor, a man's heart, a woman's heart.

Very few hearts are rejected. It is the armor that seals us off from one another and causes us to move so awkwardly through life. We recognize armor, we hear it clanking from a mile off, and we ask ourselves: "Why is he so well defended? Anyone wearing that much armor must also be well armed. Is there something I should fear?"

> **Very few hearts are rejected.**

When we remove the armor, when we come out from behind ourselves, vulnerable and without defense, there is an opportunity to understand and to be understood, an opportunity to engage in the kind of conversations some have managed to avoid having with other human beings for their entire adult lives. When you start to hear your children, your life partner, your coworker, your customer at a deeper level, you'll start getting far more information from them. The quality of your listening will allow your children to discover who they are and to start valuing themselves. They will know that you care about them, and they will eagerly commit themselves to their dreams.

Technology and Emotional Wake

Technology, as wonderful as it is, amplifies the risk of being misunderstood and presents a unique set of advantages and drawbacks. Since this book was originally published, our thumbs have become grafted to our cell phones, which we no longer use just to call and text, but also for social media. In fact, cell phones are practically an extension of the self at this point. Just yesterday, while waiting for my annual mammogram (*so much fun, having your body parts placed in a vise*), I typed notes on my cell phone for the section of the book you are reading now. Another woman checked e-mail. A young woman in red Converse sneakers arrived, sat, and pulled out her cell phone. A couple came in. While the woman filled in forms, the man's fingers were busy on his phone. Very productive, this waiting room.

> **Our thumbs have become grafted to our cell phones.**

But staring at our phone screens isn't always about getting things done and can leave a neutral or negative emotional wake. Executives read their e-mails in meetings, even when people are presenting. People set their phones next to their dinner plates in order to respond to every buzz and beep, no matter what they are doing—whether in a meeting, having a casual meal, or on a date. In a photo on Facebook, a family of five is in a tropical paradise and all of them are heads down, looking at their cell phones. Perhaps they were playing Pokémon Go.

According to a recent mobileinsurance.com survey, the average person spends up to twenty-three days a year staring at their phone screens. Almost a month per year! That doesn't surprise me. In the time I've spent playing Spider Solitaire, I could have written a novel, walked a thousand miles, benefiting my head, my heart, and my dogs, thrown more dinner parties, played my guitar, painted a landscape. Instead, I sat in my comfy chair and watched stupid things on TV while playing solitaire hour after hour. Visiting friends were happy to join me, playing Candy Crush Saga or Slither.io. For me, playing solitaire was a way to relax, to untether, to give me something to do with my hands while my head and my heart were on hiatus. Trouble was, it became habitual, a habit I needed to curtail.

The question for all of us to answer is—does the time we spend staring at our screens each day add more value to our lives or detract from our lives? How are e-mails, texts, Twitter, Snapchat, instant messaging, Instagram, WhatsApp, Periscope, Facebook, et cetera, adding to or detracting from our relationships? And do our e-mails, texts, and posts leave a positive or negative wake?

I decided to conduct my own unofficial research on the topic of how and why people use technology, how it affects their relationships, and whether they are happy with the results.

Peter Kim, an intern at Fierce, suggested that people post to Facebook because they feel the need to belong, to be a part of a community that gives them a sense of belonging. I felt Peter was touching on something important. Certainly, individuals can make new friends, build business connections, or simply extend their personal base by connecting and interacting with friends of friends and people with shared interests. If you're into duct tape art or taphophilia—a passion for cemeteries (remember Harold in the movie *Harold and Maude*?)—if you collect cigar bands or carve eggs, there is a community for you. But in addition to belonging, what other basic human needs are we striving and perhaps failing to fulfill through screen time?

Stacey Engle, EVP of marketing at Fierce, and one of my favorite millennials, had this to say: "We live in a time where everyone is more visible than ever before. We can even see how far our reach extends with profile views, shares, tweets, and 'likes.' In a world where every failure, frustration, and triumph is publicly recognized online, an unexpected yet poignant result is that conversely, many of us feel less 'seen,' both in the workplace and at home. This is where our friend and foe, technology, lurks—it can both help us and hurt us. Each time we post to Facebook, it's as if we're saying, 'Here I am. This is what I'm doing. See me!' The question remains: What is the value of being seen versus being understood? Do we need more visibility today or something deeper? We are seeing a whole lot . . . without truly 'seeing.' Today those who focus on going deeper and creating more understanding in our world will earn, attract, and retain more emotional capital, more dollars, more likes, and more shares."

We are seeing a whole lot . . . without truly "seeing."

Stacey added, "Being seen is hard. Connecting at a deep level is harder. We think we know a lot, but most of it is superficial. For some, posting, tweeting, garnering likes and recommendations are addictive, and yet true connection is also addictive and you can't have both. Any time spent on posting is time not spent on connection."

Being seen is hard. Connecting at a deep level is harder.

Our laptops also get in the way of connecting. When I'm conducting a training, quite a few people open their laptops, intending to take notes. They are surprised when I suggest that it is possible to capture every word and miss the message entirely. I ask that they close their laptops and simply be present, look into one another's eyes, take in whatever occurs.

Our intern, Areya Popal, suggested that the smartphone, to which we seem to be life-locked, creates the opportunity to exchange dialogue without the vulnerability of fully revealing ourselves. He explained, "When communication takes place online, important pieces of dialogue are left unsaid, emphasis and emotion are almost void, and the conversation becomes similar to computer code, just 1's and 0's. And because technology creates more of a reaction than an exchange, participants become less eager to say what they mean for fear of stepping on toes or saying the wrong thing, and thus beat around the bush or fail to get across important information that could lead to a Fierce conversation."

Very wise, millennials! Of course, Peter, Stacey, and Areya are certifiably "fierce," aware that a key focus of our work is to help people gain the capacity and the skill to connect with those important to their success—at a deep level.

Checking in with my teenage granddaughter Clara, I was surprised to learn that she is on her phone almost constantly because, as she puts it, "I want to know what's going on." Going on where? I ask. "Everywhere. With my friends and in the world." And what would it be like if you didn't always know what was going on? I ask. Clara couldn't answer, because she had never considered such a scenario. Thinking about her comment, I realize that for many—teenagers and adults—it is extremely important that others know what's going on with them and they expect us to take notice and comment.

You took a vacation. We saw the photos. Your cat coughed up a hair ball. We wish we hadn't seen the photo. You played golf on your birthday. You bought an espresso machine at a garage sale. You had Swedish meatballs for dinner. You updated your profile picture. It's your parents' anniversary. And we need to know all this why?

My Facebook page has been colonized by hordes of people I don't know, as well as ads for products that don't interest me. *A flashlight that casts a huge light. An effective bark beetle repellent. The biggest challenges around creating wealth and passive income while building a real estate business.* I've no idea how or why someone determined that these topics might be of interest to me. On the plus side, some people post beautiful, hilarious, inspiring photos and videos. The trouble is, on the rare occasions when I go to Facebook, I end up spending more time than I had intended.

I suspect that most screen time leaves a neutral emotional wake—an exchange of information, perhaps—though some leaves a devastatingly negative wake. Unkind comments, criticisms, body shaming, rants. What if we throttled back and considered our intention? What might we do differently if we realized that we may be losing emotional capital one e-mail, one post, one text at a time?

Stacey Engle offers these guidelines:

DO USE TEXT TO . . .

- communicate logistics and more directive statements

- share small praises and appreciation

- connect on special occasions

- talk through simple scenarios

DON'T USE TEXT TO . . .

- convey more than three sentences of thoughts at a time—a novel is not appropriate

- talk about complex emotional thoughts

- share confidential information

- confront someone

There are, of course, wonderful benefits of technology. One of my favorites is that we are able to connect virtual teams in a way never before. At Fierce, we host trainings that connect people on six continents. I can deliver a keynote without leaving my home or office. By the time you read this, our options for communicating over the Web will have expanded. For organizations with multiple offices, this is hugely important and useful. On the other hand, while virtual meetings are better than no meetings at all, everyone with whom I've spoken over the last few years expressed a need, a desire for periodic face-to-face time with colleagues, even if it required the expense of plane trips and hotels.

There is a visceral connection that is missing when we are not physically present with one another, when we are unable to interact up close and personal, when we can't detect the smile or the frown at the corner of someone's lips, when we can't pull someone aside on a break and ask a question or offer a thought, when we can't go for a coffee or a drink after a meeting and share what's happening in our lives. Talking about work is, of course, important, but we are all so much more than our jobs, and getting to know at least a bit about one another's lives outside of work helps us connect at a deeper level.

When I was running CEO groups, we began our monthly daylong meetings with a quick check-in. Each CEO quickly shared two things— his or her most significant event in the last thirty days, professionally and personally. This allowed us to tune in to the whole person, and there were times when the agenda was hijacked by our desire to help a member with a personal issue—a health crisis, a difficult, painful divorce, a troubled teenager. I brought this practice to Fierce, and until we got too big, we began each Monday with what we called "Ducks in a Row." If we did that today, it would take all morning, so we have conversation partners, groups of six who meet for an hour once a month to talk about whatever they want to talk about. *Did we approve of JoJo's choice on* The Bachelorette? *How should I have addressed a prospective client's unique*

concern? Anybody want to go to a Mariners game? I just hit my sales goal for the year and it's only June! I have filed for full-time custody of my daughter. The groups change every six months.

Speaking purely for myself, whether face-to-face or online, I'm not particularly interested in what school you went to, how much money you make, your score on the last nine holes. Many conversations remind me of a cartoon I saw years ago. A woman holding a bowl leans toward a dog. The dog is jumping. The caption: OH BOY! DOG FOOD AGAIN!

If you are an important person in my personal or professional life, I want to get past "How are you?" "I'm fine." Way past. I want to know what makes you happy, what makes you sad, angry. I want to know what you long for, what you most hope to accomplish during your lifetime, who and what you love, how you would describe your ideal day, what you would wish for if a genie popped out of a bottle. (*If I were being selfish, I'd wish that I could be fluent in every language on the planet.*) I also want to know if you've paid the price for transparency, if you're willing to live, day by day, with the consequences of authenticity. Or if you withhold your thoughts and feelings for fear of being abandoned.

What should you do when you realize that words alone may be insufficient to convey your meaning and intent? That sending another e-mail will increase the likelihood that you will be misinterpreted and leave a negative emotional wake? That an important relationship has become shallow, vulnerable? Pick up your phone! Walk down the hall. The most powerful communications technology available to any of us is eye contact. In second position is our phone, because if we can't talk face-to-face, at least we can hear each other's voices. E-mail should be our last choice. Don't sacrifice results in favor of efficiency. Stop potentially leaving a negative emotional wake in favor of saving time.

The most powerful communications technology available to any of us is eye contact.

When I don't see you, I am unaware of what may be going on for you. I am unaware of my effect on you. When I do see you, I am able to pay attention not only to the words between us but to their effect as well. *I see you. I am here.* What a lovely way to begin a conversation.

If you are still somewhat dismissive about this whole emotional wake

Learn to deliver the message *without the load.*

thing, consider that a negative emotional wake is costly. Individuals, teams, customers, and family members pay the price. In order to leave a positive wake and lessen the opportunity for an inaccurate spin to be attached to your messages, learn to deliver the message *without the load*. This is a concept that was introduced to me by my colleague Pat Murray.

Loaded messages come in many guises. At times they arrive courtesy of a person who uses sugary-sweet words yet who seems to have a malevolent undertone. Our radar picks up something else—some hidden agenda perhaps—embedded in the message, leaving us uneasy and reluctant to trust. It wasn't anything the person actually said, but rather something in the air around the message that didn't feel good. Our impeccable radar warns us to obey our instincts and be careful.

No matter how much sugar someone sprinkles throughout a loaded message, we read the underlying intent to do harm loud and clear. Consequently, we do not trust that person, we do not look forward to our next conversation, and we withhold ourselves from him or her in countless invisible ways.

Other loads are delivered straightforwardly, impossible to miss. An example is the parent who, no matter what the child has achieved, says, "That's really good, honey, but next time why don't you do it this way . . ." The load attached to this message is "Nothing you do is good enough." Once we've said it, it's out there. It's not coming back.

Once we've said it, it's out there. It's not coming back.

Likewise, many of us know people who trip all over their words and whose communication styles are inelegant, messy, or downright inappropriate, yet because there is no ulterior motive or hidden agenda attached to their messages, we are willing to listen to them and stay engaged in the conversations and in the relationships.

I often ask workshop participants to think of someone whose behavior they want to confront and imagine what they would say to that person. Then I ask each participant to identify his or her unique fingerprint—the

load it would be tempting to attach to the message. Typical responses
include such loads as . . .

- Blaming, my all-time favorite, the mother of all loads. "This whole
 thing is your fault." "You really screwed this up."

- Name-calling, labeling. "You're an insensitive narcissist." "You're
 a liar." "You're a failure."

- Using sarcasm, black humor. "Apparently, your life goal is to live
 on the cutting edge of mediocrity." "Seems you've hit bottom and
 are continuing to dig."

- Attaching global weight to tip-of-the-iceberg stuff. This small
 thing happened and it means this HUGE thing! "You don't love
 me and never did." "This ruins everything. We're finished."

- Threatening, intimidating (always a winner!). "Guess you don't
 value your job." "You'll never see your kids again." "You do this
 one more time and . . ." "Look, I don't want to pull rank, but . . ."

- Exaggerating. "You always do this." "Never once have you . . ."
 "This is the hundredth time . . ."

- Pointing to someone else's failure to communicate, assuming a
 position of superiority; the other person is clearly inferior. "You
 don't get it." "You can't handle it." "You aren't making any sense
 at all." "I can't get through to you."

- Saying, "If I were you . . ." That's a loaded phrase. If I say that,
 then you'll feel I'm saying you should have done it my way, which
 is usually what I'm saying. An additional load embedded in the
 message is: Why can't you be more like me?

- Gunnysacking, bringing up a lot of old baggage. "This is just like
 the time when you . . ."

- Assassinating someone in public. This is sneaky and cowardly,
 and we usually try to get away with it by pretending it's funny.

"Oh, yeah, Janie thinks she's pretty hot stuff!" "Apparently, George has all the answers."

- Asking "Why did you do that?" instead of "What were you trying to do?" "Why" usually triggers people. You'll get a less defensive response with the second question.

- Making blatantly negative facial expressions. No matter what I say, if I am angry or disappointed, how I really feel is written all over my face.

- Layering my interpretation on something someone has said or done; ascribing negative or false motives. "What you really mean is . . ." or "What's really going on is . . ."

- Being unresponsive, refusing to speak. Some would say this is the cruelest load you can attach. To others, it feels like a lack of caring, a lack of validation. The message: "You're dead to me" or "I don't care about this issue."

Assignment

Take a moment to recall one of your conversations at work or at home that did not go well. Forget about the other person's ineffective behavior. Focus on yourself. Revisit the conversation. Play it back in your head like a movie. See the expression on your face. What was your body language? Replay your words and listen to the tone with which they were spoken. View in your head the part of the conversation when your partner became upset or angry. What did you say or do that seemed to trigger your partner's response? Now review the list of load-attaching responses above and answer the following questions about your conversation:

What load did you attach to your message?

Is that your typical, unique fingerprint?

What effect did it have on the conversation? On the relationship?

Messages with hidden agendas usually head south in a heartbeat. In fact, the moment the underlying message is attached, whether verbal or nonverbal, one person be-

Messages with hidden agendas usually head south in a heartbeat.

comes triggered and there is no longer a conversation. Instead of a one-to-one, we have a monologue, a diatribe. Or a fight. It's impossible to have a conversation when you've already moved the other person into defensiveness. The person feels: "I just want out of this, so I'll do whatever I have to do to gut this out and get the hell outta here (and get back at him/her later)." Or we get confusion: "What do you want?" Or hurt: "How could you say that to me?"

Attaching a load to a message leaves the relationship worse off than it was before you opened your mouth. Given that one of the four purposes of all fierce conversations is to enrich relationships, we need to acknowledge our load if we have one. But beware! Don't become one of those people who are so cautious that not only is there no load, there is no message.

A Crucible

If we can agree that our goal is to deliver the message without the load, what should we do when we're triggered? When our buttons get pushed? Unfortunately, for most of us, the instant our buttons are pushed, all our hard-won skills fly straight out the window.

We all have buttons. Mine invariably get pushed when I feel that I have been grossly misinterpreted. Or when what I am saying seems not to be valued. Whether or not someone intends this, those perceptions on my part invite instant triggering. When I'm triggered, I have two ingrained reactions, two automatic, hardwired responses. One is to exit the conversation by clamming up (the silent treatment) and walking out the door. The other is to make accusations, hurl blame, and try to convince others that I am right and they are wrong. I'm not proud of this. It's just what every fiber of my body wants to do.

Of course, the instant I am triggered, my reaction triggers everyone

else in the conversation. Then they do whatever they do when they're triggered, and we quickly arrive at endgame. It's not pretty. We've all seen it happen. When we are triggered, it is essential to get ourselves untriggered and fight off the tendency to attach a load. The following story may be helpful.

Years ago, I went to Denver to spend time with Laura Mehmert, a dear friend from high school. We went to a foundry where her eight-foot bronze of a cowboy carrying a calf was being poured. In a foundry, the crucible is what holds the molten metal, which is then poured from the crucible into molds to cool and harden so that it can become the work of art conceived by the artist.

I watched as the molten bronze swirled, burbled, hissed, steamed inside the crucible. The question that intrigued me was "What is that crucible made out of? Why isn't it melting?"

The foundry owner explained, "Most crucibles are made of either clay graphite or silicon carbides—fragile materials, essentially, some of the same nonchemical ingredients in porcelain. If a crucible were dropped on a concrete floor, it would crack or shatter. When a new crucible arrives, I strike it to see if it will ring. If it has a sharp sound, it's okay. If it has a dull, thuddy sound, it's damaged."

The foundry owner warmed to the topic and continued. "The gold and silver used in computers are refined in crucibles. Your dentist has a crucible. You'll find castings in hospitals, cars, dams, wind generators, cemeteries. Crucibles have a role in forming castings that take people from birth to death."

As do our conversations.

Several weeks after visiting the foundry, I returned to Denver to see Laura's wonderful sculpture, which had been installed in a park near her home in Evergreen, Colorado. We arrived at the park in the early morning. *The Foreman* was magnificent. His long coat blew out behind him, as if he were leaning into a storm. His head was lowered toward the calf, safe in his arms. The calf seemed vulnerable, yet its eyes were soft, not frightened. As I walked around *The Foreman,* touching it, marveling at its beauty, and recalled the crusty crucible in which it had begun to take shape, I had an epiphany or, as I prefer to say, an apostrophe.

My "apostrophe" was this: What if *I* could become a crucible—a

strong, resilient vessel in which profound change could safely take place—for my clients? for my family and friends? for *myself*?

> **What if *I* could become a crucible—a strong, resilient vessel in which profound change could safely take place?**

In creating a work of art, the crucible has an important job—simply to *hold,* no matter what is poured into it, under extreme heat. I relate to the fragility of the crucible. If I get dropped, I could get hurt. I could crack or break. I am vulnerable. So are you. However, during important conversations, my job is to hold, so that we are able to discuss what needs discussing, no matter how challenging the topic and no matter how fragile and vulnerable either of us may be feeling at the time.

The image of the crucible helps me reconcile being real and having all the emotion, including the occasional charge of anger (my own or that of others), while remaining a place where what needs to occur can occur. It reminds me that my job is simply to hold, to withstand, so that whatever needs to be said, what needs to be heard, can safely be said and heard. It reminds me that the relationships central to our happiness, success, and peace of mind are works of art that form over time as a result of fierce conversations.

Each of us is a place where conversations occur. You are a physical, emotional, spiritual, and intellectual place where conversations happen. You do not need a special weekend getaway to a romantic B and B in order to have that important conversation with your significant other. You do not need a title, a boardroom, or a fancy office to have the conversation needed to enrich your relationship with your boss, colleague, or customer. You

> **Each of us is a place where conversations occur.**

do not need a diploma to be a human being, to be a friend. What is needed is *you,* willing and ready, available, clear, and clean.

Fred Quiring, a fly-fisher, uses the metaphor of an alpine lake to describe his aspirations for himself. When still, the lake notices everything that is happening. Standing on the bank, Fred can see the tiniest mayfly light on the water; he can see the trout rise. It's as if the lake has soft eyes. Eyes that miss nothing. The lake knows its own depths, what life exists in the lake, while being still and paying attention to what is happening. Fred knows from experience, however, that when the lake is

turbulent, you could drop the Empire State Building into it and the lake wouldn't notice.

When Fred becomes like that still, calm alpine lake during his conversations, others can put something difficult into the conversation and Fred can see it and respond. He can decide what to do.

In *The Amazing Adventures of Kavalier & Clay*, Michael Chabon writes, "Every universe, our own included, begins in conversation. Every golem in the history of the world . . . was summoned into existence through language, through murmuring, recital, and . . . was, literally, talked into life."

In Jewish legend, a golem is a creature made of clay and brought to life by magical incantations. It occurs to me that each of us has talked our own particular universe into existence. Every entrepreneur remembers talking his or her company into existence. And how did we get to this joyful or difficult place with our partner, with our children, with our sibling? We talked ourselves here. Or refused to talk.

The conversation is not about the relationship. The conversation *is* the relationship. All of the idols and ideas we use to defend ourselves have been talked into life. Our work, our relationships, and our lives succeed or fail, one conversation at a time. From birth to death.

Each of us has talked our own particular universe into existence.

What kind of conversational place do you want to be? Do you want to be described as a mentor, a dementor, a tormentor? Assuming the former, what words come to mind? *Centered. Present.* You fill in the rest.

What If You're Angry?

Which is worse: not delivering a message at all or delivering a message with a load attached? What about honesty, mixed with a bit of dark humor?

Can you imagine saying to someone, "I am not happy with you right now. In fact, I'm deeply angry and my intentions are less than noble, so how about having this conversation later"? Or, "Last night I had a dream in which bad things happened to you. I enjoyed the dream. Guess that means we need to talk."

Wouldn't this at least alert the individual that this is going to be an important conversation and that, therefore, it would behoove him or her to pay attention and to show up for the event? The person with whom we want to talk might come to the conversation loaded for bear, but at least we will both be fully engaged because we have been intentional about the message and its importance.

Unfortunately, what many people do with anger is bite their tongues. Fierce conversations fade and die because we don't confess, even to ourselves—much less admit to others—that we are not always operating from a base camp of love and harmony. There are occasionally dark instincts at play. Like jealousy, fear, revenge.

Being human is hard! I remember reading C. S. Lewis's *Surprised by Joy*. Looking inside himself, Lewis found "a zoo of lusts, a bedlam of ambitions, a nursery of fears, a harem of fondled hatreds." I felt elated and absolved. Was it possible that the people I admired—the good, wise people of the world—were at times like me?

The emotions to which C. S. Lewis admitted are natural and exquisitely useful feelings to have. And, as it turns out, to speak. "I am angry." "I am jealous." "I wanted to see you fail." Admittedly, it helps a lot if you are not screaming such words while pounding the table or pointing a finger at someone's nose, but it's human to be angry and it's okay to tell someone what you're feeling. Otherwise, if you serve up all your angst and fire boiled down to a pablum, you may induce profound indifference.

> If you serve up all your angst and fire boiled down to a pablum, you may induce profound indifference.

How can each of us reconcile being real, delivering the real message, while taking responsibility for our emotional wake? How do we reconcile feelings of anger with authenticity? How do we deliver the message clearly and cleanly, without the load? What is our responsibility to ourselves and to other human beings?

- Recognize that everything you say creates an emotional wake.

- Understand that you can create a wake without any awareness on your part.

- Check in frequently with others to learn what kind of wake you are creating.

- Get in touch with your intent, be it noble or sinister. If your intent is sinister, now is not the time to speak. If your intent is good, it is possible to admit to anger and still leave a positive emotional wake.

- Accept the responsibility to be present, aware, authentic, appropriate, truthful, and clear.

Going into an important conversation with no intent at all is a risky proposition. After I suggested this to a client named George, he told me the following story:

When I was pitching for my college baseball team, the catcher would often walk out to the mound when I was in trouble and ask me if I had an idea about what I was doing. And what he was referring to is that behind my next pitch would be an intent, a result that I wanted, which would then determine if I'd throw a fastball low and away, a fastball high and tight, a changeup, a slider, a curveball. So what looks like one man throwing a ball to another man with a big club in his hand is actually a well-thought-out strategy by both parties, because the batter also has an intent, a result that he's after. Trouble is, during too many of my conversations, I don't have a clue where I am going, what I am trying to do, what my intent is. Everyone thinks I'm in the conversation. After all, my mouth is open or I'm nodding my head, but I'm just throwing a ball with no intent or purpose behind it. My only hope is for extra innings so I can buy a little time and clarify what I'm trying to accomplish.

Aim for the Chopping Block

It's the idea behind your words that matters. Learning to deliver the message without the load requires that you speak with clarity, conviction, compassion, and passion. You are not required to become a wimp. You do have certain rights, you know.

- You have the right to get your core needs met in a relationship or, at least, the right not to have them violated.

- You have the right to ask dumb questions.

- You have the right not to be a victim.

- You have the right to confront issues that are troubling you.

- You have the right to disagree.

- You have the right to say yes.

- You have the right to say no.

- You have the right to not have all the answers.

My best conversations result from obeying Annie Dillard's advice about writing. In *The Writing Life,* Dillard describes learning how to chop wood: Aiming for the top of the upended log resulted in splinters and chips. It was only when the thought came to her to aim for the chopping block beneath the log that she cleaved a log cleanly in two.

My karate sensei gave me similar counsel when I lived in Japan. In karate, if you aim for the brick, you may break bones and embarrass yourself. Aim for the space beneath the brick, beyond the brick. When the brick is merely an obstacle between you and your target, it will yield.

Aim past this conversation, past these words. Where do you want to go with your work? or this individual? or this marriage? or this life? What is your destination? That's your chopping block. Aim for that in every important conversation.

Sometimes we aim at the wrong thing or forget to aim at anything. *Blah, blah, blah,* we hear ourselves saying. *Dang, I'm doing it again. Okay, where was it I wanted to go with my life?* Might recalling that help us navigate a particular conversation? Well, it can't hurt.

What if your intended destination changes? I hope it does change as you get older, as you figure out what you are and what you aren't. Life is wonderfully curly, remember?

By the way, do not begin your comments with "Truthfully . . ." or

Do not begin your
comments with
"Truthfully . . ." or
"Frankly . . ." or
"Honestly . . ."

"Frankly . . ." or "Honestly . . ." That always makes me wonder if someone wasn't speaking truthfully before. Just speak truthfully, frankly, and honestly, and get on with it.

Be Prepared

During workshops, I ask participants to think about a confrontation they need to have and to answer this question: "What do you need to do to have this conversation without attaching a load to your message?" Below are some terrific answers.

- Thinking about the wake of a boat before entering into a conversation would help me clarify the emotional wake I want to leave as a result of my comments and questions during a conversation.

- I need to keep in mind that being in a relationship with the persons close to me is more important than being right all the time.

- I need to recognize that there are multiple truths.

- When my emotions are negative, the more I say increases the likelihood that there will be a negative wake, so I need to say less and listen more.

- Be intentional and choose words that are not loaded. Find words that accurately name or describe what I want to say, but navigate intentionally in my choice of words.

- Allow space for other interpretations.

- Don't use absolutes: "You NEVER . . ." "You ALWAYS . . ."

- If I expect a load from the other side, it may prevent me from initiating or participating in a conversation. If I don't expect a load from the other side and there is a load, it may push all my buttons and I could become instantly ineffective. I need to expect nothing and be ready for anything!

If you recognize that you often leave a negative emotional wake and want to correct that, the danger for you may be in going too far over to the other side. *Well, I'm just not going to say what I'm thinking. It will come out all wrong. It will harm the relationship. Every time I try to talk about this, I get in trouble. I just won't say anything at all.*

> **The challenge is to reconcile being real and doing no harm.**

Withholding the message is as dangerous to the relationship as delivering a message with a load attached. For each of us, the challenge is to reconcile being real and doing no harm.

When Saying No Is the Solution

Over the last several years, I have developed a meaningful relationship with the word "no." I highly recommend it. If we do not learn to say no, there will be no space in our lives when a powerful yes appears. Each of us will say yes and no to people, to ideas, to belief systems, to invitations, to the myriad possibilities that present themselves over the course of our lives. It is impossible to say yes to everyone and everything. At Fierce, after having agreed to several things that didn't really serve the company, including unreasonable demands from potential clients, we adopted the slogan "Say yes to NO!" We had fun with it and, in the process, became more thoughtful when responding to requests going forward.

Saying no is not the problem; in fact, it is often the solution. It's the *way* you say no that gets you in trouble. It's the way you disagree that harms or enriches a relationship. For example, "You don't know what you're talking about" is guaranteed to prickle the person on the receiving end. "I have a different perspective" will likely go down easier and keep the

> **Saying no is not the problem; in fact, it is often the solution.**

conversation going. The challenge is to say what we need to say, what is true and right for ourselves—one conversation at a time—and to say it in a way that does not leave boats crashing against the dock in our wake.

In *Repacking Your Bags,* Richard Leider shares his personal mantra:

"I am in the right place, with the people I love, doing the right work, on purpose." I like this because it is short and simple, covers lots of important ground, and most decidedly provokes choices—about personal relationships, professional opportunities, lifestyles, and with whom and how Leider spends his time.

Sometimes people we count on fail us once too often. We come to grips with the fact that the financial value of a customer does not counterbalance the frustration of doing business with that company. We accept that an employee simply cannot succeed in the job they are in. And, most painful of all, we can no longer deny that a personal relationship cannot be saved.

We know something needs to end.

Early in any significant relationship—professional or personal—pay attention to what someone does. Relationships go on far longer than makes any sense because we don't want to believe what we see, hear, feel, and sense in our gut. We don't want it to be true. When you find yourself frustrated by someone's behavior, remind yourself that our behavior—how we show up—comes directly from our capacity, both genetic and historic. As Maya Angelou wrote, "When someone shows you who they are, believe them the first time." Do not delude yourself that if you say just the right words, in just the right tone of voice, at just the right moment, with just the right music in the background, you will rewire genetics and transform history.

> We show one another who we are every minute of every day.

Pay attention. We show one another who we are every minute of every day.

If the message you've been trying to deliver is that you want another human being to change at the core, that's unlikely to occur, so reexamine your message.

Sit, Stay!

There is one requirement: *Complete the conversation.*

Hang in there. See your conversations through to completion. No fair starting a pebble rolling and then running when the landslide begins. No fair behaving in ways guaranteed to evoke anger or fear or

sadness in any sensate human being and then exiting the conversation, declaring, "I can't talk to you. You're too angry."

If you create a mess, either single-handedly or in partnership with someone, do not bolt when things get emotional. Some topics of conversation are dicey, at best. But if you started it or you caused it, stay to the finish, even if the finish isn't what you had envisioned ahead of time. You hoped for twittering bluebirds. You ended up with a seriously teed-off condor. Sit. Stay. Complete.

Sometimes you just need a well-oiled reverse gear. "I was wrong. I'm sorry." These are important words that too often remain lodged in our throats, even when we know they are desperately needed.

Sometimes you just need a well-oiled reverse gear.

To whom do you owe an apology? Above all, admit it when you're wrong and, if it's appropriate, apologize. People who are never wrong are teetering on the edge of divinity. And likely teetering at the edge of the end of a relationship.

When Is It Okay to Lie?

I was tempted to invent an eighth principle: When all else fails, lie. We have all told lies. In fact, in my TED Talk on radical transparency, I suggested that I could have titled it: "Liar, Liar, Pants on Fire." Can you imagine what it would be like if every time we lied, our pants ignited? This would either solve the problem immediately or we'd all carry personal fire extinguishers.

I've lied to avoid inflicting undeserved and unnecessary pain on others, and sometimes to make myself look more accomplished. Not proud of this, but there it is.

Remember my artist friend Laura? When we were in high school, one winter we went to Young Life's Frontier Ranch in Colorado. There was a gorgeous camp counselor named Dieter. When he asked me if I skied, I said, "Yes!" so he invited me to go up on the lift with him. I nearly fainted. *This Nordic god wants to ski with me?* The truth was that since I had grown up in Tennessee, I had never been on skis in my life except earlier that day when I learned how to snowplow. I had no ski

clothes, no equipment, so I was in jeans and a sweatshirt and my skis and boots were rented. By the way, this was so long ago that my skis were made of wood!

Dieter's first clue that I hadn't been truthful was that I was hardly a picture of grace trying to get on the chair and I sprawled on the snow getting off at the top. Standing at the top, he asked me what level skier I was, and fool that I was, I replied with a bit of bluster, "I can take care of myself." And down the mountain he flew. I believe the sign said Black Diamond. I was petrified but gave it a go. And of course I fell. And fell. And fell. Dieter was long gone. And when I fell for the sixth or seventh time, the front half of one of my wooden skis broke off, tumbled ahead of me, lodged against a rock, jagged end up, and I fell on it. The rest of the story involved a toboggan sled, a long trip in a truck down the mountain to a hospital in the company of two counselors, and a kid with a broken leg who kept screaming, while the truck stopped periodically to pack more snow on my stomach where the ski protruded from my lower abdomen. I spent the rest of the week in the lodge in front of the fireplace.

Everyone knew that I had lied to Dieter about my abilities. Imagine the look Laura gave me the following summer, back at Frontier Ranch, when I told another handsome counselor that why yes, I could do a swan dive. If that "dive" had been filmed, you would see it on YouTube under "Worst Swan Dives in History." The landing was painful. That night in our cabin, Laura prayed aloud. "Dear Lord, please help Susan stop lying. She gets hurt every time."

But what if telling the truth could hurt someone else?

Recently, a friend named Sandy called to ask how she could tell an online dating candidate whose photo she had just seen that she was not interested in meeting him. His accompanying e-mail had read, "If you see the photo and change your mind, it's okay." Heartbreaking.

What do you do when you encounter an individual who is used to rejection and whom you, too, intend to reject? This is where that old fallback—What would love do?—comes in handy. It wouldn't have felt very loving and would have done no earthly good to give the honest reply, "I'm glad it's okay, because now that I know what you look like, I'm not interested." So Sandy lied. She e-mailed him that she had met someone else with whom she wanted to spend time.

Yes, there were issues of guilt, feeling small and petty, thinking that she shouldn't judge someone for their appearance. But the truth was, his physical appearance was not remotely attractive to Sandy and she would not have been able to get past it.

Life is short. You know what you want, but why be unkind?

Life is short. You know what you want, but why be unkind?

Where we get into trouble is in taking the high road too often. It's easy to withhold important messages from others, supposedly for the sake of being kind, when in reality what we most need to do is come out from behind ourselves into the conversation and let someone know how we really feel.

I faced a real moment of truth with my mother many years ago. My spiritual practices had diverged from hers, and because I knew it would trouble her, I avoided the topic and said as little as possible when she brought it up. "Why bring her pain?" I reasoned. "Why cause her worry?" I didn't want to try to persuade her to my beliefs. I just wanted to follow my own path and felt I could do that quietly, with no media alerts.

It had become apparent that my mother sensed my changing sensibilities, because her letters (before she got a laptop) were increasingly sprinkled with quotes from the Bible, and she seemed determined not to miss any opportunity to proselytize. It had gotten so bad that I hated to open her letters. Meanwhile, my mother, my sister, and I were going to spend a week on Sanibel Island, Florida, and I was beginning to wonder if we'd end up in one long dance of avoidance.

This was years ago, when I hadn't yet gained the courage and skill to have challenging conversations face-to-face or voice-to-voice, so I turned to my laptop. It took me the better part of a day to compose an e-mail letting her know of my concern. I wrote and rewrote it. Among other things, I wrote, "You have always valued truth, and it is wrong for me to conceal my beliefs or to withhold my concern about our upcoming vacation together. I want to enjoy every moment with you, and right now I imagine at times trying to avoid you."

I waited an agonizing two weeks to hear from my mother. When I finally did, I cried tears of relief. Her letter said, "Darling, I understand

completely. Yes, I'm sad that you no longer go to church, but don't worry. We'll have fun together in Sanibel. That's what I want too."

We had a wonderful time, shelling, swimming, eating out, just sitting quietly, talking. There was no awkwardness in our conversations, no hidden agendas. And after that trip, we began to speak freely of our beliefs, with no desire to influence the other, only to understand and explore. My mother is gone now, but she isn't finished with me. I can ask any question and know how she would respond. It is comforting to know someone that well. And be known.

Today I sometimes hear an adult say, "I can't tell my mother." "I can't talk with my friend about this." Or, "I can't tell my husband/wife." All supposedly for fear of leaving a negative wake by disappointing or hurting someone. The reality is that the negative wake is left by the lack of those very conversations, as the list of "safe" topics dwindles to a pitiful few.

Assignment

Write down the name of someone at work or at home to whom you need to deliver a message. Craft your message, taking care not to attach a load to it. Practice saying it out loud. Go to the person and say it.

Ask yourself, "To whom do I need to deliver a message, and what is the message I wish to deliver?" Here are some fictional ideas to get you started:

- My employee Carolyn. The message I want to deliver is: I'd like for you to step up to the plate on this project and become less dependent on me.

- My son, Allen. The message I want to deliver is: I'm very proud of you.

- My pushy customer. The message I want to deliver is: We've given you our best pricing, and based on your requests, we have made additional accommodations. We cannot accommodate you further.

- My husband, John. The message I want to deliver is: I am frightened that our marriage is at risk. I'd like for us to find a way back to each other.

What is your intention behind this conversation? What do you want of this relationship? Remind yourself that you have a responsibility to come out from behind yourself into the conversation and make it real, while taking responsibility for your emotional wake.

A word of congratulations. You've come a long way since chapter one. You've deepened your understanding of six principles of fierce conversations and developed your skills. You're having memorable conversations that interrogate reality, provoke learning, tackle tough issues, and enrich relationships.

You will be surprised by Principle 7. Practicing it will add the perfect grace note to your conversations yet to come.

A REFRESHER . . .

- In any important relationship, there is no trivial comment.

- Give to others what you want to receive; live the principles you are intent on learning.

- To deliver the message without the load, clarify your intent; aim for the chopping block.

- When you get triggered, become a crucible—a strong, resilient vessel in which profound change can safely take place.

- Complete the conversation.

PRINCIPLE 7

Let Silence Do the Heavy Lifting

Where in your life did you become uncomfortable with the sweet territory of silence?

—Native American saying

D o you know someone who will most likely die with his or her mouth open? Many CEOs I know would make this list. That is not good. A dazzling way with words rarely proves to be enough to guarantee success as a leader. Joseph Conrad suggested, "To have the gift of words is no such great matter. A man furnished with a long-range weapon does not become a hunter or a warrior by the mere possession of a firearm; many other qualities of character and temperament are necessary to make him either one or the other."

Many people attempt to forge relationships exclusively through words. Lots of words.

But consider the word "conversation." You'll remember that it begins with "con," which means "with" in Spanish. The best leaders talk *with* people, not *at* them. Emerging entrepreneurs have special challenges. They can get so wrapped up in telling the story of their businesses in order to attract employees, vendors, and investors that they no longer have conversations. They stick to their practiced scripts, unable to improvise or offer new insight, forever

> The best leaders talk *with* people, not *at* them.

circling back to their rehearsed messaging. They have "versations." Politicians are aces at this.

Talking *at* people, talking *to* people versus *with* people is a common affliction. In fact, on a purely practical note, did you know that eight out of ten sales proposals fail? And 50 percent of those eight fail because we spend too much time talking about the features and benefits of our product and not enough time talking with the customer, listening to learn where it hurts, so to speak, and what they actually need, *before* we explain how wonderful doing business with us would be. Several years ago, the sales team for the Northwest division of a well-known, global company went through training in fierce conversations. Following the training, they changed the customer conversation with seemingly minor, subtle shifts and outperformed all other teams worldwide.

We all know people, intent on impressing us, who talk so much that they turn us off completely. Such people are often unconscious of the effect they are having on others, as they run on endlessly about their accomplishments and clever ideas.

They may be spectacularly brilliant. They may be kind and good-hearted, with a work ethic that would buckle most people's knees. The trouble is, it wears us out to be with them. They talk incessantly, going from one story to the next, without taking a noticeable breath. Though their stories are at times entertaining and laced with insight, after a while we get the feeling that we are merely a spot on the wall to which they direct their comments.

I recall having dinner with a man who was clearly performing for everyone within earshot. Not only was he not talking with me, but he wasn't even talking at me. He was just talking, loudly enough to be overheard, hoping to impress. It was a serious turnoff. I prefer the company of those who are comfortable with silence. I'm with Sherlock Holmes, who said to his sidekick, Dr. Watson, "You have a grand gift for silence, Watson. It makes you quite invaluable as a companion."

> You have a grand gift for silence, Watson. It makes you quite invaluable as a companion.

In *Siddhartha,* Hermann Hesse writes, "Within you there is a stillness and sanctuary to which you can retreat at any time and be your-

self." *The 7 Habits of Highly Effective People* by Stephen Covey begins, "I'm busy, really busy. But sometimes I wonder if what I'm doing will make any difference in the long run." Montaigne wrote, "If my mind could gain a firm footing I would not make essays. I would make decisions. But it is always in apprenticeship and on trial."

It is exceedingly difficult, almost impossible, to gain a firm footing in conversations filled with noise. At a party recently, several guests had paired off in conversation, attempting to use the opportunity of time together to have real, meaningful talks with one another. But the noise of all the other guests interfered with their ability to discern the message and intent of the one person to whom they were trying to listen. Struggling to be heard, each speaker became louder and louder, but that only increased the total noise in the room, making it even more difficult to hear. Several individuals periodically shouted into cell phones. What happened next? Most people gave up and settled for the traditional cocktail party chitchat. As Yogi Berra said, "It was impossible to get a conversation going; everyone was talking too much."

> It was impossible to get a conversation going; everyone was talking too much.

There is a place for big, noisy gatherings. I enjoy the energy, the full sensory experience, of a space filled with high-spirited individuals: at family gatherings during the holidays, for instance, or at parties celebrating individual or organizational milestones. However, while there are remarkable conversations to be experienced in the crush of crowds, amid the din of voices and music, the need for spaciousness in our most important conversations inspires me to take work teams on retreat to places where we can build a fire, rather than to a traditional hotel. We have taken over a small lodge in Sun Valley. We have rented log homes on the Deschutes River in Bend, Oregon. We have boated in the San Juan Islands. We had time simply to hang out beside a crackling fire, cook dinner together, have s'mores, and talk about nothing, about something.

And when it was time to talk, we turned off our cell phones. In theaters an announcement is usually made before the curtain goes up. "Please turn off all cell phones, and if you have a piece of candy or a breath mint, please unwrap it now." I wish important meetings, important conversations, began with similar instructions.

Bob

On the mahogany credenza in Bob Sloan's office sat an executive version of the lava lamp, an upright glass tube in which floated glass teardrops filled with colored oil. Next to it was a rose-colored blown-glass shell. I worried for their safety, since Bob moved about his office as if he hadn't gotten the hang of steering his body. Like a helium balloon, he glanced off doorjambs and the corners of furniture.

Bob blew words like bubbles, lips puckered as if to make car sounds for the amusement of a child. Bob's pout was so extreme that by the time the sound of a word made its way from his mouth to my ears, he had gone on to the next word. The effect was that of watching an out-of-sync movie.

He went from word to word to word. Endlessly. To make matters worse, he spoke in a monotone. Consequently, I often struggled to pay attention.

During my third visit to his office, I determined to improve things, at least from my perspective. I mustered my resolve and interrupted him.

"Bob, we aren't having a conversation. I am simply enduring a monologue."

He smiled sheepishly. "Yeah, my wife tells me the same thing." And he kept right on talking. About ten minutes later, I got up and walked to the door. Bob looked at me quizzically as I paused in the doorway.

"Where are you going?"

I replied, "I'm leaving. You don't need me, and besides, I'm bored out of my mind. You remind me of someone from my past who had a style of lovemaking that did not require my presence."

"What?!"

"Never mind. The point is that I don't think you've taken a breath in the last twenty minutes, and I haven't been able to get a word in edgewise, so perhaps I'll take a little walk, visit with some of your employees."

You remind me of someone from my past who had a style of lovemaking that did not require my presence.

Bob sputtered, "Wait a second. Time with *me* is what I'm paying for."

"I see it differently." I knew I had to be bold and clear to get my message across. "You did not buy my time or my posterior in a chair. You paid to have an interaction with me and you're not getting it. Consequently, I'm having trouble paying attention. Perhaps some fresh air will revive me."

I waited as the words sank in, and then continued. "There are times for each of us when what we need most is simply to talk to someone who is really listening. There is also value in dialogue. You and I haven't had the second experience. So far, we haven't had one-to-ones. We've had 'ones.' I've got a pretty strong personality. If I've given up trying to interject a comment into our conversations, I wonder where else this is going on in your life and what price you might be paying. I hate to think what meetings are like around here."

> So far, we haven't had one-to-ones. We've had "ones."

Bob looked away, down at his desk, out the window. Finally I asked, "So where else is this going on?"

He answered immediately, quietly, "I think my wife wants a divorce." He stared at his hands. "There are probably some people here, too, who aren't happy."

"Who would that be?" I asked.

"I don't know."

"Who would it be if you did know?"

Bob smiled faintly. "Jim, my director of engineering."

"Okay, can we talk about Jim? And about your marriage? I suggest that we allow some silences as we talk, so that we can sit and think and feel and get as in touch with reality as possible." Bob nodded, I sat down again, and we began our first real conversation.

Bob was right about his wife, and sadly, it was too late to save the marriage. In *A Man Called Ove*, by Fredrik Backman, Ove describes his relationship with a neighbor. "It was more an argument where the little disagreements had ended up so entangled that every new word was treacherously booby-trapped, and in the end it wasn't possible to open one's mouth at all without setting off at least four unexploded mines from earlier conflicts. It was the sort of argument that had just run, and run, and run."

So many words, so little substance. Or we fall silent, the wrong kind of silence, like the silence Bob's wife probably fell into, married to a man who wasn't interested in what others, including his wife, might have wanted to say. And we pay the price.

The "Problem" with Silence

In an article titled "Language, Customs, and Other Cultural Tips for Job Interviews," Chinese job applicants are counseled: "The Chinese are more likely to accept or even to appreciate silent periods in conversation. American custom is not to allow long silence during conversations, especially during business meetings, including the interview. Silence makes many (but not all) Americans nervous." A Web site advises Finnish exchange students that an American characteristic is "general discomfort with silence in conversations, homes, working places."

> An American characteristic is "general discomfort with silence in conversations, homes, working places."

This strikes me as embarrassing and true. It's no wonder. From the time most Americans are small children, we are taught to dislike silence. The punishment of being sent to one's bedroom for "quiet time" or "time out" causes children to plead for mercy and promise to be good. And what is this dreaded sentence they wish to avoid? Silence.

It is a phenomenon of our times that, for many people, silence is almost unendurable. Silence makes us nervous. So do innovation, change, and genius. As adults, we fear that silence may be interpreted as low self-esteem or questionable intelligence. We feel we're expected to interject witty comments and wise observations on the spot. Many feel silence is a form of nonparticipation, signaling lack of interest. We fear people will think we have nothing more to say. The worry may be "If I just sit here and think for a moment, somebody else will jump in and say the clever thing I would have liked to say."

> Silence makes us nervous. So do innovation, change, and genius.

At a workshop with executives of a global organization moving at

the speed of light, we were discussing the question "What am I pretending not to know?" The house came down when one executive admitted, "My question ought to be 'What am I pretending *to* know?'"

For fear of being thought clueless, have you dived into a conversation, throwing out opinions, arguing your point, defending your ideas throughout a debate, only to discern later, once you stopped to catch your breath, that there was another, wiser road you could have taken?

> My question ought to be "What am I pretending *to* know?"

It is understandable that emerging leaders believe they need to be fast on their conversational feet, able to engage in clever repartee. That is what is admired and rewarded. The belief is that leaders always have answers at the ready. It's not okay to just sit there. You've got to say something.

Fierce conversations, however, *require* silence. In fact, the more emotionally loaded the subject, the more silence is required. And, of course, this carries over into our homes, into our personal relationships. Often we are simply trying to intuit something about ourselves, our companions, or the topics themselves. Sometimes we need silence in which to make a decision about the closeness we feel for our companions or the distance we feel from them. Once in a precious while, silence is merely abstinence from self-assertion. For many work teams and couples, however, it is easy to fall into a conversational pattern that contains so many words, so much white noise, that it leaves all parties deaf to any comments of substance that could have been interjected into the conversation. We are just tossing words back and forth. Our habitual ways of talking with (or *at*) each other prevent us from allowing silence to help us get in touch with what we really want to say.

> The more emotionally loaded the subject, the more silence is required.

Here are signs that indicate silence is needed. No doubt you have observed these in others, and perhaps you are guilty of some of them yourself.

- interrupting by talking over someone else

- formulating your own response while someone is talking

- responding quickly with little or no thought

- attempting to be clever, competent, impressive, charming, and so on

- jumping in with advice before an issue has been clarified

- using a silence or break in the conversation to create a distraction by changing topics

- talking in circles, nothing new emerging

- monopolizing the airspace

Slow Down

Sometimes a dramatic intervention is required to stop the words in order to start a conversation. There are issues that our colleagues and customers will ignore every time they come up. If we are not alert, we will walk with others right past the issue. We may sense that something is there, but the conversation is moving too fast. Or because we are so invested in playing the role of "expert," we fill the air with words, missing the real issue entirely.

When our ego is dialing 911, we wouldn't notice it if our own teeth were crumbling as we drone on and on. Often my role is to slow down a conversation, and silence is my great-

> Sometimes a dramatic intervention is required to stop the words in order to start a conversation.

est tool in this. As we talk with people, as we sit with them in purposeful silence, what is in the way—anger, numbness, impatience, manipulation, rigidity, blame, ego, cruelty, ambition, insensitivity, intimidation, pride— may fall away. It is in silence that such attributes, emotions, and behaviors reveal themselves as unnecessary.

I am friends with an elderly couple who held each other and cried when their border terrier died. For fifteen years the dog had slept at the foot of their bed, snoring quietly. Each night, when one of them said, "Well, I believe it's bedtime for me," the other person and the dog rose and trundled off to bed. Each took an assigned place. The three of them, breathing through the night, each shifting positions carefully so as not to disturb. And in the morning, when one got up, so did the other two.

Good morning. Sitting quietly, sipping coffee, reading the newspaper, exchanging plans for the day and dreams of the night before. When I visit them, we sit quietly and contentedly—once four of us, now three—in silence. Impossible to explain to others, great and easy friendships like this, nurtured in silence.

Have you lost a healthy, affectionate relationship with silence? Are you uncomfortable with even brief moments of silence? Do you turn on the TV, not to watch it but to be comforted by the background noise that you have come to require?

What if you turned off the TV? As much as you love music, what if you turned everything off? Pandora, Spotify . . . I've created at least thirty music stations. From John Rutter to Hawksley Workman to The Unthanks. Love them and many more. But do you know what the wind sounds like in the corn, in the hedgerows? When was the last time you listened to the sound of rain falling? Or frogs in the pond? Or cicadas in the pines? Do you know the sound of your own breathing?

Do you know the sound of your own breathing?

Middle Beach Lodge

I recall a drive to Middle Beach Lodge in Tofino, British Columbia, where I was to talk with a group of CEOs and their spouses, early one summer. The trip had required taking a floatplane from Seattle to Nanaimo. From the plane I glimpsed pods of orca whales. Striking swaths of ultramarine and emerald-green currents stippled the water. The pilot had issued earplugs, which I welcome in small planes, not just for protection from the sound of the noisy engines but because wearing them is like being underwater. Hearing is turned acutely inward. Try it. Plug up your ears and listen. You can actually hear your heartbeat. Spending an hour or so listening to one's own heartbeat while watching orcas is a blessing.

Upon arriving in Nanaimo, I rented a car and began the drive to Middle Beach Lodge. The road winds through mountain gorges, along lakes, through tunnels. I had planned to find a good radio station and

sing along, but in the mountains there was only static, so I turned it off and surrendered to the view.

Ahead of me were two and a half hours of simply looking, breathing, and being available for focused thought. A topic, a complex issue that I had skillfully postponed addressing, presented itself unbidden. I didn't know when I was going to take it on—just not anytime soon. However, driving to Tofino, with no agenda and no distraction, the internal conversation began, as circuitous as the road I was navigating. Fascinating scenery, inside and out. I arrived at the lodge in late afternoon, filled to the brim with the beauty of the physical terrain and having come to a helpful conclusion.

My hope is that, if for no other reason than to begin a practice that will enrich your conversations with yourself, you will begin to wean yourself from noise. Pull back your hand from the remote control. Mute your cell phone. Sit silently for a few moments. Might this be uncomfortable? Yes; however, there are insights and emotions that can find you in no other way than through and within silence. This is true for our conversations with others as well.

> **There are insights and emotions that can find you in no other way than through and within silence.**

During his interview with Gabriel Byrne on *Inside the Actors Studio,* host James Lipton asked his traditional questions, including, "What is your favorite sound?" Byrne answered, "Silence." I have heard that this was true for Katharine Hepburn as well.

During my conversations with the people most important to me, silence has become my favorite sound, because that is when the work is being done. Of all the tools I use during conversations and all the principles I keep in mind, silence is the most powerful of all.

The Space Between Thoughts

In conversations, as in life, less is more. It is a good idea to breathe. Stillness is good. And walking. Breathing is best. Memorable conversations include breathing space—or just space, of any kind. My motto is: *Don't just rearrange the furniture. Toss it out. Become a minimalist.*

Deepak Chopra refers to the space between thoughts as the place where insight can make itself known. The trouble is, for most of us, there is no space between thoughts. This is often true for me. To my delight, I discovered that fly-fishing is a remedy for my affliction, allowing me to flip the "off" switch in my head. When I have spent half an hour or so entirely focused on placing a fly on a particular glint of water, there begins to be spaciousness between my thoughts. These days, I fly-fish because it gives me an opportunity to visit fish in the beautiful places where they live and because I need what it does for me.

I also need what silence accomplishes during my conversations with others. Thinking back, I see that my best and most memorable conversations have been filled with silences.

Consider this: How can any of us successfully and authentically interrogate reality, provoke learning, tackle tough challenges, and enrich relationships in a talkathon, where nary a breath is allowed?

Talking does not a conversation make. Words in the air are not guaranteed to accomplish anything useful. Mabel Newcomer, author of

> **Talking does not a conversation make.**

A Century of Higher Education for American Women, said, "Never mistake activity for achievement." I would add, "Never mistake *talking* for *conversation*." The novelist Marjorie Kellogg wrote, "They had lived together for so many years that they mistook their arguments for conversation." Or *worked* together for so many years.

While the occasional stream of consciousness can be illustrative, important conversations require moments of silence during which we may reflect on what someone has said and consider our responses before opening our mouths. Otherwise, our knee-jerk responses may not reflect our highest and best thoughts. How could they? We haven't had a moment to consider what they might be.

The Rest Between Notes

Listen to almost any piece of classical music. As you listen to the conversations in your life, compare them with music performed by skilled musicians.

My gardening companion for several years was often my next-door neighbor Melinda Wang, age seven when we first met. Melinda and I had wonderfully fierce conversations while I was weeding and digging. We discussed the pros and cons of certain insects' insistence on cohabiting with us. How difficult it is to like some people. What a crazy, mixed feeling of terror and glory it is to stand before an audience. (Melinda gives violin and piano recitals; I give keynote talks.)

When Melinda spotted me unloading plants from my car, she knew where to find me for the next several hours. I had encouraged her to let herself in through the garden gate and join me. Often she found me standing still, gazing at the garden, considering moving plants from here to there like furniture, to create a more pleasing outdoor "room." Melinda instinctively fell silent, and I was grateful. Otherwise, my mind's eye would strain to bring the master plan into focus.

Special treats were the backyard concerts when Melinda brought her violin. Mozart and melons. Schubert and sugar snap peas. Years ago, my daughter Jennifer studied violin and often played for me in the garden. If you haven't planted Magic Carpet spirea and Russian sage to the tune of a Vivaldi violin concerto, you haven't lived, I tell you.

At seven, Melinda had begun to phrase the pieces she was learning with a growing sophistication. Unlike most young children who play a piece hell-bent to the end, no stops, no pianissimos, in a race to the finish, Melinda had a maturing ear. She noticed that it is in the rests between notes that music is savored. It is in the silence trembling at the end of a gorgeous musical phrase that our hearts swell. It is in that moment that we believe all things are possible, that we can be good, that perhaps we can make a contribution to mankind.

Anyone can play the notes. The magic is in the intervals, in the phrasing. That's where silence comes in.

Anyone can play the notes. The magic is in the intervals, in the phrasing.

How do we let silence do the heavy lifting? Provide it. Allow silence to fill in the greater meaning that needs to be there. When we are completely engaged in talking, all of the possibilities for the conversation grow smaller. Perhaps if I close my mouth, you'll open yours.

In *The Feast of Love,* Charles Baxter writes, "What does it mean, knowing how to keep silent? What kind of silence would this be? How does this particular silence contrast with being morosely mute? What is a knowledgeable silence? How would we know or for that matter recognize this knowledge?"

Perhaps if I close my mouth, you'll open yours.

When you ask the opening question in Mineral Rights—*What is the most important thing you and I should talk about?*—keep silent. Wait quietly. The universe will not respond if we grow uncomfortable and impatient. Sometimes all that is needed is that we get out of the way, stop trying to help.

And what do you do when the conversation has lost its way? Sometimes the simplest thing you can say is "I'm sorry, I've lost the thread."

During company meetings, often the best responses, the most brilliant solutions, come from the person who has sat silently listening for a very long time while the rest of us filled the air with debate. Even when called upon, such an individual often appears reluctant to speak, sitting in reflective silence for agonizing moments while others click ballpoint pens and check their cell phones. Then he or she speaks, and everyone else in the room is compelled to shift to a broader, wiser perspective, with the result that elegant, complete answers begin to emerge.

Dangerous Silences

Since my work emphasizes the value of silence, it is important to acknowledge that not all silence is healthy. The silence I recommend is the restful kind, the kind that invites us to hear the quieter voices, the kind that allows us to hear the grass grow and the birds sing.

I do *not* mean the silence of nonparticipation, of passivity, of *I really don't care what you do or what you think.* I do *not* mean the cold war of silence fought by couples, the indifferent silence that chills their

hearts when they are starving for conversation, close connection, time together. I do *not* mean the silence that merely denies topics that are uncomfortable.

Several months ago, in a workshop, a woman named Nora admitted that when another participant had given her feedback following an exercise, she had initially been angry. "I wanted to jump down your throat and rip it out." (It helped that Nora was smiling when she said it.)

I found this honesty appealing. In fact, the comment further endeared Nora to the others in the workshop, including the recipient of her comment. Yet later that day, a man pulled me aside, referred to Nora's comment, and said, "How'd you like to live with someone like that?" I responded, "I prefer honest, active aggression to covert passive aggression any day." Many of us have experienced hostile silences that are far more harmful than full disclosure.

Silence is a popular form of passive aggression, intended as punishment. *I don't like what you did or said, so I'm not gonna play. I will withhold myself from you. See how you like that!* It can be an attempt to manipulate, to teach others that if they behave in certain ways, there will be consequences.

This backfires, of course. Silence over a period of time regarding an important issue or question ultimately equals a decision that will likely have negative consequences. Clamming up and refusing to talk about a particular subject at home or in the workplace reflect a decision to protect yourself at all costs, including taking the risk that someone important to you may eventually choose to leave the relationship if you refuse to address the issue.

I also do *not* mean a conspiracy of silence in an organization in which team members have taken the *omertà,* the Mafia vow of silence, not to tell who did it or what's really going on. There is a long, sad history of companies who paid a very high price, one missing conversation at a time. We used to speak of Enron. Now we speak of Takata, Volkswagen, Toyota, Mitsubishi *(what is it with the automobile industry?)* . . . and by the time this is published, more companies will have joined the list.

I worked with a large team within an international organization that had requested a customized software program. The company had spent millions to build it. All the end users had been involved in the shape

and design and practicality of the program's functions. But now that it was available, very few were using it.

Forty people were assembled to address the issue. The conversation was messy, choppy, empty, full of more "huhs?" than answers. A key executive sat in the far left corner of the room. No one noticed his silence. I turned to him and asked, "Bill, why is the software not being used?" He frowned, then shrugged, opening his hands in a gesture of "How should I know?" I waited and saw his eyes rove around the room, exchanging a look of complicity with several of his team members. When I inquired about this—"Sally, Mike, Dan, as Bill looked at you and you smiled, what message were you exchanging? What is the feeling or thought shared between you?"—the three responded with absolute silence. I turned back to Bill. "Bill, I wonder if several of the people in this room could tell us what's really going on if they had your permission. Since you're their leader, the only wrong statement from you right now is silence."

He shifted, shot me a look, examined his fingernails. Then his shoulders slumped and he sighed. "I told them we don't have time for this right now. We've got other priorities." He stopped and waited for the rush of questions, waited to defend himself. No one said anything. The silence grew as we arrived at the center of what was happening.

He looked at the CEO. "I've been putting in eighteen-hour days for six months. Most everybody here has. This new software may be great, and I know we asked for it, but if you want the deliverables you posted on every chart on every wall, we can't take time off to learn a new software program. At least, not right now. So I told my team to ignore your directives and just get the job done."

The silence continued as everyone considered what had been said, knowing it to be true. The CEO's face reflected frustration but also respect as he responded, "I hear you. I get it. Okay, what do we need to do?"

Checklist

Here is a sample list of common stories or rationalizations used to mask our fear, remain silent, and avoid reality. When we tell ourselves these stories, we become nonparticipants.

- "What do I know? She's the expert."

- "No use saying anything. He doesn't care what I think."

- "I have no idea what needs to happen here, so it's best to keep my mouth shut and pretend I'm tracking."

- "Nothing I say will make any difference. Why bother?"

- "She's just going through a hard time, just needs to talk. I have thoughts, but she won't want to hear them."

- "I'm bored, fatigued, impatient with this person [and/or this topic]. I'll adopt an attitude of polite indifference and hope it's over soon."

These rationalizations cause our conversations and our relationships to slip, slide away. We are tuned out rather than tuned in. Reality is not interrogated, no learning is provoked, tough challenges are avoided, and the relationship is not enriched. Nothing memorable occurs.

In practicing Principle 7, you will experience the value of letting silence create spaciousness in your conversations, so that you and your partner can check inside and look for what is authentic and useful.

Thoughts on Silence

Silence offers us an opportunity to think and plan downboard. Each action step we decide upon will set other things in motion. None of us is behaving in a vacuum. Everything we do has consequences for the rest of the company (or the family). We need to think in terms of "If we do this, who and what will be impacted and how? What other steps may become necessary?" Sometimes teams need to sit quietly and think about these questions.

Silence allows us the space in which to focus on the cause, not the effect. Half the battle is identifying and resolving the real issues (remember Grendel's mother?), as opposed to dwelling on symptoms illustrated with long stories. In work teams, when someone brings an issue to his

or her colleagues for resolution, if we are fortunate, after an extended silence during which everyone reflects on what has been offered for discussion, someone will say, "I don't think that's the real issue. I think the real issue is . . ." And we're off and running, recognizing with relief that we are on track at last. The problem named is the problem solved. Silence allows us to reflect on and ultimately identify the problem, so that we may focus our limited time and resources on removing obstacles in the company's way.

> **Silence allows us the space in which to focus on the cause, not the effect.**

Silence allows us to reflect on basic beliefs and paradigms regarding a particular issue before moving to options and strategy. It is imperative to give ourselves and our teams the challenge and the silence in which to ask ourselves, "What beliefs that we currently hold might be in the way of innovation and improvement?" This is almost impossible for anyone to do in a room or a house full of words.

Silence allows everyone in the room to participate fully. No matter what our areas of expertise, each of us has insights and ideas about other aspects of the organization. Silence assists individuals who usually take lots of airtime to listen more and talk less. Silence allows quieter individuals an opportunity to speak. Learning is provoked for everyone.

Silence is the best-kept secret for generating family dialogue. If you want your children to talk to you, make silence your primary skill. I used to interrogate my daughters lovingly each day on the way home from school. "What did you do at school today? Did you have fun? What did you learn?" If you're a parent, you may be smiling because you know from experience that such questions rarely elicit the responses we hoped for. Gradually I learned that the more I allowed silence following my questions, the more my daughters would willingly fill it with words like "Guess what my teacher said" or "Wanna hear something really weird?" When my daughters spoke, I could entice them to continue by simply saying, "Uh-huh," "Wow," "I see," "Really?" or even "No way!" Or I could simply nod and smile.

Silence allows us to scan our heads and hearts for ground truths. Silence allows us to examine the flotsam and jetsam in our lives and to deter-

mine its usefulness, affording us an opportunity to clear our personal and corporate windshields.

What is silence trying to teach us? *It is teaching us how to feel. How to think further.* Silence encourages us to explore a more difficult peace.

Keeping Yourself Company

Awareness requires learning to keep yourself company. Years ago a client told me about his decision to go to Hawaii by himself for a few days. He had left Seattle stressed, overburdened, and obligated to make an important decision. Walking along the beach, he came across an inviting spot beneath a palm tree. He sat down and simply looked at the ocean and the beach. He explained:

> **Awareness requires learning to keep yourself company.**

> *After a while, it seemed that my breathing matched the rhythm of the waves, and then it was as if I could see all my obligations sticking up through the sand. All the decisions I needed to make, the hundred things crying for my attention, the phone calls, the e-mails waiting for me when I got back, the meetings, all sticking up in the sand. But then it was as if a wind came up and steadily blew the sand away. And when the wind stopped, there were only two things remaining. I knew exactly what those two things were, and I could see that if I moved those two things, everything else would fall into place, sort itself out. I tell you, from this point on, I'm advising anyone who's got some priorities to sort out to go to a beach or to the mountains or someplace where they can take a walk, where they can just sit quietly and breathe.*

Do you remember those conversations with yourself that I have recommended? This is where it all begins.

There are phases to the silences in my life. Early mornings are best. I wake at four in the morning—"Oh-dark-hundred," a friend calls it.

When I'm on Orcas Island, as the coffee brews, I step outside to breathe in the fragrance of the Douglas firs supporting my tree house. The scent of rain and of the lavender that I planted years ago. The lingering scent of last night's fire in the fire pit. Cracking twigs beyond the fence signal deer. My dogs, Hamish, Tallulah, and Dobby, are on alert. We are amused by early-spring frog passion, a few earnest individuals with unresolved issues. The air has weight; it slips through my fingers like a skein of silk. On clear mornings the stars take my breath away and I am made small, humbled. A good way to begin a day.

The dogs complete their fence patrol while I pour a cup of coffee and sit in my favorite chair on the deck. As dawn breaks, my view is of the stream and pond below, of feather grasses, foxglove, lupine, out to the salt water of Ship Bay. No early-morning news, no stock market report. Not even music. Just morning light and the sound of Hamish's quiet snores as he settles nearby for the first of his dozen naps for the day.

As I sit there, at times it's all I can do not to spring out of the chair and rush to my laptop, my head reeling off the dozen things I need to do that day. "Wait," I advise myself. "Be still." And then phase two arrives. The chatter fades. I begin to learn what this conversation with myself wants to be about, the conversation that began while I was sleeping.

Before any of us can hope to engage others in wonderfully fierce conversations, we must engage ourselves in a dialogue so real, so sweet, so fierce, so filled with silences that we can hear our own heartbeat. Put your fingers up to your ears and plug your ears. Listen to your heartbeat. Look in a mirror. Look deep. What might you hear if you sat in silence and conversed with that person in the mirror? Perhaps he or she has much to tell you. So take a deep breath, ground yourself, and ask the question with which you've become familiar, "What is the most important thing you and I should be talking about today?" Then step with your partners into territory where there may be dragons, where you have plenty of questions and zero answers, where you leave your expert hat out in the hall, adopt a beginner's mind, and listen with every subatomic particle of your body. Where you screw your courage to the sticking place and ask questions that expand the possibilities for everyone, in-

cluding you. And then listen. And speak again. Samuel Johnson wrote, "That is the happiest conversation where there is no competition, no vanity, but a calm quiet interchange of sentiments."

All the conversations in the world cruise on a crest of silence. And sometimes the silence overshadows the rest. Silence is where what is real can be detected. Let silence, like a Zen koan, be your riddle. Fill your conversations with silences during which reality may be interrogated, learning

All the conversations in the world cruise on a crest of silence.

may be provoked, tough challenges may be tackled, and relationships may be enriched.

Assignment

Over the next twenty-four hours, during your conversations at work and at home, give yourself a private challenge:

> *I will allow spaciousness in my conversations, so that before I speak, I can reflect on what others have said. I will invite my partners to do the same. In doing so, I hope to get closer to what is authentic and valuable.*

For most of us, building silences into our conversations feels like an unnatural act. It takes skill to make it seem natural. If you suspect that conversations filled with silence may feel strange or uncomfortable for you or others, it may help to say at some point, "I'd like a moment to reflect on what you've said." If your partners are going too fast or seem impatient with you, with the conversation, or with themselves, you might say, "I believe this is an important topic. Let's slow down a bit so we can digest what we're saying and consider where we need to go from here."

Here, as in all the assignments throughout this book, you will gain skill and insight when you debrief yourself following a conversation. Reflect on your own participation in the conversation (good or bad) and what happened as a result. It helps to use the seven principles and four

purposes of a fierce conversation as your checklist. For example, following this chapter's assignment, ask yourself, "Did I allow silence to do the heavy lifting during this conversation? Did silence help us interrogate reality, provoke learning, tackle a tough challenge, enrich our relationship?"

Include others in the debriefing. Following this chapter's assignment, for example, you might say, "Thank you for allowing spaciousness in our conversation. I found it helpful. Did you?"

Several of my clients have created their own checklists. They suggest you know you're having a fierce conversation when . . .

- you are speaking in your real voice

- you are speaking to the heart of the matter

- you are really asking and really listening

- you are generating heat

- you are enriching a relationship

- you overhear yourself saying things you didn't know you knew

- you didn't take notes, yet you remember every word

- you listened with more than your ears

- you took yourself and your companion personally, seriously

- you left the conversation satisfied, satiated, awake, fully alive, and eager for more

- you were different when the conversation was over

Personal and corporate relationships have been enriched by taking and discussing the following survey.

Assignment

Assess the degree to which fierce conversations occur in your organization and/or family. Explore your responses. Probe for full understanding of one another's views.

1 = *entirely false* **10** = *entirely true*

There are no undiscussables in our company/family.
1 2 3 4 5 6 7 8 9 10

There are no hidden agendas in our company/family.
1 2 3 4 5 6 7 8 9 10

During meetings we say what we think, invite differing views, and explore one another's thinking.
1 2 3 4 5 6 7 8 9 10

There is permission in our company/family for everyone to "show up."
1 2 3 4 5 6 7 8 9 10

When lost in the complexity of a new situation, we pay close attention to new and unfamiliar aspects rather than take only those actions that will put things back on a track we already know.
1 2 3 4 5 6 7 8 9 10

Talk about your ratings and what caused you to choose them.

Discuss what you would like your ratings to be.

Discuss what you can do to improve.

Discuss your perspectives on the following topics:

- the outcomes of the majority of the conversations in our organization/family

- how we avoid dealing with problems

- the most important thing we need to talk about

A REFRESHER . . .

- Talk *with* people, not *at* them.

- The more emotionally loaded the subject, the more silence is required.

- Use silence to slow down a conversation so that you can discover what the conversation really wants to be about.

- Allow silence to fill in the greater meaning that needs to be there.

- Allow silence to teach you how to feel.

Embracing the Principles

Let your intelligence begin to rule
Whenever you sit with others
Using this sane idea:
Leave all your cocked guns in a field
Far from us,
One of those damn things
Might go
Off.

—Hafiz, "This Sane Idea"

Some time ago I chose to live my life at the conversational cliff's edge, breathing my way through a whole series, a whole lifetime, of fierce conversations with friends, family, clients, colleagues, and, of course, myself.

While the principles of fierce conversations may be impossible to live up to every day in every conversation, they are certainly something to aim for, for your organization's sake, for the sake of your personal relationships, and most importantly, for your own sake. Don't be hard on yourself if you stumble from time to time. Don't let a failed conversation keep you from trying again. Hang on and hang in. Take it one conversation at a time, one day at a time.

Rather than settle on a plateau of "maturity," look around for people whose conversations are memorable, people who wake you up and provoke your learning—people who are real. Excellence rubs off. You will be better company for having kept the best company.

As I said earlier, Fierce is an attitude, a skillset, a mind-set, a way of life, a way of leading, a strategy for getting things done.

At Coast Capital Savings, Manager of Corporate Learning Trina Hamilton has said this about the work they've done over the years to integrate fierce conversations into their culture:

"This is an important body of work at Coast; we live to bring financial well-being to our credit union members, and that purpose is fulfilled, one member at a time, through conversations. I want those conversations to be Fierce! In 2015, we launched an in-house development program for leaders called Leaders Who Inspire. It's a cohort-based program spanning several months. Fierce conversations are the thread that holds the program together.

"Since launch, we've had almost one hundred leaders from across all business lines and representing all levels participate. At the end of the program, here are some real examples of what graduates say:

- "I shifted from holding people accountable to holding people able."

- "I learned that coaching is not about providing answers; it's helping people to find answers."

- "I tackle my toughest challenges today."

- "I learned to always ask for feedback. You never know what you might learn about yourself."

- "I communicate more effectively, resulting in richer relationships."

- "I'm not afraid to come out from behind myself and be vulnerable in conversations."

- "I am more self-aware of how I am engaging my team in real conversations that ignite confidence, courage, and purpose."

- "I treat every conversation as a relationship."

- "I stay present and curious in every conversation and have the courage to interrogate reality."

- "I am self-aware of my legacy and how I want to show up as a leader."

Trina added, "It's not just what the graduates say about their leadership that's shifted because of Fierce. It's what's happening around them and through them. I've heard countless anecdotal comments from the participants' leaders, colleagues, and team members that point to the magic ingredient behind the program.

"One senior leader told me when he walks into a branch he can tell right away if it's led by a Leaders Who Inspire graduate. He said, with a curiously delighted smile, that the energy is just . . . different.

"A graduate used the Beach Ball conversation to engage over sixty leaders in a solution-focused conversation that yielded a $100,000 return to our bottom line in one month.

"Another graduate was promoted to a very senior, strategic role. She said the program was the reason she had the courage to apply for the role.

"The chair of our board of directors received a copy of *Fierce Conversations* at a graduation event . . . and immediately had all twenty-five graduates sign it. Since then, we've given a copy of both *Fierce Conversations* and *Fierce Leadership* to every board member. One board member asked for another copy for her executive husband."

For me, an unforeseen reward for practicing the seven principles has been a sense of sinew growing throughout my body. I've lost weight. Gotten lean. Amazing. Maybe it has to do with being willing to be vulnerable, without defense. No protective mechanisms. No armor required. Perhaps it has to do with my effort to trim all that I say to the barest bone. How close to the bone can I get? How authentic? How accurate and clear? The result is that, these days, I travel light, agenda-free.

So where should you begin? By doing. Action teaches. Engaging in fierce conversations every day will reveal the value of saying what you need to say, what you long to say. Should you run out the door, collar the first poor bloke who catches your eye, and haul his sorry backside off for a fierce conversation? Not yet. Instead, begin by tuning in to yourself. Spend time alone, in silence.

When silence has performed its useful work, do listen to music. Country, classical, blues, rock, opera, celtic—whatever pleases you. Close the door, turn off the TV, silence your phone, put on music that you love, and let yourself feel.

Writing the first edition of this book, I often listened to Kelly Joe

Phelps's CD *Sky like a Broken Clock*. I love his sound, a cross between Springsteen, Dock Boggs, and someone from somewhere on the banks of the Mississippi. The lyrics are lovely but secondary. It's simply what this music evokes in me. Unbidden. Dropping me into a funky, smooth, and groovy place where I want to pour a glass of red wine, light a fire, and reminisce. I remember evenings with friends, playing our guitars and singing by the Missouri River my freshman year of college. I can see Kelly Joe Phelps's music with my eyes. He's tapped into an artery somehow. You can't get that just anywhere.

Different gifts, memories, and emotions would be evoked by listening to Rostropovich playing Bach's cello suites or to Alasdair Fraser's Scottish fiddle or Mark O'Connor's *Appalachia Waltz*. I discovered Barrington Pheloung through the *Inspector Morse* television series. Ennio Morricone because of *The Mission*. He is eighty-seven as I write this, with no plans to retire. I want him to live forever. I pick my moods with my music. Gifts, all.

Listening to music that you love will allow you to feel what is there for you to feel, even if you have locked the door and wedged a chair under the knob. That's why we need music, seek it, sometimes avoid it. There are some songs I have to turn off. Just can't take it right now.

Put down the newspaper, the magazine, the stock market report, the crumpled articles stuffed in your briefcase, your cell phone. Read a book. Don't just read nonfiction. Pick up a classic work of fiction, or a new one. Because I often quote fiction in my writing and talks, people ask me what books I've loved. So many!!! Recently, I recommend *Martin Marten* by Brian Doyle. *The Unlikely Pilgrimage of Harold Fry* by Rachel Joyce. *A Man Called Ove* by Fredrik Backman. Louise Penny's Inspector Gamache series. *All the Light We Cannot See* by Anthony Doerr. *H Is for Hawk* by Helen Macdonald. *Angle of Repose* by Wallace Stegner. *A Reliable Wife* by Robert Goolrick. *Independence Day*, by Richard Ford. Pick up Tolkien. Lose yourself with hobbits, orcs, and wizards. Lose yourself in hope of finding yourself.

If you want to meet someone who has had an extended fierce conversation with herself and offers that marvelously flawed self to any who care, read *Bird by Bird* or *Traveling Mercies* by Anne Lamott. Read *Pilgrim at Tinker Creek* by Annie Dillard. Or read *A Joseph Campbell Companion*.

I fantasize what it would be like to have these authors as neighbors. When there's a good book in the house, why turn on the TV?

Read poetry. Read good poetry, if possible. Don't try to understand it. You'll know it's good when it evokes something for you . . . a memory, a vivid picture, an emotion, an insight, a trembling of tectonic plates. Read David Whyte's poems. Pick up *The Gift: Poems by Hafiz, the Great Sufi Master*, translated by Daniel Ladinsky. Here was a man happy to be in his own skin. You will smile, laugh. Out loud.

And take walks. There has been much talk of being on the "path." It seems to me that too many people are forever seeking, never finding. Why not let the *way* itself arrive? I suspect you already know what to do. For me, the way is an ongoing, robust conversation with all that life has to offer. During walks I converse with lavender roses beside the ocean, quicksilver fishes in alpine lakes, windsong, lapping water, the wide listening sky. I take my lunch amid the blue-eyed grass and nodding campion at the foot of a laurel that has mated with a copper beech, conversing with my own essential nature. Back at home, the conversation continues with friends and family. What matters is how quickly we do what our souls direct.

One fall, after leading several workshops in London, I spent a day walking through the countryside in southern England with my friend Graham Thompson. In the late afternoon, as we returned to Graham and his wife Charlotte's home, I said, "Thank you for this glorious day."

He smiled and said, "Now you must pay. I've been asked to ring the church bells for a wedding this evening. It takes two people and my usual partner isn't feeling well."

A few hours later, I followed Graham up a rickety staircase in an ancient country church atop a hill. Graham lifted a trapdoor, and we clambered through it into a tiny belfry. The ropes to eight bells above the wooden planks over our heads were attached to eight wooden levers. There was barely time to practice six variations, including the standard peal of the highest to the lowest note. Graham managed to unstick the lever connected to the smallest bell just as the guests and bridal party arrived. When the minister rapped on the trapdoor, Graham and I looked at each other and grinned, and I pulled the first lever.

Though our concentration was intense, our first efforts were not the

joyful noise to which we aspired. But as my confidence grew and the bells responded to my touch and timing, I began to feel them in my chest—literally reverberating in my rib cage. I was not aware that Graham and I were laughing until the trapdoor lifted and someone called up to us, "They can hear you in the church."

Fierce conversations will allow you to feel. *Feel what?* Something. Anything. What music evokes. Belly laughter. Your obligation to the planet. Bells in your bones.

This fall I walked 105 miles through the Cotswolds in England. My friend Jan Dressler, who appreciates silence as much as I do, joined me. We've agreed not to talk until lunchtime. I sang now and then. Funny songs my family sang when I was a child. *Be kind to your web-footed friends for that duck may be somebody's mother.* And "That Lonesome Road." Check out James Taylor singing it on YouTube. What we sing reveals our age and our hearts.

In Elizabeth Berg's *Open House,* a character asks, "You know what a naked star is? . . . Stars with most of their gaseous atmospheres stripped away. And you know why they're revealed like that? Because of close encounters with other stars. I find something very human about that. Don't you?"

The risk is that in close encounters with others, you will be known. You will be revealed, changed. And why not? You've been strong for too many years. Try something different. Surrender. It's good to need other people. Invite them in.

Perhaps your daring disclosure will be a flop. There is nothing wrong with that. Some of us have to go too far if all of us are to move along.

Fierce conversations are not a form of showing off or parading a rich vocabulary past our companions, who yawn and tune out, afterward wondering why—after all, she was "so well spoken." Our intelligence, even our genius, is not given to us so that we can brag or take credit for it. It's given to us so that we can be of service to others in some meaningful way. Fierce conversations are an effort to understand—first of all, for yourself—something that is worthy

of your pondering. They are deeply probing explorations. Speak about the things you want to understand. Most people want to share journeys of this kind. Forget about being clever or impressive. When we furnish our past with positive events, perhaps enhancing them, and leaving out the ones we don't think others would find appealing or attractive, that leaves us as a perfect and, therefore, uninteresting human being to whom no one else who might be imperfect can relate.

Forget also about persuading others to your view. Saying something louder doesn't make it true. What is called for now is quiet integrity.

Tell the truth.

Tell the truth.

Tell the truth.

I determined long ago that to change my persona, omit my mistakes, or withhold a controversial view for fear of what others might think was not only dishonest and ineffective but would likely induce a contagious stupor, so I decided to show up authentically and consistently with everyone in my life. Might some people be put off by things I say? Certainly, and that is okay with me. If I tried to please everyone, I would lead a dull life indeed.

Might some people be put off by things I say? Certainly, and that is okay with me.

The key is for you to show up—fully. You may be among people who don't support you. You may be among people who, loving or unloving, are simply not equipped to support the ambition of engaging in fierce conversations. This is not an unusual experience. The courage to show up is both simple and daunting. Once you show up, people can see you. They can judge and criticize and gossip. Some safety and comfort are lost when an ambition or strongly felt emotion is expressed. Perhaps, if you have become impatient with the false identity you have created for yourself, life is inviting you into much larger worlds than you have imagined.

Often people tell me that they will only say what they really want to say if they're with someone who is safe. In other words, their degree of honesty is totally up to other people. This always makes my toes curl. Life isn't safe, isn't meant to be safe. It's meant to be challenging, broadening, frightening even at times. Otherwise we're not having an adven-

ture. We're just sitting on the sofa, wondering if something interesting will ever happen to us. And it probably won't unless we get up and go do something that feels a bit risky. Safety is overrated. It's time to show up.

Intimacy is required in conversation now—at home and in the workplace. We must answer the big questions in our organizations. What are the questions that need posing? Philosophers, theologians, scientists, and great teachers have debated this for ages.

What is real?

What is honest?

What is quality?

What has value?

We effect change by engaging in robust conversations with ourselves, our colleagues, our customers, our family, the world. Whether you are running a company, managing a team, governing a country, or participating in a committed personal relationship, your ability to effect change will increase as you become more responsive to your world and to the individuals who are central to your happiness and success.

My vision is that leaders of countries and companies will begin to engage in a level of dialogue rarely experienced in our shared history. During the 2016 political debate in the United States, I was reminded of something Adlai Stevenson said: "The hardest thing about any political campaign is how to win without proving that you are unworthy of winning."

When the political primaries were in full swing, voters' blood was boiling listening to would-be future leaders of the United States. Candidates from both parties left voters confused, frustrated, disgusted, frightened, and angry. An "us versus them" mentality created a wider divide than ever before. Who could voters trust? Who could really fix what's broken?

While it may sound a bit cheeky, and certain political purists may roll their eyes at the sentiment—I felt that we needed Pope Francis. If he had been

running for president, he would have gotten my vote, and I'm not Catholic. I admire this pope. Despite serious obstacles, he accomplished major bureaucratic housecleaning, set new directions and priorities for a global organization not traditionally known for its innovation, and focused the attention and resources of the Church on matters of global concern. Other popes had worked toward change and failed, some didn't even bother, and some made things worse. Pope Francis is number 266 in a long line of leaders.

Consider what the pope was up against within the Vatican and compare this to what the president of the United States is up against with Congress. Resistance to change? Check. Hidden agendas? Check. A culture of infighting and power struggles? Check. A network of powerful administrative departments that seem to despise each other? Check. Wars between conservative and liberal wings? Check. Throw in scandal, hubris, greed, cover-ups, and conference rooms full of decision makers with narcissistic personality disorder and you've pretty much got it.

So how has Pope Francis accomplished so much? Why is he so popular?

Let's start with how he became the pope: Jorge Mario Bergoglio didn't use negative television commercials, name-calling, and profanity or an overactive ego to be considered for this position of leadership. There was no us versus them, no I'm right, they're wrong. Through a miraculous process unimaginable in the United States, Pope Francis was chosen by people with strongly opposing views. I suspect he may have been chosen, in part, because of his gentle, unassuming nature. Some may have thought he could be controlled. Turns out, while he is gentle and kind he is also strong—these are all qualities that any country should be looking for in its leader.

Once chosen, it became clear that Pope Francis is a communicator. He has a Facebook page, he tweets, and when he speaks, it is without the usual Vatican filters. His goal isn't to get "likes" or to inflame, attack or defend. He has sought unity, resolution, and focused action on matters like climate change, religious persecution, and the suffering of so much of humanity. Pope Francis has sought engagement with the world, including those who do not share his beliefs.

He engaged the world, including his adversaries, one conversation

at a time, embodying a key trait of a great leader—the capacity to connect with others at a deep level. For many, Pope Francis has been a welcome change, a breath of fresh air, someone many of us would like to invite to dinner and a conversation. He has been influential, in part, because the emotional wake during and following his comments is an afterglow, not an aftermath, an aftertaste. His conversation with the head of the Russian Orthodox Church ended a nearly thousand-year schism because of deep differences. Following the conversation, Pope Francis said, "We are not competitors, but brothers." This too: Pope Francis serves as a positive role model for the young people who will soon be running our world. Consider these evocative and appropriate lyrics from the Sondheim musical *Into the Woods*:

> *Careful the things you say,*
> *Children will listen.*

We are always modeling something for our children. The question is—what are we modeling and how can we select leaders of companies and countries who will illustrate the values we wish to perpetuate?

During the 2016 U.S. political debates/debacle, I read Rohinton Mistry's *A Fine Balance*. There's a scene in which the central character, Maneck, meets a speechwriter on a train who describes his approach to his work. "I knew exactly the blather and bluster favoured by professional politicians. My *modus operandi* was simple. I made up three lists: Candidate's Accomplishments (real and imaginary), Accusations Against Opponent (including rumours, allegations, innuendoes, and lies), and Empty Promises (the more improbable the better). Then it was merely a matter of taking combinations of items from the three lists, throwing in some bombast, tossing in a few local references, and there it was—a brand-new speech. I was a real hit with my clients."

Sad and accurate. We have a long way to go.

We are a global economy, a global marketplace, relying on one another for survival. While we have a right to strongly held beliefs, our subjective truths often prevent intelligent dialogue. Multiple, competing realities must be considered and valued. Until we master the courage and

the skills needed to engage in conversations that help accomplish the goals of our shared civilization, devising a plan that transcends individual gain and personal ambition, we will move away from greatness, not toward it. It's time we mislaid all the normal words and the everyday questions that only lead to exchanges in which nothing of interest or usefulness occurs.

Whether you're trying to come up with original thinking, transform a corporate culture, improve customer-renewal rates, enhance cross-boundary collaboration, develop emerging leaders, or simply create heat, what's at the heart of fierce conversations is connection, at a deep level, with those who are important to our success and happiness. My mission is to transform the way we talk with one another. My vision is to extend this transformation beyond companies and into our global community.

Margaret Weeks, one of our marvelous "fiercelings" (much better word than employees), told me about a commercial that she loves. Now I do, too. Go to You Tube and search for "Android, be together not the same." We should be with one another like this.

It is not enough to be willing or able to speak. The time has come for you *to actually speak.* Be willing to face mutiny everywhere but in yourself. Your time of holding back, of guarding your private thoughts, is over. Your function in life is to make a declarative statement.

> It is not enough to be willing or able to speak. The time has come for you *to actually speak.*

Walt Sutton, a wise and wonderful man, gave me great advice when I decided to write this book fifteen years ago. I had so many questions. *Should I outline the whole thing? What do I do with all these notes I've made over the years? Should I edit as I go? Should I . . . ?*

> Your function in life is to make a declarative statement.

Et cetera. Walt smiled and said, "Write a shitty first draft." I laughed and breathed deeply because that, I could certainly do.

We make a start. We begin and find ourselves speaking in a deeper, richer language.

Sometimes, all we need to say, as Inspector Gamache suggests in Louise Penny's novels, is:

I don't know.
I need help.
I was wrong.
I'm sorry.

My hope is that you will sit beside someone you care for and begin.
I feel you out there, reader.

Tell me how it goes for you!

susan@fierceinc.com

HOW TO REACH US

Fierce, Inc., is dedicated to transforming the conversations central to your organization's success. Our modular training focuses on the conversations that take place every day—inside and outside of your organization. Team meetings, coaching, delegation, confrontation, feedback, accountability, negotiations, generations. You choose. You can bring us in to lead trainings within your organization, we can train and certify your own trainers to do this, or trainings can be accomplished virtually.

Ideally, senior leadership goes through a training so that they can model the behaviors and principles of "fierce." A powerful tactic is for a team tasked with delivering key goals to an organization to go through the training together. They then have an approach and a language that allows powerful collaboration and innovation.

In addition to a profound and pervasive sense of well-being, championing fierce conversations company-wide enhances employees' capacity to serve as effective agents for strategic success, structuring the basis for high levels of alignment, collaboration, and partnership at all levels within the organization and the healthier financial performance that goes with it.

We often speak to conferences and organizations globally. For inquiries about keynote talks and our services, please visit our Web site at www.fierceinc.com, which provides client case studies, our e-mail addresses, and much more.

It starts with you, of course, so you will find a User's Guide in the pages to follow, as well as an excerpt from *Fierce Leadership, A Bold Alternative to the Worst "Best" Practices of Business Today.*

You can do this.

A USER'S GUIDE

I've tried to think about what I, as a reader, would want from a user's guide. If you want to get "fierce" going in your corner of the organization, this book is an excellent jumping-off place. All the principles are here. All the tools. And if I said, "So use them," I can imagine the look on your face.

"How can I make this work? Mary in accounting hates Frank in legal and Mark in operations isn't even talking to our VP of sales. Plus if I were to ask people to say what they're really thinking, no one would speak up initially. Too many people would be afraid of looking stupid, of getting fired or yelled at, or being thought of as a troublemaker, and some people are just plain apathetic. How can I overcome this? Where do I begin?"

It's tough to get "fierce" going in an organization if you're the only one championing the cause. Often, the cultural norms embedded in the woodwork of an organization—the ground truths—are at odds with an individual or group wishing to ignite honest, intelligent, robust dialogue. In fact, one of the most common comments that comes up in

trainings is, "I'd love to have these kinds of meetings and conversations, but this level of candor would not be welcome in our culture."

My response is always, "I am looking at the culture when I look at you." You *are* the culture. It's not out there somewhere. It's right here. You're it. Every time you walk in the door, attend a meeting, have a conversation, or send an e-mail, you are reinforcing behavior, values, and attitudes that are healthy or harmful to your company's culture. And please don't point to your upbringing as having ingrained in you the "rules" by which you still operate as an adult. We all have a history. Some of us overcome it.

To experience what happens for many individuals facing obstacles—real or imagined—in practicing fierce principles within your organization, put your right arm out and point your finger, then visualize pointing it at all the people you think will thwart your efforts to practice "fierce." That's called the "accountability shuffle." He did it, she did it, they did it to me.

Blame isn't the answer and besides, as *NY Times* columnist Maureen Dowd suggests, "Woe-is-me is not an attractive narrative." Take your finger and touch your nose. This is where resolution begins. This is the accountable position. If you want to make progress toward a better "here" in your professional or personal life, identify the conversations out there with your name on them and resolve to have them with all the courage, grace, and vulnerability they require. When you see another devastating event on the evening news or your team or company receives an unexpected blow, rather than feeling helpless to effect change, remind yourself that in a very real sense, the progress of the world depends on *your* progress as an individual now, wherever *here* is at that moment.

Frequently Asked Questions

How and Where Do I Begin to Be Fierce?

There's a scene in the movie *As Good As It Gets*, which every woman I know loves. Helen Hunt has had it with Jack Nicholson's boorish behavior and is about to leave a restaurant after yet another one of his

insults. Through gritted teeth, she demands, "Say something nice to me and make it good!" He knows this is his last chance. He agonizes, squirms, and finally offers, "You make me want to be a better man."

What would you want people to say to *you*? Feel about *you*? You make me want to be a better person, a better spouse, a better parent, a better employee, a better boss, a better colleague, even . . . a better customer. So, before we focus on tips for specific situations, let's come to grips with a basic fact. Fierce conversations begin with *you* and how you show up. It requires that you model the behavior you desire from others.

Consider adopting a private, personal mantra. The mantra is: *Model what I want.* Say it over and over. *Model what I want. Model what I want. Model what I want.* This works in all parts of our lives. Essentially, it's . . . *Here's what I'd like from you. I'll go first.* It works with Fierce, too.

A simple way to begin is to start each day by choosing one of the Seven Principles of Fierce Conversations as your focus for the day. Start with the first one and work your way through them.

Let's say it is day three and you've chosen—"Be Here, Prepared to Be Nowhere Else." All day, practice giving your full attention to each person with whom you speak. And to the topic. Face your colleague straight on. Look into their eyes. Pay fierce attention to the very next words. Ask yourself, "What does this conversation want and need to be about?" Don't linger on the edges. Small confusions are easy to clear up and can lull us into thinking we've addressed our subject in a comprehensive way. Instead, ask yourself, "What is the deepest issue in this confusion?" Speak toward that, with firmness and concentration.

If you're the impatient, foot-tapping, finger-jittery type, then take some deep breaths. Sit. Stay!

Do this for an entire day. Notice what happens as a result. I think you'll be pleased. I know others will.

No matter which principle you choose to practice, in just one week, you will have practiced all seven principles. Then begin again, from the top. Imagine the shifts in your conversations and, therefore, your relationships as you become skilled at practicing the principles.

Not only will you serve as a role model for others, but your own learning will be provoked. Your development as a leader and as a human

being will accelerate. Over time, you may try to say something trivial and find that you can't do it. You must speak directly to the heart of the issue.

The results? A high level of personal authenticity, ferocious integrity, emotional honesty, genuine regard for others, sheer chutzpa, and a greater capacity to hold true to your vision and enroll others in it. Some would call this leadership.

Expect measurable results as well as those harder to measure. Clients have told us:

- "We had a Beach Ball conversation that saved over $321,000 of revenue."

- "We weren't capturing all the reimbursement we could because the team was not working well together. We now use the Beach Ball conversation model to delve into problems."

- "In the past, many of our team members were hesitant to give anything but positive feedback—especially to their managers. Large meetings were often quiet, with a couple people doing most of the talking. Fierce conversations gave us a common language and the foundation for communicating as an organization. It also provided individuals with the confidence to speak up."

- "Our teams have become more engaged, productive, and eager to resolve issues before they escalate."

I Want to Start Having Fierce Conversations at Work. How Do I Go About This and Make Sure I Don't Get Fired? Some People Just Can't Deal with Honesty.

My experience has convinced me that people don't have a problem dealing with honesty. What they can't deal with is either the way in which the message is delivered or a lack of reciprocity.

Let's talk about delivery. The #1 reason people with good intentions get in trouble with "fierce" is that they ignore Principle 6: "Take Responsibility for Your Emotional Wake." And this often stems from a belief or thought beneath our words that doesn't serve any of us. The belief is: "I own the truth about this issue." So, for example, you might deliver a

message loaded with truths, but (and I do mean BUT) if you attach blame to your message in subtle and not-so-subtle ways, or you believe the person on the receiving end is just plain wrong, the door will close!

Remember the beach ball? Who owns the truth about what color your company is? Every single person in the company owns a piece of the truth about what color the company is. The operative word is "piece." And no one owns the entire truth. No one. So, anyone who comes across as believing that they own the entire, nonnegotiable truth about a particular topic might as well forget about having a fierce conversation. They've struck out before the game began.

Become a master at telling the "truth" as best you can while acknowledging that others may have very different truths that are just as valid as yours. Describe your reality without laying blame and you won't need to worry about being fired. You'll need to prepare for your next challenging assignment.

In fact, I recently received an e-mail from an executive who enrolled himself and his direct reports in our fierce conversations training and, consequently, blames Fierce for his third move in eighteen months, due to promotions.

Makes me proud!

Modeling the principles has been a lifelong yet worthy challenge for many of our clients. Sometimes their tone of voice, choice of words, or the expression on their face can attach a load to a message that they didn't intend. If they are very lucky, the person on the receiving end will call it to their attention. Then they can apologize and try again.

And what about reciprocity? Why would others be interested in listening to your honest opinion if you yourself discount theirs? Everyone wants one person in the world to whom they can tell the truth. Are you that person? How do you respond when someone pushes back against your "truth"? Do you become defensive, argumentative, sullen? Do you do all the talking?

It seems our nature is often to flee when things get difficult or seem to be corroding part of our souls. Telling the truth is a decision, while withholding what we really think and feel—even when it impacts us negatively in the end—is an instinct. We are hardwired to protect ourselves.

If you want to have fierce conversations at work, begin by becoming someone to whom others can tell the truth! We're back to: You go first!

What Topic Should I Choose for My Team's First Beach Ball Meeting?
According to research, fifty-five million meetings occur per day. For average workers that means eight meetings per week. For managers, twelve per week. Meetings can vary from status updates to brainstorming, from company-wide to one-on-ones. They range from mission critical for completion of a project or milestone to completely useless. And let's be honest, with so many hours in meetings, it can be easy to go into autopilot. Hence, these suggestions:

Choose a high-stakes topic and engage your team in a Beach Ball conversation, during which you ask them to help you interrogate reality and design an action plan to work around, impact, change, or improve reality. The topic should be one where there is a fair amount at stake to gain or lose regarding your organization's ability to solve a significant problem, design a key strategy, evaluate an opportunity, or make an important decision for the organization.

Who Should Choose the Topic?
One of my favorite approaches is to ask the team to choose the topic. A fairly simple yet profound way to do this is to ask, "What is the most important thing we should be talking about?" Or ask, "What is the one area that, if it improved, would make the greatest difference for good for our organization? Take two minutes, no side talking, and write down your answer. Then we'll hear from each of you."

Write each suggested topic on a whiteboard or flip chart, give everyone three red dots and ask them to put their dots beside the topics they feel are most important. They can put all three dots on one topic or spread them out. Count the dots and you have your prioritized agenda. It's important to say that just because some topics didn't get lots of dots doesn't mean they aren't important. Consider scheduling one-to-one conversations with those who feel they should be addressed.

Another approach is to ask: "If you were hired to consult to our organization, what would you advise?" Or: "If you were a new compet-

itor with deep pockets, how would you put us out of business?" Or: "If nothing changes, what's likely to occur?"

These questions are bound to ignite intelligent, impassioned dialogue. If they don't, you've got a bigger problem. Your team has died. If, as usually happens, this conversation generates heat and impetus for change, everyone will walk away energized and ready for more.

If you'd like to choose the topic, ask yourself the same questions. Your answers will provide plenty of fuel for the fire.

What Are Some Examples of Topics for a Beach Ball Conversation?

- How can we strengthen our leadership bench?

- Our competition is gaining ground. What are we going to do about it?

- How can we improve sales?

- Let's explore the pros and cons of a possible acquisition.

- How can we rearrange job responsibilities to ensure that work gets done and no one burns out?

- Let's design a strategy to win this project we're bidding on.

- How can we improve customer retention?

One approach is to review the key indicators that serve as your organization's early-warning system. Your corporate intelligence. When a key indicator points to a downward trend, a conversation is provoked: We are *here*, heading in this direction. Instead, we want to head in *that* direction. We must make adjustments to the business, now, *on time*, before we arrive at a negative "suddenly." What do we need to do?

Part of your job is to spot trends quickly with the fewest clues, so that you can take appropriate actions to ensure the company's success. Key indicators help you see where you are and where you want to go. If you don't know what your key indicators are, assemble a team to identify them.

Key indicators include things like net sales, gross profit margin,

inventory turnover, sales, activities that cause sales, customer satisfaction index, number of new or renewing customers, average sales per customer, percentage market share, new product growth, and employee retention.

Every business is unique, so examine different indicators until you've identified the ones that are the real drivers of your business. Then track these with a vengeance!

Other high-level topics for Beach Ball conversations concern the three realities each organization must interrogate from time to time:

1. What values do we stand for, and are there gaps between these values and how we actually behave?

2. What are the skills and talents of our company, and are there gaps between those resources and what the market demands?

3. What opportunities does the future hold, and are there gaps between those opportunities and our ability to capitalize on them?

How Do You Have a Fierce Conversation with Someone Who Does Not Have Knowledge of the Process? Some of Us Have Tried to Educate Others and Have Been Met with Resistance. Do You Have Any Suggestions? Don't try to "educate" anybody. It's not universally welcomed. Your role is to model "fierce" without putting rules around how others behave (unless they are abusive, of course).

On the other hand, don't hide the pea. It is helpful to tell everyone what you're doing or attempting to do, what you want and why you want it. Otherwise, they may wonder about your motive.

Whatever you do or attempt to do, tell people that you are working to make a shift in your leadership approach and extend an invitation to them to join you. You might even need to apologize for previous behavior. Use your own words. This must be you speaking in your real voice, your own voice. The following just gives you an idea of the message. You might say something like:

> *Looking around this room, I recognize what a good company we have, thanks to your talent and hard work. I think you'll agree that we also have room to grow and improve. We have decisions to make, strategies*

to design, problems to solve, and opportunities to evaluate. I'm struck by the notion that all of us—myself and each of you—want to get it right AND we miss opportunities to benefit from the diversity of experience and perspective that exists in our organization. Too often, I tell you what I think and you execute without challenging my thinking. I can understand that. Frankly, I haven't extended a compelling invitation to share your views and, on occasions when you have expressed a difference of opinion, I've often tried to persuade you to my way of thinking before hearing you out. For this, I apologize. I really want to stop that. Going forward, I'd like to ignite intelligent, productive dialogue—one-on-one and as a team. Every single one of you owns a piece of the truth about this company and how we can succeed going forward, so you can count on me to tell you what I honestly think and I request that you do the same. When I ask for your suggestions, I will count on you to share them. It will be up to me to prove that I was really asking. I'll do that by really listening.

Though my next suggestion may seem self-serving, as it involves spending a few dollars, pounds, or euros, you may wish to provide training in fierce conversations. Check out the possibilities at www.fierceinc .com. At the very least, give your team members copies of this book. They will be doubly appreciative when they discover that their personal lives, as well as work lives, will benefit from putting the principles and practices to work.

How Can I Run a Really Great Meeting?

There are subquestions regarding this topic:

HOW DO I SET IT UP?

For starters, stop calling them meetings. The last thing we want to attend is another meeting. Call them *conversations*. And make them so productive, people will look forward to the next one. Extend an invitation:

I'd like to schedule a conversation with you next Wednesday from 2–4 p.m. We'll talk about (fill in the blank). This topic is significant because . . . Please come prepared to offer your perspective.

WHOM DO I INVITE?

Get creative here. This is one of your first opportunities to break the old mold. Don't just invite people with fancy titles. Whose perspective would be useful? Who is standing at the juncture where things happen? Who is standing downstream and will be impacted by the outcome? Who will implement whatever is decided? Invite your newest employee. Invite someone who works on the loading dock. Invite your administrative assistant. Invite your internal customers. *And*, why not invite a literal, card-carrying, fee-paying external customer? If the blood is draining from your face at this thought, you should definitely invite a few customers. Otherwise, you may have the common experience of designing something in which your customers have little interest.

HOW DO I PREPARE?

Use the issue preparation form introduced in chapter two. Fill it out and make copies for everyone. You might decide to send this filled-out form to everyone ahead of time. This is often very helpful. Everyone now knows exactly what the conversation is about and what you want from them. They can come prepared to contribute and/or bring with them any data that could be useful.

HOW DO I CALL THE CONVERSATION TO ORDER?

"Thank you for coming. We have (or I have) a decision to make (or a problem to solve or a strategy to design or an opportunity to evaluate) about (fill in the blank). My goal is to make the best possible decision for the organization, so I need access to all the valid data. Every person at this table is here because he or she has a valuable perspective."

HOW DO I ENCOURAGE HONESTY WHEN MANY ARE RELUCTANT TO SPEAK UP?

No matter how sincere you are, those who have had lousy experiences with honesty in the past will be reluctant to push back on your favorite ideas or anyone else's for that matter. Based on what's happened in the past, who could blame them? So, see who your takers are. Some brave

person—let's call him Dave—will venture a comment. What happens in the next few seconds will tell the tale. It is essential that you say something like:

"Thanks, Dave. Please say more about that."

This is often all it takes. Watch your facial expression and body language and bite your tongue if Dave says something with which you disagree! Instead of jumping back in to build your own case stronger, invite him to keep talking. Invite him to talk about his thinking behind his suggestion. Delete "but" from your vocabulary. Replace it with "and." Sit or stand with your arms by your sides or on the table rather than folded across your chest.

When Dave is finished, say:

"That was helpful. It took guts to say some of the things you said. Thank you for your candor."

Now, hopefully, someone else will venture forth. What usually happens is that following the first dipping of a toe into questionable waters, assuming no one dies, the next person who offers a comment will wade in a little deeper, and so on. You'll definitely find out what you're made of here. Remember, you invited their perspective. Listen to it. Honor it. Not one person on your team got up this morning, looked in the mirror, and announced, "Today, I intend to do everything I can to alienate my team, irritate my boss, and ensure that this company languishes or tanks!"

WHAT IF NO ONE SAYS ANYTHING? WHAT IF I ASK FOR THEIR IDEAS OR OPINIONS AND YOU COULD CUT THE TENSION IN THE ROOM WITH A KNIFE?

Call on someone. By name.

"Kathy, you stand right at the juncture where things happen around this issue. What are your views?"

If she says, "I don't know," say (with no sarcasm or judgment) . . .

"Well, what would it be if you did know?"

And then wait. Let silence do the heavy lifting. In fact, if later in the meeting, you call on someone who hasn't contributed and he or she says, "I don't have anything to add," I'd like you to say . . .

"What would you add if you did have something to add?"

My goal for you is that "I don't know" and "I don't have anything to add" will disappear from your organization's culture. Neither reply is useful. And neither is true. Some people just don't want to work that hard or don't want to risk putting their real thoughts on the table for everyone to see because they have a powerful and unpleasant memory of what happened the one and only time they tried.

This doesn't make them bad people. It does make them questionable employees. After all, if every time I ask for your thoughts or suggestions or opinions or analysis, you don't know or have nothing to add, then why, exactly, do I need you?

This may seem harsh. I say it because my belief is that people *do* know and have something to add. Most people take a job hoping to make a valuable contribution. It's *how* we ask for their views and how we respond when differing views are offered that tell the tale of whether or not we'll benefit ever again from someone's intelligence and creativity, whether or not our culture is enjoying the invaluable discretionary effort that is every employee's choice to give or withhold.

WHAT IF I'VE GOT A TROUBLEMAKER ON THE TEAM?

Offer some ground rules. If someone starts to criticize a team member's ideas or rolls their eyes as someone else is talking, remember, you get what you tolerate. Stop the conversation and say something like:

"George, my hope is that this conversation will provoke learning for all of us. This requires understanding everyone's perspective. I re-

spect Ann tremendously for her candor today, and I am genuinely interested in hearing what she has to say. My request is that you listen as respectfully to Ann as we intend to listen to you."

If George continues to be argumentative, try this:

"George, I need for you to find a different way of participating in this conversation. Otherwise, I'll ask you to leave."

Yes, go this far. Send a clear message from the get-go that attacks or put-downs of any kind, including sarcasm, interrupting, rolling of eyes, elbow nudging, and texting under the table are not acceptable. If you've got an incorrigible team member, have the confrontation conversation with him or her at a later time. This private, one-to-one conversation was covered in depth in chapter four.

HOW DO I SET AN EXAMPLE? WHAT DO I SAY?

How you set an example begins with the filling out of your issue preparation form. Be thorough and honest.

There will be moments during the conversation when you are asked questions and struggle to decide just how honest you want to be. If there are legal reasons why you can't answer a question, say so. People are reasonable and accepting of practical, real-world occasions when you are prevented from being as candid as you might like. Otherwise, screw your courage to the sticking place, as Shakespeare said, and answer each question honestly and completely.

Remember, everyone wants one person in the world to whom they can tell the truth and from whom they will hear the truth. Become that person.

There is something deep within us that responds to those who level with us. Who don't suggest our compromises for us.

HOW DO I END THE CONVERSATION?

There are two steps. The first is to thank everyone. And mean it. And let them know what will happen next. For example:

"Thank you for your time, intelligence, and candor during this conversation. My learning has been provoked and consequently, I feel prepared to make the best possible decision for the organization (or whatever is appropriate here). I will let you know my decision (or the next steps) by (fill in the date)."

The second step is a quick debrief of the experience. Example:

"Before we adjourn, I'd like to check in with you about what we did well and how we can improve the experience in future conversations. Let's start with how we can improve." (Always end team conversations with a focus on what went well.)

Write down what they say. Don't invite discussion or debate regarding each person's comment. Just make sure you understand their suggestion and record it. Thank each person who speaks. Ask, "How else could we improve?" over and over until you have a sense everything that needed saying has been said. Then ask:

"What did we do well?"

Record what they say here, too. Thank each person who speaks. Then suggest:

"This is helpful. I'll keep this list and post it when we have our next conversation. I expect that over time, we will become black-belt conversationalists. Thanks, everyone. Meeting adjourned."

WHAT IF THE MEETING IS VIRTUAL?

When meeting virtually with a team, leaders grapple with the issue of ensuring that everyone is engaged in the conversation, listening, contributing. You suspect they've drifted off when you ask a question and no one responds. Are they simply thinking deeply or are they starting a load of laundry, making a sandwich, playing solitaire, reading e-mails? Have they left the room?

Most often, the way we conduct virtual meetings is the problem.

The good news is, there's an easy fix: the Beach Ball approach. At the risk of repeating myself, here are the key points:

1. In the invitation you were clear regarding the topic of the meeting and why it is significant.

2. If there is information you need them to review, you sent it out and let them know that you expect them to come to the virtual meeting already having reviewed the information, prepared to share their perspective.

3. Begin the meeting on time. Never, ever wait until everyone has joined the meeting. If you do, you are teaching everyone that you will accommodate latecomers. *Remember, you get what you tolerate.*

4. Begin the virtual meeting by naming everyone who is on the call and thanking everyone for their time in preparing for the meeting. *Those who haven't prepared will scramble to review whatever you sent them and are likely not to make that mistake again.*

5. Let them know that you want to hear from everyone attending the virtual meeting and that you will call on each of them. *This alerts everyone that now would not be a good time to check their e-mails . . .*

6. Let them know that once everyone has contributed, given everything they've heard, you will close the meeting by asking each person to summarize their best counsel, opinion, advice, whatever . . . *See italics above.*

7. Tell them that you are going to talk them through the salient information from your perspective (the issue preparation form that you filled out prior to the meeting) and that you'd like them to listen carefully since you will not repeat information you will already have answered. *This quickly focuses everyone's attention.*

8. Talk them through your issue prep form. This is the issue, this is why it's significant, relevant background information, ideal outcomes, what has been done so far, options under consideration,

and what you'd do (and why you'd do it) if a decision had to be made without their input.

9. Tell them you'll allow a few minutes for clarifying questions. Ask each person to identify themselves whenever they speak. Cut it off if the questions go on and on. *Too many questions stall a discussion and, as I'm sure you've experienced—some think they will never have enough information.*

10. Assure them that you aren't looking for agreement, that your goal is to get it right, not to be right, and that you welcome competing perspectives.

11. As the meeting progresses, put a check by the name of each attendee who contributes. Call on anyone who hasn't said anything.

12. Be sure to probe so that you and everyone on the call understands where others are coming from. "Please say more about that."

13. When someone pushes back on your thinking, say, "Thank you. Tell us more."

14. When you've heard from everyone, wrap it up as you said you would. "Given everything that we've explored, take a moment to write down your best counsel and then we'll hear from each of you before we close." Give them about two minutes for this. Again, make sure each person identifies him/herself when they speak and put a check by each person as they weigh in. Call on anyone who hasn't said anything.

15. Thank them for their input. Let them know your next steps.

WHAT ABOUT ONE-TO-ONE CONVERSATIONS WITH VIRTUAL EMPLOYEES?

My guess is that your virtual one-to-ones are similar to the ones you have face-to-face. So, ask yourself: How would I describe the quality of my one-on-one conversations? Are they robust and authentic? Or shallow and superficial? Whichever qualities you choose to describe your

conversations are the qualities of your relationship with that person. After all, the conversation is the relationship. When effective, they truly give you a pulse on what needs to potentially start, stop, and continue. The insights are pure gold.

Before addressing virtual one-to-ones, here are a few tips for all one-to-one conversations.

1. **Be consistent.** Trust requires persistent identity. For most of us, the people we respect most in our lives are the ones who show up as themselves consistently. If your team members do not know how you are going to show up from one day to another, they will not trust you. It is your job to stay true to yourself—whether you are having the best or worst day.

2. **Ditch the checklist.** If you get in the habit of constantly using a list to dictate your one-to-one conversations, you might miss something important altogether. Your list may not bring up the bigger issue or challenge your team member is wrestling with. Start off with open-ended questions. Specifically: *Given everything on your plate, what's the most important thing we should be talking about today?* Let them know ahead of time that you will ask this question.

3. **Be here prepared to be nowhere else.** This means turning off the screens. Yes, whether the one-to-one is virtual or in person, close your laptop, turn away from your computer. It is easy to be distracted by shiny objects or pinging software. Physically make the space, so that you can be fully present.

4. **Let silence do the heavy lifting.** If you ask a question, allow time and space for your partner to really think about it before answering. If you are exploring a topic together, leave enough room for the other person to engage. Don't listen to respond; listen to understand. Take your time. Remember, your job is to slow the conversation down so you can discover what it really wants and needs to be about.

5. **Ask for feedback, input.** In fact, don't just ask for it; require it. In a Fierce survey, 80 percent of respondents who reported a good employee-supervisor relationship claimed that the most important thing a boss can do to create a positive working relationship is to both solicit and value their input. At the end of the day, it is important to just ask.

If some of your one-to-ones must be virtual, use technology that allows you to actually see each other. It's far easier to connect when you are looking at each other; besides, seeing *is* believing.

Your goal is threefold:

1. To connect with your team member at a deep level

2. To ensure he or she has given prior thought to this conversation and actively participates in the conversation

3. To ensure you remain current regarding what is going on that matters most to your team members

Note: We have virtual employees and partners at Fierce, Inc. Additionally, our Seattle employees often work remotely and have unlimited time off, assuming they are achieving their goals. Our Seattle office is light-filled, colorful, open, warm, and inviting, and forgive me for bragging, but we've remained on the Best Companies to Work list year after year, so in spite of the freedom everyone enjoys, our office is usually well populated. We do require everyone who lives and works elsewhere to come to the office twice a year for strategy sessions so that we can exchange information, connect, socialize, look into each other's baby browns, blues, hazels. It's a cost to bring them in, but there is no question that it's worth it. If someone can't make it to a meeting, we put them on Skype or Zoom and make a point of greeting them and asking for input.

I believe that the key to our and your success is that meetings are truly conversations, rather than leaders holding forth. Together we tackle the tough issues, practice radical transparency, and laugh a lot.

What Are Some Great Questions to Jump-Start a Fierce Conversation, Whether Virtual or in Person?

Once you and others have read the book and talked about the principles, the following questions should supply you with ample material for fierce conversations of your own. Remember, when a question is posed ceremoniously, the universe responds. Any one of these questions can ignite robust, much-needed dialogue.

1. What's the most important thing we should be talking about today?

2. What topic are you hoping I won't bring up? What topic am I hoping you won't bring up?

3. What do we believe is impossible to do, that if we were able to do it would completely change the game? How can we pull this off?

4. What values do we stand for, and are there gaps between those values and how we actually behave?

5. What is our organization pretending not to know? What are we pretending not to know?

6. How have we behaved in ways guaranteed to produce the results with which we're unhappy?

7. What's the most important decision we're facing? What's keeping us from making it?

8. If we were hired to consult to our company, what advice would we give?

9. If we were competing with our company, what strategy would we use?

10. If nothing changes, what's likely to happen?

11. What are the conversations out there with our names on them? The ones we've been avoiding for days, weeks, months, years? Who are they with and what are the topics?

12. Given everything we've explored together, what's the next most potent step we need to take? What's going to try to get in our way? When will we take it? When should we touch base about how it went and what's next?

You Emphasize That Fierce Conversations Include Telling Others How Much They Are Appreciated. What's a Powerful Way to Express Appreciation, to Tell Someone They Are Valued?

A conversation can be deadly boring or it can be a profound experience of humanity, of intimacy. Sometimes the fiercest and most intimate thing I can say is . . . *I appreciate this about you. This thing you do. The way you handled that situation.* When an entire team does this, they forge a powerful bond.

Here is a team appreciation exercise guaranteed to make a powerful, positive impact.

APPRECIATION EXPERIENCE

Pull chairs into a circle. No table in the middle. If people are holding things, ask them to put them under or behind their chair. No paper or pens, or cell phones, just empty hands. Give these instructions.

Each of you is an accomplished individual. Every time you walk in the door, you bring into the room your track record of experience, intelligence, results. And after all is said and done, the most powerful tool you have is yourself, your way of being, your way of thinking and feeling, the way you work and behave with each of us and everyone else in the organization. Who you are shows up in countless ways and has everything to do with your success.

Sometimes we forget who we are. Like a fish in the water, we don't see the water because we're in it. We don't notice how we behave. We just behave. So, I'd like to ensure that everyone in this room knows exactly what each of us values about them. Here's how we'll do this.

Each of you will have one minute to tell us what you bring to the team. Then the rest of us will have nine minutes to tell you what we appreciate about you. It's important that you look at each person as he or she speaks to you. All you are allowed to say is, "Thank you."

While waiting for your turn, resist the temptation to think about what you will say when it's your turn. Focus entirely on the team member whose turn it is at any given moment. When you speak, clarify what it is that you appreciate about this individual. "I really like you" isn't helpful. Be specific, genuine. Speak directly to the person. Look directly into his or her eyes as you speak.

10 minutes per person

1 minute: What I bring to the team is . . .

9 minutes: What I appreciate about you is . . .

It may seem old-fashioned, but I like to record each person's segment and give them the recording. (Test to make sure the microphone will pick up all comments. Have an individual recording for each person on the team.) Following these sessions, I've gotten many an e-mail from significant others who told me how proud their partner was to bring the recording home, saying, "This is what my team said to me."

To close the exercise, say: "When each of you comes into the room or into the conversation, there is something unique present that would be greatly missed if you were absent. Your qualities and accomplishments are amplified across the organization. Your impact is larger than you know. If you ever forget this or have a really bad day, play this recording to remind you who you are. What will make the biggest difference for good in the organization is that each of you continues to bring yourself fully to the task and to each conversation."

Is an Apology a Fierce Conversation?

You bet! A sincere and specific apology said while looking into someone's eyes is pretty powerful. To say to someone, "I apologize for my contribution to the problem we've been having. I recognize my own DNA in this. Please forgive me," is sometimes the *only* way to begin to turn a soured relationship around. Of course, you've gotta mean it! You can't fake fierce.

What If Someone Just Won't Talk to Me?

Continue extending the invitation. Over and over. With grace, sincerity, and skill. Until one day either this individual will accept your invitation and join you in a useful conversation *or* you will become clear that this person is in no danger of ever engaging in a productive conversation with you and it is, therefore, time to move on.

Let's face it. Not everyone on this planet is willing to or capable of showing up. Psychologists explain that some individuals believe that if they come out from behind themselves, into their conversations, and make them real, they will cease to exist. Literally. The facade they have carefully manufactured would fail and who they really are would be revealed. It's just too scary for them. Your best efforts to coax them toward authenticity, toward honesty, will fail. They just cannot, will not, play.

Take your beach ball and go home.

Can You Provide Me or My Organization with Something That Explains the Idea of "Fierce"?

Before you run your first "fierce" meeting you may wish to suggest that those who will attend watch my TED Talk, The Case for Radical Transparency. This short talk has helped many leaders introduce the idea of "fierce" to their colleagues in such a way that everyone gets the idea. It helps everyone grasp what is at stake to gain if their conversations deepen in meaning and what is at stake to lose if nothing changes. You can view the video on our Web site—www.fierceinc.com.

I'd Like My Team to Discuss the Book as a Group. Any Suggestions for Conducting the Discussions?

DISCUSSION QUESTIONS FOR THE 7 PRINCIPLES

Schedule seven "conversations" with your team. Each conversation will focus on one of the seven principles. Ask everyone to read the appropriate chapter prior to the conversation.

Begin with Principle 1: Master the courage to interrogate reality.

Give each person time to respond to each question. Remember, insight occurs in the space between words. Your collective job is to slow this conversation down so it can find out what it wants and needs to be about.

1. Imagine you are teaching this principle to a room full of people. How would you put this principle in your own words?

2. What struck you about this principle and the stories and ideas in this chapter?

3. What is your personal and/or professional experience with this principle—when you and/or others use the principle and when you and/or others disregard it?

4. What prices do we pay when we disregard this principle? What do we gain when we honor it?

5. What situations or opportunities do you encounter on a regular basis, where remembering this principle would help to interrogate reality, provoke learning, tackle tough challenges, and enrich relationships?

6. What do you think is most important to keep in mind about this principle?

7. What will try to get in your way regarding practicing this principle and how will you get around it?

8. What is at stake for you to gain if you get really good at practicing this principle? What is at stake for others who work or live with you to gain if you get really good at practicing this principle? What is at stake for your company to gain if everyone gets good at practicing this principle?

9. Any other insights?

Fierce Practice #3

From Holding People Accountable to Modeling
Accountability and Holding People Able

> *It often happens that I wake up at night and begin to
> think about a serious problem and decide I must tell
> the Pope about it. Then I wake up completely and
> remember that I am the Pope.*
>
> —Pope John XXIII

> *Out there in the real world, freedom means you have to
> admit authorship, even when your story turns out to be
> a stinker.*
>
> —Steve Toltz, *A Fraction of the Whole*

I recall hearing the true story of a pilot who landed just short of the runway in San Francisco. Luckily, no one was seriously injured, but the plane ended up partially in the water. When he was hauled to the official inquisition and asked how such a thing could have happened, he faced the battalion of lawyers and industry experts and said, "I messed up." End of statement.

Most of us would be stunned (and/or amused) to hear responses like that in business today. After all, when was the last time someone in your organization (maybe it was you) asked, "Who's accountable for this disaster?" and someone rushed forward, arms outstretched, shouting, "It was me! Hold ME accountable! I'm the one!"

Instead, we point the finger. *He, she, they, it did it! It wasn't me.* As

Steve Toltz wrote in *A Fraction of the Whole*, "The great thing about blame is that she goes wherever you send her, no questions asked."

The words "I'm holding you accountable" are spoken thousands of times a day around the world during meetings, on the phone, in hallways to individuals, teams, and, yes, teenagers. And my thought is always *Good luck with that.*

Don't get me wrong. Accountability is a big deal, one of the rarest, most precious commodities to be found. Next to human connectivity, accountability is the single most powerful, most desired, yet least understood characteristic of a successful human being and a successful environment. The long-term benefits of personal accountability have enormous implications for the quality of our lives, and there is certainly a direct correlation between a company's health and well-being and the degree of accountability displayed by its employees.

Why, then, in a study by the Table Group, did 80 percent of 132 executive teams score "red," or poor, on accountability? And why are our efforts to improve the level of accountability in organizations so ineffective?

It's because we're so busy trying to find out who is accountable that we forget to check the one place we should be looking: in the mirror.

Common wisdom tells us that powerful partnerships require that we . . .

1. understand needs;

2. clarify expectations;

3. collaborate on solutions; and

4. meet commitments.

Let's acknowledge that few of us are good at all of these steps, particularly the last one, and our efforts are further complicated because we don't understand what accountability really is, how it differs from responsibility, why it shows up, why it disappears, and what it really requires.

The purpose of this chapter is to address these issues and to provide a game plan for creating a performance culture that values initiative,

problem solving, agility, risk taking, and a bias toward action. A company filled to the brim with individuals who, instead of laying blame, willingly and gladly accept accountability for everything that's got their name on it. Given challenges, they ask themselves, what am I going to do? The answer isn't "duck and cover." They step up to the task and hold others able to do the same.

Before we dive in, to get you thinking, write down your answers to the following questions:

What is an example of an issue confronting you or your team that is made worse by a failure of accountability?

What results is this causing?

What about an example in your personal life?

What results is this causing?

Who's Accountable?

Though you may be clear with others regarding due dates for deliverables, there are inevitably going to be problems, snags, bumps, obstacles, delays. People get busy, waylaid, a colleague doesn't do his or her part,

a vendor is late with a shipment, a personal emergency (a sick child, toxic mold in the house, an injury to the family dog) derails a key member of the team.

And, too often, we give people more work than they can handle effectively, hold them accountable for getting it all done, and express frustration when they present us with a list of very good reasons for their failure to deliver. Maybe the package was mistakenly shipped to Ankora, when it was supposed to go to Anchorage. (As we speak, someone in the Niger inner delta region is trying to figure out what to do with six pallets of advanced therapy moisture lotion.)

As we speak, someone in the Niger inner delta region is trying to figure out what to do with six pallets of advanced therapy moisture lotion.

The point is, when something like this happens, our knee-jerk response is often "I want to know who's accountable for this!" And the automatic reply? "Not me!"

I remember working with a team of high potentials at a global shoe manufacturer. At one point, the founder of the company, a tall, imposing figure, walked into the room and sat in the back. I had just begun to explore the notion of accountability with the team when he stood and thundered, "What I want to know is, if we take a successful store manager and move him into a territory that's struggling and nothing improves, who's accountable—the manager or the person who moved him?"

In other words, who will receive my wrath? At which point, forty intelligent people—the future leaders of his company—did their best to shrink their subatomic particles and vanish from his radar.

Why? Because most of us associate accountability with blame, culpability, being responsible, being wrong, maybe even being fired. In fact, we'd likely define accountability as "clarity about whose head will roll when things go wrong." Given that *accountability* conjures the image of a firing squad without benefit of blindfold or last meal of Frito-Lays and Milk Duds (I admit to strange and powerful cravings), no wonder we don't eagerly raise our hands when we hear the question "Who is accountable?" Instead, we insist that he, she, it, they did it to us!

And it's no wonder. Deflecting blame seems to be in our DNA!

A marvelous example is Koko, one of the world's most famous go-rillas, known for mastering more than one thousand words in American Sign Language and, in doing so, helping to overturn preconceptions about the limits of animal intelligence. One day Koko broke one of her toys (the act was captured on video). The next day one of her trainers came in, picked up the broken toy, and asked, "Koko, what happened to your toy?"

Koko promptly pointed to the assistant trainer. True story!

Non Est Mea Culpa

Humans, including those in high places, often employ a slightly more sophisticated version of pointing. Take a statement from Attorney General Alberto Gonzales's attempt to exonerate himself from any accountability regarding the firing of U.S. attorneys: "I acknowledge that mistakes were made here."

With those words, Attorney General Alberto Gonzales was using a technique often thought to be a politician's best friend: the passive voice. Why is this technique so popular? Because the passive voice takes ac-countability out of the picture. Think about it. "Mistakes were made." There is no actor in this sentence. Why won't those pesky mistakes quit making themselves!

Passive voice has so cheapened the concept of a mea culpa that var-ious officials in government hearings and press conferences actually seem to be proud of themselves when they acknowledge that "mistakes were made."

Wouldn't it be refreshing to hear an official say, "I blew it"? After fainting from shock, most people would admire that candor and maybe trust that the same mistake would not be made again. Think about how President Obama's candid admissions of error early in his administra-tion bolstered his popularity rather than harmed it. YouTube features a clip titled "Obama on Daschle: I Made a Mistake," and several other clips in which President Obama models the kind of personal account-ability and candor we crave in our leaders today. But let's not hold our

breath that everyone will embrace this behavior, wedded as so many are to the passive voice. A duck and dodge if ever there was one.

What we want to know is what mistakes were made and who made them. Please don't give us the generic *they*—as in "They didn't handle this correctly." Which actual human beings had their hands all over this? Give us a name. Was it you? And what exactly is going to be done to correct this and ensure it doesn't happen again?

In one *9 Chickweed Lane* comic strip (rendered by Brooke McEldowney, my favorite cartoonist) the character Thorax, who sells strange goods and services from roadside stands when he isn't ruminating on his alien origins or dusting off the quantum anomaly in the tractor shed, sits at a roadside stand with a sign reading: REPUDIATIONS R US. He explains to Edda, another character:

> *Being as it is election season, I have started up a denial consultancy. While the candidates and the news media uncork their relentless gush of allegations and accusations, I stand ready to provide custom-tailored denials for every occasion. I have a new spring line of stout denials, categorical denials, unwavering denials, firm denials, swift denials, flat denials, emphatic denials, steadfast denials, outraged denials and, as summer approaches, a few angry denunciations with matching counter-accusations.*
>
> —Brooke McEldowney, *9 Chickweed Lane*

Funny and sad and true.

Of course, failings in accountability happen everywhere, not just in politics. Personally, I'd like someone to explain why Hollywood produces so many lousy movies, why I'm put on hold while a recorded message assures me that my call is important, why hosts of quilting shows sound like they're talking to three-year-olds, why I can only use my hard-earned frequent-flier miles to go to places I don't want to visit at the most inconvenient times imaginable while sitting in the last coach seat next to the toilets, why doctors with whom I have appointments think nothing of making me wait for hours, and why there still isn't a cure for the common cold. A real cure. Whom can I hold accountable for all of THAT?

And while I'm at it, to my knowledge, no individual or group has claimed culpability for the collapse of investment banks, the escalating price of gas, the failure to alert residents of Myanmar of the approaching cyclone that took the lives of one hundred thousand people, or the CIA's destruction of ninety-two interrogation videos. And will someone please tell me why Bernie Madoff did not receive swifter justice, once it was known that he had put thousands of people who trusted him in serious financial straits?

The point is: Are failures of accountability happening in your organization, in *your* life—perhaps including how you've handled or mishandled your own financial matters? (Bernie is a rat, in my opinion, but what might you have done differently?)

Before we identify the "tells" and talk about what to do, consider two competing ideas:

The progress of my organization depends on my leaders, colleagues, and customers.

or . . .

In a very real sense, the progress of my organization depends on my progress as an individual now.

To which of these beliefs do you subscribe?

One of the reasons so many of us fail to "succeed," by whatever definition we may choose, is that we believe in the first idea. In other words, we believe someone else is running the show, that our progress depends on our bosses and how they treat us, on our colleagues and how talented and helpful they are or aren't, on corporate politics, on customers and whether they have the capacity to understand why they require our products or services, on our spouses or life partners and the degree to which we do or do not feel appreciated and supported by them. And despite whatever therapy we may have endured, we still lay accountability for our progress, or the lack thereof, on our parents' doorsteps, on the degree to which our parents equipped us with all good things throughout our childhoods or messed us up forever.

This attitude certainly makes for a well-protected ego with built-in excuses for just about every eventuality. It allows us to take credit for the good stuff, but when results aren't so good, well, in that case it's not about us; it's about him, her, them, or it. We're merely well-intentioned jellyfish, buffeted by things beyond our control, carried this way and that by the waves, the tides, the politics, the marketplace, the economy, the budget. We're doing the best we can, but really, one can hardly expect us to overcome the pull of the moon.

> We're doing the best we can, but really, one can hardly expect us to overcome the pull of the moon.

On the other hand, if someone asked if we considered ourselves a victim, we'd say, "No way! I'm a powerful person, and for your information, my organization recognizes me as a high potential!"

Well, hang in there for a minute or two. Have you ever said any of the following things? Or thought them?

- My department is struggling because the strategy is flawed.

- I'm behind because so-and-so (or such-and-such) is a bottleneck.

- Our industry is suffering because the margins are tight, our unions are threatening to strike, our competition has forced us into a price war, and our customers have unreasonable expectations.

- Our problem? The price of oil! The board of directors, et cetera.

- We can't get this done without the right technology.

- I haven't been able to focus on this project because I have ADD. (*Have you noticed that some people aren't complaining when they tell you they have ADD? They're bragging!*)

I often speak at functions focused on women in leadership, offering my thoughts about what needs to happen for women to step into and remain in senior leadership roles. In 2005, when I read the Catalyst Census of Women Corporate Officers and Top Earners of the Fortune

500, I was appalled. Apparently, according to the women surveyed, the three significant barriers they face that men rarely do are

1. gender-based stereotyping;

2. exclusion from informal networks; and

3. lack of role models.

This was not the appalling part. It was the solution offered: Not that women should work to defy gender stereotypes, or make efforts to include themselves in informal networks, or strive to be better role models for their peers and for future generations of women. No, it was that companies should mandate diversity and inclusion, because clearly companies are to blame for the barriers facing women. Where's the accountability here?

I'm not suggesting that these barriers don't exist. The glass ceiling is still very real in many industries, and sadly, gender discrimination in the workplace still exists. But what appalled me was how quick the women surveyed were to deny any accountability for the struggles they face. After all, no doubt all three of those conditions existed for Madeleine Albright when she began her stint in the White House as a secretary. Lots of people wondered how "Maddie" went from secretary to secretary of state. Albright's answer: "By doing whatever I was asked to do, including making a pot of coffee, to the best of my ability. I made the best coffee to be found!"

Still, many women play the victim, blaming their flatlined careers on the company, society, the world. And then they wonder why things aren't improving. Accountability has to start from within.

For example, I agree with the female director of data management in a financial firm who suggests that where many women fail is in not being specific about their career aspirations with the people who are in a position to point them in the right direction. Not taking the time to reflect or network to understand what's out there for which they might have exactly what is needed. Not actively seeking candid feedback to learn what qualities and capabilities would make them a viable candi-

date for a new role. And not taking the steps to work on those qualities and demonstrate their considerable talents, abilities, and willingness to learn.

So I confess that I'm not sympathetic when I hear women say things like, "Me, well, the truth is, I don't have a real shot at the top because:

. . . relationships are formed on the golf course, and I'm not a golfer."

. . . I have young kids at home and can't put in the eighty-hour workweeks it takes to get ahead around here."

. . . so-and-so is plotting and scheming for the position I want, and I just won't play those games."

. . . frankly, why would I want a so-called promotion? Those guys in the C suite are miserable. I want to enjoy my weekends."

. . . people don't listen to me because I'm a woman."

I hear this last one from women a lot, and I suspect the reason nobody listens to them is that they say things like that! In my view, the best reasons are really just the worst excuses.

Years ago, a woman who reported to me complained frequently that she hadn't closed any sales because customers weren't returning her calls. I finally said, "Then make yourself the kind of person whose phone calls get returned!" She was shocked, hurt, angry. But starting the next day, her phone calls got returned, and she soon became our top salesperson. In other words, she did something differently. She changed, not the customers.

I see victim tells all the time. For example, at some point during every fierce conversations training, someone will say something like, "I would love to have amazing conversations like this in my company. It would be fantastic. But our leadership and our culture wouldn't support this level of candor."

This statement, this belief is a huge tell. Among other things, it indicates that we don't have a leader here. We may have a potential leader and very likely a delightful person, just not a leader. We have a victim.

Someone who tells him- or herself and others, "I can't be myself here," when actually, a more honest statement would be "Right now, I'm choosing not to muster the courage, will, skill, energy, focus . . . whatever . . . needed to do or say what needs doing or saying."

So if I'm in the room when someone says they can't have fierce conversations because their culture won't support it, I usually say, "Where is this so-called culture with which you're unhappy? Is it out there somewhere? Or is every person in your organization, including you, a walking hologram of the culture? As I look at you right now, I am looking at the culture!" The point is, the culture is not some nebulous and mysterious force out there somewhere. *You* are the culture. *I* am the culture. And each of us shapes that culture each time we walk into a room, pick up the phone, send an e-mail.

> *You* are the culture. *I* am the culture.

Fierce leaders know that they influence the culture one conversation at a time, responding honestly or guardedly when asked what they think. Since you are the culture, you go first! And don't point your finger at leadership—unless you ARE the leadership.

My visual for this:

WHO CAN FIX THE PROBLEMS?
(in the world, in a company, in a family)
X
ATTACH SMALL MIRROR HERE

Revisiting the two competing ideas, remember that in a very real sense, the progress of your organization depends on your progress as an individual now.

So what about the *now* part?

My thought used to be something on the order of *Look, here's the thing. I'm shoehorned into my calendar, got a to-do list that feels impossible! So how 'bout if I focus on some personal development next quarter, next year, when I have a little time?*

That was me not getting it. And then I remembered something a friend said: "Unconsciously, we're always choosing deep growth or slow

death. And sometimes sudden death." A bit dramatic, but I got it. *I* was choosing excuses, practicing victim.

So I'm reminding myself and you, the reader, that *now* is where it happens. Great stories, great changes, great results—those fatal moments, events, choices, conversations that put in place something irreversible—turn on *now*.

ACKNOWLEDGMENTS

My long-term involvement with Vistage felt to me like an ongoing gift exchange, netting me friends and colleagues internationally, as well as tremendous personal growth. If it were not for Phil and Helen Meddings, I would not have had a lively conversation over mead in a Yorkshire castle, a late-night conversation in a conservatory overlooking the Sydney Opera House, and another in a Winchester pub with a young woman who told me the story of her life including the point at which "me life went all pear shaped." If it were not for Vistage colleagues, I would not have watched fireflies from a porch in North Carolina. I would not have received unexpected aid regarding a personal decision during a banquet in San Diego. You can't get those conversations on any street corner. You know who you are. Blessings, every one.

I owe a huge debt to David Whyte for putting the words "fierce" and "conversation" together when he spoke to the Vistage community in January 1999. Those words and much else that David said that day went through me like a current, both electric and oceanic, placing me directly in the stream of what has become a great adventure.

I am deeply grateful to Chris Douglas, Kim Bohr, Stacey Engle, Jasmine Mattson, and the entire Fierce tribe in Seattle and around the world. They demonstrate Smart+Heart every day, and I love them for it.

I salute friends, family, and clients who have been game enough to put on their seat belts and go deep. Conversations with my daughter Jennifer and my granddaughters, Maizy and Clara, take my breath away. I want to be just like them when I grow up.

My agent, Janet Goldstein, kept a firm but gentle hand on the tiller. Few know how to lead so surely, with such a light touch. Janet championed and shaped the original manuscript from beginning to end, and for that, I will be eternally grateful.

Finally, I apologize to all those with whom I learned a thousand and one ways *not* to have a fierce conversation. To you, I raise my glass. Thank you for all you taught me.

INDEX

KLM Photography/Kerry Malinowski

After thirteen years leading CEO think tanks, **Susan Scott** founded Fierce Inc., a global leadership development and training company that transforms the way organizations communicate and connect with their employees and their customers.

CONNECT ONLINE

fierceinc.com